THE ART AND SCIENCE OF THE CHURCH SCREEN
IN MEDIEVAL EUROPE

BOYDELL STUDIES IN MEDIEVAL ART AND ARCHITECTURE

ISSN 2045–4902

Series Editors

Dr Julian Luxford
Professor Asa Simon Mittman

This series aims to provide a forum for debate on the art and architecture of the Middle Ages. It will cover all media, from manuscript illuminations to maps, tapestries, carvings, wall-paintings and stained glass, and all periods and regions, including Byzantine art. Both traditional and more theoretical approaches to the subject are welcome.

Proposals or queries should be sent in the first instance to the editors or to the publisher, at the addresses given below.

Dr Julian Luxford, School of Art History, University of St Andrews, 79 North Street, St Andrews, Fife KY16 9AL, UK

Professor Asa Simon Mittman, Department of Art and Art History, California State University at Chico, Chico, CA 95929-0820, USA

Boydell & Brewer, PO Box 9, Woodbridge, Suffolk IP12 3DF, UK

Previously published titles in the series are listed at the back of this volume.

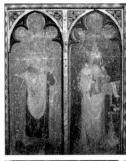

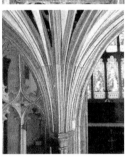

THE ART AND SCIENCE OF THE CHURCH SCREEN IN MEDIEVAL EUROPE

MAKING, MEANING, PRESERVING

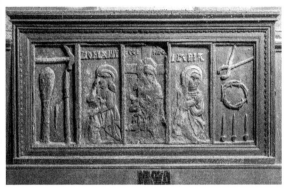

Edited by Spike Bucklow, Richard Marks
and Lucy Wrapson

THE BOYDELL PRESS

First published 2017
The Boydell Press, Woodbridge
Paperback edition 2020

ISBN 978 1 78327 123 8 hardback
ISBN 978 1 78327 535 9 paperback

The Boydell Press is an imprint of Boydell & Brewer Ltd
PO Box 9, Woodbridge, Suffolk, IP12 3DF, UK
and of Boydell & Brewer Inc.
668 Mount Hope Ave, Rochester, NY 14620–2731, USA
website: www.boydellandbrewer.com

The publisher has no responsibility for the continued existence or accuracy
of URLs for external or third-party internet websites referred to in this book,
and does not guarantee that any content on such websites is, or will remain,
accurate or appropriate

A CIP catalogue record for this book is available
from the British Library

This publication is printed on acid-free paper

Printed and bound in Great Britain by TJ International Ltd, Padstow, Cornwall

CONTENTS

List of Illustrations vii
List of Contributors xvi
Preface xvii

 Introduction 1
 Paul Binski

1 Framing the Rood in medieval England and Wales 7
 Richard Marks

2 Science and the screen 30
 Spike Bucklow

3 Towards a new methodological approach for 45
 interpreting workshop activity and dating
 medieval church screens
 Lucy Wrapson

4 Texts and detexting on late medieval English 71
 church screens
 David Griffith

5 Sacred kingship, genealogy and the late medieval 100
 rood screen: Catfield and beyond
 Julian Luxford

6 West Country rood screens: construction and 123
 practice
 H. Harrison and J. West

7 The polychromy of Devon screens: preliminary 150
 analytical results
 Lucy Wrapson and Eddie Sinclair

8 Moving pictures on the Gothic choir screen 176
 Jacqueline E. Jung

9 The preserving power of Calvinism: 195
 pre-Reformation chancel screens in the
 Netherlands
 Justin E. A. Kroesen

10 Recovering the lost rood screens of medieval 220
 and Renaissance Italy
 Donal Cooper

11 Choir screens and rood lofts in Scandinavian 246
 parish churches before 1300
 Ebbe Nyborg

Bibliography 262
Index of names and places 296

ILLUSTRATIONS

PLATES I–XXXI (BETWEEN PAGES 78 AND 79)

I Dauntsey (Wiltshire). Last Judgement tympanum over chancel arch (Photo: Hugh Harrison)

II Wenhaston (Suffolk). Last Judgement tympanum (Photo: David Griffith)

III Salisbury, SS Thomas and Edmund (Wiltshire). Last Judgement (Photo: David Griffith)

IV Strensham (Worcestershire). Rood loft panels (Photo: David Griffith)

V Azurite paint on Bramfield (Suffolk) rood screen (Photo: Lucy Wrapson © Hamilton Kerr Institute, University of Cambridge)

VI Light transmitted through azurite particles (Photo: Spike Bucklow © Hamilton Kerr Institute, University of Cambridge)

VII Azurite particles seen under crossed-polars (Photo: Spike Bucklow © Hamilton Kerr Institute, University of Cambridge)

VIII Endgrain of an oak panel showing medullary rays and annual growth rings (Photo: Chris Titmus © Hamilton Kerr Institute, University of Cambridge)

IX Matching tin relief from Alburgh, Trunch and South Burlingham pulpit (Photo: Lucy Wrapson © Hamilton Kerr Institute, University of Cambridge)

X Matching stencils from Thwaite, South Burlingham pulpit, Lessingham, Fritton and Alburgh (Photo: Lucy Wrapson © Hamilton Kerr Institute, University of Cambridge)

XI Binham Priory (Norfolk), rood screen dado panel (Photo: David Griffith)

XII Thornham (Norfolk), King David and Jeremias from a sequence of biblical figures with prophetic texts (Photo: David Griffith)

XIII Gateley (Norfolk), the Virgin Mary ('Sancta Maria') and the uncanonized 'Sca Puella Ridibowne' (Photo: David Griffith)

XIV Ashton (Devon), north aisle chapel screen (Photo: David Griffith)

XV Catfield: the rood screen from the south-west (Photo: Julian
 Luxford)
XVI Catfield: the north side of the dado (Photo: Julian Luxford)
XVII Catfield: the south side of the dado (Photo: Julian Luxford)
XVIII Catfield: the kings in compartments N5 and N6: SS Sebert (?)
 and Kenelm (Photo: Julian Luxford)
XIX Kentisbeare (Devon). Original screen thoughout (Photo: Hugh
 Harrison)
XX Hennock (Devon). The ceilure in its traditional position above
 the rood screen (Photo: Hugh Harrison)
XXI Kenton (Devon). The horizontal emphasis of a Devon screen
 even with its gallery front (Photo: Hugh Harrison)
XXII Halberton (Devon). A screen built in the centre of the arched
 arch (Photo: Hugh Harrison)
XXIII Wolborough (Devon). A door with a grown durn as the hanging
 stile (Photo: Hugh Harrison)
XXIV Kenton (Devon). Nineteenth-century tabernacles and figures with
 original bases (Photo: Hugh Harrison)
XXV Kenton (Devon). Two of the canopied niches that decorate the
 doorway (Photo: Hugh Harrison)
XXVI High Ham (Somerset). The typical canopied heads to the tracery
 lights (Photo: Hugh Harrison)
XXVII Sancreed (Cornwall). A typically Cornish dado mixing figures
 and animals with repeated patterns (Photo: Hugh Harrison)
XXVIII A graphic illustrating the minimal core of a rood screen post at
 springing height (Photo: Hugh Harrison)
XXIX Drawing showing construction of typical vaulted rood loft, as
 seen at High Ham (Somerset) (Photo: Hugh Harrison)
XXX Drawing showing the two types of rood screen main arcade
 tracery (Photo: Hugh Harrison)
XXXI Pilton (Devon) compared with Lapford (Devon) (Photo: Hugh
 Harrison)

 PLATES XXXII–LXII (BETWEEN PAGES 238 AND 239)

XXXII Norton Fitzwarren (Somerset). The narrative carving showing
 hunting and ploughing, wrestling and rude pea shooting (Photo:
 Hugh Harrison)
XXXIII Holne (Devon) compared with Tintagel (Cornwall) (Photo: Hugh
 Harrison)
XXXIV The rood screen at Holne (Devon), after conservation treatment
 (Photo © Eddie Sinclair)
XXXV Holne rood screen compared with Kenton screen (Photo of
 Holne © Mark Somerville. Photo of Kenton © Eddie Sinclair)
XXXVI Details from figures on the north and south side of the chancel

screen at Holcombe Burnell (Devon) (Photo © Lucy Wrapson, Hamilton Kerr Institute, University of Cambridge)

XXXVII Muntin at Bridford (Devon) showing the lead tin yellow scheme on the reverse and the gilded scheme on the front (Photo © Lucy Wrapson, Hamilton Kerr Institute, University of Cambridge)

XXXVIII The screen and pulpit at Holne form a set together (Photo © Eddie Sinclair)

XXXIX The *Annunciation* from the screen at Buckland-in-the-Moor (Devon) (Photo © Eddie Sinclair)

XL The *Visitation* from the reverse side of the screen at Ashton (Devon) (Photo © Lucy Wrapson, Hamilton Kerr Institute, University of Cambridge)

XLI Cross-section from Sherford rood screen (Devon), bay 1, north end screen (Photo © Lucy Wrapson, Hamilton Kerr Institute, University of Cambridge)

XLII Detail from the screen at Lanreath (Cornwall) (Photo © Eddie Sinclair)

XLIII Infrared photograph showing a *pentimento* in St Thecla's arm, Holcombe Burnell (Photo © Lucy Wrapson, Hamilton Kerr Institute, University of Cambridge)

XLIV Cross-section from Willand rood screen (Devon) in normal and ultraviolet light, from the southernmost bay, crimson from flower (Photo © Lucy Wrapson, Hamilton Kerr Institute, University of Cambridge)

XLV Cheriton Bishop (Devon): lead tin yellow haloes and croziers, gilded tracery and wings (Photo © Lucy Wrapson, Hamilton Kerr Institute, University of Cambridge)

XLVI Bridford: gilded dado figures (Photo © Eddie Sinclair)

XLVII The plank and muntin screen at Marker's Cottage (Devon) (Photo © Eddie Sinclair. Reproduced by kind permission of the National Trust)

XLVIII Detail of the pelican in her piety from the plank and muntin screen at Little Harvey Farm (Devon) (Photo © Eddie Sinclair)

XLIX Naumburg Cathedral, west choir screen (Photo: Jacqueline Jung)

L Naumburg Cathedral, west choir screen, relief of Christ before Pilate (Photo: Jacqueline Jung)

LI Krewerd, village church, gallery (c.1300) and organ (1531) viewed from the nave (Photo: Justin Kroesen and Regnerus Steensma)

LII Ter Apel, former monastery church, gallery (c.1500) viewed from the chancel (Photo: Justin Kroesen and Regnerus Steensma)

LIII Easterein/Oosterend, village church, gallery (1554) viewed from the nave (Photo: Regnerus Steensma)

LIV Map of the Netherlands showing the geographical spread of pre-Reformation screens and galleries (Drawing: Justin Kroesen)

LV Amsterdam, New Church, Protestant screen (1647–50) viewed from the nave (Photo: Regnerus Steensma)

LVI Noordwijk-Binnen, St Jerome, Protestant screen with text panels
 (c.1650) viewed from the nave (Photo: Regnerus Steensma)
LVII Giotto and workshop, *The Miracle of the Crib at Greccio*, fresco,
 c.1290–97, Upper Church, Basilica of San Francesco (Stefan
 Diller, assisi.de)
LVIII Montano d'Arezzo (attrib.), *Blessed Ambrogio Sansedoni
 Preaching*, fresco, c.1290, San Domenico, Arezzo (Photo: Donal
 Cooper)
LIX Angelo and Bartolomeo degli Erri, *Saint Vincent Ferrer Baptizing
 Two Converts*, tempera on panel, 61 x 34cm, c.1460–80,
 Gemäldegalerie, Kunsthistorisches Museum, Vienna (formerly
 San Domenico, Modena) (KHM Museumsverband)
LX Giotto and workshop, *Funeral of Saint Francis and Verification
 of the Stigmata*, fresco, c.1290–97, Upper Church, Basilica of San
 Francesco, Assisi (Stefan Diller, assisi.de)
LXI Titian, *Assunta*, oil on panel, 690 x 360cm, 1516–18, Basilica
 of Santa Maria Gloriosa dei Frari, Venice, viewed through
 the central doorway of the choir screen, sculpted by Pietro
 Lombardo's workshop in 1475 (Photo: Donal Cooper, courtesy of
 the Curia Patriarcale, Venice)
LXII Torpo stave church, Norway, rood altar ciborium (and remains
 of rood loft) (Photo: Birger Lindstad © Directorate for Cultural
 Heritage, Norway)

FIGURES

Fig. 1.1 Burton Dassett (Warwickshire). Detail of Rood over chancel 11
 arch (Photo: Perry Lithgow Partnership)
Fig. 1.2 Ludham (Norfolk). Rood tympanum (Photo: David Griffith) 12
Fig. 1.3 Kingston (Cambridgeshire). Outlines of Rood and angels 14
 over chancel (Photo: Perry Lithgow Partnership)
Fig. 1.4 Raunds (Northamptonshire). Rood outline (Photo: David 14
 Griffith)
Fig. 1.5 Great Hockham (Norfolk). Outlines of Rood/Trinity and 15
 Annunciation over chancel arch (Photo: David Griffith)
Fig. 1.6 Bettws Gwerfil Goch (Clwyd). Rood loft panels (Photo: 17
 RCAHMW)
Fig. 1.7 Llanelian yn Rhos (Clwyd). Rood loft panels (Photos: 19
 RCAHMW)
Fig. 1.8 Weston Longville (Norfolk). Screen dado apostles and 20
 bidding prayer for Richard Lyon (Photo: David Griffith)
Fig. 1.9 North Crawley (Buckinghamshire). Screen dado (Photo: 23
 David Griffith)
Fig. 1.10 Hempstead (Norfolk). Screen dado, including SS Blaise 26
 and Erasmus (Photo: Lucy Wrapson © Hamilton Kerr
 Institute, University of Cambridge)

Fig. 1.11 Foxley (Norfolk). Screen dado with donors (Photo: David 28
 Griffith)

Fig. 3.1 Bench-end figures at St John's College, Cambridge and 54
 Jesus College, Cambridge
Fig. 3.2 Fourteenth-century rood screen transom moulding 57
 profiles
Fig. 3.3 Early fifteenth-century rood screen transom moulding 57
 profiles (1400–59) with average or inscribed dates
Fig. 3.4. Mid- to late fifteenth-century transom moulding 57
 profiles (1460–99) with average or inscribed dates
Fig. 3.5 Sixteenth-century transom moulding profiles with average 57
 or inscribed dates
Fig. 3.6 Rood screen transom joints: mason's mitre at Ranworth 59
 (Norfolk), scribed at Southwold (Suffolk), hybrid at
 Tacolneston (Norfolk)
Fig. 3.7 Barton Turf and Westwick rood screen transom moulding 62
 profiles
Fig. 3.8 Barton Turf and Westwick rood screen tracery heads 62
Fig. 3.9 Barton Turf and Westwick rood screen tracery bases 62
Fig. 3.10 Brettenham and Ipswich St Matthew's screens 63
Fig. 3.11 Moulding profiles at a) Southwold north and b) south 64
 parcloses, c) Woodbridge and e) Brettenham
Fig. 3.12 Woodbridge and Southwold north and south parclose 64
 tracery heads
 *Chapter 3: All photos Lucy Wrapson © Hamilton Kerr Institute, University of
 Cambridge.*

Fig. 4.1 Grundisburgh (Suffolk), parclose screen dado panel with 83
 sacred trigram 'IHS' in quincunx and 'Maria Regina',
 probably mid- to late fifteenth century
Fig. 4.2 Weasenham, All Saints (Norfolk), SS Jerome and Gregory, 86
 from the rood screen dado
Fig. 4.3 South Walsham (Norfolk), part of Latin and English 91
 inscription commemorating the painting of the screen as
 the gift of John Galt and his unnamed wife, probably
 mid-fifteenth century
Fig. 4.4 Cawston (Norfolk), 'God spede the plow', opening section 93
 of a carved inscription on west end gallery, probably late
 fifteenth century
Fig. 4.5 Campsall (Yorkshire), English verse inscription carved on 95
 rood screen sill, probably second half of the fifteenth century
Fig. 4.6 North Walsham (Norfolk), door of the former chapel of 97
 Thomas of Canterbury, late fifteenth century, with defaced
 Latin inscription marking benefaction of the fraternity
 Chapter 4: All photos © David Griffith.

Fig. 5.1 Catfield (Norfolk): the nave, looking east towards the screen 102
 and chancel (Photo: Julian Luxford)
Fig. 5.2 University of St Andrews Library, MS 38660, m. 2 (front): 118
 detail of a later fifteenth-century genealogical roll of English
 kings, partly in English (Photo: University of St Andrews
 Library, MS 38660, m. 2 (front), with thanks to Rachel Hart)
Fig. 5.3 BL, MS Royal 1.B.X, f. 1v: a genealogical stemma of the 120
 mid-fifteenth century which includes Christ (Photo:
 reproduced by permission of the British Library Board)
Fig. 5.4 East Harling (Norfolk): panel from the dado of a fifteenth- 122
 century screen showing a Tree of Jesse containing a
 Crucifixion (Photo: Julian Luxford)

Fig. 6.1 Cullompton (Devon). The deep candlebeam with holes for 131
 the candles in the top edge, sitting on the bressummer
 beam which has mortices for the gallery front
Fig. 6.2 North Huish (Devon). An example of a screen with 132
 rectangular main arcade tracery panels which fit in slots
 cut through the main posts
Fig. 6.3 Hennock (Devon). A screen with arched main arcade 132
 tracery panels and arch braces morticed into the sides of
 the main posts and into the underside of the head-beam
Fig. 6.4 Halberton (Devon). A deep *tas-de-charge* employed in the 133
 vaulting
Fig. 6.5 Uffculme (Devon). The vault rib loosely tenoned into 134
 junction of the transverse rib and lierne rib
Fig. 6.6 Uffculme (Devon). The decayed vault partially rebuilt 134
 showing the *tas-de-charge* in opposition, also the
 transverse vaulting rib
Fig. 6.7 Halberton (Devon). The different weight vault structure 136
 can be seen on both sides of the screen
Fig. 6.8 Composite showing joint types: a) Holne (Devon), b) High 138
 Ham (Somerset), c) Sherford (Devon), d) West Worlington
 (Devon)
Fig. 6.9 Dittisham (Devon). Jack Palmer, foreman of St Sidwell's 139
 Art Works, fitting a temporarily curved vault rib
Chapter 6: All photos © Hugh Harrison.

Fig. 8.1 Florence, Santissima Annunziata, model of the apparatus for 178
 the *Annunciation* play (Photo: R. Benini, M. Bertoni; Leo
 S. Olschki Editore; after Hall, 'The *Tramezzo* in the Italian
 Renaissance', Fig. 8)
Fig. 8.2 Havelberg Cathedral, choir screen ensemble (Photo: 181
 Jacqueline Jung)
Fig. 8.3 Havelberg Cathedral, ground plan with liturgical settings 181
 indicated (Photo: after Georg Dehio, *Handbuch der
 deutschen Kunstdenkmäler: Sachsen Anhalt I*, updated by

Ute Bednarz, Folkhard Cremer et al. (Munich: Deutscher
Kunstverlag, 2002), p. 380)

Fig. 8.4 Gelnhausen, St Mary, choir screen with view to high altar 183
 (Photos and digital manipulation: Jacqueline Jung)

Fig. 8.5 Chartres Cathedral, choir screen, plan and elevation 188
 (Photo: after Mallion, *Chartres*, p. 84)

Fig. 8.6 Chartres Cathedral, reliefs from choir screen (Photos: after 190
 Jung, *The Gothic Screen*, Fig. 102, Col. Pls XXVIII, XXIX,
 and Fig. 160; digital montage: Jacqueline Jung)

Fig. 8.7 Chartres Cathedral, reliefs from choir screen (Photo: 190
 Jacqueline Jung)

Fig. 9.1 Schoonhoven, St Bartholomew, gallery (c.1550) viewed 198
 from the nave (Photo: Regnerus Steensma)

Fig. 9.2 Leiden, St Peter, screen (1425–50) viewed from the nave 203
 (Photo: Justin Kroesen and Regnerus Steensma)

Fig. 9.3 Haarlem, St Bavo, screen (1507–14) viewed from the nave 203
 (Photo: Regnerus Steensma)

Fig. 9.4 Weesp, St Laurence, screen (c.1525) viewed from the 206
 chancel (Photo: Regnerus Steensma)

Fig. 9.5 Utrecht, St James, tripartite screen (1500–25) extending 206
 over three aisles (Photo: Regnerus Steensma)

Fig. 9.6 Naarden, St Vitus, screen (1531) viewed from the nave 209
 (Photo: Regnerus Steensma)

Fig. 9.7 Enkhuizen, St Gommarus, screen (1542) viewed from the 210
 nave (Photo: Regnerus Steensma)

Fig. 9.8 Monnickendam, St Nicholas, screen (1545–50) viewed 212
 from the nave (Photo: Regnerus Steensma)

Fig. 9.9 Oosthuizen, screen (c.1550) viewed from the nave (Photo: 213
 Regnerus Steensma)

Fig. 9.10 Noordwolde, village church, permanent fittings for the 217
 Lord's Supper in the former chancel, c.1660 (Photo:
 Regnerus Steensma)

Fig. 10.1 Vittore Carpaccio, *Vision of Prior Ottobon in the Church* 222
 of Sant'Antonio in Castello, Venice, oil on canvas, 123 x
 177.5cm, c.1512, Gallerie dell'Accademia, Venice (Photo
 © Photo SCALA, Florence, courtesy of the Ministero
 Beni e Att. Culturali)

Fig. 10.2 Marcia Hall, isometric reconstruction of the *tramezzo* 225
 screen in Santa Croce, Florence (Reproduced courtesy
 of Marcia Hall)

Fig. 10.3 Nave screen, c.1189, Badia di Santa Maria, Vezzolano 228
 (Photo: Nicola Quirico)

Fig. 10.4 Nave screen, c.1300, Badia di Sant'Andrea in Flumine, 228
 Ponzano Romano (© J. Paul Getty Trust. Getty Research
 Institute, Los Angeles (86.P.8))

Fig. 10.5 Fra Giovanni da Pistoia(?), *Project for, or Plan of, San* 232
 Francesco, Arezzo, pen and ink on parchment, mid-
 fourteenth century, Archivio Capitolare, Arezzo (Carte di
 varie provenienza n. 873) (Fondazione archivi e biblioteche
 diocesani, Arezzo)
Fig. 10.6 Anonymous Florentine artist, *Fra Girolamo Savonarola* 237
 Preaching in Florence Cathedral, woodcut illustration
 from the *Compendio di revelatione dello inutile servo di*
 Iesu Christo frate Hieronymo da Ferrara dell'Ordine de
 Frate Predicatori, Florence, 1496 (Inc 6316.10 (A),
 Houghton Library, Harvard University; image in the
 public domain)

Fig. 11.1 Hopperstad stave church, Norway, chancel arch forming 249
 a 'false' screen (Drawing: G. A. Bull. © Directorate for
 Cultural Heritage, Norway)
Fig. 11.2 Torpo stave church, Norway, 'gallery front' of 'screen' 250
 with runic inscription: 'Torolf made this church'
 (Measurement by G. A. Bull 1855. Drawing: after
 Norges Kirker)
Fig. 11.3 Torpo stave church, Norway, perspectives of nave with 251
 reconstruction of *antesancta* by Håkon Christie 1981
 (Drawing: after *Norges Kirker*)
Fig. 11.4 Eidfjord church, Norway, choir screen, c.1300 251
 (Reconstructed by Anne Marta Hoff. After Hoff, *Korskillet*)
Fig. 11.5 Rygge church, Norway, chancel arch wall with internal 252
 stairs leading to open arcade above the arch (Drawing:
 G. A. Bull. © Directorate for Cultural Heritage, Norway)
Fig. 11.6 Tingvoll church, Norway, reconstruction of an *antesanctum* 253
 with choir screen and rood loft, early thirteenth century
 (Drawing: Hoff, 'Korskiljevegen')
Fig. 11.7 Kinn church, Norway, rood loft c.1250, reinstalled 1911–12 254
 (Photo: © Directorate for Cultural Heritage, Norway)
Fig. 11.8 Stånga church, Gotland, Sweden (Drawing: after Roosval, 255
 'Triumfkrucifixet')
Fig. 11.9 Danish brick-built choir screens, c.1200. Tikøb church 256
 (Reconstructed by Elna Møller, 1967). Ørslev church
 (Reconstructed by the author)
Fig. 11.10 Bjerning church, Denmark (North Schleswig), choir screen, 257
 c.1220. Relief of the Last Judgement and an ecclesiastical
 donor, National Museum, Copenhagen, Denmark (Photo:
 National Museum). Reconstruction of *antesanctum* with
 choir screen (Reconstructed by the author)
Fig. 11.11 Halk church, Denmark (North Schleswig), reconstruction 258
 of screening rood altar arched retable, c.1250 (Reconstructed
 by the author)

Fig. 11.12 Nordhackstedt (Nørre Haksted) church, Germany (South 259
 Schleswig), reconstruction of rood loft, c.1285 (Reconstructed
 by the author)

TABLES

Table 3.1 Datable Norfolk and Suffolk screens and joint types 49
Table 7.1 Church screens 162
Table 7.2 Plank and muntin screens 163

GRAPHS

Graph 3.1 Graph to show joint type compared with average dates 60
 of screens in Norfolk and Suffolk

The editors, contributors and publishers are grateful to all the institutions and persons listed for permission to reproduce the materials in which they hold copyright. Every effort has been made to trace the copyright holders; apologies are offered for any omission, and the publishers will be pleased to add any necessary acknowledgement in subsequent editions.

CONTRIBUTORS

Paul Binski	University of Cambridge
Spike Bucklow	Hamilton Kerr Institute, University of Cambridge
Donal Cooper	University of Cambridge
David Griffith	University of Birmingham
Hugh Harrison	Independent scholar
Jacqueline E. Jung	Yale University
Justin E. A. Kroesen	University of Bergen, Norway
Julian Luxford	University of St Andrews
Richard Marks	University of Cambridge
Ebbe Nyborg	The National Museum of Denmark
Eddie Sinclair	Independent scholar
Jeffrey West	Independent scholar
Lucy Wrapson	Hamilton Kerr Institute, University of Cambridge

PREFACE

The essays which comprise this book are the fruits of an interdisciplinary conference held in Cambridge in April 2012 entitled 'The Art and Science of Medieval Church Screens'. Convened by the Cambridge University Medieval Panel Painting Research Centre, the conference brought together leading art historians, religious historians and conservators at Cambridge's Centre for Research in the Arts, Social Sciences and Humanities (CRASSH). The objective of the conference was to shape new understandings of old barriers: the richly carved and painted screens which filled medieval churches. In this vein, the essays in this book range geographically from Italy to Scandinavia and thematically tackle the subject from scientific and art-historical perspectives, as well as through integration of the two.

We would like to acknowledge the contributions not only of the authors, but of others, both institutions and individuals, to the publication of this volume. Mention should be made of CRASSH who supported, hosted and publicized the conference at which these papers were given, and Helga Brandt in particular for her work on this. The editorial committee would like to thank Tim Knox, Bill Weiller and The Mellon Center for British Art for their generous financial support. Particular mention should go to the Leverhulme Trust for their funding of Spike Bucklow and Lucy Wrapson's work on East Anglian rood screens which inspired the conference in the first place. The essays' authors would like to express their gratitude to those individuals and organizations who have supported their work in myriad ways: John Allan, Keith Bacon, Paul Binski, Spike Bucklow, Rachel Canty, Elizabeth Cheadle, The Churches Buildings Council, Simon Cotton, Tobit Curteis, The Hamilton Kerr Institute, Hugh Harrison, Catherine Hassall, The Headley Trust, The Heritage Lottery Fund, Susie Hulbert and the Anna Hulbert archive, Nick Humphries for access to a Devon screen dado at the V&A Museum, Roger and Jackie Jackson, David King, Richard Marks, The Monument Trust, The National Trust, Pauline Plummer, Ian Tyers and Lucy Wrapson. A word of thanks is also owed to all those

churchwardens and members of the public who have raised funds for the conservation of English rood screens in the past forty years and who have unlocked churches for many of our contributors.

Finally we are greatly indebted to Caroline Palmer of Boydell and Brewer and to the publishers themselves for their support of this book which has been long in the gestation, but which we hope has been worth the labour.

Spike Bucklow, Richard Marks and Lucy Wrapson
University of Cambridge

INTRODUCTION

PAUL BINSKI

In 1959 the Cambridge academic, novelist and mandarin C. P. Snow delivered a lecture entitled 'The Two Cultures and the Scientific Revolution'[1] in which he lamented that 'the whole of western society is increasingly being split into two groups', by which he meant on the one hand literary intellectuals, and on the other the scientists, physical scientists especially. As an opening to a book on medieval church screens, Snow's ambitious theory might seem overemphatic. I raise it solely to introduce a series of essays which includes scientists and artists working in perfect harmony to try to understand a form of medieval church furnishing widespread in the Catholic and Orthodox spheres. In the light of such cooperation Snow's distinction quickly becomes too categorical. In practice, the existence of a set of common problems allows us to set aside disciplinary differences or hierarchy, not least when many of the scientists involved are also practising art historians. Since the nineteenth century some of the humanities, after all, have laid claim to being scientific: hence the German expression *Kunstwissenschaft*, the 'science' of art history which manifested itself in a formalism which claimed to be methodical, value-free, scientifically neutral. We are familiar too with the expressions 'human science', 'social science' and 'moral science'. Snow's distinction is, in reality, clouded by an extraordinary range and overlap of beliefs, claims and practices within the humanities themselves. Some of these are reflected in the essays which follow, which, it is hoped, will help set aside the idea that, as Spike Bucklow states in his contribution on science and the screen, medieval church screens and science might initially seem odd bedfellows.

The conference from which this volume has developed was organized under the auspices of the Centre for Research in the Arts, Social Sciences and Humanities, the Hamilton Kerr Institute (the easel painting conservation unit of the Fitzwilliam Museum) and the Department of

[1] Later published in *The Two Cultures and the Scientific Revolution* (London, 1959).

History of Art at Cambridge University. The interest in Cambridge in rood screens has been a natural development of a number of conservation projects conducted at the Hamilton Kerr Institute over the past two decades, including the conservation of the great Westminster and Thornham Parva Retables, two magnificent medieval altarpieces dating to the thirteenth and fourteenth centuries.[2] Because Cambridge lies on the western fringes of medieval East Anglia, and because Norfolk in particular preserves unusually large numbers of later medieval (generally late fifteenth and early sixteenth) painted rood screens, its university is ideally located to consider a hinterland of medieval art and architecture almost unsurpassed in northern Europe. Cambridge is also a great science university; but in recent years its historians, like many of their contemporaries working in Europe, Russia and North America, have turned their attention to the material culture of religion as never before, and the imagery of the rood, the great Cross, and its supporting screens has inevitably been drawn into the discussion.[3] So the aims of the conference were several. Bringing conservators, scientists, historians of religion and art historians together was a priority. So too were regional and internationalist perspectives, recognizing that the use of painted wooden partitions in churches was common to pretty well all parts of Christendom. The essays published here, drawn from different areas of England, Europe and North America, reflect this new richness of study.

A brief introduction is not the moment for a potted history of the study of church screens. This is a huge topic whose literature extends well back into the nineteenth century, indeed to the time when the creation of new rood screens was a matter of active interest and controversy with the rise of religious revivalism and what in England was known as 'ecclesiology'. In England, to concentrate for moment on just one sphere, A. W. Pugin's *Treatise on Church Screens and Rood Lofts* (1851) was one of the founding documents of a general school of thought, generally 'High Anglican' or Catholic in confession, which included F. Bligh Bond (1864–1945), the Benedictine monk Dom Bede Camm (1864–1942), Francis Bond and

[2] See A. Massing (ed.), *The Thornham Parva Retable: Technique, Conservation and Context of an English Medieval Painting* (Cambridge and Turnhout, 2003); P. Binski and A. Massing (eds), *The Westminster Retable* (London and Turnhout, 2009).

[3] I cite for instance such works as N. J. Morgan, 'The Norwegian and Swedish *Crucifixi Dolorosi* c.1300–50 in their European Context', in J. Nadolny et al. (eds), *Medieval Painting in Northern Europe: Techniques, Analysis, Art History. Studies in Commemoration of the 70th birthday of Unn Plahter*, (London, 2006), pp. 266–78; R. Marks, 'To the Honour and Pleasure of Almighty God, and to the Comfort of the Parishioners: The Rood and Remembrance', in Z. Opačić and A. Timmermann (eds), *Image, Memory and Devotion: Liber Amicorum Paul Crossley* (Studies in Gothic Art, vol. 2) (Turnhout, 2011), pp. 213–23; R. Marks, 'From Langford to South Cerney: The Rood in Anglo-Norman England': The George Zarnecki Memorial Lecture, *Journal of the British Archaeological Association*, 164 (2011), pp. 172–210; J. M. Munns, 'The Cross of Christ and Anglo-Norman Religious Imagination' (PhD thesis, University of Cambridge, 2010).

Aymer Vallance (1862–1943), whose works are cited in the essays which
follow. These writers were all empiricist rather than analytical by method,
and the role of art history in them was small and seems to have emerged
first in the writings on Norfolk rood screens by W. G. Constable, the first
Director of the Courtauld Institute, in 1929.[4]

What is striking, again from the English perspective, is how academic
enquiry into such screens virtually collapsed between about 1940 and the
late 1980s. Some conservation work continued, notably by Pauline Plummer
at Ranworth and elsewhere, and there were some important exceptions to
this dearth such as the studies of Italian *tramezzi* by Marcia B. Hall.[5] But
quite suddenly from around 1990 screens took on an entirely new and
unexpected academic glamour, to the point where they could actually be
the subject of major articles by younger scholars such as Jacqueline Jung's
study of the screen at Naumburg in the *Art Bulletin*.[6] The reasons for this
are complex and lie as much with the history of religion and religious
practice as with art history or science and conservation, though the
expansion of medieval art history in universities from the 1960s onwards
is likely to have been an element. Important to it appears to have been a
common interest in all disciplines in the nexus of religion and life lived, in
the constitutive role of religion, religious practice and the perception and
function of images, which lent vividness and edge to the newly emergent
thinking about performativity, visuality and human conduct typical of the
academy at least in the English-speaking world. With this new ambition
went a new preoccupation with drilling down into the social fabric of
religion within specific periods and communities. The parish emerged as a
microcosm of much larger issues of the sort exemplified either on the large
scale in Eamon Duffy's *The Stripping of the Altars*, or in terms of exacting
local study by Simon Cotton's work in the late 1980s on Norfolk rood
screens, and by our contributor Richard Marks's work on late medieval
piety and devotion.[7] This fine tradition is continued in the present volume
in the essays by Julian Luxford on the screen at Catfield in Norfolk, and
by Hugh Harrison, Eddie Sinclair and Lucy Wrapson on the remarkable

4 W. G. Constable, 'Some East Anglian Rood-screen Paintings', *The Connoisseur*, 84
(1929), pp. 141–7, 211–20, 290–4, 358–63.
5 M. B. Hall, 'The "Tramezzo" in Santa Croce, Florence and Domenico Veneziano's
Fresco', *The Burlington Magazine*, 112 (1970), pp. 797–9; M. B. Hall, 'The "Tramezzo" in
Santa Croce, Florence, Reconstructed', *The Art Bulletin*, 56 (1974), pp. 325–41; M. B. Hall,
'The "Ponte" in Santa Maria Novella: The Problem of the Rood Screen in Italy', *Journal of
the Warburg and Courtauld Institutes*, 37 (1974), pp. 157–73.
6 J. Jung, 'Beyond the Barrier: The Unifying Role of the Choir Screen in Gothic
Churches', *Art Bulletin*, 82:4 (2000), pp. 622–57.
7 S. Cotton, 'Mediaeval Roodscreens in Norfolk: Their Construction and Painting
Dates', *Norfolk Archaeology*, 40 (1987), pp. 44–54; E. Duffy, *The Stripping of the Altars*
(New Haven, 1992), and see also E. Duffy, 'The Parish, Piety, and Patronage in Late
Medieval East Anglia: The Evidence of Rood Screens', in K. French, G. Gibbs and B.
Kümin (eds), *The Parish in English Life 1400–1600* (Manchester, 1997), pp. 133–62; R.
Marks, *Image and Devotion in Late Medieval England* (Stroud, 2004).

screens in Devon. Writing about medieval Scandinavia before 1300, Ebbe Nyborg reminds us not only that the tradition of screening in churches is an old one, but also that Scandinavia's extraordinary survivals of early polychromed church furnishing have much to tell us about what is lost from north-western Europe as a whole.

Church screens, in other words, have risen to prominence as but one aspect of the human sciences, whether anthropological, religious, ethical, aesthetic or perceptual (the study of the senses, sight and touch especially). The question for those working on such screens, or indeed any aspect of the figurative arts of the medieval church, is how and to what extent these topics of investigation can and should mesh together. In this regard one thing is clear: screens may be regarded as a genre, but no genre can be studied in isolation. In 1999 the present writer published a paper on the art of the medieval parish church whose underlying purpose was to question precisely the dichotomy of Snow's *The Two Cultures* apparent within art history and its related disciplines.[8] This was a reaction against the media-based empiricism of much British art-historical enquiry which in its tendency to specialist focus militated against a more totalizing or 'holistic' account of such arts operating within a social environment, the larger place of religious belief and practice. Central to it was the doctrine that the importance of visual art forms in the religious and social domains derives from the fact that such forms have agency, specifically aesthetic agency: 'the images and installations in parish churches, their colour, technique, expressivity and – dare I say it? – style are constitutive elements in the gestalt of late-medieval art.'[9] It was time in my view for synthesis, not analysis; time for the reinsertion of the human subject into the problem; and time to look once more at actual works of art. It will be obvious too that this sentiment, which I think is now much more widely shared than it was in the 1990s, was also a reaction against the over-textualization of medieval culture which the current emphasis on 'materiality' purports to address.

As frames, then, church screens themselves require framing, setting them within the context either of related and ancillary objects in what Richard Marks calls the *schema*, or of human perception and behaviour, the topic of Jacqueline Jung's discussion of screens and their dynamic relationship with their mobile recipients. Such essays demonstrate a justified dissatisfaction with any method that severs artefact from human agency. Because both audience and object possess agency, this relationship is never simple. There are no 'correct' readings of painted church screens, not least in regard to their balancing of realism and artificiality. As Donal Cooper in his rich essay on the Italian evidence indicates at the outset, such

[8] See P. Binski, 'The English Parish Church and its Art in the Later Middle Ages: A Review of the Problem', *Studies in Iconography* 20 (1999), pp. 1–25.

[9] Binski, 'The English Parish Church', p. 19.

is the power of images that the agency of images could even be deadly. But – contrary to some important writing on the art or images in the Middle Ages – images were not necessarily perceived to be the things they purported to be (for example the saints), and also had deficiencies which actual human behaviour could point up, rather than conceal, precisely by drawing attention to the artificiality of any artwork.[10] This is the cruel message of a devastating passage in Book 6 of Quintilian's *Institutio oratoria* which exposes the incompetence of images, as opposed to words, when used misguidedly, the image ending up a target of mockery because the social occasion required something else.[11] In this lies an important but frequently neglected warning for image-study more generally: that situations have agency as well as objects and subjects, and situations are not always predictable or easy to manage. The issue of text matters too. As David Griffith shows in his essay on texting and detexting, the Reformation took a lively interest in just this issue though, as Justin Kroesen also points out in his study of the virtues of Calvinism for the preservation of artefacts in the Netherlands, the results could be paradoxical.

The debate about the competence of images, however, is far wider than our present concern. What we can agree, and what lies at the heart of many of the essays in this volume, is that the apprehension of church screens is and was necessarily *social*. The ramifications of this concern more than the issues of church and community, and whether screens divided or united, matters dependent to a certain extent on the confessional stance of the historian and which were very apparent in the literature on the topic in the 1990s. What matters too is the persuasive power of the art form itself. While we might argue about the power of frames and painted images, few of us could dispute that, like great sculpted church portals, screens were intended to create a sense of occasion, causing us to pause, to be orientated (that is, directed towards the east), initiating us into the possibility of admission into something unimaginably grander than our own sphere, setting the tone like some grand introit or exordium.[12] In such cases it is not helpful simply to think of the screen as either a barrier or a non-barrier: it is an eloquent, crafted surface. The saints painted or carved on screens direct us to doctrine: they preface and indicate. But in

[10] I allude here, *inter alia*, to the works of C. W. Bynum and H. Belting, such as C. W. Bynum, *Christian Materiality* (New York, 2011) and H. Belting, *Likeness and Presence* (Chicago, 1997) but see specifically D. Freedberg, *The Power of Images: Studies in the History and Theory of Response* (Chicago and London, 1989) and for penetrating reviews of the latter stressing the limitations of images not their powers, see E. Gombrich, 'The Edge of Delusion', *New York Review of Books*, 15 (1990), pp. 6–9, and for a critique of the 'immanence' theories implicit in the work of Freedberg and Bynum, A. C. Danto's review of Freedberg, *The Art Bulletin*, 72:2 (1990) pp. 341–2.
[11] Quintilian, *Institutio oratoria*, Books IV–VI, trans. H. E. Butler, Loeb Classical Library, 125 (Cambridge, MA, 1921), pp. 406–9 (VI. I. 40).
[12] Here I take up M. Carruthers, *The Craft of Thought: Meditation, Rhetoric and the Making of Images, 400–1200* (Cambridge, 1998), pp. 222–3.

their magnificence and sense of occasion they create that dispensation to confident belief that lies at the heart of recent rhetorical discussion of medieval imagery. The saints are demonstrative pointers and also witnesses to *evidentia* to which we, as persons, become witnesses in turn. The point is that the artifice of the screen warms us up to ardent belief – to refer to the language of excitation used in the pastoral discussion of the role of images – that by such means the devotion of the faithful should be fired up: *cum propter hoc excitetur devotio fidelium*. Our assent to the doctrines becomes heartfelt, not just intellectual.

The vividness of the imagery and workmanship of screens is important. In his *Considerations sur saint Joseph*, Jean Gerson (1363–1429), the influential French theologian, made an observation concerning *evidentia* which also assists our understanding that such arts are social and aesthetic. He said that devout affection is moved more by details (*particuliers*) than by abstract universals (*universeles*).[13] From the thirteenth century onwards – and indeed possibly earlier – church screens, whether sculpted or painted, operated typically through details, through their complex specificity, whether this detailing was painted, moulded and gilded, carved or inscribed. They possessed a particular eloquence, that of particularity, which is often shielded by the term 'realism'. This realism, to be sure, is a means of persuasion; but its essence, to make a final point, is that it is *crafted*. In this sense the 'materiality' of the screen is a prerequisite of its capacity to excite, and absorb, and so too of its social agency. Materiality study recognizes, perhaps belatedly, that Modernist criticism tended to privilege form over matter, text over body. For this reason in part, 'crafting' has become a new focus of attention with the rise of rhetorical analysis.

But it is also exactly the juncture where art and science meet because, powerful as the human eye is, and eloquent as the documents occasionally are, scientific analysis of woodwork, of grounds, pigments, gilding and tooling tells us with confidence what it was that went into the crafting of these things in the first place. Such analysis brings us dramatically to one very important social reality of our screens – that as well as being important agents in shaping medieval faith, they were also human artefacts made by those who possessed not just belief, but art.

[13] Jean Gerson, '*Considerations sur saint Joseph*', in P. Glorieux (ed.), *Jean Gerson, Oeuvres complètes* (Paris, 1960–73), vol. 7, pt 1, p. 65.

FRAMING THE ROOD IN MEDIEVAL ENGLAND AND WALES

RICHARD MARKS

In his will made in 1482 John Rogere, Esquire of Freefolk in Hampshire included this petition:

> beseking and requiring my seid lord Jhesus of grace and mercy for all my seid offenses and synnes and to putt betwyxt my soule for all my seid offensis and his rightuysnesse in the day of jugement of my seid soule his mercy principally and the redemption of his bitter passion; adding therto the martirdome cleine streite leving and penance of all the holy company in hevyn of which I besech my lord God of his high grace to be partiner ine for that my goode dedes can not suffice by the which mercy passion and excellent grace I beleve hooly to be savid. The which request, prayer and beleve beyng nowe in holy mynde I beseke all hevyn, erth and angelis, cristen men and soules to wytnesse at the high daye of dome … I bequeth my soule to my lord Goddis mercy that made yt by the bitter passion of his dere son and that may be receyvid into his blisse to glorifie the highe mageste of the blissid trinite eternally.[1]

Rogere's will encompasses the full economy of salvation: the redemptive power of Christ's sacrifice on the cross, the role of the saints (the holy

[1] L. Boatwright, M. Habberjom and P. Hammond (eds), *The Logge Register of Prerogative Court of Canterbury Wills 1479–1486*, Richard III Society, 2008, 1, p. 309 (no. 302). Similar wording was required by William Donyngton for his grave in the London Charterhouse and can still be seen on the brass to John and Alys Spycer at Burford (Oxon). See ibid., vol. 2, p. 56 (no. 209) and R. Marks, '*To the Honour and Pleasure of Almighty God, and to the Comfort of the Parishioners:* The Rood and Remembrance', in Z. Opačić and A. Timmermann (eds), *Image, Memory and Devotion: Liber Amicorum Paul Crossley* (Studies in Gothic Art, vol. 2) (Turnhout, 2011), pp. 213–23.

company of heaven) as intercessors, the salvatory value of good works (and their insufficiency by themselves) and ultimately, how an individual is judged at the last. Representations of Christ on the cross abounded in the medieval church, in windows, on walls, altarpieces, vestments and liturgical vessels and books. The most prominent and important (and a *sine qua non*) was located at the junction between nave and chancel or, in cathedral and monastic churches, between ritual choir and nave. 'Sett on hey in holy chirch' is how the Rood is described by John Mirk, but there is no modern English equivalent terminology of the German *Triumphkreuz* and related linguistic variations which indicates its particular significance in this location: here throughout western Christendom Christ as Lord and King through the ritual celebration of His sacrifice in the Mass offered the promise of salvation.[2]

The origins of the *Triumphkreuz* are traceable back to Carolingian times. The image became increasingly popular during the eleventh century and during the following century was probably universal from Scandinavia to Catalonia. Monumental stone Roods in reliefs occur in England prior to the Norman Conquest at Bitton and Bibury (Gloucestershire) and almost certainly at Bradford on Avon (Wiltshire). It is therefore safe to assume that the *Triumphkreuz* was a universal feature of English secular and monastic establishments pre-1066. Similarly the surviving traces of St John at Halford (Warwickshire) (stone relief) and Kempley (Gloucestershire) as well as the wooden head and a foot of Christ found at South Cerney (Gloucestershire) show that Rood groups were a feature of parish churches from at least the second quarter of the twelfth century and probably some decades earlier.[3]

Further support for the presence of parochial Roods lies in the painted imagery on and around the chancel arch of several Sussex churches of c.1080–1120, which David Park has pointed out would lack meaning without the presence of a *Triumphkreuz*. He has also observed that a Rood must have formed part of the late twelfth-century Passion cycle above the nave north arcade at Ickleton (Cambridgeshire).[4]

Well before Rogere's will, the Rood was therefore framed by

2 T. Erbe (ed.), *Mirk's Festial*, Early English Text Society Extra Series, 96 Pt 1 (1905), p. 171. The literature on the *Triumphkreuz* is immense. Useful compendia are M. Beer, *Triumphkreuze des Mittelalters: Ein Beitrag zu Typus ind Genese im 12. und 13. Jahrhundert* (Regensburg, 2005) and J. E. A. Kroesen and R. Steensma, *The Interior of the Medieval Village Church* (Louvain, Paris and Dudley, MA, 2005), pp. 214–37.
3 R. Marks, 'From Langford to South Cerney: The Rood in Anglo-Norman England': The George Zarnecki Memorial Lecture, *Journal of the British Archaeological Association*, 164 (2011), pp. 172–210.
4 D. Park, 'Romanesque Wall Paintings at Ickleton', in N. Stratford (ed.), *Romanesque and Gothic: Essays for George Zarnecki* (Woodbridge, 1987), pp. 159–69. The pair of censing angels flanking the chancel arch at Nether Wallop (Hants) also points to the former presence of a Rood. See also J. M. Munns, 'The Cross of Christ and Anglo-Norman Religious Imagination' (PhD thesis, University of Cambridge, 2010), 1, pp. 72–5, 83–7.

visual representations of other elements of the Last Things in various configurations. By framing I mean the structures and surfaces associated with the Rood, horizontal as well as vertical, which provided the fields for that imagery and thus defined Rood space. Nowhere in medieval Europe and Scandinavia matches the quantity of the Rood-centred imagery exhibited by the parish churches of late medieval England and Wales. The significance of these 'frames' was not confined to iconographical meaning. Surviving Rood figures, outlines, corbels and pedestals show that, as in some continental parish churches, many were small in scale, so enclosing imagery enhanced their importance.[5]

The images and associated texts themselves might also be conceived of in terms of eschatological frames or narratives of various kinds – iconographical, sacramental, liturgical, commemorative, social, topographical – occurring in various and often overlapping configurations and combinations and for the most part not confined exclusively to one kind of surface or medium. While what has come down to us today is a tiny (and uneven) fragment of what formerly existed, it is I believe possible to reconstruct the broad parameters of these frames for the Rood in the English and Welsh parish church which attained their greatest extent and variety in the last one hundred or so years before the Reformation.

In addition to adjacent walls, these 'frames' might include tympana, floors, panelled celures in the roof bay nearest to the Rood and even the more elaborate nave roofs, some or all of which might be inscribed with imagery and texts. Of prime importance in late medieval England and Wales was the rood screen, for which there were a number of terms, including 'rood loft', 'solar', 'candlebeam' and 'perch', a varied terminology which has created problems in interpretation.[6]

The English and Welsh late medieval parochial rood screen performed, with variations, four functions. It marked the threshold/boundary/partition between the most sacred part of the church (the chancel) and the lay domain (the nave). Secondly, the screen was integrated with the Rood and its associated imagery. Thirdly, through place, image and word (inscribed or spoken in liturgical commemoration) the Rood was localized in each parish. Lastly, it stood as a memorial to those who funded the screen.[7]

[5] For example, the mural Rood group at Ashampstead (Berkshire), the Christ at Cartmel Fell, the outlines at East Shefford (Berkshire), Llanelieu (Powys) and the Holy Trinity Guild Chapel at Stratford-upon-Avon (Warwickshire), the corbels at Glatton (Cambridgeshire) and screen pedestals at Brushford (Devon). For some comparably diminutive parochial *Triumphkreuz* Roods on the Continent see Kroesen and Steensma, *The Interior*, Pls 10.30, 10.35, 10.37, 10.40, 10.42, 10.43, 11.1, 11.16.

[6] See S. Cotton, 'Mediaeval Roodscreens in Norfolk: Their Construction and Painting Dates', *Norfolk Archaeology*, 40 (1987), pp. 44–54; P. Northeast, 'Suffolk Churches in the Later Middle Ages: The Evidence of Wills', in C. Harper-Bill, C. Rawcliffe and R. Wilson (eds), *East Anglia's History: Studies in Honour of Norman Scarfe* (Woodbridge, 2002), p. 98.

[7] For studies of the functions of screens, their imagery and diversity see E. Duffy, *The*

The screen thus simultaneously faced upwards and outwards into the parish community. If the first two functions were common to rood screen imagery throughout western Christendom, the last two were very much an insular feature. Indeed, in parts of England the saints – universal, national and local – who as intercessors for individuals and communities had a major salvatory role – feature in abundance on rood screens. And this imagery, along with that in windows and on walls and sepulchral monuments, reflected the increasing engagement (and visibility) of the laity as a whole with the embellishment of their parish churches. The result, especially in the far West Country and East Anglia, was an enrichment of parochial screens by means of image, word and symbol in paint, wood and alabaster without parallel in western Europe and to which Jacqueline Jung's assessment of earlier screens as 'powerful, subtle, and beautiful vehicles of communication and community' applies.[8]

The focus of this essay therefore is on rood screens not as isolated features, but as part of the *schema* as a whole at the east end of the nave, *schema* which were not invariably immutable, but subject to alteration and replacement. For example, recent conservation has revealed that the imposing Doom painted on the tympanum at Dauntsey (Wiltshire) replaced a pair of angels censing the Rood group on a star-spangled background. Conversely at Burton Dassett (Warwickshire) a mural Doom was erased by angels censing the Rood group (Fig. 1.1).[9] Even in an integrated scheme each element was not necessarily carried out in a single campaign. Indeed, the sole evidence known to me of the coordinated creation of a Doom and a screen is at Marston Moretaine (Bedfordshire) where bequests were made between 1500 and 1505 to both features. Unusually, too, remains of both have survived.[10]

However singular their role was, as marking the boundary between the clerical and lay domains these compartmentalizing devices are by no means uniform. The most open comprised the Rood group floating in space on the roodbeam, as at Denston (Suffolk) and Tunstead (Norfolk).

Stripping of the Altars: Traditional Religion in England c.1400–c.1580 (New Haven, 1992), pp. 111–12, 'both a barrier and no barrier', pp. 157–60, 171–83; Duffy, 'The Parish, Piety, and Patronage in Late Medieval East Anglia: The Evidence of Rood Screens', in K. French, G. Gibbs and B. Kumin (eds), *The Parish in English Life 1400–1600* (Manchester, 1997), pp. 133–62. Helen Lunnon perceives screens as 'gates of heaven' (H. E. Lunnon, 'Observations on the Changing Form of Chancel Screens in Late Medieval Norfolk', *Journal of the British Archaeological Association*, 163 (2010), pp. 120–2). For European and Scandinavian rood screen imagery see Kroesen and Steensma, *The Interior*.
8 J. Jung, 'Beyond the Barrier: The Unifying Role of the Choir Screen in Gothic Churches', *Art Bulletin*, 82:4 (2000), p. 650.
9 I am indebted to Hugh Harrison for information on and illustrations of the Dauntsey conservation programme and to the Perry Lithgow Partnership for Burton Dassett.
10 Bequests to the painting of rood loft occur in 1500, 1500/1 (x2) and 1503 and to 'the painting of the dome in the rood loft 3 s 4d.' in 1505 (A. E. Cirket (ed.), *English Wills, c.1498–1526*, Bedfordshire Historical Record Society, 37 (1957), nos 21d, 23, 23d, 34, 76d, pp. 9, 11, 29).

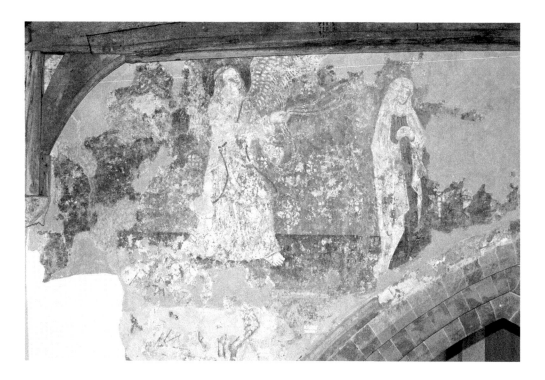

At the other extreme are churches like Dauntsey, Llanelieu (Powys) and Coates-by-Stow (Lincolnshire) where the utilization of wooden, lath and plaster and canvas tympana as a field for the Rood and Rood-centric imagery, to an extent unparalleled in western Europe and Scandinavia virtually seals off the chancel from the nave and reduces the traceried openings of the screen almost to the status of apertures in a solid wall (Pl. I).

Will references and records of destroyed tympana reveal that such structures were more common, especially in single-storey churches like those of Cornwall and Devon, than the few survivors indicate.[11] Their presence at Ludham and Wenhaston demonstrates that even in the case of the lofty parish churches of late medieval East Anglia, the flow of space between nave and chancel which we are accustomed to take as the norm gives a highly misleading impression of their medieval appearance (Fig. 1.2, Pl. II).[12]

FIG. 1.1. BURTON DASSETT (WARWICK-SHIRE). DETAIL OF ROOD OVER CHANCEL ARCH.

[11] For lost as well as existing tympana see A. Vallance, *English Church Screens* (London, 1936), pp.16–29, Pls 26–30, 32–7, 42, 43, 46, 47. For Llanelieu see F. H. Crossley and M. H. Ridgway, 'Screens, Lofts and Stalls, Situated in Wales and Monmouthshire', *Archaeologia Cambrensis*, 102 (1952–53), pp. 66–8; R. Wheeler, *The Medieval Church Screens of the Southern Marches* (Woonton Almeley, 2006), pp. 185–6, Pl. 9.

[12] The Ludham loft is missing, but its location is shown by the entrance from the roodstairs. These were not isolated examples in this part of eastern England. In 1457 a testator bequeathed to Old Newton church in Suffolk 'boards, to make a reredos at the back of the crucifix (unum reredos ad dorsum crucifixi) in an honest and good manner,

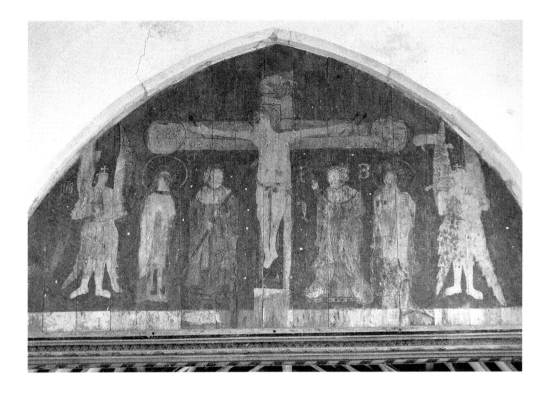

FIG. 1.2. LUDHAM
(NORFOLK). ROOD
TYMPANUM.

The picture, therefore, is one of diversity, diversity which embraces period, scale, design, materials and imagery both between and within regions and yet did not impact on the contemporary perception of the juncture between chancel and nave as an emphatic boundary, whether material or symbolic, as indicated by a Kent will of 1507: 'To the new painting of the Rood and for to *close* [my italics] between the Church and the Chancel and to make a seler over the Rood, £3'.[13]

Establishing the extent of this diversity is problematic because of the scale of screen destruction and displacement, not solely during the Reformation, but also in subsequent centuries (notably of screens in the eighteenth and nineteenth centuries and through replacement and reconstruction of earlier schemes prior to the Reformation).[14] Nowhere

to be provided for the carpenter and the parishioners of the same town', John Jenowr, 1457 (P. Northeast (ed.), *Wills of the Archdeaconry of Sudbury: 1439–1474: I Wills from the Register 'Baldwyne' Part I: 1439–1461*, Suffolk Records Society, 44 (Woodbridge, 2001), no. 908, p. 325). For Wenhaston see K. Whale, 'The Wenhaston Doom: A Biography of a Sixteenth-century Panel Painting', *Proc. Suffolk Institute of Archaeology*, 39 (2009), pp. 299–316.

[13] A. Hussey, *Testamenta Cantiana … East Kent*, Kent Archaeological Society (1907), p. 228. The church was largely demolished and replaced in 1873–75 by a building on a different site; the rood screen was retained.

[14] For a local study of post-Reformation destruction see A. Vallance, 'The History of Roods, Screens, and Lofts in the East Riding', *Yorkshire Archaeological Journal*, 24 (1922), pp. 109–85.

does there survive a single pictorial scheme embracing every eschatological element invoked in Rogere's will. It is therefore impossible to establish how frequently the sacred order of things was replicated visually from floor to roof at the chancel arch by every element in an ascending and linked hierarchy of sanctity. For this reason this essay is a reconstruction made up of diverse fragments.

At its simplest, the Rood with the attendant Virgin and St John are placed against a surface (either a wall or a tympanum) on a plain ground, as at Coates by Stow (Lincolnshire), and with a simple flower-strewn ground signifying the life-giving cross. Frequently the group is accompanied by ancillary figures. At Ludham (Norfolk) the tympanum above the roodbeam is painted with cherubim flanking the Rood group (Fig. 1.2). This dates from Queen Mary's reign, but cherubim were present as early as c.1070–77 on the roodbeam of Canterbury Cathedral and nearly a century later in the same location at Westminster Abbey. Their presence links the Rood with the Last Judgement in accordance with Exodus 25:10–21 and Hebrews 9; at Ludham, too, Christ's suffering is emphasized by Longinus and Stephaton.[15] Leaving aside the cherubim, the angelic host performing a variety of actions appears in association with the Rood. The most common is censing, as at Burton Dassett (Warwickshire), Dauntsey (Wiltshire) (under the present Doom) and Inglesham (Wiltshire), Ellingham (Hampshire), Hook Norton (Oxfordshire) and Kingston (Cambridgeshire) (Figs 1.1, 1.3, Pl. I).

At Kingston a specifically Eucharistic narrative is introduced by other angels catching in chalices the blood from Christ's wounds, an imagery found in depictions of the Crucifixion opposite the canon of the Mass in missals.[16] Several Rood outlines as at Raunds (Northamptonshire) are in the form of the *lignum vitae* cross, the symbolic tree of life given to mankind through Christ's sacrifice, an imagery used in hymns of the Cross, notably during the Good Friday liturgy (Fig. 1.4**)**. Prominent too at Raunds and also East Shefford (Berkshire) is the sacred monogram IHS, presumably connected with the feast of the Name of Jesus.[17]

Other forms of Rood imagery occur. On the wall above the chancel arch of Great Hockham in Norfolk the Rood forms part of a Trinity, reflecting the church's dedication. This finds an echo in the Crucifixion page in the Abingdon Missal (Oxford, Bodleian Lib. MS Digby 227, vol. 1, f. 113v), in which the Trinity is linked with the Crucifixion in the form of the dove of the Holy Ghost perched on the cross-arm and God the Father

[15] The earliest existing representations of cherubim with a Rood group is in Halberstadt Cathedral, Germany, of c.1210–15; see Beer, *Triumphkreuze*, pp. 116–30, 196–205; P. H. Brieger, 'England's Contribution to the Origin and Development of the Triumphal Cross'. *Medieval Studies*, 4 (1942), pp. 85–96; Munns, 'Cross of Christ', pp. 85–7.
[16] See for example BL MS Add. 58078 (K. L. Scott, *Later Gothic Manuscripts 1390–1490* (A Survey of Manuscripts Illuminated in the British Isles) (London, 1996), 1, cat. 113v, Ill.103).
[17] R. W. Pfaff, *New Liturgical Feasts in Later Medieval England* (Oxford, 1970), pp. 62–83.

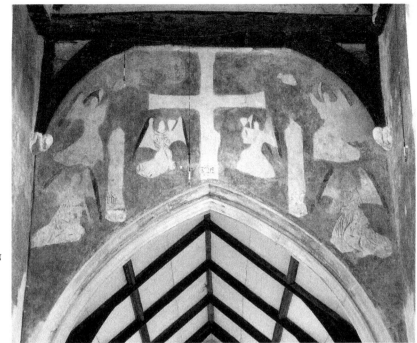

FIG. 1.3. KINGSTON
(CAMBRIDGE-
SHIRE). OUTLINES
OF ROOD AND
ANGELS OVER
CHANCEL.

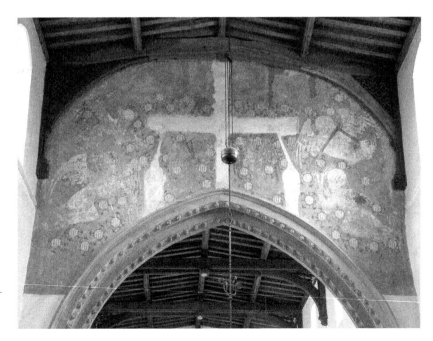

FIG. 1.4. RAUNDS
(NORTHAMPTON-
SHIRE). ROOD
OUTLINE.

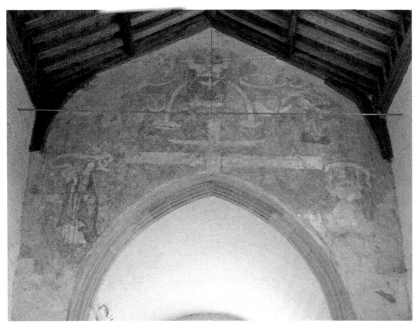

FIG. 1.5. GREAT
HOCKHAM
(NORFOLK).
OUTLINES
OF ROOD/
TRINITY AND
ANNUNCIATION
OVER CHANCEL
ARCH

with open arms (Fig. 1.5).[18] The meaning of this scheme is related to a passage in Rogere's will:

'I bequeth my soule to my lord Goddis mercy that made yt by the bitter passion of his dere son and that may be receyvid into his blisse to glorifie the highe mageste of the blissid trinite eternally.'[19]

In the Abingdon Missal Crucifixion page an angel holds a shield bearing Christ's five wounds. Angels also occur holding Passion emblems in association with the crucified Christ at Raunds and several other locations (Fig. 1.4). Similar visual allusions occur in the Pietàs painted on the side walls and piers respectively of the chancel arches at Hornton and Thame (Oxfordshire), the latter especially closely linked with the Rood by the prominent cross behind the Virgin and the tears of blood she is shedding which manifest her share in Christ's redeeming Passion.[20]–

Direct allusions in word and image to the Rood also occur on screens, as at Campsall (Yorkshire, West Riding):

[18] Scott, *Later Gothic Manuscripts*, 2, cat. 101a, Ill.382. The author observes that the combination of the two subjects is probably unique in this period.

[19] Boatwright, Habberjom and Hammond, *Logge*, 1, p. 309.

[20] R. Marks, 'Viewing Our Lady of Pity', in *Magistro et Amico. Amici Discipulique Lechowi Kalinowskiemu w osiemdziesieciolecie urodzin* (Krakow, 2002), pp. 102, 113–14, Ill.4. repr. in Marks, *Studies in the Art and Imagery of the Middle Ages* (London, 2012), pp. 558–9, 574–5, Fig. 4.

Let fal down thyn ne, & lift up thy hart:
Behold thy Maker on yond cros al to to[rn];
Remember his Wondis that for the did smart,
Gotyn withowut syn, and on a Virgin bor(n),
All His hed percid with a crown of thorne.
Alas! man, thy hart oght to brast in too.
Bewar of the Deuyl whan he blawis his hor(n),
And prais thi gode aungel conne the.[21]

At Bettws Gwerfil Goch, Denbighshire (now in Clwyd), the imagery of what must have been the front to the rood loft formed an integral part of the Rood, with the low-relief figures of the mourning Virgin and St John (now in reversed positions) flanking the image of Christ labelled *Ecce Homo* occupying the central three of five small panels; in the outer panels are the Passion emblems. The probable date is the late fifteenth or early sixteenth century (Fig. 1.6). In 1729 the panels stood against one of the chancel walls and subsequently were re-located to the north wall of the now destroyed singing gallery before their cleaning, framing and use as the reredos for the communion table, probably as a result of the church restoration in 1882. Thomas's suggestion, repeating that made earlier by Bloxham that they were part of the rood loft, is supported by comparison in size and compartmentalization with other Welsh lofts (e.g. Cascob, Llanfilo and Llangeview, also St Margarets, Herefordshire).[22] Passion emblems occur elsewhere on screen dados. At Chesterfield (Derbyshire) and Hitcham (Suffolk) they are held by angels; at Blackawton (Devon) they are present on shields. On the Blundeston (Suffolk) screen dado angels hold scrolls bearing *Passio Christi Salvatoris*. Here the referent is eschatological: on Judgement Day the instruments of the Passion will appear.[23]

[21] J. E. Morris, *Little Guides: The West Riding of Yorkshire* (2nd edn revised, London, 1923), p. 147. Campsall is one of a group of late medieval churches in West Yorkshire with vernacular texts. Another also relating to the Rood is in the nave roof at Almondbury, where Christ admonishes blasphemers (Morris, *Little Guides: The West Riding*, pp. 82–3).

[22] Archdeacon Thomas, 'Montgomeryshire Screens and Rood-lofts', *Archaeologia Cambrensis* 6th series, 4 Pt 2 (1902), pp. 94–6 (citing Bloxham, *Principles of Gothic Ecclesiastical Architecture in England*, 2 (London, 1882), p. 42). D. R. Thomas, *The History of the Diocese of St Asaph*, 2 (Oswestry, 1911), p. 137 (including caption to a photograph of the panels). The entire artefact measures 4ft 3in. x 2ft 3in. For comparisons of size and compartmentalization see Wheeler, *Medieval Church Screens*, pp. 63, 163, 191, 245. For other studies of screens in Wales and adjoining English counties see C. Tracy, 'Three Rood-screens in South-east Wales', in J. R. Kenyon and D. M. Williams (eds), *Cardiff: Architecture and Archaeology in the Medieval Diocese of Llandaff*, British Archaeological Association Conference Transactions, 29 (2006), pp. 161–201 and the articles by Crossley and Ridgway in *Archaeologia Cambrensis*.

[23] Erbe (ed.), *Mirk's Festial*, p. 252; R. Woolf, *The English Religious Lyric in the Middle Ages* (Oxford, 1968), p. 208.

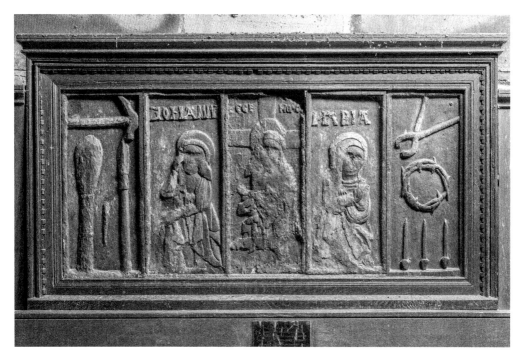

FIG. 1.6. BETTWS
GWERFIL GOCH
(CLWYD). ROOD
LOFT PANELS

THE DOOM/LAST JUDGEMENT

From the twelfth century the Doom or Last Judgement – the soteriological exposition of salvation encompassing earthly and sacred history – was the most common imagery around the chancel arch. In this location the Last Judgement was visually linked with the *Triumphkreuz,* the ultimate symbol of Christ's sacrifice for mankind. Jane Ashby in her unpublished dissertation listed 117 Last Judgements or Dooms (both existing and recorded) executed between the twelfth and sixteenth centuries in this position. Of these she attributed only a handful to dates before the late thirteenth century and the majority to the fifteenth and early sixteenth centuries.[24]

The explosion in the popularity of this theme is bound up with the acceptance of the doctrine of purgatory formulated in the twelfth century

[24] J. E. Ashby, 'English Medieval Murals of the Doom: A Descriptive Catalogue and Introduction' (MPhil thesis, University of York, 1980), pp. 21, 27–105, 166. See also R. Rosewell, *Medieval Wall Paintings in English and Welsh Churches* (Woodbridge, 2008), pp. 72–81, 345–6. The discovery of the Last Judgement mural over the chancel arch at Houghton-on-the-Hill (Norfolk) has pushed back the date of its appearance in this location to somewhere between c.1080 and 1100 (Munns, 'Cross of Christ', pp. 28–32). That many more Dooms formerly existed is demonstrated by texts on roodbeams from Matthew 24:34 and 41 separating the elect from the damned (Hemingford Abbots (Cambridgeshire), Bromsgrove (Worcestershire), Penshurst (Kent), Thurleigh (Bedfordshire) and Wood Eaton (Oxfordshire); Ashby, 'English Medieval Murals', p. 405.)

and established at the councils of Lyon in 1245 and 1274 with its stress on good works, the intercession of the saints and divine judgement (Matthew 25:29–46).[25] This theological shift is reflected in a change in the representation of Christ, now showing the Passion wounds and seated on a rainbow instead of a throne and with the Virgin and St John the Baptist (sometimes John the Evangelist) kneeling in intercession for mankind. The apostles, too, often participate in accordance with Matthew 19:28. Increasingly, too, the spaces allocated to the torments of Hell and the concomitant rewards of Heaven are emphasized (Pl. III).[26] Ashby noted that surviving examples are overwhelmingly concentrated on the eastern side of England between Lincoln and Lewes (Sussex), with Salisbury marking the westernmost boundary.[27] Amongst the explanations she put forward for this geographical bias was the strong antiquarian interest in this area from the late nineteenth century, when extensive church restoration proved revelatory. Although tympana in wood, canvas or lath and plaster are cited, she was unaware of the Doom at Wenhaston near the Suffolk coast to the east; also the Doom over the chancel arch at Wrexham and the compressed Doom painted on what evidently was the rood loft or at least its central section in the church of St Elian at Llanelian yn Rhos (Clwyd), which moves the western boundary into Wales (Fig. 1.7).[28] There is little reason to doubt therefore that the Last Judgement in association with the Rood could be found throughout England and Wales.

THE HOLY COMPANY IN HEVYN

The Llanelian Doom includes the weighing of souls, with the Virgin placing her rosary in St Michael's scales to tip the balance in favour of the figure being weighed against a devil. In another panel is St Eustace, converted to Christianity through seeing a stag with a crucifix between its antlers.[29]

[25] The classic study is J. le Goff, *The Birth of Purgatory* (Chicago, 1986); see also Duffy, *The Stripping of the Altars*, pp. 338–76 and A. Caiger-Smith, *English Medieval Mural Paintings* (Oxford, 1963), pp. 31–43. For a localized impact see E. C. Tingle, *Purgatory and Piety in Brittany 1480–1720* (Farnham, 2012).

[26] Ashby, 'English Medieval Murals', pp. 64–6; Caiger-Smith, *English Medieval Mural Paintings*, pp. 34–5.

[27] Ashby, 'English Medieval Murals', p. 24, Fig. II.

[28] For Wrexham see Rosewell, *Medieval Wall Paintings*, p. 308. The Llanelian paintings were restored in 1874. That the panels belonged to a rood loft is clear from a note of c.1770–80 made by the Welsh antiquary Thomas Pennant, which stated that they were located in a gallery separating the chancel from the nave. That the loft is incomplete is indicated by its relatively short length compared with the width of the church and Pennant being informed that there were formerly many more 'saints' (notes in the RCHM (Wales) files). S. R. Glynne noted that in his day the loft was in the west gallery ('Notes', *Arch. Cambrensis*, 5th series, 1 (1884), p. 100).

[29] For the Virgin's intercession in the weighing of souls see A. Caiger-Smith, *English Medieval Wall-Paintings* (Oxford, 1963), pp. 60–2. For St Eustace see F. S. Ellis (ed.), *The*

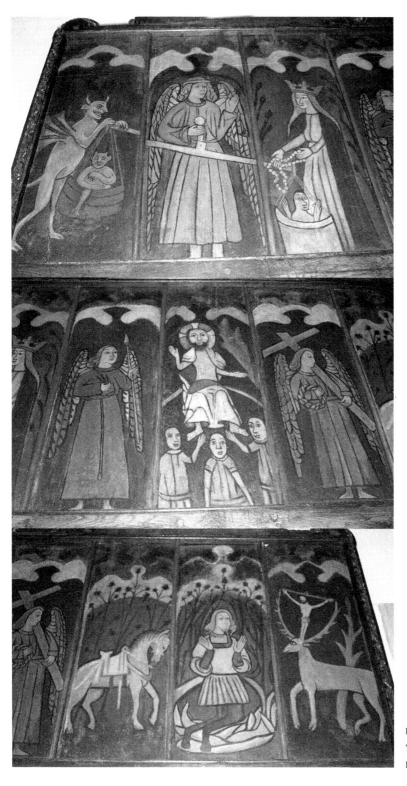

FIG. 1.7. LLANELIAN
YN RHOS (CLWYD).
ROOD LOFT PANELS.

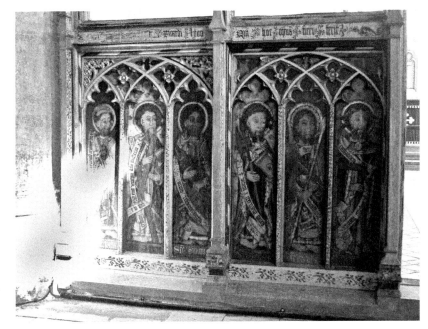

FIG. 1.8. WESTON
LONGVILLE
(NORFOLK).
SCREEN DADO
APOSTLES AND
BIDDING PRAYER
FOR RICHARD
LYON.

These panels bring us back to the rood screen which provided the
principal field for the 'holy company in hevyn' invoked in Rogere's
will. The most common subjects on screen dados are the apostles, the
assembled witnesses to the Second Coming, sometimes paired with the
prophets, their Old Testament precursors. The verses of the Creed which
each of the apostles was said to have contributed after Pentecost sometimes
appear on scrolls, a feature with a liturgical reference as an integral part
of the Mass. As early as 1155-60, the apostles were represented on the
Durham Cathedral pulpitum, as recorded in the *Rites of Durham* and on
surviving roodbeams in northern Europe from the early thirteenth century
(Halberstadt Cathedral).[30] In the fifteenth and early sixteenth centuries
they were a common feature of parochial screens. Eamon Duffy cites
twenty-seven apostle sets on the dados of forty-two Devon screens, and
twenty-four on eighty Norfolk screens (Fig. 1.8).[31] By contrast in Suffolk

Golden Legend or Lives of the Saints as Englished by William Caxton, vol. 6 (London,
1900), p. 84. A similar abbreviated version of the Doom appears in the chancel arch
murals at Cowlinge (Suffolk).

[30] J. T. Fowler (ed.), *Rites of Durham*, Surtees Society, 107 (1902), p. 33; see also T. E.
Russo, 'The Romanesque Rood Screen of Durham Cathedral: Context and Form', in
D. Rollason, M. Harvey and M. Prestwich (eds.), *Anglo-Norman Durham 1093–1193*
(Woodbridge, 1994), pp. 266–7. For Halberstadt see J. Jung, *The Gothic Screen, Space,
Sculpture, and Community in the Cathedrals of France and Germany, ca. 1200–1400*
(Cambridge, 2013), p. 48, Fig. 39.

[31] Duffy, 'The Parish', p. 149. My figures differ slightly, but without significantly altering
the ratio.

they are present on a mere seven out of thirty-nine screens, and there are no apostle sets at all in the Midland and southern counties surveyed by Lillie, with the exception of a solitary example of Latchingdon, and as that is in Essex it can be considered to belong to East Anglia.[32]

Common the apostles might be, but even allowing for losses, given their centrality in eschatology and their role in Christ's mission we might ask why they are not more or less ubiquitous. Secondly how might we account for the numerical differences between Devon and Norfolk and between Norfolk and Suffolk? Then there is the matter of the numerous rood screens outside Devon and East Anglia and some, mainly scattered, locations in the Midlands which today exhibit few traces of any imagery yet for which there are copious references in churchwardens' accounts and wills from Lincolnshire to Wiltshire in the South-West and Kent and Sussex in the South-East. These show that the presence of the apostles on screens was widespread, if not more or less universal. To select just two examples: in 1533 the churchwardens of St John the Baptist's church in Bristol paid £2 13s 4d 'for peynting of the nether roode and lofte more with the ij small images and the xij apostles with the angels…………..ij li xiij s iiij d.' On the other side of England eleven years earlier a testator left £2 to Horsham church (Sussex) 'unto the making of xij Appostelles to the Rodelofte'.[33]

The terminology of these references brings the rood loft, the major missing component of the Rood frame, back into the discussion. The rood loft, either as a separate structure or part of a screen, existed in parish churches from at least the thirteenth century and by the early sixteenth century was an extremely common feature.[34] As has already been observed, contemporary terminology presents a difficulty with 'rood loft' used as a catch-all which could include the screen proper. While not every late medieval parish church screen had images in their lofts or even on their dados, nonetheless it is evident from surviving traces and documents that the loft provided a major field for imagery (hence too their rate of destruction in the Reformation) in paint, wood and alabaster and in some areas more so than the screen dado.

A key document is the screen at Strensham (Worcestershire), which is not only outside Devon and East Anglia, but is also the sole rood loft to retain its imagery *in toto* (Pl. IV). This screen has not attracted the attention

[32] W. W. Lillie, 'Medieval Paintings on the Screens of the Parish Churches of Mid and Southern England', *Journal of the British Archaeological Association*, 3rd series, 9 (1944), p. 34.

[33] J. C. Cox, *Churchwardens' Accounts* (London, 1913), p. 179; R. Garraway Rice and W. H. Godfrey (eds), *Transcripts of Sussex Wills*, vol. 2, Sussex Record Society, 42 (1937), p. 346. For Midland screens see Lillie, 'Medieval paintings'.

[34] Vallance, *English Church Screens*, pp. 66–85. That lofts may not have been universal is perhaps indicated by Helen Lunnon's fieldwork-based study of fourteenth- and early fifteenth-century screens in the Breckland part of Norfolk, in nearly one-fifth showed no trace of a loft (Lunnon, 'The Changing Form of Chancel Screens', pp. 120–2).

it merits.[35] Now installed at the west end of the nave, the design of the screen with the superstructure supported by pillars shows that the loft was the sole bearer of images. In the centre of the row in the face of the loft is Christ with an orb, that is, as king, flanked by the apostles and ten saints (all overpainted). he occurs in this location with the apostles on continental screens, as on the Naumburg Cathedral east choir screen (c.1230) and St Peter's church at Stendal (fourteenth-century figures on a fifteenth-century screen).[36] Unlike Strensham, in both these examples are enthroned and occupy more space. A bequest in 1504 towards the extant screen at Eye (Suffolk) refers to a figure of Christ in the same position on the loft: 'the middle pane ('medylpanne') of the new candlebeam in which shall stand an image of our lord to be painted, if it may be borne', Joan Busby, widow.[37]

Was the prominence accorded to the apostles on the Strensham loft exceptional, or is it representative of other loft imagery? With the dearth of surviving lofts direct evidence is sparse. The head-beam of the Bishops Lydeard (Somerset) screen is carved with the Apostles Creed text which suggests the presence of the apostles above. The frieze of grapes and vineleaves below the text is a common feature of screen ornamentation and its reference to Christ's words to the apostles ('I am the vine and ye are the branches', John 15:5) is also an indication. Another approach is to take into account what is present and what is absent from imagery on screen dados. Thus where only prophets are represented on the central dados of screens, as at North Crawley (Buckinghamshire), it is a reasonable assumption that the apostles were in the loft (Fig. 1.9).

The same might hold true where neither prophets nor apostles are depicted on the dado, as in the case of about one-third of Devon screens and two-thirds or so of Norfolk screens for which visual or documentary evidence survives. In Suffolk the case is even stronger as the instances of dado apostles are relatively few. For this county there are two further pointers in this direction. Writing probably in the 1580s or 1590s, Roger Martyn recalled Long Melford church as it existed prior to the Reformation. Immediately following a description of the chanting of the Passion on Good Friday by a priest standing next to the Rood in the loft, which extended the breadth of the church, Martyn noted that 'the side thereof towards the body of the church in 12 partitions in boards was fair painted the images of the 12 Apostles'. While he may have been referring to the screen dado, the context makes it more likely that he was alluding to the loft front. At Blythburgh, another of Suffolk's finest late medieval churches, the figures in relief of God

[35] It is mentioned briefly and illustrated in F. Bond and B. Camm, *Roodscreens and Roodlofts* (London, 1909), 1, pp. 91, 107, Pl. XXXIXa and Wheeler, *Medieval Church Screens*, pp. 66, 115, Pl. 11.

[36] Jung, *The Gothic Screen*, Col. Pl. III; M. Schmelzer, *Der Mittelalterliche Lettner im deutschsprachigen Raum. Typologie und Funktion* (Petersberg, 2004), p. 124, Pl. 83.

[37] P. Northeast transcript of a will in the Suffolk Record Office.

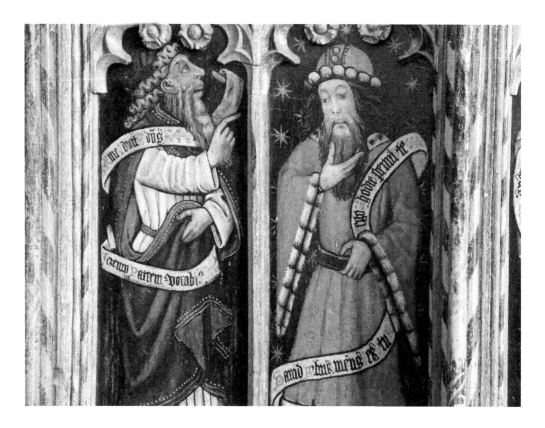

the Father, the apostles, the Virgin and several saints now set in the choir-stall frontals in the same county probably came from the rood loft.[38]

While Llanelian yn Rhos and Strensham show that there was no blueprint for loft imagery, the prominence and centrality of the apostles at the latter is consonant with much testamentary evidence. Overwhelmingly from Kent to Bristol and as far north as Lincolnshire, where loft imagery is specified it is of the apostles, as exemplified by the Bristol and Horsham bequests cited above. The presence of the apostles in the rood loft may also explain their absence from the Doom tympana at Dauntsey, St Michael's church at Albans (Hertfordshire) and Wenhaston (Pl. I). There is of course the danger in taking too literally prepositions such as 'upon', 'in' or 'before'. Nevertheless details of the Lenten veil which covered the Rood sometimes point in the same direction, as at Otterden in Kent, where a testator in 1524 left 4d towards the cost of a cloth to cover the twelve apostles in the rood loft.[39]

FIG. 1.9. NORTH CRAWLEY (BUCK-INGHAMSHIRE). SCREEN DADO.

[38] D. Dymond and C. Paine, *Five Centuries of an English Parish Church: The State of Melford Church, Suffolk* (Cambridge, 2012), p. 62. For Blythburgh see H. M. Cautley, *Suffolk Churches and their Treasures* (Ipswich, 1954), p. 229. In the seventeenth century they were used as part of the schoolroom fittings in the church. These carvings will be the subject of an article by the present author.

[39] Hussey, *Testamenta Cantiana ... East Kent*, p. 244.

None of this is empirically verifiable; amongst other factors no account is taken of any duplication, such as when lofts were additions to existing screens, or conversely where there never was a loft. Nevertheless, where they were in place, lofts were sites of great liturgical and ritual significance, especially on major feasts, as recorded by Martyn at Long Melford. This plus their proximity to the Rood and function as a platform for lights explains their mass destruction during the Reformation. In Norfolk and Wales, while allowance has to be made for post-Reformation amendments and restorations, there is evidence that some lofts had openwork fronts, that is, they were without imagery.[40] In Devon, where the majority of screen dados have apostles, the case may have been different. Here the predominant features of the few surviving lofts are elaborately framed niches whose width suggests that they may have contained narrative scenes rather than single images.[41]

The use of the term 'pageants' rather than images which occurs in several West Country churchwardens' accounts for screens perhaps points in this direction.[42] A model may have been the Exeter Cathedral pulpitum of 1318–25, where a carved Last Judgement was flanked by narrative panels, probably of the Passion.[43]

Strensham also demonstrates that the loft was not the exclusive preserve of the apostles. It comprised a gallery of saints, with the apostles flanked by the images of John the Baptist, Lawrence, Stephen, Anthony, Blaise, three unidentified prelates, Edmund king and martyr and a second king holding a spit, the last perceptively identified by Julian Luxford as Edward II (Pl. IV).[44]

Such an array was by no means unique. Alice Chester in 1483 funded 'a new rood loft in carved work with twenty-two images' in All Saints church, Bristol, and also there are nineteen loft compartments at St Margarets (Herefordshire), twenty-five at Llannano (Radnorshire) and the remarkable total of sixty-nine mentioned at Yatton (Somerset).[45]

The Strensham saints form a pictorial calendar – as on screen dados, neither organized chronologically nor in respect of liturgical use, but a

[40] For example Upper Sheringham (Norfolk), Patrishow (Radnorshire).
[41] Atherington is an example.
[42] For examples of the term 'pageants' see M. A. Williams, 'Medieval English Roodscreens with Special Reference to Devon' (PhD thesis, University of Exeter, 2008), pp. 114, 118.
[43] V. Sekules, 'The Liturgical Furnishings of the Choir of Exeter Cathedral', in F. Kelly (ed.), *Medieval Art and Architecture at Exeter Cathedral*, British Archaeological Association Conference Transactions, 11 (1991), p. 177.
[44] J. Luxford, 'The Iconography of "Saint" Edward II', *Burlington Magazine*, 154 (December 2012), pp. 832–3.
[45] For Bristol see Duffy, 'The Parish', pp. 140–2, citing C. Burgess (ed.), *The Pre-Reformation Records of All Saints' Bristol*, Bristol Record Society, 16 (1995), 1, p. 16. For illustrations of St Margarets and Llanano see Wheeler, *Medieval Church Screens*, pp. 245–6, 169, Pl. 8. For Yatton see E. Hobhouse (ed.), *Churchwardens' Accounts*, Somerset Record Society, 4 (1890), p. 98 – the last probably included small tabernacle images.

selection determined by the concerns, livelihoods and interests of the parish community and the individuals who comprised that community. Whether or not they duplicated or complemented the stock of devotional images found elsewhere in the church, the saints on the Strensham screen acted as intercessors and advocates for the faithful of the parish. Collectively by their presence alongside the apostles, the assembled witnesses to the Second Coming, and proximity to the Rood, they forged a direct link between salvation, the community of Strensham and the individuals who comprised that community. In such gatherings, saints enjoying national or international status rub shoulders with those whose devotional appeal was much more restricted and even with figures who never found their way into official liturgical calendars.[46]

Some saints could be invoked for assistance in quotidian life. St Anthony was held to be efficacious in the curing of swine-fever and cattle ailments, and for the sick and physically afflicted his bodily torments were a source of solace and comfort. St Blaise, represented close by in the glass of Great Malvern Priory, was invoked by those engaged in the wool and cloth trades. Not only occupational but also regional identities were manifested at Strensham through him. The wool trade in the form of cloth-making was the city of Worcester's chief industry. In Henry VIII's reign Leland observed that 'noe towne of England, at this present tyme, maketh so many cloathes yearly, as this towne doth'.[47] The efficacy of relics of saints who were familiar with the area would account for the inclusion of Edward II with his shrine at Gloucester and the site of his murder at Berkeley, only 35 miles from Strensham. Given that his body was at Worcester it would not be surprising if St Oswald was one of the prelates, either as bishop of Worcester or as archbishop of York.[48] Local and 'livelihood' saints such as these embedded the Rood and the Last Judgement in each community; secondly, each individual within that community was linked with the salvatory chain by the presence of their particular sacred helper.

[46] An example is John Schorn, represented on screens in Devon and East Anglia (R. Marks, 'A Late Medieval Pilgrimage Cult: Master John Schorn of North Marston and Windsor', in L. Keen and E. Scarff (eds), *Windsor: Medieval Art and Archaeology of the Thames Valley*, British Archaeological Association Conference Transactions, 25 (2002), pp. 192–207.

[47] L. Toulmin Smith (ed.), *The Itinerary of John Leland in or about the years 1535–1543*, vol. 2 (Illinois, 1963), p. 91. See also Duffy, *The Stripping of the Altars*, pp. 155–205; Duffy, 'The Parish', pp. 150–6.

[48] Locus was not confined to the screen. The mural scheme over the chancel arch at Hook Norton (Oxon) includes SS Peter and Paul; the church today is dedicated to the former and before the Reformation both were probably the patronal saints. The Doom in Holy Trinity church, Coventry includes alewives amongst the damned, a trade which gave rise to civic regulations in the city during the fifteenth century (M. Gill, 'The Doom in Holy Trinity Church and Wall-painting in Medieval Coventry', in L. Monckton and R. K. Morris (eds), *Coventry: Medieval Art, Architecture and Archaeology in the City and its Vicinity*, British Archaeological Association Conference Transactions, 33 (2011), pp. 215–16, Fig. 4).

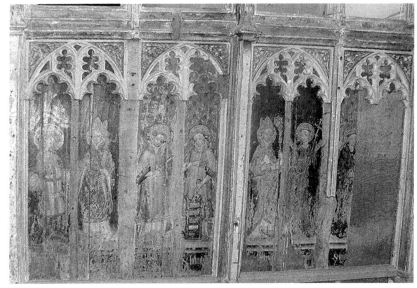

FIG. 1.10. HEMP-
STEAD (NORFOLK).
SCREEN DADO,
INCLUDING SS
BLAISE AND
ERASMUS.

A similar diversity of saints can be found on screens in Devon, where SS Sativola and Urith represent local cults. East Anglia, with SS Edmund, Etheldreda, Walstan, William of Norwich and others, was even richer in saints who through their familiarity with the locality were particularly qualified to act as helpers and intercessors for those who resided there. Together with saints like Edward the Confessor, Henry VI, Becket and Dunstan who enjoyed national status, they bear witness to the strength of insular cults in late medieval England. William of Norwich was not only native to East Anglia, but was also linked visually with the Rood, not as at Llanelian by St Eustace through the presence of a crucifix (Fig. 1.7), but by the emblems of his own death by crucifixion. On the screen dado at Worstead (Norfolk) his image was located immediately to the north of the central entrance to the chancel together with that of St Wilgefortis/ Uncumber with the cross of her own crucifixion, thereby associating them visually with the Rood above.[49]

Jacqueline Jung's observation that the sculptures on the great French and German thirteenth- and fourteenth-century stone screens made the 'sacred accessible, comprehensible, relatable to all' is applicable to the English and Welsh late medieval parochial screens, but by different means.[50] The former provided exemplary models for lay conduct through

[49] For St William see M. R. James and A. Jessopp (eds), *The Life and Miracles of St William of Norwich* (Cambridge, 1896); for St Wilgefortis see R. Marks, 'The Dean and the Bearded Lady: Aspects of the Cult of St Wilgefortis/Uncumber in England', in J. Luxford and M. Michael (eds), *Tributes to Nigel Morgan. Contexts of Medieval Art: Images, Objects and Ideas* (London and Turnhout, 2010), pp. 349–63.

[50] Jung, *The Gothic Screen*, p. 197.

physiognomy, lay clothing and dramatic narrative, the latter spoke to their parishioners primarily through static figures with emblems comprising the tools or products of their livelihood (the wool-carder of St Blaise, the windlass of St Erasmus, the horseshoe, anvil and goldsmithswork of St Eligius, St Anthony's pig, St Sitha's keys or kitchen utensils). Literally as well as metaphorically too, the siting of the saints on screen dados placed them at the level of parishioners (Fig. 1.10).[51] It is the latter who, either singly or collectively, funded the making or embellishments of the structures and surfaces associated with the *Triumphkreuz* which will form the final part of this essay.

THE SOCIAL FRAME

Wills and churchwardens' accounts are a mine of information on the funding of screens in late medieval parish churches throughout England by the laity both collectively and individually. Yet commemoration of benefactors by image and text, a subject that has been explored by Eamon Duffy, is largely confined to East Anglia, whereas their presence in windows is universal.[52] Losses, above all of rood lofts, are an obvious factor and there are a few isolated occurrences in Cambridgeshire, Northamptonshire and Devon, but why East Anglia should be exceptional is not something I can explain, other than to observe that the region (or regions) was wealthy and in the parishes particular pride was taken in the embellishing of the church. Whether this is relevant or not, late medieval East Anglia had what appears to be a developed, even distinctive, devotional culture manifested in the concentration of home-grown saints and the spiritual writings of Julian of Norwich, Osbern Bokenham and John Lydgate.[53]

Wills and inscriptions demonstrate that donors contributed to screens as a whole or specified parts only. Such benefactions might be acknowledged by the representation of the donor with the saint depicted in that panel, as at Foxley, where John Baymonde and his wife kneel before SS Ambrose and Jerome on the screen doors (Fig. 1.11). The heads of the Doctors are inclined towards the couple, listening to the supplications for their souls on scrolls, and hence by centrality of location, pose and exclusive association they are privileged over all other contributors.

Similarly at Weston Longville, Richard Lyon is identified for his 'good work' in funding the screen *in toto* (Fig. 1.8). In return for praying

[51] Duffy, *The Stripping of the Altars*, pp. 155–83.
[52] Duffy, 'The Parish'.
[53] Lillie, 'Medieval Paintings', p. 45 notes lost donor figures at two churches, one in Cambridgeshire and the other in Northamptonshire. There is also a pair at East Portlemouth, Devon (Bond and Camm, *Roodscreens*, 2, p. 216; Williams, 'Medieval English Roodscreens', p. 217. For spiritual life in eastern England see G. McMurray Gibson, *The Theater of Devotion: East Anglian Drama and Society in the Late Middle Ages* (Chicago and London, 1989).

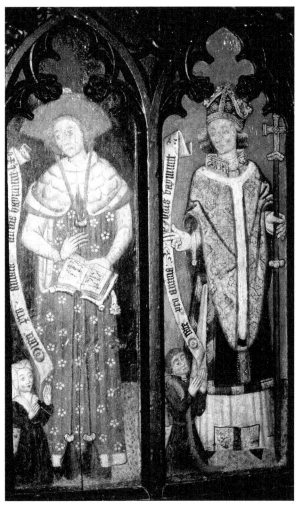

for the souls of a donor family on the lost screen at Kettering (Northamptonshire) a spiritual boon was offered: 'Whoso redis mi name shal have godys blyssing and our lady, and my wffis doo say the same.'[54]

Texts and images such as these had a dual function. They solicited prayers for their donors from their fellow-parishioners in perpetuity and presented models of exemplary lay piety. All this emphasizes the nave and its fittings and furnishings predominantly as lay space, indicated by the 1520 contract for making the rood loft in Great St Mary's church in Cambridge, which was to be made as stipulated by the churchwardens and named parishioners 'by th'assent and consent of all ye parochianers'.[55] References to philanthropy being contingent on communal consultation convey an impression of social cohesion and harmony transcending differences in wealth and status. Whether or not such representations in word and image reflected the reality of life as it was lived, the discourse of donation has a contemporary resonance.[56] Today we are only too well aware of the power of money to wield power and influence.

FIG. 1.11. FOXLEY (NORFOLK). SCREEN DADO WITH DONORS.

The inscription on the screen at Ludham requests prayers for all its benefactors, but only the principal donors are named and the very considerable amount they gave spelt out:

> Pray for the sowle of John [surname erased, but it was Salmon] and Cycyly his wyf that gave forten pounde and for alle other benefactors made in the year of ower lord god MCCCCLXXXXIII.

54 Lillie, 'Medieval Paintings', p. 45.
55 E. Venables, 'The Church of St Mary the Great, Cambridge', *Archaeological Journal*, 12 (1855), p. 251.
56 For a critical examination of the concept of communal harmony see G. Rosser, *The Art of Solidarity in the Middle Ages: Guilds in England 1250–1550* (Oxford, 2015).

Unlike the anonymous benefactors, the identification of the Salmons meant that they could be named in the prayers of the community. Funding on the scale of that of the Salmons was rewarded by the major privilege of burial in front of the rood screen under slabs with commemorative inscriptions, that is, in close proximity to the saintly intercessors and advocates and below the source of salvation, the crucified Christ himself, so that they were, as Julian Luxford eloquently puts it, perpetually anointed by Christ's redeeming blood.[57] By the late Middle Ages, interment below or near the Rood was a much coveted and prestigious site for the laity, eligibility for which seems to have been based on one of, or a combination of, social status and generosity to the church fabric and fittings, especially the Rood and its screen.[58] For the likes of the Salmons, through screen, grave-slab and grave-site, selfhood and identity were asserted and social distinctions emphasized, not erased. 'It is easier for a camel to go through the eye of an needle, than for a rich man to enter into the kingdom of God' say the Gospels (Matthew 19:24, Mark 10:25).[59]

Whether or not Richard Lyon, the Baymondes and the Salmons were the equivalents of today's hedge-fund managers and investment bankers, it might well be the case that their largesse was exercised in recognition of this text and thus were mindful of their need to execute good works on a generous scale. For them charity and enhancement of the parish church was not just a social obligation but an essential pathway to salvation: John Mirk preached that on Judgement Day to rich men 'that han done no mercy' Christ will say 'Goo ye curset lystes ynto ye payne of helle … yn that day; ther schall no pleder helpe, ne gold, ne syluyr, ne othyr yftes; but as a man hath don, he schall haue.'[60] Fortunately perhaps it is not for us to make windows into the souls of these folk or to know whether their benefactions succeeded in purchasing paradise.

[57] J. Luxford, 'The Sparham Corpse Panels: Unique Revelations of Death from Late Fifteenth-century England', *Antiquaries Journal*, 90 (2010), p. 331.
[58] Marks, *'To the Honour and Pleasure'*, p. 218. See also K. Imesch, 'The Altar of the Holy Cross and the Ideal of Adam's Progeny: ut paradysiace loca possideat regionis', in E. E. Dubrick and B. I. Gusick (eds), *Death and Dying in the Middle Ages* (New York, 1999), pp. 73–106; N. Rogers, 'Hic Iacet …: The Location of Monuments in Late Medieval Parish Churches', in C. Burgess and E. Duffy (eds), *The Parish in Late Medieval England*, Harlaxton Medieval Studies, 14 (Donington, 2006), pp. 261–81; Jung, 'Beyond the Barrier', esp. pp. 629–30; Jung, *The Gothic Screen*, pp. 63–4.
[59] This is not the message of the Wenhaston screen, where a king, a queen, a pope and a cardinal are welcomed at the gates of Heaven by St Peter.
[60] Erbe (ed.), *Mirk's Festial*, p. 4.

2

SCIENCE AND THE SCREEN

SPIKE BUCKLOW

Medieval rood screens and modern science might initially seem odd bedfellows. My chapter suggests that even though the cultural issues that underlie such an impression are relatively recent, they are already starting to look somewhat outdated. It attempts a brief overview of what science can offer the current study of screens, together with an assessment of what screens historically offered science. It suggests that the current activities of analytical scientists and art historians are related and that they share common roots in the fifteenth and sixteenth centuries. It concludes that historic artefacts like church screens can benefit from being studied in parallel, using the complementary methods of art history and science.

The 2012 'Art and Science of Medieval Church Screens' conference marked the end of a three-year survey of rood screens in East Anglia, one aim of which was to establish a strategy to provide for their long-term conservation needs. Varying degrees of intervention, on both the screens and the churches that house them, are required to ensure their survival and such interventions need to be informed by knowledge of the screens' material compositions. This knowledge is necessary because different materials and combinations of materials respond differently to their environments. For example, particular materials and combinations may be tolerant of, or sensitive to, ambient levels of light and humidity or the presence of particular gases in a church. Although the physical and chemical reactions between screens and their environments may be slow in terms of an individual's lifetime, over centuries, the fading of pigments, the warping and splitting of wood, or the corrosion of metals can have devastating visual and physical effects. The introduction of heating in churches in the nineteenth century, and neglect and the change in use of church buildings in the twentieth century, have all contributed to accelerated degradation of painted church furniture and, as organic yet immobile architectural features, painted rood screens have been particularly hard hit.

The identification of rood screens' original materials and an under-standing of material combinations – the consequence of historic artists' techniques – were facilitated by the methods of modern science. The chapter starts with an illustrative review of how various material components of, and combinations in, rood screens might be identified. It then considers the circumstances in which rood screens were made and suggests the – perhaps unforeseen, but none the less significant – role that screen-making played in the development of modern science.

ARTISTS' MATERIALS – TIMBERS

Although a comprehensive survey of timbers in European church screens has yet to be undertaken, inspection of the wood in East Anglian English rood screens suggests that it is exclusively oak. This preliminary identification is based on an assessment of 'figure', the visible patterns that show on the cut wood's surface. As such, the initial means of assigning wood species is identical – in perceptual and cognitive terms – to the connoisseurial attribution of works of art. (The identity of wood species based on figure is usually confirmed by the microscopic examination of anatomical features. Although mediated by specialist equipment this task also involves the creation of taxonomies and the placing of individual visual structures within those taxonomies, so is again an essentially connoisseurial activity.) One key visible feature that enabled the identification of oak was the presence of smooth 'tiger stripes', of up to a centimetre or so in width, cutting across the more roughly textured wood grain. These are usually easy to see with the naked eye on the exposed unpainted or stripped backs of dado panels on rood screens.

The tiger stripes are macroscopic anatomical features (medullary rays) which are particularly prominent in oak. They are obvious the moment the timber is split or sawn and their significance as an attributional feature is widely known. Another anatomical feature is also exposed upon chopping or sawing timber but, whilst equally easy to see, its full significance is only slowly emerging in the literature. In the fourth century BC, Theophrastus noted the circular growth rings 'like an onion' in silver-fir trees.[1] Their significance as annual markers of tree growth was noted in a twelfth-century Chinese ghost story and was later commented on in the West.[2] In the late fifteenth century, Leonardo da Vinci correlated the relative thickness of growth rings to 'years which were damper or drier'.[3] In the late sixteenth century, Michel de Montaigne recorded an unnamed carpenter who claimed to know not only the age, but also the original orientation, of

[1] A. Hort (trans.), *Theophrastus: Enquiry into plants*, vol. 1 (London, 1916), p. 423.
[2] J. Needham, *Science and Civilisation in China, Volume 6* (Cambridge, 2000), pp. 631–2.
[3] Codex Urbinas Latinus, 1270; M. Kemp and M. Walker (trans and eds), *Leonardo on Painting* (New Haven, 1989), p. 178.

the trees that sourced his pieces of wood simply by examining variations in their growth rings – he said that annual rings were generally thinner on the northern side of the tree.[4]

Montaigne's record of a chance conversation whilst on his travels through Italy in 1580 is significant because it acknowledges the existence of a body of knowledge in the craft tradition that, being transmitted orally, has hitherto usually escaped the academy. Indeed, a tree's annual growth rings would have no place in popular ghost stories if their significance was not relatively common knowledge, available to the majority of those who might read ghost stories.

Some aspects of this historic body of craft knowledge have now been codified in the discipline of dendrochonology. This discipline involves comparing the particular sequence of relatively thick or thin growth rings in one piece of timber with the sequences of ring thicknesses in other pieces of timber with known origins. By a statistical analysis of the match between novel and established sequences, a chronological and geographical origin for the tree that provided the timber in question can sometimes be determined. (Some types of tree are 'complacent' and their ring width does not vary with the weather, whilst even some 'sensitive' trees will not record weather patterns if they have a constant local source of water.)

The dendrochonologist Ian Tyers examined the growth rings exposed along the top edge of an oak panel depicting St Apollonia from a Norfolk rood screen dated, on stylistic grounds, to c.1480.[5] (The panel is a fragment from St Augustine's church, Norwich, Churches Conservation Trust and is now in St Peter Hungate church.) The single panel was made from two joined boards. Details about one of these boards could not be determined by dendrochronology, but the other board had a pattern of growth rings that corresponded to the period between 1250 and 1393. The sapwood rings – the tree's most recent growth rings, immediately beneath the bark – had been removed because they are particularly vulnerable to attack from insects. Assuming an average of eight sap rings, this finding

4 D. M. Frame (ed. and trans.), *The Complete Works of Michel de Montaigne* (London, 1958), p. 1011.
5 L. Wrapson, 'St Apollonia: HKI# 2700', Unpublished Report, Hamilton Kerr Institute, University of Cambridge (Cambridge, 2013). As Lucy Wrapson's report demonstrates, the panel is unusual in that it has painted rather than applied tracery, both at the top and at the bottom of the figure. The panel is of the correct design and scale to have been part of a rood or parclose screen, and its iconoclastic damage indicates it must have been on public display during either the Reformation or Civil War. Typically screens were painted after they were constructed and this can be seen to be the case here, as there is a lip or barb of paint around the edge of the boards, indicating it has been removed from a wooden framing into which it was set at the time of painting. Furthermore, the early dendrochronology date relative to the painting can be explained: as there is no sapwood and the boards are heavily trimmed, this probably provides an artificially early *terminus post quem* for the painting. Secondly, the boards appear to have been repurposed: two large compass marks can be seen on the reverse of the boards, indicating they may have hung around in a workshop for some time before being installed.

suggests that the tree would have been felled no earlier than about 1401. The pattern of growth rings corresponded most closely to sequences found in trees that grew in the eastern Baltic region. The board for this East Anglian church panel was therefore imported, probably via the Hanseatic port of Gdansk and Lynn/Bishops Lynn/Kings Lynn or Great Yarmouth, around the beginning of the fifteenth century. The finding was not too surprising, since trade in Baltic oak was extensive from the fourteenth to mid-seventeenth century.[6] Using statistical matches of growth sequences, other oak that is chronologically and geographically related to the tree that supplied one-half of the St Apollonia panel has been identified. To date, these related pieces of oak include boat planks, coffin boards and a church boss from Yorkshire, a Copenhagen barrel as well as boards from a church and a shipwreck in Poland, all from the late fourteenth and early fifteenth centuries.[7] Assuming stylistic dating of the St Apollonia panel to be correct, and there is no suggestion that it is not, the wood either lay unused for some time or may have been reused.

From the identification of sources for individual timbers used across northern Europe, modern science has been able to harness the natural patterns found on the end of pieces of wood to throw light upon cultural patterns of wood use, trade and differences in forest management. Further study might determine the extent to which local East Anglian oak could also have been used for some parts of some screens. However, this single, far from prestigious, example suggests that the late fifteenth-century East Anglian rood screen carpenter was integrated into a pan-European network of craftsmen, at least as far as their access to timber was concerned.

ARTISTS' MATERIALS – PIGMENTS

Pigments are the coloured solid powders that are mixed and distributed in a liquid medium which, when it dries, forms a solid matrix that binds the pigments in place. The identification of the media used in rood screen paint was selective rather than comprehensive but all the materials that were sampled were found to conform to standard contemporary northern European painting practice for easel paintings. The initial preparative layer was applied in animal glue and later paint layers were applied in linseed oil, sometimes with additives, such as pine resin.

The pigment in the initial (lowest) preparatory paint layer of all sampled rood screens was chalk and its identification was undertaken by examining a microscopic sample taken from a damaged area of painting. (The identification was confirmed, non-invasively, on a wide number

[6] I. Tyers, 'Aspects of the European Trade in Oak Boards to England', in J. Kirby, S. Nash and J. Cannon (eds), *Trade in Artists' Materials* (London 2010), pp. 42–9.

[7] I. Tyers, 'Report 504'. Unpublished Report, held at the Hamilton Kerr Institute, University of Cambridge (Cambridge, 2013).

of screens by using a technique known as portable X-ray fluorescence.)
Chalk is readily available across East Anglia and may even have been dug
up in the parish in which the painters were working – further analysis
to determine the chalk's original locations is planned. For example, the
identification of micro fossils in chalk, again from the connoisseurial
visual inspection of anatomical structures, allowed the original source of
the chalk used in the preparatory layers of the Thornham Parva Retable
(c.1330) to be located around East Harling, a few miles from Thetford,
where the painting was probably executed.[8]

Microscopic samples taken from other damages allowed the identification
of pigments in the upper paint layers. These were identified using the
technique of Polarized Light Microscopy. This, like dendrochronology
and the identification of chalk's origins, is based on the visual comparison
of selected natural features of a material. In the case of timber, the visual
features in question were determined by the direction in which the wood
was cut. For example, radial longitudinal sections can show tiger stripes,
whilst transverse sections will show growth rings. In the case of pigments,
the visual features are determined by the ways in which an individual
particle is illuminated. The same particle is examined with light that
reflects from its surface and also with light that is transmitted through its
bulk. The light that passes through the particle is examined to see how it
is changed by the particle, including changes in the overall direction of the
ray of light or, with polarized light, changes of direction within the ray of
light. The exact details of these changes are of no concern in the context
of this essay, merely the fact that a number of changes are possible.

When ordinary light bounces off the surface of particles of azurite, for
example, it looks dark blue (Pl. V). When ordinary light passes through
a single particle of azurite, it looks pale blue (Pl. VI). When polarized
light passes through that same particle, it can take on rainbow-like colours
similar to those seen when petrol spills onto a wet road (Pl. VII). These
optical changes (amongst others) allow it to be identified as azurite, as
opposed to other possible blue pigments like indigo, ultramarine and
possibly smalt, if original, or cobalt, Prussian blue and a multitude of
other modern synthetic blues, if applied at a later date.

In Polarized Light Microscopy, pigments are identified by noting
the way in which light interacts with the material in a number of
circumstances. With half-a-dozen or so different appearances in half-
a-dozen or so different circumstances, a unique identity can usually be
inferred. And the way in which a scientist infers the material's identity
from its circumstantial appearances is exactly the same as the way an art
historian identifies a figure in a painting. Imagine, for example, a male
figure in a painting with a religious context. He is clad in fur and has bare

[8] S. Bucklow, 'Analysis of the Chalk Ground', in A. Massing (ed.), *The Thornham Parva Retable* (London, 2004), p. 225.

feet. He may hold a lamb. If he is in the company of other similarly dressed men accompanied by other animals, he is probably a shepherd. Yet if he is alone or with other people who are not similarly dressed and do not have animals, he is probably St John the Baptist. It is the same combination of visible attributes and contexts that allows pigment identifications to be made.

The identification of all the pigments used in rood screens enabled an assessment of the painters' palettes. The full list of pigments found on rood screens suggested a range and variation in the use of pigments that was broadly similar to the range and variation of pigments used at the same time across the whole of Europe. The artists' materials were essentially the same in East Anglian rood screens, in continental European screens and in late medieval polychromy, including panel painting and sculpture.[9] In other words, East Anglian rood screen painters, like their carpenter colleagues, were connected, via their materials, to a much wider tradition.

ARTISTS' METHODS – CARPENTERS

The identification of eastern Baltic oak placed the East Anglian St Apollonia rood screen carpenter in the same supply chain as many other European carpenters. And exactly how they used their oak provides clues to their relationships with individual carpenters, even when the record of names and the secure attribution of works to individuals are patchy. Unfortunately, however, few clues come from the way in which the oak was prepared for painted dado panels on rood screens. This is because eastern Baltic oak was chosen for its particular working properties – its straight grain made it easy to split and guaranteed radial boards that would not warp. As such, its means of working varied little. Initially, the timber was split and then adzed to render more or less parallel-faced boards. Later, the timber was sawn (St Apollonia's board was radially sawn). The difference between split or radially sawn wood is significant further up the supply chain but, as yet, is less significant for studies of variation in practice amongst individual rood screen carpenters.

As pieces of timber, rood screen dado panels may have been technically similar to ship-planks or coffin-boards, but other parts of the rood screen structure were much less generic. Different cuts of wood behave differently (as well as looking different). For example, whilst split or radially sawn oak has a relatively low tendency to warp, non-radially sawn oak is inherently prone to warping. Another expression of oak's different behaviours in different orientations is the fact that expansion and contraction are greater across the grain (where narrow growth rings are seen) rather than

[9] D. Park, 'The Polychromy of English Medieval Sculpture', in S. Boldrick, D. Park and P. Williamson (eds), *Wonder: Painted Sculpture from Medieval England* (Leeds, 2003), pp. 31–54.

along the grain (where wide tiger stripes might be seen). Over time, this difference in behaviour can lead to warping or splitting and the opening of cross-grain joints, which is the main reason why fluctuation of humidity and temperature in churches can have a catastrophic effect on complex or constrained wooden structures.

It is most practical to make long architectural elements, like roof beams, with a single piece of wood. Thus the rood screen's long, thin stanchions and its long, thin transoms are both made with the wood grain running along their lengths. The intersection of (vertical) stanchions and (horizontal) transoms therefore involves a difference in orientation of the wood grain. Initially, the difference in orientation was hidden beneath the painted polychromy. But, over decades or centuries, stanchions and transoms expanded and contracted in response to seasonal variations in humidity and the effect was more marked across their widths than along their lengths. Consequently, joints between the stanchions and transoms (where one member's width met the other's length and vice versa) opened up. This cracked the painted polychromy and revealed gaps of bare wood. Observing this failure, generations of carpenters developed new ways of making these joints so that the unavoidable effect of cross-grain movement was less visually disruptive.[10] Lucy Wrapson has traced the occurrence of various types of stanchion–transom joints in East Anglian rood screens and from them emerge chronological and geographical patterns that allow us to infer the transmission of individual carpenters' influence on neighbouring practitioners. The earlier mason's mitre join is found at Barton Turf, Norfolk (c.1480), whilst the later scribed joint is found at Bramfield, Suffolk (c.1500–15), for example.[11] Such slowly changing routine carpentry methods have previously escaped notice yet, in concert with other data, they are very valuable in helping clarify the date of a rood screen's construction.

Another change in technical methods that has potential to throw light on artists' practices involves the creation of the profiles that decorate lengths of wood like stanchions or transoms. The relative complexity of these carved profiles was subject to geographical variation and to changes in fashion over time, as outlined by Lucy Wrapson in this volume. However, the way in which each individual profile was made could also differ. Profiles could be carved either free-hand with simple chisels or they could be made using planes with complex customized metal blades. (Inconsistencies in East Anglian rood screen transom mouldings suggest that they were exclusively hand-carved with simple gouges and

[10] T. Howson, 'Suffolk Church Screens: Their Production in the Late Middle Ages and their Conservation Today' (PGDip in Building Conservation thesis, Architectural Association, London, 2009), p. 42; L. J. Wrapson, 'Patterns of Production: A Technical Art Historical Study of East Anglia's Late Medieval Screens' (PhD thesis, University of Cambridge, 2013), pp. 81–2.
[11] Wrapson, 'Patterns of Production', pp. 541 and 548.

chisels. Since customized blades were made freehand by an ironmonger, identical moulding profiles on different rood screens, if found, would suggest the use of the same tools in each case.) With due caution, this physical evidence may imply connections between the individual hands or workshops responsible for those screens in which identically produced profiles occur. Analogous connections between individuals or workshops and extant screens can also be discerned in technical methods employed by the painters.

ARTISTS' METHODS – PAINTERS

Artists' adherence to a well-established and stable tradition means that the wide variety of painting materials found on rood screens has not, thus far, enabled particular patterns of use to emerge across East Anglia. In other words, the choice of material by painters in the region shows a high level of uniformity. Nonetheless, distinct differences are evident between the use of pigments in East Anglia and the South-West (see Wrapson and Sinclair, in this volume).

However, identifying painting materials is much easier than characterizing the ways in which they are actually used by individual painters. Unlike wood, paint is a relatively amorphous material and the options it offers the craftsperson are therefore relatively unconstrained. It follows that, when compared to carpenters, there is much greater scope for idiosyncrasy in the use of materials by painters. Yet there are some aspects of painting that are sufficiently constrained to make characterization, and therefore systematic comparison, simple and unambiguous. These more tractable aspects of painters' methods are usually associated with the decorative, as opposed to figurative, aspects of painting.

Decorative motifs occur in the background of figurative painting on many dado panels, some of which are based upon the Cloth of Honour and feature brocade textile patterns. It has been noted that templates for creating brocade patterns were highly valued in Germany, and were passed down through families in the Netherlands.[12] Such templates could be cartoons for guiding a drawn design that was then elaborated upon with paint, but in East Anglian rood screens they tended to be schematic pre-cut stencils that were placed directly on the panel to be painted. These relatively thin flexible templates were not particularly durable but there is evidence of the same stencils being used on a number of different screens,

[12] S. H. Goddard, 'Brocade Patterns in the Shop of the Master of Frankfurt: An Accessory to Stylistic Analysis', *The Art Bulletin*, 67:3 (1985), p. 407; L. Campbell, 'The Early Netherlandish Painters and their Workshops', in D. Hollanders-Favert and R. van Schoute (eds), *Le dessin sous-jacent dans la peinture, Maitre de Flemalle–van der Weyden Colloque III* (Louvain, 1979), p. 53

on backgrounds and at times on brocades, which are presumably products of the same itinerant painters' workshop.

Gold leaf was applied sparingly on rood screens, usually in a manner that ensured maximum visual impact and often also using stencils. The use of low-relief decoration to create a play of reflected light is a commonplace in gilding and the marks left by punches, for example, have been used to plot the use of the same individual tools on numerous panels across Italy.[13] In Italy, broader low-relief surface features were created with the highly labour-intensive method of 'pastiglia', but in Northern Europe similar effects were achieved with the less labour-intensive method of 'tin-relief'. This technique involved tin foil that had been pressed into carved moulds acting as the mass-produced substrate for decorative mordant gilding. The tin-relief carved moulds bore the same relationship to painted decoration that complex plane-blades have to the profiles of (non-freehand) stanchions and transoms.

Many East Anglian rood screens have this type of low-relief gilding and the use of the same tin-relief moulds is evident in several churches. It is also evident on other polychrome church furniture. As demonstrated in Lucy Wrapson's chapter in this volume, the pulpit (but not rood screen) in South Burlingham shows the use of gilding stencils that were also used on the screen in Alburgh, nearly 20 miles to the south. The pulpit also shows the use of the same tin-relief mould that was used on the screen in Trunch, nearly 20 miles to the north. Technical similarities connect some northern panels of the screen at Trunch with screens in Alburgh, Thwaite, Fritton St Catherine's and a second phase of work on Lessingham screen as well as on the pulpit. The presence of the same gilding stencils and tin-relief patterns on screens in these objects suggests that they may be the products of the same itinerant painters' workshop. Similarly, absence of the same gilding stencils and tin-relief patterns on South Burlingham's screen and pulpit suggests that the two objects were the products of different workshops.

The use of templates was not an innovation, new to the making of rood screens. Yet the particular context in which they were used was new. For several centuries, templates (to guide the cutting of stone blocks, for example) had been a key mechanism for the hierarchical centralized coordination of out-sourced labour in the building of great cathedrals.[14] Yet later, in the making of rood screens, templates turned into labour-saving and productivity-increasing devices made by and for autonomous craftspeople. Typical specifications in the commissioning of rood screens often involved comparisons with existing neighbouring screens, so templates also facilitated the replication of products for diverse and

[13] E. Skaug, *Punchmarks from Giotto to Fra Angelico* (Oslo, 1994).
[14] D. Turnbull, 'The Ad Hoc Collective Work of Building Gothic Cathedrals', *Science, Technology and Human Values*, 18:3 (1993), pp. 321–4.

distributed patrons.[15] In other words, the template changed its function. In the cathedral-building campaigns of the thirteenth and fourteenth centuries, the template was imposed by an architect on numerous craftspeople in order to serve an overarching producer's often innovative requirements. On the other hand, in the making of modest parish church screens in the fifteenth and sixteenth centuries, the template had become something that could be harnessed by the individual craftsperson in order to facilitate the satisfaction of relatively conservative consumer tastes.

Template-use exemplifies the technical and social contexts in which cathedrals and rood screens were made and this is directly relevant to the development of the modern analytical scientific methods that have been used to study the products of their work.

SCIENTISTS' METHODS – DEVELOPMENT

This section considers art, craft and science as separate cultural activities without reference to their common roots in the Christian world, for which see, for example, Burtt and Bynum.[16] Neither does it engage in the various understandings of artists' materials that played a role in the trajectories taken by Christian art, one aspect of which was the destruction of rood lofts and the overpainting of rood screens in East Anglia.[17]

An example of a modern scientific method relevant to the study of screens is dendrochronology. This involves making repeated accurate measurements and then processing them statistically. The activity is obviously scientific and many would see it as completely unconnected to the art and craft of making rood screens, even if it might throw some light on those activities as a means of providing an appropriate *terminus post quem*. Yet whilst it may seem that dendrochronology is akin to the reading of thick–thin barcode sequences in modern supermarkets, it is in fact directly related to chiromancy, or, literally, 'hand reading', that was undertaken by the craftsmen who made the screens in the first place. The lines on a piece of wood gave insights into its origin, character and likely future behaviour, just as the lines on someone's hand had divinatory significance.[18] (It should be noted that in addition to a reading *of* the hand, there is of course also a kinaesthetic reading *with* the hand as part of multi-

[15] S. Cotton, 'Mediæval Roodscreens in Norfolk: Their Construction and Painting Dates', *Norfolk Archaeology*, 40:1 (1987), pp. 44–54.
[16] E. A. Burtt, *The Metaphysical Foundations of Modern Physical Science* (London, 1925); C. W. Bynum, *Christian Materiality* (New York, 2011).
[17] K. Jonckheere, 'Images of Stone', in A.-S. Lehmenn, F. Scholten and P. Chapman (eds), *Meaning in Materials: Nederlands Kunsthistorisch Jaarboek*. 62 (2012), pp. 117–46; L. J. Wrapson, 'East Anglian Medieval Church Screens: A Brief Guide to their Physical History', *Bulletin of the Hamilton Kerr Institute*, 4 (2013), pp. 33–47.
[18] M. Baxandall, *The Limewood Sculptors of Renaissance Germany* (New Haven, 1995), pp. 27–49.

sensorial vision.[19] This type of 'hand reading', whilst highly developed in the medieval rood screen carpenter and painter, has been largely eclipsed under the influence of modern science.)

To the extent that complex constructs like rood screens survive intact, they bear witness to the carpenter's skilled chiromancy of lines, including oak's growth rings and medullary rays. Those same skills were hinted at by Michel de Montaigne's reported conversation with an Italian cabinet maker, and their link with modern dendrochronology is evident in the work of the Royal Society in the second half of the seventeenth century.[20] Chemists like Robert Boyle were interested in the activities of craftspeople, and projects like the History of Trades attempted to use craft practices as sources of knowledge about the behaviour of matter. The results were published as works of natural philosophy, which, incidentally, failed to credit the contributions of fifteenth- and sixteenth-century craftspeople.[21]

According to Edgar Zilsel, modern science started when the methods of academic scholars and practising artisans merged in the sixteenth century. He said that the 'upper stratum could contribute logical training, learning and theoretical interest; the lower stratum added causal spirit, experimentation, measurement, quantitative rules of operation, disregard of school authority and objective cooperation.'[22] Not all historians of science agreed, see for example Hall.[23] But I would suggest that a tradition of 'objective cooperation' amongst craftspeople would have been strongly encouraged by the multidisciplinary making of rood screens for local parish churches which has been called 'the most important single focus there has ever been for corporate artistic patronage and devotional investment in the local communities of England.'[24] Screens depended on cooperative incremental financial benefaction and cooperative incremental technical execution and the end result was a negotiated entity in collective ownership. The carpenters and painters who made them had to operate in a market that included many other itinerant craftspeople who all worked and lived in close proximity with their immediate patrons. Indeed, craftspeople could themselves be patrons such as the case of carpenter Thomas Loveday's patronage of the roof at Gestingthorpe, Essex.[25] East Anglian rood screens were very public

[19] J. J. Gibson, *The Ecological Approach to Visual Perception* (Hillsdale, 1986).
[20] K. H. Ochs, 'The Royal Society of London's History of Trades Programme: An Early Episode in Applied Science', *Notes and Records of the Royal Society of London*, 39:2 (1985), pp. 129–58.
[21] P. O. Long, 'The Openness of Knowledge: An Ideal and its Context in Sixteenth-century Writings on Mining', *Technology and Culture*, 32:2 (1991), pp. 354–5.
[22] E. Zilsel, 'The Sociological Roots of Science', *Social Studies of Science*, 30:6 (2000), p. 945.
[23] A. R. Hall, 'The Scholar and the Craftsman in the Scientific Revolution', in M. Clagett (ed.), *Critical Problems in the History of Science* (Madison, 1962), pp. 3–24.
[24] E. Duffy, 'The Parish, Piety, and Patronage in Late Medieval East Anglia: The Evidence of Rood Screens', in K. French, G. Gibbs and B. Kümin (eds), *The Parish in English Life, 1400–1600*, (Manchester, 1997), p. 162.
[25] Wrapson, 'Patterns of Production', pp. 167–8.

enterprises. One of the central tenets of cooperative incremental science, as outlined by Francis Bacon, was the 'benefit of mankind', yet the concept of 'public benefit' was invoked three times in a 1486 craft manual by the mason Mathias Roriczer, over a century before Bacon.[26]

Fellows of the Royal Society were particularly interested in craftspeople's dyes and pigments because of the enormous commercial value attached to colour.[27] They were also interested because of the age-old connection between pigments and drugs, as institutionalized in the guild of St Luke.[28] If the craftspeople themselves remained unacknowledged, early volumes of the Royal Society's *Philosophical Transactions* nonetheless contained numerous articles on the sources, properties and processing of dyes and pigments used in rood screens. They include kermes, cochineal, alum (required to fix these colours), copper green and lead white, amongst others, together with a catalogue of forty-four colours (with 119 painted-out samples) used by painters.[29] East Anglia's screen painters were an integral part of the craft community in which knowledge of these materials developed and resided.

The activities of the Royal Society emerged within an intellectual framework established at the beginning of the seventeenth century by the likes of Francis Bacon and René Descartes. In his 1605 *The Advancement of Learning*, Bacon recommended focusing science on that which could be characterized with materials or simple operations, dismissing tasks 'which consist principally in the subtle motion of the hands ... [as being of] less use'.[30] As a direct result of this chosen focus, modern science has proved highly successful in the characterization of materials – through denrochronology or Polarized Light Microscopy, for example. It has been much less successful in characterizing artists' idiosyncratic paint-handling skills. (Although methods relevant to 'subtle motions of the hand' are now in development.)[31]

[26] E. Zilsel, 'The Genesis of the Concept of Scientific Progress', *Journal of the History of Ideas*, 6:3 (1945), p. 333.

[27] R. A. Donkin, 'Spanish Red: An Ethnographical Study of Cochineal and the Opuntia Cactus', *Transactions of the American Philosophical Society*, 67:5 (1977), pp. 3–84.

[28] G. P. Lomazzo, *A Tracte Containing the Artes of Curious Paintinge Carvinge and Buildinge, Englished by Robert Haydocke (1598)*, Oxford (Farnborough, 1970).

[29] Anon., 'An accompt of the use of the grain of kermes', *Philosophical Transactions*, 1 (1665–66), pp. 935–6; Anon., 'Observations concerning cochineel', *Philosophical Transactions*, 3 (1668), pp. 796–7; D. Colwall, 'An Account of the English alum-works', *Philosophical Transactions*, 12 (1677–78), pp. 1052–6; D. Colwall, 'An Account of the way of making English green-copperas', *Philosophical Transactions*, 12. (1677–78), pp. 1056–9; P. Vernatti, 'A relation on the making of ceruse', *Philosophical Transactions*, 12 (1677–78), pp. 935–6; R. Waller, 'A catalogue of simple and mixt colours, with a specimen of each colour prefixt to its proper name', *Philosophical Transactions*, 16 (1686–92), pp. 24–32.

[30] F. Bacon, *Of the Proficience and Advancement of Learning, Divine and Human* (Oxford, 1605), pp. 257–8; W. E. Houghton, 'The History of Trades: Its Relation to Seventeenth Century Thought as Seen in Bacon, Evelyn and Boyle', *Journal of the History of Ideas*, 2:1 (1941), p. 38.

[31] S. Lyu, D. Rockmore and H. Farid, 'A Digital Technique for Art Authentication',

SCIENTISTS' METHODS – PRACTICE

In theory, modern science is a systematic method of examination, comparison and hypothesis building-and-testing. In practice, it is a learned cultural activity that is undertaken in a community that is managed both formally and informally.[32] I have rather flippantly likened dendrochronology to supermarket barcode reading. However, in practice, there are two reasons why the analogy is inaccurate and misleading. First, the context in which the reading takes place is different. There are a handful of dendrochronologists working in the United Kingdom whilst there are hundreds of thousands of barcode readers across the country (or millions, if the related QR-code readers in mobile phones are included). The scale of the two activities renders them very different in social terms, comparable to the differences found in template-use in a thirteenth-century cathedral and in sixteenth-century parish churches.

Second, the content of what is being read is very different. The supermarket barcode is an artificial pattern specifically designed to be unambiguous, whilst trees' growth rings are natural patterns that possess considerable potential for ambiguity. The ways in which practising scientists deal with such ambiguities have only recently started to be addressed in the literature.[33] As a result of such studies, mainstream mid- to late twentieth-century approaches to the understanding of practices in general have been called into question. This is mainly due to the recognition of two factors – the tacit nature of much of an individual's knowledge about their own practice, and the embedded social nature of all practices.[34]

A specific example of how ambiguity can arise in the annual growth rings of wood is very kindly given by Ian Tyers. The medullary rays in oak cut across growth rings, since the rays are radial and the rings are concentric (Pl. VIII). As the tree grows, the trunk may twist or bend along its length as the tree responds to its environment – other trees, prevailing wind, availability of light, etc. This is more often the case in English oak, since the growing tree's immediate environment in England was more diverse than that provided by Baltic forests.[35] As the tree twisted, the internal tensions were dissipated by the growth rings on one side of a ray 'jumping' in a manner that Tyers describes as 'analogous to geological faults in a quarry section' so that the same-year rings become staggered and no longer line up across the ray. In a large piece of wood, such 'jumps'

Proceedings of the National Academy of Sciences, 101:49 (2004), pp. 17006–10.
[32] J. Lave, *Cognition in Practice* (Cambridge, 1998); J. Lave and E. Wenger, *Situated Learning* (Cambridge, 1991); E. Wenger, *Communities of Practice* (Cambridge, 1998).
[33] S. Delamont and P. Atkinson, 'Doctoring Uncertainty: Mastering Craft Knowledge', *Social Studies of Science*. 31:1 (2002), pp. 87–107.
[34] M. Polanyi, *The Tacit Dimension* (London, 1966); H. Collins, *Tacit and Explicit Knowledge* (Chicago, 2010); S. Turner, *The Social Theory of Practices; tradition, tacit knowledge and presuppositions* (Chicago, 1994).
[35] S. Bucklow, *The Riddle of the Image* (London, 2014), pp. 204–7.

can be recognized by reference to both sides of the ray, but if the visible section of wood is very limited – as on the bevelled edge of a thin radial panel painting – then there may be no context to enable the apparently missing or extra years to be inferred. If such 'jumps' are suspected, then growth rings on the other end of the panel are examined to try and synchronize the sequences at the top and bottom of the painting. In a thin sample which cannot provide reference to both sides of a ray, a 'jump' may be suspected because of 'subtle lines in the rays ... differences of density within the vessels ... [or] colouration changes'. It is not always possible to resolve these ambiguities and a date range for the piece of wood may not be forthcoming. Success in such cases depends on 'experience' since 'you cannot teach stuff like that'.[36]

The fact that Ian Tyers draws upon his experience to resolve ambiguities indicates that scientists have to be able to resort to something very similar to what a connoisseur might call 'impressions of quality' when making their judgements. Yet, because of the type of phenomenon they study, scientists may sometimes also be able to test their subjective impressions by using other methods that identify objective evidence. One example of testable 'gestalt appreciation' of complex visual phenomena is the instant, at-a-distance and unaccountable identification of moss species in the field that can be checked by examination of a microscopic sample's morphology back in the laboratory.[37]

Fifteenth- and sixteenth-century craftspeople were fully aware of what historians and sociologists of science are only now slowly rediscovering. After all, they called their crafts 'mysteries' and they conscientiously transmitted 'secrets' that were manifest as non-discursive knowledge 'secreted' physically within their bodies and socially within their guilds.[38]

Before the eighteenth century, 'art' meant any skill that could be learned (even if it could not be taught). But art's meaning has changed. By the late twentieth century, some connoisseurs were seeking empirical objective quantitative data with which to test subjective qualitative art-historical judgements.[39] And, at the same time, anthropologists were beginning to recognize the ways in which subjective qualitative judgements underlie the apparently empirical objective quantitative data upon which science is built. The past decade or so has witnessed an increased recognition of commonality across the 'two cultures'. Both cultures engage in positivist

[36] Personal communication with Ian Tyers: 17 November 2014.
[37] R. Ellis, 'Jizz and the Joy of Pattern Recognition', *Social Studies of Science*, 41:6 (2011), pp. 769–90.
[38] P. H. Smith, *The Body of the Artisan* (Chicago, 2004) and Bucklow, *Riddle of the Image*, pp. 19–22.
[39] P. Cannon-Brookes, 'Art History, Connoisseurship and Scientific Literacy', *The International Journal of Museum Management and Curatorship*, 7 (1988), pp. 5–10; M. Kirby Talley, 'Connoisseurship and the Methodology of the Rembrandt Research Project', *The International Journal of Museum Management and Curatorship*, 8 (1988), pp. 175–214.

analysis and both also engage in interpretive narrative. The fundamental difference between art and science (or technology) that was confidently asserted in the nineteenth and twentieth centuries is now very much open to question.[40]

Those carpenters and painters who actually made rood screens may have worked within dichotomies – Art and Nature, or Art and Genius, for example – but, for them, art and science were one.[41] Astrologically, artists and those who would later become known as scientists were both 'children of Mercury'.[42] I would suggest that rood screens themselves are best understood in terms that straddle the arts and the sciences. The combination of essays presented in this volume attempts just that.

[40] T. Ingold, *The Perception of the Environment* (London, 2000), pp. 349–54.
[41] G. de Lorris and J. de Meun, *The Romance of the Rose*, trans. F. Horgan (Oxford, 1994), vol. 9, pp. 246–58.
[42] D. V. Geronimus and L. A. Waldman, 'Children of Mercury: New Light on the Members of the Florentine Company of St. Luke, c.1475–1525', *Mitteilungen des Kunstihistorischen Institutes in Florenz*, 47:1 (2003), pp. 118–58.

TOWARDS A NEW METHODOLOGICAL APPROACH FOR INTERPRETING WORKSHOP ACTIVITY AND DATING MEDIEVAL CHURCH SCREENS

3

LUCY WRAPSON

Traditional writing about East Anglian rood screens has been antiquarian in outlook and descriptive in nature.[1] More recent studies treat rood screens as vehicles for the exploration of iconography, patronage and evidence for specific religious practices, especially on the eve of the Reformation.[2] While the existing literature has examined certain surface aspects of East Anglian rood screens, for example iconography, this has been to the exclusion of the physical structure, carpentry and material

[1] A. M. Baker, *English Panel Paintings 1400–1558: A Survey of Figure Paintings on East Anglian Rood Screens*, ed. and updated A. Ballantyne and P. Plummer (London, 2011); F. Bond and D. Camm, *Roodscreens and Roodlofts* (London, 1909); F. Bond, *Screens and Galleries in English Churches* (Oxford, 1908); A. Vallance, *English Church Screens* (London, 1936).

[2] E. Duffy, 'Holy maydens, holy wyfes: The Cult of Women Saints in Fifteenth- and Sixteenth-century England', in W. Sheils and D. Wood (eds), *Women in the Church: Papers Read at the 1989 Summer Meeting and the 1990 Winter Meeting of the Ecclesiastical History Society* (Oxford, 1990), pp. 175–96; E. Duffy, *The Stripping of the Altars: Traditional Religion in England c.1400–c.1580* (New Haven, 1992); E. Duffy, 'The Parish, Piety, and Patronage in Late Medieval East Anglia: The Evidence of Rood Screens', in K. French, G. Gibbs and B. Kümin (eds), *The Parish in English Life, 1400–1600* (Manchester, 1997), pp. 133–62.

characteristics of the screens as a whole. Lacking from the literature of
East Anglian rood screens is a thorough, integrated technical study of
the woodwork and painted surfaces of screens (where the latter survive).
Rood screens have been used as starting points for discourse, but not as
valuable primary sources.

Typically, chancel or rood screens, as they came to be known in the
nineteenth century during the so-called 'rood screen controversy', originally
formed part of a greater whole, physically and in iconographic terms, the
elements of which had different evolutions and which were dismantled
by varying degrees in the Reformation and Civil War.[3] It is commonly
accepted, and evident from the proliferation of rood loft stairs, that by the
mid-fifteenth century virtually every parish church had a chancel screen.
At that point, the ensemble tended to consist of a solid lower dado, about
a metre and a half in height, topped with Perpendicular-style traceried
openings through which the high altar could be seen. Usually the screen
was galleried with a rood loft and topped by the Rood, Mary and John
the Evangelist. This Rood group might be placed either on a separate
roodbeam, as at Tunstead in Norfolk, or placed upon the rood loft itself;
it might be backed by a painted tympanum or decorated chancel arch,
with censing angels or a Doom. Screens had both stylistic and regional
variations.

This essay proposes an integrated methodology for interpreting rood
screens based on the examination of over 500 medieval rood and parclose
screens in Norfolk, Suffolk and Cambridgeshire, surveyed over a three-
year period by the author with the support of the Leverhulme Trust.[4] It
demonstrates the efficacy of the approach through case studies selected
from the wider study, which used the methodology to date all known
East Anglian screens, uncovering the output of twenty-nine medieval
carpentry and thirteen medieval painting workshops.[5]

Physical and documentary evidence should be taken together to assist

[3] The term 'rood screen' is the conflation of two separate but interrelated entities, the
rood loft and the chancel screen which habitually supported it. 'Rood screen' is a modern
term, probably originating in the 1830s during the Gothic Revival. The commissioners
of screens termed them *candlebeams*, *perkes* and *rood lofts* fairly interchangeably,
even when paying for a pane of painting on the dado. Almost all of the terms used
contemporaneously for screens are expressions of part for the whole, much as 'rood
screen' is today. For further discussion of terminology see H. Lunnon, 'Observations on
the Changing Form of Chancel Screens in Late Medieval Norfolk', *Journal of the British
Archaeological Association*, 163 (2010), pp. 110–31. For the rood screen controversy see B.
Ward, *The Sequel to Catholic Emancipation* (London, 1915), pp. 261–78.
[4] For the purposes of the study, East Anglia was defined as Norfolk, Suffolk and the
historical boundaries of Cambridgeshire. This includes the Isle of Ely, but excludes
Huntingdonshire and the Soke of Peterborough. It is also the historical dioceses of Ely
and Norwich. See D. Dymond and E. Martin, *An Historical Atlas of Suffolk* (Lavenham,
1988), pp. 22–3. Of identified screens and related objects 531 out of 544 were examined;
those examples unexamined were due to inaccessibility.
[5] L. Wrapson, 'Patterns of Production: A Technical Art Historical Study of East Anglia's
Late Medieval Screens' (PhD thesis, University of Cambridge, 2013).

with dating, to forge a chronological typology of screens. The physical evidence is varied and its value cumulative. It includes both the structure and the painted schemes, where they survive. The standard examination of screens involved site visits, detailed observation and photography, followed by invasive and non-invasive analysis of pigments and binding media. Moulding profiles, jointing types, carved details, technical and stylistic judgements of painting dates (including via costume and the use of portraiture and landscape) all contributed to an overall typology and dating structure.[6] Tree-ring dating was a further dating method utilized, though it provides a date range or a *terminus post quem* rather than a definitive year. Measurements of panel width, dado height and overall width of screen were made so that the originality of the screen to its present location could be assessed, as well as trends of panel shape, width and transom height. This was tied to documentary evidence, which typically takes the form of will bequests and, occasionally, contracts for the building and decorating of screens. There are also some instances of surviving and recorded inscriptions, painted and, at times, carved onto screens. Examination focused on key points of comparison, pertinent to both the structure of the screen and the painting on it, where extant. In examining the structures of screens, transom to stanchion jointing type, transom moulding profile shape, dado tracery head and base designs, spandrel carving motifs and upper fenestration design and motifs were the main comparators. For the paintings, underdrawing and painting style, diagnostic features such as costume, flooring, copying from continental prints, landscape and portraiture were looked at closely, as were repeat patterns such as tin relief and stencils. Pigment and medium identification, including characteristic use of certain pigments, was a further consideration.

These types of information were recorded to characterize how screens were made, but also to assess whether different screens were made by the same craftsmen. When coupled with the dating evidence provided from wills and from inscriptions, a typological chronology could be formed. Certain structural and painted features arose at certain dates, or within specific workshops. Though many craftsmen's names survive, few can be tied to extant work.

Of the surviving 544 pieces of screenwork in and from East Anglia, only 100 are figurative and a further 100 or so have decorative paint schemes. This lack of iconographic evidence shows the importance of developing an approach which integrates carpentry and other physical characteristics to date screens' painting which, where it survives, provides

6 For information about costume see M. Scott, *Late Gothic Europe, 1400–1500* (London, 1980); F. Piponnier and P. Mane, *Dress in the Middle Ages* (London, 1997); L. Monnas, *Merchants, Princes and Painters: Silk Fabrics in Italian and Northern Paintings, 1300–1550* (New Haven and London, 2008).

important supportive evidence. Added to this is the examination of the underdrawing of screens using infrared photography which has allowed for comparisons to be made of the planning stages of painting. Careful recording and comparisons of repeat motifs such as stencils and cast-relief patterns have been used to determine the spread of painting workshop activity over large distances.

DATA AND DATES

Within East Anglia, 112 surviving screens have some form of dating evidence (roughly a fifth of surviving screens) (Table 3.1). The dates for the screens chiefly come from bequests left in wills, published in two key articles, one for Norfolk, another Suffolk.[7] Dates were also compiled for Cambridgeshire in the course of this study, where there are nine surviving dated screens.[8] In conjunction with the methodology outlined in this paper, it has been possible to apply the information gained from these examples to the other screens and fragments in the region, a further 431 objects.

HISTORICAL DATING EVIDENCE

As the evidence from screens and churchwardens' accounts demonstrates, significant periods of time could elapse between the commissioning of a screen and its decoration. This could be due to funding shortfalls, but also because large projects inherently took considerable time and manpower to complete. The implications of protracted fundraising seem to have been that a painting workshop might move on to the next funded project. This appears likely to have happened at Trunch and at Cawston, where more than one painting workshop can be seen to be at work on the same screen.

A well-documented example is at Great St Mary's, Cambridge. The screen does not survive, but the indenture for its construction is extant, as are the churchwardens' accounts demonstrating its financing.[9] Great St Mary's was a wealthy church and so the process of ordering the new screen is likely to represent a well-funded and large project (as can be seen

7 S. Cotton, 'Mediæval Roodscreens in Norfolk: Their Construction and Painting Dates', *Norfolk Archaeology*, 40:1 (1987), pp. 44–54; S. Cotton, H. Lunnon and L. Wrapson, 'Medieval Rood Screens in Suffolk: Their Construction and Painting Dates', *Proceedings of the Suffolk Institute of Archaeology*, 43:2 (2014), pp. 219–34
8 I am grateful to Simon Cotton for sharing the dates he has for Cambridgeshire screens. Cotton, personal communication: Barton (1381), Burwell (1476), Cheveley (1478), Foxton (1510), Little Abington (1501), Little Gransden (1497), Melbourn (1506), St John's College (now Whissendine, Rutland) (1516), Soham (1485).
9 J. E. Foster (ed.), *Churchwardens' Accounts of St Mary the Great, Cambridge from 1504 to 1635* (Cambridge, 1905); S. Sandars and E. Venables, *Historical and Architectural Notes on Great St. Mary's Church Together with the Annals of the Church* (Cambridge, 1869).

TABLE 3.1. DATABLE NORFOLK AND SUFFOLK SCREENS AND JOINT TYPES

Where there are numerous bequests, an average is taken unless the screen is dated by inscription, in which case that date is used.

Church name and screen	Average date/ inscription	Transom to stanchion joint type
Acle	1496	Mason's mitre
Alburgh	1464	Mason's mitre with frieze
Alby	1512	Scribed
Attleborough	1458	Mason's mitre
Aylsham	1507	Mason's mitre with frieze
Barking	1464	Mason's mitre
Barningham	1469	Mason's mitre with frieze
Bawburgh	1511	Scribed
Bedfield	1528	Scribed
Beeston Regis	1519	Scribed
Bridgham	1475	Mason's mitre
Brundish	1504	Hybrid
Burnham Norton	1458	Mason's mitre
Burstall	1515	Scribed
Butley	1465	Mason's mitre
Buxton	1519	Hybrid
Carbrooke	1521	Scribed
Carleton Rode	1476	Mason's mitre
Cawston	1488	Scribed
Charsfield	1515	Mason's mitre
Chilton	1500	Mason's mitre
Clare	1482	Mason's mitre
Coddenham	1534	Scribed
Combs	1474	Mason's mitre with frieze
Corpusty	1519	Scribed
Cratfield	1461	Mason's mitre with frieze
Deopham	1488	Mason's mitre
East Harling	1504	Scribed
Edgefield parclose	1526	Scribed
Eye	1511	Scribed
Filby	1487	Scribed
Foulden	1484	Hybrid

Church name and screen	Average date/ inscription	Transom to stanchion joint type
Foxley	1472	Hybrid
Fressingfield	1449	Mason's mitre
Fritton St Catherine	1520	Scribed
Garboldisham	1520	Scribed
Gateley	1485	Mason's mitre
Gooderstone	1446	Mason's mitre
Happisburgh	1422	Mason's mitre
Hardley	1510	Mason's mitre
Hardwick	1500	Scribed
Harpley	1407	Mason's mitre
Hawkedon	1472	Scribed
Hawstead	1477	Mason's mitre
Heydon	1480	Mason's mitre
Hollesley	1496	Mason's mitre
Horsford	1503	Scribed
Horsham St Faith	1528	Scribed
Ixworth	1493	Mason's mitre with frieze
Kersey	1463	Mason's mitre
Lavenham	1520	Mason's mitre
Layham	1441	Scribed
Laxfield	1472	Mason's mitre
Lessingham	1503	Scribed
Lindsey	1462	Mason's mitre
Litcham	1492	Mason's mitre
Loddon	1500	Scribed
Ludham	1493	Hybrid
Marsham	1506	Mason's mitre with frieze
Mattishall	1453	Mason's mitre with frieze
Newbourne	1516	Scribed
North Burlingham	1536	Scribed
North Elmham	1474	Hybrid
Northrepps	1514	Scribed
North Tuddenham	1502	Mason's mitre
Offton	1515	Mason's mitre
Potter Heigham	1498	Scribed
Ranworth	1479	Mason's mitre

Church name and screen	Average date/ inscription	Transom to stanchion joint type
Risby	1436	Mason's mitre
Salthouse	1513	Scribed
Shelton	1529	Scribed
Snetterton	1466	Mason's mitre with frieze
Sotterley	1471	Mason's mitre
South Walsham	1437	Mason's mitre
Southwold	1469	Mason's mitre
Sprowston	1505	Hybrid
Stibbard	1461	Mason's mitre
Stoke by Nayland	1484	Mason's mitre
Sudbury St Gregory	1457	Mason's mitre
Suffield	1488	Scribed
Swafield	1454	Mason's mitre with frieze
Swanton Abbot	1455	Mason's mitre
Tacolneston	1500	Hybrid
Thornham	1488	Scribed
Tivetshall	1505	Mason's mitre
Troston	1459	Mason's mitre
Trunch	1502	Scribed
Tunstead	1480	Hybrid
Upton	1505	Mason's mitre
Walberswick	1499	Mason's mitre
Walsham-le-Willows	1445	Mason's mitre with frieze
Watlington	1456	Mason's mitre
Wellingham	1532	Scribed
Westhall	1509	Mason's mitre with frieze
Weston Longville	1492	Mason's mitre
Wiggenhall St Mary the Virgin	1508	Mason's mitre
Wingfield	1454	Mason's mitre
Wiveton	1484	Mason's mitre
Woodbridge	1454	Mason's mitre
Woolpit	1466	Mason's mitre with frieze
Worstead	1512	Scribed
Wyverstone	1491	Mason's mitre with frieze
Yaxham	1484	Mason's mitre
Yelverton	1505	Mason's mitre

from the description of the screen which requests that it have three doors, and cross the nave and both aisles). In 1514 the rood turret was complete.[10] In 1520, a contract was made between the church officials and the carvers, and by 1523, the carpentry was finished, including the sculptural figures. Two heads of workshops were indentured and there is an implication that their sons were involved, as the heirs were bound to the contract.[11] The hiring of two named master carpenters suggests that the church wanted to have this large screen constructed swiftly, and it took three years to complete. As well as the indenture, donations to the screen survive in the churchwardens' accounts. One of these, in 1525, refers to the 'guylding of the Trinite'.[12] The indication is therefore that painting, of which gilding is a part (and which is often referred to in will bequests, being the most expensive aspect of the painted decoration), took at least another two years, making the construction and decoration a five-year project. There may have been a degree of seasonality for the painting – oil dries faster in the summer months and the light is better – but there is no evidence either way as to whether craftsmen worked seasonally. Notably, there was a division of labour between carpenters and painters, a division seen in both Devon and East Anglia, time and time again.

The process was undeniably more protracted at Cawston in Norfolk. The first known bequest to the screen was made in 1460, the last in 1504.[13] The inscription on the screen refers to one set of donors, William and Alice Athereth, who paid for painting eight north side panels in 1490.[14] The presence of three, possibly four, different painting workshops implies that the painting was done in a piecemeal fashion due to patronage and funding.[15] Based on an average of its will bequests (1488), Cawston therefore can credibly be said to have a date range of c.1480–1504.

IDENTIFYING WORKSHOP AND COMMISSIONING ACTIVITIES: 'LYKE OR BETTER'

Medieval contracts or the stipulations for memorials found in wills often state models upon which objects are to be based, saying that the new work should be after the model, though as good or better. This is a commonly found contractual trope in many different types of commission.

10 Sandars and Venables, *Historical and Architectural Notes*, p. 19.
11 Carpentry businesses were often family-centred affairs, as demonstrated by Appendix 3 of Wrapson 'Patterns of Production'.
12 Foster, *Churchwardens' Accounts of St Mary the Great*, p. 60.
13 Cotton, 'Mediæval Roodscreens in Norfolk', p. 47.
14 The name is variously recorded as Atereth, Athereth and At Heth. See ibid., p. 47 and Baker, *English Panel Paintings*, p. 219.
15 Three workshops/painters are proposed by Strange and Baker. See E. F. Strange, 'The Rood-screen of Cawston Church', *The Second Annual Volume of the Walpole Society*, 2 (1912–13), pp. 81–7 and Baker, *English Panel Paintings*, p. 132.

In relation to the patronage of screens, Robert Northern's will of 1508 asks that the screen be 'aft the newe perke in the chapel of the ffelde in Norwiche'.[16] At Great St Mary's in Cambridge, the front side of the screen was commissioned to resemble Thriplow (Cambridgeshire), and the back Gazeley (Suffolk).[17]

The documentation for the rood screen at Banwell church in Somerset explicitly includes costs 'for paper to draw the draft of ye rode loft', and the screen design was based on St Erth in Cornwall which was visited by Banwell's churchwarden along with two paid individuals (probably including the unnamed carver).[18] Sadly, the St Erth screen does not survive.

In fact only rarely does this type of statement or contract survive alongside the objects it describes. The significance of this is that it might be hard to distinguish between the outputs of the same workshops and those screens which consciously emulate one another at the request of a patron; although on the plus side, it does help to establish a relative chronology of works where a new commission is based upon an existing screen. Indeed, to further complicate the matter, it may be that sometimes the objects to be emulated were in fact other works by the same indentured craftsmen. Therefore, some idea of how a pair or trio of objects with this stipulation relate is important when considering the subject of related works.

Happily, in one instance – a set of choir stalls – the contract and one of two models on which they were based survives, albeit in a fragmentary state: choir stalls at St John's College and Jesus College, Cambridge. The 1516 St John's stalls were the work of Thomas Loveday, who also constructed the screen. The comparison between the objects is useful because the indenture for the work at St John's is extant and it states that the choir stalls are to be based on those at Jesus and Pembroke Hall (the latter are lost). The c.1500 choir stalls and misericords at Jesus College survive partially having been incorporated into nineteenth-century stalls. The choir stalls at St John's College were retained when the chapel was replaced in the nineteenth century, although the screen was sold to Whissendine in Rutland.

The Jesus stalls survive in a fragmentary state mainly in the form of misericords and figurative bench ends. The cresting is not extant. The stalls at St John's are near complete, and are only part-restored. The poppy heads and figurative bench ends survive well. The figurative bench ends at Jesus appear to have had significant influence on the design of the stalls at St John's (Fig. 3.1), though the quality is lower and the intricacy of the carving is less at St John's. The similarity is, however, generic,

[16] Cotton, 'Mediæval Roodscreens in Norfolk', p. 44.
[17] Sandars and Venables, *Historical and Architectural Notes*, p. 67.
[18] J. Harvey, *English Medieval Architects: A Biographical Dictionary Down to 1550*
(Gloucester, 1987), p. 13; C. Taylor, 'Banwell Screen and Rood-loft', *Transactions of the Bristol and Gloucestershire Archaeological Society*, 35 (1912), pp. 116–38.

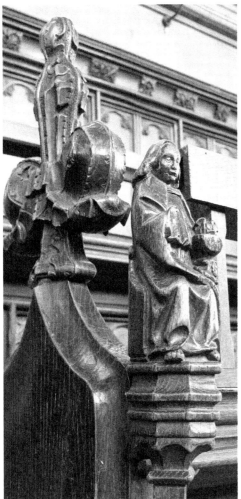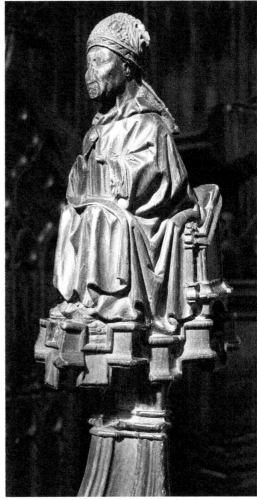

FIG. 3.1.

BENCH-END

FIGURES AT ST

JOHN'S COLLEGE,

CAMBRIDGE AND

JESUS COLLEGE,

CAMBRIDGE.

and the Jesus figures are much larger. In comparison, the related screens outlined below are more than thematically similar. On screens, the same motifs, mouldings and spandrel carvings are repeated to a much greater extent than the Jesus and St John's carving. Obviously it is not possible to assess the proximity of the Pembroke Hall model to the St John's stalls, but that two models were stipulated indicates that they were not slavishly copied down to the moulding profiles, but instead used to determine design and quality.

CARPENTRY STYLES AS A DATING TOOL: TRANSOM MOULDINGS AND JOINT TYPES

During the screens survey, transom moulding profiles were taken from over 400 objects, among them chancel screens, choir screens, tower screens and

parclose screens.[19] Studies of the Gothic period have shown that designs and motifs could travel with itinerant craftsmen and knowledgeable patrons.[20] Fawcett demonstrated this in Norfolk and Suffolk, identifying the work of the Wiveton and Great Walsingham masons at other churches in both counties.[21] Haward identified the output of groups of East Anglian masons and carpenters, specifically of church arcades and roofs.[22] The same principles can be applied to the workshop outputs of screen carvers and painters in East Anglia. More than 400 transom moulding profiles have been taken and compared for this aspect of the study.[23]

Moulding shapes and tracery patterns on screens appear to have been somewhat behind the then contemporary architectural fashion. Morris's study of English Gothic moulding profiles in architectural contexts is between 1250 and 1400, the most active period of innovation. Morris states that: 'In fifteenth-century Perpendicular ... it seems that extremely few new ideas appear in mouldings, and there is no evident pattern of stylistic development.'[24] As far as the rood screens of Norfolk and Suffolk are concerned, the change from Decorated to Perpendicular-style screens probably came about in 1380–1400, some thirty years after the commensurate change in architectural style, based on dated examples in Harvey.[25] However, it is far from certain that traditional dates for Decorated-period screens are accurate, as they lack the documentation of the later screens. Viewed as a corpus of objects, gradual design change can be perceived throughout the period until the Reformation. Notably, a new stanchion to transom jointing flourished about the same time as the start of the Tudor dynasty; also by the sixteenth century, screen dados began to widen once more, probably to accommodate an increasing desire for depicting narrative scenes set in credible recessional space.

The carpentry of screens has been compared on a variety of details, some technical, some stylistic. The method is one well established in art history: in a Morellian vein, transom moulding profiles or repeat spandrel

[19] Moulding profiles were taken using a plastic moulding profile gauge to avoid damage to paint.

[20] R. K. Morris, 'The Development of Later Gothic Mouldings in England c.1250–1400. Part 1', *Architectural History*, 21 (1978), pp. 18–57.

[21] R. Fawcett, 'A Group of Churches by the Architect of Great Walsingham', *Norfolk Archaeology*, 37:3 (1980), pp. 277–94; R. Fawcett, 'St. Mary at Wiveton in Norfolk, and a group of churches attributed to its mason', *The Antiquaries Journal*, 62: 1 (1982), pp. 35–56; R. Fawcett, 'The Master Masons of Later Medieval Norfolk', in S. Margeson, B. Ayers and S. Heywood (eds), *A Festival of Norfolk Archaeology* (Norwich, 1996), pp. 101–26; E. Roberts, 'Moulding Analysis and Architectural Research', *Architectural History*, 20 (1977), pp. 5–13.

[22] B. Haward, *Suffolk Medieval Church Arcades, 1150–1550* (Ipswich, 1993); B. Haward, *Suffolk Medieval Church Roof Carvings: A Photographic Survey of Carvings on Hammerbeam Roofs* (Ipswich, 1999); B. Haward, *Master Mason Hawes of Occold, Suffolk and John Hore Master Carpenter of Diss* (Bury St Edmunds, 2000).

[23] Transoms do not always survive, hence the number is not higher.

[24] Morris, 'Development of Later Gothic Mouldings in England', pp. 18–27.

[25] J. Harvey, *The Perpendicular Style 1330–1485* (London, 1978).

motifs are the equivalent of the ears or hands painted by old masters, or to use an example from the history of painting technique by way of comparison, the transom moulding profile is akin to the punch tools belonging to a Sienese painting *bottega*.[26] As Haward states, multiple points of close comparison, such as the repeated use of standardized forms, define credible relationships.[27] Moulding profiles in particular are indicative, as Coldstream relates when discussing the output of stonemasons: 'Masons' templates, used to define the shapes of the mouldings, were designed by the master mason and can be regarded as his personal signature.'[28] The same has proven to be the case with transom profiles on screens, which are an unconscious signature, particularly when assessed along other points of comparison.[29]

The moulding profiles taken were typically limited to transoms due to the time constraints of measuring large numbers of screens. Profile measurement took place chiefly in Norfolk, Suffolk and Cambridgeshire, though more than fifty comparative moulding profiles were taken from screen transoms in Devon, Essex, Huntingdonshire, Oxfordshire, Sussex and Brittany. Notable trends have come to light through this work, and are represented here in the diagrams grouping Norfolk and Suffolk screens by date. Fourteenth-century screens possess simple transom moulding profiles, usually in a square section, but at times with rounded corners or flat chamfers (Fig. 3.2). Fourteenth-century screens can only be identified stylistically, as there is limited or no dating evidence for such screens from surviving wills (mainly due to their limited survival, but perhaps also because the nature of patronage changed with the rise of the compartmentalized figurative dado). There is, however, considerable consensus on what constitutes a Decorated-period screen. At about the turn of the fifteenth century, screen moulding profiles began to increase in complexity, and rood screen moulding profiles became typically more elaborate towards the western, public face. Although some remained essentially square in section, the fashion came about for a more elongated, polygonal section with numerous ogees, fillets and casements (Fig. 3.3). The division of dated Suffolk and Norfolk screen transoms into the date range 1400–59 is arbitrary, but instructive, as a direct comparison with screens from the date range 1460–99 indicates (Fig. 3.4).

The latter half of the fifteenth century saw an increase in the size of

[26] G. Morelli, *Italian Painters: Critical Studies of their Works*, trans. C. J. Ffoulkes (London, 1893); R. Wollheim, 'Giovanni Morelli and the Origins of Scientific Connoisseurship', in *On Art and Mind: Essays and Lectures* (London, 1973), pp. 177–201; E. Skaug, *Punchmarks from Giotto to Fra Angelico* (Oslo, 1994).

[27] Haward, *Suffolk Medieval Church Roof Carvings*, 33.

[28] N. Coldstream, *Medieval Craftsmen: Masons and Sculptors* (London, 1991), p. 30.

[29] As close examination reveals, screen transoms were not shaped with moulding planes, hence there is discernible variation between different sections. This is perhaps due to the practicalities of the scaling up and scaling down of the transoms required for different screens.

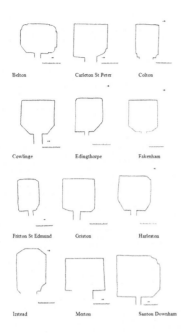

FIG. 3.2. FOURTEENTH-CENTURY ROOD
SCREEN TRANSOM MOULDING PROFILES.

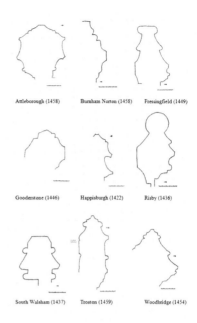

FIG. 3.3. EARLY FIFTEENTH-CENTURY ROOD
SCREEN TRANSOM MOULDING PROFILES (1400–59)
WITH AVERAGE OR INSCRIBED DATES.

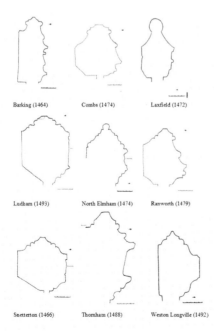

FIG. 3.4. MID- TO LATE FIFTEENTH-CENTURY TRANSOM
MOULDING PROFILES (1460–99) WITH AVERAGE OR
INSCRIBED DATES.

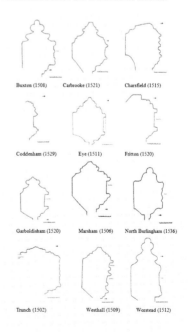

FIG. 3.5. SIXTEENTH-CENTURY TRANSOM
MOULDING PROFILES WITH AVERAGE OR
INSCRIBED DATES.

transoms and their intricacy. A specific type of transom, in which there is a frieze of brattishing in the centre of the rail, or in which this is omitted but there is instead a space provided for a dedicatory inscription, came to the fore in the second half of the century.

Sixteenth-century transoms in Norfolk and Suffolk are typified by being heavier weight, larger and more elaborate than earlier examples, a continuation of the trend already visible in the latter half of the fifteenth century (Fig. 3.5). However, sixteenth-century transoms are, as a rule, less diverse and varied than those of the fifteenth century. There are, however, some regional differences. The inscription type of moulding profile found in Norfolk was more popular there than in Suffolk. While there are some transoms of this type to be found in Suffolk (like Yaxley), instead sixteenth-century screens there tend to have elaborate sequences of ogees, bowtells and casements (like Westhall), and to be elongated. Some transom moulding profiles have such close resemblance that, when coupled with several other close points of comparison, they evidently are the output of the same craftsmen.

An examination of jointing techniques is also of great utility in dating. Howson, following discussion with Hugh Harrison, was the first to note that there are two main approaches to jointing the junction between transom and pier on fifteenth- and sixteenth-century Perpendicular-style screens in East Anglia.[30] Howson surveyed forty-seven Norfolk and Suffolk screens, noting the treatment of this junction. He concluded that mason's mitre joints, an earlier joint type, were superseded by the superior scribed joints. Howson compared the joint types with known and dated will bequests, principally taken from Cotton and Northeast.[31] While acknowledging the difficulties associated with dating screen construction and dating from will evidence (as has been shown, screens could be built and decorated over a protracted time-period as funds were raised), he concluded that the scribed transom to stanchion joint was used first in the 1480s and was used invariably after 1505. The period from c.1480 until c.1500 was one where both jointing techniques were used, with the scribed joint finding increasing favour. An undated Norfolk or Suffolk screen with scribed joints is therefore likely to have been made

[30] Howson was advised by Harrison, who noted the distinct jointing types on West Country screens. See T. Howson, 'Suffolk Church Screens: Their Production in the Late Middle Ages and their Conservation Today' (PGDip in Building Conservation thesis, Architectural Association, London, 2009), pp. 42–3. Tracy and Harrison discuss joint types at lengths in their work about the choir stalls at Amiens Cathedral: C. Tracy and H. Harrison, *The Choir Stalls of Amiens Cathedral* (Reading, 2004), pp. 127–69.

[31] Baker, *English Panel Paintings*; Cotton, 'Mediaeval Roodscreens in Norfolk'; Cotton, Lunnon and Wrapson, 'Medieval Roodscreens in Suffolk'; P. Northeast (ed.), *Wills of the Archdeaconry of Sudbury, part I, 1439–1461*, Suffolk Records Society, 44 (Woodbridge, 2001); P. Northeast and H. Falvey (eds), *Wills of the Archdeaconry of Sudbury, part II, 1461–1474*, Suffolk Records Society, 53 (Woodbridge, 2010); P. Northeast and H. Falvey (eds), *Index of Wills of the Archdeaconry of Sudbury, 1439–1474* (Woodbridge, 2010).

c.1485–1536; an undated Perpendicular screen with mason's mitre joints probably dates from between c.1400 and 1505. Howson also noted some instances of hybridized joints, where elements of both jointed methods were present, specifically where a scribed joint was employed, but that a slight mason's mitre return was carved on the upright member. These screens with 'hybrid' joints he dated c.1485–1505.

In a mason's mitre joint, the two members being joined meet as for a butt joint, but a small section of one member is removed, forming a socket into which the end of the other fits (Fig. 3.6). In the case of a mason's mitre on a screen, the mouldings are returned on the stanchion to align with the transom mouldings. In scribed joints, the transom piece is carved to align with the mouldings of the upright pier. There is little or no return of the mouldings on the pier (to match the transom). The scribed joint can be considered superior and to have replaced the mason's mitre system because, unlike the mason's mitre, it does not open up as the wood shrinks across the grain over time; the scribed joint disguises this shrinkage. It is also a faster joint to make. A hybrid joint is essentially a scribed joint with a slight mason's mitre return.

The present work more than doubles the number of screens whose joints have been studied and compared with dating evidence. The dates given are an average of known will bequests, except in cases where the date survives on the screen or is recorded. In those cases, the date given on the screen is used. Widening the numbers of screens assessed in this way has validated Howson's findings, but it has added more, quantitively and qualitatively. As well as confirming that the trends Howson described were accurate for the larger set of datable screens, and that there are mason's mitre, hybrid and scribed-jointed transom joints among the dataset, another variant was observed while compiling this aspect of the study.

At times, mason's mitre jointed screens have an insert or frieze that runs over part of the joint, at least partially obscuring it. This frieze is sometimes

FIG. 3.6. ROOD SCREEN TRANSOM JOINTS: MASON'S MITRE AT RANWORTH (NORFOLK), SCRIBED AT SOUTHWOLD (SUFFOLK), HYBRID AT TACOLNESTON (NORFOLK).

GRAPH 3.1. GRAPH TO SHOW JOINT TYPE COMPARED WITH
AVERAGE DATES OF SCREENS IN NORFOLK AND SUFFOLK

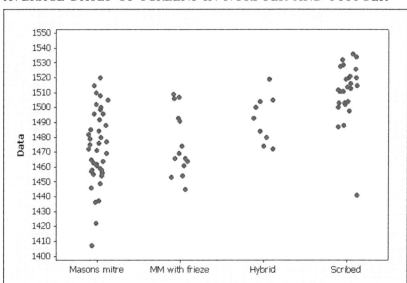

a vine trail or floriate design or, more commonly, decorative brattishing.
This design change may have come about due to fashion. However, it may
also have arisen because it was observed that mason's mitre joints would
open up as the wood shrunk across the grain over time. An insert of this
type disguised this. Noting and plotting the instances of where a frieze
is found is suggestive, mason's mitre joints with covering friezes of this
type arise later than typical mason's mitre joints, and typically predate
hybrid and scribed joints, although there is some overlap (Graph 3.1).[32]
This graph of joint types clearly demonstrates the succession of jointing
types on Norfolk and Suffolk screens, based on the data compiled and
detailed in Table 3.1. It provides an evidence-based framework for dating
previously undated screens.

This work demonstrates that the introduction of the hybrid and scribed
joint in Suffolk and Norfolk came a little earlier than the c.1485 date
suggested by Howson, although it is by this date that it was widespread.
The presence of hybrid/scribed jointing on the 1474 screen at North
Elmham is the earliest secure instance.[33] This screen was formerly dated

[32] Some surviving works can seem at variance with the date of surviving bequests, as
in the case of the 1441 outlier on the graph at Layham, Suffolk. This is probably because
aspects of rood screen and loft were replaced without leaving an archival trail. Layham
has a scribed-jointed transom, which is strongly indicative of a late fifteenth- or early
sixteenth-century date. This rood loft must have predated the existing screen but has
since been lost.
[33] Bodleian Gough MS Norfolk 4 f. 179. 'On ye screen many sts and Orate p(ro) a(n)i(m)

on its doors, as noted by Blomefield. It is not known whether the date was carved or painted, as it is uncertain on which set of doors it was situated. However, it was probably a painted date, in which case the construction of the screen likely took place some years before. Tunstead's hybrid jointed screen is described as 'newly made' in 1470.[34]

The scribed joint does not appear to have found favour in Cambridgeshire in the same way it did in Suffolk and Norfolk, and it is for this reason that the dating information for Cambridgeshire has not been included in this graph. In only one instance is a scribed joint found on a dated (1516) Cambridgeshire screen, and this is the example from St John's College known to have been undertaken by Thomas Loveday, a Suffolk craftsman. Better dating evidence might find trends similar to Suffolk and Norfolk, but equally, it may be that those instances of scribed-jointed screens are down to the presence of Norfolk and Suffolk carpenters in Cambridgeshire.

CARPENTRY GROUPINGS

Twenty-nine carpentry groupings were identified in the course of the study. Two sets of East Anglian screens are soundly attributable with named carpenters, Thomas Gooch and Thomas Loveday, both Sudbury-based craftsmen.[35] A third group of works might be the output of William Alcock, but the evidence is more circumstantial.[36] All other carpentry groupings are derived from examination of the objects themselves. There are larger numbers of carpentry groupings than painting groupings, due to the better survival of wood over paint. Two examples are given here, to demonstrate the application of the methodology. As outlined in Table 3.1, this compares transom to stanchion jointing type, transom moulding profile shape, dado tracery head and base design, spandrel carving style and motifs and upper fenestration design and motifs to assess similarity and difference.

WESTWICK AND BARTON TURF (C.1480–90)
The rood screens at Westwick and Barton Turf are within three miles of each other and were evidently the output of the same carpentry workshop, probably located nearby. Their transom moulding profiles are near-identical (Fig. 3.7), as is the dado upper tracery and spandrel carvings (Fig. 3.8). In addition the design of the cusped quatrefoil at the base of the

ab(us) roberti pynnis & margarete uxoris sue et omnium benefactorum eor(um) qui hoc opus fecerunt pingi an(n)o d(omi)ni M°ccc°lxxiiij°.' This inscription is somewhat unusual in being in Latin: most donors' inscriptions are in the vernacular. Parkin, who wrote up Blomefield's notes for this volume in Blomefield's series, omitted the date. I am grateful to David King and Simon Cotton for this reference.

34 Cotton, 'Mediaeval Roodscreens in Norfolk', p. 52.
35 I will be discussing these workshops in a forthcoming paper.
36 Wrapson, 'Patterns of Production', pp. 178–82.

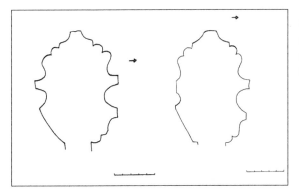

FIG. 3.7. BARTON TURF
AND WESTWICK ROOD
SCREEN TRANSOM
MOULDING PROFILES.

FIG. 3.8. BARTON TURF AND
WESTWICK ROOD SCREEN
TRACERY HEADS.

FIG. 3.9. BARTON
TURF AND
WESTWICK ROOD
SCREEN TRACERY
BASES.

dado is comparable, although at Westwick the design is turned through 45 degrees compared with Barton Turf (Fig. 3.9). Both screens have mason's mitre transom jointing. At Barton Turf the design of the underside of the rood loft can be seen, which projected only westwards. One panel of the rib-vaulting survives painted blue with gold stars. At Westwick, the upper part of the screen is largely non-original and therefore cannot be used for comparison. The upper fenestration at Barton Turf is notable for its feathered cusping, a strongly local Norfolk feature.

There is no direct dating evidence from inscriptions or wills for either screen. However, the paintings at Barton Turf relate closely to those at St Michael at Plea in Norwich, parts of which are now in Norwich Cathedral. Despite this, the date given for paintings at St Michael at

 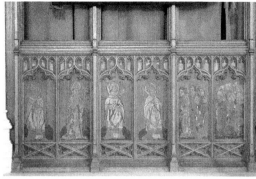

FIG. 3.10.
BRETTENHAM
AND IPSWICH
ST MATTHEW'S
SCREENS.

Plea, a 1504 bequest by a Katharine Bewfield, may well be too late for the design of the screen and the style of the paintings at Barton Turf, which have been traditionally dated to c.1440, but are probably therefore closer to c.1480-90.[37] The painting on the two screens at Barton Turf and Westwick is evidently the product of different workshops, one of many instances demonstrating the typical separation of the craft disciplines of construction and painting.

WOODBRIDGE GROUP (C.1448–70)

Woodbridge is about 27 miles from Southwold by road, but despite the relatively long distance, there is strong evidence that the two Southwold parclose screens and the former rood screen at Woodbridge were made by the same craftsmen. Although the evidence is less strong, it is possible too that the remains of screens at Brettenham and St Matthew's, Ipswich were also made by the same workshop (Fig. 3.10). Brettenham has several points of comparison such as the transom moulding profile and the dado tracery head. However, Ipswich can be compared only on the shape of its now-lost dado tracery (as only the panels and none of the framework of the screen are original) and so its inclusion in the group is more tentative, based as it is on fewer points of comparison.

The evidence is somewhat complicated by the fact that the panels at Woodbridge have been separated from the frameworks of the screen, though thankfully both parts have been kept and replicas added to the originals in the restoration of 1898.[38] In addition, although the upper fenestration at Southwold survives, it does not at Woodbridge, meaning that the comparison must rest on aspects of the dados. The upper fenestration at Southwold exhibits the remains of sprung vaulting and also the use of feathered cusping, a motif found mainly in Norfolk and north-east Suffolk. The upper part of the parcloses has been restored.

The moulding profiles of the four screens with surviving transoms follow

[37] Cotton, 'Mediaeval Roodscreens in Norfolk', p. 46; P. Lasko and N. J. Morgan, *Mediæval Art in East Anglia 1300–1520* (London and Norwich, 1973), pp. 48–9.
[38] Known from a brass plaque attached to the screen.

FIG. 3.11.
MOULDING
PROFILES AT A)
SOUTHWOLD
NORTH AND B)
SOUTH PARCLOSES,
C) WOODBRIDGE
AND D)
BRETTENHAM.

the same sequence of curves, ogees and bowtells (Fig. 3.11). The dado tracery at the head of the panels is near-identical. On all three screens, there is a carved shield at the base of the dado, although designs differ on all three screens, even the two parcloses (Fig. 3.12). The ghosting (an absence of painting where the tracery once covered the underlying wood) exhibited on the original painted Woodbridge panels indicates, as usual, that they were painted once the screen had been constructed. All three screens have mason's mitre jointing to their transoms.

FIG. 3.12.
WOODBRIDGE
AND SOUTHWOLD
NORTH AND
SOUTH PARCLOSE
TRACERY HEADS.

The dating evidence from will bequests corroborates the link between the three screens. The Southwold parcloses and Woodbridge screen have early bequests, among the surviving data. £10 was left to paint the Rood group at Woodbridge in 1448 by John Albred, Agnes Albred left 10 marks to paint the candlebeam in 1458. Galf. Hyll left '6s 8d' to paint the new screen in 1456. At Southwold, John Colton left £20 to making the new candlebeam in 1459 and John Taylour left '20s' to the same purpose in the same year. An additional bequest for the construction, this time specifically of a parclose, 'ad factur particu', is also recorded in 1461, and there are bequests for its decoration in 1470, 1474 and 1481.[39] The evidence suggests therefore that Woodbridge was constructed from c.1448 and being painted in c.1456. Southwold's parcloses were constructed from c.1459 and painted from c.1470. There is a reference to painting the candlebeam at Ipswich St Matthew dating from 1494, but the screen that survives at Ipswich St

[39] Cotton, 'Mediaeval Roodscreens in Norfolk'; Cotton, Lunnon and Wrapson, 'Medieval Roodscreens in Suffolk', p. 228.

Matthew may have been a parclose screen surrounding a guild chapel, as it depicts confraternity members, rather than the rood screen.[40]

There is good evidence that the dates given for Southwold should be taken to refer to the parclose screens rather than the rood screen itself. The painting and the design of the central portion suggests a sixteenth-century date for that part of the screen even though there is no direct will bequest referring to it.

PAINTING GROUPS

As with the structures of rood screens, the paintings on them can also be formed into groups of closely related works that are the output of the same workshops. Painting has traditionally been heralded as the more important aspect of the craft than the structure. This viewpoint has more lineage in the literature than attributions to specific carpenters. Thirteen sets of related works were identified in this study.

According to Vallance, Howard recognized the Ranworth artists as having more than one surviving work, although I have not found this expressed in his published work.[41] Strange also correctly noted the relationship between Marsham, Aylsham and some of the paintings on the south side at Cawston, citing Wardle.[42] The existence of related screen paintings was evidently widely recognized in the early twentieth-century rood screen studies: Constable writing in *The Connoisseur* in 1929 rightly considered North Walsham to be a member of the Ranworth group, but he erroneously included Ludham, Barton Turf and Tunstead.[43] Briggs, in an award-winning 1934 essay, also recognized affinities between paintings, but provided no dating framework.[44] Briggs divided Norfolk's screens into three groups: the Ranworth group, Coast group and Central group. However, the comparisons are highly inaccurate; a comparatively early screen such as Hempstead is included in the same group as sixteenth-century Lessingham. Her Ranworth group includes both c.1446 Gooderstone and 1536 North Burlingham, and can be discounted.

Baker's work, beginning with her 1938 thesis and culminating with her book published posthumously in 2011, has widened this idea more than any other studies.[45] Some of the observations in Baker's book are in

[40] Cotton, Lunnon and Wrapson, 'Medieval Roodscreens in Suffolk', p. 226.
[41] Vallance, *English Church Screens*, p. 58.
[42] Strange, 'The Rood-screen of Cawston Church', pp. 81–7.
[43] W. G. Constable, 'Some East Anglian Rood-screen Paintings', *The Connoisseur*, 84 (1929), p. 220.
[44] O. M. Briggs, 'Some Painted Screens of Norfolk', *Journal of the Royal Institute of British Architects*, 3rd series, 41:19 (1934), pp. 997–1016.
[45] A. M. Baker, 'Figure Painting on Rood-screens in Churches of Norfolk and South Devonshire (PhD thesis, Courtauld Institute of Art, University of London, 1938); Baker, *English Panel Paintings*.

fact Plummer's and are therefore based on accurate, detailed observation, sometimes made in the course of conservation treatment. Nevertheless, a firmer understanding of techniques in a documentary context in the wake of studies by Howard, Plahter, Tångeberg and Nadolny, and in England, the work on medieval painting at the Hamilton Kerr Institute, allows a closer reading of related rood screen paintings.[46] As with carpentry, there are paintings that are the output of the same workshops, sometimes of more than one generation, and they can be identified as such on the basis of stylistic comparison, but also technically. This type of comparison includes Baker's 'stylistic relationships', but goes beyond it.

There are divisions to be made between stylistic similarities, deliberate emulation of one workshop by another, the products of the same workshop by different hands, the products of different workshops on the same screen, and the products of the same painter with and without other members of the workshop. These distinctions carefully made can inform an understanding of rood screen patronage, but also provide insight into division of labour and workshop practice.

Broad stylistic affinity in painting is found at the same date. Screens at Carleton Rode, Swafield and Tunstead share a visual affinity, including the depiction of webbed haloes, and calligraphic, comparatively flat faces with limited modelling. However, this is to do with being from a similar date rather than from being the same painters at work. Will bequests suggest that they were made within thirty years.[47]

No distinction has been made in the traditional literature between the different levels of relationship between works. That is to say, paintings that

[46] P. Binski and A. Massing (eds), *The Westminster Retable* (London and Turnhout, 2009); H. Howard, *Pigments of English Medieval Wall Painting* (London, 2003); A. Massing (ed.), *The Thornham Parva Retable: Technique, Conservation and Context of an English Medieval Painting* (Cambridge and Turnhout, 2003); J. Nadolny, 'The Techniques and Use of Gilded Relief Decoration by Northern European Painters c. 1200–1500' (PhD thesis, Courtauld Institute of Art, University of London, 2001); J. Nadolny, 'All that's burnished isn't bole: Reflections on Medieval Water Gilding Part 1: Early Medieval to 1300', in J. Nadolny et al. (eds), *Medieval Painting in Northern Europe: Techniques, Analysis, Art History* (London, 2006), pp. 148–62; J. Nadolny, 'One Craft, Many Names: Gilders, Preparers, and Polychrome Painters in the Fifteenth and Sixteenth Centuries', in J. Bridgeland (ed.), *ICOM-CC Preprints, 15th Triennial Meeting, New Delhi, 22–26 September 2008*, 2 vols (New Delhi, 2008), vol. 1, pp. 10–17; J. Nadolny, 'Documentary Sources for the Use of Moulds in the Production of Tin-relief: Cause and Effect', in E. Hermens and J. Townsend (eds), *Sources and Serendipity: Testimonies of Artists' Practice. ICOM-CC Working Group on Art Technological Source Research (ATSR) 3rd International Symposium, Glasgow University, Scotland, 12–13 June 2008* (London, 2009), pp. 39–49; U. Plahter, E. Hohler and N. Morgan, *Painted Altar Frontals of Norway, 1250–1350*, 3 vols (London, 2004); C. Stroo (ed.), *Pre-Eyckian Panel Painting in the Low Countries* (Brussels, 2009); P. Tångeberg, 'Polychrome Sculpture in Sweden', *Studies in Conservation*, 15 (1970), pp. 316–26; P. Tångeberg, *Mittelalterliche Holzskulpturen und Altarschreine in Schweden* (Stockholm, 1986); P. Tångeberg, *Retabel und Altarschreine des 14. Jahrhunderts. Schwedische Altarausstattungen in ihren europäischen Kontext* (Stockholm, 2005).
[47] Cotton, 'Mediaeval Roodscreens in Norfolk', pp. 44–52. The 1454 date at Swafield is to the construction of the screen, and so is therefore early in the making process.

can be shown to have the same stencils, coupled with powerful stylistic affinities have been regarded in the same manner as works which have broader stylistic convergences, but little or no technical relationship. Baker's related groupings contain many excellent observations but where they fall down is that they are based solely on stylistic affinity, and not on a combination of technical and stylistic information.[48] Painting groups at Ranworth and Aylsham are explored in articles elsewhere.[49]

THE ALBURGH GROUP

This group of related works crosses the boundaries between objects: rood screens and pulpits and between decorative and figurative ornament. The members of this group can be identified as Alburgh, Thwaite All Saints, Fritton St Catherine, Trunch, South Burlingham pulpit, Lessingham and perhaps also Loddon. The Alburgh group are linked by their stencils and cast-relief patterns, both types of decoration that can be shown to have come from the same moulds and templates (Pls IX and X).[50] The workshop is also characteristic in its use of azurite, silver and gold leaf for stencils, and extensive use of freehand piped pastiglia (a technique distinct from the cast relief) over which gilding was applied. The workshop decorated screens and pulpits, as the pulpit from South Burlingham (St Edmund) demonstrates, and the dating evidence suggests that they operated between c.1500 and 1528 (the Alburgh 1464 date can be considered early, as this was a bequest of money towards the building not the painting of the screen).[51] The orbit of the workshop surrounds Norwich, and the distribution suggests a workshop based in that city. All related works are within Norfolk, but some of the southern works were close to the Norfolk/Suffolk border.

This workshop is unusual in that the set of related screens contains both decorative and figurative members, and its decorative screens are considerably more elaborate and high status than many, with extensive oil and probable water gilding, pastiglia and cast-relief methods, azurite and red lake pigments. In one instance, when covering an earlier painting scheme at Lessingham, the painters painted on paper glued over the screen dado panels.[52]

[48] Baker, *English Panel Paintings*, pp. 54–5.

[49] L. Wrapson, 'Ranworth and its Associated Paintings: A Norwich Workshop', in T. Heslop and H. Lunnon (eds), *Norwich. Medieval and Early Modern Art, Architecture and Archaeology*, The British Archaeological Association Conference Transactions, 38 (Leeds, 2015), pp. 216–37; L. Wrapson, 'Prints and Pastiglia: The Surviving Paintings of a Late-medieval East Anglian Workshop', in A. Wallert et al. (eds), *Postprints of Painting Techniques, History Materials and Studio Practice. A Conference Held at the Rijksmuseum, Amsterdam*, 18, 19 and 20 September 2013 (Amsterdam, forthcoming).

[50] The muntins at St Catherine's, Fritton, have been hacked back, which is probably why no tin relief survives.

[51] Cotton, 'Mediaeval Roodscreens in Norfolk', pp. 44–52.

[52] The paper was probably not brought pre-painted, as there is a distinction between

On the decorative screens at Alburgh and Thwaite All Saints, as well as on the South Burlingham pulpit and figurative screen at St Catherine's, Fritton, the workshop were the only painters to work on the screens, as these are unified schemes. The screen at Loddon has been associated with the group on the basis of its tin-relief decorations, a relationship noted by Plummer and published by Cotton.[53] However, the patterns while similar are not identical and the panels have been so badly damaged through overcleaning and subsequent repainting that it is difficult to be certain if the same workshop was present. It may be that the Loddon screen is less closely associated with the group than they are to each other. Loddon's tin relief is, however, identical to that on the font at Westhall.

The situation on the rood screens at Trunch and from Lessingham is also complicated. It appears that two, possibly three, different workshops and at least three painters were involved in the decoration of Trunch's rood screen. The painting on the muntins, mullions and transom of the first two bays of the north side of the screen is by the same workshop as Alburgh (and the other related works). Characteristic stencils, tin relief, freehand and pastiglia can be seen on the surrounds of the panels of the first two bays, containing the first four figures.

However, the figures of St Thomas, St Philip, St James the Less and St Matthew, who occupy this section of the screen, do not appear to have been painted by the Alburgh workshop. They differ stylistically from the figure painting at Fritton St Catherine, and do not share the same stencils as the Alburgh workshop.[54] Possibly the work of the Alburgh painters was never completed at Trunch. Alternatively, the panels were renewed in the medieval period, perhaps replacing an earlier scheme which did not have figures. If this was the case, the previous design was scraped back very carefully, as there is no obvious visual evidence.

At Lessingham, the Alburgh painters were the second set of craftsmen to paint the screen, decorating it over the work of another medieval workshop.[55] All the upper surface of the paintings appears to be the work of the Alburgh painters, although the repainting has been undertaken on paper on the dado panels, with traces of the original lying underneath.

the north and the south side dados. On the original north side, the papers were pasted in a rectangular format, so that much of the background was also covered. This area was decorated with paint and stencils in the usual vein. However, because of the paper substrate, the gilding did not take well to the surface. The painters mitigated for this on the south side of the dado, by cutting the figures out. There is no evidence that the green paint and stencils on the north side are from a different campaign of painting than the figures and so the implication is that the paper was painted on site and used to obscure the previous design.

53 Cotton, 'Mediaeval Roodscreens in Norfolk', p. 46.
54 It is, of course, possible that they hired a figure painter in for this purpose.
55 The Lessingham screen used to be in the now-closed museum at St Peter Hungate in Norwich, but is currently in storage in the Norfolk Museums and Archaeology Service store at Gressenhall, Norfolk. There are plans to reinstate it in the church at Lessingham.

Paintings on several other screens have been tied to some of the works in this group, although this is the first time that the group have outlined as fully as here. Mortlock stated that the 'gesso' (tin-relief) saints at Thwaite All Saints were like Aylsham.[56] This observation is not incorrect, they do resemble one another closely, but examination reveals that they are not from the same mould. Aylsham, Cawston and Marsham all share relief saints that do come from the same tin-relief mould, because they too are the output of the same workshop.[57] The presence of a very similar cast-relief saint on the screen at Thwaite All Saints and Aylsham is indicative of the date of both screens, early in the sixteenth century, and may even indicate a knowledge or emulation of one screen by another workshop.

Duffy identified the second scheme on the screen at Lessingham as being Marian in date (1553–58), an idea followed in Baker.[58] However, given the relationship to two different late medieval workshops (the Alburgh workshop described here and the Belaugh/Foulden doors workshop), this dating is no longer supportable. Instead, the will bequest of 1508 is most likely to relate to the second, Alburgh group scheme. Belaugh's screen has no known date, but Foulden's screen was termed 'lately made' in 1484. The two painted schemes at Lessingham might be about ten to fifteen years apart in date, the later painters perhaps being brought in to complete unfinished work, or to replace unsatisfactory painting. Unfinished work is by no means unheard of – St Catherine's Fritton was never completed and the painting on the screen at Salle was also probably never finished. However, it is difficult to assess the state of completion of Lessingham's first scheme: the second painters appear to have roughed the surface up before applying their paint. It is worth noting that the lower scheme at Lessingham is a standard Apostle screen, the upper saints a more eclectic set. The palette used by the painters was wide, particularly for decorative screens. It is also traditional in the context of screen paintings.

PLANS FOR THE FUTURE: NETWORK ANALYSIS

The methodology as currently employed has involved manually grouping carpentry and painting groups and has done so with considerable success. However, this still leaves ample scope for using more scientific methods to assess the data that has been gathered. Seriation, or relational statistics, a method of placing an assemblage of undated objects into a sequence,

[56] D. P. Mortlock and C. V. Roberts, *The Guide to Norfolk Churches* (Cambridge, 2007), p. 287.
[57] Wrapson, 'Prints and Pastiglia'.
[58] E. Duffy, *Saints, Sacrilege, Sedition: Religion and Conflict in the Tudor Reformations* (London, 2012), p. 80; Duffy, 'The Parish', pp. 133–62; Baker, *English Panel Paintings*, p. 155.

was developed by Flinders Petrie in the late nineteenth century.[59] Petrie used it as a method of creating a contextual chronological sequence in the absence of dates or stratigraphic data, listing grave contents on card strips and reordering them into the most logical sequence according to design styles. Renfrew and Bahn describe two forms of seriation since developed: contextual seriation is based on the presence or absence of a design, and frequency seriation measures the proportional abundance or absence of a design style.[60] More recently, network analytical approaches have been developed in material culture studies which examine relationships between complex and diverse entities such as places, peoples, traits and objects.[61] Complex multi-modal and visual data such as that gathered in the course of this study is well suited to statistical interrogation using these methods.

East Anglian screens are a set of objects of changing style with consistent features: the initial grouping of related works indicates that network analysis is likely to work in this context, which should include Geographic Information Systems (GIS) mapping and the locations of known carpenters, of which more than 500 have been collated for the period. Usefully, there is an external dating system applicable to screens, which can be used to test the results of statistical analysis rigorously. What may prove more problematic might be the regional stylistic differences seen in Norfolk, Suffolk and Cambridgeshire.

Nonetheless, this essay has outlined a new combined methodology used to assess how East Anglia's late medieval screens were made and thereby determine the first evidence-based chronology of the corpus as a whole; a chronology that it is hoped will be developed and refined into the future. Attention to both style and technique, focusing on specific relevant details has been demonstrated to tie objects together where documentary evidence of authorship is lacking. This demonstrates the utility of looking at a large body of surviving medieval artistic production in new ways: collating the related works of carpentry and painting has revealed demonstrable and quantifiable patterns of production for rood screens in late medieval East Anglia thanks to the remarkably large numbers of surviving objects.

[59] C. Renfrew and P. Bahn, *Archaeology: Theories, Methods, and Practice* (London, 1996), p. 116.
[60] Ibid., pp. 116–17.
[61] T. Brughmans, 'Connecting the Dots: Towards Archaeological Network Analysis', *Oxford Journal of Archaeology*, 29 (2010), pp. 277–303; C. Knappett, *Network Analysis in Archaeology: New Approaches to Regional Interaction* (Oxford, 2013).

TEXTS AND DETEXTING ON LATE MEDIEVAL ENGLISH CHURCH SCREENS

4

DAVID GRIFFITH

Few disputes divided early Reformation England as did the making and usage of images. For reformers images embodied Romish superstition and idolatry and denied the basic tenets of true Christian living, justification by faith alone and the sufficiency of the Word. For traditionalists the assault on images threatened the nature of worship itself. Images allowed the faithful to understand their faith by calling to mind the lives of the saints and by visualizing church doctrine, the sacraments and the liturgy. They also shaped social identity and practice. With the fabric and furnishings of parish churches largely paid for by the lay community, imagery created powerful emotional and memorial ties with the faithful departed. Generations of past worshippers had shaped a world of holy icons and visual guides to the faith, often with themselves depicted as onlookers within the church environment. From the mid-1530s onwards these expressions of traditional belief and worship were systematically desanctified – devotional images in churches throughout the land were destroyed, covered over and defaced. Resistance to reform continued, especially in the North and West, and the restoration of Catholic worship during Mary's reign saw renewed use of images, old and new, but Elizabeth's accession marked a decisive assertion of Protestant teachings and the pre-eminence of scripture. The Elizabethan Settlement of 1559 looked to halt the wanton destruction that previous reforms had unleashed but the casting down of images continued long after.[1]

[1] I am grateful to the organizers of the Cambridge conference for the invitation to speak and to the editors of the present volume. Lucy Wrapson and Simon Cotton graciously

Central to this 'stripping of the altars' was the supplanting of images by 'goodly' texts.[2] In the early years of reform many parishes held radical forces in check, encouraged by Henry VIII's innate conservatism and his government's rowing back from earlier positions, but as the culture of change took root the iconomachs and iconoclasts gained the upper hand.[3] And as the new order gave opportunities to pluck down offensive idols, so the publication of vernacular scripture and texts provided the materials for their replacement. The 'Second Royal Injunctions' of September 1538, drawn up by Thomas Cromwell, enjoined congregations to learn the Lord's Prayer, the Apostle's Creed and the Ten Commandments in English.[4] The Books of Common Prayer of Edward VI's reign placed an additional requirement upon the laity to make the general confession, while the revised communion service also required recitation of the Lord's Prayer and a response to the Ten Commandments. As tools in a new catechism, the Lord's Prayer, Creed and Commandments were reproduced on walls and panels, and supplemented with other improving scriptural texts, often warning against idolatry.[5]

The bedrock of this word-based faith was, of course, Holy Writ in English. Cromwell's Injunctions required every church to display

> one book of the whole Bible of the largest in English, and the same set up within some convenient place within the said church that you have cure of, whereas your parishioners may most commodiously resort to the same and read it.

The printing of this Great Bible, largely the work of Miles Coverdale, was complete by April 1539. The second edition of 1540 carried a prologue by Thomas Cranmer, archbishop of Canterbury, and a frontispiece stating 'This is the Bible appointed to the use of the churches.' For Cranmer the communality of ownership underpinned the role of the preacher and the importance of private meditation upon God's word: 'geve eare to that, that is sayd by the preacher: but that also, when ye be at home in your houses, ye apply yourselves from tyme to time to the reading of holy scriptures'.[6] This attests to both linguistic and spatial imperatives within the church. As

replied to my requests for information; Richard Marks deserves special notice for his expert guidance, as does Rachel Canty for discussing work in progress.

[2] Seminal studies include J. Phillips, *The Reformation of the Images: Destruction of Art in England, 1535–1660* (London, 1973); R. Whiting, *The Blind Devotion of the People: Popular Religion and the English Reformation* (Cambridge, 1989); E. Duffy, *The Stripping of the Altars: Traditional Religion in England c.1400–c.1580*, 2nd edn (London, 2005); R. Whiting, *The Reformation of the English Parish Church* (Cambridge, 2010). Margaret Aston's monumental *Broken Idols of the English Reformation* (Cambridge, 2015) will become the standard work on the subject of late sixteenth- and seventeenth-century iconoclasm.

[3] Philips, *Reformation of the Images*, pp. 82–90.

[4] W. H. Frere (ed.), *Visitation Articles and Injunctions of the Period of the Reformation*, 3 vols (London, 1910), II, p. 36.

[5] Aston, *Broken Idols*, pp. 912–27.

[6] Anon., *The Byble in Englyshe* (London, 1540), prologue.

vernacular scripture became central to communal and private worship so the reordering of the interior shifted the focus from altar and priest to pulpit and preacher. These complete versions of the Bible were supplemented by large numbers of printed editions of the New Testament and sections of the Old, especially the Psalms and those books, like Ecclesiastes and Kings, that were deemed to be prophetic of the break from Rome and demonstrative of Divine support for reform.[7] The vernacularization of the English Church reached another significant milestone with the publication of the first edition of the Book of Common Prayer in 1549. This was the first prayer book in English to include complete forms of worship for both daily and Sunday services. It marked a decisive rejection of Latin liturgy and ritual and was a key to the dismantling of Catholic forms of worship in the period.

As the major item of church furniture the rood screen and loft was a site for mounting holy texts. Churchwardens' accounts suggest that many parishes adopted the practice, though the loss of so many screens makes it difficult to appreciate precisely which texts were favoured or the ways in which they were displayed. In the early years of Edward's reign parishioners at Boxford (Suffolk) paid for 'wrytyng on the candelbeme', while those at Ashburton (Devon) and Smarden (Kent) had texts painted on their rood lofts.[8] The passage from the Psalms seen by the eighteenth-century antiquary Thomas Martin 'upon part of a gallery on the organ loft' at Deopham (Norfolk) may be similarly dated.[9] Marian reversions saw the Ashburton and Smarden texts put down in 1554–55 but both lofts were dismantled under Elizabethan reform. The same zigzag course was evident in the urban parishes. Edwardian churchwardens of the London parish of St Mary at Hill paid £4 for their rood loft to be adorned with scriptural texts only for them to be scoured less than a decade later under Marian edicts.[10]

Of these early palimpsests, the best known is at the former Benedictine Priory of Binham, near Walsingham in north Norfolk. The nave was given over to the parochial congregation and the rood screen carried both painted saints on the dado and a Latin benefactory dedication on the sill.

[7] See S. Wabuda, *Preaching During the English Reformation* (Cambridge, 2002), and A. Ryrie, *The Gospel and Henry VIII: Evangelicals in the Early English Reformation* (Cambridge, 2003).
[8] P. Northeast (ed.), *Boxford Church Warden Accounts 1530–1561*, Suffolk Record Society, 23 (Woodbridge, 1982), p. 58; A. Hanham (ed.), *Churchwardens' Accounts of Ashburton, 1479–1580*, Devon and Cornwall Record Society, new series 15 (Torquay, 1970), pp. 125, 131; F. Haslewood, 'Notes from the Records of Smarden Church', *Archaeologia Cantiana*, 9 (1874), pp. 224–35.
[9] Norwich, Norfolk Record Office, MS Rye 17/3, f. 13.
[10] H. Littlehales (ed.), *The Medieval Records of a London City Church: St Mary at Hill, 1420–1559*, 2 vols, Early English Text Society, Original Series, 125, 128 (1904–5) 2, pp. 387, 397. For an exhaustive account of events in the capital see S. Brigden, *London and the Reformation* (Oxford, 1989; new edn London, 2014).

Perhaps as early as the late 1540s, the donor's inscription was erased and the images whitewashed and overwritten with New Testament passages; the five remaining sections carry texts from the Epistles of Peter, Timothy and Colossians. These seek to fashion a new sense of community based upon direct apprehension and application of Christ's teachings and in so doing they offer a direct affront to traditional practices passage. Peter (1:13–16) is recruited to reject the intolerable 'old lustes' of traditional Catholic worship (Pl. XI):

> Be sober and trust perfectly on the grace that is brought unto you by ye declaryng of Iesus christ as obedient chyldren, that ye geve not youre selves ouer unto old lustes, by which ye were led whan as yet ye were ignoraunt of christ. But as he which called you is holy, even so be ye holy also in all maner of conuersacyon, because it is written: Be ye holy, for I am holy saithe ye lord.

The injunctions against covetousness and materialism from 1 Timothy are equally proscriptive and in the context of a former monastic establishment have particular pertinence. It is not insignificant that some of the strongest resistance to reform in Norfolk came from this part of the county. In the spring and summer of 1537 the Crown had executed more than a dozen local men for their part in plots to prevent Walsingham Priory and other institutions being despoiled.[11] At the grassroots level such texts witness significant theological change: the communion of saints had finally been ousted by a community shaped by the Word of God. In the context of the rapid and inevitably provocative Edwardian reforms this choice of texts seems particularly directive. They offer unambiguous scriptural authority for the reform of abuse and 'euyll doinge'. At Binham and elsewhere parochial reading thus became a means to salvation harnessed by the power of the preacher's delivery.

The introduction of new vernacular reading practices has traditionally been seen as empowering the laity in the face of a self-interested and authoritarian clergy and a key strategy in the overthrow of a monolithic, Latinate and abusive institution. Recent scholarship has come to recognize how this kind of historiography itself typifies fundamentalist attitudes to worship, occluding the dynamics of medieval textual culture and valorizing restrictive reading practices. In a compelling revisionist response to reading cultures of the period, James Simpson argues that far from liberating readers from clerical misinterpretation of the scriptures this created 'newly impersonal and imperious forms of textuality and of the application of fewer textual instruments to larger jurisdictions'.[12]

[11] C. E. Moreton, 'The Walsingham Conspiracy of 1537', *Historical Research*, 63 (1990), pp. 29–43.

[12] J. Simpson, *Burning to Read: English Fundamentalism and its Reformation Opponents* (London, 2007), p. 3.

Simpson's primary concern is the printed book but his arguments have implications that extend far beyond the physical confines of the page, not least in understanding the nature and significance of written texts used in the minimalist decorative schemes of post-Reformation ecclesiastical buildings. The essential differences between visual and verbal signs had been a particular concern since the end of the fourteenth century, focused and energized by Lollard objections to imagery.[13] Undoubtedly there were constraints upon vernacular theology in the post-Arundel environment but the textual forms of the late medieval Church were many and various and often intimately connected to devotional imagery. The Injunctions of the late 1530s broke the essential link between worship and image thus rupturing the complex text–image narratives of late medieval church art. While these texts often remained, some for many generations, they no longer played a role in authorized worship or belief. In Simpson's terms, 'reading displaced images; the written, the unwritten; worship, idolatry'.[14] Indeed, what the early reformers saw as the liberation of reading practices through unmediated access to the Word of God constituted a silencing of the many voices and authors present in late medieval church spaces. These reformed reading practices are embodied in the black letter shapes of the biblical text framed in their narrow unadorned borders – regular, adamant, unyielding in their consistency. For a sense of the processes at work here we might turn to Armando Petrucci's celebrated study of public writing in western cultures since the fall of Rome. He describes how the waning of literacy had by the early Middle Ages reduced the great body of classical public writing to a shadow of its former size and influence and he argues that the narrowing of inscriptional forms and function may explain why the graphic production of the early Middle Ages depended so heavily upon the book as a model for scripts and layouts.[15] From this we might say that a resurgence of epigraphic forms is also manifested in the public space of the late medieval church and that the rise of graphic monolithism in post-Reformation England, the inscribing of scriptures to the near exclusion of other textual forms, symbolizes a curtailing of public literacy and communicative acts between individuals and groups within the community.

That general access to vernacular scripture was not authorized by the pre-Reformation Church allowed evangelical preachers and intellectuals to make play of its opposition and to raise clamour against perceived material and spiritual injustices. In *Obedience of a Christian Man* (1528), Tyndale rails against the 'devilish falsheed' that 'will not sofre the scripture to be

[13] See especially M. Aston, *Lollards and Reformers: Images and Literacy in Late Medieval Religion* (London, 1984).

[14] Simpson, *Burning to Read*, p.15.

[15] A. Petrucci, *Public Lettering: Script, Power, and Culture*, trans. L. Lappin (London, 1993), pp. 1–3.

had in the Englysh tonge, nether any worke to be made that shulde bringe
the people to knowledge of the trueth'.[16] The equally pungent rhetoric
of Simon Fish's *A Supplicacyon for the Beggers* (1529) asserts the 'cloked
ypochrisi' of priests who sought to prevent the Bible from going 'a brode
yn [its] moder tong'.[17] Such tracts played a vital role in the development
of a reformist anti-Papist agenda but they are of their nature intensely
partisan and construct a laity entirely starved of spiritual sustenance.
To those of this sensibility the late medieval epigraphical tradition was
dissimulation, geared towards propping up false gods – the intercessory
function of saints, the Virgin Mary, purgatory and the Mass. Reform
demanded an agenda of image destruction and inscriptional erasure, or
what I call here detexting.

The removal of erroneous and offensive material followed by the
reinscription of officially sanctioned scriptural texts, as at Binham, was
then central to the construction of a new Protestant identity.[18] However,
even a cursory glance at the late medieval epigraphic corpus shows that the
reformers had their work cut out if blanket coverage was to be achieved. For
traditional believers at least, the church space was diversely constituted and
far from being the domain of the clerical class. It was rather an environment
in which lay influence had come to play a central role and which was
determined at the local level by individual, family and group patronage.
The burgeoning textualization of the late medieval parish encompassed a
diversity of form, content and linguistic register and inscriptions appeared
on all aspects of its fabric, fittings and other adornments.[19] That vernacular
scripture was regulated before the 1530s should not, however, blur our
understanding of the relationship between Latin and English at this date.
The two languages were not polarized. Latin was the natural medium of
many aspects of church teaching and of the Bible – and necessary in certain
contexts – but the increasing laicization of the church space gave rise also
to an increasing number of the congregation wanting texts in their mother
tongue. In some senses, the renewal of devotional energies generated by
newly fashioned visual and material content is paralleled by the increased
functionality and versatility of English. And the rood screen with its loft and
tympanum, as well as parclose and other screens, became a favoured site for
lay investment and for the resulting textual display.

[16] W. Tyndale, *The Obedience of a Christen Man* (Antwerp, 1528), f. lxiii.
[17] S. Fish, *A Supplicacyon for the Beggers* (Antwerp, 1529), sig. A6ᵛ.
[18] The impact of this kind of polemic in the capital is examined in meticulous detail by
Brigden, *London and the Reformation*.
[19] Important recent studies include R. Marks, 'Picturing Word and Text in the Late
Medieval Parish Church', in L. Clark, M. Jurkowski and C. Richmond (eds), *Image, Text
and Church 1380–1600: Essays for Margaret Aston*, (Toronto, 2009), pp. 162–202; and M.
Gray, 'Images of Words: Iconographies of Text and in the Construction of Sacred Space
in Medieval Church Wall Painting', in J. Sterrett and P. Thomas (eds), *Sacred Space, Sacred
Text: Architectural, Spiritual and Literary Convergences in England and Wales* (Leiden,
2011), pp. 15–34.

INSCRIPTIONS AND *MISE EN TEXTE*

During the fifteenth and into the early sixteenth century the expansion of lay involvement in the Church became manifest in countless communal and individual gifts and bequests.[20] This demand was met by a skilled workforce in various trades, from glaziers and painters, to carpenters, textile workers, masons, ironworkers and so on. The make-up of these trades in relation to the construction and decoration of the largest regional corpus of English screens, in East Anglia, has been carefully considered by Lucy Wrapson.[21] Her assessment – necessarily conditional in the absence of contractual documents or signed work – is that all of those named as gravers, painters or stainers in the freeman rolls could potentially have decorated a rood screen. This implies a pool of craftsmen and women who could be called upon to paint inscriptional texts even if not possessed of any specialist sign-writing skills. Curiously, this aspect of the painter's art has received no special consideration, either in relation to screens or on comparable media such as glass or mural painting. Given a scenario with a general division of labour we might anticipate a body of competent work with occasional outliers, from excellent to poor and worse. Indeed, while there is a sizeable body of proficient work, as well as instances of cramped and awkwardly shaped letters, there are also numerous instances of expertly lettered inscriptions that speak of training and high production values. This spectrum of expertise might be thought comparable to the degrees of professionalism in late medieval manuscript production, from the expertly drawn formal scripts of illuminated manuscripts to the solidly professional work of, for example, business texts or imaginative texts for lesser patrons, to the amateurish and inconsistent cursive hands turning out undistinguished copies for personal use. In epigraphical terms it may be that a degree of specialization developed in workshops so that experienced hands took on expensive commissions with considerable wordage, as at Burnham Norton or Thornham (Norfolk), or where the lettering was central to the design and involved intricate rubrication and scribal contractions, as in

[20] S. Cotton, 'Medieval Roodscreens in Norfolk: Their Construction and Painting Dates', *Norfolk Archaeology* 40 (1987), pp. 44–54; S. Cotton, H. Lunnon and L. Wrapson, 'Medieval Rood Screens in Suffolk: Their Construction and Painting Dates', *Proceedings of the Suffolk Institute of Archaeology and History*, 43:2 (2014), pp. 219–34; W.W. Lillie, 'Screenwork in the County of Suffolk, III, Panels Painted with Saints', *Proceedings of the Suffolk Institute of Archaeology*, 20 (1930), pp. 214–26, 255–64; 21 (1933), pp. 179–202; 22 (1936), pp. 126-26; and M. A. Williams, 'Medieval English Roodscreens, with Special Reference to Devon' (PhD thesis, University of Exeter, 2008).

[21] L. Wrapson, 'East Anglian Rood Screens: The Practicalities of Production', in P. Binski and E. A. New (eds), *Patrons and Professional in the Middle Ages* (Stamford, 2011), pp. 386–405 (pp. 390–2). See also A. M. Baker, *English Panel Paintings 1400–1558: A Survey of Figure Paintings on East Anglian Rood Screens* (London, 2011); and J. Mitchell, 'Painting in East Anglia around 1500', in John Mitchell (ed.), *England and the Continent in the Middle Ages: Studies in Memory of Andrew Martindale* (Stamford, 2000), pp. 365–80.

the complex scroll work at Sparham or in the dedication for the Bacon family at St Catherine, Fritton (Norfolk). With so much work done *in situ* it seems likely that only the more skilled workers would be handed the demanding task of complex lettering outside the controlled environment of the workshop. Such as these might have developed expertise in the kind of multi-media workshop David King associates with the Norwich glazier William Heyward,[22] though there is as yet no entirely compelling evidence that can correlate painted inscriptions on screens with those on glass. In regions where screen inscriptions were routinely carved rather than painted – in Yorkshire, Nottinghamshire and Cheshire – the quality of woodworking indicates execution by practised hands. The expertly carved text on the ringers' gallery at Worstead (Norfolk) and Cawston in Norfolk show this kind of craftsmanship could be found elsewhere but no doubt at a higher price than painted work.

With few exceptions the style of lettering used on screens, both painted and carved, is the Gothic display script commonly known as black letter, more formally as textura, a mixed script of majuscule and minuscule letters. This corresponds to the construction and decoration of English screens from the mid–late fourteenth to the early sixteenth centuries. Late medieval English epigraphical traditions before this date, roughly 1150–1350, show the coexistence of textura and the uncial script commonly known as Lombardic capitals. From around 1350 black letter became the dominant form – sometimes in a transitional state utilizing Lombardics as initials – and was used extensively on glass, wood and wall surfaces and in carved inscriptions on metal and stone monuments. In discussing the popularity of textura as a written display script, Wakelin notes that the term derives from the Latin perfect passive participle 'textus' meaning 'woven', a reference to its immediate visual impact.[23] It is characterized by thickly drawn vertical strokes or minims, complemented by thinner lines on horizontal and diagonal axes, particularly as flourishes on descenders and ascenders. It often features serifs on many letters, such as squared or lozenged feet.[24] Medieval epigraphers, eschewing the variety of scripts of manuscript culture, developed textura over a period of roughly two and a half centuries.[25] Three broad phases are distinguishable, though there are no established divisions between them. The emergent form in the early to mid-fourteenth century often shows bold and well-spaced

[22] D. King, 'A Multi-Media Workshop in Late Medieval Norwich – A New Look at William Heyward', in C. De Ruyt (ed.), *Lumières, formes et couleurs: mélanges en hommage à Yvette Vanden Bemden* (Namur, 2008), pp. 193–204.

[23] H. Cockerham's *English Dictionarie* of 1623 uniquely uses the word 'detext' to mean 'unwoven', which has influenced my decision to use it here.

[24] D. Wakelin, 'Writing the Words', in A. Gillespie and D. Wakelin (eds), *The Production of Books in England 1350–1500* (Cambridge, 2011), pp. 34–58.

[25] A useful overview is given by Sally Badham and Martin Biddle, 'Inscriptions in the Painting', in M. Biddle (ed.), *King Arthur's Round Table* (Woodbridge, 2000), pp. 255–83.

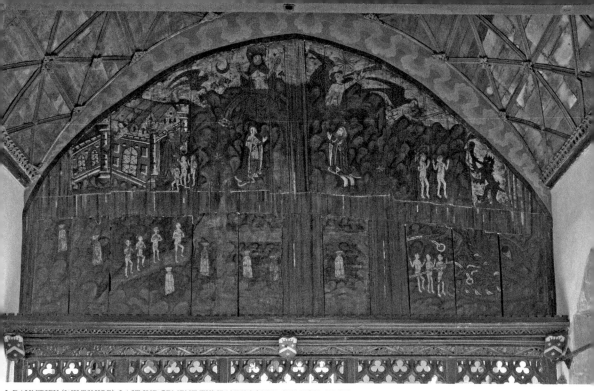

I. DAUNTSEY (WILTSHIRE). LAST JUDGEMENT TYMPANUM OVER CHANCEL ARCH.

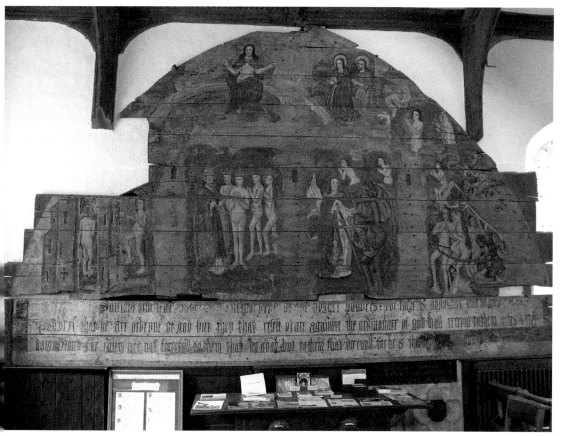

II. WENHASTON (SUFFOLK). LAST JUDGEMENT TYMPANUM.

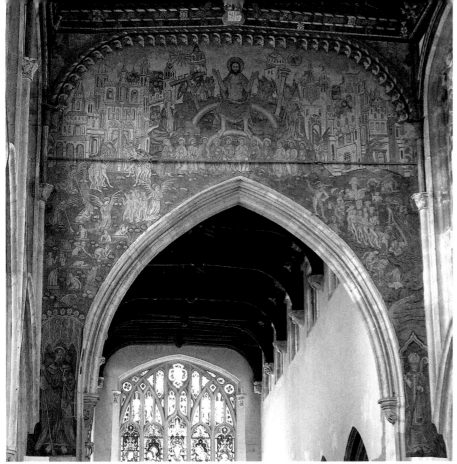

III. SALISBURY, SS THOMAS AND EDMUND (WILTSHIRE). LAST JUDGEMENT.

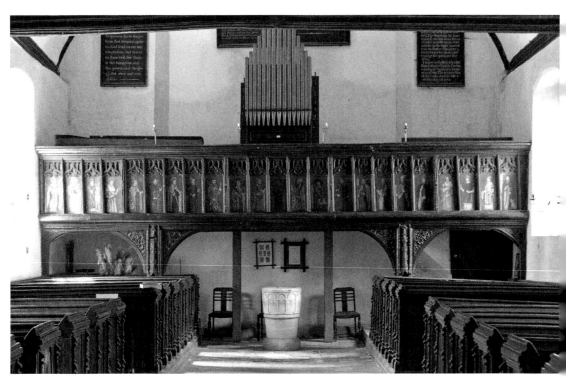

IV. STRENSHAM (WORCESTERSHIRE). ROOD LOFT PANELS.

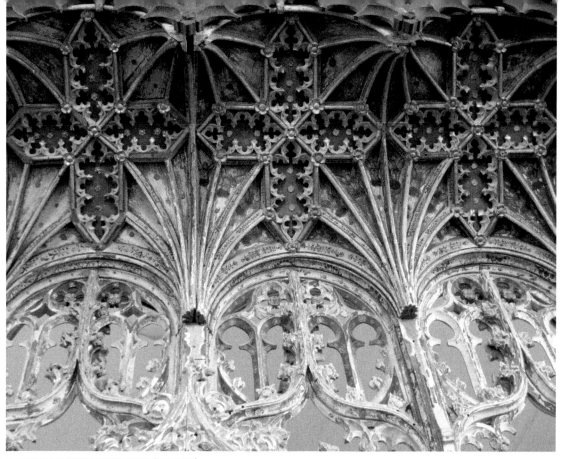

V. AZURITE PAINT ON BRAMFIELD (SUFFOLK) ROOD SCREEN.

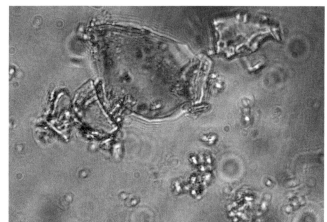

VI. LIGHT TRANSMITTED THROUGH AZURITE PARTICLES.

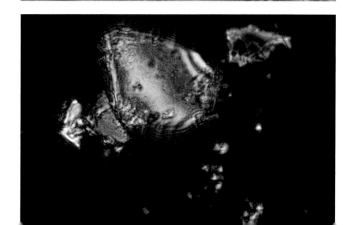

VII. THE SAME AZURITE PARTICLES SEEN UNDER CROSSED-POLARS.

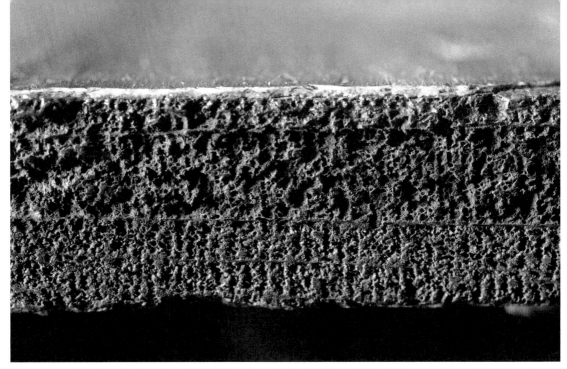

VIII. ENDGRAIN OF AN OAK PANEL SHOWING MEDULLARY RAYS (HORIZONTAL STRUCTURES) AND ANNUAL GROWTH RINGS (VERTICAL STRUCTURES).

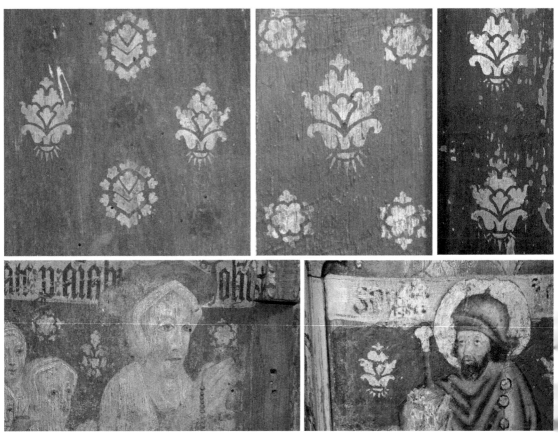

IX. MATCHING TIN RELIEF FROM ALBURGH, TRUNCH AND SOUTH BURLINGHAM PULPIT.

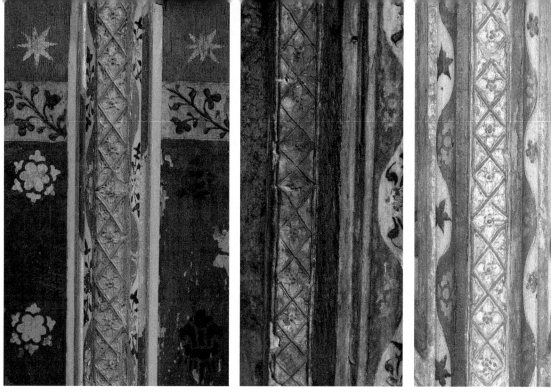

X. MATCHING STENCILS FROM THWAITE, SOUTH BURLINGHAM PULPIT, LESSINGHAM, FRITTON AND ALBURGH.

XI. BINHAM PRIORY (NORFOLK), ROOD SCREEN DADO PANEL, PROBABLY LATE FIFTEENTH CENTURY, WITH MID-SIXTEENTH-CENTURY SCRIPTURAL TEXTS PAINTED OVER PRE-REFORMATION SAINTS.

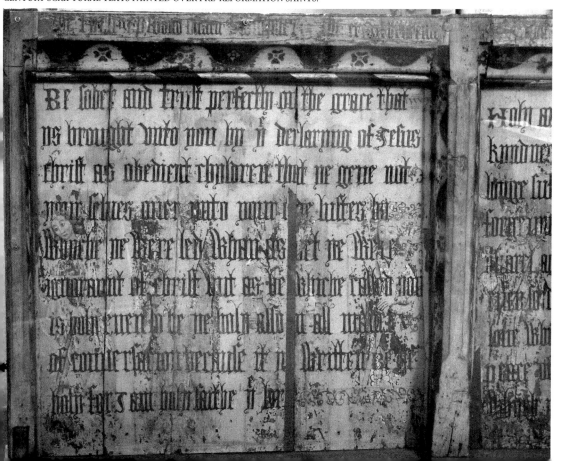

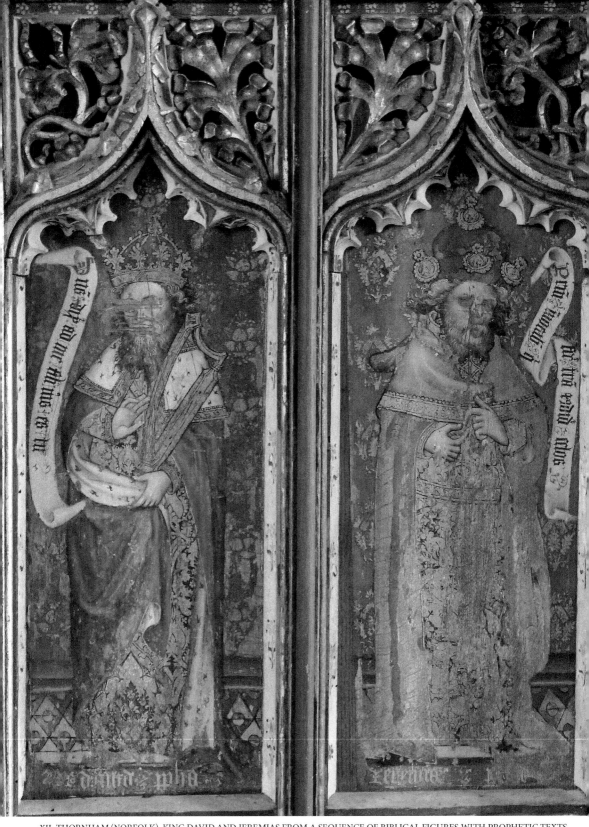

XII. THORNHAM (NORFOLK), KING DAVID AND JEREMIAS FROM A SEQUENCE OF BIBLICAL FIGURES WITH PROPHETIC TEXTS, FROM THE ROOD SCREEN DADO, THE GIFT OF JOHN AND CLARICE MILLER C.1488.

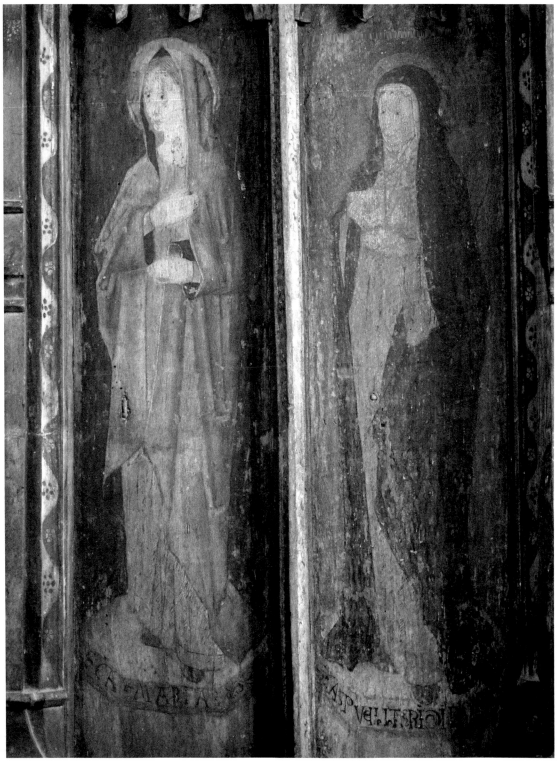

XIII. GATELEY (NORFOLK), THE VIRGIN MARY ('SANCTA MARIA') AND THE UNCANONIZED 'SCA PUELLA RIDIBOWNE' WITH TITLE INSCRIPTIONS IN UNCIALS, FROM THE ROOD SCREEN DADO, C.1500–20.

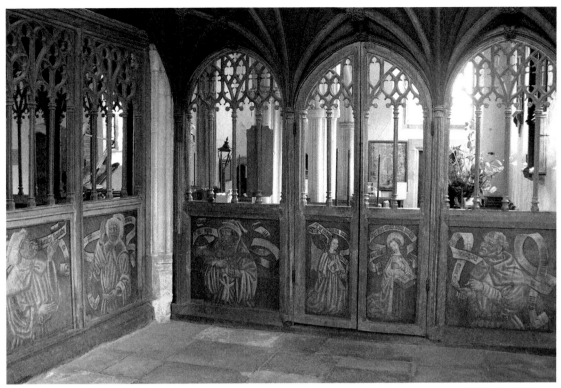

XIV. ASHTON (DEVON), NORTH AISLE CHAPEL SCREEN, WITH LATIN TEXTS TAKEN FROM THE LITURGY OF THE FEAST OF THE TRANSFIGURATION, LATE FIFTEENTH OR EARLY SIXTEENTH CENTURY.

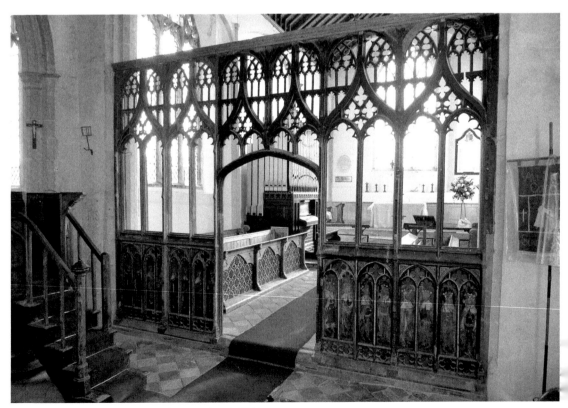

XV. CATFIELD: THE ROOD SCREEN FROM THE SOUTH-WEST.

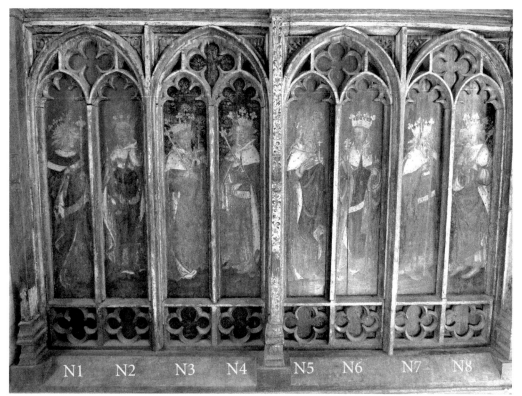

XVI. CATFIELD: THE NORTH SIDE OF THE DADO, SHOWING FROM LEFT TO RIGHT COMPARTMENTS N1 – N8.

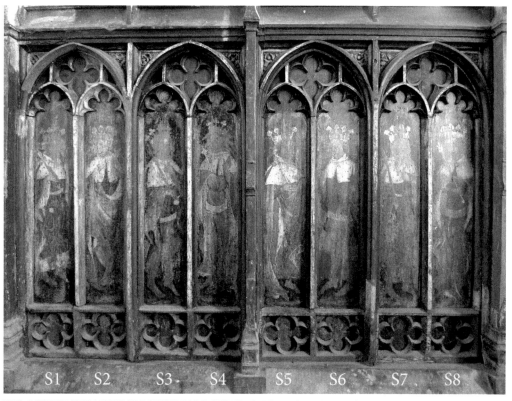

XVII. CATFIELD: THE SOUTH SIDE OF THE DADO, SHOWING FROM RIGHT TO LEFT COMPARTMENTS S1 – S8.

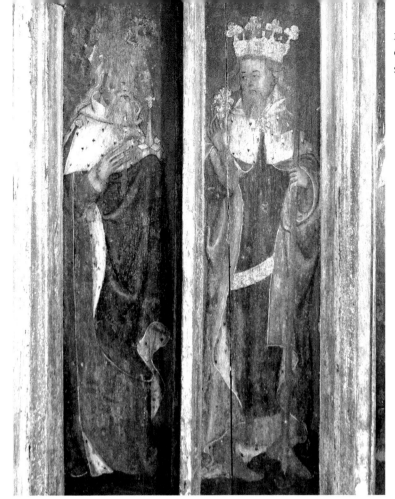

XVIII. CATFIELD: THE KINGS IN COMPARTMENTS N5 AND N6: SS SEBERT (?) AND KENELM.

XIX. KENTISBEARE (DEVON). ORIGINAL SCREEN THOUGHOUT. THIS SHOWS THAT THE LOFT IS SUPPORTED BY THE SCREEN EXCEPT POSSIBLY AT EACH END.

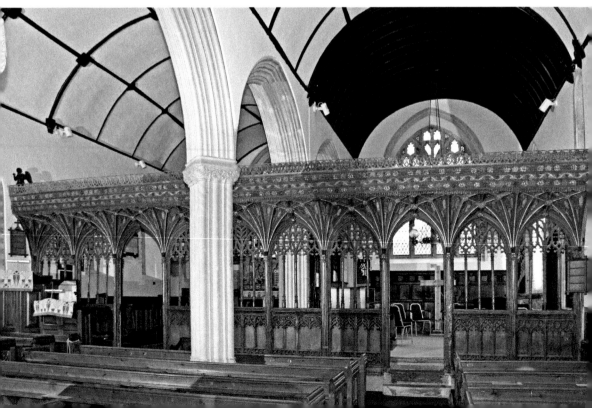

XX. HENNOCK (DEVON). THE CEILURE IN ITS
TRADITIONAL POSITION ABOVE THE ROOD SCREEN.
THIS CEILURE WAS RESTORED IN THE 1970S.

XXI. KENTON (DEVON). THE
HORIZONTAL EMPHASIS OF A DEVON
SCREEN EVEN WITH ITS GALLERY
FRONT. THIS IS PARTLY ORIGINAL
AND WAS RESTORED IN THE EARLY
TWENTIETH CENTURY.

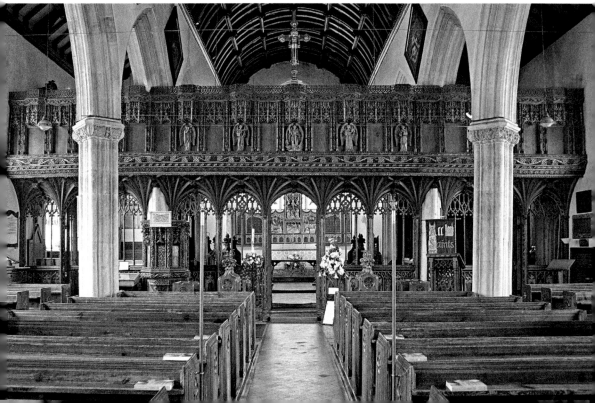

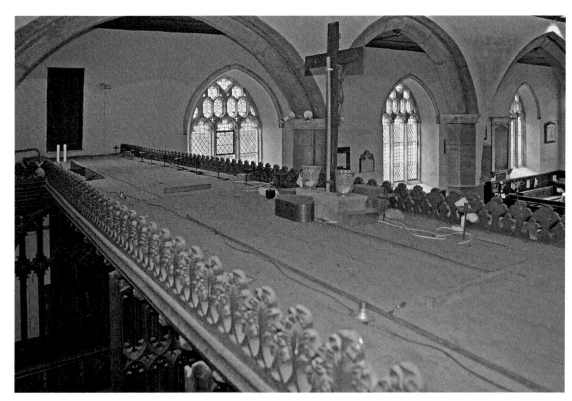

XXII. HALBERTON (DEVON). A SCREEN BUILT IN THE CENTRE OF THE ARCHED ARCH. ALTHOUGH THE ROOD LOFT GALLERIES ARE MISSING, IT WILL BE SEEN THAT FULL ACCESS WOULD BE AVAILABLE ALONG THE LENGTH OF THE SCREEN.

XXIII. WOLBOROUGH (DEVON). A DOOR WITH A GROWN DURN AS THE HANGING STILE. NOTE THERE IS NO JOINT AT THE SPRINGING LINE, SO A PIECE OF TIMBER WAS CHOSEN WITH A NATURAL CURVE IN IT.

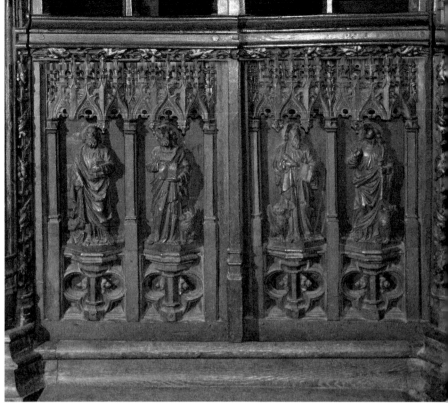

XXIV. KENTON (DEVON). ALTHOUGH THE TABERNACLES AND FIGURES ARE NINETEENTH CENTURY, THE BASES ARE ORIGINAL. THE RESTORED WORK WAS CARRIED OUT BY HERBERT READ.

XXV. KENTON (DEVON). TWO OF THE CANOPIED NICHES THAT DECORATE THE DOORWAY. THE FIGURES CARRY THEIR ATTRIBUTES.

XXVI. HIGH HAM (SOMERSET). THE TYPICAL CANOPIED HEADS TO THE TRACERY LIGHTS.

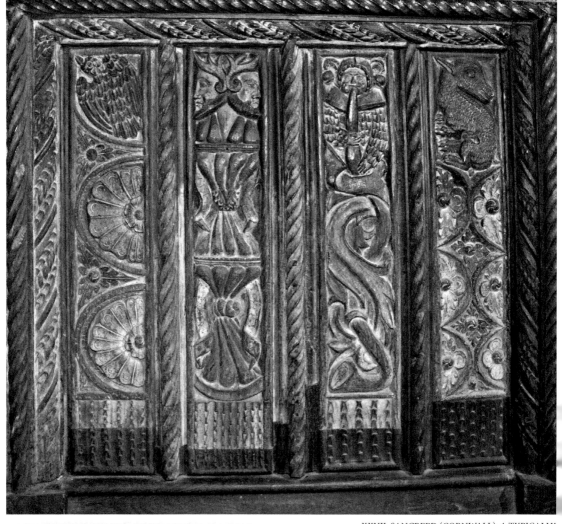

XXVII. SANCREED (CORNWALL). A TYPICALLY CORNISH DADO MIXING FIGURES AND ANIMALS WITH REPEATED PATTERNS.

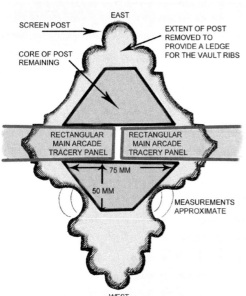

EAST

SCREEN POST

EXTENT OF POST
REMOVED TO
PROVIDE A LEDGE
FOR THE VAULT RIBS

CORE OF POST
REMAINING

RECTANGULAR
MAIN ARCADE
TRACERY PANEL

RECTANGULAR
MAIN ARCADE
TRACERY PANEL

75 MM

50 MM

MEASUREMENTS
APPROXIMATE

WEST

PLAN VIEW OF MAIN SCREEN POST
AT SPRINGING LINE

XXVIII. A GRAPHIC ILLUSTRATING THE MINIMAL CORE OF A ROOD SCREEN POST AT SPRINGING HEIGHT THAT HAS TO SUPPORT THE WEIGHT OF THE ROOD LOFT ABOVE.

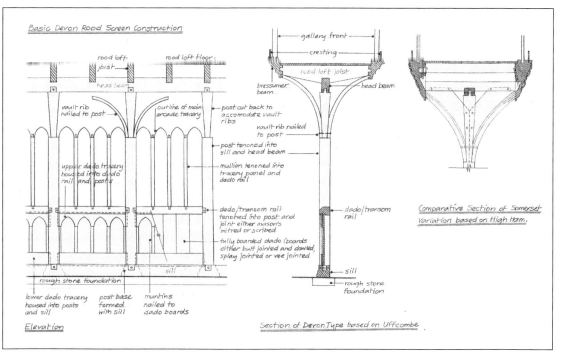

Basic Devon Rood Screen Construction

rood loft joist

rood loft floor

head beam

vault rib nailed to post

outline of main arcade tracery

upper dado tracery housed into dado rail and posts

gallery front

cresting

rood loft joist

bressumer beam

head beam

post cut back to accomodate vault ribs

vault rib nailed to post

post tenoned into sill and head beam

mullion tenoned into tracery panel and dado rail

dado/transom rail tenoned into post and joint either mason's mitred or scribed

fully boarded dado (boards either butt jointed and dowled, splay jointed or vee jointed)

dado/transom rail

sill

rough stone foundation

Comparative Section of Somerset Variation based on High Ham.

rough stone foundation

sill

lower dado tracery housed into posts and sill

post base formed with sill

muntins nailed to dado boards

Elevation

Section of Devon Type based on Uffcombe.

XXIX. DRAWING SHOWING CONSTRUCTION OF TYPICAL VAULTED ROOD LOFT SHOWING LOFT JOISTS AND VAULTED ARCH RIBS SUPPORTING THE BRESSUMMER BEAMS ON THE EAST AND WEST SIDES. THE GALLERY FRONTS RISE UP ABOVE THE BRESSUMMER BEAMS. THE RIGHT-HAND DRAWING SHOWS THE EXTRA SUPPORT FOR THE BRESSUMMER BEAMS FROM DEEP ARCH BRACES BEHIND THE TRANSVERSE VAULT RIB, AS SEEN AT HIGH HAM (SOMERSET).

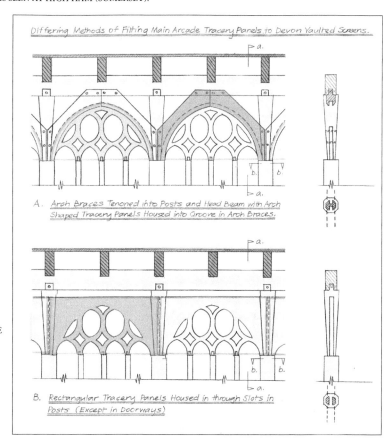

Differing Methods of Fitting Main Arcade Tracery Panels to Devon Vaulted Screens.

A. Arch Braces Tenoned into Posts and Head Beam with Arch Shaped Tracery Panels Housed into Groove in Arch Braces.

B. Rectangular Tracery Panels Housed in through Slots in Posts (Except in Doorways)

XXX. DRAWING SHOWING THE TWO TYPES OF ROOD SCREEN MAIN ARCADE TRACERY. THE TOP DRAWING SHOWS STANDARD ARCH BRACES WITH ARCHED TRACERY PANEL. THE LOWER DRAWING SHOWS A RECTANGULAR TRACERY PANEL WHICH SPANS FROM POST TO POST.

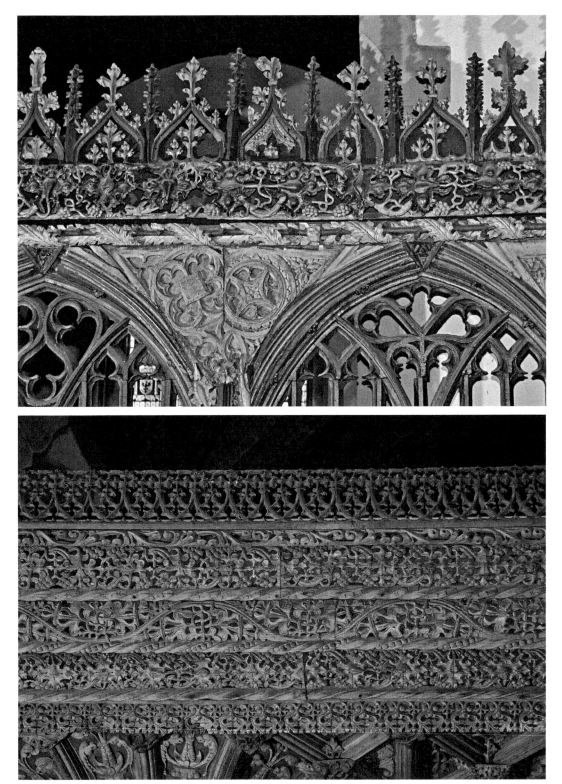

XXXI. PILTON (DEVON) COMPARED WITH LAPFORD (DEVON). AT PILTON NOTE THE BOLD FOLIAGE TRAIL WITH DIFFERING VINE TENDRILS THROUGHOUT, ALSO EACH LEAF IS DIFFERENT IN DETAIL FROM THE OTHERS. THE AARON'S ROD ORNAMENT BELOW THE VINE TRAIL IS MASSIVE AND CARVED WITH VIGOUR, NOTE ALSO THE SPANDREL PANELS WITH THEIR DECORATED PERIOD TRACERY DESIGNS. IN COMPARISON LAPFORD IS INTRICATE BUT REPETITIVE SIXTEENTH-CENTURY WORK.

minims. By the middle of the following century, and by this point used for all manner of public display, the letter shapes are less varied, with limited use of majuscules, greater prevalence of 'biting' (the tendency of one letter to absorb part of another), and minims that are frequently joined at head and base regardless of the letter form depicted. In a script that uses no bows, loops or curved strokes this compression can be difficult to negotiate visually and often leads to so-called 'minim confusion', especially for words with a series of short stroke letters (as in the word 'minim' itself). Efforts to improve the legibility of epigraphic texts include use of punctuation and diacritical marks to separate words, including regular use of the punctus (·), which functions as a short pause that in modern usage might approximate to the use of a comma or semicolon, various line fillers to separate words, and the superscript dot to distinguish the letter 'y' from 'þ'. A final phase from roughly the middle of the fifteenth century through to the mid-sixteenth century sees greater freedom of line, including occasional use of curves and loops in letter forms, bifurcated ascenders and descenders, and a tendency to ornament individual letters or graphs with superfluous trailing lines (otiose strokes) and with exaggerated decorations known as cadels or strapwork. That so many of the commissions for the painting of screens date from this final phase of textura has the happy result of general legibility of all manner of inscriptions. Many of these closely replicate the *mise en texte* of scribal compositions with rubrication, ruling, extensive use of contraction and abbreviation, and pronounced word separation by means of line fillers and pseudo-punctuation marks. In some cases, notably on banner scrolls, this looks like direct mimicry of written forms, though there is nothing to rival the extraordinary 'pages' of literary texts that adorn the Clopton chapel at Long Melford (Suffolk).[26]

This extensive use of contractions signals the need to compress text into limited space. Arrangements of lengthy scriptural or liturgical quotations such as the articles of the Creed and the Old Testament prophetic texts must have been recorded in pattern books, printed sheets, or similar exemplars held by large and small ateliers. Bespoke texts recording patronage and intercessory prayers seem at first sight to require a greater degree of improvisation but on close inspection the contractions are invariably in standard formulae such as 'Orate pro animabus'. What the surviving corpus makes clear is that there is little correlation between technical proficiency and the use of contractions. That even the least skilful painters working on less prestigious commissions made use of contracted and abbreviated forms indicates how scribal practices had become embedded in epigraphic production by the fifteenth century. These shorthand signs include:

[26] See my *The Material Word: Vernacular Inscriptions from Later Medieval England* (Turnhout, forthcoming).

(i) superscript characters ('wt' for 'with' or 'þt' for 'that')
(ii) the common tilde, ¯ , implying omitted letters, especially
consonants (as with the 'm' and 'n' in anima)
(iii) various brevigraphs or special signs, notably: the Tironian
graph (a crossed figure 7) for Latin 'et'; the terminal 'es'
graph which looks like an oversized and often titled cursive
'e' and generally marks a plural '-es' ending; a raised figure
9 representing the Latin nominative ending -*us*; the '-bus'
abbreviation that looks like a b followed by a semicolon or
sometimes a figure 3 (as in 'animabus'); an elevated and inverted
figure 6 for the 'con-' prefix
(iv) a variety of ornamented p forms with crossbars applied to the
descenders to represent such Latin syllables as 'per', 'pre' and 'pro'
(v) the r loop (a mark above the line approximating an elongated
pendant comma) generally representing 'er'.[27]

Familiarity with these technical features is necessary for accurate
transcription of screen inscriptions and for ongoing assessment of the
activities of artists and craftsmen who produced them. Notable examples
of these forms appear in the Creed texts at Kenton (Devon) and the Old
Testament prophetic texts at Thornham (Norfolk) (Pl. XII). Proliferation
of abbreviations is perhaps to be expected for scriptural texts with an
established tradition of scribal contraction but the different usage of
contractions and brevigraphs for the same text in different locations,
sometimes to match the length of the inscription to the space available,
implies confident handling by generations of craftsmen. This mastery of
the *mise en texte*, including rubrication ruling, contractions, graphs and
decorative flourishes, is naturally, but not exclusively, linked to high-quality
inscriptional work. The finest examples are mostly from Norfolk and
include the work at Aylsham (1507), St Catherine Fritton (c.1511), Burnham
Norton (1458), North Burlingham St Andrew (1536), Sparham (c.1480
x 1500), Weston Longville (c.1472) and especially Thornham (c.1488).
The titles at Southwold (late fifteenth century, Suffolk) are impressive as
are the scriptural texts at Bramfield (probably early sixteenth century).
It is interesting to note that the celebrated figure paintings at Ranworth
(Norfolk) are unaccompanied by inscriptions (only the apostles have
titles), though the painted text and musical notation on the rare surviving
lectern are expertly handled. The screens of the West Country generally
present lesser-quality work, but in Devon the scrolls at Ashton are very
finely executed and the Creed sentences at Chudleigh are designed to look
like paper scrolls with rubrication, neat rulings and floral line fillers. Both
are probably from the third quarter of the fifteenth century.

27 For the scribal equivalents see A. Derolez, *The Palaeography of Gothic Manuscript
Books: From the Twelfth to the Early Sixteenth Century* (Cambridge, 2003).

Exceptions to black letter script on screens and related woodwork are very rare. Notable examples at Bramfield, Gateley and Salthouse (both Norfolk) use uncials (Pl. XIII), all three as name labels for saints and prophets. An inscription at Salthouse gives a secure dating of 1513, and the lettering at Gateley and Bramfield strongly suggests similar dates. The appearance of uncials with their rounded majuscules during the period dominated by textura might suggest deliberate archaism but it remained a popular script for bells and is found occasionally in other contexts. Early sixteenth-century Lombardic are like some of the classically inspired humanistic scripts favoured across Europe from the fifteenth century, but in combining aspects of textura, notably in the use of Gothic capitals and serifs, they are more obviously transitional.[28] Nicholas Riall usefully describes it as a Romano-Gothic form and identifies numerous examples in the display scripts of parish and greater churches in the southern counties, including on the Waller monument at Stoke Dry (Hampshire), the entrance of the Draper chantry at Christchurch priory (Dorset) and Bishop Fox's chantry chapel at Winchester Cathedral.[29] The usual dating for this transitional period is the 1510s through the 1530s and the screen examples all appear to come from the earlier part of this span. Salthouse church was built by Sir Henry Heydon and completed by 1503 and there are bequests to the painting of the 'new perke' from 1510.[30] In 1524 Bramfield's vicar, William Sunham, bequeathed 40 marks to various adornments of the church including the painting of the altar 'table', and the screen painting may well be coeval.[31] The Gateley screen is also undated but the letters resemble those on the contemporary monument at Foulsham for Robert Colles and his wife Cecily from c.1500 – the villages are close neighbours and cross-media influence should not be ruled out.[32] Analogous letters are found in the short inscription on the screen at Marwood (Devon) to parson Sir John Beaupel or Brapaul who was rector in 1520.[33] This invites comparison with the carved inscription on the screen at Llanfair Waterdine commemorating the gift of the rector Matthew ap Jevan, who was parish priest from 1485 into the 1520s, and with lettering on contemporary Welsh domestic woodwork.[34] The capital

[28] The Bramfield text reverses this with an initial Lombardics followed by black letter.
[29] See N. Riall, 'All'antica Ornament During the First Renaissance in England: The Case of the Draper Chapel at Christchurch Priory', *Proceedings of the Dorset Natural History and Archaeological Society*, 129 (2008), pp. 25–37; and 'The Waller Tomb at Stoke Charity, Hampshire: Conservative Monument or a Late Pre-Renaissance, Perpendicular Work?', *The Journal of the British Archaeological Association*, 166 (2013), pp. 157–78.
[30] Cotton, 'Medieval Norfolk Screens', p. 51.
[31] Norwich Record Office, Norwich Consistory Court wills, Hyrnyng 124.
[32] The Colles inscription was sufficiently interesting for Martin to make a careful transcription: Norwich, Norfolk Record Office, MS Rye 17/2, f. 115ʳ.
[33] Williams, 'Medieval English Roodscreens', p. 326. Beaupel may have survived into Elizabeth's reign but the screens appear to be Henrician.
[34] N. Riall, 'A Tudor Cupboard at Cotehele and Associated Carpentry Work from the Welsh Marches', *Regional Furniture*, 26 (2012), pp. 23–72.

letters painted on the top of what remains of the screen panelling at Mylor church, the sole surviving medieval inscription in Cornish, must also be of this date. It is noticeable that these traditions hardly penetrated the north and east of the country where both painted and carved inscriptions continued to use textura.

TAXONOMIES

This work signifies a mature tradition of text-making within the medieval parish church that met a range of memorial and devotional needs, was accessible to pockets of varying depths, and remained vigorous even in the generations of reform. To better understand the nature and function of this corpus what follows might be described as a taxonomy of screen inscriptions, that is, a scheme to classify the various textual species based on their shared characteristics and functions. It is organized into six distinct categories but with a known corpus of some 200 discrete inscriptions some smaller groupings are here collapsed into larger ones: simple names or labels; sacred monograms; Latin scriptural and liturgical texts; records of benefaction in Latin and English; devotional texts in Latin and English; and post-Reformation scriptural texts. Consideration of inscriptions damaged or obliterated through a process of detexting completes the survey.

While some screens identify sacred figures by visual rather than verbal signification – an object or attribute such as Peter's keys, Barbara's tower or the more unusual horned Moses at Ipplepen (Devon) – many facilitate recognition by a combination of image and text. The more common form of inscription is the label or title (L. *titulus*, pl. *tituli*). Examples are numerous and mirror practices in wall painting and stained and painted glass. For the most part these are declarative statements of identity and are written, often less than expertly, below, alongside or above (sometimes in the spandrels) the saint or holy figure. Distinctive variations can be seen on the screens at Wolborough (Devon), Garboldisham, Horsham St Faith and Salle (all Norfolk) and Westhall (Suffolk). More sophisticated work includes *tituli* on small scrolls below or adjacent to the figure, as at Southwold and at Stoke Gabriel (Devon); on longer winding scrolls such as those at East Ruston and Barton Turf (Norfolk) or Ipplepen; and on figure pedestals, in imitation of the plastic arts, as at Gateley and North Burlingham, St Andrew (Norfolk).

Even if, as Michael Camille suggests, *tituli* were not meant to be read but 'served only to authenticate the image', this is active signification rather than mere decoration.[35] The same holds true for the use of sacred

35 M. Camille, 'The Language of Images in Medieval England 1200–1400', in J. J. G. Alexander and P. Binski (eds), *Age of Chivalry* (London, 1987), pp. 33–40.

monograms or trigrams. These
graphic representations can appear
less distinctive than figures or *tituli*
but they play an important role
within the church's signification
system acting as prompts to prayers
and bespeaking accentuated forms
of devotion within the community.
In other words, such graphs have
a performative impulse. On the
surviving dado panels of Acle's
rood screen the sacred trigram
'IHS' to represent the Holy Name
is interspersed with an 'E' crossed
with arrows signifying the local
saint Edmund who was martyred
by the Danes and is the church's
patron. Likewise, the panels at
Castle Acre, originally part of an
aisle screen, are decorated with
'MR' (Maria Regina) and 'N'
monograms denoting that the

FIG. 4.1.
GRUNDISBURGH
(SUFFOLK),
PARCLOSE
SCREEN DADO
PANEL WITH
SACRED
TRIGRAM 'IHS' IN
QUINCUNX AND
'MARIA REGINA',
PROBABLY
MID- TO LATE
FIFTEENTH
CENTURY.

chapels were dedicated to the Blessed Virgin and Nicholas. The MR ligature
may have worked as a mnemonic or visualization of the popular Marian
anthem 'Salve, Regina, mater misericordia'. At Grundisburgh (Suffolk)
(Fig. 4.1) the dado of the fifteenth-century south aisle parclose screen is
stencilled with a quincunx of 'IHS', representing the Five Wounds, and four
MRs. The feast of the Holy Name was popular throughout the Norwich
diocese during the fifteenth century and this trigram may be witness to
a Jesus altar that was maintained through the benefaction of parishioners
such as John Awall (d.1501) and his wife Margery whose mural brass
calling for pardon is nearby. The existing south aisle was built by their son
Thomas Wall, citizen of London and salt merchant, who by his will of 1530
asked his widow Alice to establish 'an honest seculier preest' in the church
to sing for his soul and those of his parents.[36] Purely decorative motifs on
East Anglian screens can be seen on the panels at Deopham and Thompson
(Norfolk), none of which bear figural representations; non-graphic stencils
are often used to powder the background of panels with holy figures as at
Tunstead and Seething (Norfolk) and Eye and Nayland (Suffolk).

[36] The National Archive, PROB 11/24, f. 41v. Walle chose to be buried in St Botolph's,
London. H. Blake, G. Egan, J. Hurst and E. New, 'From Popular Devotion to Resistance
and Revival in England: The Cult of the Holy Name of Jesus and the Reformation', in D.
Gaimster and R. Gilchrist (eds), *The Archaeology of Reformation 1480–1580* (Leeds, 2003),
pp. 175–203.

In considering the speech scrolls bearing Latin text in the glazing of great Gothic churches, Camille further puzzles how those without formal Latin training could understand the writing and wonders whether the words in so many Gothic pictures 'serve aesthetic rather than functional purposes'.[37] There is an element of truth here but the improved levels of literacy of the later medieval period and the habitual involvement of the laity in commissions require greater recognition of texts as active components within the screen *mise en scène*. As 'a frame for liturgical drama',[38] the screen supported visual and meditative activities that involved engagement with a range of inscriptional texts from the monogrammatic to lengthy passages of Latin scripture and English dialectal verse. As a unit the screen and its tympanum offered a complex eschatological image which set the crucified Christ, flanked by the Virgin and the Evangelist John, against a backdrop of the Last Judgement. The ranks of saints and martyrs on the dado and loft acted as witnesses to Christ and as intercessors for his grace. Most carry no more than their names but the figures of Barbara and Paul at Thornham speak for them all. She announces 'martirio meo deu(m) adoro' ('I worship God through my marytrdom') and he 'P(rae)dico vob(is) ih(esu)m Christ(um)' ('I preach to you Jesus Christ'). At Blundeston (Suffolk) angels bearing scrolls with 'Passio Chr(ist)i Salv(atoris)' proclaim the possibility of redemption through the merits of Christ's Passion. Other familiar sets included the apostles, prophets and Church Doctors, all of whom could be depicted bearing Latin scrolls, including the text of the Creed that was familiar from its recitation at Sunday Mass. The linking of the apostles with Creed texts became a common feature of *pastoralia* and examples appear on Devon screens at Bovey Tracey and Kenton and in Norfolk at Gooderstone, Mattishall, Ringland (an imperfect set), Salle (in the transoms), Weston Longville, Wickmere (only two snatches remain) and formerly at Thetford St Peter.[39] Old Testament prophets with messianic texts still feature at Thornham, Coddenham (damaged) in Suffolk, and in the south Midlands at North Crawley (Buckinghamshire) and on the four surviving panels at Marston Moretaine (Bedfordshire). The scheme at Chudleigh has alternating prophets bearing messianic texts with apostles each bearing his own Creed clause. A unique selection of Old Testament prophetic texts was juxtaposed with sentences of the Creed at All Saints, Poringland (Norfolk), now destroyed. The screen and related seating in the chancel appear to have been commissioned by the rector Robert Draper, alias Parsons, who held the living from 1473 to 1490, and a number of the unusual texts derive from antiphons in the breviary.[40]

[37] Camille, 'Language of Images', p. 34.
[38] Duffy, *The Stripping of the Altars*, p. 112.
[39] The lost screen at Thetford is described in F. Blomefield and C. Parkin, *An Essay Towards a Topographical History of the County of Norfolk*, 11 vols (London, 1805–10), 2, p. 2.
[40] Neither Blomefield and Parkin (*Topographical History*, 5, p. 400) nor Baker (pp.

The Four Doctors of the Church are often named and occasionally labelled 'doctoris', as at All Saints, Weasenham (Norfolk), and 'papa', 'cardinalus' and 'episcopus' on the fifteenth-century screen at Houghton St Giles (Norfolk). An unusual representation is on the pulpit at Castle Acre (Norfolk), where each is accompanied by a Latin scroll text extolling the virtue of preaching; the precise derivation of these is difficult to ascertain.[41] The Doctors often appear on screen doors, but of the surviving examples only Weasenham bears a significant inscription. A scroll over St Gregory's writing desk has the phrase 'felix culpa' ('happy guilt') from the typological hymn, the Exultet, sung during the Easter Vigil on Easter Saturday (Fig. 4.2).

Passages drawn from the evangelists are equally purposeful and evidence lay familiarity with the Gospels and the liturgy, most directly through Books of Hours or *Horae*. The first section in the Book of Hours, following on from the Calendar, is a series of Gospel readings or Lessons by the four evangelists which opens with John on Patmos announcing the Word, who is Christ, as the beginning and end of all things and of man's need of redemption. Further readings from Matthew, Mark and Luke recount major events in the Life of the Saviour from the Incarnation to the Ascension. These four readings are not always found in early *Horae* but by the fifteenth century they had become standard. As Roger Wieck notes, their appearance in the *Horae* derives from their use as Lessons read at Mass on four of the Church's major feasts: Christmas Day, 25 December (John 1:1–14); the Annunciation on 25 March (Luke 1:26–38); Epiphany, 6 January (Matthew 2:1–12); and the Ascension, a moveable feast dependent upon the date of Easter (Mark 16:14–20).[42] Given lay familiarity with these Lessons it is no surprise to find passages appearing on the screens. The first verse of John's Gospel 'In principio erat verbum' appears, with spelling errors, on the screen at Sotterley and the parclose at Brent Eleigh (both Suffolk).[43] More extensive are the texts accompanying the beautiful figures at Bramfield. John does not bear a scroll but Luke's announces the Annunciation, 'Missus est [angelus] Gabriel' (Luke 1: 26). Matthew and Mark are labelled in black letter but their texts have been transposed: Mark begins Matthew's account of the Three Magi 'Cu(m) natus ih(esu)s in bedelem iude' ('When Jesus was born in Bethlehem of Judea', Matthew 2:1), and Matthew has Mark 16:14 'Recu(m)be(n)tibus u(n)

171–2) give chapter and verse. The unique verses are: Daniel 9:26, Haggai 2:5, Judges 20:1, Malachi 2:16, Zacharais 11:9, Jeremias 21:8

[41] The full Latin texts are given by J. J. G. Alexander, 'The Pulpit with the Four Doctors at St James, Castle Acre, Norfolk', in N. Rogers (ed.), *England in the Fifteenth Century: Proceedings of the 1992 Harlaxton Symposium*, (Stamford, 1994), pp. 198–206, esp. p. 130. He rejects the notion that the pulpit panels were once part of the rood screen dado.

[42] A useful overview of the structure of the Book of Hours is R. S. Wieck, 'Prayer for the People: The Book of Hours', in R. Hammerling (ed.), *The History of Prayer: The First to the Fifteenth Century* (Leiden, 2008), pp. 389–440.

[43] The Sotterley text may well be the result of later repainting.

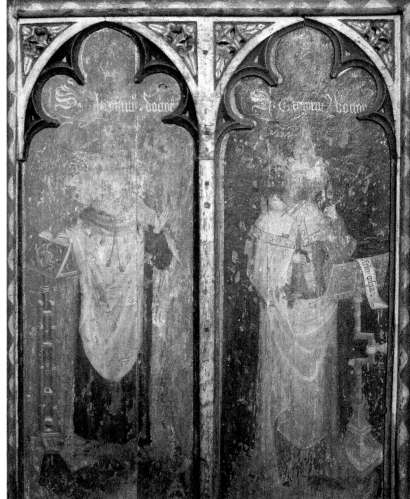

FIG. 4.2.
WEASENHAM, ALL
SAINTS (NORFOLK),
SS JEROME AND
GREGORY, FROM
THE ROOD SCREEN
DADO. A SCROLL
BEARING 'FELIX
CULPA', FROM THE
EASTER VIGIL
LITURGY, RESTS
ON GREGORY'S
WRITING DESK,
FIFTEENTH
CENTURY.

idecim discipul(is) ('when the eleven disciples were sitting together'). The images on the screen at Crostwight were destroyed during a nineteenth-century restoration but Dawson Turner's drawings show this same passage from Mark as well as the first line of Matthew's gospel, 'Liber generationis Jchr' ('The book of the generation of Jesus Christ').[44] At Foulden the four evangelists were depicted on the doors but only Matthew and Mark remain; their texts are difficult to pinpoint but may be the opening words of Matthew 8:14 and Mark 10:17, which tell of Jesus' ministry. The remaining figure at Bramfield is Mary Magdalene; next to her the panel has been thoroughly scraped but we might speculate that it showed Lazarus. This

[44] The screen was destroyed during nineteenth-century restorations but a record of the texts is given by Dawson Turner in his illustrations of Blomefield (British Library, Add. MS 23054, f. 122).

pairing appears at Thornham with scrolls bearing witness to faith, the
forgiveness of sins, and Christ's powers of redemption (Mary Magdalene:
'Tulerunt Dominum meum' ('They have taken away my Lord', John 20:13));
Lazarus: 'Per me multi crediderunt in Jesum' ('By me many have believed
in Jesus', an allusion to John 11:45). Mary Magdalene frequently appears in
suffrages in late medieval Books of Hours, and in the Office of the Dead
Lazarus prefigures the saved at the Last Trump. A further witness is the
apostle Thomas at Worstead (Norfolk), whose open book reads, 'Beati qui
viderunt et crediderunt' ('Blessed are they who have not seen and have
believed', John 20:29). This is from the Gospel reading on Low Sunday,
the Sunday after Easter, and celebrates the Divine promise manifested in
the sacrament of the altar. Running across much of the screen at Yelverton
(Norfolk) an angelic choir sings the opening of the Gloria on behalf of the
donor Thomas Hotte (d.1505) and his wife Beatrice: 'Gloria in excels(is) deo
et in terro pax ho(m)i(ni)b(us) bon(a)e voluntatis laudam(us) [te]' ('Glory
to God in the highest and peace on earth to men of goodwill').[45] Snatches
from the Psalms echo celebratory scriptural passages (46:2 'Omnes gentes
plaudite [manibus]' ('Clap your hands, all ye nations'), and 145:1 'Lauda
anima mea' ('My soul praise')) echo celebratory scriptural passages. Also
from the Ordinary of the Mass comes the 'S(an)c(tu)s S(an)c(tu)s S(an)
c(tu)s' held by the Seraphim from the Nine Orders of Angels at Southwold.

While it is not always possible to identify precise liturgical or literary
referents it is clear that the choice of text could be particular and significant.
Learned schemes may have been commissioned by educated priests but
may also indicate 'theological self-consciousness' amongst the laity.[46] Julian
Luxford has shown as much in his discussion of the texts on the surviving
panels at Sparham, including passages from Job that were used in the
Dirige of the Office of the Dead.[47] Another celebrated extant example is at
Ashton where the late fifteenth- or early sixteenth-century prophets on the
parclose screens bear scrolls with messianic texts taken from the antiphons
and readings of the newly instituted feast of the Transfiguration (Pl. XIV).
Ashton's senior lay patrons at the time were members of the Chudleigh
family and it is difficult to disagree with Marion Glasscoe's assessment that
this attests to the 'influence of educated patronage with access to skills and
imaginative theological understanding of a high order'.[48] No information
about patronage survives for the now lost screen at St Peter's at Rounds
(Northamptonshire) but antiquarian drawings show a pictorial narrative
relating the story of Joseph with accompanying passages from Genesis

[45] My transcription practice uses brackets to expand contractions and abbreviations and
square brackets for illegible, lost or otherwise missing text.
[46] Duffy, 'The Parish', p. 150.
[47] J. Luxford, 'The Sparham Corpse Panels: Unique Revelations of Death from Late
Fifteenth-century England', *Antiquaries Journal*, 90 (2010), pp. 1–42.
[48] M. Glasscoe, 'Late Medieval Paintings in Ashton Church', *Journal of the British
Archaeological Association*, 140 (1987), pp. 182–90.

37–45. Images of the Creation of Adam and Eve and the Expulsion appear at Poringland (Norfolk), Bradninch (Devon), Bozeat (Northamptonshire) and at Kempston (Bedfordshire), but the Raunds screen is the only known example of an Old Testament narrative with accompanying scriptural text.[49] The screen is undated and without further evidence it is difficult to go beyond ascribing it to the fifteenth century. Drawings made for John Bridges' county history by the Flemish artist Peter Tillemans between 1719 and 1721 indicate that the sequence was on the coving atop open tracery that gave sight into the south chapel.[50] Bridges notes that 'The east end of both iles is parted off by a screen. On that dividing the south ile, are painted eight different squares with inscriptions underneath relating to the history of Joseph.'[51] The heavily abbreviated text did not offer absolute correspondence with the Vulgate but such a sophisticated scheme points towards a commission similar to that at Ashton. Raunds had an active lay community with two guilds, and numerous bequests and donations to the fabric and fittings are recorded in surviving wills.[52]

These examples suggest advanced levels of Latinity in certain sections of the late medieval lay congregation. Other Latin inscriptions are heavily formulaic but attest to widespread involvement of lay patrons in the construction and adornment of screens and of a primary impulse to mark the investment. Records of benefaction are essentially calls for repayment. If the driving concern of the benefactor is 'How may I save my soul?', the answer is by financial investment in parish resources. Just as the sacred monogram is a trigger to prayer, the memorial text engenders or activates a more personal negotiation between the benefactor, often but not always deceased, and the spectator. Epitaphs motivate a personal communication mediated through text and they address themselves directly to an audience urging the onlooker or passer-by to voice the inscription. The 'Orate pro' formula is after all an imperative: read the prayer and remember the dead. This 'call and response' is part of the soundscape of the church environment and we should expect as many of this type of inscriptions as appear in other media. In short, prompts for remembrance increasingly

49 The screen at Olney (Bucks.), destroyed in 1854, was said to show Elijah fed by ravens (3 Kings 17) but this was probably a misidentification: T. Wright, *The Town of Cowper: Or the Literary and Historical Associations of Olney and its Neighbourhood* (London, 1886), p. 28.
50 British Library, Add. MS 32467, ff. 220–1 (reproduced in B. A. Bailey (ed.), *Northamptonshire in the Early Eighteenth Century: The Drawings of Peter Tillemans and Others* (Northampton, 1996), p. 177).
51 P. Whalley, *The history and antiquities of Northamptonshire: compiled from the manuscript collections of the late learned antiquary John Bridges, Esq.*, 2 vols (Oxford, 1791), II, p. 188. Brief descriptions of the image are given in the 1791 volume of *The Gentleman's Magazine*, by which time the inscriptions were only partly legible. The screen seems to have survived the disastrous collapse of the spire in 1826 and may have survived at least until 1837.
52 See R. M. Serjeantson and H. Isham Longden, 'The Parish Churches and Religious Houses of Northamptonshire: Their Dedications, Altars, Images and Lights', *Archaeological Journal*, 70 (1913), pp. 217–452 (pp. 396–8).

find textualized form on the surfaces of the medieval church interior. It is worth remembering that while surviving screens date from the period of Latin and English domination this does not preclude the existence of French texts on earlier screen furniture.

Memorialization is fostered by a sense of distinct personal identity which explains the growing number of self-representations on screens from the early fifteenth century as well as the increasing variety of epitaphs in both Latin and the vernacular. Those who bore the largest part of the financial outlay, the 'proper cost', acquired the memorial rights and often declared the investment.[53] An inscription at Wellingham (Norfolk), dated to 1532, calls spectators to remember Robert Dorant and his three wives, and is 'pro bono statu ac benivolencia o(mni)um benefactorum qui hoc opus pingi fecerunt'.[54] Similar phrasing for Robert and Margaret Pynning and other benefactors existed on the lost chancel doors at North Elmham (Norfolk),[55] while at Burnham Norton (Norfolk) a now badly damaged panel still names William and Joanna Groom 'qui istam fabrica(m) fecer(u)nt depingi in hon[ore]', this work being done in 1458.[56] The destroyed screen from Cromer (Norfolk) announced that John and Agnes Brown had paid for the whole screen and its decoration ('qui totum hoc opus cu(m) pictura fieri feceru(n)t').[57] The sill of the screen at Felmersham (Bedfordshire) says that Richard and Annete King 'constructorum istius operis' and at Worstead (Norfolk) a small and apparently unrecorded fragment of woodwork, possibly from the now lost rood loft and now affixed to the west wall, speaks of an unknown donor and 'Isabell hys wyfe the wheche bare the cost of thys werk'. In 1490 William and Alice Athereth 'dede these iiii Panys Peynte be the excecutoris lyff' at Cawston (Norfolk), and in 1529 at Staunton (Nottinghamshire) Simon Yates made the 'tabnacull of or ladie' and rood loft 'of his own p(ro)pere expenses of his charetie'. Similar texts are found at Methwold (c.1462), Heydon (1480), Ludham (1493), Aylsham (1507), Northrepps (c.1514) (all Norfolk), Malpas (before 1530, Cheshire), Swine (1531, Yorkshire) and uniquely in Welsh at Llanfair Waterdine (Shropshire) as the gift of Sir Matthew and Meuruc Pichgar of Colunwy (Clun) who set it up for £10 between them ('Syr Made

[53] Duffy, 'The Parish', pp. 141–2.
[54] The inscription is now damaged. Martin made a transcription in 1737 (Norwich, Norfolk Record Office, MS Rye 17/5, f. 85ʳ): 'Orate pro a(n)i(m)abus Roberti Dorant Beatrice Isabella et Agnetis uxorum suroum et pro bono statu ac benivolencia o(mni)m benefactorum qui hoc opus pingi fecerunt ... ex vostra caritate pro anima Johe Neell orate sit ue ... eius' ('Pray for the souls of Robert Dorant and his wives Beatrice, Isabella and Agnes and for the good estate and goodwill of all the benefactors who caused this work to be painted ... and of his charity pray for the souls of John Neell; pray').
[55] Blomefield and Parkin, *Topographical History*, 9, p. 494.
[56] A more complete text than now exists is recorded by Blomefield and Parkin, *Topographical History*, 7, p. 17.
[57] Norwich, Norfolk Record Office, MS Rye 17/1, 233ʳ. This record does not appear in Cotton.

a m(e)uruc Pichgar colunw ae gosodes o ddec Pund cyrufudd'), probably in the 1520s.[58] The screen from Woodbridge (Suffolk) formerly included a lengthy text recording that the painting, including 'crucis crucifixi Marie Archangelorum et totius candel-beme', was a 1448 gift of John and Agnes Albrede.[59] Thomas Martin recorded two English inscriptions each with rebus on the now lost rood loft at Acle (Norfolk) – a man kneeling with a swan for William and Joanna Swann, and two men, one with a square, for John and Edmund Clamp 'þ(a)t ded mak thys loft'.[60] William Ungot (d.1484), 'capellanus', and his parents paid for some aspect of the screen at Croxton, Norfolk, and a donor portrait and text records the gift of Thomas Cove (d.1446), master of the college of priests at Attleborough. Two interesting examples of code-switching suggest that familiarity with Latin did not always stretch beyond the basic formulae. At South Walsham, John Galt, a liberated serf, was sufficiently well positioned to pay for the screen decoration, even if the decorative work betrayed a limited budget. His inscription, probably from the later fifteenth century, presents Norfolk orthography in the pronoun 'qweche' and may evidence a local painter recording an oral commission: 'Orate pro a(n)i(m)abus iohannis galt et uxorum eius the qweche han doon pey(n)tyn is perke' (Fig. 4.3).[61] What is surely the latest recorded example dates from the last year of Mary's reign at Hubberholme (Yorkshire) where the master craftsman celebrated his own work by carving a blended inscription on the beam, 'Anno do(mini) MCCCCC lviij hoc opus erat Willi(a)m Jake carpe(n)t(er)'.

In some cases this personalization extends to the use of Latin prayers. At Houghton St Giles (Norfolk) a female donor praying to a favoured saint bears a scroll 'Silvester s(an)c(t)e me tua salve prece' ('St Silvester bless me by your saving prayer'); the lost screen from Erpingham (Norfolk) showed a donor with prayer scroll for the child-saint Robert of Bury ('Sancte Roberte Succurre mihi Pie') ('Merciful Saint Robert help me');[62] two panels now reset into the pulpit at Wickmere show a couple with their children bearing scrolls 'Ihu fili dei mei miserere Will[elmi]' ('Jesus Son of God have mercy on me, William') and 'Sc. depem xpe mei Agnetis' ('Christ have mercy on me, Agnes'). Scrolls at Edgefield (Norfolk) speak for William Harstong (d.1526) and family – 'In Domino co(n)fido' ('In God I trust') and 'Memento fine quia morieris' ('Remember the end for you shall die'). This use of *memento mori* texts, more common in wall paintings, finds its best expression at Guilden Morden (Cambridgeshire), which boasts an unusual arrangement of its screens where two side

58 Riall, 'A Tudor Cupboard', pp. 57–9.
59 BL, Add. MS 8987; Cotton, Lunnon and Wrapson, 'Medieval Rood Screens', p. 23.
60 Blomefield and Parkin, *Topographical History*, 2, p. 153; Cotton, 'Mediaeval Roodscreens in Norfolk', pp. 47–8; Norwich, Norfolk Record Office, MS Rye 17/1, f. 11r. The Acle record, as yet undated, does not appear in Cotton.
61 Cotton, 'Mediaeval Roodscreens in Norfolk', p. 52.
62 Blomefield and Parkin, *Topographical History*, 6, p. 412.

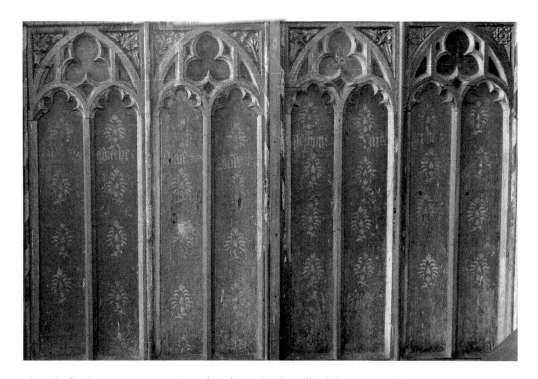

chapels flank a passageway into the chancel. The sill of the passage bears a prayerful quatrain (heavily restored): 'Ad mortem dura(m) Ih(es)u de me cape curam / Vitam venturam post mortem redde securam / Fac me confessum rogo te Deus ante recessum / Et post decessum celo michi dirige gressum' ('Jesus, in Death's dark vale, be Thou my stay / Make safe my life to come from every foe, / Grant me confession Lord ere hence I go, / And then to heaven do thou make straight my way').[63] This may or may not link to some form of confessional use for the chapels but it certainly echoes other hortatory epigraphs, as on the *manus meditationis* painted on what may have been a monastic confessional carrel that migrated to Bishops Canning (Wiltshire) after the Dissolution.[64] At Farthinghoe (Northamptonshire) the Lady chapel was enclosed by screens bearing a combination of scripture and Latin texts from the *ars moriendi* tradition interwoven with injunctions to pray to Our Lady – the remedy for sin and despair – and English versions of the same.[65] On the north side, 'In omnibus operibus tuis memorato novissima tua et in aeternum non peccabis' ('In all thy works be mindful of thy last end and thou wilt never sin', Ecclesiastes 7:40). On the east end, 'Hac non vade via, nisi dicas Ave

FIG. 4.3. SOUTH WALSHAM (NORFOLK), PART OF LATIN AND ENGLISH INSCRIPTION COMMEMO-RATING THE PAINTING OF THE SCREEN AS THE GIFT OF JOHN GALT AND HIS UNNAMED WIFE, PROBABLY MID-FIFTEENTH CENTURY.

[63] Edward Conybeare's free translation captures the weak prosody of the original: *Highways and Byways in Cambridge and Ely* (London, 1910), p. 263.
[64] Marks, 'Picturing Word and Text', p. 202; and J. M. Massing, 'Writing on Hands', *Print Quarterly*, 20 (2003), pp. 414–18.
[65] Whalley, *Northamptonshire*, I, p.170.

Maria, Semper erit sine re qui michi dicit Ave' ('No one go away unless an Ave Maria has been prayed, May they always be without woe who say Ave').[66] On the north side in the aisle, 'Every time thow goste this way, Ave Maria look thos say; Nor he schall never wyll off woo, That saythe an Ave as he goo.' At the west end, 'Be thou wil, or be thou woo, Here Saint Johnes gospel or thou goo.' Below this last inscription was another *memento mori* text, 'Mors tua, mors Christi, fraus mundi, glori Caeli, Et dolor Inferni sint meditanda tibi' ('Contemplate your death, Christ's death, the deceits of the world, the glory of heaven, and the torment of hell'). *Memento mori* and *ars moriendi* appear less frequently on screens than elsewhere in the church space but the link here to Marian prayer demonstrates the fundamental interconnectedness of inscriptions within the church space and their primary impulse as calls to prayer.

Inscriptions also mark collective benefaction, whether as formal organizations such as guilds or what appear to be looser groupings within the congregation. Norfolk guild inscriptions are found at North Walsham for Thomas of Canterbury and at Attleborough for All Saints. It is likely that the unique image of guild members from St Matthew, Ipswich (Suffolk) also bore some inscriptional record. A fragmentary text at Stambourne (Essex) notes 'the good benefactorys of this churche', while the screen of the chantry chapel of the Blessed Virgin Mary at Swine (Yorkshire) bears a carved Latin inscription from the early 1530s that calls to memory its Master Thomas Bywatter and all of its past and future chaplains.[67]

While Latin is the natural language of record for most joint benefactors, both clerical and lay, there is also a distinctive group of English inscriptions which celebrate the activities and benefaction of the menfolk of the parish. These appear on west end screens and in two cases appear to record ritualistic language. They are linked to the church festival of Plough Monday, the first working day after Epiphany when the plough was blessed in church and paraded through the village. Offerings were collected for the guild coffers, to maintain lights before images across the parish, the so called plough lights, and for general parish finances.[68] Details of these

66 'Semper erit sine re qui michi dicit Ave' may be an error for or mistranscription of 'Sit semper sine ve qui michi dicit Ave'. A version of the first sentence is carved above the south door in Ropsley (Lincs.) and both were recorded in 1630 as part of a Seven Works of Mercy window at the Devon church of Monkleigh (T. Westcote, *A View of Devonshire in MDCXXX: With a Pedigree of its Gentry*, ed. George Oliver and Pitman Jones (Exeter, 1845), p. 335).

67 G. Poulson, *The History and Antiquities of the Seignory of Holderness in the East-Riding of Yorkshire* (York, 1841), pp. 87–8.

68 Duffy, *The Strippping of the Altars*, p. 13. For Plough guild activities in Swaffham, which included a Plough Book that recorded money paid into the church coffers, see K. Farnhill, *Guilds and the Parish Community in Late Medieval East Anglia, c.1470–1550* (York, 2001), pp. 103–15. Hocktide, the days following Easter, were explicitly linked to female fundraising: K. L. French, 'Women in the Late Medieval English Parish', in M. C. Erler and M. Kowaleski (eds), *Gendering the Master Narrative: Woman and Power in the Middle Ages* (Ithaca, 2003), pp. 156–73 (p. 166).

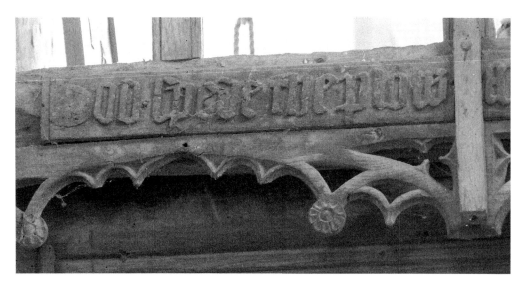

festivities are lost from the churchwarden's records but these inscriptions give some sense of agricultural labour at the heart of village life and of the drinking culture of working men. The west or belfry screen at Cawston extends and localizes the 'God spede the plow' couplet that seems to have had currency from at least the fourteenth century and is used as a caption for an illustration of two men ploughing at the opening of a fifteenth-century *Piers Plowman* manuscript.[69] The fourth line of the inscription is damaged where the bell ropes have pulled but it can be reconstructed from Blomefield's eighteenth-century transcription (Fig. 4.4):

FIG. 4.4.
CAWSTON
(NORFOLK),
'GOD SPEDE THE
PLOW', OPENING
SECTION OF
A CARVED
INSCRIPTION
ON WEST
END GALLERY,
PROBABLY LATE
FIFTEENTH
CENTURY.

> God spede the plow
> and send us ale corn enow
> our purpose for to mak
> [at crow of cok of] þe plo(w)lete of Sygate
> Be mery and glade
> Wat goodale þis work mad.

A plough light stood at the Sygate crossroad just north of the village; Wat Goodale was a medieval John Barleycorn, the personified church ale that raised the funds.[70] A similar *esprit de corps* is conveyed in the carved inscription on the so-called bachelors' screen at Thorpe-le-Soken (Essex): 'This cost is the bachelors made by ales, ihesu be ther med'. In Middle English 'mede' means reward but there is a broad wink to the profitability and conviviality of the church ales. So too in 1501 the men of Worstead celebrated their corporation and its benefit to parish life in the gift of a

[69] Cambridge, Trinity College, MS R.3.14, f. iii[b].
[70] William Gelyons was benefactor of various plough lights in the church and parish, including at Sygate: Blomefield and Parkin, *Topographical History*, 6, pp. 264–5.

ringers' gallery with an expertly carved inscription: 'Thys werk was made in þe ȝer of God MCCCCCI at þe propyr cost of the catell of þe chyrche of Worsted callyd þe bachellers lyte þ(a)t god p(re)serve w(i)t(h) all the b(e)n(e)factors of þe same now and ev(er) ame(n). Than wer husbo(n)dis Crystofyr Ra(n)t Jeferey Dey.'[71]

Vernacular voices are an important part of the plurality of expression in the later medieval church space. Latin was the language of scripture and liturgy and was also deemed to be generally appropriate for formal records such as memorialization but, as these bachelors' screens demonstrate, certain individuals and groupings found natural expression in a more demotic register. A now lost inscription from Kettering, probably of the later fifteenth century, indicates what for many must have been the particular immediacy of English. Below a Latin 'Orate pro' for William Burgess and his wives Alice and Joan there is a calling out to a vernacular reading community, 'Whoso redis mi name shal have godys blyssing and our lady / And my wyfis doo say the same.'[72] On the pulpit at Horsham St Faith (Norfolk), dated to 1480, a Benedictine monk kneeling before the Virgin calls out 'M(er)cyful lady qwene of hevy(n) kepe me fro þe dedly syn(n)ys sevyn', a variation on couplets found elsewhere as in the fourteenth-century wall painting at Broughton (Oxfordshire). An English prayer carved below the sill across the full width of the rood screen at Campsall (Yorkshire) (Fig. 4.5) offers another intersection between epigraphic and manuscript cultures. This deeply cut carving voices a Yorkshire congregation, with distinctive orthography to match:

> let fal downe thyn ne & lift up thy hart
> behald thy maker on yond cros al to to(rn)
> remembir his wondis that for the did smart
> gotyn withowut syn and on a virgin bor(n)
> al his hed percid with a crown of thorne
> alas man thy hart oght to brest in too
> bewar of the dwyl whan he blawis his ho(r)n
> and prai thi gode aungel conve the.

There is no manuscript witness for this poem and it may have been composed specifically for this context. It certainly demonstrates the epigraphic potential of devotional materials circulating at the end of the

[71] A now lost text at Garboldisham (Norfolk) announced that the young men ('younglings') of the parish had paid for the roof: Blomefield and Parkin, *Topographical History*, 1, p. 268.
[72] Whalley, *Northamptonshire*, I, p. 219; Bridges notes that this was above a painting of Burgess and his wives and children on the back of a screen dividing the north aisle from the chancel, which suggests this was the family chapel though it may have served as a guild chapel (Oxford, Bodleian Library, MS Top. Northants e2, f. 95).

fifteenth century.[73] Useful comparison may be made with the Passion
poem in seven six-line stanzas carved into the roof cornice at Almondbury
(Yorkshire) that opens 'Thow man unkynd / have in thy mynd / my blody
face / my wondys wyde'. This relates to the lyric 'O man unkinde' found in
various northern and East Anglian manuscripts, including British Library,
Add. MS 37049, an anthology of c.1460 from Yorkshire or Lincolnshire
and probably of Carthusian origin, and also in the commonplace book
(c.1470–1500) of Robert Reynes, churchwarden at Acle (Oxford, Bodleian
Library, MS Tanner 407, f. 52v). A variant of the first stanza also features
in the late fifteenth-century indulgence roll now Yale University, Beinecke
Library 410, probably from Lincolnshire, where it accompanies an image of
the Man of Sorrows and the *arma Christi*. This roll offers another glimpse
of the multi-media appeal of short memorable verses. The second of its
three segments declares the prayer 'Jhesu for thy holy name / and for thy
bitter passion / Save us from synne and shame and endless dampnacioun.'
This popular verse on the Holy Name has twenty manuscript and three
print extant witnesses and survives in fragmentary form on a narrow
wooden strip that may once have formed part of a screen at Warkworth
(Northamptonshire).[74] A final articulation of Christ's merciful and
redeeming power, little removed from post-Reformation responses in
fact, is the inscription on the late fifteenth-century painted panel of the
Kiss of Judas formerly at Grafton Regis (Northamptonshire) and recently

[73] This unique text is erroneously described as 'inscribed on a wall' by A. S. G. Edwards,
'Middle English Inscriptional Verse Texts', in J. Scattergood and J. Boffey (eds), *Texts and
their Contexts: Papers from the Early Book Society* (Dublin, 1997), pp. 26–43, esp. p. 35.
This set of Yorkshire inscriptions is discussed in detail in my *The Material World*.
[74] The longer version was extant in the early eighteenth century, as recorded in Bridges
(Whalley, *Northamptonshire*, I, p. 219).

purchased by the Fitzwilliam Museum, Cambridge.[75] This panel from
c.1470 is probably of the Coventry school and may have been part of a
tympanum, as seen at Mitcheldean (Gloucestershire) and perhaps also at
St Cuthbert, Thetford (Norfolk) which had painted 'several saints and the
history of our Saviour's Passion'.[76] In the upper register the sacred trigram
'IHS', crowned, is repeated four times, while below the painting is a couplet,
expertly drawn with strapwork. This expresses faith in the redeeming
power of Jesus: 'Ihesu mercy and ever mercy / For in thy mercy wholly
trust.' Such examples of meditative piety demonstrate the vibrancy of late
medieval lay religious culture and the increasing importance of English as
its mode of expression. That they appear in works of such obvious quality
as this demonstrates the prestige of English letters by this date.

CONDEMNATION OF MEMORY

If the representation of Christ's Passion typifies a late medieval devotional
aesthetic, its antithesis is the Protestant idolizing of scripture. This
suppression of traditional beliefs and habits is exemplified by the fate of
the Binham screen and of the Cambridge Kiss of Judas panel – turned
around, whitewashed and covered with black letter text, perhaps for
use as a decalogue board. This rewriting of the church space was a
deliberate attempt to create uniformity and to reject the diverse textual
activity of previous generations. It compares with the classical tradition of
damnatio memoriae, a modern neologism coined to describe the process
of dishonouring a person and persons who had brought discredit upon
the Roman state. In the ancient world this process of condemnation, of
sanctioning memory, involved the complete destruction of the disgraced
person's portrait or sculpted image.[77] The practice involved *abolitio nominis*
or the erasure of the name of the disgraced and even those of family
members from all forms of record – annals, *fasti* (lists of official business),
statuary, coins, inscriptions. In some cases only part of an inscription was
erased so as to emphasize the act of denigration, 'so that viewers could be
sensible of the downfall of the individual who had been condemned and
remained on public display'.[78] These acts of deliberate, authorized violence
must be seen, as Harriet Flower reminds us, as political rhetoric, 'a claim
on the part of the powerful to impose a narrative and to control the past'.[79]

[75] I am grateful to Lucy Wrapson for details of recent conservation work on the panel.
My comments are indebted to her descriptions though any errors are my own.
[76] Blomefield and Parkin, *Topographical History*, 2, p. 65.
[77] E. R. Varner, *Mutilation and Transformation: 'Damnatio Memoriae' and Roman
Imperial Portraiture* (Leiden, 2004); and S. Benoist (ed.), *Mémoire et histoire: les
procédures de condemnation dans l'Antiquité romaine* (Metz, 2008).
[78] A. E. Cooley, *The Cambridge Manual of Latin Epigraphy* (Cambridge, 2012), p. 312.
[79] H. I. Flower, *The Art of Forgetting: Disgrace and Oblivion in Roman Political Culture*
(Chapel Hill, 2006), p. 9.

In Reformation England similar narratives of power shaped responses to the medieval epigraphic record. Inscriptions were wilfully detexted and the fabric of belief unwoven. These early reformist attacks are of their nature expressions of anxiety and contest within the community, and the strength of Protestant antipathy to Catholic worship in the early years can be measured by the defacement of screens that bore witness to the cult of Thomas of Canterbury, Henry VIII's *bête noire*. Two important surviving examples come from north-east Norfolk. At North Burlingham, St Andrew, names and faces of various saints on the screen have been scraped and marked but the attack on Becket has almost obliterated both the figure and his name. At North Walsham a shrine to the saint housed in the south chapel attracted pilgrims en route to the Rood at Bromholm priory. Here the inscription on what remains of the chapel screen has been carefully defaced by the excision of the saint's name (Fig. 4.6):

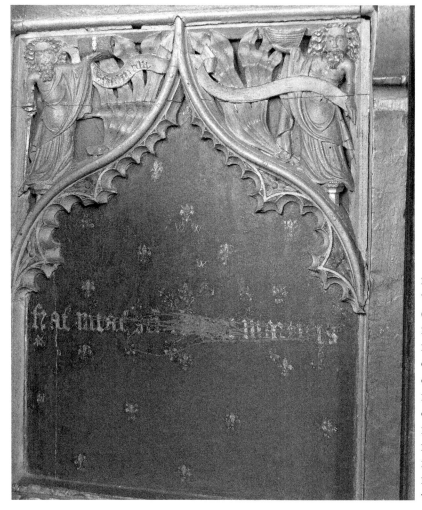

FIG. 4.6. NORTH WALSHAM (NORFOLK), DOOR OF THE FORMER CHAPEL OF THOMAS OF CANTERBURY, LATE FIFTEETH CENTURY, WITH DEFACED LATIN INSCRIPTION MARKING BENEFACTION OF THE FRATERNITY.

'Orate pro animabus fratrum et sororum … frat(er)nitatis sci [thomae] martiris'. Saints on screens across the country suffered similar titular erasures as at Salthouse (Norfolk), Kelshall (Hertfordshire) and Bloxham (Oxfordshire), while at Attleborough, Edgefield and Heydon (all Norfolk) reformers targeted the 'Orate pro anima/animabus' in personal records of benefaction as if to silence Latin incantations and their empty promises. At Ludham (Norfolk) the surname of the donor John Salmon has been carefully chiselled out of the carved inscription on the sill of the screen, and the sill inscription for John and Elizabeth Cordia at Gillingham, St Mary (Norfolk) shows a similar erasure of the 'Pray for the sowle' formula. Elsewhere Latin scriptural and liturgical texts were expunged, most determinedly on the doors at Weasenham, All Saints. By ensuring that the offending text remained visible, these post-medieval erasures condemn both the record of the individual and the act of memorialization. They render inscriptions inert, smother their dynamism and their participation in the performative and intellectual activities central to late medieval forms of worship and commemoration. The cancellation of an inscribed text signalled the negation of its contents, a symbolic abolition of memory. And it deliberately leaves a visible scar as its own memorial or mark of rejection.

It is difficult to date with any certainty these acts of erasure. There was widespread masking and mutilation of texts in the early years of the Reformation, as seen most obviously with the Becket texts, and yet the records of surviving inscriptions made by eighteenth-century antiquarians indicate that many survived not only the first phase of iconoclasm but further waves of seventeenth-century destruction. Indeed, many of the surviving instances of detexting may be the result of attacks that followed the injunction to destroy inscriptional texts in the parliamentary ordinance of August 1643.[80] Iconoclasm often led to wholesale destruction of painted glass but such acts were not so ruinous for the carved and painted texts of wooden screens. In fact, many inscriptions, in both Latin and the vernacular, appear not to have been targeted even when associated images were deliberately mutilated. At Ringland (Norfolk) the faces and hands of the apostles have been methodically gouged away but the Creed texts hardly touched; so too at Weston Longville (Norfolk) the Creed sentences remain but the Latin benefactory inscription is defaced and the saints' faces scoured. These remind us that there were alternatives to the removal of offending texts and that there was ambivalence as to what to do with the enormous body of inscriptions bequeathed by medieval forebears. Non-epitaphic Latin inscriptions survive in number, including well-preserved examples at Pertenhall and Marston Moretaine (Bedfordshire) and North Crawley (Buckinghamshire, restored), Guilden

[80] J. Spraggon, *Puritan Iconoclasm during the English Civil War* (Woodbridge, 2003), pp. 76–8.

Morden (Cambridgeshire), Chudleigh, Kenton and Bovey Tracey (Devon), Burnham Norton, Castle Acre (pulpit), Foulden, Gooderstone, Mattishall, Sparham, Thornham, Wellingham and Yelverton (Norfolk), Staunton (Nottinghamshire), and at Blundeston, Coddenham and Westhall (Suffolk). Likewise, Latin dedicatory inscriptions remain at Felmersham (Bedfordshire), Trunch, Foxley, Fritton St Catherine, Horsham St Faith (all Norfolk). English survivals can be found at Cawston and Yelverton (Norfolk), Stambourne (Essex) and Westhall (Suffolk). Neither the English inscriptions on the west end galleries at Cawston, Worstead and Thorpe-le-Soken nor the long prayer text on Campsall's rood screen were targeted and all survive in good condition. These extant inscriptions, as well as significant ones known to have survived into the eighteenth century, as at Cromer, Erpingham, Salle, Thetford St Peter (all Norfolk), and Woodbridge (Suffolk), imply that with texts rendered inert by reformed worship, especially those in a defunct language, they were no longer seen as threatening. Unspoken, denied their liturgical contexts, and out of the eye-line of worshippers whose interests were no longer focused upon the altar in the chancel, they were marginalized and devalued. If, as in the classical world, early reformist erasures were intended to provide worshippers with a permanent warning of idolatrous words, the longevity of the surviving corpus indicates slow and inevitable drift into meaninglessness and possessing only antiquarian interest.

In conclusion, the inscriptional corpus on English screens indicates that in the later medieval period screens testify to the increasingly important role material culture had as the bearer of text and that these inscriptions are witness to multiple communicative utterances. Further, they demonstrate an increased confidence in the use of the vernacular that matches evidence seen in other media. Though the Reformation brought an abrupt end to the textual dynamism of the church space, echoes of the communities and their faith can be heard in the voices captured on screen inscriptions.

5
SACRED KINGSHIP, GENEALOGY AND THE LATE MEDIEVAL ROOD SCREEN: CATFIELD AND BEYOND

JULIAN LUXFORD

While the breadth of analysis which medieval church screens invite is undeniably appealing, it is also problematic. Anyone conjuring with the topic faces issues of environment, structure, function, meaning, artistry, iconography and patronage, and has to negotiate familiar dichotomies, for example between case study and synthesis, greater churches and parochial ones, and rood screens and parcloses. Scientific analysis is also a consideration, as judgements about dating, artistic practice, iconoclastic erasures and the original colouring of screens can be improved or corrected by specialized tools which do what old-fashioned looking and ratiocination cannot. Of course, the reflective scholar feels that such reduction of a complex entity into its parts neglects some original state of holism, in which the entity's physical attributes and historical condition were somehow conflated. But if this *je ne sais quoi* is not an illusion, then it is at least something which cognition struggles to process. In art history, the normal way of responding to the challenge has been to build consideration of spatial and material integration into one's work. Indeed, such considerations have been present in writing on screens for the best part of two centuries, and have even come to be regarded as problems in their own right.[1] A large difficulty in all this is naturally a

[1] See e.g. R. Hart, 'Description of the Engraving from the Ranworth Screen', *Norfolk Archaeology*, 1 (1847), p. 325: 'In our churches, *as they were*, architecture and tinted glass, panel-painting, sculpture, and embroidery, harmonised most beautifully with each other

deficit of information about the Middle Ages. Wherever the medievalist turns, history fails him or her miserably, and scholars should only work with what they have.

This essay is neither a theoretical reflection on the study of screens nor an attempt to dissolve them back into the culture from which they emerged. Rather, these preliminary remarks are offered as an apology for turning to a single screen in a rural parish church, something I find reflexively unsettling, especially in the context of a volume which ranges so widely over its theme. In support of my approach, the reasons for choosing the rood screen at Catfield in Norfolk are not all local in character. It is true that this screen merits attention in its own right and will receive it here. Its surviving imagery, a series of sixteen kings, is both typologically striking and contextually unique, and displays an iconographic logic rare on screens apart from apostle sets and orders of angels. But study of this imagery inevitably leads one into the domain of cathedral and monastic screens, and sheds light on the contemporary enthusiasm for English royal saints, a distinctive but understudied aspect of late medieval devotion. The kings at Catfield also help to clarify an instinct about the historical understanding of rood screen imagery which, if sound, has a transcendent relevance. This is that screens with saints on them presented their beholders with an illustration of the conferment of grace, which according to *The Golden Legend* was one of the three main fruits of Christ's passion.[2] Explanation of this idea involves an analogy with the layout of the manuscript genealogies that were popular at the end of the Middle Ages. Like the imagery of figured screens, this layout was formally diagrammatic, gave precedence to a founding figure and was read from top to bottom. For this analogy to work, one has to accept that such genealogies were sufficiently familiar to have induced a sequential, top-down reading of screens. I hope this is simple enough to do in light of the plentiful evidence for their manufacture and distribution. Of equal significance for the argument is the genealogical contextualization of Christ, the common manifestations of which are perfectly familiar and will also be touched on here.

For present purposes, the screen's local setting can only be briefly explained. Catfield is a Broadland village some 12 miles north-east of Norwich. In the late Middle Ages, other prosperous villages with handsome churches of their own surrounded it, and surviving Catfield wills suggest a high degree of social interaction with these places. Catfield's church, dedicated to All Saints, has the rectilinear form and

… The eye was not arrested by the beauty of *detached parts*, but by the general effect of *the whole*, to which these parts were made subservient.' Compare W. Sauerländer, 'Integration: An Open or Closed Proposal?', in V. C. Raguin, K. Brush and P. Draper (eds), *Artistic Integration in Gothic Buildings* (Toronto, 1995), pp. 3–18.
2 F. S. Ellis (ed.), *The Golden Legend, or Lives of the Saints, as Englished by William Caxton* (London, 1900), I, pp. 74–5.

flint and stone construction normal in the area. There is a west tower, nave of five bays and a proportionately large two-bay chancel. With regard to the screen, the salient architectural points are these. First, the chancel arch in which the screen is fitted is of the same date as the nave, which was built in the second half of the fourteenth century (Fig. 5.1). It is high and wide, and there is no physical evidence that it ever had a wooden tympanum. The Rood, which stood on the screen, presumably always had the east window for its backdrop. Second, the chancel itself is of later date, rebuilt for a rector named John Walters and completed in 1471. This information, from an inscription on Walters's tomb, was recorded in the early seventeenth century and is reliable.[3] Third, the helical rood stair common in late medieval parish churches is absent here, but steps built into the window-jambs in the eastern bays of the aisles suggest that access to the loft was along the connecting lofts of parclose screens which caged these bays (such screens survive at Beeston-next-Mileham in Norfolk and Dennington in Suffolk). The final relevant point is that the aisle windows are large enough to compensate for the lack of a nave clerestory. Even assuming some coloured glass, the screen must have been well enough lit by day to make its images clearly visible.

A detailed picture of the screen's artistic setting is impossible. Wills

3 J. Luxford, 'Catfield Church, Norfolk: A Lost Rectorial Brass and an Early Case of Brass-Preservation', *Journal of the British Archaeological Association*, 167 (2014), pp. 205–12.

are the only useful archival source, and little imagery survives. Besides a record of a few coats of arms, nothing is known about the glass. Above the nave arcades are various wall paintings of the later fourteenth century, displaying a medley of subjects including scenes from the life of Christ interspersed with saints' martyrdoms and moral diagrams. These are now practically invisible, and although recorded in the mid-nineteenth century, not all of the subject matter is clear.[4] The most interesting in relation to the screen is a wheel of fortune at the west end on the north side, with its four kings crying 'regnabo', 'regno', 'regnavi' and 'non regno' in agreement with their positions. In the fifteenth century the church hosted guilds dedicated to the Virgin Mary, All Saints and Thomas of Canterbury, and images of all three are mentioned independently in wills, along with a panel painting of the apostle Thomas. Tabernacles are specified for sculpted images of All Saints and the Virgin, both of which seem to have been in the chancel (that of the Virgin certainly was). These were apparently the images required by ecclesiastical statute, but others representing the same subjects probably existed in the nave as focal points for the guilds.[5] There was a 'canopy about the sacrament' on the high altar, and lights to the Virgin, St Nicholas, All Souls, the sepulchre and what testators variously called 'crucifixus', 'sancte crucis', 'the high rode' and 'the blisside Rode on the perke': as usual in the parochial arena, the Rood light attracted the most generous gifts. Otherwise, there is evidence only for a handful of brass epitaphs, none of them apart from Walters's inscription remotely suggestive of involvement with the screen. What the wills do evoke, through their various requests for trentals and short-term chantries, is the church's general busyness and commemorative hum.[6]

What remains of the screen are its vertical elements up to the top of the fenestration, which is closed off by a moulded head-beam (Pl. XV). The loft and its supporting apparatus have vanished, and there are no traces on the jambs of the chancel arch or east nave wall to indicate its height or lateral

[4] D. Turner, 'Mural Paintings in Catfield Church', *Norfolk Archaeology*, 1 (1847), pp. 133–9.
[5] R. Marks, *Image and Devotion in Late Medieval England* (Stroud, 2004), pp. 61, 73 (statutory images).
[6] Wills recording images, guilds, lights and/or commemoration are Norfolk Record Office, Norwich Consistory Court (hereafter NRO, NCC) registers Harsyk, f. 242r (1390s); Doke, f. 98r (1439); Wylbey, f. 95r–v (1447); Brosyard, ff. 44r–v (1457), 192v–193r (1460), 261v, 272r–v (both 1461); Gelour, f. 211r–v (John Walters, 1478: image and tabernacle of the Virgin; missal, vestment and chalice); Paynot, f. 44r (1473); Caston, ff. 144v (1482), 169r (1483: requesting chancel burial; image and tabernacle of All Saints); Normande, ff. 19v (1486), 47v–48r (1493); Wight, f. 69r (1499); Popy, f. 386r (1503); Ryxe, f. 245v (1505); Spyltymbre, f. 309r–v (1510); Robynson, ff. 105v–107r (1520: 'blisside Rode'); Herman, ff. 27r, 33r–v (both 1523, the latter mentioning the image of Thomas of Canterbury); Alpe, ff. 63v–65r (1528); Hyll, ff. 53v–54r (1537); Daynes, ff. 21v–23r, 41r (both 1538), 133r–v (1541); NRO, MS Rye 3, vol. 2, p. 410 (1476: high altar canopy); F. Blomefield and C. Parkin, *An Essay Towards a Topographical History of the County of Norfolk* (London, 1808), pp. 292–3 (1510: 'table of St Thomas of Ynde').

projection, although it presumably connected at right angles with the lofts of the chapel screens. In its present state the screen is 5m wide and 3.84m high. It is divided into six bays of nearly equal width, and has elaborate tracery with ogee arches, copious panelling and a great deal of cusping. The doorway is ostentatiously large, occupying the two central bays of the screen to a little under two-thirds of their height. There is no evidence to suggest that it was ever equipped with doors, a characteristic shared with other screens in the region. The effect is evocative – and must have been even more so originally. This open arch not only enabled a generous view of the high altar, it drew the gaze into the chancel, and whatever the worshipper in the nave observed through it was framed by animated, meaningful images.[7] Here the biblical metaphor of Christ as the door to salvation, embellished in vernacular treatises circulating in the fifteenth century, was conspicuous by design, together with the concomitant notion that the screen itself was a point of transition from a mundane to a higher state.[8] At Catfield, the wide and permanent void under the rood makes the screen seem less a physical barrier to unauthorized entry than a force field, whose penetration was legitimate – even encouraged – but at the same time a test of personal conscience. According to one's state of mind, the janitor-figures to left and right of the doorway might be understood as guardians or a welcoming committee.

As noted, Catfield has sixteen such figures, which is a large but certainly not unparalleled number (Pls XVI and XVII). The four bays that contain them are logically subdivided, so that each has two 'windows' composed of two cusped, lancet-shaped panels. These windows are alternately red and green, the normal colour scheme for East Anglian screens and symbolically appropriate to the saintly classes of martyrs (whose blood was shed) and confessors (the roots of whose faith were 'alive and quick in the earth').[9] The kings are arranged in pairs and associated by their *actio* – gestures, facial expressions and body language – with images of prophets and apostles.[10] None of them looks out at the viewer, which is usual in painted screen imagery. The three ages of adulthood counted by medieval encyclopaedists are suggested by the nature of the figures' hair: beardlessness identifies youth (seven figures), a brown beard and hair implies maturity (six figures) and a white-grey beard and hair signifies old age (three figures).[11] The kings wear fluttering mantles over either

[7] For the framing of ritual by the imagery of monumental screens see the excellent discussion in J. E. Jung, *The Gothic Screen: Space, Sculpture and Community in the Cathedrals of France and Germany, ca. 1200–1400* (Cambridge, 2013), pp. 71–103.

[8] John 10:7, 9: compare London, BL Add. MS 35298, ff. 168v, 169r; H. N. MacCracken, 'Magnificencia Ecclesie', *Proceedings of the Modern Language Association*, 24 (1909), p. 695.

[9] Compare W. H. St J. Hope and E. G. C. F. Atchley, *An Introduction to English Liturgical Colours* (London, 1920), pp. 27–9, 31–3, 35, 58–9; Ellis (ed.), *Golden Legend*, 6, pp. 103–4 (quotation).

[10] See e.g. J. Hanson, 'The Prophets in Discussion', *Florilegium*, 17 (2000), pp. 73–97.

[11] See R. Gilchrist, *Medieval Life: Archaeology and the Life Course* (Woodbridge, 2012),

loose tunics with horizontal belts or tighter fitting garments apparently intended for armour, with pinched waists and golden baldrics. Their costume is red or green, accented here and there by blue or mauve; and it hardly needs saying that figures clad in red occupy green panels and vice versa. All but one have broad ermine tippets fastened with gold clasps, and all without exception wear decorative open crowns of the sort used during the fifteenth century to embellish votive statues, and common in contemporary manuscript painting and stained glass.[12] Their boots have pointy toes, and they stand upon a semblance of grassy ground. For all this, their present state gives only a cloudy impression of what they must have looked like before they were defaced and painted out.[13] They were clearly designed to enchant viewers aesthetically, through the mobile duct of their draperies, sweet intensity of their expressions and shimmering brilliance of their ornaments (Pl. XVIII).

Dating these figures closely is difficult. Previous estimates have ranged between the 1420s and the late fifteenth century, and my own instinct is to place them at or near the end of this period.[14] An early date is sometimes suggested because the architecture of Catfield's screen is a simplified version of the extant screen at Happisburgh, and a screen at Happisburgh is mentioned in a will of 1422.[15] But this is not much to go on: construction of the documented screen at Happisburgh could have been delayed (money was not necessarily spent when it was given), and the designer of Catfield's screen may anyway have followed an older exemplar recommended by its patron. Such cases are documented, and churchwardens or their agents sometimes travelled around in search of suitable models.[16] The date of the screen's architecture matters here, because it is very unlikely that the dado would have been left

pp. 32–7.

[12] See e.g. R. Marks and P. Williamson (eds), *Gothic: Art for England, 1400–1540* (exhib. cat., London, 2003), pp.154–5; K. L. Scott, *Later Gothic Manuscripts 1390–1490*, 2 vols (London, 1996), 1, Ills 345, 368, 370–2, 397–8; R. Marks, *Stained Glass in England During the Middle Ages* (London, 1993), Figs 81, 142–4, 163, 169; Pls XIX, XXIII.

[13] They were not rediscovered until 1873, which explains the paucity of antiquarian sources for them. Work on the screen in 1985 by Pauline Plummer was left incomplete for want of money.

[14] For a late fifteenth-century dating see e.g. A. E. Nichols, *The Early Art of Norfolk: A Subject List of Extant and Lost Art Including Items Relevant to Early Drama* (Kalamazoo, MI, 2002), pp. 167, 187, 189, 224; N. Pevsner and B. Wilson, *The Buildings of England. Norfolk 1: Norwich and North-East* (London, 2002), p. 428.

[15] A. Baker, *English Panel Paintings 1400–1558: A Survey of Figure Paintings on East Anglian Rood Screens*, ed. and updated A. Ballantyne and P. Plummer (London, 2011), p. 130; S. Cotton, 'Mediaeval Roodscreens in Norfolk: Their Construction and Painting Dates', *Norfolk Archaeology*, 40 (1987–89), p. 48. See also L. J. Wrapson, 'Patterns of Production: A Technical Art Historical Study of East Anglia's Late Medieval Screens' (PhD thesis, University of Cambridge, 2013), p. 556 (suggesting 'c.1430–60').

[16] E. Duffy, 'The Parish, Piety and Patronage in Late Medieval East Anglia: The Evidence of Rood Screens', in K. French, G. Gibbs and B. Kümin (eds), *The Parish in English Life 1400–1600* (Manchester, 1997), pp. 141, 146–8.

unpainted for long, and even less so that the current figures replace an earlier scheme. But it is no easier to tie the painting in with the rebuilding of the chancel around 1471, for the chancel arch, as noted above, is of a piece with the nave. And the style and iconography of the painting, including the costumes and ornaments, are similarly unhelpful, particularly in their abraded state. The figures' suave, rhythmic, delicate handling is recognizably that of the International Style, but this was a style that hung on in English panel painting well into the second half of the fifteenth century. Their hair is arranged in corkscrew curls of a sort found in manuscript painting of the early 1400s, but present in panel painting, stained glass and sculpture for a century after this.[17] Finally, the historical chronology of these kings cannot help, as the latest of them died centuries before the screen was made. Thus, saving some technical discovery or *deus ex archivo*, a broad dating between c.1430 and c.1475 is all it is reasonable to suggest.

As noted previously, the iconography at Catfield is unique. To my knowledge, no other surviving screen in a parish church has more than four kings on it, and while these may be paired up, as at Barton Turf and Ludham, they are combined with non-royal saints in what looks to modern eyes an unsystematic arrangement. The Catfield kings are an ensemble, and this all but proves that a persuasive individual such as a rector or local gentleman with a taste for such imagery was responsible for them: they look like the product of a personal enthusiasm.[18] In most cases, popular helper saints, whose variety in terms of gender and special efficacy reflected parish demographics, occupied the west faces of screens. The processes by which screen imagery was determined are unclear, but must normally have involved official, collective sanction of some kind.[19] If such a decision does underlie the choice of kings at Catfield, then it was evidently taken in response to some now-lost ensemble elsewhere (which would still not explain why this imagery was thought appropriate for a parish rood screen), or else a desire to do something novel and patriotic that would mark the church out; but the latter suggestion hardly rings true as a basis for excluding the apostles and other trusted advocates.[20] There are no obvious grounds for suspecting the intervention of a more elevated patron than a rector like John Walters, and one is obliged to accept that the parish was both willing to take what it was offered and content to

[17] For an early example see Scott, *Later Gothic Manuscripts*, 1, ill. 103 (the Wyndham-Payne leaf, made c.1410). The Ranworth group of painters reproduced this feature, as did the sculptor of the kings on York Minster's pulpitum and various alabasterers.

[18] The lost fifteenth-century screen at Poringland, just south of Norwich, also had an inclusive programme of images and was certainly built by a rector: Blomefield and Parkin, *Topographical History*, 5, pp. 440–1.

[19] Compare E. Duffy, *The Stripping of the Altars: Traditional Religion in England c.1400–c.1580*, 2nd edn (London, 2005), pp. 159–60.

[20] It is unlikely that the images marked some extraordinary event like a royal visit which occurred when the screen was being installed.

keep it once it was *in situ*. Devotional patriotism is probably as good an explanation for this willingness as apathy or lack of agency on the part of the churchwardens.

In any case, the screen does include a few familiar saints, and at least one – Edmund – who was ubiquitous in late medieval East Anglia. Little has been said to this point about the identities of the kings; it is time to address the matter. The first task is to classify them. As the genealogy given at the beginning of the Gospel of St Matthew includes sixteen kings, and as Christ himself topped the screen in martyred glory, it should be asked whether the Catfield panels represent Christ's ancestors.[21] The answer is no – as indicated, they include Anglo-Saxon kings identifiable by attribute – but the agreement of number relates to what is said later on and should be held in mind. Neither was the aim to present a succession of kings culminating in a current one, as it often was in English Gothic art. There is a correspondence, inexact but immediately felt, between Catfield's figures and the main image programmes of transverse screens in English cathedrals and monasteries at the time, which seems to have consisted almost exclusively of kings. Examples are known from the cathedrals of Canterbury, Durham, Old St Paul's, Salisbury, Wells and York, the first and last of which survive. Chester Abbey's pulpitum also displayed images of kings from William I to Henry VII.[22] Sanctity was never necessary for inclusion in these schemes and, indeed, saintly kings seldom seem to have appeared in them (Canterbury and Durham are exceptions): in most cases – as with series of kings depicted in other contexts and media – the beholder was offered an unbroken line which emphasized institutional prestige, loyalty and an expectation of royal favour, as well as the monarch's role as defender of religion and the superior status conveyed by his anointment. Knowledge of one or more of these schemes probably does help to explain the choice of imagery at Catfield, which would have gained prestige by association with great and solemn institutions.[23] But parish churches had their own image-logic, according to which the rood screen was reserved for either saints or prophecy. In this regard, at least, Catfield is surely conventional: its kings look saintly in their location, the objects they hold and their general attitudes (the kings of the surviving great screens do not converse with one another but stare outwards), and the comparative evidence offered below establishes a clear context for

[21] Matthew 1:1–17.

[22] C. Wilson, 'Rulers, Artificers and Shoppers: Richard II's Remodelling of Westminster Hall, 1393–99', in D. Gordon, L. Monnas and C. Elam (eds), *The Regal Image of Richard II and the Wilton Diptych* (London, 1997), pp. 33–59, 274–88 (at p. 283 n. 74): 'there appears to be no evidence that the major niches of choir-screens in the greater English churches ever contained anything other than images of royal rulers'. See also L. Slater, 'Visual Reflections on History and Kingship in the Medieval English Great Church', *Journal of the British Archaeological Association*, 167 (2014), pp. 83–108; A. Vallance, *Greater English Church Screens* (London, 1947), p. 97 (Chester).

[23] No evidence survives for the iconography of such monumental screens in East Anglia.

identifying them as such.[24] If there is an ordering principle here, then it is evidently devotional hierarchy rather than chronology, with the two most prestigious saints out of date order but flanking the chancel entrance. The absence of conventional haloes, noted in past assessments of the figures' status, is actually irrelevant, for the brow of each is already girt with the *coronam vitae* that scripture promises to those who endure trials for Christ's sake.[25] Enough of the figures are identifiable to show that they do not follow any strict sequence. The glue that holds them together is royalty and sanctity.

Only three of the kings can be safely identified by their attributes, while the identities of three more seem probable. In other cases, separate figures hold an object that would be appropriate to a particular royal saint, making it likely that this saint is included but unclear which figure represents him. In some cases they hold only swords or sceptres, which were generic attributes of kings in art. Originally, it was intended to identify the figures with labels, and white banderols were painted for the purpose on the sloping face of the transom above them (Pl. XVII, top left). This at least shows that viewers were not expected to recognize them on the basis of attributes or spiritual insight alone; but the names were never inscribed, and the failure to do so means that at least half of the figures will remain unidentifiable. Nevertheless, it is clear enough that all were supposed to represent English kings who had lived and died before the Norman Conquest, in that misty period when, as the chroniclers had it, violence and sanctity were the motive powers of history, and beautiful, Christian princes were strewn and cut down like flowers of the field. The main basis for this classification is by analogy with other sources in which English royal saints are grouped together. These sources, which never seem to have been collected or studied together, illustrate the dominant, essentially genealogical model of medieval history writing in their isolation of a special class of saint and presentation of its members in sequences defined by discrete listing, or, in art, pictorial isolation (one to a panel, pane or roundel).

Current assumptions about later medieval history encourage the view that this marshalling of indigenous, saintly kings originally responded to royal interests and had a political dimension. That may well be true: while the kings involved had long been individually worshipped by the custodians and devotees of their cults, collective interest in them first emerges clearly in the personal religion of Henry III, who believed that eleven pre-Conquest monarchs had been canonized – he could remember their names – and trusted his sister Isabella's soul to the

[24] It is usually assumed that all of the figures are saintly, but the case has never been made.
[25] James 1:12; Revelation 2:10. Round haloes would also have obscured the crowns which were so aesthetically important at Catfield.

special guardianship of four of them when she married the Holy Roman emperor Frederick II (Henry had images of them put onto her crown).[26] The idea is encouraged by an early pictorial example. When the vestibule of the chapter house at York Minster was glazed around 1300, a window displaying royal genealogy was juxtaposed with another showing saintly kings in a manifestation of the familiar idea that royal prerogative was communicated metaphysically, via sacred history, as well as through blood and anointment.[27] It is also supported by later evidence. When Henry V returned to London after Agincourt, one of the honorific pageants included a *tableau vivant* featuring twelve English kings, both martyrs and confessors, identified by their costumes and attributes. They, or others present, chanted Psalm 44: 'I will not trust in my bow, neither shall my sword save me; thou hast saved us from them that afflict us, and hast put them to shame that hate us.'[28] Here history thanked its champion as the psalmist had thanked God, and simultaneously made the same point as the windows at York. Shortly after this, John Capgrave's *Liber de Illustribus Henricis*, written to flatter Henry VI, named eight Anglo-Saxon kings – four martyrs, four confessors – as 'first among all the holy kings of this, our country'. Capgrave evidently knew of others besides those he mentioned.[29] Around 1441, a window was put into the Old Library at All Souls College at Oxford which had among its fifteen figures ten ancestor kings of Henry VI who were known or reputed to be saints, including nine out of the ten who had lived before the Conquest.[30] Only those found in the Sarum rite seem to have had name-labels including the word 'sanctus', but a reputation for sanctity may have influenced the choices all the same. And when the chantry chapel of Arthur, Prince of Wales (d. 1502) went up at Worcester Cathedral in the early sixteenth century, it included a set of eleven sculpted royal saints. In this case, two of the figures (Edward II and Henry VI) post-dated the Conquest, but the others were Anglo-Saxon.[31]

[26] H. R. Luard (ed.), *Chronica maiora Matthaei Parisiensis, monachi S. Albani*, 5 (London, 1880), p. 617; O. Lehmann-Brockhaus (ed.), *Lateinische Schriftquellen zur Kunst in England, Wales und Schottland vom Jahre 901 bis zum Jahre 1307* (Munich, 1956), p. 275 (no. 6169). For individual reverence of Anglo-Saxon royal saints see J. Hughes, 'The Monarch as an Object of Liturgical Veneration', in A. J. Duggan (ed.), *Kings and Kingship in Medieval Europe* (London, 1993), pp. 375–424 (particularly pp. 382–7); S. J. Ridyard, *The Royal Saints of Anglo-Saxon England: A Study of West Saxon and East Anglian Cults* (Cambridge, 1988).

[27] Marks, *Stained Glass*, p. 88.

[28] Psalm 44:7–8. N. Coldstream, '"Pavilion'd in Splendour": Henry V's Agincourt Pageants', *Journal of the British Archaeological Association*, 165 (2012), pp. 162, 167.

[29] F. C. Hingeston (ed.), *Johannis Capgrave, Liber de Illustribus Henricis* (London, 1858), p. 185; D. King, *The Medieval Stained Glass of St Peter Mancroft, Norwich* (Oxford, 2006), p. cxci.

[30] R. Marks, 'Yorkist–Lancastrian Political and Genealogical Propaganda in the Visual Arts', *Family History*, 12 (1982), p. 152. The most detailed study is F. E. Hutchinson, *Medieval Glass at All Souls College* (London, 1949), pp. 37–61.

[31] P. G. Lindley, 'Worcester and Westminster: The Figure-Sculpture of Prince Arthur's

Naturally, it would be futile to try to separate out the political and devotional elements in these cycles. The imagery of Isabella's crown or Henry V's pageant only got into diplomacy because it was grounded in religious conviction. But other manifestations of the theme not connected with royal patronage or prince-pleasing are found tucked away in private books or displayed in situations never likely to attract royal notice and approval. Catfield's paintings are one example. Another, from the 1450s, was formerly in the east window of the north aisle at the parish church of St Peter Mancroft in Norwich (nine of its figures survive, though displaced).[32] This was one of several series of figures employed to fill the minor lights of windows in the same church (the others included sainted archbishops, prophets and ancestors of Christ), and although it is possible to connect it with contemporary politics, the evidence for doing so is very slight.[33] With the other series of figures, it looks like a tidy-minded response to the conundrum of filling the minor, regular fields created by complex tracery. This does not unduly downplay its significance, because in order to be selected it had to represent a contemporary devotional current. The parallels for it, not least at Catfield, show that it was no isolated quirk of patronage. As suggested, these parallels extend to privately owned books. There is a carefully written and embellished 'Nomina Regum Sanctorum Anglie' in Oxford, Bodleian Library, MS Bodley 596 (f. 43r–v), which dates from around 1400 and may come from Westminster Abbey. This includes fifteen kings, fourteen Anglo-Saxon ones plus Edward II, with cross-references to Ranulph Higden's *Polychronicon*. This popular chronicle is not, however, the only authority for the list, as Higden does not refer to most of its members as saints. Some other source informed it: of 'Alfwoldus', king of Northumbria, its compiler notes that 'I believe that this king is also called Alwynus', suggesting a broader field of reference.[34] This list evidently circulated widely, as an early sixteenth-century copy of it was included in Cambridge, Corpus Christi College, MS 177 (f. 136r), a theological miscellany probably also from some religious house.[35] A handsome psalter of the 1450s or 1460s, now Oxford, Trinity College MS 46 (ff. 166v–167v), has a different list, containing sixteen pre-Conquest

Chapel', in S. Gunn and L. Monckton (eds), *Arthur Tudor, Prince of Wales: Life, Death and Commemoration* (Woodbridge, 2009), pp. 145, 147, 149. Eight of these can be certainly identified, and two others have saint-attributes.

[32] King, *Mancroft*, pp. clxxxviii–cxcvii, 83, 88–91, 95–6, 99–100, 103.

[33] It includes St Alban as a king, which has been tentatively linked to the devotion of Humphrey, duke of Gloucester (King, *Mancroft*, p. cxcv). However, this has earlier, mundane parallels, e.g. in Oxford, Bodleian Library (hereafter OBL), MS Rawlinson D 939, a single-sheet almanac of c.1400 including a crowned figure holding a sceptre and book or charter labelled 'Albanus rex'.

[34] This means Alfwald I (d. 788), whom Higden also calls 'Sanctus Alfwoldus'.

[35] M. R. James, *A Descriptive Catalogue of the Manuscripts in the Library of Corpus Christi College, Cambridge* (Cambridge, 1912), I, pp. 411–12.

English kings grouped together as martyrs (seven) and confessors (nine). This seems to have been compiled and written in London.[36] And a monk of St Augustine's abbey at Canterbury named Clement, active at the same time, recorded in a memorandum that of the 140 English kings between the birth of Christ and Edward the Confessor, six were martyrs and six ended their days as monks. He listed the names, stating that he got the information from a chronicle of Dunstable priory.[37] No foreign ruler is included in any of these sources: there is no Charlemagne, no Olaf, no Sigismund. Englishness is a condition of inclusion, as is representation in the annals of national history (there are no Walstans of Bawburgh, either). Combined with the secular imagery of Catfield and Mancroft, the date and monastic provenance of these manuscripts suggest the social reach of the phenomenon. While professional religious may have been the first to put such lists together, the sainted kings of England were public devotional property by the late Middle Ages.

Where known, the membership of these series and lists varies to the extent that no one example can reliably serve as a basis for identifying the Catfield kings. Some saints – Oswald, Edmund, Edward the Confessor – are standard and others usual, but each case has its peculiarities: for instance, the psalter list includes Lucius, Alfred and Edgar among the confessors, Alban is represented at Mancroft, and Ethelbald, Ethelbright and Edmund Ironside are among the names in Bodley 596 and Corpus Christi 177. A more or less symmetrical distinction of martyrs and confessors evidently mattered to their compilers, and this, at least, is accommodated at Catfield by the red and green colour scheme, although at an individual level it is doubtful that martyrs always stand against red backgrounds and confessors green ones. There is a similar ambiguity about attributes, which vary in the pictorial cycles mentioned here and the iconography of kingship generally. While the attributes included at Catfield were evidently supposed to be appropriate to the figures that hold them, only Edmund's arrow and Edward the Confessor's ring are familiar enough for them to be identified at first sight. For present purposes, the clearest way of dealing with individual identifications is by listing the figures by number (N[orth]1–8 [Pl. XVI] and S[outh]1–8 [Pl. XVII]) according to the panel they occupy, and starting on either side with the panel furthest from the doorway:

[36] On the manuscript see A. I. Doyle, 'Stephen Dodesham of Witham and Sheen', in P. R. Robinson and R. Zim (eds), *Of the Making of Books: Medieval Manuscripts, their Scribes and Readers: Essays Presented to M. B. Parkes* (Aldershot, 1997), pp. 95–6.
[37] Although not the *Annales de Dunstaplia* published among the *Annales Monastici* in the Rolls Series. OBL, MS Rawlinson B150, f. 1*r (a singleton, tipped in after the first leaf): illustrated in B. C. Barker-Benfield (ed.), *St Augustine's Abbey, Canterbury*, I (London, 2008), Pl. 7c.

N1. A middle-aged king holding a sceptre and pointing at it with his free hand. He is the only figure without an ermine tippet. The anomaly is deliberate and a chasuble seems intended. Although not in a monk's habit, the gesture may suggest Sigebert (d. 664), a king of the East Saxons who according to the *Polychronicon* was dragged out of the monastery he had retired to and murdered 'bearing only a sceptre [*virga*] in his hand'.[38] Sigebert is in the Trinity College psalter list (f. 166v).

N2. A young king holding a sword and pointing at it. If, as assumed with N1, the gesture has narrative significance, then he is surely a martyr. This king has the pinched waist and baldric that suggest armour.

N3. A middle-aged king, holding a sceptre and small cruciform church. Ann Nichols suggested Athelstan (d. 939), because he is shown with a church in the glass at St Peter Mancroft.[39] But the Mancroft sequence is not a reliable template for Catfield, and there is another figure on the screen with a church (N5). Moreover, several other pre-Conquest kings with saintly reputations are shown in art with model buildings (Constantine, Ethelbert of Kent, Offa, Edgar). In support of Nichols's identification is a contemporary image of Athelstan holding a church at Milton Abbey in Dorset (which, however, he founded), and an independent record of 'sanctus Athelstanus, quondam rex Anglorum' in a late fourteenth-century relic list. Conversely, Ethelbert of Kent, who Higden represented as a church builder and the first Christian king of Britain, is at least as strong a candidate for identification here (if he is not shown at N5: see below).[40]

N4. A young king with a sceptre, wearing the pinched waist, armour-like costume. The left hand clasps the baldric.

N5. An old king holding a cruciform church, here with a spire terminating in a gold cross (Pl. XVIII). This suggests St Paul's Cathedral, which was known for its prodigious spire topped with a golden cross and ball with relics in it.[41] Sebert (d. 694), king of the East Saxons, is a candidate, as the *Polychronicon* credits him with construction of the first St Paul's. Sebert is in

[38] C. Babington and J. R. Lumby (eds), *Polychronicon Ranulphi Higden monachi Cestrensis*, 6 (London, 1876), p. 6.
[39] Nichols, *Early Art*, p. 167.
[40] London, Lambeth Palace Library (hereafter LPL), MS 99, f. 194r (relic list); Babington and Lumby (eds), *Polychronicon*, 5, 1874, pp. 396–400, 424–6.
[41] LPL, MS 1106, f. 96r; see also C. Louis (ed.), *The Commonplace Book of Robert Reynes of Acle: An Edition of Tanner MS 407* (New York, 1980), pp. 227, 438.

the Bodley 596 (f. 43r) and Corpus Christi 177 lists. Lucius and (following Bede) Ethelbert of Kent were also considered founders of St Paul's: both are among the confessors in the Trinity College psalter list (f. 167r). Ethelbert is shown with a church on the pulpitum at Canterbury Cathedral and Lucius appears to have been represented on the Lady chapel reredos at St Peter's abbey at Gloucester.[42] See also N3.

N6. A middle-aged king holding a gold lily in one hand and a halberd in the other (Pl. XVIII). This is St Kenelm (d. 812 or 821), a Sarum saint (17 July), who was beheaded. He is also shown crowned and holding a halberd in the Sherborne Missal (BL, Add. MS 74236, p. 492). The lily flower is a recognized attribute of his.[43] This figure is usually called St Olaf, but it lacks the loaves appropriate to that king in a cycle whose artist or patron was intent on including such attributes.

N7. An old man, holding a spear and pointing at his interlocutor. Possibly St Oswin, king of Bernicia (d. 651), whose relics were kept at Tynemouth and St Albans. According to tradition, he was stabbed in the side with a spear: he is shown with this weapon in Matthew Paris's *Abbreviatio Chronicorum* (BL, MS Cotton Claudius D.VI, f. 7r) on the brass of Abbot Thomas de la Mare at St Albans and on the fourteenth-century seal of Tynemouth priory.[44]

N8. A young king holding a ring and sceptre, meant for Edward the Confessor, who is also depicted as a young man on screens at Eye in Suffolk, Plymtree in Devon and the fourteenth-century panels now at Kingston Lacy.[45] He was a Sarum saint (13 October; the feast of his translation).

[42] Babington and Lumby (eds), *Polychronicon*, 5, p. 410. Westminster's monks claimed Sebert as their founder, and he thus appears holding a church on Henry V's chapel in the abbey: W. H. St J. Hope, 'The Funeral, Monument, and Chantry Chapel of King Henry the Fifth', *Archaeologia*, 65 (1914), p. 161. D. J. Knight, *King Lucius of Britain* (Stroud, 2008), pp. 82–3; R. D. Short, 'Graffiti on the Reredos of the Lady Chapel at Gloucester Cathedral', *Transactions of the Bristol and Gloucester Archaeological Society*, 67 (1946–48), pp. 35–6; B. Colgrave and R. A. B. Mynors (eds and trans), *Bede's Ecclesiastical History of the English People* (Oxford, 1969), p. 142.
[43] Scott, *Later Gothic Manuscripts*, 2, p. 50 (no. 9); for the blossoming lily, see F. C. Husenbeth, *Emblems of Saints by Which They Are Distinguished in Works of Art*, 3rd edn (Norwich, 1882), p. 125; S. Lewis, *The Art of Matthew Paris in the Chronica Majora* (Aldershot, 1987), p. 151; M. Gill, '"Kenelm Cunebearn ... Haudes Bereafed": A Reconstructed Cycle of Wall Paintings from St Kenelm's Chapel, Romsley', *Journal of the British Archaeological Association*, 149 (1996), p. 30.
[44] Lewis, *Matthew Paris*, p. 151; J. Luxford, 'Manuscripts, History and Aesthetic Interests at Tynemouth Priory', in J. Ashbee and J. Luxford (eds), *Newcastle and Northumberland: Roman and Medieval Art and Architecture*, British Archaeological Association Conference Transactions, 36 (Leeds, 2013), pp. 196, 198.
[45] Baker, *English Panel Paintings*, p. 74; F. Bond and B. Camm, *Roodscreens and Roodlofts,*

S8. A young king with golden, shoulder-length hair, sometimes identified as a queen. He holds a sceptre, points to his partner figure and wears the pinched waist, armour-like costume.

S7. An old king, holding a spear and pointing at it. He may have been intended for Oswin: see N7.

S6. A young king, holding a halberd and pointing at his interlocutor. He must be some such martyr *decapitatus* as Ethelbert II of the East Angles (d. 794), who was a popular saint, or Fremund (d. 886), paired by John Lydgate with St Edmund, but there is nothing to show which one.[46]

S5. A sceptred, middle-aged king, holding an object reverently in a fold of his mantle. The object has been erased, but one can see that it was a gold cross (hence its erasure), mounted on a book or base of some sort. This is thus probably St Oswald (d. 642), a king of Bernicia and a Sarum saint (5 August): the attribute commemorates his planting of a cross on the battle site at 'Heavenfield', near Hexham. Matthew Paris showed him with the cross, as did two windows at Durham Cathedral. He is on the screens at Horsham St Faith (Norfolk), Woodbridge (Suffolk), and also in the Mancroft window, but with different attributes.[47]

S4. A middle-aged king with sceptre and gesticulating hand. He wears the pinched-waist costume resembling armour, and is unique at Catfield in wearing a short dagger in a red sheath. This might suggest Edward the Martyr if S2 were not a more likely candidate for that saint.

S3. A young king, holding a sword to which he points. This probably indicates a martyr.

S2. Again, a young king, pointing at an erased object held in his left hand. This object was evidently a large knife, suggesting St Edward the Martyr (d. 978), king of the English and a Sarum saint (18 March), who was murdered with such an object. He holds a knife in the painting of him on the Woodbridge screen

2 vols (London, 1909), 2, p. 229; C. Tracy, 'An English Painted Screen at Kingston Lacy', *Apollo*, 146 (1997), pp. 21, 24.

[46] There is a fragmentary figure of St Fremund in a chancel window at Dauntsey (Wilts.): according to a seventeenth-century description, this represented 'a King holding the head of a young King in his hand'. See R. Marks, *Windows and Wills: Fenestration and Glazing Bequests in England and Wales 1277–1583* (forthcoming).

[47] Husenbeth, *Emblems*, p. 160; Lewis, *Matthew Paris*, p. 149; J. T. Fowler (ed.), *Rites of Durham*, Surtees Society, 107 (1902), pp. 115, 117; Baker, *English Panel Paintings*, pp. 149, 209.

(an accurate copy of a lost original), on Prince Arthur's chapel at
Worcester and elsewhere.[48]

S1. A middle-aged king with a gold-tipped arrow in his right
hand. His left hand points to his pendant figure. This is St
Edmund (d. 869), king of the East Angles and also a Sarum saint
(20 November).

This accounts for the figures individually, although the impact of the
ensemble was clearly intended to transcend that of the parts, as it was
with the statues on any cathedral pulpitum. The Rood with its attendant
figures of Mary and John has of course to be factored into this whole, and
this brings me to the hypothetical matters outlined in the introduction.[49]
To begin with, it needs to be acknowledged that wherever it existed,
the relationship of Rood group to subordinate imagery is likely to have
generated specific devotional coherences in the minds of viewers. A sense
of this arises where donors are represented on a screen or there is evidence
that panels were commissioned by different people at different times. But
this situational rapport was bound up with a generic semiotics rooted
in scripture and theology, according to which the overriding example of
humility and sacrifice set by the crucified Christ was reflected in the saints
positioned beneath him. In practice, appreciation of this example must
have been substantially a product of how rood screen imagery was read,
from top to bottom (the eye being drawn first to the Crucifixion, if not the
altar beyond) and then laterally, across the loft (if it had imagery) and dado.
It also had to do with spatial and physical proximity: the dado figures were
set directly under the Rood on the same north–south axis, and occupied
the same piece of furniture. In this way, any viewer of a screen with saints
on it was presented with a sacred hierarchy expressed in terms of size and
elevation as well as iconography. In the context of this hierarchy, the status
of Christ validated that of his saints. Where these saints are apostles, the
validation was recorded in the Bible – 'I am the vine, you the branches'
– while for most others it was illustrated in sermons, the legendary and
the collects and sequences of the missal.[50] Standing at the level of the
people, and turned bodily towards them, the saints then functioned to
convey this spiritual authority outward, into the community of the parish,
through a combination of model holiness, promise of intercession and
friendly good will. The legendary explained their intermediary status in
various ways: the saints, it says, are the 'heirs of God and our dukes and
leaders', 'leaders of grace and all human lineage' and so on.[51] The directness

[48] Baker, *English Panel Paintings*, p. 209; Lindley, 'Worcester and Westminster', pp. 147, 149.
[49] Compare Duffy, *The Stripping of the Altars*, pp. 157–9.
[50] John 15:5: see also Matthew 10; Mark 3:13–19; Luke 9:1–17; John 17.
[51] Ellis (ed.), *Golden Legend*, 6, pp. 97–8.

of communication at this mundane level – as the legendary also pointed out – is evoked in the Bible: '[A]s many as received him, he empowered to be made the sons of God.'[52] As Eamon Duffy has explained, 'affectionate dependence' on the saints played a large part in this reception.[53] Catfield's screen illustrates the concept in a special way, by emphasizing the status of Christ as *rex regum*, born of royal blood and ruler over the earthly kings whose chief occupation was to serve their people.[54]

This idea about the perception of rood screens and their imagery is perfectly compatible with others, according to which such screens were complex microcosms of the heavenly hierarchy (Duffy), or representatives *in nuce* of the churches they stood in (Jacqueline Jung), or thresholds of physical and spiritual translation.[55] In essence, what I am proposing is similar to Duffy's idea: the screen epitomized the heavenly hierarchy and implied by its iconographic arrangement how pious beholders were related to this. Although this hypothesis can hardly be developed at length here, the genealogical analogy promised at the outset will serve to illustrate a possible route into the process. Genealogical manuscripts and the interpretation of screen imagery have been brought together before, and with reference to Catfield too. Specifically, Ann Nichols suggests that familiarity with royal pedigrees explains the choice of imagery and also furnishes a model for understanding the figures as a chronological sequence.[56] While this essay has argued against a chronological reading, Nichols's instinct is sound to the extent that such pedigrees must have been largely responsible for the mental images fifteenth-century people had of sequences of rulers: a suitably informed viewer's ideas about the Catfield screen may well have been influenced by this association. However, I also think that the connection with genealogy helps to justify the reading of screen imagery offered above in broader terms, for genealogy was a pervasive phenomenon which illustrated the same top-down transfer of power and embodied the same idea of spiritual legitimization. The reasoning here is only partially dependent on artistic comparisons, although word imagery is consistently influential, not least because the biblical language of vines and branches is also that of pedigree. In fact, rood screen iconography can be said to have expressed both historical and spiritual genealogy, the two types embodied in the Gospel accounts of Christ's ancestors (Matthew's the kingly, consanguineous descent, Luke's the priestly and spiritual). In historical terms, a screen's iconography summarized the

[52] John 1:12; Ellis (ed.), *Golden Legend*, 6, p. 98.
[53] Duffy, *The Stripping of the Atars*, pp. 155–205 (p. 161 for quotation).
[54] I Timothy 6:15; Revelation 1:5, 17:14, 19:16; Ellis (ed.), *Golden Legend*, I, p. 69; G. L. Harriss, 'The King and His Subjects', in R. Horrox (ed.), *Fifteenth-Century Attitudes: Perceptions of Society in Late Medieval England* (Cambridge, 1994), pp. 13–28.
[55] Duffy, *The Stripping of the Altars*, p. 158; Jung, *The Gothic Screen*, p. 200.
[56] Nichols, *Early Art*, p. 317.

development of Christianity from its author down through the apostles or generations of holy men and women described in hagiographies and chronicles to the present time. In a spiritual sense, it exhibited the descent of grace through the sanctified agents of Christ and into the community of believers. This community was temporarily present in the nave on Sundays and permanently represented by the graves and monuments lying there. In both cases, Christ *in extremis* represented a founder figure, the point of origin of true, soterial religion. As such, he was a counterpart of the king, nobleman or other figure situated at the beginning of a genealogical roll or book as the *fons et origo* of some strain of blood and entitlement.

Comparisons with visual culture become useful here. To begin with, it may be noted that a figured rood screen represents a sort of diagram, with clearly defined, populated compartments and levels at different heights connected by vertical lines.[57] It shares this layout with various types of schema, of which the manuscript genealogy was only the most popular in England in the late Middle Ages.[58] In these manuscripts, descent is traced along stemmata which are regularly interrupted by horizontal registers of images or names, standing for individual generations and their members (Fig. 5.2). Thus, while the dominant impetus is vertical, the reader is also induced at stages to read horizontally, across space, as one would scan the panels of a rood loft or dado. Hand in hand with this analogy goes a stress on the commonness and breadth of knowledge of such genealogies. This is partially indicated by the number of surviving rolls. No complete census of surviving manuscripts and fragments exists: of those in roll form devoted to English kings, Oliver de Laborderie counts forty-one made before 1422, and production increased greatly in the reigns of Henry VI and Edward IV.[59] It is anyway safe to conclude that the surviving corpus amounts to only a fraction of the original total, and the rolls were matched by genealogies in books which were vertically read from page to page, a model found early on in Matthew Paris's *Chronica Majora* (Cambridge, Corpus Christi College MS 16, f. iii recto–verso). The pedigrees of individual families also have to be taken into account.[60]

[57] This observation also applies to windows with complex tracery and sequences of imagery.
[58] On the late medieval tendency to represent things diagrammatically, see M. Evans, 'The Geometry of the Mind', *Architectural Association Quarterly*, 12 (1980), pp. 31–55.
[59] O. de Laborderie, *Histoire, mémoire et pouvoir: les genealogies en rouleau des rois d'Angleterre (1250–1422)* (Paris, 2013), p. 26 *et passim*; S. Anglo, 'The *British History* in Early Tudor Propaganda, with an Appendix of Manuscript Pedigrees of the Kings of England, Henry VI to Henry VIII', *Bulletin of the John Rylands Library*, 44 (1961–62), pp. 17–48.
[60] For these, see in general J. Spence, 'Genealogies of Noble Families in Anglo-Norman' and J. Denton, 'Genealogy and Gentility: Social Status in Provincial England', in R. L. Radulescu and E. D. Kennedy (eds), *Broken Lines: Genealogical Literature in Medieval Britain and France* (Turnhout, 2008), pp. 63–77 and 143–58; C. Klapisch-Zuber, *L'ombre des ancêtres: essai sur l'imaginaire médiéval de la parenté* (Paris, 2000).

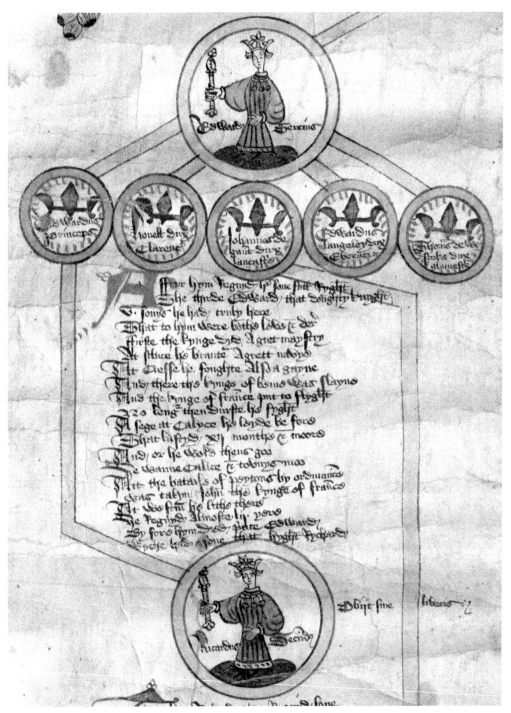

FIG. 5.2. UNIVERSITY OF ST ANDREWS LIBRARY, MS 38660, M. 2 (FRONT): DETAIL OF A LATER
FIFTEENTH-CENTURY GENEALOGICAL ROLL OF ENGLISH KINGS, PARTLY IN ENGLISH.

Their use is sometimes mentioned in surviving Norfolk records in ways that suggest a far-reaching currency. They were, for example, produced in court cases, and it is obvious that prosperous people, at least, were familiar with them as a matter of education as well as curiosity.[61] Their simplest and surely commonest manifestation is represented by the descent of Sir William of Witchingham drawn on a spare leaf in the Jennys commonplace book, an East Anglian manuscript of the late fifteenth century now in Cambridge (Cambridge, University Library, Add. MS 7912, f. 4r). The usership of genealogies in the fifteenth century has been characterized as 'an ever widening literate public of nobles, gentry, civil servants, lawyers and merchants', to which the priesthood can naturally be added.[62] By the late Middle Ages they were increasingly written in English (e.g. Fig. 5.2), and their structure duly influenced the layout of suites of tombs on church pavements and the iconography of individual monuments.[63] All of this suggests that the visual presentation of genealogy was familiar and stimulated analogies.

Christ had his own place in this genealogical model. For one thing, he had a historically contextualized pedigree of great popularity – Peter of Poitiers's *Compendium historiae in genealogia Christi* – which was typically designed according to the circle-and-line format normal in manuscript genealogies.[64] He also had a place in pedigrees of English kings, with the calculated suggestion of a blood relationship: England's rulers traced their origins via the kings of Wessex to Noah, and Noah is named in the Lucan genealogy as an ancestor of Christ.[65] In fact, the whole model was authorized and promoted by the sacred genealogies of the Gospels, which were rehearsed in chronicles and put Christ into the same sort of relationship as that described in the pedigrees of kings and noblemen.[66] A vivid sense of this exists in the crowded stemmata showing the lineage of Christ and the Holy Family that were produced in the fifteenth century (Fig. 5.3).[67] Conversely, the language of the Gospel

[61] London, College of Arms, MS PCM, I, pp. 56–7, 257, 411–12, 436–7; II, pp. 5–8, 33 (pedigrees cited in an early fifteenth-century trial in the Court of Chivalry). Nothing is recorded here of manuscript form, but 'lines of descent' are mentioned (PCM, I, pp. 411–12).
[62] *The Scroll Considerans (Magdalene MS 248) Giving the Descent from Adam to Henry VI*, trans. J. E. T. Brown, intro. G. L. Harriss (Oxford, 1999), p. 5.
[63] N. Saul, 'Bold as Brass: Secular Display in English Medieval Brasses', in P. Coss and M. Keen (eds), *Heraldry, Pageantry and Social Display in Medieval England* (Woodbridge, 2002), pp. 187–94; Denton, 'Genealogy and Gentility', *passim*; Fowler, *Rites of Durham*, p. 15. The brass of Sir Roger Le Strange (d. 1506) at Hunstanton is a Norfolk example.
[64] W. H. Monroe, '13th and Early 14th Century Illustrated Genealogical Manuscripts in Roll and Codex: Peter of Poitiers' *Compendium*, Universal Histories and Chronicles of the Kings of England' (PhD thesis, Courtauld Institute of Art, 1989), pp. 79–218, 403–510.
[65] R. A. B. Mynors, M. Winterbottom and R. M. Thomson (eds and trans), William of Malmesbury, *Gesta Regum Anglorum* (Oxford, 1998–99), I, p. 176.
[66] See e.g. H. R. Luard (ed.), *Flores Historiarum* (London, 1890), I, pp. 83–4.
[67] See e.g. K. L. Scott, 'The Genealogical Genre: BL Royal MS I.B.X', in Scott, *Tradition*

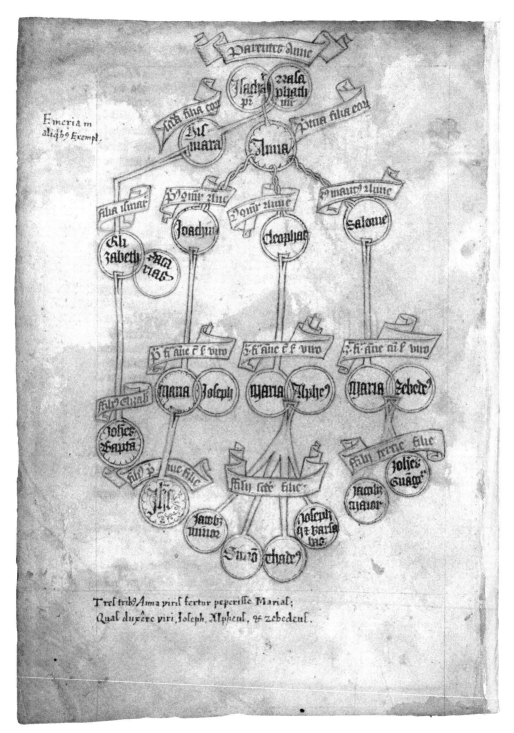

FIG. 5.3 BL, MS ROYAL 1.B.X, F. 1V: A GENEALOGICAL STEMMA OF THE MID-FIFTEENTH
CENTURY WHICH INCLUDES CHRIST.

genealogies was appropriated to dignify the pedigrees of particular, mundane individuals: an example local to Catfield is in a chronicle from St Benet of Holm (the abbey was one of Catfield's rectors), where links in King Alfred's lineage are given in the serial *qui fuit* form used in the third chapter of Luke.[68] These Gospel genealogies were read out in parish churches at matins on the feasts of the Nativity (Matthew) and Epiphany (Luke).[69] At Catfield, where they will have been included in the manual that a chaplain named William Steyngale gave to the church in 1482, the sixteen kings listed by Matthew were perhaps associated with the sixteen crowned figures beneath Christ on the dado of the screen.[70] The biblical pedigrees were of course associated with the prophecy of Isaiah chapter 11, whose arboreal metaphor was the basis of an entire iconographic tradition. The Tree of Jesse was read inversely, from bottom to top, but it resembled the arrangement of a rood screen in presenting Christ at the summit of a populated structure with lateral ramification. A parallel between the Tree of Jesse and the structuration of rood screens was recognized and occasionally realized in Norfolk. At East Rudham, the panels of the now-destroyed rood screen displayed a series of Christ's ancestors, while at East Harling, a surviving dado panel encapsulates the East Rudham ensemble by presenting a Jesse Tree with a Crucifixion at its centre (Fig. 5.4).[71] This enlightened synthesis was not new: it is also found in the early fourteenth century, in the Psalm 1 miniatures of some important English psalters, for example BL, Add. MS 49622, f. 8r (Gorleston Psalter); LPL, MS 233, f. 15r (Bardolf-Vaux Psalter); OBL, MS Barlow 22, f. 15r (Barlow Psalter). At Southwold (Suffolk) and Chudleigh (Devon), the presence of King David on the rood screen dados provides a fainter echo of the same concept.[72]

Whatever the common validity of this idea, its historical purchase – like that of practically all such ideas – can only have been occasional and circumstantial. People did not always understand rood screens in this way. My attempt to recover an aspect of the devotional valency of these screens will, I hope, be assessed with this in mind. Their manifestation of the descent of grace was perhaps most readily appreciated by those who sought permanent representation before them, as Nicholas Croydy did

and *Innovation in Later Medieval English Manuscripts* (London, 2007), pp. 87–117; Eton College, MS 213, f. 106v.

[68] H. Ellis (ed.), *Chronica Johannis de Oxenedes* (London, 1859), p. 3; compare Luard (ed.), *Flores Historiarum*, I, p. 444.

[69] F. Procter and C. Wordsworth (eds), *Brevarium ad usum insignis ecclesiae Sarum*, 3 vols (Cambridge, 1882–86), I [1882], cols clxxxvi–clxxxvii, cccxxviii–cccxxix; A. J. Collins (ed.), *Manuale ad vsum percelebris ecclesie Sarisburiensis* (Chichester, 1960), pp. 5, 7.

[70] NRO, NCC register Caston, f. 116r.

[71] Nichols, *Early Art*, p. 45; NRO, MS Rye 17, vol. 3, p. 157 (East Rudham).

[72] Baker, *English Panel Paintings*, p. 188; Bond and Camm, *Roodscreens*, 2, p. 260.

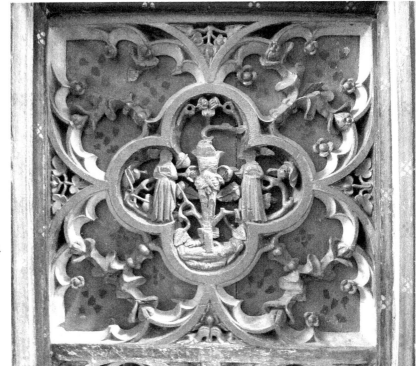

FIG. 5.4. EAST
HARLING
(NORFOLK): PANEL
FROM THE DADO
OF A FIFTEENTH-
CENTURY SCREEN
SHOWING A
TREE OF JESSE
CONTAINING A
CRUCIFIXION.

when requesting burial 'in ecclesia de Catfeld ante crucifixum'.[73] What I
can hope to have demonstrated, rather than suggested, is the interest of
the Catfield screen in and of itself, which embodies a contemporary but
acquired devotional taste and gains in terms of semantic complexity by
its association with sacred and profane genealogy, the image regimen of
great churches and the general prestige of kingship. It seems reasonable,
at least, to think that these aspects of the screen's iconography informed
and enriched medieval experience of it.[74]

73 NRO, NCC, register Wylbey, f. 95r.
74 I thank in particular Keith Bacon for access to All Saints Catfield, David King for
advice about the church's glass and Lucy Wrapson for discussing the screen on site and
lending me her PhD thesis.

WEST COUNTRY ROOD SCREENS: CONSTRUCTION AND PRACTICE

H. HARRISON AND J. WEST

Though not intended as a national corpus of late medieval and post-medieval screens, Frederick Bligh Bond and Dom Bede Camm's *Roodscreens and Roodlofts* has long been regarded as the standard work of reference on screens in Cornwall, Devon and Somerset. Since its publication in 1909, chancel screens – or the partitions associated with roods and rood lofts – have remained of interest to historians and ecclesiologists writing about the local church in late medieval England.[1] Not only has research extended Bond and Camm's topographical compass into Gloucestershire and Dorset, but it has also revealed new evidence for the settlement of immigrant craftsmen in Devon and Cornwall and reassessed their

[1] General histories of medieval screens remain those of F. Bond, *Screens and Galleries in English Churches* (London, 1908); F. B. Bond and Dom B. Camm, *Roodscreens and Roodlofts*, 2 vols (London, 1909) and, notably, A. Vallance, *English Church Screens: Being Great Roods, Screenwork and Rood-Lofts of Parish Churches in England and Wales* (London, 1936) and A. Vallance, *Greater English Screens: Being Great Roods, Screenwork and Rood-Lofts in Cathedral, Monastic and Collegiate Churches in England and Wales* (London, 1947). For the Reformation see E. Duffy, *The Stripping of the Altars: Traditional Religion in England c.1400–c.1580* (New Haven, 1992); C. Haigh, *English Reformations: Religion, Politics, and Society under the Tudors* (Oxford, 1993); P. Marshall, *Reformation England 1480–1642*, 2nd edn (London, 2012); R. Whiting, *The Reformation of the English Parish Church* (Cambridge, 2010) and E. Duffy, *Saints, Sacrilege and Sedition: Religion and Conflict in the Tudor Reformations* (London, 2012). For the progress of the Reformation in south-west England, see R. Whiting, 'Abominable Idols: Images and Image Breaking under Henry VIII', *Journal of Ecclesiastical History*, 33 (1982), pp. 30–47; R. Whiting, *The Blind Devotion of the People: Popular Religion and the English Reformation* (Cambridge, 1989) and K. L. French, *The People of the Parish: Community Life in a Late Medieval English Diocese* (Philadelphia, 2001).

contribution to the style and construction of screens in the South-West.[2] Seen through the lens of churchwardens' accounts, the commissioning of a screen with all its accoutrements was a considerable undertaking for which contracts typically identify the models to be followed, the obligations of craftsmen, and sometimes the quality and condition of the materials to be used.[3] Such commissions were also of importance to the local economy, as is apparent from related payments made to foresters, carpenters, carvers, blacksmiths, painters, gilders, braziers, locksmiths, needle-women and, on occasion, masons and alabastermen. While questions remain about process and workshop practice, churchwardens' accounts not only indicate the kinds of work and materials involved in making a screen, but they can also offer insights into the roles and activities of patrons and craftsmen, the acquisition and movement of materials, and the rates for skilled and unskilled labour, as well as the cost of board and lodging, and the hire of horses which were used by parishioners to visit forests for the buying of timber, to visit craftsmen to discuss commissions, or to visit churches that might provide models for the screens, lofts or images being actively considered.

Before discussing the structural carpentry of pre-Reformation screens in the West Country, it may be worth recalling Aymer Vallance's observation that '[t]he word "screen" itself cannot claim any antiquity ... and does not seem to have been introduced before the seventeenth century'.[4] Like the word 'screen', terms such as *perclose* or *interclose* in

2 For the distribution of screens in Dorset and Gloucestershire, see E. T. Long, 'The Church Screens of Dorset', *Proceedings of the Dorset Natural History and Archaeological Society*, 42 (1921), pp. 61–80 and N. Oakey, 'Fixtures or Fittings? Can Surviving Pre-Reformation Ecclesiastical Material Culture be Used as a Barometer of Contemporary Attitudes to the Reformation in England?', in D. Gaimster and R. Gilchrist (eds), *The Archaeology of Reformation* (Leeds, 2003), pp. 58–72. Although the presence of immigrant craftsmen in the South-West was noted by Bond, *Screens and Galleries*, p. 87, Bond and Camm, *Roodscreens*, pp. 89–92 and by Vallance, *English Church Screens*, p. 54, the documentary and archaeological evidence marshalled by J. Allan, 'Breton Woodworkers in the Immigrant Communities of South-west England, 1500–1550', *Post-Medieval Archaeology*, 48:2 (2014), pp. 320–56, sets a new datum for the subject.
3 Though 'green' or unseasoned timber was in general use, Salzman suggested that the desirability of seasoned wood was recognized: a factor that may lie behind indenture requirements for the use of 'hable [fit, suitable] oke without sappe, rifte, wyndshakk or other deformatiff hurtefull'; 'good Substancyall and hable waynescote'; 'seiasoned tymber', or 'hart of oke', for which see the Appendix 'Quality and condition of wood' and 'Wainscot', as well as L. F. Salzman, *Building in England Down to 1540: A Documentary History* (Oxford, 1952), p. 239. On the drying of timber, see also J. Dawes, 'Timberwork and Construction', in A. Baker, *English Panel Paintings 1400–1558: A Survey of Figure Paintings on East Anglian Rood Screens*, ed. and updated A. Ballantyne and P. Plummer (London, 2011), p. 100.
4 The term 'West Country' here refers to the counties of Cornwall, Devon, Dorset, Gloucestershire, Somerset and Wiltshire, which, before the nineteenth century, were almost coterminous with the dioceses of Exeter, Bath and Wells, Gloucester (from 1541, administered with Worcester 1552–54), Bristol (from 1542, including the city of Bristol and the county of Dorset), and that part of the diocese of Salisbury that is in Wiltshire. On the late medieval use of 'screen' see Vallance, *English Church Screens*, p. 31 and W. J. Pressey,

use in the fifteenth and sixteenth centuries convey the idea of a 'closynge betwyxte the chyrche and the chawnsell', and this was a requirement of the Order issued by Elizabeth I in 1561 which stated that there should be 'a comely partition between the chancel and the church' and required that 'where no partition is standing, there is to be one appointed'.[5] Even so, given the visibility of screens at ground level, it is perhaps surprising that so little if anything is said in contemporary documents about their design, however 'utilitarian' their function. Parishes appear to have relied on the models named in indentures as the agreed brief for what was to be made, and the indenture of 1531 for a new rood loft at Stratton (Cornwall) may be typical in saying nothing about the form of the *interclosys*, although it is clear about their position and extent, and likewise clear about the unusual method of payment by the linear foot.[6] In the absence of drawings or other written specification, when compared with the detail supplied for the screen to be built at All Saints Bristol under the wills of Henry and Alice Chester of c.1480, the parishioners at Stratton appear to have been content that the screen they had commissioned would resemble those seen and vouched for by fellow parishioners as providing suitable models for the new work.[7]

The First Book of the Churchwardens' Accounts of Heybridge, Essex, c.1509–1532, Heybridge (Heybridge, 1938), p. 31. Pressey makes reference to 'the carryng of the skreene' at Heybridge (Essex) in 1525. Though like the scrinei at Ashburton (Somerset), which had its floor/base-boards (planchying) replaced in 1521–22, the context of the Heybridge reference points to a portable object such as a shrine (scrinium) or chest and the same might conceivably be true of the 'scrinio' at Tintinhull (Somerset) for which a key was bought in 1466–67, for which see Appendix 'Screen': A67–8 1521–22; T191 1466–67.

[5] For text references see Appendix 'Screen': C65 1520; S92 1531; Y114 of 1482. While Vallance's emphatic statement that Bishop John Hooper's injunctions of 1551–52 corroborated his view that the function of screens was 'primarily utilitarian', the bishop's wish to see the removal of 'separations between the ministers and the people' betrays a perception of screens as a boundary; in which role Richard Hooker (c.1554–1600) averred that there should be only one partition 'between the clergy and the rest' (Bond and Camm, *Roodscreens*, p. 117; Vallance, *English Church Screens*). For the view that screens were both a 'barrier and no barrier' see Duffy, *The Stripping of the Altars*, pp. 111–12; Whiting, *Reformation*, pp. 3–5. For Bishop Hooper's injunctions for the dioceses of Gloucester and Worcester, see Vallance, *English Church Screens*, p. 32; W. H. Frere (ed.), *Visitation Articles and Injunctions of the Period of the Reformation*, 3 vols (London, 1910), vol. 2, pp. 284–5 (item 16)); for the Order appertaining to lofts and screens issued by Elizabeth I in 1561, see Bond and Camm, *Roodscreens*, p. 105; Frere (ed.), *Visitation Articles*, vol. 3, pp. 108–10.

[6] Bond, *Screens and Galleries*, pp. 40–1; for the position and extent of the screens see Appendix 'Screen': S92, 1531; for the method of payment, which Bond thought 'very curious', see Appendix 'Screen': S94, 1531; for the full text of the indenture, see R. Goulding, *Records of the Charity Known as Blanchminster's Charity in the Parish of Stratton, County of Cornwall until the Year 1832* (Stratton and Bude, 1890).

[7] For All Saints Bristol, see C. Burgess (ed.), *The Pre-Reformation Records of All Saints' Bristol*, Bristol Record Society, 16 (1995), pp. 15–17; E. Duffy, 'Late Medieval Religion' in R. Marks and P. Williamson (eds), *Gothic Art for England 1400–1547* (London, 2003), pp. 56–7. For parishioners' expenses, see Appendix 'Models': Y86 1447–48; Appendix 'Images': P71 1521. The suggestion (French, *The People of the Parish*, p. 158) that a payment for the purchase of 'paper to draw the draft of ye rode-lofte' at Banwell (Somerset) shows

As in other parts of England, roods and rood lofts in West Country churches did not long survive the Edwardian phase of the Reformation and, as elsewhere, the Order of 1561 ensured that their subsequent loss was virtually complete. But for a complete section of the north rood loft at Atherington (Devon) of c.1500, and the remains of the east side of the loft at Marwood (Devon) of c.1520, there would be little to indicate the richness of what has been lost.[8] The story of roods is bleaker still, although in addition to the unique fifteenth-century 'Golgotha' at Cullompton (Devon) the recent discovery of a fifteenth-century (?) cross-arm at St Winfrid, Branscomb is of considerable interest and deserving of detailed study and publication.[9]

With the exception of stone screens and parclose screens built in wood – which are not discussed in the following pages – Bond and Camm suggested that a majority of the surviving vaulted screens in West Country churches were built between c.1470 and c.1520.[10] While a proportion of this group stems from the furnishing needs of new churches and church extensions built in the South-West during the fifteenth and sixteenth centuries, it must be assumed that post-Reformation rebuilding and the reordering of church interiors in the eighteenth and nineteenth centuries, will have adversely affected the survival of what survived the Reformation.[11] The Reformation was not the only agent of change, however, and though the reasons for replacing a screen are seldom documented, wills and churchwardens' accounts reveal that screens, lofts and roods were replaced even before the Reformation quickened. At Banwell (Somerset),

parishioners drafting their own plans for a new loft is questionable both on grounds of ability and in relation to another payment made in the same year for 'the making of the Endentur and the oblygacyon for the Kervar' – for which the paper was surely bought

[8] Bond and Camm, *Roodscreens*, p. 92 and Pls LXXV a and b.

[9] Vallance, *English Church Screens*, p. 12. Hanham suggested that the payment 'for the caryage of the rock of the rode and the crosse' in 1555–56 might refer to a 'Golgotha' base similar to that at Cullompton (A. Hanham (ed.), *Churchwardens' Accounts of Ashburton 1479–1580*, Devon and Cornwall Record Society, new series, 15 (Exeter, 1970), pp. 134 and 208). In addition to the Durham cross-arm discovered in 1905–6, the tally of British Rood group images comprises the corpora from Cartmel Fell (Cumbria), South Cerney (Gloucestershire), Kemeys Inferior (Monmouthshire) and Mochdre (Montgomeryshire), and a solitary figure of the Virgin at Mochdre, for which see Vallance, *English Church Screens*, p. 12 and Figs 1–9; M. Redknap, 'The Medieval Wooden Crucifix Figure from Kemeys Inferior and its Church', with a contribution by P. Hill, *The Monmouthshire Antiquary*, 16 (2000), pp. 11–43; R. Marks and and P. Williamson (eds), *Gothic: Art for England, 1400–1540* (exhib. cat., London, 2003), cat. no. 268.

[10] Based on Bond and Camm, *Roodscreens*, p. 277, who dated the main building period of vaulted Devon screens to between 1420 and 1540.

[11] For church building in Devon in the sixteenth century, see H. M. Colvin, 'Church Building in Devon in the Sixteenth Century', in *Essays in Architectural History* (New Haven and London, 1999), pp. 22–51. Though Bond and Camm acknowledged the losses caused by the Puritans, their criticism of the 'ignorant prejudice' and '[horribly rampant] vandalism' of the nineteenth century leaves no doubt that they held the nineteenth century responsible for the destruction of large numbers of late medieval screens as listed in their Appendix E (Bond and Camm, *Roodscreens*, pp. 64, 120, 284–5, 377–8).

for example, the old screen was taken down in 1522. Three years later its replacement was being gilded, and six years after that, in 1531, the old 'Rode' was sold 'for the value of 65 bushels of wheat'.[12] A more 'piecemeal' approach to replacement or refurbishment seems to have been taken at Tintinhull (Somerset) where, in 1451–52, the stone-breasting of the old screen was retained while the upper parts of the screen were replaced. Though the design of the original screen is not recorded, a receipt noted in the churchwardens' accounts for 1451–52 records the sale of 'two pieces of oak called *liernes* [ribs] from the old rood loft'.[13] While this shows that the upper parts or the screen and loft were made of wood rather than stone, the reference to *liernes* suggests that the original screen was also vaulted, although when it was built is not known.

Bond and Camm, who considered the West Country to be particularly rich in vaulted screens, dated the introduction of vaults to about 1420, based on the date which they had ascribed to their earliest examples at Halberton, Pilton and Uffculme.[14] Aymer Vallance, who placed the advent of vaulting after the middle of the fifteenth century, linked the development to that of the rood loft, and observed that those screens built before the introduction of rood lofts were adapted to carry them by the addition of coving, which is to say, by the addition of 'curved panelling' to mask the junction of the screen and loft.[15] If the use of coving should be seen as reflecting a transition between early 'wall-screens' and the vaulted screens with lofts of the fifteenth and sixteenth centuries, a key element of that transition was the move away from rectangular-headed screens to an integrated sequence of arched 'window' openings and vault compartments that flowed seamlessly upward towards the loft. In the

[12] Bond and Camm, *Roodscreens*, p. 147. Clear evidence for Katherine French's assertion (French, *The People of the Parish*, pp. 158, 267, note 74) that the carver built the Banwell screen in his workshop, disassembled it and then moved it to the church for installation, would be of considerable interest in terms of workshop practice
[13] 'pro ij lignis quercinis vocatis liernes de veteri rodelofte'. See Appendix 'Sale of old screen timber': T184 1451–52. The Tintinhull screen was recently discussed by Audrey Baker who argued for a single programme of work extending over fifty years, in preference to the piecemeal and episodic approach to repair and maintenance suggested here. The end date of 1494–95 for the completion of the screen is inferred from a series of undated account entries between 1484 and 1496, during which time no payment appears to have been made for the addition of vaulting to which Baker refers: A. Baker, *English Panel Paintings 1400–1558: A Survey of Figure Paintings on East Anglian Rood Screens*, ed. and updated A. Ballantyne and P. Plummer (London, 2011), p. 93.
[14] Bond and Camm, *Roodscreens*, pp. 277, 315, 340, 356–8 and Pl. LXXXIXb, where in the caption the vault is described as a 'lantern' type, of which Halberton and Uffculme were the only examples. Recent inspection of the screen revealed that the backs of the ribs in each case are rebated to receive panel-infills.
[15] Vallance, *English Church Screens*, pp. 44–5. For the use of coving for canopies over altars see Lapford (Devon) and Swymbridge (Devon) (Bond, *Screens and Galleries*, Fig. 61), and image niches, see Combe Martin (Devon), and Plymtree (Devon) (Bond and Camm, *Roodscreens*, p. 342, Pl. CXI) and Vallance, *English Church Screens*, p. 39. For references to altars associated with screens, see Appendix 'Altars': B16 c.1480 and S92 1531.

absence of a framework of securely dated examples, a working hypothesis might be to accept that in the West Country during the first half of the fifteenth century all three 'types' of screen were concurrent, as might be illustrated by the early fifteenth-century wall-screen at Alford (Somerset), the mid-fifteenth-century coved screens at Raddington (Somerset) and Willand (Devon), and the vaulted screens of the mid-fifteenth century at Halberton (Devon) and Pilton (Devon).[16] If, as Vallance suggested, wall-screens were on occasion adapted to take lofts, the catalyst for the development was to have a loft of sufficient depth to provide for its functions.[17]

Unlike East Anglian screens, where vaulting is generally shallow, West Country screens are characterized by comparatively deep vaults on both east and west faces which support – or appear to support – a loft of some 6ft (1.84m) in depth and, as at Atherington (Devon), of a similar height. Though the bressummer beam could also be braced by attachment to the building, in churches such as Cullompton (Devon), Kentisbeare (Devon) (Pl. XIX) or Wolborough (Devon), where the screen extends across the full width of the interior, for much if not all of its length the loft is supported only by the screen which is no more than one-eighth of the width of the loft above it. With the construction of the loft hidden by the vaulting, the massive loft rises from between the arcaded lights to effect a fluent and graceful transition from vertical to the horizontal cornice at the junction of the screen and loft. How this was achieved takes us beyond the written record to the material evidence of the screens themselves, and the remainder of this chapter will draw on observations made during the course of conservation, reinstatement or repair.

WEST COUNTRY ROOD SCREENS: CONSTRUCTION AND PRACTICE

When seen from the viewpoint of their construction, screens arguably have less to do with aesthetic effects than with the methods and materials required to build a stable, load-bearing structure that fulfils the functions for which it was designed. In its immediate context, the screen occupies the lowest tier of a vertically layered composition in which the timber frame of the screen stands on the ground with little formal foundation beneath the sill, and the loft, rood and ceilure rise above it (Pl. XX). From the point of view of aesthetics the screen, with its panelled dado and

[16] For Alford, Raddington, Willand, Pilton and Halberton see Bond and Camm, *Roodscreens*, pp. 143, 187–8 and Fig. 99, 361, Pl. LXXX, 340 and Fig. 110, 315 and Pl. LXXXVIIa. Bond and Camm's suggestion that the Alford screen may have originated elsewhere is invalidated by the treatment of the outer bays, which have clearly been made to fit the existing opening.

[17] On the function of rood lofts, see Vallance, *English Church Screens*, pp. 68–72.

tracery, was part of an ensemble that was fully carved and ornamented, coloured and gilded, and provided with image niches and ornamented tabernacles, painted figures and 'histories', Rood groups and images of saints, all of which were illuminated by a complement of lights, and were the focus of devotional attention and functional activity. Whether discussing a continuous three-aisle screen such as that at Cullompton (Devon) or a modest but beautifully proportioned chancel screen such as that at High Ham (Somerset), the function remains the same even if structural niceties appear to differ.

One aspect of that difference lies in the architectural context of screens and, in particular, how they relate to the fabric of the buildings in which they stand. While screens in Somerset are generally taller than those in Devon and Cornwall, their height is further emphasized by positioning the screen within the chancel arch or between the nave arcades, while in Devon it is the width that is emphasized by the horizontal extent of the cornice (Pl. XXI), and by the uninterrupted extension of the screen across the aisles with little apparent regard to its position in relation to the arcades. At Halberton (Devon) the screen aligns with the centre of the arcade arches; at Chagford (Devon), Dunchideock (Devon) and Uffculme (Devon) it stands slightly forward of the arcade piers; and at Alphington (Devon) and Combe Martin (Devon) it runs between the nave piers. As a consequence and unless lofts could win additional support from the north and south church walls at each end, in Devon the screen was the only means of support. For Devon carpenters, while alignment of the screen with the arcade piers offered some benefit in terms of stability, it had disadvantages in terms of access from aisle to aisle along the length of the loft, as was recognized at Stratton (Cornwall), where the builders were required to level up the nave and aisle and to 'devys and make a waye and a going by or under the Archys of the pylers'.[18] Halberton (considered by Bond and Camm to be an early screen) solved this problem by positioning the screen in the middle of the nave arcade arches (Pl. XXII): a few other Devon churches solved it by making a hole in the arcade wall, such as at Payhembury (Devon).

Once the position of a screen within the church had been decided – and a position between the first set of nave piers was normal – the dimensions of the screen were determined initially by the building. Rather than a set of standard measurements, it seems that subdivision into bays of equal width was determined so long as the number of bays allowed for a centre bay for the doors (or gates as formally termed) to provide access between nave and chancel. The same principle of subdivision in the aisles followed that in the nave, though the narrower aisles normally allowed for only

[18] For Stratton, see Appendix 'Access': S93, 1531. For a discussion of access to rood lofts, and notably the introduction of rood stairs, see Vallance, *English Church Screens*, pp. 66–75; see also Bond, *Screens and Galleries*, p. 115.

three bays with the doors in the centre. Where the aisles are very narrow there may only be room for two bays, in which case the doors are found in the inside bay. The width of bay can vary considerably between the aisle and nave. Although a preference for bays of equal width has the ring of aesthetic priority, it is no less obviously a constructional consideration in that the main posts would be more evenly spaced along the screen-head for the distribution of load.

A primary example of the regional differences between West Country screens is apparent in the way in which doors are incorporated into the overall design.[19] Rather than increase the apparent thickness of the main posts by hanging the doors directly on them, in Devon and Cornwall the posts are rebated to accommodate the doors, which are moulded to replicate the profile of the main posts with the result that the doors blend into the screen and the absolute regularity of the bay design is preserved. In Somerset and Wiltshire, however, the converse is true. Rather than being disguised, the doors are almost advertised by their decoration and the use of a carved door-head.

This design feature created a problem for the construction of rood screen doors, for in order to maintain the standard post widths, and dado and sill rail heights, the arched hanging stiles and meeting stiles had to be very thin. While the height of the dado rail was preserved, the height of the bottom rail was reduced substantially. Adding to the weakness of an arched door where the joint at the springing line of the hanging stile is always a weak joint, none of the rails is tall enough to have wide tenons to prevent the door racking, so many (perhaps all) have dropped. The time-honoured cure was to plane off the bottom edge, which merely reduces the joint height of the bottom rail to the meeting stile. In at least one instance, at Wolborough (Devon), the rood screen doors have been made using grown durns, that is, an arched hanging stile made from a naturally grown timber (Pl. XXIII). This seems to show that the carpenters recognized the weak construction of the doors and made efforts to counteract this when they could.

In rare instances the centre doors are additionally decorated in the dado with tabernacle work as can be seen at Kenton (Devon) (Pl. XXIV). Also at Kenton, as well as North Bovey and Manaton (all in Devon), the jambs and archivolts of the doorways are all decorated with tabernacled niches containing figures (Pl. XXV). In very rare instances in Devon screens the dado panels are decorated with carved figures rather than painting such as at Bridford (Devon) (see Wrapson and Sinclair, below, Pl. XLVI), but in Somerset screens all dado panels are decorated with carved canopies (Pl.

[19] Vallance convincingly refuted Francis Howard's statement about doors not being a necessary element of screen design, and with it denied a perceived difference between screens in the West Country – where doors are invariable – and East Anglia – where doors are the exception (Vallance, *English Church Screens*, pp. 33–4).

XXVI). In Cornwall, the dado is decorated with a wild array of patterns and figures and foliage (Pl. XXVII).

The difficulty that Devon and Cornwall carpenters had created for themselves was how to develop a vault out of the main posts of the screen without disrupting the upward flow of the mouldings from the posts into the vaulting ribs. Their solution was to cut back the posts (Pls XXVIII and XXIX) at the springing point of the vault to form a ledge on which to rest the vault ribs, thereby producing a visually fluent line from the uprights into the vault. The effect of the resulting reduction in thickness might not have been of any consequence were it not for the fact that the posts support the screen's head-beam on which rest the loft's massive floor joists jointed into the beam above each post and in the centre of each bay (Pl. XXX). Furthermore, at each end of the floor joists is a bressummer beam on which were built the gallery fronts and backs. And, if the Cullompton screen was typical, on the west side of the loft – resting on the bressummer – was a candlebeam of substantial dimension (Fig. 6.1). Finally, and of some weight overall, were the oak boards of the rood loft floor. The total weight supported by the screen posts was therefore considerable, and in

FIG. 6.1. CULLOMPTON (DEVON). THE DEEP CANDLEBEAM WITH HOLES FOR THE CANDLES IN THE TOP EDGE, SITTING ON THE BRESSUMMER BEAM WHICH HAS MORTICES FOR THE GALLERY FRONT.

addition to removing wood from the entire perimeter of the posts for the springing of the vault ribs, in some screens slots were also cut through the posts from side to side and down to the springing line to house the rectangular main arcade tracery panels (Fig. 6.2). This seemingly illogical construction results in the retention of only two sections of the post core which are continuous from top to bottom and measure approximately 60mm x 50mm in cross-section. The alternative, which seems more logical, involves inserting arch braces from the springing line of the posts to the centre line of the head-beam in each bay. These braces are then carved to form the outside ribs of the fan vault, and they are also grooved to contain the arched tracery head of the main arcade. However, similar to the technique of cutting slots in the sides of the posts, the mortices required for the arch braces also removed considerable mass from the posts just in the area where they are most diminished (Fig. 6.3). Though

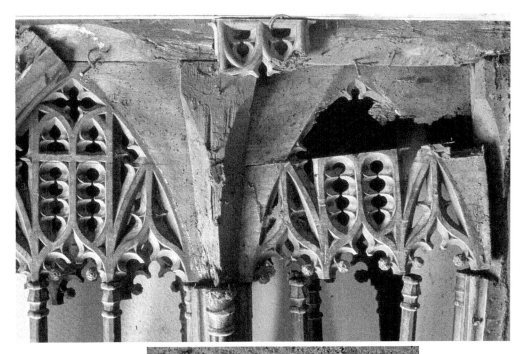

FIG. 6.2. NORTH
HUISH (DEVON).
AN EXAMPLE OF
A SCREEN WITH
RECTANGULAR
MAIN ARCADE
TRACERY PANELS
WHICH FIT
IN SLOTS CUT
THROUGH THE
MAIN POSTS.
THIS PHOTO
SHOWS THE
SCREEN BEFORE
CONSERVATION.

FIG. 6.3. HENNOCK
(DEVON). A
SCREEN WITH
ARCHED MAIN
ARCADE TRACERY
PANELS AND ARCH
BRACES MORTICED
INTO THE SIDES OF
THE MAIN POSTS
AND INTO THE
UNDERSIDE OF
THE HEAD-BEAM.

the rectangular tracery panel might be a slightly later development, not enough screens have been recorded to justify this suggestion, nor is there sufficient evidence on which to determine whether the different techniques for mounting the main arcade tracery panels are regional.

A refined solution to the problem of how to attach the vaulting ribs to the posts was achieved at Halberton (Devon) and Uffculme (Devon) where a *tas-de-charge* was let into the front faces of the posts to provide an improved bearing for the ribs (Fig. 6.4). As in stonework, the aesthetic advantage of the *tas-de-charge* was that it maintained the form and line of the ribs to their point of convergence at the springing line without reducing the actual dimension of the individual ribs to achieve it. Whatever its merits, unfortunately the *tas-de-charge* was not generally adopted.

Where the rectangular tracery panels were used the ribs at the vault edges were nailed to the face of the tracery panels, neatly following the line of the carved tracery to establish a moulded frame for the tracery and a neat abutment of screen and vault at the vault edges. The remaining vaulting ribs could then be nailed to the springing point of the vault on the posts and either to the bottom edge of the bressummer or to the lierne ribs. From limited experience of actually having dismantled certain vaults for repair, it was found that the vault ribs are jointed to the bressummer beam and lierne ribs with simple halving joints or mortise and tenon joints (Fig 6.5). Though the resultant vault panels between the ribs varied in size and shape, deep rebates were cut in the backs of the vaulting ribs to form housings into which bespoke panels of comparable depth were fitted to provide vault webbing at an even plane behind the ribs.

Given the weight and potential instability of a wide loft on top of a narrow screen, it must be asked whether the vault was intended to provide structural support, or whether it was merely an elegant solution to the task of concealing the junction between loft and screen. Whatever the perceived intention, the function of the vault cannot be discussed without reference to the main support for the loft in the shape of substantial joists that are spaced on the head-beam so as to provide a joist over each post and another over the junction of each section of the vault along its length. A housing cut in the lower edge of each joist extends down the sides of the head-beam to nearly its full depth, forming a 'T'-shaped post at

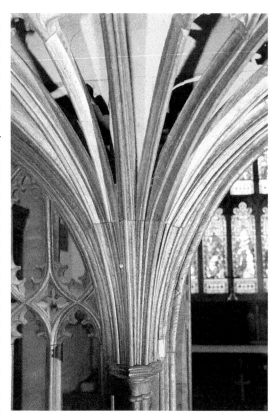

FIG. 6.4.
HALBERTON
(DEVON). A DEEP
TAS-DE-CHARGE
EMPLOYED IN
THE VAULTING.

FIG. 6.5. UFFCULME
(DEVON). THE
VAULT RIB LOOSELY
TENONED INTO
JUNCTION OF THE
TRANSVERSE RIB
AND LIERNE RIB.
NOTE THE DEEP
REBATE IN THE
TOP EDGE OF THE
VAULT RIB TO
TAKE THE VAULT
PANEL. NOTE ALSO
THE CARPENTER'S
NUMBER. THE
RECESSES IN THE
OTHER RIBS ARE
UNEXPLAINED.

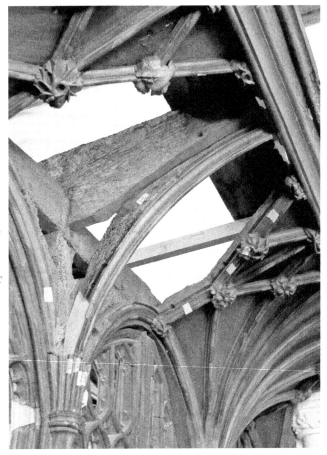

FIG. 6.6. UFFCULME
(DEVON). THE
DECAYED VAULT
PARTIALLY REBUILT
SHOWING THE
TAS-DE-CHARGE IN
POSITION, ALSO
THE TRANSVERSE
VAULTING RIB.
NOTE THE ROOD
LOFT FLOOR DEEP
JOIST CLASPED
OVER THE HEAD-
BEAM.

each bay division and a further joist is fitted in the centre of each bay, whose purpose it was to ensure that the loft remained horizontal. The lower edges of the joists are angled upward towards their ends in line with the vault and are tenoned into the bressummer beams on each side. So certain were the joiners of the rigidity achieved by clasping the head-beam in the underside of the joists, that typically these joints were not further strengthened by the addition of oak pins (Fig 6.6).

It must be assumed that the vault ribs provide some support to the bressummer beams even though at the springing they are tapered to almost nothing, and their joints with the bressummer beam are not reliable in tension as the mortise and tenon joints are not secured with pins. In this context the vault panels themselves which are of some thickness and, therefore, potentially strong, also contributed to the cumulative support to the bressummer beams as in compression the elements of the vault bind together to resist considerable load. Though not fully explored, inspection of the rood screen vault at High Ham (Somerset) seemed to show a different and more positive support for the bressummer beams using deep arch braces in addition to the joists that are tenoned into the front and back of the posts at springing height, and into the back of both bressummer beams. Until there is opportunity to investigate Somerset screen vaults in detail, nothing more can be said with certainty about their construction.

A further reflection of the development of the vault is illustrated by Halberton (Devon) where construction differs on either side of the screen (Fig. 6.7). Bond and Camm point to the lack of vault panels as an original feature, but the fact that the surviving spandrel panels are solid must point to there having been vault panels throughout. On the west side comparatively thin ribs make provision for vaulting panels that are thick and heavy, in contrast to the east side, and the use of thicker ribs, but thin panels. Whereas the combination of smaller ribs and thicker panels on the west side is enough to withstand compressive forces, on the east side the central rib takes the form and dimension of an arch-brace and is held in position by mortise and tenon joints which together contain compressive forces without the assistance of the thicker vault panels.

With the pulling down of lofts in the mid- and later sixteenth century many screens lost their vaults, though spandrel panels and odd lengths of running ornament from cornices were often nailed over the triangular spaces on the main screen frame left bare by the removal of the vault, of which Bridford, North Bovey and Sherford (all in Devon) are characteristic examples.

The ubiquitous vine-trail (running ornament) found on nearly every West Country screen was produced on the basis of relatively few themes and almost endless variations of detail. Each length of carving differed from the one above it and the one below, and likewise from screen to screen, notwithstanding general similarities of theme or design. While the study of the ornament suggests itself as a likely means of identifying individual

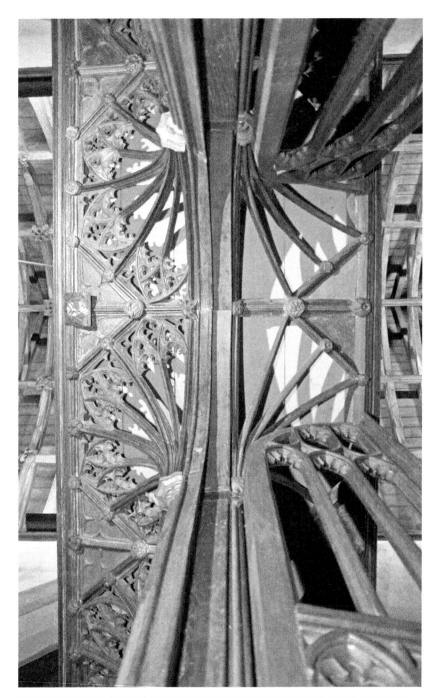

FIG. 6.7. HALBERTON (DEVON). THE DIFFERENT WEIGHT VAULT STRUCTURE CAN BE SEEN ON BOTH SIDES OF THE SCREEN. NOTE THE DECORATED WEST VAULT AND PLAIN EAST VAULT.

craftsmen, it is not known whether patterns were dictated by the master carver, or whether different carvers produced their own particular patterns. The effect is one of considerable richness of ornament, enhanced by lengths of carving of convex section which were nailed over concave channels cut in the front of the bressummer. While the use of piercing and undercutting gave depth and vitality to the form and complexity of the leaves and tendrils, the whole effect was further enhanced by the interplay of light and deep shadow created between the carving and its concave background. This type of cornice ornament demonstrates more clearly than any other aspect of the carving a decline from the earlier screens to the latest. Thus the ornament found on Pilton (Devon) screen near Barnstaple (which is early) is bold, full of character and far less repetitive, and produces an ornament of considerable quality and importance (Pl. XXXI). At Lapford (Devon) or Carhampton (Somerset) the carving dazzles by the intricacy and extent of the work, and although the effect is rich, it cannot stand detailed scrutiny. Though foliate ornament is ubiquitous, a few examples survive of narrative carving, fabulous beasts, and genre scenes of farming, working and riding to hounds, as can be seen on at least two screens: at Norton Fitzwarren (Somerset) (Pl. XXXII) and St Buryan (Cornwall).

In common with other examples of timber-framed construction, mortise and tenon joints and mason's mitres are the mainstay of West Country screens. The only location where mouldings on both elements of the joint intersect is the junction of the transom rail with the post. In probably most West Country screens this joint is a standard mason's mitre, although variant forms of mitres including rebated mason's mitres and combination mason's mitre and scribed joints are found (Fig. 6.8). Fully scribed joints were also employed. The scribed mason's mitre is prevalent in Wiltshire, and there are examples of the rebated mason's mitre at Sherford (Devon) and the fully scribed joint at West Worlington (Devon). All of the variants and scribed joints have one aim, which is to reduce the impact of the joint of the rail in line with the edge of the post and bring it closer to the inside edge of the intersecting moulds where the joint would be on a true mitre. This location of the joint was realized automatically in the scribed joint. In the present state of research it is not known whether the development of variants was triggered by economy or aesthetics, or whether the use of particular joints can be regarded as indicators of date. What can be said is that notwithstanding the concealing layers of polychromy, nothing disguises the joint which inevitably develops where the posts shrink away from the dado rails when the joint is a mason's mitre. This vertical line at each end of the rail visually shortens it from its design length measured from mitre to mitre, to its actual length measured from the post to post. The difference is significant in so far as it alters the apparent proportions of the screen. Consequently, the development of modified joints seems to be predicated on a need to establish the visual proportions of the screen in relation to the true length of the dado rail and recognizing that the scribed joint carries

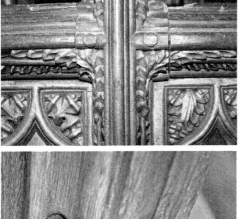

FROM LEFT TO RIGHT UPPER A), B), C)
D) BELOW

FIG. 6.8. COMPOSITE SHOWING JOINT TYPES: A) HOLNE (DEVON). A TYPICAL MASON'S MITRE JOINT WITH THE
RAIL SHOULDERS ON THE LINE OF THE EDGE OF THE POST. B) HIGH HAM (SOMERSET). A COMBINATION MASON'S
MITRE AND SCRIBE JOINT WHERE THE BEAD AT THE WIDEST POINT OF THE DADO RAIL MOULD INTERSECTS
WITH THE BEAD ON THE POST. IT IS NOT A TRUE SCRIBE AS THE POST MOULD IS NOT CUT IN REVERSE ON THE
SHOULDERS OF THE RAIL. THIS TYPE OF JOINT IS COMMONLY FOUND ON EAST SOMERSET SCREENS AND THOSE
IN WILTSHIRE. C) SHERFORD (DEVON). A MASON'S MITRE WITH THE SHOULDER LENGTHENED TO INTERSECT
WITH THE BEAD MOULD AT THE EDGE OF THE CARVED ORNAMENT. D) WEST WORLINGTON (DEVON). A TRUE
SCRIBE JOINT WITH THE POST MOULD CUT IN REVERSE ON THE SHOULDERS OF THE RAIL.

the line of the dado rail through to the full extent of the mitre.[20] Although
the scribed joint happens also to be easier and quicker to make, their
development had already taken place in France.[21]

[20] Some years ago I pointed these various joints out to Tim Howson then preparing
his dissertation on Suffolk rood screens, and he applied the variation to over forty
dated screens and found that in Suffolk the first scribed joint can be seen on Thornham
(Norfolk) screen (1488) and the last mason's mitre on Yelverton (Norfolk) screen (1505).
As he pointed out, this gives an indication of date. On this basis it seems that the change
from one joint to another was aesthetic. The best scribed joint in the West Country is
at West Worlington, which has Breton features. The lack of securely datable screens in
the West Country represents a difficulty in developing a similar dating framework. In
this connection it is worth noting that sophisticated scribed joints were already in use in
Rouen choir stalls in the 1470s. For more on dating East Anglian screens from joints, see
Wrapson in this volume, above.
[21] C. Tracy and H. Harrison, *The Choir Stalls of Amiens Cathedral* (Reading, 2004), p. 140.

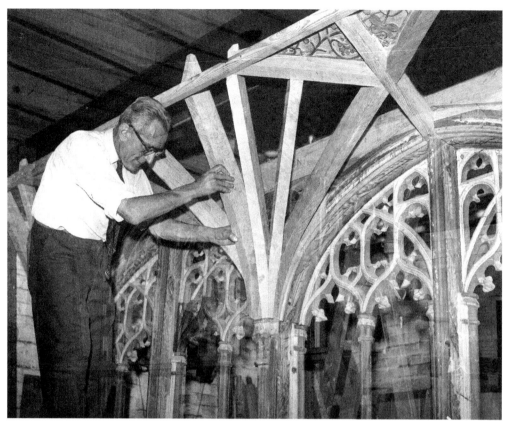

FIG. 6.9.
DITTISHAM
(DEVON).
JACK PALMER,
FOREMAN OF
ST SIDWELL'S
ART WORKS
(WHICH BECAME
HERBERT READ
LTD) FITTING A
TEMPORARILY
CURVED VAULT
RIB.

AFTERWORD

Photographs that came into my possession after taking over the company of St Sidwell's Artworks in 1972 record the building of a new vault to the rood screen at Dittisham (Devon) in the mid-1950s. Figure 6.9 shows the foreman joiner, Jack Palmer, fitting a rib which is roughly shaped and unmoulded. Note that the old screen is erected in the workshop and the projection of the bressummer has been decided and marked by the temporary fitting of a batten. This allows the transverse ribs to be cut to length, and the survival of the vault spandrel panels shows where the lierne ribs are located and their angle and joint with the bressummer beam. The reason surviving vault spandrel panels are so important when recreating a lost vault is that they have considerable influence on the projection of the vault and, thus, on its actual design. The east/west length of the spandrel panel determines the position of the intersection of the first rib and the transverse rib and, as the angle between the ribs in a fan vault should be equal, this dimension also determines the spacing of all the ribs. The only way this can be changed is by varying either the projection of the vault as a whole, or by varying its geometry. The bigger

the spandrel panels, the wider the vault has to be to accommodate them so that the angle of the first rib to the screen and first rib to second rib are all the same.

The sweep on the ribs when first fitted is approximate so that, as shown in the photograph, the vault can be set up with the ribs correctly positioned, but only roughly shaped in their curvature. Jack Palmer told me that it was at this stage that the master carpenter – in this case, Dick Read – would critically assess the sweep of the ribs and ask for the sweep to be adjusted to ensure the fluid sweep of the vault. When this was done, the ribs can be rebated to take the vault panels that are carved from the solid to match the sweeps of the ribs. The last work could then be carried out, which was to mould the ribs.

APPENDIX: REFERENCES RELATING TO THE MANUFACTURE OF ENGLISH SCREENS

Churchwardens' Accounts are grouped by subject and the entries listed alphabetically by place as abbreviated [A = Ashburton (Devon); B = Bristol, All Saints; C = Cambridge, St Mary (indenture); C [F] = Cambridge [Foster]; Hy = Heybridge (Essex); M = Mere (Wiltshire); N = Nettlecombe (Somerset); NP = North Petherwin (Somerset); P = Pilton (Somerset); S = Stratton; T = Tintinhull (Somerset); Te = Tempsford (Bedfordshire); Tr = Trull (Somerset); Tv = Tavistock (Devon); Y = Yatton (Somerset)]; followed by the page number of the edition used, then the page or folio number of the original (when available), and finally the date of the Account entry. References to unpublished accounts are indicated in the text and included in the Bibliography.

MATERIALS: WOOD
Felling (associated with the commissioning of a rood loft)

NP, 3	parishoners ride to Hatherleigh to buy timber (Whiting 1989, 52)
Y86, p. 11, 1447–48	to Crosse and J. Hylman here [their] costys rydyng to Selwudde (Selwood forest) … 8d
Y86, p. 11, 1447–48	to John … vor vyllyng [felling] anoke … 1d
Y88, p. 16, 1447–48	vor anoke ybow3t of J. Hykks and the vyllyng of the same … 13d
Y88, p. 16, 1447–48	(four entries for an expedition of 2 days for 4 men to Congresbury to fell, cut and carry wood back to Yatton at a cost of 6s 1d)

Preparing (sawing/cutting/jointing)

| T194, p. 89, 1482–83 | pro facture le mortise ad deponendum lignum intus [upright for rood] … 2d |
| Y88, p. 16, 1447–48 | (third of four entries relating to a visit to Congresbury to fell, cut and carry timber) |

vor cottyng [as opposed to felling] of the same tymbyr to v men in mete and
dryng and hyre … 9d

Quality and condition of wood

C65, —, 1520	And all the pryncypall Bacs and Crownes for ye great housyngs therof and ye Archeboteyns [arch-braces] thereunto belonging, schal be of good and hable [fit, suitable] oke without sappe, rifte [cleft], wyndshakk [wind shake], or other deformatiff hurtefull.
C65, —, 1520	And all Tymber of the same Roodloft schal be full seiasoned tymber … The pillours therof schal be of full seisoned oke (cf. C65 at 'Images', below)
S93, —, 1531	Also … that all the tymber of ye same worke shall be substantcyally sesynyd and of on maner of drying
(Tempsford, Bedfordshire) 1512	Indenture: the builders of the rode loft 'shalfind [sic] clene sesonable hart of oke for all and euery aforesed' (Salzman 1952, 564)
Y158, p. 144, 1536	Payd to Thomas Carpynter for laying up [seasoning] the tymber

Amassing wood

A68, f. 78, 1521–22	3 pieces of good timber received as a gift from the Abbot of Buckfast
T185, p. 50, 1451–52	It. in expensis diversorum hominum adquirentum ij plaustratas [wagonloads] Meremii [of timber] à Montagu [Montacute] usque Tyntenhull … 8d
Y87, p. 15, 1447–48	à R. Dornebarne pro ij bus [i.e. duobus] tabulis vocatis 'planks'… 12d
Y87, p. 15, 1447–48	à W. Mydwynter pro j tabula vocata 'plank' … 3d
Y87, p. 15, 1447–48	à R. Mei pro duobus lignis vocatis ij 'plocks' (blocks) … 2d
Y87, p. 15, 1447–48	à J. Rynd pro lingo vocato a ploke (block) … 2d

Wainscot – and other timber imports via Bridgwater, Bristol, Southampton

A68, f. 79 1521–22	Making and cost of le rodeloft … £4-4s.-9½d. paid for wynscote (57s.-3d.) tymber, board, carriage and other necessary costs … £13-6s.-8d.
C64–5, —,1520	all the Howsyngs [tabernacles], Crests, Voults, Orbs [blind niches between statues], Lyntells, Vorcers [voussoirs], Crownes, Archeboteyns [arch-braces], and Bacs for the small Housyngs, and all the Dores, fynyalls, and gabeletts therof, schal be of good Substancyall and hable [fit] waynescote
T180, p. 37, 1441–42	pro viij tabulis vocatis Weynescote borde pro australi hostio ecclesie de novo facte, pro tabula xiiijd …

	9s-4d (+ nails, ironwork, ring pull & boss, carpenter's costs)
T185, p. 50, 1451–52	It. Johanni Brayne de Stoke pro Meremiis [timber] vocatis waynscote pro dicto Rodelofte faciendo ab eo empties in grosso … 6s-8d
Tr282, —, 1537–38	for Walsche [Welsh] bordes & carrying off the same from Brygewater … 7s
Tr283, —, 1539–40	for bordys at Brygewater … 10d
Y87, p. 16, 1447–48	ypayd for weynscot … 7s
Y88, p. 16, 1447–48	pro tabulis vocatis wenscote numero xxiij … 23s-4d (+ 6d expenses & 16d for carriage down to Bristol + 6d for carriage from the landing place (rypa) at Bristol to Redcliffe + 4d for meat and drink for the same)
Y96, p. 37, 1454	for bords from Sowtheampton … 6s-8d
Y96, p. 37, 1454	for ij bords boffte at Brystow … 4s-10d (+ [p. 38] 6s-8d for carriage of boards between Southampton and Chew + 10d for carriage from Chew to Yatton)
Y100, p. 63, 1459	for walsche [Welsh] bord and plankys … 33s : xxx zeme of bordys, xijd., the zeme, and iij zeme of plangys xij. the zeme (cf. Y119, p. 202)
Bristol, Table of Enrolled Customs Accounts No. 10, p. 258 (28 Feb. 1480)	Seint Sebastian of Guetaria Lope from Flanders with a cargo of madder, tar, hops & 6c (cwt) of wainscot, the latter valued at £12-0s.-0d.

Sale of old screen timber (pre-Reformation)

Banwell,—, 1531	The Rode was sold for the value of 68 bushels of wheat and taken to Uphill for shipment (Bond and Camm 1909, 147)
T184, p. 49, 1451–52	(list of receipts from the sale of a log, and both used and cut timber) pro ij lignis quercinis vocatis liernes [ribs] de veteri rodelofte … 18d pro vj gistis [joists] ligneis venditis … 4d
T184, p. 50, 1451–52	It. diversis hominibus locatis ad deponendum le Old Rodelofte … 18d
? Y89 p. 20, 1448	(It. recepimus) … pro antiquis tabulis quas vendimus Johanni Clerico … 20d
? Y89 p. 20, 1448	(It. recepimus) … de W. Stabbe de tabula … 6s-8d
Y98, p. 44, 1455	for takeyng a don of the olde loffte and makyng of the trestell … 12d

Tools and materials

Y93, p. 27, 1451	for glewe for the Aler … 4d

Models

C65, —, 1520	And the briste [breast, forepart] of the sayd Rodde Loft schal be after and accordyng to the briste of ye Roddelofte within ye parisshe Chirche of Tripplow … [t]he bakkesyde of the sayd Roddeloft to be also lyke to the bakkesyde of the Roodelofte of Gasseley
S92, —,1531	and the same Rodloft to be made after the patron forme and facyon yn euery thyng as the rodeloft of Seyntt Kew ys made
S92, —, 1531	Also … that the sayd John Daw & John Pares schall make or cawse to be made yn the back of the seyd mydell rome [centre aisle] of the sayd Church a Crucyfyx with a Mary and John and all other werkemanshepp after the patron ffascyon and workmanshepp in euery thing as hytt ys aboute ye Crucyfyx yn the bake of the mydell Church [aisle] of leskard [Liskeard] Church
Y86, p. 11, 1447–48	vor iij men rydyng to Estun (Easton in Gordano) to se the alle [awlie, i.e. gallery, rood loft] … 3d (Cox 1913, 175)

Screen

A67–8, f. 78, 1521–22	for making le planchyng [floor, floorboards] of the tower and a certain screen [scrinei (Hanham 1970, 68) 'chest']
C65, —, 1520	after the Roddeloft the perclose of the quyer with a double dore, the percloses of the ij chappells eyther side of them with a single dore
Hy31, —, 1525	Item payd for carryng of the skreene [shrine or box] in the cherche … 2s
S92, —, 1531	Also … that the sayd John Daw and John Pares schall make or cawse to be made ij interclosys of tymber fro pyler [pillar] to pyler the on [one] between the sowth Amletory [ambulatory? i.e. aisle] and the quer of the sayd church and the other between ye northe Amletory and the sayd quere of the sayd church euery of them fro sayd Rodloft upwards vnto the pylers nex the hye Awter and ht [it] to be made with the ly3th [length] of the vawte of the sayd Rodloft after the patron & facyon as the interclose between the Amletores yn the parrysh Church of Synt colombe the over [St Columb Major].
S94, —, 1531	the sayd John Chamond (et al.) shall content & pay or cause to be contentyd & payd vnto ye sayd John Daw & John Pares xlvjs. viijd. includyng all the premyses to be yn & for euery fote of the worke of

the bred [breadth] of the sayd church of Stratton to be metyn [measured] appone ye grownd along by the sayd Rodloft & no other Interclose to be metyn but to go yn the same & for ye same mony from the North wall of the sayd church vnto the sowth wall ther of ye same church all the sayd worke to be concludyd with the forsayd xlvjs. viijd. the fote payable

T185, p. 50, 1451–52 It Johanni Brayne, cum serviente suo, locatis per unum diem ad bordandam et emendandan clausuram pone crucem, videl. inter naveu ecclesie et cancellam … 10d

T191, p. 76, 1466–67 pro scrinio [shrine or box] in ecclesia et clavis ad idem … 5d

Y114, p. 161, 1482 for the closynge [Hobhouse, n2 = parclose] betwyxte the chyrche and the chawnsell, and for mete and drynge and naylys … 20d

Loft

A101, f. 131, 1539–40 for mendyng le teyllis [tiles] in the church and for the new lock to the door of le rowdeloft … 5s

B16, p. 141, c.1480 the said Alice … let be made a new rood loft in carved work filled with 22 images, at her proper cost: of the which images three are principal – a Trinity in the middle, a Christopher in the north side, and a Michael in the south side, and besides this, each of the 2 pillars bearing up the loft has 4 houses there set on in carved work with an image in each house

M, —, —, 1558 for makynge of a dore to the Rode lofte

M, —, —, 1558 for Jemewes [hinges] and nayles to the same ['Rode lofte']

N79, —, 1544–45 a key for the rodelaufte dore … 2d

P55, —, 1508 Item payed for xij ellys [measurement of length] of leynen clothe for the Rode loȝfte … 7s-7d

P55, —, 1508 Item for lynes and rynges for the sayed clothe … 7d

P66, p. 27, c.1498 payd to Robert Carver for making off the Trayle [carved 'vine-scroll'] under the rodelofte … 3s-6d

T185, p. 50, 1451–52 Solut. [allowed] Thome Dayfote carpentario locato ad faciendum le Rodelofte ut in Meremiis ligneis ex conventione … 40s

T185, p. 50, 1451–52 It. in clavis et ceteris ferramentis ad dictum Rodelofte empties hoc anno … 8d

T185, p. 50, 1451–52 It. Willelmo Perys locato ad faciendum de novo xl Judaces ligneas [wooden light-holders] ad pertandum luminaria stantia coram alta cruce ad thascam … 10d

T185, p. 50, 1451–52 It. Willelmo Golyght locato per unum diem coadjuvante T. Dayfote ad levandum solarium [loft] subtus le Rodelofte ad thascam … 4d

1204, p. 125, 1538–39	It. carpentario ad faciendum finem operis domus ecclesie, viz, silarium [i.e solarium – loft] ibidem … 11s-4d
Tr283, —, 1539–40	John Bynny for works of the rodlawt … 30s
Tr283, —,1539–40	for nayles to the rodlaute … 18d
Tv4, —,1538–39	for rushes brought for strewing the rode loft before the high cross [solario st'aiedo cor alt cruces] … 1d.
Tv19, —, 1392–93	Itm payed for a looke & James [hinges (gemmes)] to the dowre in the Rode loft … 8d.
Y88, p. 17, 1447–48	Johanni Crosse ['carpentario' Y90, p. 22] pro factura solarii [lofts] in parte solutionis … £5-6s-8d
Y90, p. 22, 1450	Johanni Crosse pro solario … 13s-4d (cf. Y91, Y92, Y93, Y95)
Y96, p. 38, 1454	for yren to the rodeloffte, payde to J. Smyth … 2s-6d
Y98, p. 43, 1455	for the chandeler yn the rodelofte, to Jenkin Smyth of Comysbury … 23s-4d
Y98, p. 44, 1455	for colde [charcoal] whyche J. Smythe made upon the yren werke … 18d
Y107, p. 96, 1470	for amending of the vyne in the rodelofte …1d
Y132, p. 313, 1512	for ij flowrs [i.e. floors – floorboards?] to ye Rode lofte … 4d

Rood, roodbeam, candlebeam

A134, f. 164v, 1555–56	to William Cocke and Robert Harrell for caryage of the rock of the rode and the crosse … 3s-4d
C65–6, —, 1520	and schall also set up a Beme wherupon the Roodloft schall stonde lyke unto the Beme within the sayde Roodeloft of Gasseley … And also schall make a Candylbeme mete and convenyent for our Ladye Chappell within the said Chirche of Seynt Mary
T192, p. 83, 1473–76	pro facture de le bemme cruces [high cross-beam]
T194, p. 89, 1482–83	pro celatione [tympanum] Alti cruces … 24s

Images

B15, 139, c.1480	the said Alice … has let made in carved work a tabernacle with a Trinity in the middle over the Image of Jesus … & had it gilded most worshipfully
B16, 139, c.1480	the said Alice … let carve at her own expense a tabernacle to the North side of the said altar with 3 stories of Our Lady: one of the stories of Our Lady of Pity, the second of the Salutation of Our Lady, and the third of the Assumption of Our Lady
C65, —, 1520	And all the Yomags therof schal be of good pyketurs, fourmes, and Vicenamyes [physiognomies] without Ryfts, Crakks, or other deformatyvys

C [F] 53, —, 1523	Item for holowyng[22] of ye ymagesse of mari & Jhon [sic] … 8d
M, —, —, 1559	Payd in Earneste [token of contractual agreement, 'deposit'][23] toward the makynge of the Image of Seynt Michell
M, —, —, 1561	defacynge the Images of the twelve apostles which were painted in the fface of the Rode lofte (cf. 'Painting', below, CWA Bristol St John the Baptist, 1533)
P71, —, 1521	Itm for myne [i.e. William Sargeant] expense to Exsetter to speke wt ye carver … 2s-4d
S92, —, 1531	with ij images & tabernacles for them [north and south altars] and the same Imagys and other work ether to be orbett and wroft after the patron and workemanshepp as at Seynt Kew aforsayd the on Image to be of Seyntt Armell the other to be of the Visitacon off owr blessed lady

[22] In his account of the furnishing of Great St Mary's, Cambridge in the 1520s, Canon Venables pointed to the completion of the new screen around 1523 when payment was made for the 'hallowing' of the images of the Virgin Mary and St John (S. Sandars and E. Venables, *Historical and Architectural Notes on Great St. Mary's Church Together with the Annals of the Church* (Cambridge, 1869), p. 67; J. E. Foster (ed.), *Churchwardens' Accounts of St Mary the Great, Cambridge, from 1504 to 1635* (Cambridge, 1905), p. 53). Rather than the 'hallowing' of the images, the text refers to the 'holowyng of ye ymagesse of mari & Jhon': a process by which heartwood at the back of a carved figure is 'hollowed out' to assist evaporation and prevent the risk of splitting and warping, and also to reduce weight. Evidence of 'hollowing out' in continental late medieval figure carving has been noted in a variety of woods, e.g. oak, lime, Siberian pine, willow and nut-woods, for which see: P. Tångeberg *Mittelalterliche Holzskulpturen und Altarschreine in Schweden* (Stockholm, 1986), pp. 26–30 and 30–2; M. Baxandall, *The Limewood Sculptors of Renaissance Germany* (New Haven, 1995), p. 36 and Fig. 15, citing F. Schweingruber, 'Botanischholztechnologische Bermerkungen zu den Untersuchungen mittelalterliche Skulpturen', *Zeitschrift für Schweizerische Archäologie und Kunstgeschichte*, 30 (1973), p. 87; and D. Berné (ed) *Sculptures souabes de la fin du Moyen Âge*, Exhibition Catalogue, Musée de Cluny (Paris, 2015), pp. 10–11, Figs 4–6. Though a comparable corpus of examples cannot be assembled from late medieval England, evidence of datable examples of the practice have been noted in the St Michael and the Dragon in Trondheim but assigned to a Westminster carver and dated 1250–60 (N. Stratford in *Age of Chivalry*, ed. J. J. G. Alexander and P. Binski (London, 1987), cat. no. 290); the oak funerary effigy of Sir Robert du Bois (c.1340) which was 'hollowed out and filled with burned coals to absorb moisture' (V. Sekules in *Age of Chivalry*, ed. J. J. G. Alexander and P. Binski (London, 1987), cat. no. 731; D. Park in *Wonder: Painted Sculpture from Medieval England*, ed. S. Boldrick, D. Park and P. Williamson (Leeds, 2003), cat. no. 5); and both the fifteenth-century corpus from Cartmell Fell (Cumbria) (Vallance, *English Church Screens*, p. 12 and Fig. 5) and from Kemeys Inferior (Redknap, 'The Medieval Wooden Crucifix', p. 16 and Fig. 3).

[23] An *earnest* was a sum of money paid as an instalment especially for securing a contract. For illustrations of such payments at Yatton (Somerset) see Bishop Hobhouse (ed.), *Church-Wardens' Accounts*, Somerset Record Society, 4 (1890): (clerk) Y95, p. 37, 1454; (carpenter) Y100, p. 64, 1459–60; (stainer) Y137, p. 364, 1519; (carpenter) Y149, p. 132, 1535. Though not referred to as such, the provision of ale to the carpenter John Crosse in 1455 to make him 'well-willed' might be regarded as an earnest for accounting purposes (Y98, p. 43, 1455).

Y98, p. 44, 1455	to setting up of the ymages … 4d
Y98, p. 44, 1455	for the ymages to the rodeloffte yn number lxix … £3-10s-4d
[? Y99, p. 50, 1457	for making faste of the emagys at the hye Croce … 12d]
Y171, p. 100, 1559	in expenses at the plucking down of the Images … 6d

Ceilure

T194, p. 89, 1482–83	pro celatione [tympanum] Alti cruces … 24s
T194, p. 96, 1482–96	
	pro le sylyng ecclesie … 2s-9d
	pro picture alti cruces … 6s-7d
	pro pictatione alti cruces et pro cilatione supra … £4-40d [sic]
	pro facture le cylyng … 15s
Y96, p. 37, 1454	for yren worke for the syler [ceilure] … 20d
Y96, p. 38, 1454	for nayls boffte to the syler … 1d
Y96, p. 38, 1454	to Crosse at a payment for the syler … 20s
Y96, p. 38, 1454	to Crosse at another tyme for the syler … 20s
Y96, p. 38 1454	y payde to Crosse to the syler … 6s-8d

Altars

| B16, 140, c.1480 | Also the said Alice has let made to be carved at her own expense a new front to an altar in the south aisle of the church, called the rood altar with 5 principal Images: one of St. Anne, the second of Mary Magdalen, the third of St. Giles, the fourth of St. Erasmus, the fifth of St. Anthony. And in addition a crucifix with Mary and John over a door by the altar, also she has gilded all that front full worshipfully as it appears |
| S92, —, 1531 | the sayd John Daw & John Pares schall make or cawse to be made ij Auwters of tymber one bothe ended of the sayd Rodlofte that is to weytt on by the sowther wall and another by ye northe wall of the said church |

Materials: masonry

T185, p. 50, 1451–52	It. Johanni Stibi pro liberis petris pro dicto Rodelofte ab eo empties … 12d
T185, p. 50, 1451–52	It. servienti Johannis Davy pro muro petrino in parte boreali de la Rodelofte emendando, cum ijd. solutis pro prandio suo … 5d
T185, p. 50, 1451–52	It. Henrico Mason de Odecumbe, et Thome Bouryng locatis ad emendandum defectus muri petrini ex

utraque parte ecclesie, videl. ad implendum foramina ubi vetus Rodelofte, prius fuit, ad thascam … 7d

Alabaster

A101, f. 124, 1537–38	paid for 2 pagentis of alabaster for le rowdeloft by the high cross … 10s-4d
T185, p. 50, 1451–52	It. cuidam homini vocatos alabaster-man in arameanda et conventione unius tabelli alabastri … 1d
T186, p. 52, 1452–53	E quibus pecuniis allocator de xxxvijs. Iijd. Solutis ad tabellam alabastriam nuper emptam ut fatetur per parochianos
T186, p. 52, 1452–53	de vjs. viijd. solutis pro predicta tabella alabastria per manus Robertis Aught unde dicti custodum onerantur super arreragiis … ut fatetur super computum per parochianos predictos

Painting

(Banwell), 1525	Paid to Robert Hopton for gylting in ye Rodelofte, and for stayning of the clothe afore the Rodelofte … £5 (Bond and Camm 1909, 147)
(CWA Bodmin), 1507–8	£12 paid to 2 craftsmen 'for the painting of four histories in the rood loft' (Whiting 1989, 203)
(CWA Bristol, St John the Baptist) [Cox, CWA 179] 1533	Paid unto old Solbe for peynting of oure rode lofte and mending the images … £3 Unto the said old Solbe for peynting of the nether roode and the lofte more with the ij small images and the xij apostles with the angels … £2-13s-4d
P55, —, 1508	Item payed to dd. [David] Jonys the peynter of the Rode loӡthe the xijth of aprile … 26s-8d
P55, —, 1508	Item payed to dd. Jonys the peynter the day of the feste of Saynt Petyr and Paule … £3-6s-8d
T188, p. 64, 1459–60	uno peynter pro peyntyng de la Rodeloft ut in parte pecunie sue … 13s-4d
T189, p. 69, 1462–63	Allowed to J. Bole the sum which he had laid out for the painting of the Rood loft … 20d
Y95, p. 37, 1454	payede for divers colers to the Aler … 6s-6d
Y95, p. 37, 1454	for colcrs late botte at Bristow … 2s-1d
Y95, p. 37, 1454	for the paynter ys hyre a wyke [week] … 20d (+ 2d for ys bedde)
Y96, p. 38, 1454	for colers … 13s-6d
Y96, p. 38, 1454	for feschyng [fetching] of a stone from Chelvey to grynde colers therwith … 1d
Y96, p. 38, 1454	for a quart of peyntyng oyle … 5d
Y96, p. 38, 1454	for dyvers colers boffte … 22s
Y96, p. 38, 1454	payede for golde to paynte the angell … 6s

Y97, p. 43, 1455	a potell of paynters oyl … 10d
Y97, p. 43, 1455	for vernaysche, a pound and a quarter … 10d
Y97, p. 43, 1455	for glew and diverse colers for the loffte … 4s-10d
Y100, p. 63, 1459	for peyntyng the Rodelofte … £3
Y132, p. 306, 1511–12	to John Wakelyn for peyntyng and gyldyng of ye church … £12-16s-8d
Y132, p. 312, 1512–13	payd for gyldyng to John Wakelyn … 26s-8d
	It. to ye same for gyldyng … 26s-8d
	It. to ye same J. Wakelyn … 20s and 6s-8d
Y133, p. 315, 1512–13	to John Wakelyn for gyldyng … 6s-8d
Y133, p. 321, 1513–14	for gyldyng to John Wakelyn … 46s-8d
Y133, p. 315, 1512–13	to John Wakelyn for gyldyng … 6s-8d
Y134, p. 330, 1514	to John Wakelyn for gyldyng Seynt Thomas and ye rele [corona] … 10s

Access

S93, —, 1531	Also the sayd J. Dawes and J. Pares … for to Rere the wall plate of the northe wall of the sayd church so that hytt [it] may agre with the myddyll roff of the same church [aisle] and to devyse and make a waye and a goyng by or under the Archys of the pylers of the Amletores [walkways] of the sayd church so yt [that] a man may go throw the sayd Rodloft from on Amletore to another

Miscellaneous expenses

A67, f. 78, 1521–22	5s allowed for rent of Sir John Shilton's former house because it was used for church purposes for le kervers le rodeloft

7

THE POLYCHROMY OF DEVON SCREENS: PRELIMINARY ANALYTICAL RESULTS

LUCY WRAPSON AND EDDIE SINCLAIR

Around 140 late medieval church screens, many of them richly painted, survive in the county of Devon in England's South-West.[1] This makes Devon the third most populous county in terms of screens, after Norfolk and Suffolk, with the second highest number of figuratively painted screens in England after Norfolk.[2] Devon's rood screens came to the wider attention of ecclesiologists and antiquaries in the nineteenth and early twentieth centuries, featuring in Stabb's church guides, as well as the key national books on the subject of screens, Bligh Bond and Bede Camm, Bond and Vallance.[3] An in-depth study of Devon screens formed the focus of Bligh Bond and Bede Camm's two-volume work.

Devon screens are typically wider and less tall than those in East

[1] There is no definitive current list of extant Devon screens, as to assess the numbers accurately would involve site visits throughout Devon, compared with the recorded examples in J. Stabb, *Some Old Devon Churches: Their Rood-screens, Pulpits, Fonts, etc.* (London, 1908); M. A. Williams, 'Medieval English Roodscreens with Special Reference to Devon' (PhD thesis, University of Exeter, 2008) and F. Bond and D. Camm, *Roodscreens and Roodlofts* (London, 1909). Such work is outside the scope of the present essay. This number is based on Williams, 'Medieval English Roodscreens', but includes examples he missed, such as fragments at Huntsham.

[2] Devon figurative screens number 43 (although this depends upon one's definition). Norfolk has 96 figurative screens, Suffolk 37 (L. J. Wrapson, 'Patterns of Production: A Technical Art Historical Study of East Anglia's Late Medieval Screens' (PhD thesis, University of Cambridge, 2013). It should be stressed that East Anglia and Devon are not the only regions to have figurative screens, but are the two most studied by the authors.

[3] Stabb, *Some Old Devon Churches*; Bond and Camm, *Roodscreens*; F. Bond, *Screens and Galleries in English Churches* (Oxford, 1908); A. Vallance, *English Church Screens* (London, 1936).

Anglia (Pl. XXXIV). They often have more ornate and lavish carving than their eastern counterparts. Technically and stylistically, the painting differs between the two regions. In Devon screens have red earth/red lead grounds as opposed to white chalk grounds and Devon painting is typified by its lively, rustic style and greater use of narrative scenes compared with East Anglia. Despite this, Devon screens share in common with their East Anglian cousins the use of high-quality traditional materials such as azurite and gold leaf and their depiction of figures along the dados of the screens. They also share a history of dismantling and image removal during the Reformation, Civil War and into the eighteenth and nineteenth centuries.[4] As rood stairs indicate, by the late fifteenth century rood screens were widespread in Devon. They also had either integral or closely associated roods or rood lofts.[5] Traditional West Country terminology for these structures included the words *aller*, *soller* and *rood loft*, all in reference to the loft or balcony.[6] These terms were regionally more popular than *perke* used in Norfolk, and *candlebeam*, a Suffolk word.[7] This chapter uses the shorthand 'rood screen', though in the knowledge that it is a comparative neologism, probably developed in the 1830s and gaining widespread use after the 1848 rood screen controversy.[8]

While an understanding of screens is best fostered through an integrated study of their structure and painting, much remains to be said about their painted decoration, and polychromy is the focus of this chapter. Scholarship on the painting on screens has typically been antiquarian in nature and focused on their iconography. The more modern literature seeks to understand some of the more unusual and regional aspects of Devon's screens, such as the depiction of classical sibyls and of local female saints such as St Sidwell and St Urith.[9] Technical study of screens has remained limited, often unpublished and generally allied to conservation work and led by conservation questions. Despite this, Anna Hulbert published several important articles concerning screens, including a key paper in 1990 which

4 L. J. Wrapson, 'East Anglian Medieval Church Screens: A Brief Guide to their Physical History', *Bulletin of the Hamilton Kerr Institute*, 4 (2013), pp. 33–47.
5 J. Schweiso, 'Rood Stairs – an Analysis Based Upon a Systematic Sample from Three English Counties', *Church Archaeology*, 10 (2006), pp. 51–65.
6 E. Hobhouse (ed.), *Churchwardens' Accounts of Croscombe, Pilton, Patton, Tintinhull, Morebath and St Michael's, Bath, Ranging from A. D. 1349–1560*, Somerset Record Society, 4 (London, 1890).
7 S. Cotton, 'Mediæval Roodscreens in Norfolk: Their Construction and Painting Dates', *Norfolk Archaeology*, 40 (1987), pp. 44–54; S. Cotton, H. Lunnon and L. Wrapson, 'Medieval Rood Screens in Suffolk: Their Construction and Painting Dates', *Proceedings of the Suffolk Institute of Archaeology*, 43:2 (2014), pp. 219–34.
8 B. Ward, *The Sequel to Catholic Emancipation* (London, 1915), pp. 261–78.
9 A. M. Baker, 'Representations of Sibyls on Rood-screens in Devon', *Report and Transactions of the Devonshire Association*, 136 (2004), pp. 71–97; E. Duffy, 'Holy maydens, holy wyfes: The Cult of Women Saints in Fifteenth- and Sixteenth-century England', in W. J. Sheils and D. Wood (eds), *Women in the Church: Papers Read at the 1989 Summer Meeting and the 1990 Winter Meeting of the Ecclesiastical History Society* (Oxford, 1990), pp. 175–96.

saw the bringing together of rood screen conservation specialists east and west with the collaborative efforts of Pauline Plummer.[10] More recently, Eddie Sinclair has brought Devon's screens to the attention of a national and international audience.[11] However, the practicalities of conservation have meant that there has typically been little opportunity to explore the materials and techniques of Devon screens in depth. This chapter goes some way to redress that balance, drawing together unpublished analysis from Anna Hulbert's archive (from screens at Manaton, Bridford and Hennock), from Elizabeth Cheadle's work on the architectural elements of the screen at Pilton, from analysis by Catherine Hassall in support of the conservation project by Jane Rutherfoord (assisted by Eddie Sinclair) and Eddie Sinclair at Torbryan, as well as from collaborations between the authors, including with Catherine Hassall.[12]

Depending on the precise definition, some forty-three figurative rood screens survive in and from Devon, out of as many as 140 screens and fragments.[13] This chapter draws together information from eighteen screens, two of which are not figurative but retain extensive medieval painted decoration, as well as one roodbeam.[14] This represents some 12 per cent of surviving church screens, a higher proportion have therefore been studied than is usually possible for, say, the *oeuvre* of an Old Master painter.

Also included here for the first time are results from pigment analysis of secular plank and muntin (stud and panel) screens.[15] These screens which

[10] A. Hulbert, 'Painted Ceilings and Screens', in P. Burman (ed.), *Treasure on Earth: A Good Housekeeping Guide to Churches and their Contents* (London, 1994), pp. 34–48; A. Hulbert, 'Notes on Techniques of English Medieval Polychromy on Church Furnishings', in J. Black (ed.), *Recent Advances in the Conservation and Analysis of Artifacts* (London, 1987), pp. 277–9; P. Plummer and A. Hulbert, 'English Polychromed Church Screens and the Problems of their Conservation in Situ', in *Cleaning, Retouching and Coatings: Technology and Practice for Easel Paintings and Polychrome Sculpture, Preprints of the contributions to the IIC Brussels Congress*, 3–7 September 1990 (London, 1990), pp. 47–51.
[11] E. Sinclair, 'Investigating the Medieval Polychromy of West Country Rood Screens', in N. Streeton and K. Kollandsrud (eds), *Paint and Piety: Collected Essays on Medieval Painting and Polychrome Sculpture* (London, 2014), pp. 131–48; E. Sinclair, 'Surviving Against All Odds: A Devon Late Medieval Rood Screen and a Tyrolese Altarpiece', in D. Odgers and L. Humphries (eds), *Polychrome Wood: Post-prints of a Conference in Two Parts Organised by The Institute of Conservation Stone and Wall Paintings Group, Hampton Court Palace, October 2007 and March 2008* (London, 2010), pp. 53–64.
[12] The authors extend their gratitude to Elizabeth Cheadle, Catherine Hassall and Jane Rutherfoord. Thanks are also due to Susie Hulbert for access to Anna Hulbert's archive.
[13] This number includes some *ex situ* fragments such as the dado at the Victoria and Albert Museum in London and the Ashprington doors in the Royal Albert Memorial Museum in Exeter.
[14] The Uffculme and Willand screens are not figurative, but analysis has revealed some fascinating results. At Bow (Nymet Tracey), another non-figurative rood screen was conserved (by Eddie Sinclair) in the early 1980s. This was found to retain extensive medieval polychromy, but no analysis was carried out. Also non-figurative, the screen in Littlehempston church retains an eighteenth-/nineteenth-century paint scheme over what could be a medieval red earth ground; no further medieval colour was noted during conservation (by Eddie Sinclair).
[15] Marker's Cottage, Little Harvey Farm, Osmonds Farmhouse, No. 21 The Mint (two

separate the principal ground-floor rooms are a characteristic feature of the late medieval West Country houses.[16] Their function was both structural and decorative, and whilst many still survive, most have been stripped and lost their painted decoration. These screens probably originate in the fifteenth century 'as low partitions in open halls and continue in use in two-storey houses until the end of the seventeenth century'.[17] Those screens that do retain evidence of painting throw light on the appearance of early domestic interiors, suggesting the status of different rooms, as well as providing information on the materials and techniques available for vernacular buildings.[18]

Five Tudor-period plank and muntin screens are therefore included in this survey, for comparison with the decorative techniques of ecclesiastical screens. While these screens can differ from rood screens in their medium (they are probably largely glue-bound), they are likely to have been painted by the same craftsmen as church screens. Their inclusion also serves to highlight Devon's supremacy in the survival of this type of painted screen decoration and to demonstrate the variety of surviving West Country polychromy, undertaken in more than one medium.

DATING AND GROUPING DEVON CHURCH SCREENS

Considerable time could elapse between the beginning of rood screen construction and completion. This could be due to funding shortfalls, but also because large projects inherently took considerable time and manpower to complete. Technical evidence can indicate such a gap: Catherine Hassall found a dirt layer beneath the paint on the sill at Combe Martin, indicating that this part of the screen had time to get dirty before painting had commenced. Churchwardens' accounts can be explicit in detailing the time taken to build and decorate a rood loft. At Tintinhull in Somerset, the screen took forty-three years to build and decorate, from the removal of the old loft in 1451/52 until the painting of the high cross and ceilure in 1494/95.[19] A completion date carved or painted on a screen, or a will bequest to its construction or painting, therefore must take this into account.

Exeter's Probate Registry, containing Devon's un-transcribed medieval wills, was destroyed by German bombing in 1942. It is thought from

screens).
16 E. Sinclair and I. Richardson, 'The Polychrome-decorated Plank-and-muntin Screen at Marker's Cottage, Broadclyst, Devon, and its Context', in J. Allan, N. Alcock and D. Dawson (eds), *West Country Households 1500–1700* (Woodbridge, 2015).
17 P. Beacham, *Devon Building: An Introduction to Local Traditions* (Tiverton, 1990).
18 J. Ayres, *Domestic Interiors: The British Tradition 1500–1850* (New Haven, 2003).
19 Hobhouse (ed.), *Churchwardens' Accounts*, pp. 184–95.

pre-war transcripts that relatively few pre-1530s wills were extant in any
case.[20] However, Devon wills from the Prerogative Court at Canterbury
have survived, and a sample 97 out of a total of 626 of them were read by
Williams in the course of his doctorate on Devon screens. These revealed
six bequests to screens from testators, five for Devon, one for a screen in
Somerset.[21] Of these, two screens are extant (Bampton and Chulmleigh).
Further reading of the Prerogative Court at Canterbury wills would
probably yield more references. Pevsner and Cherry report several further
dates for Devon screens, including the stone screen at Totnes, which was
apparently commenced in 1459/60.[22] Accounts for the construction of the
rood screen in St Saviour's in Dartmouth date to 1496.[23] Interestingly, the
parcloses in St Saviour bear the arms and initials of town mayor James
Pelliton and date from 1567–68. By way of comparison, few East Anglian
rood screens survive from so late a date.

In addition to this, Somerset records provide a date for Devon's
surviving Pilton screen as the rector of the church of Norton Fitzwarren
left money to the painting of one 'pageant' in the rood loft in the church
of Pilton (1509).[24] Court records provide information for the dating of
the screen at Atherington, which, given the style and date, must mean
the north side screen. Chancery pleas from 1544 to 1547 were made by
Roger Goderd, John Hull and John Parrys (carpenter, carver and joiner).[25]
Parrys is the same man as Pares from Northlew in Devon, recorded as
responsible alongside Cornishman John Daw for the carving of the rood
screen at Stratton in Cornwall between 1534 and 1539.[26] The Atherington
screen may well have been made directly after Stratton, as late as the early
1540s, well into the start of the Reformation.

Some additional dates can be gleaned from the screens themselves.
Bridford's opulent late Perpendicular/Renaissance screen is closely
associated with a plaque decorated in vermilion and lead tin yellow
which must have come from the reverse of the screen/loft because it
closely shares the colour scheme. This plaque displays the initials WS for

[20] Williams, 'Medieval English Roodscreens'.
[21] The five Devon churches are: Bampton (1509), Plymouth (St Andrew) (1509),
Chulmleigh (1528), Honiton (St Michael) (1529) and Tiverton (1524). The Somerset church
is Wellington (1495).
[22] N. Pevsner and B. Cherry, *The Buildings of England: Devon*, revised edn (New Haven
and London, 2002), p. 868.
[23] Ibid., p. 323.
[24] Pilton in Devon rather than Somerset is meant, as Martyn makes explicit in his will.
F. W. Weaver, *Somerset Mediaeval Wills 1501–30*, Somerset Record Society, 19 (Taunton,
1903), p. 136.
[25] The National Archives (K), C1/1116. John Parrys, carver of North Lew is also referred
to in a Court of Common Pleas Plea Roll in 1536 (The National Archives CP40/1088,
f2822). John Parrys and John Frye, both carvers of North Lew, were prosecuted for
trespass and close against a William Burdon.
[26] R. Goulding, *Records of the Charity Known as Blanchminster's Charity in the Parish of
Stratton, County of Cornwall until the Year 1832* (Stratton and Bude, 1890), pp. 91–4.

rector Walter Southcote (1508–50), although where its creation falls in his incumbency is not known. Its style may suggest a mid- to late date within the range, though the screen was probably not made after the 1540s due to the prevailing state of Reform. In a similar vein, Marwood's screen doors record its donation by the rector Sir John Beaupel. He was rector in 1520.[27]

Blackawton's date (c.1509–26) can be ascertained from the presence of the initials of Henry VIII and Catherine of Aragon.[28] Holne screen and pulpit, which are a matching set, can perhaps be dated in a similar vein from the coat of arms of Hugh Oldham, bishop of Exeter (1504–19) on the pulpit.[29] Broadwoodwidger's screen is apparently of similar style with the church's benches, one of which bears the date 1529.[30] Devon screens often comprise sets with benches and pulpits, a situation not mirrored in the east of England.

Twelve of Devon's c.140 screens therefore have some kind of date (9 per cent), not the five outlined by Williams.[31] More will bequests may yet be found, which would make a beneficial contribution to the whole chronology. Yet this is already a significant basis on which to ground stylistic typologies and dating. Despite Williams's unwarranted scepticism on the subject, detailed observations can find credible groupings.[32] Although, as he states, simple screens can be late, general trends can still be cautiously used to forge a credible chronology. This approach can be demonstrated to work for East Anglia, where there is a large volume of objects and where there are large numbers of surviving dates (see Wrapson in this volume). One hundred and twelve screens in Norfolk, Suffolk and Cambridgeshire have some form of dating evidence. This represents about a fifth of all surviving material.[33] An examination of dated East Anglian moulding profiles, shown to increase in complexity over time, clearly demonstrates the efficacy of this approach (see Wrapson in this volume).

Bond and Camm developed a chronology for Devon screens, which was largely accepted by Pevsner. While it might benefit from being refined, particularly in combination with technical study, it is a sound starting point for a chronological typology for screens. It is, for example, known that the same craftsmen made more than one screen, as the documentary relationship of Stratton to Atherington indicates. Bond and Camm also

[27] Pevsner and Cherry assert that East Allington's rood screen can be dated 1547 from a carved inscription; a late date, even by Devon standards (Pevsner and Cherry, *Buildings of England: Devon*, pp. 346 and 563). However, inspection on site reveals only a carved date of 1633 on the screen. It may be that the 1547 date recorded was inscribed on a part of the screen that since has been lost.
[28] Ibid., p. 186.
[29] Stabb, *Some Old Devon Churches*, p. 124.
[30] Pevsner and Cherry, *Buildings of England: Devon*, p. 219.
[31] Williams, 'Medieval English Roodscreens', p. 186.
[32] Ibid., pp. 177–86.
[33] Cotton, 'Mediæval Roodscreens in Norfolk'; Cotton, Lunnon and Wrapson, 'Medieval Rood Screens in Suffolk'.

made further useful observations, noting a subgroup of Breton-made or influenced screens.[34] Indeed, as Allan demonstrates, Breton and Dutch carvers were fairly numerous in Devon and Cornwall in the sixteenth century.[35] Documentary evidence shows that the now-lost screen at North Petherwin in Cornwall was made by Bretons.[36] This distinctive subgroup of screens may include Huxham, with its Breton-style tracery and linenfold dado.

Work done in East Anglia highlights the benefit of exploring jointing evidence as indicative of dating.[37] Hugh Harrison has also pointed out the presence of laminated construction as indicative of construction methods brought in by continental craftsmen.[38] It is hoped that future study of the design, structure and decoration of screens will be used to date more rigorously the full body of surviving screens. The feeling of the authors, from screen design and decorative style, is that Devon's surviving screens are typically a little later in date than East Anglia's, which centre on the period 1480–1510. Screens appear to have continued to be made in Devon somewhat later than in East Anglia, as the tragic 1540s example of Atherington, for which the carpenters were not paid, indicates.

DIVISION OF LABOUR AND THE MAKING OF SCREENS

The evidence from East Anglian screen-making indicates that the crafts of carving and painting screens were typically separate.[39] Groups of attributable carving works can be put together (twenty-nine for the East Anglia region) and also groups of attributed painting work can be associated for the region (thirteen for the East Anglian region). These groups do not interrelate to any significant extent, as can be indicated by an examination of the rood screens at Barton Turf and Westwick which were evidently made by the same carpentry workshop, but not decorated by the same painters (see Wrapson in this volume). The implication is that the crafts were distinct, and subcontracting by carpenters to painters does not appear to have been the norm. The screen at St Catherine's church, Fritton, Norfolk typifies this. The spandrel carving over the head of St Jude was not completed, leaving the painters to cram the saint in beneath the uncarved wood.

[34] Bond and Camm, *Roodscreens*, pp. 306–7.
[35] J. Allan, 'Breton Woodworkers in the Immigrant Communities of South-west England, 1500–1550', *Post-Medieval Archaeology*, 48:2 (2014), pp. 320–56.
[36] Cornwall Record Office: P 167/5/1, ff. 36v, 43r, 49v.
[37] T. Howson, 'Suffolk Church Screens: Their Production in the Late Middle Ages and their Conservation Today' (PGDip in Building Conservation thesis, Architectural Association, London, 2009); Wrapson, 'Patterns of Production'.
[38] Personal communication.
[39] Wrapson, 'Patterns of Production'.

Devon screens have not been analysed by the authors to the same degree, but the visual evidence would seem to suggest a broadly similar picture to that found in East Anglia. Devon screen carvers can be seen in more than one location, as demonstrated by Bond and Camm's most reliable 'types', such as the Breton-style screens. Devon screen painters can also be seen in more than one location. An example of this is St Simon at Kenton, who appears to be by the same painter as one of the painters of the screen at Holne (Pl. XXXV). The key point here is that screens made by the same painters do not seem to correlate with those made by the same carpenters, although this point has not yet been tested with the same rigour as it has for the East Anglian material.

The churchwardens' accounts at Ashburton record both the rood loft's construction and decoration in considerable detail, alongside other painting work in the church.[40] Both a carpenter, John Ford, and painters Anthony Painter and Nicholas Stainer are recorded. Mentioned by name as working on wall paintings and even painting the costumes of the church's players in 1536/37, it is likely that these men were also responsible for painting the rood loft as mentioned in entries in 1538/39. The year before, in 1537/38, two 'pageants' of alabaster were put on the rood loft in front of the Rood. There was no distinction between wall painters and painters on wood at this date, and even though the distinction was made between painters and stainers, the terms were often used interchangeably when referring to the same men in different documents, as can be demonstrated in the case of painter John Blomfeld of Bury St Edmunds who is referred to as a painter and stainer in different documents.[41]

Churchwardens' accounts for neighbouring Somerset back up this general division of labour. The accounts from Tintinhull and Pilton indicate a similar situation as Ashburton. At Pilton, both a carver, Robert Carver brought in 'for makyng off the Trayle under the rodelofte', and painters, David Jonys and his servant Wyllyam Ffeyzand, are named.[42] One can imagine a situation where a team of two might work, with a more skilled individual on one side of the door, less skilled on the other side, as appears to have been the case at Holcombe Burnell (Pl. XXXVI).

Interestingly, at Yatton, while the carpenter, John Crosse, is named in the accounts (he was a local man, one of the lightmen for the church and evidently well known to the churchwardens), the painter is named by profession alone (and perhaps therefore can be assumed to have come from further afield). At Yatton, Crosse appears to have acted as a foreman

[40] A. Hanham (ed.), *Churchwardens' Accounts of Ashburton, 1479–1580*, Devon and Cornwall Record Society, new series, 15 (Exeter, 1970).
[41] For this see Court of Common Pleas, Plea Rolls, The National Archive, CP40/1013 d854, f945, f969; CP40/1023 d727; CP40/1060 f5093.
[42] Hobhouse (ed.), *Church Wardens' Accounts*, p. 66.

or middleman on behalf of the parish, and he had an apprentice working with him.

As records show, carpentry was the more expensive part of the commission and the carpenters, joiners and carvers (for whom these professional terms were often used interchangeably) were the more important parties than the painters. As much is indicated by the fact that Chulmleigh rood screen, dated 1528, is signed by John the Carver, perhaps because he was a donor as well as craftsman, but also perhaps because his was the greater contribution than that of the painter.[43]

The churchwardens' records at Yatton in Somerset give some insight into the processes behind commissioning a screen. The churchwardens purchased trees in the forest of Selwood and arranged and paid for their cutting and preparation. Three men from the village were sent to Easton-in-Gordano to inspect the rood loft there, while another man was sent to Bristol to inspect a retable. The following year carpentry work began, and the accounts show continued gifts of wainscot and planks for the project.

TRADITIONS AND CONVENTIONS OF POLYCHROMY

Some south-western churchwardens' accounts are explicit in their discussion of artists' materials. Those for Yatton refer to 'oyle', 'vernaysche', 'glew', 'diverse colers for the loffte', 'chelke and greyecayk and paper', the latter perhaps implying the use of preparatory drawings or sketches taken from screens elsewhere.[44] Gold for the angel was stipulated separately. The colours came from Bristol, some 13 miles away, and a stone was brought from Chelvey, a neighbouring settlement, for the colours to be ground upon. Records at Ashburton also mention the purchase of oil. In contrast, the painters at Pilton appear to have come with their materials, as the only additional purchase for their work listed in the churchwardens' accounts is a table.

Rood lofts were decorated according to certain conventions and traditions. These conventions were local, but have strong points of comparison between regions. Technical study also indicates that colour scheme choices were guided by the level of funding for the construction and decoration. This can be seen in both East Anglia and Devon, and in both regions the more expensive pigments are centred on the front, west face of the screen and the higher parts of the structure nearer the Rood. At Hardwick in Norfolk, genuine gilding replaces lead tin yellow mimicking gold, from above the dado transom of the screen. As the screen ascends towards the most important part of the structure, the now-lost Rood, the

[43] Carpenter and Sudbury Burgess Thomas Loveday signed the roof at Gestingthorpe, Essex, as donor and maker. Wrapson, 'Patterns of Production', pp. 150–60.
[44] Hobhouse (ed.), *Church Wardens' Accounts*, pp. 96–8.

materials increase in their value. In much the same way there is a clear demarcation between the front and the back of the screen at Bridford (Pl. XXXVII). On the reverse, the scheme is mainly undertaken in lead tin yellow and vermilion over a red earth and probable red lead ground (tested using X-Ray Fluorescence Spectroscopy (XRF)). On the front, gilding and costly azurite are used instead. Colour schemes on Devon screens are often closely tied with those on pulpits, as can be seen at Holne (Pl. XXXVIII), where happily the pulpit will soon join the screen in being cleaned and conserved. The level of funding available for a screen can sometimes be indicated by the presence or absence of blue pigments. No blue is found on the lower reaches of Combe Martin or Ashton.

Choices of gold leaf versus orpiment and lead tin yellow were not always cost-guided, as is discussed later in this chapter in more depth. Instead other factors played a role, such as the contrasting visual effects of different materials juxtaposed, and the desire to use paint to represent haloes and metals representatively rather than materially.

In surviving examples in Devon, the backgrounds to the figure panels are most often painted black, as is the case in almost half of the surviving figurative screens.[45] At times, figures are painted on white backgrounds and, less commonly, on blue backgrounds.[46] Counterchange also proved popular; in some locations the dado panels alternate black and white, and in others alternating red and green panels are also found.[47] Perhaps towards the latter end of the making of screens (as can be proved to be the case in East Anglia) figures were positioned in Renaissance-style landscapes, or in the case of Whimple, in front of red brick buildings and green vegetation.[48]

In East Anglia, the backgrounds of screens are very rarely black, the only surviving example being the south parclose screen at Southwold. There instead, alternating red and green dominates, and there is only one instance in which the background is a pale white, decorated with floriated patterns in a brighter white (Irstead). Screens with Renaissance-style landscapes survive in greater numbers in East Anglia than in Devon, but perhaps only because there are more surviving screens (Wiggenhall St

[45] Alphington, Ashprington doors, Bradninch, Buckland-in-the-Moor, Chivelstone, Dodbrooke, East Portlemouth, St Mary Steps, Exeter, Heavitree, Holcombe Burnell, Kenn, Kingsteignton, Mamhead, Manaton, Peter Tavy, Plymtree, South Milton, Torbryan, Ugborough, Wolborough, dado from the V&A Museum.

[46] The figures are on white backgrounds at Bere Ferrers, Bovey Tracey, Chudleigh, St Saviour's Dartmouth, Dittisham and Ipplepen. Blue backgrounds can be seen behind the sculpted figures at Bridford, at Hennock and Stoke Gabriel. The originality of the background at Stoke Gabriel is uncertain, as it appears to have been overpainted, but has not been analysed.

[47] Black and white alternating panels are found at Blackawton, Cheriton Bishop, Harberton, Holne, Kenton and Widecombe in the Moor. Red and green counterchange is found at Alphington (north aisle, south aisle), Ashton, Berry Pomeroy, on the lower panels at Bridford, Combe Martin, St Saviour Dartmouth doors and Pilton.

[48] Powderham, Sherford and Whimple.

Mary the Virgin, Belstead, Wellingham, Beeston-next-Mileham). The five
or so that survive are datable to the sixteenth century. Also found on East
Anglian screens in the later examples are red and green cloths of honour
held behind figures, often with a sky or landscape above.

In Devon, rood screen dados are more often historiated than those
in East Anglia. Narrative scenes include the *Nativity*, *Annunciation* and
Visitation (Pls XXXIX and XL). This can lead to the same saint appearing,
in different settings, upon the same screen, as is the case with the Virgin
Mary at Buckland. Both the will of Pilton (Devon) screen donor Thomas
Martyn and the churchwarden's accounts for the screen at Ashburton
call the individual panels of screens 'pageants'; they are typically termed
'panes' in Norfolk and Suffolk wills. This perhaps demonstrates an inherent
understanding of the greater preponderance for narrative on Devon
screens, which are likened therefore to the scenes in plays.

In Devon, a number of screens have figure painting front and back, again
following certain conventions, which can be hard to fathom fully today.
The Devon paintings on the front face, just like those of East Anglia, are
typically religious figures, although there are slight differences between the
regions in the presence of classical sibyls in Devon, the greater fondness
for narrative scenes and Italianate grotesque work. Paintings on the reverse
face of Devon screens are often jocular and/or admonitory, perhaps
showing behavioural exemplars or otherworldly figures (as at Bridford).
They do not have tracery heads like the figures of the front, and are often
grisaille or limited in palette range (Ashton, Bridford and Buckland). In
contrast, in East Anglia, the painting on the reverse of screens is solely
decorative, the only exception to this being Swanton Abbot which was
restored by a past incumbent who turned the figure panels round to face
the chancel between 1906 and 1913.[49]

Despite these significant local variants, there are a number of shared
conventions east and west, including the decoration of beading with
barber's pole, of gilded trails with matt azurite set behind, and of sills
painted with imitation stone and marble. Stencils in gold and silver are
found on screens in both regions, but in Devon their use is habitually
limited to the structures around figure panels, whereas in East Anglia they
are also found upon the figure panels. More white floriated patterns are
to be found on the verticals of East Anglia than Devon, largely due to
the greater intricacy of carving found in Devon obviating this type of
decoration.

Equally, the intricacy of Devon carving seems to have removed the
need for pastiglia, tin relief or inlayed glass as part of the decoration of
screens. The presence of what appears to be tin relief on the sixteenth-

[49] A. M. Baker, *English Panel Paintings 1400–1558: A Survey of Figure Paintings on East
Anglian Rood Screens*, ed. and updated A. Ballantyne and P. Plummer (London, 2011), pp.
191–2.

century wall painting of the Assumption in Exeter Cathedral suggests that the technique was known by painters in the region, and its discovery analytically on fourteenth-century tombs in the cathedral indicates that this had been the case for a considerable period of time.[50]

THE CASE STUDIES

Cross-section samples were set in polyester resin and reflected light microscopy was carried out on a Zeiss Axioskop microscope. Observations about layer structure and material content were made at 200 and 500X magnification in normal light, bright field and ultraviolet light. Where possible, material used for paint dispersions was taken from the same tiny sample fragments as cross-sections. All layers were sampled, mounted and then examined using a Leitz Ortholux II Polarising microscope. Scanning Electron Microscopy/Energy Dispersive X-Ray Analysis (SEM/EDX) analysis was undertaken where questions remained after the stereomicroscopy and polarized light microscopy examination of samples. This was done using an Oxford Instruments Silicon Lithium EDX Spectrometer with INCA software. X-Ray Fluorescence Spectroscopy was undertaken *in situ* using a portable Bruker Tracer-III instrument (Tables 7.1 and 7.2).

GROUNDS AND INTERMEDIATE PREPARATORY LAYERS

It has long been known that Devon screens exploit the rich red ochre soils of the county for use in their grounds. However, far from being red ochre alone, many Devon screen ground layers are mixtures of doubtless locally sourced red earth and the manufactured pigment red lead. The implication is, therefore, that the choice to paint on a red ground was not solely the efficacy of a locally available cheap material. In addition, wider technical study has revealed that many of the grounds on Devon screens are double grounds with materially distinct layers. The lower layer often is a yellower red earth and is less refined than the second, redder layer (typically of red ochre mixed with red lead) which lies on top (Pl. XLI). Examples of this less-refined lower ground layer can be seen at Bridford, Combe Martin, Sherford and Torbryan, and SEM/EDX analysis indicates the greater presence of silicates, titanium and nickel, all impurities associated with the source of the red ochre in the lower layers.

[50] One effigy of a knight, thought to be that of Sir Henry de Boxe (d.1316–17), retains extensive elements of tin-relief chain mail, whilst the back wall of the monument is strewn with applied fleur-de-lys, although this latter could belong to a later medieval redecoration. Analysis was carried out by Catherine Hassall and Eddie Sinclair. The description of the technique on the wall painting is based on visual examination.

TABLE 7.1 CHURCH SCREENS

Sample origin	Location	No. samples	No. XRF readings (by Lucy Wrapson)
Eddie Sinclair (analysis Lucy Wrapson)	Alphington	26	
	Ashton		20
Anna Hulbert (analysis Lucy Wrapson)	Bridford	1	16
Eddie Sinclair (analysis Lucy Wrapson)	Buckland-in-the-Moor	15	
	Cheriton Bishop		15
Eddie Sinclair (analysis Catherine Hassall and Lucy Wrapson)	Combe Martin	39	
Eddie Sinclair (analysis Lucy Wrapson)	Cullompton Golgotha roodbeam	1	
Eddie Sinclair (analysis Lucy Wrapson)	East Portlemouth	14	
Eddie Sinclair (analysis Lucy Wrapson)	Heavitree	2	
	Holcombe Burnell		16
Eddie Sinclair (analysis Catherine Hassall)	Holne	23	
Anna Hulbert (analysis Lucy Wrapson)	Hennock	1	
Anna Hulbert (analysis Lucy Wrapson)	Manaton	3	
Elizabeth Cheadle (analysis Lucy Wrapson)	Pilton	5	
Eddie Sinclair (analysis Catherine Hassall and Lucy Wrapson)	Sherford	17	
Eddie Sinclair (analysis Lucy Wrapson)	South Pool	17	

Sample origin	Location	No. samples	No. XRF readings (by Lucy Wrapson)
Eddie Sinclair/Jane Rutherfoord (analysis Catherine Hassall and Lucy Wrapson)	Torbryan	21	
Anna Hulbert (analysis Catherine Hassall)	Uffculme	6	
Eddie Sinclair (analysis Lucy Wrapson)	V&A Adoration of the Magi*	13	
Eddie Sinclair (analysis Lucy Wrapson)	Willand	14	

*Many thanks to Nick Humphries for allowing investigations to take place.

Note Many of these screens have unpublished condition reports and technical reports which are outlined in the Bibliography.

TABLE 7.2 PLANK AND MUNTIN SCREENS

Sample origin	Location	No. samples	No. XRF readings
Eddie Sinclair (analysis Lucy Wrapson)	Little Harvey Farm	3	11
Eddie Sinclair (analysis Eddie Sinclair and Catherine Hassall)	Marker's Cottage	15	
Eddie Sinclair (analysis Catherine Hassall)	21 The Mint, east screen	5	
Eddie Sinclair (analysis Catherine Hassall)	21 The Mint, west screen	6	
Eddie Sinclair (analysis Catherine Hassall)	Osmonds Farmhouse	7	

At East Portlemouth, the lowest layer is a refined red earth, the subsequent red layer is predominately red lead. At Manaton, as many as five successive ground layers can be perceived. At Holne, a very thin chalk layer was applied before the first red ground. Minor variations and differences between screens are found: at South Pool, two reds are present, the lower being largely red earth, the upper red lead. The red lead layer may be an intermediate layer in oil over the chiefly red earth glue-bound ground. At Uffculme, the red earth lower layer is mixed with a little vermilion, and lead white, while passages of red paint also contain red lead. In short, the painters could vary their reds with several available pigments to desired visual effect. It was also noted during conservation treatment that the screen in Littlehempston church has what appears to be an overall red earth ground, thought to be medieval, despite the rest of the paint being eighteenth- or nineteenth-century.

Just occasionally, Devon screens and related objects deviate more substantially from the usual fifteenth-/sixteenth-century red grounds. For example, Cullompton's Golgotha roodbeam has a yellow ochre and chalk ground. Most notable is the case of Buckland-in-the-Moor, where the figure paintings are on a white, chalk ground, a choice of build-up in common with medieval paintings from Norfolk to Yorkshire, and from the thirteenth century until the Reformation. At Buckland, the surrounds of the panels and the architectural superstructure are undertaken in the traditional manner over the red ground. Some of the panels on the screen at Lanreath in Cornwall appear to be on chalk, while other panels and the superstructure have a red ground. Buckland and Lanreath in no way stylistically seem to have been painted by the same workshop (Pls XXXIX and XLII). One possible explanation for Buckland, that the figure panels were painted by a different workshop from the rest, is not borne out by physical examination (in both cases the relationship between the two parts of the screen is intimate). Instead, the white ground was probably chosen in preference for depicting what was to lie above.

Coloured grounds have been found in Northern European painting of the medieval tradition, as well as later coming to the fore in Italian sixteenth-century painting on canvas. Scharff proposes that coloured grounds, where found on Northern European medieval paintings, might be linked to the use of oil as a medium for those grounds. While this might be true in the case of painting on stone, in which an initial oil layer instead of a glue-bound layer is required, it does not explain red grounds on Devon screens, of which some at least are glue-bound.[51]

Quite when and why the red ground polychromy tradition arose is not

[51] M. Scharff, 'Early Medieval Painting Techniques in Northern Europe: A Discussion of the Use of Coloured Grounds and Other Notable Techniques', in U. Schiessl and R. Kühnen (eds), *Polychrome Skulptur in Europa, Tagungsbeiträge, Hochschule für Bildende Künste* (Dresden, 1999), pp. 47–52.

known. It may simply be a local tradition, developed for being robust and/
or to be efficacious to the widespread application of gold leaf. Plummer
and Hulbert raised the point concerning red grounds in contrast with
chalk or gesso grounds, noting that though they are regularly underbound,
they are more stable.[52] Study of 120 East Anglian grounds reveals them all
to be chalk-based, with one example only of a chalk and glass ground.[53]
Red grounds may have dominated in the West Country for this practical
reason. The local availability of the red earth component could also have
added to their popularity. In addition, the beautifully carved cornices of
Devon screens are heavily gilded, whereas figure panels, though of greater
interest now, are a lesser part of the Rood ensemble as a whole. A red
colour imparts a warmth to gilding, when used in either the mordant
or the water-gilded technique. Although some specifically applied yellow,
orange and buff coloured mordant layers can be seen on Devon screens
(as at Sherford), specifically in those areas adjacent to dado panels, there
are also instances in which the red grounds or red priming layers are used
directly as bases for mordant gilding, for example on the cornice of the
rood screen at South Pool.

An alternative explanation is that the red ground tradition came in
from abroad, perhaps from Brittany, just as Breton carvers came in to
create the screens at Coleridge, Brushford and Colebrooke. However, the
evidence for this hypothesis is scant, as the polychromy on Breton screens
is often reworked and survives poorly. The only Breton screen on which
an original red ground layer could be readily discerned in a visual analysis
of the earliest Breton examples was the seventeenth-century example at
Saint-Nicolas at Priziac. The medieval screens, dating to c.1485, such as
the Chapel of Kerfons at Ploubezre, the Chapel of Lambader at Plouvorn
and Saint-Fiacre at Le Faouët, were either stripped or have been repainted.

Devon ground layers have been considered to be glue-bound, largely
based on their behaviour during conservation treatment (they are water-
soluble and often underbound and so must be treated with great care
during cleaning). Although a wide-scale survey has not been undertaken,
this is most likely an accurate assessment. Fourier Transform Infrared
Spectroscopy of a sample from the screen at Combe Martin, undertaken
by Dr Brian Singer, indicated the presence of protein.[54]

Layers which can be described as 'sealants', 'primings' or perhaps more
accurately as 'intermediate layers' are often found on Devon screens. The
language of sealants, primings and intermediate layers can be controversial,
and recently attempts have been made to clarify terminology.[55] A sealant

[52] Plummer and Hulbert, 'English Polychromed Church Screens', p. 49.
[53] Wrapson, 'Patterns of Production', p. 355. Gypsum was only ever found to be a minor
component of grounds.
[54] B. Singer, 'Investigation of Paint Samples from 15th and 16th Century English Rood
Screen Paintings', Unpublished Report, Northumbria University (Northumbria, 2012).
[55] A. Vandivere, 'From the Ground Up: Surface and Sub-Surface Effects in Fifteenth- and

layer was required before the oil painting could commence over a glue-bound ground, otherwise the paint would be absorbed by the ground layer. This intermediate layer might be glue or oil, and there can be considerable difficulty in separating layers sufficiently to test media with certainty, as paint binding media can also settle out and move over time.

At Combe Martin, the priming or sealant is a red lead layer in some places. In other situations, it is colourless. It may be that the secondary red layer found on numerous screens can be considered a 'priming' or intermediate layer, as it is probably the first layer in oil after the ground. However, without carefully pinpointed medium analysis, it is difficult to generalize.

Notably, the painting of the figure panels with a white or grey priming is a widespread though not ubiquitous practice found among distinct workshops. At Holne, the figures are underpainted in lead white, as they are on all three parts of the screen at Alphington. At Sherford, the layer is a warm lead white, also containing a little red ochre, and it is observed under both the sky and one of the figures. At Torbryan, a buff lead white containing underlayer was found beneath the green drapery of a figure. The section of screen dado from the V&A also exhibits this practice, though there the underlayer is a grey/buff containing more earth pigments and charcoal along with lead white. The visual appearance and interaction of all these pale paint layers as viewed in cross-section indicates that the priming layers are oil-bound, but this has not been tested instrumentally and will hopefully be the focus of future research.[56]

The practice of underpainting figure panels with pale paints indicates that the figure panels were by no means the key area of the painting and nor were red grounds considered suited to them. This lends weight to the argument that the red grounds on Devon screens were for the overall benefit of gilding and polychromy, and not for the figure paintings.

Our contemporary cultural attitude to historical figurative painting, favouring it over architectural paint, can skew the assessment of medieval polychromy. That the figure paintings survive from a largely dismantled structure can lead to them being accorded greater significance than they were viewed with at the time. In fact, the hierarchical use of pigments indicates the much greater significance of the sculptures of the loft and rood, the theological 'business end' of the Rood ensemble.

Sixteenth-Century Netherlandish Paintings' (PhD thesis, University of Amsterdam, 2013).

[56] The sample locations at Manaton and Hennock are not known, and so this could not be assessed for those screens. The screen at Bridford has a sculpted dado, and no samples have been taken from the reverse paintings, therefore the presence of an underlayer has not been assessed there. Those screens which have been subject to XRF analysis only cannot be assessed in this way (Ashton, Holcombe Burnell and Cheriton Bishop). The samples from Pilton, Heavitree and Uffculme were from the architectural surrounds. The sample from Cullompton is from a roodbeam rather than a painted figure panel, and Willand is not a figurative screen.

UNDERDRAWING

Underdrawing was captured in a sample from Holne doors by Eddie Sinclair and Catherine Hassall and shown to be carbon black. Underdrawing was also perceived using a modified infrared sensitive camera on the rood screen at Holcombe Burnell, where a *pentimento* was viewed on the sleeve of the figure of St Thecla (Pl. XLIII).[57] There the shape of her arm was delineated beneath the sleeve, but this shape was not painted in in the final stages.

It is thought in this case that carbon black was used. The use of red grounds probably means that where underdrawing is present on Devon screens, it most likely was undertaken using a black or dark pigment, rather than red. Red grounds can make underdrawing difficult to perceive, even where carbon black has been used as at Holne. The viewing of underdrawing using an infrared sensitive camera is not as easily done as with a more penetrative vidicon or equivalent digital system. Moreover, the visibility of carbon underdrawing is typically heightened in those situations in which the underdrawing is drawn or painted onto a reflective white surface such as a chalk ground.

BINDING MEDIA

In the course of the present study, two samples from the screen at Combe Martin were subject to Fourier Transform Infrared Spectroscopy. This was undertaken by Dr Brian Singer. The sample was divided into two pieces, the ground and the upper layers. A drying oil was found to be present in the upper layers and animal glue was found to be the binding medium of the lower layers. Use of animal glue as the binding medium for the ground is consistent with Northern European painting practice, even while the pigmentation is more unusual and typically associated with oil-based grounds.[58] The use of oil for the paint layers is consistent with Northern European painting practice and is also made clear by churchwardens' accounts.

PAINT LAYERS AND PIGMENTS

The pigments and paint layers on Devon's screens are traditional materially and in their style of application, though a slightly wider palette of pigments has been found on Devon screens when compared with East Anglia (there is, for example, a wider use of orpiment, and malachite as well as azurite has been found). On the figure panels, there is limited

[57] Using a modified Canon 30D with infrared filters.
[58] Scharff, 'Early Medieval Painting Techniques in Northern Europe', pp. 47–52.

wet-in-wet blending, though its use, and the use of impasto, is found more readily in the sixteenth century as Renaissance ideas come to be felt. While Devon figure painting is considered rustic in design, the painters can be demonstrated to understand, use and manipulate their paint to good effect. This can be seen in the addition of synthetic copper greens to blacks, probably to benefit lustre and aid drying and also in the underlayering systems for blue pigments, for example, where the light-sensitive indigo is layered beneath azurite to give the azurite more impact.

BLACK

Most of the black pigments on the screens examined were char blacks derived from plant material, which is often clearly visible in PLM. A vine black, probably derived from soot, was observed on the screen at Willand. In the examples studied, no bone black has been found, however, it is likely that further testing of other screens would find this pigment, as it was certainly available, and the portable XRF instrument, used without a helium vacuum, is not able to detect phosphorus reliably.

Deliberately black paint passages containing copper were found on the backgrounds of the panels at Holcombe Burnell and Cheriton Bishop, on St Leonard's cloak at Ashton, and on the barber's pole on the south side of the door at Willand. Copper was observed using XRF on the backgrounds of the four figure panels tested at Holcombe Burnell, at Cheriton Bishop and Ashton, and using SEM/EDX and PLM on the cross-section sample from Willand. PLM indicated that the material in the Willand case was an isotropic synthetic copper green such as verdigris or copper resinate. It is likely that a green glaze was used to adjust the lustre and drying properties of the black, as copper pigments are known for aiding drying.

BROWN

Comparatively few brown passages of paint have been sampled. Where there have been samples, browns are typically achieved with blends of charcoal black and red and yellow ochres (V&A dado).

WHITE AND COLOURLESS

Lead white, chalk and silicates are the white and colourless pigments that predominate on screens. Lead white is typically used in garments and in flesh painting, and was found on all the church screens examined. Chalk is sometimes found as an extender in other pigment mixes, and is discernible in PLM from the presence of coccoliths. Chalk was found as the chief component of the ground on the figure panels at Buckland and also as a thin preparatory layer before the red grounds at Holne. An instance of the use of a bone white was identified using PLM in a sample from Heavitree and was targeted using SEM/EDX and found to have been a component in the ground layer.

RED

Red is used to great effect on Devon screens, from the lustrous red lake glazes over gold and silver leaf to opaque red leads, vermilions and red earths. These pigments are present on most screens. Although the red lake pigments have not been analysed using High Performance Liquid Chromatography, examination using stereomicroscopy and PLM indicates that they are probably mixed sources of lakes, derived from cloth shearings, as in several instances the samples display both the typical orange fluorescence of madder and the particles of another, darker, red lake (Pl. XLIV). The practice of preparing lakes as pigments extracted from dyed cloths was quite common in this period.[59]

GREEN

Synthetic copper greens such as verdigris and copper oleates and resinates are the predominant greens found on Devon screens. Mixed greens, comprising blue and yellow pigments, have not been found, though synthetic copper greens are at times mixed with lead tin yellow. Both malachite and a synthetic copper green were identified on the screen at Willand, using PLM. Malachite has not to date been identified on screens in East Anglia.

BLUE

Azurite and indigo are regularly found on Devon screens, often used in layered effect. Indigo mixed with lead white acts as an underlayer for azurite layers on the section of screen dado now in the V&A, Buckland-in-the-Moor and also on the screens at Alphington. Indigo and azurite are mixed together with lead white at Buckland-in-the-Moor. The azurite colour is bolstered with a grey underlayer at Heavitree. In no instance so far tested have smalt, ultramarine or vivianite been found. Sometimes blue pigments are absent from lower reaches of screens, as at Ashton. This might well be financially motivated, as blue pigments were among the most expensive. Screens without blue are also often those which have less gold leaf and more lead tin yellow/orpiment instead.

YELLOW

Yellow ochre, lead tin yellow and orpiment are the yellow pigments found on screens. Ochres are consistently used in the mordant mixtures beneath gilding and are seen in brown paint passages. Orpiment was a mining by-product and is notably more present in Devon in an area of silver mining (and also close to Cornwall where mining was a key industry). It can be seen at Combe Martin and Willand. In contrast, in East Anglia, only one example of orpiment has been found, at Stradishall in Suffolk.

[59] J. Kirby, M. Spring and C. Higgitt, 'The Technology of Red Lake Manufacture: Study of the Dyestuff Substrate', *The National Gallery Technical Bulletin*, 26 (2005), pp. 71–87.

Orpiment is sometimes used in place of gold on spandrel carvings (for example, at Combe Martin). At times it replaces gold in the depiction of haloes. Lead tin yellow is also used for drapery, haloes, and for the depiction of metal croziers, buckles and so forth on dado panels.

The choice of paint over metal leaf in the depiction of metallic objects and haloes is a fascinating one. The dated evidence from Norfolk and Suffolk shows that a transition took place in that region between about 1480 and 1500. Two screens there, painted by the same workshop but dated c.1479 and c.1500 respectively, demonstrate the transition clearly. At Ranworth, St Philip's bread basket is painted in black lines over a silver basket, the precious bread being symbolized by the precious material. On the chancel screen at Southwold, it is instead modelled perspectively in ochres and lead tin yellow, a response to Renaissance ideas. Many Devon screens, which seem to be likely from figure costumes and style to be sixteenth century in date, resemble the Southwold screen in the use of painted modelling rather than metal leaf.

Although it has been suggested that the painters of rood screen frameworks were distinct from the painters of the panels, technical examination reveals this not to be the case, neither in Devon nor in East Anglia.[60] Despite this, there is often a distinction between the genuine gold leaf used on three-dimensional polychrome structures such as dado tracery heads and the lead tin yellow and orpiment that mimic gold on the two-dimensional dado boards (Pl. XLV). This division is probably best explained in terms of mindset rather than division of labour, or cost. Devon's screen painters seem to have seen a distinction between the mode of depiction for three-dimensional structures, on a red ground and using genuine gold leaf, and two-dimensional flat panels, which were to mimic the fall of light on metallic surfaces using paint. This is demonstrated well at Bridford, where the three-dimensional dado figures are gilded, compared with the screen at Cheriton Bishop, where the haloes and croziers are depicted with lead tin yellow (Pl. XLVI).

SILVER AND GOLD

Silver and gold leaf are both found on screens, often in alternating stencil patterns on the structural elements. Metal leaves are also found on barber's pole elements and on Aaron's rod and vine-trail decorations. The red and green grapes of the vine-trail cornices are typically lustrous red and green glazes painted over silver. The cornices of screens are also often richly gilded, as these were important parts of the screen, supporting the loft and closer to the Rood than the dado. SEM/EDX analysis of gold leaf from Willand reveals it to be almost pure gold, with only a little silver.

60 S. Medlar, 'Decorative Motifs on Norfolk's Medieval Rood-screens', *The Quarterly: The Journal of the Norfolk Archaeological and Historical Research Group*, 30 (1998), pp. 6–10.

DECORATIVE TECHNIQUES

Tin-relief patterns and applied glass decorations are not found on Devon screens, unlike those in East Anglia. While there are gilded stencils, they do not powder the backgrounds of the dado panels to the same extent as in the eastern counties. This is probably just a matter of stylistic choice. However, the probable reason for there being fewer decorative techniques used on the surface of screens is the high degree of carving on Devon screens, which obviates the need for such methods.

VARNISHES

As has been demonstrated, churchwardens' accounts from the West Country explicitly refer to the purchase of varnish for the decoration of screens and so its use can be reasonably expected. There is evidence for the application of varnish on medieval painted wooden surfaces, often comprising a drying oil, sometimes resin and oil, or resin alone.[61] For the earlier medieval period in particular, varnishes were not applied throughout the whole surface, nor were they always the last process to take place. For example, in the case of the Westminster Retable, the figures were varnished, but not the background, and, moreover, some of the hemline details were painted over the varnish layer.[62]

Screens were often the recipients of early whitewashing and repaints, plus they are large structures, so they have traditionally been less subject to repeat cycles of cleaning and revarnishing than panel paintings now found in a gallery context. This means that early, likely original, varnishes remain on certain screens, particularly beneath early non-original schemes. A number of sixteenth-century screens were defaced, dismantled and/or covered over within only a few years of having been completed. Atherington is an especially poignant case, after all the carpenters were never paid and it was rendered obsolete almost immediately and possibly never painted. This does mean though that Devon screens are an important body of painted objects through which to understand the nature of early varnishes. Although specialist analysis has not been undertaken on these paintings, some conclusions can be tentatively drawn.

Possible original varnishes were noted at Combe Martin, Uffculme, Pilton, Sherford and Torbryan. At Uffculme, Catherine Hassall found what she suggests is an oil varnish, sandwiched between the original and restored schemes; there was no ultraviolet fluorescence. In much the same

[61] M. L. Sauerberg, H. Howard et al., 'The Final Touches: Evidence from the Study of Varnishes on Medieval Polychromy in England', *Die Sprache des Materials – Kölner Maltechnik des Spätmittelalters im Kontext, Zeitschrift für Kunsttechnologie und Konservierung*, 26:1 (2012), pp. 241–58.

[62] P. Binski, and A. Massing (eds), *The Westminster Retable* (London and Turnhout, 2009), pp. 244–6.

way, at Torbryan several coats of varnish and dirt lie between nineteenth-century overpaint and original paint layers. At Sherford a thin layer of varnish over the gold was seen beneath the overpaint, but it is not clear if this is original. At Combe Martin, another early varnish can be seen beneath a hand-ground white putty. In this case, the layer fluoresces and probably contains resin.

Varnishes do not necessarily appear to have been applied over the whole architectural structure, although systematic targeted sampling would be required to understand better their original distribution. Although it was not possible as part of the current work to analyse the constituents of the varnishes in these cases, it is hoped that this can be explored in the future, preferably using a technique such as Attenuated Total Reflectance Fourier Transform Infrared Spectroscopy (ATR-FTIR) on these same samples.

PLANK AND MUNTIN SCREENS

Devon's secular screens are even rarer survivors than its church screens. As stated above, plank and muntin screens are found along passageways and as partitions between the main rooms of medieval Devon houses. Analysis from five screens has been brought together here. Three of these screens are from a secular context, at Marker's Cottage, Little Harvey Farm and Osmonds Farm, and two derive from the refectory of the Benedictine Priory of St Nicholas in Exeter (now 21 The Mint). It is appreciated that, in their case, the term secular is pushing the boundary of definitions. However, these screens were sited outside a worship context and have features in common with both the decorative traditions of church screens and those of secular plank and muntin screens.

The screen at Marker's Cottage (Pl. XLVII) has a bold diaper pattern with stylized pomegranate motifs, foliage and scroll work, as well as a figure of St Andrew and the faint traces of a figure in a mandorla, presumably the Virgin Mary.[63] The screen is thought to date from c.1520–50 and retains paintings on both sides, although the best preserved paintings are those facing into the parlour. The painted scheme comprises iron oxide red, red lead, calcium carbonate white and carbon black, while the yellow was undertaken using the more costly pigment orpiment, and glazing with red lake. The oak boards were initially painted with chalk before the background colours were applied. Although medium analysis has not been undertaken, the opacity of the calcium carbonate white indicates a non-oil medium, probably glue. This was confirmed by solubility tests during conservation cleaning. However, one area of the painting, a red trellis pattern, was found to be insoluble and had probably received an additional glaze in egg or oil.

[63] Sinclair and Richardson, 'The Polychrome-decorated Plank-and-muntin Screen'.

Marker's compares quite closely materially with the sixteenth-century screens at both Little Harvey Farm and Osmonds Farm. Little Harvey Farm's screen is decorated with a diaper pattern and religious motifs, specifically the pelican in her piety (Pl. XLVIII). The screen at Little Harvey Farm appears to have been decorated in two phases, with a red ground in each. Initially, a red ground was applied, which in turn was covered with a charcoal black. This was then regrounded in red lead and iron oxide red before the decorative designs were undertaken in iron oxide red, red lead, calcium carbonate white and charcoal black and possibly with the use of a yellow organic glaze or oil. The opacity of the calcium carbonate white, as well as the appearance of the paint film, suggests a glue medium.

The screen at Osmonds Farm was initially covered with a black charcoal layer, thought to be deliberate rather than soot, perhaps an early or temporary scheme. Black was found to be a ground colour on some Scottish ceilings of the period 1550–1650.[64] The Osmonds screen was later covered with a chalk ground on which coloured layers of red lead, carbon black, yellow ochre and some orpiment were painted. The design, considered seventeeth century in date, is of strapwork and flowers in yellow and red. Although no medium analysis was undertaken, practical cleaning tests suggested a glue-based medium.

The terminology surrounding water-soluble paints can be problematic, and near-contemporary sources refer to 'distemper', 'cole' and 'watercolour' sometimes interchangeably in connection with decorative painting.[65] The thick, durable and probably originally varnished paints of the type found on plank and muntin screens find their closest surviving description in the 'cole' method outlined by John Guillim in this book on painting, which probably dates to the end of the sixteenth century. The 'cole' he describes is a thicker glue than size, but it is also derived from animal skin. He also describes how to varnish painting in both glue and oil, though, interestingly, egg tempera painting is mentioned only as a novel alternative to oil.[66] Murray found glue-bound media to predominate on Scottish Renaissance ceilings of the period 1550–1650, and two Welsh plank and muntin screens of c.1550 were also determined to be glue-bound.[67]

[64] A. Murray, 'Scottish Renaissance Timber Painted Ceilings and the Stirling Heads Project', in D. Odgers and L. Humphries (eds), *Polychrome Wood. Post-prints of a Conference in Two Parts Organised by The Institute of Conservation Stone and Wall Paintings Group, Hampton Court Palace October 2007 and March 2008* (London, 2010), p. 180.

[65] J. Murrell, 'John Guillim's Book: A Heraldic Painter's Vade Mecum', *The Walpole Society*, 57 (1993–94), p. 7.

[66] Ibid.

[67] Murray, 'Scottish Renaissance Timber Painted Ceilings', p. 180; R. McNeilage, 'Secular and Sacred: Two Case Studies in Polychromed Wood', in D. Odgers and L. Humphries (eds), *Polychrome Wood. Post-prints of a Conference in Two Parts Organised by The Institute of Conservation Stone and Wall Paintings Group, Hampton Court Palace October 2007 and March 2008* (London, 2010), pp. 216–17.

The presence of a non-water-soluble glaze at Marker's Cottage is an interesting discovery among the decorative domestic schemes, hinting as it does at the diversity of media employed for domestic screens. Varnish layers were found on the secular screens, but their originality can be hard to assess, as with church screens. Given what Guillim describes, as well as the darkened varnished surfaces that survive, it seems highly likely that varnishes were originally used.

The screens at 21 The Mint make for a fascinating comparison with the domestic plank and muntin screens outlined above. Both screens face one another along a passage. The east screen is a simple plank and muntin screen decorated with red and green alternating panels. The studs between are yellow, with black decoration. The green, a mixed green containing orpiment and indigo, is thought to be a secondary scheme dating from the later sixteenth or seventeenth centuries, but it likely replaced an original scheme of the same colour. However, the decoration on this screen is rather like a hybrid between the alternating panels of a rood screen and the black on yellow decoration of a plank and muntin screen in a Devon hall house. The west screen is more elaborately carved and in design is closer to a rood screen. It formerly was sited at the opposite end in the refectory. It has a ground and priming of red ochre and red lead as well as paint layers of yellow ochre, verdigris and red lead. The presence of lead white, and the glossy appearance of the paint film, as well as its behaviour in samples and in conservation, all suggest the use of oil as the medium in these two screens. As such, these two, understandably given their location, have more affinity with church screens, specifically in the choice of medium, in the use of red grounds and in the alternation of red and green. Notably, though, they share with plank and muntin screens the use of black over yellow for decorative motifs, probably because of their setting. Oil-based paints were probably more expensive, taking longer to dry and it is probably because the refectory screens were better funded than their domestic counterparts that this method was employed.

CONCLUSION

This chapter reviews what is currently known about the polychromy of Devon screens, identifying materials and trends over a wider body of work than has been previously attempted. The techniques of a variety of non-church screens are also outlined here for the first time, revealing them to be an important body of paintings undertaken sometimes in glue and sometimes in oil.

There are several key discoveries that come from the new analysis, as well as from an assessment of past analysis. Among the rood screens, a greater diversity of ground and priming layers was found, involving more red lead and unrefined earth pigments than had previously been noted, as

well as the presence of a chalk-grounded dado at Buckland. The presence of white and grey underlayers on figurative panels was uncovered in the painting of different workshops. This strongly suggests that the choice of red grounds on Devon screens related to the wider polychromy and especially gilding of the rood loft and not to the dado of the screen structure.

The use of lead tin yellow and orpiment to represent metal, gold and light effects on the figurative dados of screens also raised interesting questions. While the same broad representational trend is found on screens in Norfolk from about 1500, the practice is more widespread in Devon. It perhaps reflects what is implied by dated examples and by design and stylistic features on Devon screens: that a slightly higher percentage of those surviving in the county are of sixteenth-century date than in Norfolk.

This division between paint and gilding is a more sophisticated idea than the simple earthy appearance of screens of Devon might at first suggest. To consider the uncomplicated design of figures indicative of their being poorly painted is to misinterpret Devon polychromy. Devon rood screen paintings have sound technical understanding of materials, and a full range of medieval pigments which must have derived from both near and far. Screen painting existed within a decorative tradition, despite an apparent simplicity. Moreover, Devon's screen painters demonstrated the then contemporary influence of continental works of art in the depiction of sibyls, grisailles, strapwork and grotesques, responding to the art of mainland Europe rather differently than the painters of screens in East Anglia.

From a technical perspective, more remains to be done to understand painting in Devon in the late medieval period better. Further study of the red lake pigments, of original and early varnishes and of the distribution of glue and oil within the paint structures would all increase our understanding. However, it is hoped that this essay encourages an appreciation of Devon's polychrome screens, representatives of a different painting tradition from the Court and from the rood screens of the east of England.

8
MOVING PICTURES ON THE GOTHIC CHOIR SCREEN

JACQUELINE E. JUNG

To speak of 'moving pictures' on a 'big screen' is to evoke a quintessentially modern experience,[1] one that involves sitting in one place watching ephemeral images flow by before one's eyes, across a suspended support that, ideally, must remain invisible.[2] The 'moving images' this essay addresses, by contrast, and the mode of perception they required, were of a very different variety. The men and women who inhabited medieval churches were often themselves on the move, whether in the course of processional liturgies, private devotions to saints or commemorations for the dead, or more pragmatic wanderings (popping

[1] I wrote this essay for the CRASSH conference in April 2012, at the same time as I was making final revisions to my book manuscript *The Gothic Screen: Space, Sculpture, and Community in the Cathedrals of France and Germany, ca. 1200–1400* (Cambridge, 2013). As a sneak preview of that project, the paper incorporated many ideas and several substantial passages from the book, though the unifying theme of movement was something new. Only slightly revised since its initial presentation, the present essay includes a rather embarrassing number of self-referential notes; with them I wish merely to direct readers to the extensive bibliography and fuller image arrays they will find in my book, and to pinpoint the areas that are discussed more fully or from a different angle there. I am immeasurably grateful for Paul Binski and his colleagues in CRASSH for inviting me to share my work in what was a most illuminating symposium at Cambridge, and to the other participants for helping me to press my ideas further.

[2] See the remarks by S. Eisenstein, 'Montage and Architecture' (1938), *Assemblage*, 10 (December 1989), p. 111, contrasting the experience of film as 'a multiplicity of phenomena, far apart in time and space, gathered in a certain sequence into a single meaningful concept, . . . pass[ing] in front of a moving spectator' with pre-modern experiences in which 'the spectator moved between [a series of] carefully disposed phenomena that he absorbed sequentially with his visual sense.' The medieval cathedral, with its screens and chapels embellished by diverse colours and programs of imagery in a variety of media, lends itself especially well to being considered a kind of proto-cinema in three dimensions.

in to salute a St Christopher mural, say, or taking shelter from the rain). In churches large and small, the screens at the threshold of the church's nave and liturgical choir controlled and channelled people's movement, keeping casual visitors out of the sanctuary during recitations of the Divine Office and ensuring that passage between zones would always be recognized as a special and serious event.

The sculpted imagery that embellished the nave-facing surfaces of the monumental stone screens in continental churches in the later Middle Ages responded to the presumed mobility of viewers in various ways. Sometimes, as we shall see, scenes were so arrayed as to be 'turned on' in the course of dramatic rites; this seems to have been the case at Havelberg Cathedral. Sometimes they urged beholders to shift standpoints and catch different views into the choir, as in the church of St Mary in Gelnhausen. Sometimes they arrested beholders by presenting them with 'freeze-frame' compositions of complex actions unfolding, or drew them near to participate in more intimate scenes, as happened at Naumburg Cathedral (Pl. XLIX). And sometimes they thematized motion itself, drawing the spatial dynamics of communication within the cathedral into the drama of sacred history, as at the Cathedral of Notre-Dame in Chartres.

In all these cases, the choir screen did not *hinder* vision, as has so often been averred; far from it.[3] It presented beholders with a visual experience no less rich, dynamic and memorable than the modern movie screen – an experience that was further enhanced, we must always recall, by the sounds of chant and reading; the aromas of candles, oil and incense; and visual-tactile ephemera such as curtains and tapestries. In contrast with the situation in cinemas, the physical structure of the choir screen played an integral role in determining how its imagery would be apprehended and absorbed. And that imagery directed itself not just to sets of eyes but to fully embodied beholders – viewers whom the images also aimed to *move* inwardly, through a heightened emotional rhetoric, through the modernization of depicted costumes and settings, or through thematic inflections that made biblical tales relatable to Northern European men and women of various social strata.

It is important of course to keep in mind that the images that animated choir screens in such ways were not always set in stone; sometimes (probably indeed more often than we know) screens set the stage for three-dimensional spectacles that involved living actors and complicated props. A Russian Orthodox bishop named Abram of Souzdal famously described two such performances he witnessed while visiting Florence on ecclesiastical business in 1439.[4] The first took place in the monastery

[3] For post-medieval accusations of screens obstructing vision – often a handy excuse for tearing them down – see Jung, *The Gothic Screen*, pp. 12–17.

[4] The full account of these spectacles is provided, in English translation, in P. Meredith

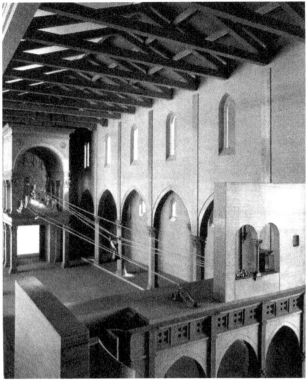

FIG. 8.1. FLORENCE,
SANTISSIMA
ANNUNZIATA,
MODEL OF THE
APPARATUS
FOR THE
ANNUNCIATION
PLAY (PHOTO:
AFTER HALL,
*TRAMEZZO IN
THE ITALIAN
RENAISSANCE*).

church of Santa Annunziata. For the occasion, he tells us, a large scaffold had been erected over the church's western entrance. There, enthroned on a circular stepped podium, sat a man representing God the Father, surrounded by singing children and brightly gleaming oil lamps (a thousand, by Abram's reckoning). But the crowd assembled in the nave kept its eyes fixed on the large stone structure in the centre of the church (Abram calls this a *tramezzo* or a *ponte*), where curtains were drawn back to reveal a man in a maiden's garb sitting next to a small bed, 'all full of beauty, wonder, and grace'. The quiet scene did not last long, as four prophets soon joined this Virgin Mary; and for the next half-hour, they paced back and forth atop the screen, brandishing scrolls and casting them down as they argued over when the Messiah would come. Those viewers who found themselves zoning out during this lengthy interlude were jolted back to attention when bolts of thunder emanating from the western scaffold silenced the men, and, to the accompaniment of more blazing lights and singing children, a 'beautiful, curly-headed youth, dressed in a robe as white as snow … [and] holding a branch in his hand' swooped over their heads.

Like the rest of the audience, Abram was dazzled – but the mechanics were lost on no one: Abram tells us all about the elaborate rope-and-pulley system, rigged up high overhead, that effected the angel's journey from the scaffold of heaven to the Virgin's chamber on the *tramezzo* (Fig. 8.1).[5] Mary was less impressed; she rebuked the intruder for his 'foolish speech' (the *Ave Maria!*) and warned him to leave before her husband found him

and J. E. Tailby (eds), *The Staging of Religious Drama in Europe in the Later Middle Ages: Texts and Documents in English Translation* (Kalamazoo, 1982), pp. 243–7. See also O. K. Larson, 'Bishop Abraham of Souzdal's Description of *Sacre Rapprezentazioni*', *Educational Theatre Journal*, 9 (October 1957), pp. 208–13; M. B. Hall, 'The *Tramezzo* in the Italian Renaissance, Revisited', in S. E. J. Gerstel (ed.), *Thresholds of the Sacred: Architectural, Art Historical, Liturgical, and Theological Perspectives on Religious Screens, East and West* (Washington, DC, 2006), pp. 222–3.

5 See also Hall, '*Tramezzo* in the Italian Renaissance', p. 222.

and 'cut [off his] head with an axe'. Only when she 'lifted her eyes' to find God, perched back on the western scaffolding, did she acquiesce. His mission accomplished, the angel soared back down the ropes, this time '[singing] jubilantly . . . and [moving] his hands about . . . as if he were really flying'. Most marvellous of all, it seems, was the fact that the spark-shooting flames that also 'poured forth and spread with increasing intensity and noise [along the ropes] from the high scaffold, lighting the lamps of the church', managed not to 'burn the clothes of the spectators or cause any harm'. With the angel's safe arrival in heaven, and the closing of curtains around him, the spectacle came to an end. Abram feared he could not do it justice in words.

Two months later, Abram witnessed a production he called 'even more marvellous' during the feast of the Ascension celebrated in the church of Santa Maria del Carmine.[6] There the platform of the *tramezzo* had been outfitted with stage sets representing Jerusalem as a 'stone castle, magnificently adorned' (on the north, or left-hand, side) and a mountain, '10 and a half feet high' (on the south side). High above, near the vaults, stood another scaffold, painted with heavenly bodies and inhabited by a man dressed as God the Father. As the hours unfolded, children dressed as angels and men representing Christ, Mary, the Magdalene and the apostles slowly proceeded, conversing, from Jerusalem to the Mount of Olives; the apostles, our guide notes, 'walked barefoot and were dressed as they can be seen in holy paintings'. As Jesus finally took leave of his companions, thunder clapped again and an elaborate contraption of ropes and gears hoisted him high into the heavenly zone where his Father waited, his throne surrounded again by radiant lamps and spinning discs painted with life-sized angels.

Although the Florentine performances Bishop Abram described may have been exceptional in their technical (and pyrotechnical!) derring-do, they fit into a longer tradition of creating mobile, three-dimensional pictures within and across church interiors in the course of liturgical dramas. We might think here of the late medieval practice of pulling a sculpture of the Risen Christ into a *Himmelloch* (hole of heaven) in a church's vault on Ascension Sunday[7] – but the entire nave could also be made into a theatrical space. Choir screens played a crucial role both as stages (as in Florence) and as thresholds from which actors would make their appearances and as a kind of proscenium framing the action.

Take the case of Havelberg Cathedral, whose historiated choir

6 See Meredith and Trailby (eds), *Staging of Religious Drama*, pp. 245–7; and Hall, '*Tramezzo* in the Italian Renaissance', p. 223, with a model of the screen and its mechanical accoutrements.
7 See J. Tripps, *Das handelnde Bildwerk in der Gotik*, 2nd edn (Berlin, 2000); H.-J. Krause, '"Imago ascensionis" und "Himmelloch". Zum "Bild"-Gebrauch in der spätmittelalterlichen Liturgie', in F. Möbius and E. Schubert (eds), *Skulptur des Mittelalters: Funktion und Gestalt* (Weimar, 1987), pp. 280–354.

enclosures and screen were created between around 1395 and 1411 (Figs
8.2 and 8.3).[8] The rubrics for an Easter Morning play from the cathedral's
early fifteenth-century *Ordinarium* divide the church into three main
zones: the *presbyterium* in the choir, which serves as a kind of backstage
area (Fig. 8.3 A); the *monasterium*, corresponding to the bays just west
of the choir screen (and the Holy Cross altar that stood before it; Fig.
8.3 B); and the *monumentum*, a temporary tomb structure set up at the
western end of the nave, near the entrance to the church (Fig. 8.3 C).[9]
The ritual began with the *chorus* – a group of singers – moving out of
the presbytery and taking their places *in monasterium*. They were joined
by the three Maries, who entered that zone one by one, each singing a
different antiphon. After collective singing, the trio journeyed together
down the nave towards the sepulchre, where the *Quem queritis* dialogue
played out with a pair of angels who waited there. Disappointed in
their mission, the Maries returned to the Cross altar area. Two of them
disappeared back into the presbytery, while the third, Mary Magdalene,
circled alone around the space (*circuiens cantat*), singing a long lament. As
she wandered, a cleric dressed as the Saviour emerged from the presbytery;
the ensuing conversation with Mary culminated in the *Noli me tangere*
scene. After Christ retreated behind the screen, the Magdalene returned
to her cyclical movement, voicing meditations on the Lord's sacrifice and
its resultant redemption of humanity. Her musings were soon interrupted
again, this time by Peter and John, who emerged through the screen's two
doorways, conversed briefly with Mary, and then raced down the nave to
the *monumentum*. (The youthful St John won, as usual, and waited for
St Peter at the finish line.)[10] Finding the tomb empty, they returned to
the *monasterium* and raised a cross onto the pulpit (*in ambone levantes
Crucem*), leading the congregation in the singing of a vernacular hymn,
Crist is up gestanden – Christ is risen.

Now, there is of course nothing terribly unusual about the staging of
an Easter play at various stations within and around the church's nave.[11]
The Havelberg play, moreover, seems not to have exploited the dramatic
potential of the screen's upper level in the way the Florentine spectacles
did, leaving it to function chiefly as a pedestal for the cross elevated at the

8 Jung, *The Gothic Screen*, pp. 76–8, 153–6; C. Lichte, 'Der Havelberger Lettner als
Bühne: Zum Verhältnis von Bildprogramm und Liturgie', in L. Lambacher and F. M.
Kammel (eds), *Die mittelalterliche Plastik in der Mark Brandenburg* (Berlin, 1990), pp.
101–7.
9 The relevant text – from the fifteenth-century Havelberg *Liber Ordinarius* housed
in Wolfenbüttel, Herzog-August-Bibliothek, 84.2.Aug.fol. – is given by C. Lichte, *Die
Inszenierung einer Wallfahrt: Der Lettner im Havelberger Dom und das Wilsnacker
Wunderblut* (Worms, 1990), pp. 131–3.
10 See D. H. Ogden, 'Gesture and Characterization in the Liturgical Drama', in C.
Davidson (ed.), *Gesture in Medieval Drama and Art* (Kalamazoo, 2001), p. 30.
11 For other cases, see D. H. Ogden, *The Staging of Drama in the Medieval Church*
(Newark, DE, 2002), pp. 39–99.

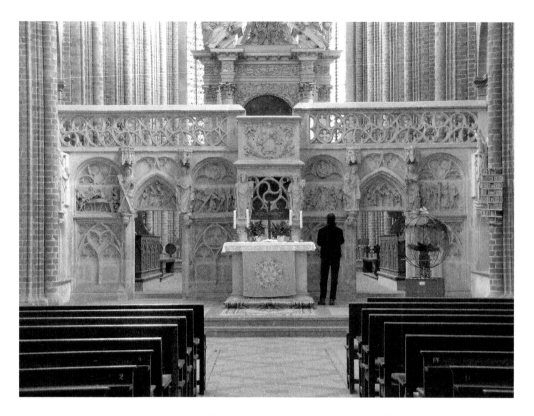

drama's conclusion. That presumably small-scale cross would itself have been rather dwarfed by the monumental Crucifixion group that hovered, then as now, on a beam high above. But the rubrics of the text prompt us to consider the role the screen played as a *frame* for the actions set in the *monasterium* – above all, the long scenes in which the character of Mary Magdalene walked in circles reflecting aloud on her grief over the Lord's disappearance and, later, her awe at his return. For as she moved around, presumably carrying a candle (it was, after all, the wee hours of the morning), she would have let glimmer into view a series of narrative

FIG. 8.2.
HAVELBERG
CATHEDRAL,
CHOIR SCREEN
ENSEMBLE WITH
CROSS ALTAR
(LOCATION B IN
PLAN BELOW).

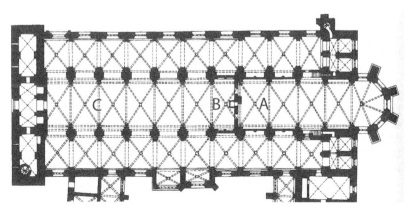

FIG. 8.3.
HAVELBERG
CATHEDRAL,
GROUND
PLAN WITH
LITURGICAL
SETTINGS
INDICATED.

reliefs that showed, with an astonishing pitch of expressivity, what had led up to this moment.[12] Arranged counter-clockwise across the surfaces of the surrounding screen walls, people witnessed Christ's appearances before Caiaphas and Pilate (south enclosing wall); his Flagellation and Crowning with Thorns (on the right-hand face of the choir screen; see Fig. 8.2); and finally, in a protracted action sequence, Christ's carrying of the Cross, nailing to the Cross (both on the left-hand face of the screen; Fig. 8.2), the raising of the Cross, and the canonical Crucifixion scene with Mary and John (on the north enclosing wall). Both the tight focus on conflict and violence and the emphasis on the subhuman quality of the brutes who degrade the innocent Jesus give this visual narrative something of the unsavoury flavour of Mel Gibson's filmic take on the Passion.[13] But this is no horror story – at least not when seen in the context of the Havelberg Easter drama. For as Mary circled around this space, the individual scenes – flickering briefly into view, one by one, in the glow of her candlelight – would have assumed the character of flashbacks, recollections of the awful events that the Resurrection was about to put right. In this sense the counter-intuitive directional compositions of the individual scenes, which have the characters' movements proceed from left to right even though the episodes are arrayed from right to left, take on a certain logic. Whatever direction the Magdalene character was walking as she circumambulated the zone around the Cross altar, the audience would have observed the Passion scenes slip into view not as a continuous narrative but as a series of snapshots – memories of discrete moments popping up like thought-bubbles over her head before falling back into darkness. With the elevation of the crucifix onto the ambo, those scenes could finally be stilled, and take their place as the support and backdrop to the drama's redemptive finale.

If, at Havelberg Cathedral, the narrative images on the choir screen were animated by the movements of the actors during the Easter play, in the parish church of St Mary at Gelnhausen it was the sculpted figures that orchestrated certain kinds of motion (Fig. 8.4).[14] As one approaches

[12] In the discussion about this paper at the 2012 symposium, Professor Eamon Duffy rightly expressed scepticism that the light from a hand-held candle would have illuminated these reliefs very brightly. Even if the scenes were dimly and briefly lit, however, I imagine they would have been apprehensible to people who had seen them with more or less regularity over the course of a lifetime – indeed, that they could have assumed even greater animation and force for flashing swiftly into view and then retreating. We must of course also reckon with the church being bedecked with scores of large, slow-burning candles on such a major feast day, as has been documented for late medieval Cologne Cathedral and others; see E.-M. Kreuz, 'Spuren des Lichts in mittelalterlichen Kirchen', in Regensburger Domstiftung (ed.), *Dom im Licht – Licht im Dom: Vom Umgang mit Licht in Sakralbauten in Geschichte und Gegenwart* (Regensburg, 2004), pp. 69–72.
[13] See T. K. Beal and T. Linafelt (eds), *Mel Gibson's Bible: Religion, Popular Culture, and The Passion of the Christ* (Chicago, 2005).
[14] Jung, *The Gothic Screen*, pp. 78–80, 131–2, 134. The most thoroughgoing discussion of this screen remains H. Krohm and A. Markschies, 'Der Lettner der Marienkirche

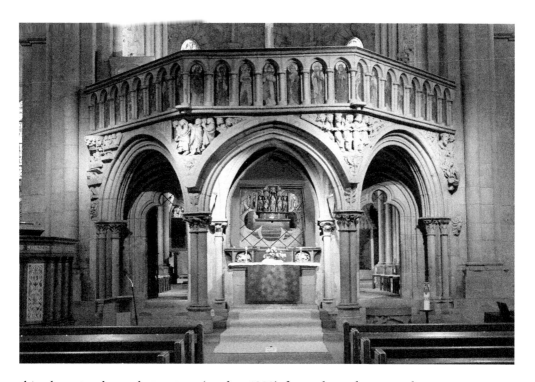

this elegant polygonal structure (made c.1250) from along the nave, the frontal face seems increasingly to flex outward, accentuating the deep space where it canopies the Cross altar.[15] Although that altar was clearly the focal point during public Masses, the figures who occupy the spandrels above create a tension by turning *away* from it. They march, rather, around each obtuse corner, forming a series of three compositions – from the front, from the corner and from the angled face of the screen. Along the way we come to see not only the end of the Elect's journey – the open portal of a little Gothic building – but also a tightly framed view of the high altar, framed by the anthropomorphic arched door of the screen. The Damned are less enthusiastic in their progress, turning back to gaze imploringly at beholders, but they too lead us around the corner where we find both their fearsome end in a fire-spewing hell-mouth – and, again, the salvific spectacle of the altar. Viewers lingering in this station had only to shift a step or so further on to make out the painted tabernacle where the Eucharistic host was reserved – a kind of balm and promise of grace accessible to the living, if no longer a help to the unlucky Damned.[16]

The Gelnhausen screen, like many others, operates on the assumption

FIG. 8.4.
GELNHAUSEN,
ST MARY, CHOIR
SCREEN WITH
SPECULATIVE
VIEW TO HIGH
ALTAR (PHOTO-
MONTAGE)

in Gelnhausen: Grundlagen einer Neubewertung', *Zeitschrift des deutschen Vereins für Kunstwissenschaft* 48 (1994), pp. 7–59.
[15] See Jung, *The Gothic Screen*, Fig. 19 and Col. Pl. V.
[16] For another instance of a planned association of a tabernacle with a screen, see V. Kessel, 'The High Gothic Liturgical Furnishings of the Church of Our Lady (Liebfrauenkirche) in Oberwesel', in U. Engel and A. Gajewski (eds), *Mainz and the*

that the human gaze is active, potent, quasi-tactile in its ability to grasp external stimuli and plant them firmly into the memory or heart; the doors of choir screens helped channel the gaze onto the components of the choir interior that were particularly efficacious while blocking out visual distractions such as the canons themselves, arrayed in their stalls along the side walls.[17] At Gelnhausen, the central bay of the choir screen, which sheltered the Cross altar in the Middle Ages just as it does today, also played the role of a kind of lens aimed at the high altar. A set of panels carved in low relief added to this zone in the sixteenth century – a kind of built-in retable – now obscures a great six-lobed oculus piercing the straight wall of the screen. Slideable wings at the centre of the early modern ensemble open to reveal the high altar hovering, like a little panel painting, over the Cross altar. In the thirteenth century, when the Cross altar stood free, viewers in the nave could have beheld the high altar encompassed by the flower-like oculus, which would have lent it the character of a heavenly vision brought close to earth in the course of the Mass. (Fig. 8.4 shows a montage of the high altar framed by the window over the Cross altar. The perspective is, obviously, skewed; the high altar would have appeared somewhat smaller in its frame than it does here, and the altarpiece atop it post-dates the screen. What I aim to convey with my digital reconstruction is the general effect of this spatial device.)

At the threshold to the west choir of Naumburg Cathedral, a different kind of vision takes shape before us; here the crucified Christ and his grieving companions, all carved in stone, have descended from what would have been their expected location atop or over the choir screen down into the openings of the choir screen doors (Pl. XLIX).[18] With the starkly humanized body of Christ set into direct alignment with the altar in the west choir, dedicated to his mother Mary, we are able to visualize with astonishing clarity the identity of the modest wafer consecrated there with the flesh of the sacrificed Saviour. The west choir screen, made in the early to mid-1250s, stands in dialogue with its more massive and austere counterpart at the eastern end of the nave, which in turn houses the Holy Cross altar where the lay public typically heard Masses.[19] Whether or not they had occasion to enter the choir, people looking towards the west were literally beckoned towards the screen by the life-sized figures of Mary and John, who turn their tear-swollen faces towards the nave while gesturing simultaneously back towards the altar and inward towards the crucified Christ. The latter figure, in the meantime, aligns himself variously with

Middle Rhine Valley: Medieval Art, Architecture, and Archaeology, British Archaeological Association Conference Transactions, 30 (Leeds, 2007), pp. 193–203.

[17] For the potentially distracting effects of laity seeing or being seen by the clergy during services, see Jung, *The Gothic Screen*, p. 25.

[18] See ibid., pp. 46–53; M. Beer, *Triumphkreuze des Mittelalters: Ein Beitrag zu Typus und Genese im 12. und 13. Jahrhundert* (Regensburg, 2005).

[19] Jung, *The Gothic Screen*, pp. 37–41.

the four male donor figures deep in the apse, as if sheltering and giving sanction to these long-dead benefactors and the aristocratic virtues they embodied.[20]

As we move closer to the threshold, the relation between Christ and those donor figures – who, from a distance, appear positioned right under his arms, close to his chest – shifts; they slide downward and become smaller relative to Christ's imposing body, which comes to be the sole focus. As we move into the threshold, the crucifix itself shifts appearance, as the head that formerly seemed to sag now appears to turn towards us, the nearly closed eyes now seem cast in our direction, the mouth that seemed to hang slack, exhaling its last breath, now appears to open as if addressing us.[21]

This quasi-lenticular image of Christ, which changes from appearing dead to appearing alive as the viewer moves, forms the climactic centre of a structure whose upper surface teems with simulated movement. Rarely in medieval art do we find such a concerted effort to capture fleeting actions as in the balustrade reliefs of the Naumburg west choir screen. Each apostle at the Last Supper, the first image in the condensed Passion narrative, is caught in the process of eating – from the balding figure who grasps a fish at the right-hand end of the table to his neighbour who knocks back some wine, from St Peter, nibbling a morsel, to St John, who fingers a napkin.[22] Judas fishes around in the sop-bowl just as Christ, his frontal face slowing the action, reaches across the table to feed him – but even this gesture, with its liturgical resonances, is brought back into the normal flow of time when Christ pulls back his sleeve to prevent it from falling into the common dish. Judas's unworthy reception of the host from his Lord – additionally discourteous because he simultaneously takes food for himself – contrasts strikingly with his receipt of the silver coins from Caiaphas in the next scene. Here, too, there is a split-second quality to the action, as, rather than having him hand over a money bag, as many contemporary artists were wont to do, this sculptor lets Caiaphas pour the loose coins into Judas's veiled hands. The artist further ratchets up the tension by having the rather rushed transaction at the center bracketed by the bodies of anonymous courtiers, who lean in to commiserate with their neighbours, creating a conspiratorial and claustrophobic environment.[23]

If the Payment scene shows pressure tightening inward, the next relief is expansive in its actions.[24] This one is framed, on the back plane, by one figure preparing to beat a retreat towards the right, and another starting to pull Jesus – again a central, frontal anchor to the swirling activity around

[20] Ibid., pp. 80–91.
[21] Ibid., pp. 89–90 for further discussion and illustration of this point.
[22] See ibid., pp. 175–9.
[23] Ibid., pp. 156–9.
[24] Ibid., pp. 159–64.

him – towards the left. The Arrest is one of several narrative moments condensed into this single frame: Judas's identification of his lord with a kiss precedes the apprehension of Christ proper, which we find enacted, rather roughly, by a man in a Jewish cap bearing the sword of legal authority, while Peter, in an unusually swashbuckling manoeuvre, swings a great broadsword down upon the poor servant Malchus, who sinks down in the corner while attempting to ward off the blow. Any thirteenth-century beholder would have known that a sword like this was not designed for clipping delicate appendages. As countless battle scenes from thirteenth-century manuscripts confirm, the double-handed broadsword was made for hacking through limbs, skulls and armour.[25] It is fortunate for Malchus that *only* his ear is about to be injured; Peter's sword has been deflected from what we must assume was its intended target, the servant's head, by the hand of Christ, which presses very subtly forward in space. Like the flames on a soldier's torch that flicker and curl high above, the half-severed ear places us in a continuous present; the action is always ongoing.

And yet it soon becomes a component of memory. We see this happen in the gesture of the maid in the following scene, who turns back as if to remind Peter of his recent heroic defence of his lord. Cowering under his cloak, the Prince of Apostles tries to scramble over the screen's great central gable – but no protection will he find on the other side. For there another pair of whispering soldiers stands guard outside Pilate's chamber, where proceedings against Christ are already underway.[26] Here the narrative unfolds from left to right, with a plaintiff striding forth to levy his accusation; the stubborn silence of the prisoner; Pilate's declaration of innocence; and, finally, the washing of his hands. In a move reminiscent of Caiaphas's, as he let the coins spill into Judas's cloak, a servant pours water into Pilate's outstretched hand. It puddles there for a moment before, we surmise, flowing further into the basin, while the servant looks down at us, his expression as aloof as Christ's own (Pl. L). In so doing, he simultaneously halts the narrative flow and positions beholders as part of the crowd, prompting them to reflect on their own role in what many medieval Christians imagined to be the continual persecution of the Lord. The results of the unhappy verdict came to view on the last two reliefs,

[25] See, for example, the quasi-cinematic pair of images in which Charlemagne smashes his broadsword down onto an opponent's head, slicing straight through the poor man's pot-helmet, in a manuscript of Der Stricker's *Karl der Große* (St. Gall, Kantonsbibliothek [Vadiana], MS 302 Vad., f. 66r). The image is reproduced in colour in J. E. Jung, 'Das Programm des Westlettners', in H. Krohm and H. Kunde (eds), *Der Naumburger Meister: Bildhauer und Architekt im Europe der Kathedralen*, 3 vols (Petersberg, 2011), 2, p. 1143. One also thinks of the many gruesome confrontations of broadswords and skulls (helmeted or not) that pepper the Morgan Picture Bible (New York, Pierpont Morgan Library, MS M.638), a work exactly contemporaneous with the Naumburg reliefs; see W. Noel and D. Weiss (eds), *The Book of Kings: Art, War, and the Morgan Library's Medieval Picture Bible* (Baltimore, 2002), pp. 33, 38, 52, 54, 108.

[26] Jung, *The Gothic Screen*, pp. 164–6.

which showed the Flagellation and Carrying of the Cross. What we see today are the rather charmingly crude wooden replacements made over a span of twelve weeks in 1747, to replace the stone reliefs that had been badly damaged in a fire some 200 years earlier.[27] We know from the surviving contract that the craftsman, a local turner called Johann Jacob Lütticke, was entrusted with copying the compositions of the originals, but how much he succeeded is anyone's guess.[28] In keeping with the boldness of the thirteenth-century artist's compositional designs is the way in which, in the final relief, Christ angles his body as if he is about to stagger right off the screen – a perfectly appropriate flourish to a programme whose climax is seen closer to the ground, in the Crucifixion group at the portal.

But the real finale shimmers into view just above that, in the quatrefoil at the centre of the gable.[29] Flanked by angels bearing miniature instruments of the Passion, the glorified body of Christ in Majesty now recedes both behind thick layers of clothing and into the comparatively ethereal medium of paint. Indeed the ethereal, superhuman character of the heavenly Christ is accentuated by its contrast with the material things that surround him, which project in plaster low relief – the *arma*, the throne, the embroidered hems of his garment, even, oddly, his halo. His right hand rises and his left hand sinks in a gesture of ongoing judgement – a theme that is also highlighted in the words of the inscription encircling the image: *Arbiter hic sedis / agnos distinguit ab edis. Dura sit an grata, / tenet hic sententia lata* ('Here, on his throne, the judge separates the lambs from the goats. Be it harsh or happy, the sentence rendered here is eternally binding'). The combination of the present tense and the assertion of spatial present-ness – *hic*, here, in this place – joins the figure's seemingly moving hands to create the impression of ongoing activity, in a way visually distinct from, but conceptually akin to, the always ongoing Crucifixion below.

Thus even the seemingly timeless heavenly vision of the enthroned, divine Saviour – the ultimate triumph of God over the foibles of human social interactions and the vulnerability of human flesh – winds up again pointing back to the viewer, with his or her own weaknesses and capacity for sin. What we find at Naumburg is a gritty tale of betrayal, corruption, violence and one fateful miscarriage of justice – a story in which the contrasting outcomes of the two supporting characters, Judas, hanging by his neck from a tree, and Peter, the ultimately repentant head

[27] Ibid., pp. 149.
[28] See E. Schubert, *Der Naumburger Dom* (Halle a. d. Saale, 1997), p. 160. He did continue the Gothic sculptor's practice of updating the figures' costumes to include contemporary styles – and took some liberties in rendering other social types, for instance giving a Roman soldier a Jewish funnel cap with a natty little feather on top!
[29] Jung, *The Gothic Screen*, pp. 59–60; and S. Ruf, 'Der erhöhte Christus als Richter und Erlöser: Das Gemälde im Giebelfeld des Naumburger Westlettners', in Krohm and Kunde (eds), *Der Naumburger Meister*, 3 (2012), pp. 300–17.

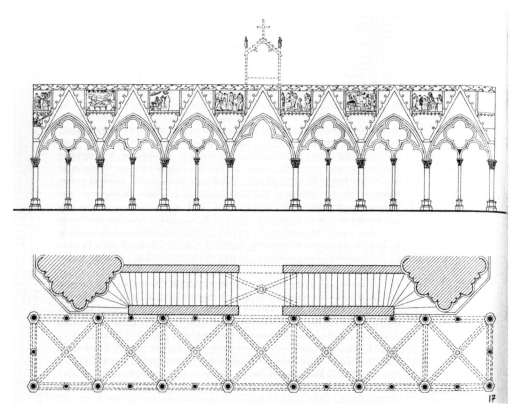

FIG. 8.5. CHARTRES
CATHEDRAL,
CHOIR SCREEN,
PLAN AND
ELEVATION
(PHOTO: AFTER
MALLION,
CHARTRES, P. 84).

FIG. 8.5. CHARTRES CATHEDRAL, CHOIR SCREEN, PLAN AND ELEVATION (PHOTO: AFTER MALLION, *CHARTRES*, P. 84).

of the Christian Church, are left unseen (though were well known to the audience); in which the human demise of the hero takes centre stage; and in which the only real glory to be seen takes the form of the light shimmering through the tops of the windows in the apse. If the dark 'realism' of the Naumburg Passion programme has something of, say, a Martin Scorsese movie to it, the Infancy drama that unfolds across the thirteenth-century choir screen at Chartres Cathedral – a tale of two journeys, punctuated by irruptions of the supernatural – is decidedly more Spielbergian in its fantastic character.

Built between about 1235 and 1250, and demolished starting on 25 April 1763, the *jubé* at Chartres was one of the most splendid choir screens of its era – and, like any good blockbuster, it was also one of the largest (Fig. 8.5). In what remains the most thoroughgoing analysis of the surviving evidence, Jean Mallion in 1964 determined its length to have been about 20.5 metres and its height about 5.25 metres.[30] Extending between the cathedral's two eastern crossing piers, the screen not only formed the terminus to the nave for people coming in through the western portals on feast days; it also comprised a significant part of the devotional-mnemonic

30 J. Mallion, *Chartres: Le jubé de la cathédrale* (Chartres, 1964).

route sketched out by Paul Crossley, which linked the Marian scenes on the north transept portals to the *Notre Dame de la Belle Verrière* window in the south ambulatory and on into the choir, which housed a shrine of the Sacred Tunic.[31] Anyone proceeding in this direction would have been able to trace the story of Christ's infancy, from north to south, in the spandrels lining the upper balustrade of the arcaded screen – but what they saw there was less a series of self-contained vignettes full of condensed action, such as we observed at Naumburg, than a more leisurely sequence of interwoven narratives that highlighted the twin themes of communication and revelation (Figs 8.6, 8.7).

A pair of journeys – one literal, one metaphorical – structures this telling of the Christmas story.[32] The first begins with a conversation: two bodies, nearly mirror images of one another, meet in a narrow space, hands uplifted in excited speech (Fig. 8.6 a). Surprisingly, in this Annunciation scene the angel has not fluttered in from outside (that is, the left-hand border); it is Mary who stands at the margin, leading, with the turn of her body, to the next relief, where the presence that remains unseen in this image assumes visible and tangible, form. The Nativity scene on the *jubé* – so unusual in the active role it accords St Joseph, gently arranging his wife's blankets – is also alone among the numerous depictions of this episode at Chartres – on the Royal Portal, the north transept and the Infancy Window on the west façade – in allowing the Virgin not just to look at but to *touch* her new baby (Fig. 8.6 b). With the utmost tenderness she draws her son's swaddling blanket down under his tiny chin to further reveal his face, while clasping her own veil as if to see him even better. The twist of the Virgin's shoulders and the odd sweep of her arm across her body, would have surely looked more natural when seen from a standpoint more than four metres below. In a foreshortened perspective, Mary's face would have appeared to turn towards viewers, while the baby's would have turned towards her, and his little head would have seemed to nestle itself into the open space between her arms. It is to be hoped that one day this and the other spectacular carvings from the Chartres choir screen will be put on public display, preferably in something resembling their original arrangement, so that they can be examined as they were meant to be seen.[33] As of 2013, hidden under plastic sheets in the cathedral's south

[31] P. Crossley, '*Ductus* and *memoria*: Chartres Cathedral and the Workings of Rhetoric', in M. Carruthers (ed.), *Rhetoric Beyond Words: Delight and Persuasion in the Arts of the Middle Ages* (Cambridge, 2010), pp. 214–49. See also Crossley, 'The Integrated Cathedral: Thoughts on "Holism" and Gothic Architecture', in E. S. Lane, E. C. Pastan, and E. M. Shortell (eds), *The Four Modes of Seeing: Approaches to Medieval Imagery in Honor of Madeline Harrison Caviness* (Farnham, 2009), pp. 157–73, an article beautifully complemented by Claudine Lautier, 'The Sacred Topography of Chartres Cathedral: The Reliquary Chasse of the Virgin in the Liturgical Choir and Stained-Glass Decoration', in ibid., pp. 174–96.

[32] Jung, *The Gothic Screen*, pp. 116–24.

[33] By contrast, in the spacious and remarkably luminous crypt of Bourges Cathedral

FIG. 8.6. CHARTRES CATHEDRAL, RELIEFS FROM CHOIR SCREEN (LEFT SIDE) a, b, c, d.

FIG. 8.7. CHARTRES CATHEDRAL, RELIEFS FROM CHOIR SCREEN (RIGHT SIDE) a, b, c, d.

tower, they are as inaccessible to viewers as the holy Infant himself was to the public, tucked away in his small cloth-lined chamber and visible only to his parents (and a pair of privileged barnyard animals).

The next time we encounter the Child, he is still intimately bound to his mother – circumscribed now by the contours of her body (Fig. 8.7 a). But others see him. Guided not just by the swirling star but by an angel, the Three Magi pause to pay homage to the little king on his mother's lap. Although they are kept physically separate from the object of their attention, their reverent postures and joyful facial expressions indicate the satisfaction of sight; they enjoy a sort of *Augenkommunion*, an optical engagement with the Body of Christ that, medieval viewers knew, could effectively supplant its physical consumption in the Eucharist.[34] Yet, as people also knew, that Body must be made *materially* accessible as well – and that is precisely what we see happen in the next, and last, Christocentric episode on the Chartres choir screen (Fig. 8.7 c). Now Mary, accompanied by Joseph and a pair of beautifully garbed attendants, processes to an altar, where the good priest Simeon awaits. The latter leans forward and tilts his head back, as if to emphasize that his recognition of the Child's divinity took place through spiritual, not bodily, vision – and he lifts his veiled hands to receive the weight of the Baby's small frame. The image marks a radical departure from what we find in the twelfth-century Royal Portal, where the infant stands on the altar like a statue, displaying himself as the true *imago dei* that supplants all idols.[35] Here, on the screen, it is the act of *transfer* that is paramount. The Christ Child has moved from the intimate realm of his mother, to a more open area where he may be adored from a distance, to the public sphere, where he becomes accessible to all, physically as well as visually, through the mediation of liturgy.

Interspersed with the Child's journey is a rather more swashbuckling one, a tale with a decidedly less happy ending (if we assume that the final image on the screen showed the Massacre of the Innocents).[36] This one, too, starts with a conversation: the Magi, embarking on their quest for the rumoured Messiah, receive instructions from the haughty King Herod to return with their findings so that he might pay homage too (Fig. 8.6 d). Or so he claimed – for this is a story of communication gone awry. The

one finds the sculptural and architectural remains of the thirteenth-century choir screen beautifully arrayed, and the Musée de l'Oeuvre Notre-Dame in Strasbourg features a reconstructed bay of that church's choir screen that includes several of its surviving statues and relief fragments. A magnificent foliate capital inhabited by a mermaid and other fanciful beasts from the frontal arcade of the Chartres *jubé*, and a relief showing one of the evangelists at work, are displayed at the Musée du Louvre in Paris, but the narrative reliefs await their long-overdue exhibition to the public.

[34] See most recently S. Biernoff, *Sight and Embodiment in the Middle Ages* (London, 2002).

[35] For the comparison, see Jung, *The Gothic Screen*, pp. 120–1.

[36] For this sequence, see ibid., pp.179–84.

Magi learn of Herod's secret plan to kill the little king from an angel who bursts into their insulated chamber (a room that indeed recalls the space of the Nativity) to warn them to take an alternate route (Fig. 8.7 b). The faces of the kings, who all sleep in a single bed, are shown in an almost cinematic progression from sleep to wakefulness.[37] The hands, too, shift from self-involvement (the youngest king wrapping his cloak around his body for greater warmth) to openness to the divine; the eldest king, at the top, braces his legs against the wall as if he is about to spring into action. Lucky for them all, a stableboy has already harnessed a trio of horses and leads them outdoors to await their new adventure.

Seeing the sprightly horses poised at this threshold might have prompted viewers to think of the farmyard animals they had encountered elsewhere on the screen's façade – both the docile beasts that warmed the newborn's manger with their breath and the flocks that nibbled grass in the immediately adjacent relief (Fig. 8.6 c). In this remarkable rendition of the Annunciation to the Shepherds, all action stops – the scene is about listening. It is true that the solitary shepherd we see today was once joined by a companion, but the latter stood at the opposite side of the rocky hill that frames our fellow on the right; there would have been none of the slapstick jostling and stumbling about that both earlier and later artists would find so pleasing in this scene of rustic content.[38] Rather, stooping to rest on his staff, our shepherd swivels his heavy head back over his shoulder, quietly absorbing the message coming from above. The angels who speak to him now survive only as a series of hands, six in all, that alternately point to and grasp a banderole once painted with the words *Gloria in excelsis Deo* – the hymn, based on the angels' announcement in the Gospel of Luke, sung during festal Masses throughout the liturgical year (except during Advent and Lent).[39] The song took shape in the early fourth century as a communal component of the Mass involving the participation of the lay and clerical assembly, but by the thirteenth its performance had grown more complex and was performed chiefly by the cathedral canons. Thus the image of the Shepherds at Chartres, complementing that of the Magi's Dream, presents an idealized model of the aural dynamics within the church – the voices of God's representatives spilling downward from on high (think of clerics positioned atop the screen to the reading of scriptures, or their voices pouring from behind

[37] The head of the central Magus, 'restored after a plaster cast', appears in the photo by M. Hirmer in W. Sauerländer, *Gothic Sculpture in France, 1140–1270* (New York, 1972), Pl. 127, top. I include that image in my photomontage, Fig. 8.6.
[38] See T. A. Heslop, 'Romanesque Painting and Social Distinction: The Magi and the Shepherds', in D. Williams (ed.), *England in the Twelfth Century: Proceedings of the 1988 Harlaxton Symposium* (Woodbridge, 1990), pp. 137–52; J. J. G. Alexander, '*Labeur* and *Paresse*: Ideological Representations of Medieval Peasant Labor', *Art Bulletin*, 72 (1990), pp. 445–6.
[39] J. Jungmann, *The Mass of the Roman Rite: Its Origins and Development*, 2 vols (New York, 1959), 1, pp. 346–59.

the screen, over its surfaces and through its doors), into the receptive ears of listeners.[40]

Liturgists have long noted that the full hymn of the *Gloria* to which our shepherd relief alludes consisted of three main thematic parts; taking the angels' 'song on the night of the Nativity' as its point of departure, it moved singers and listeners into a praise of God the Father before invoking Christ the Son.[41] The screen at Chartres dispenses with images of the Father, but did lead people to various manifestations of the Son beyond the Infancy narrative, as they moved into the vaulted space below the screen's platform. Looking up at the keystones that crowned their passage – just a few of which survive – they beheld him in several forms.[42] Over one bay, he appeared in his symbolic guise of sacrificial Lamb. Over another, he took the form of a child seated on his Mother's lap, the pair surrounded by censing angels – a scene that hearkens back to the great Throne of Wisdom composition in the *Belle Verrière* window in the south ambulatory. And finally he sat there enthroned as wise and benevolent man, blessing all who passed under him. The latter keystone most likely hung in the central vault; the figures on the sides – evangelists writing at their desks while their symbolic animals urge them on – are oriented in such a way as to look right-side-up to viewers approaching from any cardinal direction, even as they flip upside-down, and indeed become all but invisible, when one looks at the keystone directly from below. Christ, the keystone, *is* the words that the holy men write. A *view* of him supplants and supersedes textual mediation.

The depiction of the evangelists and Christ in the choir screen's vault complements the little reliefs of the Gospel writers at work, arrayed in the spandrels below the narratives on the screen's frontal face.[43] And both remind us of the choir screen's function as the locus of liturgical readings – the Gospels and Epistles. The images on screens complemented those readings, to be sure; the emphasis on the Infancy narrative at Chartres and the Passion narrative at Naumburg and Havelberg (as well as at Amiens, Bourges, Modena and certainly many others) surely aimed to solidify the lessons of the major feast days laypeople were required to attend, Christmas and Easter. But other thirteenth-century screens eschewed textual references; that at Strasbourg Cathedral, for example, included, along with its standing figures of saints, vignettes of the Seven Works of Mercy playing out in urban settings – a choice of imagery very clearly aimed

[40] For the appearance and use of the platforms of screens, see Jung, *The Gothic Screen*, pp. 53–9.

[41] Jungmann, *Mass of the Roman Rite*, 1, pp. 349–50.

[42] For further discussion of sculpted images under this (and other) screen's vaults, see Jung, *The Gothic Screen*, pp. 61–2. Two of the keystones are reproduced there as Figs 54 and 55. See also Mallion, *Chartres*, pp. 161–6.

[43] One of these is displayed at the Musée du Louvre in Paris. See also Jung, *The Gothic Screen*, p. 184.

at (and indeed only really relevant to) the laymen and women who funded and made special use of this nave.[44] With its civic patronage Strasbourg was an exceptional case – but in the other instances we've observed, even the images with the most conventional-seeming iconography (the Nativity, the Crucifixion, the Last Judgement) wind up exceeding their textual referents and complicating existing pictorial traditions. Their placement at a sacred threshold – one that could be crossed at certain opportunities, to be sure, but one before which people also lingered and from which they were vocally addressed – imbued the images with special significance, allowing them to gain different nuances from the actions performed around them. If screens themselves created sacred space precisely in the act of concealing it (even if that concealment was only partial), the sculptures employed a straightforward, highly mimetic visual style to bring forth sacred truths – truths both about humanity's continued culpability and need for redemption *and* (on a more upbeat note) about God's ability to act in the world, the grace-giving power of rituals, about the urgency of social justice.[45] Like any good rhetorical art, they operated in a dynamic relationship with their recipients, recipients whom their creators conceived from the outset to be *grounded*, physically and conceptually – people who would be looking at the works from a variety of standpoints and seeing it through the filter of *both* liturgical performances, ongoing in the church, *and* with their knowledge of life in the world outside.[46] If, as we are coming increasingly to understand, exterior portals offered people a preview of what awaited them inside the church, choir screens, deep at the heart of the building, impressed upon their memories the imagery they should carry with them back out into the world.[47] In that sense, their movement never ceased.

44 Ibid., pp. 139–44.
45 For further discussion of the images' vernacularity, defined in terms of accessibility, see ibid., pp. 194–7.
46 On the rhetorical force of Gothic images, see P. Binski, *Becket's Crown: Art and Imagination in Gothic England, 1170–1300* (New Haven, 2004); and the essays in C. S. Jaeger (ed.), *Magnificence and the Sublime in Medieval Aesthetics* (New York, 2010).
47 See W. Sauerländer, 'Reliquien, Altäre und Portale', in N. Bock et al. (eds), *Kunst und Liturgie im Mittelalter* (Munich, 2000), pp. 121–34.

THE PRESERVING POWER OF CALVINISM: PRE-REFORMATION CHANCEL SCREENS IN THE NETHERLANDS

JUSTIN E. A. KROESEN

Alongside the vast destruction of church interiors which took place during the Calvinist Reformation in the Netherlands, some medieval furnishings survived the Protestant purge, at times in remarkable numbers. Today, some 160 medieval baptismal fonts may be admired, most of which returned to the churches after having been used for secular purposes in the centuries after the Reformation.[1] Carved sets of choir stalls survive in around twenty-five churches in the Netherlands, while the number of surviving pre-Reformation pulpits amounts to around fifteen.[2] Another category which can be found relatively often are medieval screens and galleries, present in some thirty-five churches. This essay studies these pre-Reformation choir partitions, both with and without galleries. The last section discusses the reasons for their preservation in Dutch Protestantism, contrary to so many other medieval fittings which were removed during sixteenth-century Iconoclasm and its aftermath.[3]

[1] For a survey of medieval baptismal fonts in the medieval diocese of Utrecht, see M. Schönlank-Van der Wal, 'Romanesque and Gothic Stone Baptismal Fonts in the Diocese of Utrecht', in E. de Bièvre (ed.), *Utrecht, Britain and the Continent: Archaeology, Art and Architecture*, British Archaeological Association Conference Transactions, 18 (1996), pp. 163–71.

[2] For choir stalls, see R. Steensma, *De koorbanken in de Martinikerk te Bolsward en hun Europese context* (Gorredijk, 2012), where the fine Bolsward stalls are discussed in relation to other sets in the Netherlands. For medieval pulpits, see Steensma, *Protestantse kerken. Hun pracht en kracht,* 2nd edn (Gorredijk, 2014), pp. 61–6.

[3] Studies on Dutch pre-Reformation church furnishings in English include W. Th.

SCREENS WITH GALLERIES ('DOKSALEN')

Medieval choir partitions occur in three variants in medieval churches in the Netherlands.[4] The first is a simple partition in the form of a transversal stone wall, of which only two examples survive. The partitioning wall in the former Franciscans' church in Maastricht, in the extreme south of the country, dates from the period when the church was built – the late thirteenth and early fourteenth centuries. The painted Annunciation scene which is featured above the central doorway on the east side was added in the early sixteenth century. The second partitioning wall is found at Leegkerk in the northern province of Groningen. It was probably erected in the existing thirteenth-century church during the first half of the sixteenth century. After the Reformation the opening between the screen and the arch was walled up and a text panel was installed. In a number of medieval churches across the country, the walls betray the existence of choir partitions of a similar kind.

The second type of choir partition is the rood screen with a loft or gallery, which in English is also referred to as *pulpitum*. In Dutch, this type is called 'doksaal', a term which is probably derived from 'doxology', the hymn of praise which was sung from the gallery.[5] Of these galleries, eight examples are found today in the Netherlands.

Stone galleries survive in Ter Apel (former monastery) and Krewerd in the province of Groningen[6] and in Amersfoort (St George) and Rhenen (St Cunera) in the province of Utrecht. They display a variety of forms and styles. The gallery at Krewerd is Late Romanesque and dates from around 1300, which is remarkably early especially since it was erected in a modest country church (Pl. LI). It forms an impressive ensemble with the organ dating from 1531 which sits on top, one of the oldest instruments preserved *in situ* in Europe. Its central passage, now with carved wooden doors from c.1530, is flanked by two wide round arches which originally served as frames for two side altars.[7] The galleries at Ter Apel and Amersfoort are both Late Gothic. The screen in Ter Apel, which belonged to a monastery of Crutched Friars, is entirely closed (Pl. LII). The loft rests

Kloek et al. (eds), *Art before the Iconoclasm: Northern Netherlandish Art 1525–1580*, 2 vols [exhib. cat., Rijksmuseum, Amsterdam] (Amsterdam, 1986); and J. D. Bangs, *Church Art and Architecture in the Low Countries before 1566: Sixteenth Century Essays and Studies* (Kirksville, MO, 1997).

[4] The classic study of the development and spread of medieval choir partitions in the Netherlands and Belgium is J. Steppe, *Het koordoksaal in de Nederlanden* (Brussels, 1952).

[5] In German, the rood screen with a loft is called 'Lettner', a term derived from the Latin *lectorium* or *lectionarium* ('reading place'), whereas in French, the gallery is known as 'jubé', the first word of the formula *Jube domine benedicere*, which is pronounced by the deacon before reading the scriptures.

[6] On rood screens in Groningen and traces of removed ones, see T. Brandsma, 'Doxalen in de Groninger Ommelanden', 1 and 2, *Groninger kerken*, 11 (1994), pp. 103–18 and 141–51.

[7] Of an early screen with similar characteristics in nearby Leermens, only the southernmost of originally five arches survives, see ibid., 1, pp. 111–14.

on two massive walls which enclose a corridor through which the friars could enter the church without being seen by the faithful. The west side features shallow niches flanked by small piscinas which recall two side altars which originally stood here. The screen in Amersfoort from c.1480 has a five-arched open loggia structure, following a type often found in Germany. Originally it provided space for three side altars.[8] Carved openwork wooden doors in the second and fourth bays provide access to the chancel. The gallery is supported by eight stone corbels showing carved figures, and it has parapets with openwork tracery on both sides. The rood screen in Rhenen is carried out in Renaissance style, which points to a date around 1550. The three round arches rest on four red marble columns and are separated by four herms and caryatids showing the ages of mankind. The spandrels feature eight virtues.

Four surviving Dutch rood screens are carried out in wood. The most elaborate architectural decorations are found in the Gothic gallery from Helvoirt in the province of Brabant, which was transferred to the Rijksmuseum in Amsterdam in 1896. The rood loft, of which the central section projects, rests on wooden coving above an openwork screen. The parapet is divided into thirteen sections with carved arches, which probably held representations of Christ and the apostles. Access to the chancel was via two doors on either side of a central section where an altar must have stood.[9] The rood loft in Holwierde in the province of Groningen is simpler in decoration and rests on a wooden screen of a remarkably closed nature: of six lancet openings on both sides of the central doors, only three are original.[10] Both wooden examples are particularly interesting from a British perspective, since their structure and style are quite similar to those found in Britain and French Brittany, while – surprisingly – parallels among German and Scandinavian galleries are virtually unknown.

Two wooden rood screens were carried out in fully fledged Renaissance style, dating from around 1550. The first example, in Easterein/Oosterend in the province of Frisia (Friesland/Fryslân), has a remarkable structure comprising two superimposed tripartite arcades (Pl. LIII). The upper storey is crowned by a text frieze on both sides, with passages from the Bible. Another inscription praises the quality of the gallery itself and ends with the name of 'Hein H' and the year 1554.[11] The lower storey is crowned

[8] Of stone screens that were partially preserved or which are known from historic depictions, those in St Peter's in 's-Hertogenbosch in Brabant (with five ogee arches, as shown in a painting by Pieter Saenredam) and St Peter's in Utrecht (in Renaissance style, also depicted by Saenredam) deserve mentioning.

[9] R. Steensma, 'Het middeleeuwse doksaal in Nederland', *Jaarboek voor liturgie-onderzoek*, 16 (2000), p. 197.

[10] New openings were pierced during a rigorous and injudicious restoration in 1945–51, when the seventeenth-century organ was removed from the gallery, and the pulpit from the same period placed in front of the central doors.

[11] This name has been connected to Hein Hagarth, who was working in the Antwerp workshop of Cornelis Floris de Vriendt.

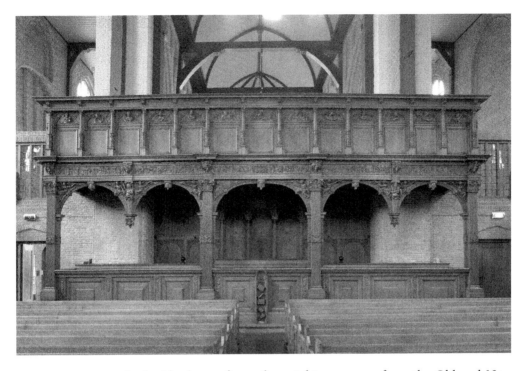

FIG. 9.1.
SCHOONHOVEN,
ST BARTHOLOMEW,
GALLERY (C.1550)
VIEWED FROM
THE NAVE.

on both sides by no fewer than eighteen scenes from the Old and New Testaments. Conspicuously, the imagery is not chronologically organized and does not show a clear typological pattern.[12] The spandrels are richly decorated with grotesques and cartouches showing lion's heads, human figurines, masks and foliage. A second wooden rood screen in Renaissance style from the mid-sixteenth century is found in St Bartholomew's in Schoonhoven in the province of South Holland (Fig. 9.1).[13] The space under the gallery was transformed into a pew in 1646. Its gallery rests on four columns which frame three sections, of which the central is narrower. Angels can be seen in the spandrels, while those in the central arch feature the Annunciation. The parapet is divided into thirteen sections which were probably originally painted. The arches above each panel feature Christ bearing the cross, Pilate and Caiaphas and a series of angels holding the Instruments of the Passion. The parapet rests on a frieze which shows five times three biblical scenes following a typological scheme.[14]

12 Therefore, the key to its iconographical programme has not yet been found. See H. Miedema, 'De bijbelse ikonografie van twee monumenten: de "kraak" te Oosterend (Fr.) en het grafmonument van Edo Wiemken te Jever', *Bulletin van de Koninklijke Nederlandse Oudheidkundige Bond* (1978), pp. 61–88.
13 See H. van Duinen, *Het doksaal van de Grote of St. Bartholomeuskerk te Schoonhoven* (Amsterdam, 2004).
14 See Steensma, *Protestantse kerken*, p. 105: 1 Annunciation, Nativity and Message to the Shepherds, 2 Adoration of the Magi, twelve-year-old Jesus in the Temple and Baptism in the Jordan, 3 Manna, the Last Supper and Abraham and Melchisedek, 4 Prayer on the

In both structure and details, the Schoonhoven screen is reminiscent of the rood loft in King's College Chapel in Cambridge, which was created between 1532 and 1536 by a certain 'Philip the Carver' at the behest of King Henry VIII. Nikolaus Pevsner considered the screen (and the choir stalls) to be 'the most exquisite piece of Italian decoration surviving in England'.[15] It would be worthwhile studying the relationship between the two galleries, in view of a possible Netherlandish inspiration of the latter. It is worth mentioning, as circumstantial evidence, that King's College Chapel does have a clear Netherlandish connection in its stained-glass windows. Of all the windows in the chapel, all but one are of Flemish origin. In view of the scarcity of surviving rood screens and lofts, in both the Northern and the Southern Netherlands, however, any possible model of inspiration for the Cambridge screen would have to be hypothetical.

The survival of eight galleries and evidence of another fifty to sixty lost examples may not seem very much in relation to the approximately 800 existing medieval churches in the Netherlands. However, when seen in a European perspective a different picture comes to the fore. The Dutch examples represent the third largest stock of rood screens and lofts of any continental European country. In Germany, some forty galleries are preserved, whereas in France no more than twenty survive.[16] All German rood screens are of stone and brick. Most examples are found in what are now Lutheran cathedrals and large parish churches, while the six surviving examples in East Frisia are exceptional in that they belong to modest country churches.[17] In France, stone screens in cathedrals and large churches are very rare, the Champagne examples at Ste Madeleine in Troyes and Notre-Dame de L'Épine being great exceptions, while most French screens are built of wood and survive in small country churches in Brittany.[18] In eastern Central Europe and in Scandinavia, few surviving galleries can be found, while in Mediterranean countries, the choir partition developed along entirely different lines.[19] It is not easy to establish the number of surviving rood screens with lofts in British churches. Examples of massive stone *pulpita* are found in a number of English cathedrals and collegiate churches, including Canterbury, Exeter,

Mount of Olives, Moses with the Brass Serpent and Entombment, and 5 The Saving of Jonah, the Resurrection and Samson Holding the Gates of Gaza.

[15] N. Pevsner, *An Outline of European Architecture* (Harmondsworth, 1963), p. 292.

[16] For rood lofts in Germany, see M. Schmelzer, *Der mittelalterliche Lettner im deutschsprachigen Raum. Typologie und Funktion* (Petersberg, 2004); and for France see B. Chedozeau, *Choeur clos, choeur ouvert: de l'église médiévale à l'église tridentine (France, XVIIe–XVIIIe siècle)* (Paris, 1998).

[17] On East Frisian screens, see J. E. A. Kroesen and R. Steensma, *Ostfriesische Kirchen und ihre mittelalterliche Ausstattung* (Petersberg, 2011), pp. 165–77.

[18] On the screens of Brittany, see Y. Pelletier, *Les jubés de Bretagne* (Rennes, 1986).

[19] In some Italian churches, the difference in height between the chancel and nave was marked by an openwork 'tramezzo', while in Spain the choir was separated at the rear by a 'trascoro'. Both categories are hardly comparable with the screens and lofts north of the Alps.

Lincoln, Ripon, Southwell, Winchester and York. Wooden galleries survive in country churches across the country, such as Kenton and Atherington (Devon), Flamborough (Yorkshire) and particularly in Wales, for example in Derwen (Clwyd), Llananno and Patricio (Powys), Llaneilian (Gwynedd) and Llangwm Uchaf (Gwent).[20] Wooden chancel screens, which survive in hundreds of parish churches throughout Britain, often show evidence of having originally supported a gallery, destroyed at the time of the Reformation.

CHANCEL SCREENS 'KOORHEKKEN'

Whereas the Dutch stock of rood screens with galleries is the third largest in continental Europe, the Netherlands surpasses even Germany and France when it comes to the third type of medieval choir partition: wooden chancel screens without lofts. Of these, around twenty-five examples are either preserved in their entirety or to a large extent. In France, a thorough search could bring to light only a handful, while in the whole of Germany – so rich in medieval church furnishings, especially in the Lutheran areas – they amount to five or six. Most impressive among German medieval screens are the two Late Gothic examples in St Mary's and St Jacob's in Stendal, west of Berlin. Both screens are filled with checked iron traceries and crowned by a monumental Calvary group. Of the screens in the country churches at Kotzenbüll in Schleswig-Holstein and Resterhafe in East Frisia, only the open upper section with wooden traceries is preserved. In Belgium, a single Late Gothic screen from the priory of Notre-Dame du Val des Écoliers in Mons, in Hainaut, is now kept in the Royal Museum for Art and History in Brussels.[21] A lone Scandinavian screen is found in the wooden stave church in Hopperstad on the Sogne-fjord. It has early Gothic characteristics and can be dated to the late thirteenth century, making it one of the oldest known examples in Europe.[22] The screen which closes off the chancel of St Nicholas's (now cathedral) in Swiss Fribourg consists of an iron frame entirely filled with checked iron traceries.[23] The only country which – by far – surpasses the

[20] Classic studies on rood screens and lofts in Britain are: J. C. Cox and A. Harvey, *English Church Furniture* (London, 1907), pp. 82–143; F. Bond, *Screens and Galleries in English Churches* (London, 1908); and A. Vallance, *Greater English Church Screens* (London, 1947). See also R. Marks, 'Framing the Rood' in this volume.

[21] I thank Marguerite Coppens for this information.

[22] On Norwegian choir partitions, see A. M. Hoff, 'The Area between Chancel and Nave in Norway's Medieval Parish Churches: An Outline of the Subject's Research Status, with a Survey of Selected Scandinavian Literature', *Jaarboek voor liturgie-onderzoek*, 19 (2003), pp. 147–74. On the treatment of the choir boundary in Swedish churches and the absence of screens there, see A. Nilsén, *Focal Point of the Sacred Space: The Boundary between Chancel and Nave in Swedish Rural Churches: From Romanesque to Neo-Gothic* (Uppsala, 2003).

[23] The design of the Fribourg screen is somewhat reminiscent of the monumental

number of screens in the Netherlands is Britain. Estimates of the number of surviving screens (both originally with and without lofts) here vary from more than 500 to around 1,000. The wealth of British – particularly English – screens is a major theme in this volume, and for their most important aspects we may refer to the other contributions.

This essay presents a survey of all surviving pre-Reformation chancel screens in the Netherlands.[24] Only screens which stand (or stood) in front of the chancel have been included, while screens which closed off side chapels or other secondary spaces are left aside. All surviving Dutch pre-Reformation screens date from the fifteenth and sixteenth centuries. The lower section or dado, which has an average height of around one metre, has a closed nature and is often decorated with carvings. An openwork section usually sits above, filled with vertical bars and tracery at the top. Remarkably, most Dutch screens have metal fillings carried out in iron or brass, contrary to other countries, where most traceries are carved in wood. Thus, the wooden frame of which the upper section is filled with metal bars may be described as a 'Netherlandish type' of screen. Geographically, most surviving screens are concentrated in the west of the country, in West-Frisia north of Amsterdam, as well as in and around Het Gooi, a region south-east of the same city, around Rotterdam in South Holland and surrounding the estuary of the river IJssel in the provinces of Overijssel and Gelderland (Pl. LIV).

Stylistically, the pre-Reformation screens in the Netherlands can be divided into two categories, namely Late Gothic and Early Renaissance. Since the Reformation took hold in the country only at a relatively late date, between 1570 in the West and as late as 1594 and 1598 in the north-eastern provinces of Groningen and Drenthe, the share of Renaissance examples is considerable. However, the transition between both styles was very gradual, with no clear turning point. An illustration of this are the discussions within the chapter of Utrecht in 1519 concerning a new screen for the sanctuary in the cathedral, which is known locally as the 'Dom-church'.[25] The original design in the Gothic style by Jan van den Eynde, a brass smith from Mechlin in Brabant, was rejected by Bishop David of Burgundy since he considered it to be too old-fashioned. Instead, the prelate wished a screen in the new 'classic' style. Thereupon the chapter ordered a screen in so-called 'antique'

iron screens, called 'rejas' in Spanish cathedrals and other churches. Here, the spatial organization of choir and altar area was very different, however, so that they can hardly be said to be 'chancel screens'.

[24] In 2005, I published a first survey in Dutch: 'Voorreformatorische koorhekken in Nederland', *Jaarboek voor liturgie-onderzoek*, 21 (2005), pp. 129–57. All examples in the provinces of North and South Holland are studied in Kroesen, 'Die tralyen voert choer. Middeleeuwse koorafscheidingen in Holland', *Bulletin van de Stichting Oude Hollandse Kerken*, 61 (2005), pp. 3–29.

[25] See D. Bierens de Haan, *Het houtsnijwerk in Nederland tijdens de Gothiek en de Renaissance* ('s-Gravenhage, 1921), pp. 105–9.

forms with the Antwerp caster Gregorius Wellemans. In his design, however, Wellemans allegedly only achieved the adoption of isolated elements in Renaissance style in a largely Gothic pattern. Even after invoking the assistance of French brass workers, he could not please the canons with a screen in the pursued 'modern' style, as a result of which it was never carried out.

GOTHIC SCREENS

The oldest surviving chancel screen in a Dutch church today is found in St Peter's in Leiden in South Holland (Fig. 9.2).[26] It is generally thought to have been created between 1425 and 1450. It is constructed from sturdy wooden beams with only limited decoration, including a number of tiny carved roses on the main posts. The present bars in the upper section were added in the eighteenth century. The screen is known to have carried a large Crucifixion group, which was taken down at the time of the Reformation and replaced by the current text panel showing the Ten Commandments and texts related to the Last Supper. The upper beam carries inscriptions on both sides. On the nave side, it reads: 'Ghebenedijt Sij Die Soete Name Ons heren Jhesu Christi Ende die Naem Der Soete Maget Marie Inder Ewicheyt' ('Blessed be the Sweet Name of Our Lord Jesus Christ and the Name of the Sweet Virgin Mary in Eternity'). The chancel side clearly addresses the clerics, where it is written in Latin: *Dum Cantor Populum mulcet Suis vocibus Deum Irritat Pravis Moribus. D(ivus). Bernardus* ('While the cantor pleases the people with his sounds, he incenses God with his bad manners, such says the divine Bernardus').[27] This beam and its inscriptions are now concealed behind two Renaissance friezes from c.1550–60 of which the original location is unknown. Apparently, the Protestants wished to retain the screen as such but decided to hide these explicitly Catholic inscriptions.

The richest Late Gothic screen preserved in the Netherlands is found in St Bavo's in Haarlem in North Holland (Fig. 9.3).[28] It was created between 1509 and 1517 by a certain Stephen the Woodcarver with brass works by Jan Fyerens from Mechlin.[29] It is composed of a closed dado with carved panels and a tall openwork upper section with brass bars alternating with candlesticks. The bars end in patterns of intricate tracery with round and

[26] J. E. A. Kroesen, 'Het oudste koorhek van Nederland', in E. den Hartog and J. Veerman (eds), *De Pieterskerk in Leiden. Bouwgeschiedenis, inrichting en gedenktekens* (Zwolle, 2011), pp. 235–9.

[27] These inscriptions were studied by A. Eekhof, 'Opschriften op het koorhek in de Pieterskerk in Leiden', *Nederlandsch Archief voor Kerkgeschiedenis*, 23/4 (1930), p. 277.

[28] See J. A. J. M. Verspaandonk, 'Het koorhek in de Grote of St. Bavokerk', *Haerlem Jaarboek* (Haarlem, 1991), pp. 29–47; and A. Peters, *Tot cieraad van de Kerk en van een schone glans: het koorhek in de Grote of Sint-Bavokerk te Haarlem* (Haarlem, 1998).

[29] A. M. Koldeweij, 'Over Jan Fierens, geelgieter te Mechelen', in J.N. de Boer et al. (eds), *De Bavo te boek. Bij het gereedkomen van de restauratie van de Grote of St.-Bavokerk te Haarlem* (Haarlem, 1985), pp. 150–5.

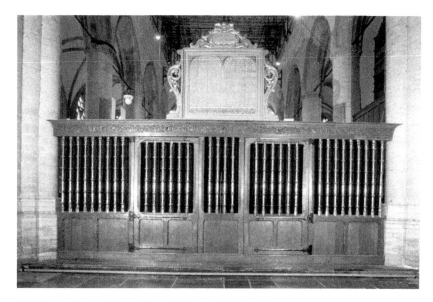

FIG. 9.2. LEIDEN,
ST PETER,
SCREEN (1425–50)
VIEWED FROM
THE NAVE.

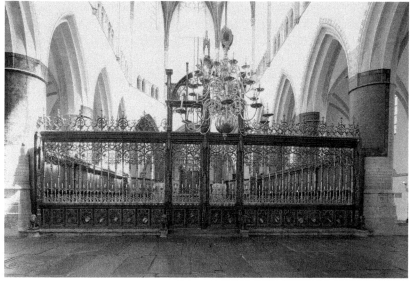

FIG. 9.3.
HAARLEM, ST
BAVO, SCREEN
(1507–14) VIEWED
FROM THE NAVE.

pointed arches framing foliage and bunches of grapes. The west side is richly decorated, with the now empty niches on each one of the main posts originally holding sculptures of the patron St Bavo and the four evangelists. The twenty dado panels show the shields of thirteen towns in the county of Holland.[30] To these are added the arms of Engelbrecht Willemsz Wisse, priest in Haarlem and dean of the nearby Kennemerland,

[30] Haarlem, Leiden, Gouda, Alkmaar, Enkhuizen, Monnickendam, Dordrecht, Delft, Amsterdam, Hoorn, Edam, Medemblik and Beverwijk. In contrast, the chancel side of the dado is remarkably austere.

and four fantasy coats of arms on the central doors. The emblems are held by a variety of figures, including a muzzled bear, a griffin, a basilisk, a monkey, a savage and a lion. On the outer panels of the dado a man and a woman holding a rosary are depicted biting a pillar. These 'pillar biters' most probably represent people who are continuously at prayer, and are believed to be the symbols of hypocrisy or sanctimoniousness.[31] Standing on pedestals in front of the screen on the west side are four animals. The central doors are flanked by two kneeling lions with their heads turned towards the centre, while two dogs facing outward are standing on both ends of the screen. Both dogs carry a puppy, the male dog in a bag before his chest and the female in a cloth around her neck. It is difficult to determine the meaning of these four animals: do they represent true and false piety, or do the dogs represent fidelity while the lions guard the entrance to the sanctuary?[32]

On either side of the brass cresting on top of the transversal beam an angel is represented. Candles were placed on the pins in between, as is apparent from contemporary written records.[33] The middle section, as in Leiden, carried a Calvary group, which was replaced by a text panel after the Reformation; the present crowning in Neo-Gothic forms was added by the restoration architect P. J. H. Cuypers in 1877. The Rood is mentioned in a record from 1574, where it is said to stand on a 'berychen' ('bergje' = little mountain), a reference to the hill of Golgotha.[34] The missing cross in Haarlem is referred to by a Latin text inscribed on the chancel side of the beam, which reads: *O crux gloriosa, O crux adoranda, O lignum preciosum et ammirabile signum, Super quod et dyabolus est victuus et mundus Christi sanguine redemptus, alleluia* ('O cross full of glory, o venerable cross, o precious wood and admirable sign, upon which the devil was vanquished and the world was redeemed by the blood of Christ, Halleluia'), followed by the name of Wilhelmus Ban and the year 1550 on the right.[35] Apart from Leiden and Haarlem, only one other screen is known to have carried an inscription, in Heinenoord near Rotterdam. Of this example, only the upper beam survives; it was discovered underneath the organ during restoration of the church in 1971.[36] The present screen is

[31] Cf. Verspaandonk, 'Het koorhek', p. 37.
[32] See Bierens de Haan, *Het houtsnijwerk*, p. 65; and Verspaandonk, 'Het koorhek', pp. 42–3.
[33] It is mentioned in a record from 1528 that thirteen candles were lit during Holy Mass, cf. Bierens de Haan, *Het houtsnijwerk*, p. 65
[34] Such a representation can still be seen in the Calvary group in the country church of Hanselaer near Kalkar, Germany, close to the Dutch border.
[35] Cited after G. Delleman, *Een rondleiding door de Grote of St.-Bavokerk te Haarlem* (Haarlem, 1985), p. 41.
[36] It measures c.5 metres, with a height of 21cm and a width varying between 12 and 18.5cm. See J. E. A. Kroesen, 'Die tralyen voert choer – enkele aanvullingen', *Bulletin van de Stichting Oude Hollandse Kerken*, 69 (2009), pp. 18–21. A similar discovery was made in 1959 in the church at Benschop in the province of Utrecht.

a modern reconstruction following the model of nearby Mijnsheerenland (see below). The text is damaged, but can be reconstructed as follows: 'O [folk en] wilt niet wanhopen want gods bermherticheijt [duer]t altijt [voirt]' ('O, folk, do not despair, because God's mercifulness is eternal').[37] Judging from the Late Gothic letter form, it must have originated shortly after 1500.

Simpler and less decorated Gothic models are also found in a number of smaller churches. In the collegiate church at Naaldwijk near The Hague the dado is entirely filled with folding panels separated from each other by slender pinnacles. The brass bars are crowned by intricate wooden tracery. Access to the choir is via two doors on either side of the central section which now serves as a background to the pulpit from 1619 which was moved here during a modern restoration.[38] The screen in Mijnsheerenland near Rotterdam dates from around 1500 and has similar folding panels in the dado, framed by heavy beams. The simplicity of the slender wrought-iron bars in the openwork upper section is striking. During restoration in 1963–65 the four main sections of this screen were made moveable.[39] The Late Gothic screen in the church at Abbenbroek, south of Rotterdam, which dates from c.1500, was integrated into a high partitioning wall in 1625. On this occasion most balusters were replaced.[40] In the Great Church alias Our Lady's of Breda in the province of Brabant the central doors in the choir screen from 1581 show Late Gothic decorations. It has been suggested that these belonged to a fully fledged choir gallery that was destroyed during the Iconoclasm of 1566.[41] The dado of the screen at Nisse in the province of Zeeland features ogee arches and mouchette motifs, while the upper zone is crowned by ogee arches with fine wooden tracery inside, suggesting a date around 1525. During the move from the chancel arch to its current position in the north transept it had to be shortened. This probably occurred when a new chancel screen was installed during the seventeenth century.

Two screens in town churches of North Holland can be dated to the same period around 1525. The wooden frame of the screen in the church of St Laurence in Weesp near Amsterdam regained its original red-and-blue polychromy during restoration in 1968–78 (Fig. 9.4).[42] The brass bars with intricate Gothic traceries at the top were probably cast by the above-mentioned Mechlin brass worker Jan van den Eynde. The middle section between the two doors has two openings with consoles at the bottom

[37] This partial reconstruction of the text is thanks to Mr Alex van der Woel, churchwarden of the local parish. I thank him for his kind assistance.
[38] Steensma, *Protestantse kerken*, pp. 110–11.
[39] Ibid., p. 110.
[40] Kroesen, 'Voorreformatorische koorhekken', p. 137.
[41] G. van Wezel et al., *De Onze Lieve Vrouwekerk en de grafkapel voor Oranje-Nassau te Breda* (Zwolle/Zeist, 2003), pp. 134–6.
[42] Steensma, *Protestantse kerken*, p. 112.

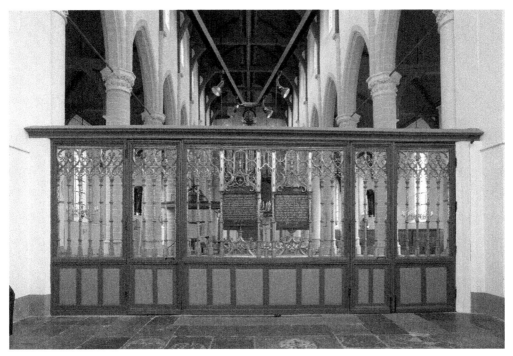

FIG. 9.4. WEESP, ST LAURENCE, SCREEN (C.1525) VIEWED FROM THE CHANCEL.

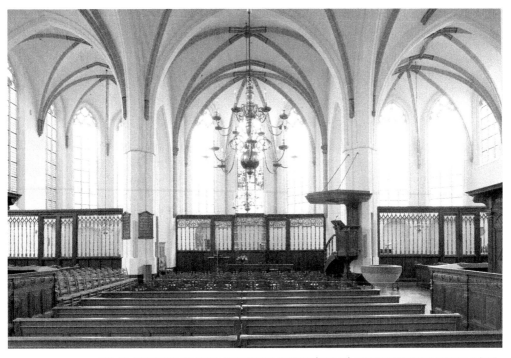

FIG. 9.5. UTRECHT, ST JAMES, TRIPARTITE SCREEN (1500–25) EXTENDING OVER THREE AISLES.

and richer traceries than in the flanking sections. Originally, the consoles probably supported round sculptures, possibly an angel and the Virgin Mary as a representation of the Annunciation. These were replaced after the Reformation by text panels with the Ten Commandments, the Creed, the Beatitudes and a prayer. The screen in St Laurence's at Alkmaar also originated around 1525. The five dividing columns are decorated with twisted pinnacles bearing consoles which must have supported statuettes. It was heavily restored during the nineteenth century, when the original metal bars were replaced by the current wooden ones.[43] Of the original screen in the Great Church at Elburg in the province of Gelderland (Guelders), which originated during the second quarter of the sixteenth century, rearrangements in 1808 only spared the upper zone with brass traceries. The chancel arch, by way of exception, has retained its original cross-beam on which a Calvary group must have rested.[44]

The most impressive ensemble of Late Gothic screens in the Netherlands is found in St James's parish church in Utrecht (Fig. 9.5). With its later alterations, it provides a good survey of stylistic developments in the sixteenth century and of the treatment of choir partitions in early Calvinism. The screens extend over all three aisles of the church, a sight which is reminiscent of the many elaborate tripartite screens in the south-west of England.[45] All sections were probably created at the same time during the first quarter of the sixteenth century, as the Late Gothic folding panels in the dados indicate. During the Iconoclasm of 1566, the copper bars in the central section vanished and were replaced in the following year by traceries cast by the Antwerp brass worker Jan de Clerck. The design of tracery at the top emanates a remarkable Gothicizing manner, which was probably intended to preserve a certain unity within the screen as a whole. Remarkably, the central section of the middle screen projects forward, with twisted columns and two kneeling figures – of a man and a woman – at the easternmost corners on the east side. It has been suggested that this projection originally provided space for a free-standing tabernacle tower. In this case the carved figures would pay eternal tribute to the sacrament stored in this position, clearly visible to the faithful in the nave.[46]

The screen in Poortugaal near Rotterdam probably dates to around 1530 and marks the transition between the Gothic and Renaissance styles. During the nineteenth century, it was integrated into a glass partition which fills the entire chancel arch. In 1923–24 this was moved in its entirety one bay to the east. The screen is divided into four sections, as

[43] See C. Rogge, *Grote of St. Laurenskerk Alkmaar. Rapport over het kerkgebouw en inventaris* (Alkmaar, 1996).

[44] R. Stenvert et al., *Monumenten in Nederland: Gelderland* (Zwolle/Zeist, 2000), p. 162.

[45] Examples are found in Ashton, Bridford and Harberton, all in Devon, and Altarnun in Cornwall. During a modern restoration, the middle section of the Utrecht screen was moved one bay further east to create more space for liturgical ceremonies.

[46] See *Jacobikerk Utrecht* (local guidebook) (Utrecht, 1977).

in Mijnsheerenland, with simple folding panels in the dado. Contrary to that screen, however, the openwork section has classic lathed balusters carved in wood. Striking details are two jars in the outermost frames, which probably refer to the ampullae with water and wine used during Mass. The branches that seem to spring from them may represent the vine tendril, which reinforces the reference to the Eucharist.[47] The screen in the church at Epe in the province of Gelderland also combines Gothic and Renaissance characteristics. While the dado is filled with Gothic folding panels, the lathed wooden bars in the upper section are in the Renaissance style. These are crowned by a tracery pattern of intersecting round arches, creating a Gothicizing effect. The woodcarver, who showed his familiarity with the 'antique' style in the balusters, apparently still had to resort to the Gothic manner in his execution of the dado and the traceries. Very similar traceries can be seen in a low railing in the church of St Martin in Bolsward (Frisia). Contrary to Epe, here the Renaissance is not present in the carvings of the bars below. Probably, this is the only surviving part of a fully fledged Late Gothic screen.

EARLY RENAISSANCE SCREENS

The screen in St Vitus at Naarden near Amsterdam dates from 1531 and is generally considered the first among surviving screens in the Netherlands in which the Renaissance style dominates (Fig. 9.6).[48] Although the dado displays some Gothicizing tracery, the Renaissance becomes apparent in the carvings of the wooden bars, showing medallions, masks and volutes. The crowning frieze on the nave side features a series of heads of rulers and nobles on either side of three allegorical female figures in the central section which represent – from left to right – Faith, Hope and Love (Charity). Faith carries a cross and next to her stands a chalice as a symbol of the Catholic Mass. The vessel is of tiny proportions, which is probably the reason why it escaped the attention of the Iconoclasts. Charity in the middle carries a child and a cornucopia, while Hope is a winged figure with folded hands. The Christian virtues are flanked by Emperor Charles V, count of Holland since 1515, on the right and his sister, Mary of Hungary, whom he had appointed as Governess in the Netherlands in 1531, on the left. Her piety is visualized by fleeing demons on either side. Further to the right is Antoine de Lalaing and Hoogstraten, stadtholder of Holland from 1522, and his spouse. To the left are Jan van Alkemade, bailiff of Gooiland between 1523 and 1533. On the chancel side the frieze shows the different social strata, represented by a nobleman and woman, a burgher and his wife, and a farming couple. Flanking the centre are female

[47] Kroesen, 'Die tralyen voert choer – enkele aanvullingen', pp. 16–17.
[48] J. Kroonenburg et al., *De Grote Kerk van Naarden in historisch perspectief* (Naarden, 1984), p. 50. The present crowning dates from 1978.

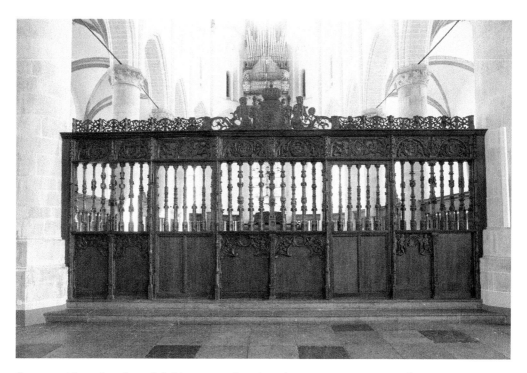

figures with a plough and fishing nets, showing the most important crafts in sixteenth-century Naarden.

The dado of the Naarden screen has carvings on the nave side in five of the eight sections with some remarkable imagery. To the left are two haloed child angels holding a vessel, which has been interpreted as a censer.[49] In the next section, male and a female angels flank a heraldic emblem showing the Holland lion. Left of the centre, the same coat of arms can be seen, flanked by two angels, one of whom is asleep holding a spear, while the other carries a cross and is awake. Its meaning seems to be that in times of peace, weapons may remain tacit but Faith should always be awake.[50] The next section depicts remnants of a chalice, damaged during the Reformation, between two bunches of grapes. The right section shows the Naarden coat of arms flanked by two armed angels holding a bow and a sword. The crown above the emblem reads 'alle vleis is hoei' ('all flesh is grass'), a citation taken from Isaiah 14:6.

The screen in St Gommarus's or Westerkerk in Enkhuizen in northern North Holland represents one of the most important examples of pure Renaissance woodcarving in the Netherlands (Fig. 9.7). The inscribed number '1542' can be taken as its date of origin.[51] The screen is divided into six sections by projecting rectangular flat posts with *a candelieri* ornaments

FIG. 9.6. NAARDEN, ST VITUS, SCREEN (1531) VIEWED FROM THE NAVE.

[49] Ibid., p. 51.
[50] Ibid.
[51] J. S. Witsen Elias, *Koorbanken, koorhekken en kansels* (Amsterdam, 1946), p. 52.

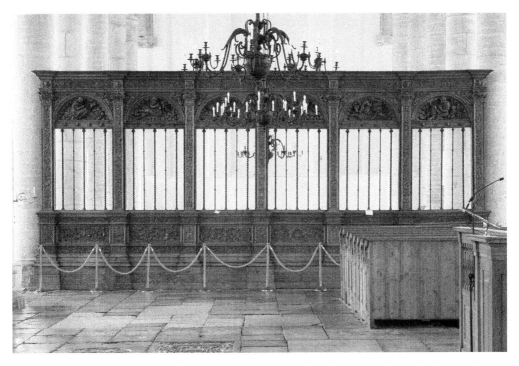

FIG. 9.7.
ENKHUIZEN,
ST GOMMARUS,
SCREEN (1542)
VIEWED FROM
THE NAVE.

and capitals decorated with putti and volutes. The low dado has elegant carvings reminiscent of the Spanish *plateresco* or silversmith-style. Between the foliage, birds, heads, busts and fantasy figurines can be seen: the second panel from the left shows the wine god with a number of tappers. Above the dado is a tall openwork section from which the original brass bars were confiscated in 1572 and replaced by wooden ones. The present simple iron tracery dates from the nineteenth century.[52] On the nave side, each compartment is crowned by a shell-shaped niche with a demi-figure in very high relief, flanked by hovering angels in the spandrels. The first two from the left depict the evangelists St John and St Matthew writing, accompanied by their creatures, an eagle and an angel. On the right are St Luke with his ox and St Mark with his lion. The two central fields feature Christ as *Salvator Mundi* holding the globe and Moses with the stone tablets. The tympana on the chancel side are shallower and show putti with wreaths with busts and female nudes. Left of the centre, the coat of arms of Emperor Charles V can be seen flanked by columns and lions. Banderoles around the columns are inscribed with his motto *plus oultre* ('plus ultra'). The survival of this elegant screen during Dutch Calvinism is rather astonishing, especially in view of its explicit iconography, as carved depictions of Christ were usually erased or damaged. In Enkhuizen, as we have seen in Naarden, even the signs of the Spanish emperor (although himself a Netherlander by birth) were left

[52] P. Don et al., *Kunstreisboek Noord-Holland* (Weesp, 1987), p. 254.

intact. Ironically, shortly after, the brass bars from the screen were used to finance the war against the same power.

The model of the Enkhuizen screen was closely followed in the church of St Nicholas or Bovenkerk, in Kampen in the province of Overijssel. Created ten years later, in 1552, this screen is somewhat simpler and less refined in execution.[53] It is divided into seven compartments, of which all but one are crowned by shell-shaped tympana displaying busts in high relief. As in Enkhuizen, the nave side shows the four evangelists, Moses, and Christ as *Salvator Mundi*. Here also, the chancel side of the screen is austere and has only shallow decorations. Contrary to Enkhuizen, in Kampen the original brass bars have been preserved. Those in the central section date from 1940 when they were inserted to replace wooden bars. Several contemporary records indicate that this section originally held a tower-shaped Eucharistic tabernacle.[54] This tower was commissioned by the Kampen town council from a brass worker in Mechlin in 1498, some fifty years prior to the screen. Tabernacles of brass are very rare: surviving examples include the village church at Bocholt, in eastern Belgium, and in St Mary's in Lübeck in northern Germany.[55] A visible reminder of the presence of the tabernacle in the centre of the Kampen screen are six angels swinging censers, carved on the posts on the nave side. Angels with censers were a well-known motif around tabernacles during the late Middle Ages in the Netherlands, and we also find them in the arcades surrounding the now lost tabernacles on the north side of the chancels in the Old and New Churches in Amsterdam.[56]

Another very decorated Early Renaissance screen is found in the Great Church alias St Nicholas at Monnickendam, north of Amsterdam (Fig. 9.8). It is divided into five sections by projecting posts with twisted pinnacles of a strikingly Gothic thrust at the front and now empty niches at the top. Another Gothicizing detail is the vine tendril under the (renewed) architrave. On the dado and in the traceries, however, the Renaissance reigns supreme. The dado panels on the nave side show elegant vase and candelabra motifs between foliage, and animal heads on the panels of the dado. The carved balusters are crowned by very rich traceries which include foliage, masks in wreaths and putti. There are dates inscribed on two of the balusters, 1562 and 1563. In view of strong similarities with the Early Renaissance screens described above, however, a date around 1545–50 would seem to be more natural, and the inscribed dates may therefore refer to partial renewals.

[53] Witsen Elias, *Koorbanken*, p. 56.
[54] See R. Steensma, *Het gebruik van de middeleeuwse kerken in Overijssel voor de katholieke eredienst* (Delden, 2005), pp. 17–20.
[55] Both towers are analysed by A. Timmermann, *Real Presence: Sacrament Houses and the Body of Christ, c. 1270–1600* (Turnhout, 2009), pp. 107–10 and 184–7.
[56] See R. Steensma, 'Nissen en schilderingen als sporen van de katholieke eredienst in de middeleeuwse kerken van Noord-Holland', *Bulletin van de Stichting Oude Hollandse Kerken*, 59 (2004), pp. 8–10.

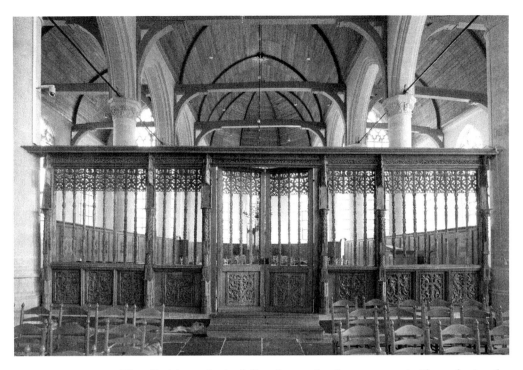

FIG. 9.8.
MONNICKENDAM,
ST NICHOLAS,
SCREEN (1545–50)
VIEWED FROM
THE NAVE.

The Gothic style is fully absent in the screen at Abcoude in the province of Utrecht, which is dated to 1542.[57] Its crowning architrave, on which the original gold-and-blue polychromy has been restored, displays a variety of birds, grotesques and foliage in which masks, horse and angel heads, herms and satyrs can be discerned. The upper section is filled with a round-arched arcade resting on grooved balusters decorated with acanthus foliage at the bottom, while the spandrels between the arches feature a row of masks. The dado on the nave side features a row of lion heads and green men in rhombic frames on the panels and on the fronts of the projecting posts.[58] The screen in Abcoude shows close similarities to the screen in nearby Nederhorst den Berg, of which four of originally five sections are preserved. It was restored to its original position in 2007, where it had stood until 1939.[59] As in Abcoude, the crowning above the lathed balusters is shaped as a round-arched arcade, but with no decorations in the spandrels. The closed dado panels are decorated with a row of masks set within framing rhombs. A round-arched arcade also fills the upper section of the screen in Workum in the northern province of Frisia, of which two-thirds survive. An inscription reads that it was

[57] Cf. R. Stenvert et al., *Monumenten in Nederland: Utrecht* (Zwolle/Zeist, 1996), p. 56.
[58] The screen now serves as a background to the Renaissance pulpit with carved figures representing the four evangelists, which can also be dated to the middle of the sixteenth century. It was probably moved here in 1633.
[59] Kroesen, 'Die tralyen voert choer – enkele aanvullingen', p. 17.

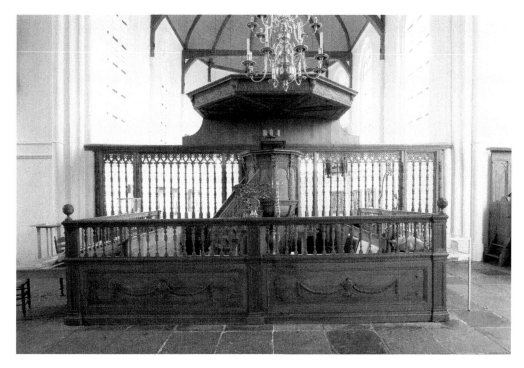

created by a certain Klaas Tjebbeszoon ('Claes Thiebbezoen') in the year
1569. The crowning frieze shows roses between male and female heads
which face each other.[60]

Other Renaissance screens carry no date or cannot be directly related to
other dated examples, so that a general origin between 1540 and 1560 may
be assumed. The screen in Oosthuizen in North Holland features lathed
candelabra balusters and a crowning in which acanthus leaves and dolphins
can be seen (Fig. 9.9). After the Reformation, the chancel was reused as
a house for the verger and his family, and a solid wall was erected in the
chancel arch.[61] The pulpit was moved to its present location in front of the
screen in 1664.[62] The screen seems to have undergone several important
changes, for example in the middle section behind the pulpit, which is
made up of solid board. Of the screen at Geervliet south of Rotterdam
only two sections were preserved when these were inserted as doors in a
new partition in front of the chancel after the Reformation.[63] The closed

FIG. 9.9.
OOSTHUIZEN,
SCREEN (C.1550)
VIEWED FROM
THE NAVE.

[60] On the Workum screen, its removal and replacement, see R. Steensma, *Opdat de
ruimten meevieren. Een studie over de spanning tussen liturgie en monumentenzorg bij de
herinrichting en het gebruik van monumentale hervormde kerken* (Baarn, 1982), pp. 56–64.
[61] This partition wall was removed again in 1922.
[62] On the church at Oosthuizen, see 'De Grote Kerk van Oosthuizen. Opnieuw
oogverblindend en oorstrelend', a special issue of the *Bulletin van de Stichting Oude
Hollandse Kerken*, 57 (2003).
[63] Text panels, with the Ten Commandments and other texts, accompanied by rich
heraldry, were installed on top in 1588, see Steensma, *Protestantse kerken*, pp. 173–4. In

dado is divided into rectangular sections with simple frames, while the openwork section above has grooved wooden balusters in Renaissance style decorated with acanthus foliage ending in elegant curved traceries at the top. Of humble execution is the Renaissance screen in the church at Marsum in the province of Groningen. Above a remarkably high, closed dado is an openwork section with square wooden bars, except for those in the central doors which show a simple lathed profile. This screen is traditionally dated to the second half of the sixteenth century.[64] The Reformation was only introduced here in 1594, so that the origins of this screen probably still lie in the Catholic period.

THE 'PRESERVING POWER' OF CALVINISM

The above survey of surviving pre-Reformation choir partitions, including eight galleries and twenty-five chancel screens in Dutch Calvinist churches, which were so thoroughly purged by the Iconoclasts, may come as a surprise. Although few in number, their preservation rate is still among the highest in continental Europe. Written sources indicate that screens were initially maintained in an even greater number of churches, where they were later removed due to a growth of the community or in the course of liturgical rearrangements. It may be concluded that, contrary to virtually all other 'Papist' furnishings, including altars, retables, saints' sculptures, roods and baptismal fonts, screens were relatively often left intact by Dutch Calvinists. The reasons behind this must be sought in the treatment of the formerly sacred domain of the chancel. These spaces were either hived off from the nave and put to purely practical use, became public 'mausoleums' for the elites in society or were used for the celebration of the Lord's Supper, the Calvinist continuation of the Catholic Eucharist.[65] In all of these scenarios, the presence of a chancel screen offered important practical advantages, and its use was thus continued, altered or became 'frozen'.[66]

the nineteenth century, the arch above this partition was filled with glass, so that the chancel is now entirely severed from the nave.

[64] M. D. Ozinga, *De Nederlandsche Monumenten van Geschiedenis en Kunst IV: De provincie Groningen – Oost-Groningen* ('s-Gravenhage, 1940), p. 18; and R. Stenvert et al., *Monumenten in Nederland: Groningen* (Zwolle/Zeist, 1998), p. 158.

[65] Calvinist adaptations of medieval chancels are discussed more extensively in my recent article 'Accommodating Calvinism: The Appropriation of Medieval Church Interiors for Protestant Worship in the Netherlands after the Reformation', in Jan Harasimowicz (ed.), *Protestantischer Kirchenbau der frühen Neuzeit in Europa. Grundlagen und neue Forschungskonzepte* (Regensburg, 2015), pp. 81–98.

[66] The three options mentioned are inspired by an essay on surviving medieval furnishings in Lutheran churches in Germany by F. Schmidt, 'Die Fülle der erhaltenen Denkmäler. Ein kurzer Überblick', in J. M. Fritz (ed.), *Die bewahrende Kraft des Luthertums. Mittelalterliche Kunstwerke in evangelischen Kirchen* (Regensburg, 1997), pp. 71–8.

Most significant was the use of the chancel for the celebration of the Lord's Supper ('Avondmaal', lit. 'evening meal'). Contrary to the Catholic tradition, this ceremony was not enacted every week, but rather, on average, some four times a year.[67] Following the model of the Last Supper of Christ and his disciples, most communities preferred a seated celebration, using long, temporarily placed tables of simple design which could accommodate a large number of believers, whether or not all at once or in several 'shifts'. The use of such tables required considerable space, which was often found in the wide central corridor in front of the pulpit, in a side aisle or in the emptied chancel.[68] In the latter case, this would imply a perhaps unexpected – if not unintended – form of ritual continuity: the chancel retained its function as a stage for the Lord's Meal, with the Catholic Mass being replaced by the Calvinist Lord's Supper. The theological implications of this ritual continuity have been little recognized in scholarship, nor has the spread of this custom been thoroughly studied to date. Material vestiges indicate that the administration of the Lord's Supper in the chancel was much more common than is usually assumed, at least during the first centuries following the Reformation.[69] Screens served a practical purpose in that they visually and physically divided the preaching area in the nave, which was accessible to all, from the ritual domain in the chancel, where only those among the believers who were considered 'truly converted' ('bekeerd') could attend.[70]

A clear indication of the Protestant use of the chancel for the celebration of the Lord's Supper are crowning text panels on top of a number of screens. In the church of St Peter's in Leiden, as was mentioned above, the medieval Calvary group was removed from the Gothic screen and replaced by a large text panel. On the nave side, it features the Ten Commandments, while the chancel side has a passage from the letter of St Paul to the Corinthians referring to the Communion.[71] Two text panels inserted in the screen at Weesp show the Commandments and the Creed on the nave side, and the Beatitudes and a prayer inspired by Proverbs. The presence of the Ten Commandments at the threshold of the chancel must be understood as an admonition to the believers on their way to the Lord's table: prior to their partaking of the holy meal, believers ought to

[67] See C. A. van Swigchem et al., *Een Huis voor het Woord. Het protestantse kerkinterieur in Nederland tot 1900* ('s-Gravenhage/Zeist, 1984), p. 213.
[68] Ibid., p. 215.
[69] Cf. A. Baljeu and J. E. A. Kroesen, 'Der Groninger Abendmahlschor und seine Beziehung zu Ostfriesland', *Emder Jahrbuch für historische Landeskunde Ostfrieslands*, 93 (2013), p. 160.
[70] The same practical considerations probably also played a role in the survival of a considerable number of choir stalls in Dutch Calvinist churches, as mentioned above. These seats, formerly reserved for the monks or canons, now served as seats for the participants in the ritual meal.
[71] Interestingly, during the restoration in 1983–84, this turned out to be a reused panel created before the Reformation.

examine their conscience thoroughly by contemplating their sins, as these were mirrored by the biblical Commandments. In St Bavo's in Haarlem in 1580 a large panel with texts relating to the Lord's Supper was installed on the axis of the choir, where the high altar had stood until shortly before.[72] The Gothic choir stalls which survive here were undoubtedly used for the new Protestant ritual. In St Stephen's in Nijmegen, in the same position in which the tabernacle had stood on the north side of the chancel, the text of passages from 1 Corinthians 10 and 11 and a number of references to the Gospels were painted.[73]

The province of Groningen is exceptional in that in the chancels of several churches sets of permanent tables and benches from the seventeenth and eighteenth centuries have been preserved, which clearly indicates that this part of the building was exclusively used for the Lord's Supper.[74] The earliest preserved ensemble is found in Noordwolde and dates from c.1660 (Fig. 9.10). Here, the chancel is screened off from the nave by a low railing with carved decorations. Another elegant set of furnishings for the Lord's Supper is preserved at Zandeweer, where the centrally located Communion table with marble top is surrounded by a simple wooden bench which runs along the chancel walls. The table is placed on a brass slab which gives access to a burial cave for the local nobility underneath the choir. As was often the case, here, the furnishings for the Lord's Supper were donated by the landed nobles. In nearby Huizinge, nothing remains of the original seating and tables, but the screen clearly sets the chancel apart for the celebration of the ritual Supper. The crowning panel shows the coats of arms of Berend Coenders, lord of nearby Fraam Manor, on the nave side, while his name and titles and that of his wife can be seen on the chancel side. Conspicuously, passages from the Letter to the Romans are only referred to on smaller side panels.

The screen in Huizinge is dated to 1641, some fifty years after the Reformation. Chancel screens created by Protestants are no exception in the Netherlands, and they even outnumber the medieval ones by some twenty-five to sixty.[75] In the Great Church at Medemblik in North Holland, the screen was installed right after the transition, as is stated in an inscription above the central doors: 'Tmisbruijk in Gods kerck allengskens ingecomen is hier wederom anno 1572 afgenomen' ('The abuse which was gradually

[72] 1 Corinthians 11:23–6, Matthew 26:26, Mark 14:22, Luke 22:19 and 1 Corinthians 10:16. Mia Mochizuki discusses this remarkable panel in her thorough study of St Bavo's in Haarlem but hardly relates its contents to the celebration of the Supper in this realm. See M. Mochizuki, *The Netherlandish Image after Iconoclasm, 1566–1672: Material Religion in the Dutch Golden Age* (Aldershot, 2008), pp. 127ff.

[73] Steensma, *Protestantse kerken*, pp. 184–5.

[74] In Groningen, thirty-three monumental churches are known to have possessed such sets of furnishings: see Baljeu and Kroesen, 'Der Groninger Abendmahlschor', pp. 157–67. In other parts of the country, such furnishings are only found exceptionally.

[75] See Steensma, *Protestantse kerken*, pp. 115–23; and Van Swigchem et al., *Een Huis voor het Woord*, pp. 208–11.

introduced into God's church was abolished again here in the year 1572').[76] The monumental partition in the New Church in Amsterdam, created in 1647–50 by Jan Lutma, is a splendid example of a Protestant screen (Pl. LV). It follows the common model of the medieval chancel screen, with a closed dado and openwork upper section; the dado is carried out in black-and-white marble while the screen is filled with brass tracery. No reference is made to the celebration of the Communion – on top of the screen, two centrally placed lions hold the Amsterdam coat of arms, while the chancel side shows the town seal and a merchant ship. Many other Protestant screens are crowned by text panels, which usually follow the standard pattern: the Commandments between the Creed and Our Lord on the nave side, and passages referring to the Last Supper facing the chancel.[77] Well-preserved seventeenth-century screens-cum-text panels survive in Noordwijk-Binnen (South Holland) (Pl. LVI) and Kimswerd (Frisia), while the contemporary ensemble in Bleiswijk, near Rotterdam, dominates the church interior in the manner of a scriptured iconostasis.[78]

FIG. 9.10. NOORDWOLDE, VILLAGE CHURCH, PERMANENT FITTINGS FOR THE LORD'S SUPPER IN THE FORMER CHANCEL, C.1660.

[76] Steensma, *Protestantse kerken*, p. 116.
[77] To date, text panels in this position in Dutch Protestant churches remain largely unstudied, both spatially, materially and 'iconographically', nor have their theological contents been fundamentally analysed. In September 2015, Jacolien Wubs started a PhD project at the University of Groningen entitled 'To Proclaim, to Instruct and to Discipline: The Visuality of Texts in Calvinist Churches during the Dutch Republic', supervised by Professor Raingard Esser and myself.
[78] See Van Swigchem et al., *Een Huis voor het Woord*, pp. 268–81; and Steensma,

Just how natural the presence of a screen must have felt to early Dutch Calvinists is illustrated by the furnishings of the church in Maassluis, near Rotterdam, which was built between 1629 and 1639. The ground plan of this church has the shape of a Greek cross, with arms of equal length. This model, which was considered particularly suitable for the Protestant church service, with its concentration on the reading and explanation of the Word from the centrally placed pulpit, would be followed widely in the later seventeenth century. Interestingly, the church of Maassluis was provided with a bell tower, placed in a traditional position on the west side, which is not the case with many other seventeenth-century centrally built churches. Strikingly, the church was provided with a monumental wooden screen from 1660 which sets apart one of the limbs of the building for the Lord's Supper, called the 'Bruyloft des Lams' ('Wedding of the Lamb') in the inscription. The crowning text panel is flanked by two ship models. Since Protestants in the early Dutch Republic were used to seeing medieval chancels with this function, it can hardly be a coincidence that it was precisely the eastern limb which was chosen for this purpose.

CONCLUSION

It may come as a surprise that Dutch Calvinism, which in so many ways attempted to erase all Catholic vestiges from medieval church interiors, also exerted certain preserving effects, particularly on medieval screens and galleries. Pre-Reformation rood screens and lofts are found in more than thirty churches throughout the country. The stock of preserved rood lofts in the Netherlands is second on the Continent only to Germany and France, while the country's screens without galleries are only outnumbered by those in Britain. Many other partitions were initially retained, but eventually removed due to later rearrangements. In this sense, analogous to the much celebrated 'preserving power of Lutheranism', we could speak of a modest 'preserving power of Calvinism' when it comes to choir partitions. All screens – at least those without galleries – date from the Late Gothic and Early Renaissance periods, and many were carried out in a hybrid transitional style in the second quarter of the sixteenth century. The typical Netherlandish chancel screen consists of a wooden frame with a closed dado and an openwork upper section with metal traceries in brass or iron, and is crowned by an ornamental architrave. The iconography shows a great variety, including biblical scenes and figures, evangelists, wreaths and masks, putti, heraldry and scenes from everyday life.

The reasons for their survival must be sought in the Calvinist treatment of the emptied chancel. In some churches, this was hived off from the church and put to practical use, whereas elsewhere it was turned into a

Protestantse kerken, pp. 115–23 and 166–73.

mausoleum for the elites. Another 'new' and probably quite widespread usage of the chancel was found in the celebration of the Lord's Supper, which was in fact a continuation of its original purpose as a stage for the Mass. In all of these instances, a screen had great practical value. Where the chancel was used for the celebration of the Lord's Supper, screens were often equipped with text panels on which the Ten Commandments, the Creed, the Lord's Prayer and other passages were found. These panels functioned as dividing devices between the 'truly converted' believers at the table and those who remained in the nave. This setting apart of the chancel certainly had sacralizing overtones, which may sound paradoxical in the context of Dutch Calvinism, so vehemently opposed to any notion of sacred space.

10

RECOVERING THE LOST ROOD SCREENS OF MEDIEVAL AND RENAISSANCE ITALY

DONAL COOPER

According to a story that circulated widely amongst the medieval Franciscans, the younger friars of a certain convent had grown accustomed to laugh and joke when celebrating the divine office – we can picture the scene in the back row of the choir stalls. One evening, however, while singing Compline, these ill-disciplined Franciscans were dealt an unexpected rebuke. The wooden crucifix, which surmounted the doorway to their choir, swivelled around by some miraculous force to face them. Its new audience was terrified by the spectacle, so much so that some of them dropped dead shortly afterwards.[1] Aside from the predictable moral lesson, the legend is thin on specifics, but it assumes an easy familiarity with the basic spatial coordinates of a conventual choir precinct, with a crucifix facing outwards towards the nave above its western door, also the

[1] From Fra Bartolomeo da Pisa's *Liber de Conformitate Vitae Beati Francisci ad Vitam Domini Iesu*, completed in 1399 for presentation at the Order's General Chapter in Assisi in August that year but drawing on a broad range of earlier Franciscan texts, see *Analecta Franciscana*, 4 (Quaracchi, 1906), p. 546: 'quodam sero, dum in completorio fratres rident nimis dissolute, crux lignea, quae stat super ostium chori, fragore stupdendo se vertit ad fratres et timorem maximum eis incussit, et plures eorum in brevi decesserunt ex hac vita'. The story's origins are English rather than Italian. It first appears in Thomas of Eccleston's *De Adventu Fratrum Minorum in Angliam* composed before c.1258, see J. S. Brewer (ed.), *Monumenta Franciscana* (London, 1858), p. 20. The church is specified as Greyfriars, Oxford. However, while the vision of the crucifix and choir occurred to a friar through a dream in Thomas's version, Bartolomeo simplified the story by removing the mediating dream so that the vision was experienced directly by the community gathered in their stalls. Bartolomeo also altered Thomas's text from 'crucifixus qui stetit ad ostium chori' to 'crux lignea, quae stat super ostium chori', thus presenting a clearer picture of the arrangement to his readers.

central opening in the church's choir screen. The friars were accustomed to viewing the back of the cross from the comfort of their stalls; to find it facing them overturned the expected order of their surroundings.

The most famous representation of a choir screen in Italian art, the fresco of the *Crib at Greccio* in the Upper Church at Assisi (Pl. LVII), makes similar demands on the beholder.[2] This essay would be much easier to write had the artist at Assisi – and Giotto surely has a hand here – only chosen to paint the front instead. The reversal of the screen probably has iconographic significance for the Greccio story and the masking of the crucifix's painted face avoids a problematic double take with the vision of the Christ Child that appears in St Francis's arms. But the legend cited above also reminds us that an audience of Franciscan friars would have seen the backs of many such screens.[3] Indeed, it would have been the side with which they were most familiar. The modern viewer tends to dwell on the laity in the fresco – the well-dressed burghers within the choir, the devout women without, pressing around the door.[4] But the fresco is in the Mother Church of the Franciscan Order and Franciscan friars were probably its principal intended audience.[5]

Both the crucifix vision and the *Crib at Greccio* fresco imply multiple viewpoints and different audiences, confirming that by the late Middle Ages an Italian chronicler or painter could take the structure, function and decoration of screens for granted. In Italy the active engagement with the visual characteristics of screens also found expression in the rich Latin

[2] For recent readings of this fresco, see C. Frugoni, 'Sui vari significati del Natale di Greccio, nei testi e nelle immagini', *Frate Francesco*, 70 (2004), pp. 35–147 (esp. pp. 88–109); J. Robson, 'Assisi, Rome and the *Miracle of the Crib at Greccio*', in Z. Opačić and A. Timmermann (eds), *Image, Memory and Devotion: Liber Amicorum Paul Crossley* (Turnhout, 2011), pp. 145–55. For the dating of the Saint Francis Cycle to c.1290–95, see D. Cooper and J. Robson, '"A Great Sumptuousness of Paintings": Frescos and Franciscan Poverty at Assisi in 1288 and 1312' and P. Binski, 'The Patronage and Date of the Legend of St Francis in the Upper Church of S. Francesco at Assisi', both published in *The Burlington Magazine*, 151 (2009), pp. 656–62 and pp. 663–5.

[3] At Assisi itself, a monumental choir screen separated nave and transept in the Lower Church, see I. Hueck, 'Der Lettner der Unterkirche von San Francesco in Assisi', *Mitteilungen des Kunsthistorischen Institutes in Florenz*, 28 (1984), pp. 173–202. The situation in the Upper Church is less clear but the initial arrangement there may also have incorporated a screen, see I. Hueck, 'La Basilica Superiore come luogo liturgico: l'arredo e il programma della decorazione', in G. Basile and P. Magro (eds), *Il cantiere pittorico della Basilica Superiore di San Francesco in Assisi* (Assisi, 2001), pp. 43–69. Remarkably, however, both spaces had already been cleared of any dividing screens by c.1300. For an alternative reconstruction of the cosmatesque fragments associated by Hueck with the Lower Church screen, see P. Theis, 'Die Oberkirche von S. Francesco in Assisi oder *De Missa Pontificali*: zur Ausstattung eines päpstlichen Sakralraumes', *Römische Historische Mitteilungen*, 46 (2004), pp. 125–64.

[4] B. A. Mulvaney, 'The Beholder as Witness: The *Crib at Greccio* from the Upper Church of San Francesco, Assisi and Franciscan Influence on Late Medieval Art in Italy', in W. R. Cook (ed.), *The Art of the Franciscan Order in Italy* (Leiden, 2005), pp. 169–88.

[5] D. Cooper and J. Robson, *The Making of Assisi: The Pope, the Franciscans and the Painting of the Basilica* (New Haven and London, 2013), p. 229.

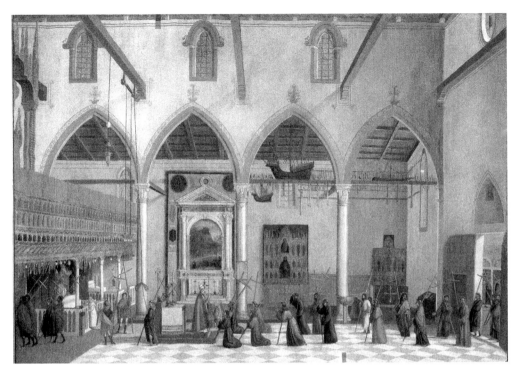

and vernacular vocabulary that evolved to describe them. As elsewhere in Europe, screens could be described as pulpits, a straightforward allusion to their role as platforms for preaching and reading liturgical lessons.[6] But arcaded variants could be called *ponti* or *pontili*, conjuring the image of an arched bridge spanning the breadth of the nave.[7] Terminology varied from region to region. So, for example, in northern Italy screens were widely known as *barchi*.[8] Some *barchi* were stone structures while others were wooden: the elaborately carved example in the Venetian church of Sant'Antonio in Castello was recorded in detail by Vittore Carpaccio c.1512 (Fig. 10.1). In Bologna – and almost nowhere else it seems – arcaded screens were styled passageways or *corridoi*.[9] Meanwhile, more

6 To cite one of numerous possible examples, the screen in the Lower Church at Assisi was termed a 'pulpitum' in contemporary sources, see Hueck, *Der Lettner der Unterkirche*, pp. 173–4.

7 T. Franco, 'Attorno al "pontile che traversava la Chiesa": spazio liturgico e scultura in Santa Anastasia', in P. Marini and C. Campanella (eds), *La Basilica di Santa Anastasia a Verona* (Verona, 2011), pp. 33–49. For Sant'Anastasia, Verona, see also G. Rama, 'Spazio e liturgia in una chiesa dei frati predicatori: S. Anastasia in Verona (sec. XIII–XIV)', *Atti e memorie dell'Accademia di Agricoltura, Scienze e Lettere di Verona*, 177 (2000–1), pp. 395–419 (esp. pp. 398–404).

8 P. Modesti, 'I cori nelle chiese veneziane e la visita apostolica del 1581. Il "barco" di Santa Maria della Carità', *Arte veneta*, 59 (2002), pp. 39–65.

9 F. Massaccesi, 'Il "corridore" della chiesa agostiniana di San Giacomo Maggiore a Bologna: prime ipotesi riscostruttive', *Zeitschrift für Kunstgeschichte*, 77 (2014), pp. 1–26. The term travelled as far as Rimini, where it was applied to the screen in the local

rudimentary masonry screens across Italy were simply called walls: *muri* or *muriccioli*.[10] The most common specific term, especially in central Italy, was *tramezzo* – a direct rendering of the Latin *intermedio* – a word that suggests both partition and insertion, hence the modern application of its diminutive *tramezzino* to the everyday sandwich.[11]

Our understanding of this vocabulary is relatively recent.[12] Indeed, compared to other European countries, the study of Italian screens is still in its infancy: more traditional histories of Italian ecclesiastical architecture take no account of them. The chief reason is survival, for only a tiny handful of medieval or Renaissance screens remain *in situ* across the entire peninsula – around two dozen depending on one's definition. East Anglia alone boasts more. Due to a complex set of historical circumstances to which we shall return, almost all screens in Italian churches had been removed by 1600. Once church interiors had been cleared it is difficult to exaggerate the extent to which the memory of screens fell away. Without the persistence of surviving examples the process of forgetting enveloped the very words used to describe them. As a result, scholars often failed to recognize screens when they encountered them in historical texts and archival documentation.

Giorgio Vasari's *Lives of the Artists* is a classic case in point. Vasari knew a lot about screens: he was responsible for dismantling several of the most impressive Florentine examples in the 1560s, rescuing elements of their fresco decoration along the way through salvage operations that were

Augustinian church, see C. Valdameri, 'Considerazioni sullo scomparso pontile di San Giovanni Evangelista in Rimini e sulla presenza a Rimini di Fra Carnevale', *Romagna arte e storia* 91 (2011), pp. 5–24, citing the detailed description in C. Clementini, *Racconto istorico della fondatione di Rimino, e dell'origine, e vite de' Malatesti* (Rimini, 1616), p. 578, published shortly after the screen's removal. According to Clementini the 'corridoio o andito di pietra' supported the church's organ at its centre and sheltered four altars below.

[10] T. Franco, 'Sul "muricciolo" nella chiesa di Sant'Andrea di Sommacampagna "per il quale restavan divisi gli uomini dalle donne"', *Hortus Artium Medievalium*, 14 (2008), pp. 181–91.

[11] The first edition of the *Vocabolario degli Accademici della Crusca* (Venice, 1612), p. 898, defined 'tramezzo' as: 'Ciò, che tra l'una cosa, e l'altra è posto di mezzo, per dividere, e scompartire, e distinguere. Lat. *quod est intermedium*.' However, it was only with the 4th edition (Florence, 1729–38), vol. V, p. 125, that the *Vocabulario* included an explicit reference to a choir screen, citing Giambattista Gelli's 1543 play *La Sporta*, printed in 1548, in which (at the beginning of Act V) one of the protagonists enters the Florentine church of the Carmine 'per quella porta, che è fra il tramezo & la cappella maggiore'. The Carmine's *tramezzo* had been demolished in 1568 almost two centuries before the reference found its way into the lexicon. A detailed description of the vaulted screen and its altars in the Carmine's archives was published by U. Procacci, 'L'incendio della chiesa del Carmine nel 1771', *Rivista d'arte*, 14 (1932), p. 144, n. 1.

[12] For example, A. De Marchi, 'Il "podiolus" e il "pergulum" di Santa Caterina a Treviso: cronologia e funzione delle pitture murali in rapporto allo sviluppo della fabbrica architettonica', in A. C. Quintavalle (ed.), *Medioevo: arte e storia* (Milan, 2008), pp. 385–407, esp. pp. 389–91, distinguished for the first time between the terms 'pergola' (a colonnaded structure) and 'pergulum' (a raised pulpit).

remarkable for the time.[13] Vasari frequently referred to screens in his *Lives*, almost always using the term *tramezzo*.[14] But even in this bible of Italian art history the word was frequently misunderstood by modern editors, a confusion that becomes obvious when reading the *Lives* in translation: the Penguin English-language edition of 1965 renders *tramezzo* variously as 'balcony', 'transept', 'gallery' and 'nave', but never as 'screen'.[15] This inherited ignorance marks Italy out from the countries of Northern Europe and has coloured research through most of the twentieth century. Even where choir screens were clearly documented, scholars tended to understate their significance and characterize them as alien insertions. Writing in 1966, the author of the Pelican History of Art volume on medieval Italy considered that the *tramezzo* screen in Santa Croce, Florence 'would once have ... obscured the architectural unity' of the church prior to its removal by Vasari in 1566.[16]

The watershed arrived only a few years later, in 1974, when Marcia Hall published two seminal articles on the *ponte* screen in the Dominican church of Santa Maria Novella in Florence and the *tramezzo* in Santa Croce (Fig. 10.2), the foundations of which had been revealed by chance in the wake of the 1966 flood.[17] Not only were Hall's reconstructions indisputably convincing, the monuments she presented were architecturally far more impressive than anyone had imagined. One can sense Marcia Hall's work percolating through the literature over the next two decades, but it was really from the mid-1990s onwards that the reconstruction of screens and related issues of church furniture began to shift into the academic mainstream.[18] Since 2000, Italian scholars like Giovanna Valenzano, Tiziana Franco and Andrea De Marchi have produced a stream of publications in

[13] For Vasari's detachment of Domenico Veneziano's fresco of *Saints John the Baptist and Francis* from the *tramezzo* in Santa Croce in 1566, one of the earliest operations of its kind, see M. Hall, 'The "Tramezzo" in Santa Croce, Florence and Domenico Veneziano's Fresco', *The Burlington Magazine*, 112 (1970), pp. 797–9.
[14] Vasari used the word fifty-one times in the second edition of the *Lives* published in 1568, see P. Barocchi et al. (eds), *Giorgio Vasari: Le vite, indice di frequenza*, vol. I (Pisa, 1994), p. 449.
[15] G. Bull (ed. and trans.), *Giorgio Vasari: The Lives of the Artists* (London, 1965); see, for example, p. 225 where the specified location of Botticelli's fresco of *Saint Augustine* at Ognissanti 'nel tramezzo alla porta che va in coro' is rendered as 'in the gallery by the door leading to the choir'.
[16] J. White, *Art and Architecture in Italy, 1250 to 1400* (Harmondsworth, 1966), p. 11.
[17] M. Hall, 'The "Tramezzo" in Santa Croce, Florence, Reconstructed', *The Art Bulletin*, 56 (1974), pp. 325–41; M. Hall, 'The "Ponte" in Santa Maria Novella: The Problem of the Rood Screen in Italy', *Journal of the Warburg and Courtauld Institutes*, 37 (1974), pp. 157–73. See also Hall's reflections on the broader issues raised by the two Florentine examples: M. Hall, 'The Italian Rood Screen: Some Implications for Liturgy and Function', in S. Bertelli and G. Ramakus (eds), *Essays Presented to Myron P. Gilmore*, vol. II (Florence, 1978), pp. 213–18. The scholar returned to the theme more recently in M. Hall, 'The *Tramezzo* in the Italian Renaissance, Revisited', in S. E. J. Gerstel (ed.), *Thresholds of the Sacred: Architectural, Art Historical, Liturgical, and Theological Perspectives on Religious Screens, East and West* (Dumbarton Oaks, 2006), pp. 215–32.
[18] A trend characterized by the discussions of screens incorporated into introductory

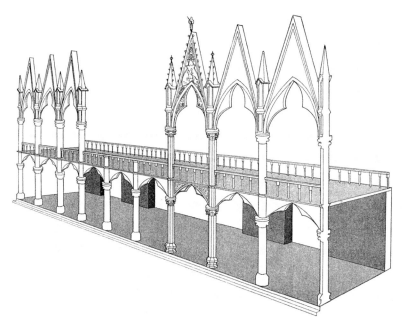

FIG. 10.2. MARCIA HALL, ISOMETRIC RECONSTRUCTION OF THE *TRAMEZZO* SCREEN IN SANTA CROCE, FLORENCE.

the area.[19] Michele Bacci and Joanna Cannon have meanwhile established the central significance of screens within broader treatments of Italian church interiors.[20] We know vastly more than we did even ten years ago about the appearance of Italian screens, why they were built and why they were destroyed.

It is important, however, to remember that this surge in interest is very recent, and that enormous gaps remain. We still know next to nothing about Italian parish churches, including the numerous baptismal *pievi* that survive from the Middle Ages.[21] Prominent cathedrals like those in

surveys of ecclesiastical art and architecture, see E. Welch, *Art and Society in Italy, 1350–1500* (Oxford, 1997), pp. 184–5.

[19] For examples, see the contributions by these authors to the important collection of essays: A. C. Quintavalle (ed.), *Arredi liturgici e architettura* (Milan, 2007): G. Valenzano, 'La suddivisione dello spazio nelle chiese mendicanti: sulle trace dei tramezzi delle Venezie', pp. 99–114; T. Franco, 'Appunti sulla decorazione dei tramezzi nelle chiese mendicanti: la chiesa dei Domenicani a Bolzano e di Sant'Anastasia a Verona', pp. 115–28; A. De Marchi, 'Due fregi misconosciuti e il problema del tramezzo in San Fermo Maggiore a Verona', pp. 129–42.

[20] M. Bacci, *Lo spazio dell'anima: vita di una chiesa medievale* (Rome, 2005), esp. pp. 79–85, and Fig. 1 at p. 175; J. Cannon, *Religious Poverty, Visual Riches: Art in the Dominican Churches of Central Italy in the Thirteenth and Fourteenth Centuries* (New Haven and London, 2013), esp. pp. 25–45. Screens are also prominent in the important reassessment of mendicant architecture by C. Bruzelius, *Preaching, Building, and Burying: Friars in the Medieval City* (New Haven and London, 2014), esp. pp. 11, 24, 31, 57, 97.

[21] A number of studies are beginning to shed light on this neglected area. Z. Murat, 'Il *podium* della pieve di Monselice nella descrizione di Pietro Barozzi', *Musica e Figura*, 1 (2011), pp. 87–117, exploits the detailed 1489 visitation led by the archbishop of Padua Pietro Barozzi, which described a deep 'podium' in the Pieve of Santa Giustina at

Florence and Siena have been the subject of intensive study, although by
and large this has only highlighted their profound idiosyncrasies.[22] The
vast bulk of effective research has been directed towards the churches of
the mendicant orders, above all the Franciscans and Dominicans.[23] Our
understanding of Italian ecclesiastical fabric therefore presents an inverted
image of the English situation: we have a wealth of mendicant material
and remain largely ignorant of practice in the parishes.

This essay cannot hope to overcome the Italian bias towards the
mendicants, especially as the author's own research focuses on the
Franciscans.[24] But it will attempt to review the most significant trends in
the study of choir screens and related aspects of ecclesiastical furniture in
Italy. To this end it is divided into four sections. The first addresses the
material fabric of screens, their construction and appearance. The second
considers what they were for, in particular how they regulated physical
and visual access to different zones of the church interior. The third
investigates the figurative decoration of screens, from mural paintings to

Monselice that divided the men from the women and which bore the church's organs
on its raised platform. Franco, 'Sul "muricciolo" nella chiesa di Sant'Andrea', publishes
evidence for dividing walls in a number of parish churches in the dioceses of Verona
and Padua. We are better informed regarding parish churches in Venice, for a recent
overview see P. Modesti, 'I cori nelle chiese parrocchiali veneziane fra Rinascimento e
riforma tridentina', in S. Frommel and L. Lecomte (eds), *La place du choeur: architecture
et liturgie du Moyen Âge aux temps modernes* (Paris, 2012), pp. 141–53. P. Humfrey, 'Cima
da Conegliano, Sebastiano Mariani, and Alvise Vivarini at the East End of S. Giovanni in
Bragora in Venice', *The Art Bulletin*, 62 (1980), pp. 350–63, included a detailed discussion
of the screen erected in this Venetian parish church in 1490, reconstructed from
documents and surviving fragments as a solid parapet surmounted by an open pilastrade.
[22] In both cases, the choir precincts for the canons were located beneath the respective
domes and did not incorporate anterior screens. For Florence, see L. A. Waldman, 'Dal
Medioevo alla Controriforma: i cori di Santa Maria del Fiore / From the Middle Ages to
the Counter-Reformation: The Choirs of Santa Maria del Fiore', in T. Verdon (ed.), *Sotto
il cielo della cupola: il coro di Santa Maria del Fiore dal Rinascimento al 2000: progetti de
Brunelleschi, Bandinelli, Botta, Brenner, Gabetti e Isola, Graves, Hollein, Isozaki, Nouvel,
Rossi* (Milan, 1997), pp. 37–68 (including valuable discussion of the temporary choir
precinct used between 1380 and 1436). For Siena, see E. Struchholz, *Die Choranlagen und
Chorgestühle des Sieneser Domes* (Münster, 1995), whose findings supersede the earlier
reconstructions by K. van der Ploeg, *Art, Architecture and Liturgy: Siena Cathedral in
the Middle Ages* (Groningen, 1993). The best evidence for a monumental screen in a
metropolitan context comes from Modena, where a Romanesque *pontile* survives in
the local cathedral, dismantled in 1593 but rebuilt in the twentieth century; its original
appearance is much debated, see D. Cunningham, 'One *pontile*, two *pontili*: The Choir
Screens of Modena Cathedral', *Renaissance Studies*, 19 (2005), pp. 673–85.
[23] This interest in the churches of the regular clergy does not, on the whole, extend to
those of female monastic communities, where there is some evidence that naves were
divided by screens (leaving to one side the separate and much better studied issue of
nuns' choirs which were usually elevated above the nave or located beside the main vessel
of the church). For an illuminating case study, see G. Guazzini, 'San Pier Maggiore a
Pistoia: un inedito libro di testamenti trecenteschi ed una proposta ricostruzione degli
assetti interni', *Bullettino storico Pistoiese*, 114 (2012), pp. 57–88.
[24] An interest that dates back to my doctoral research: D. Cooper, '"In medio ecclesiae":
Screens, Crucifixes and Shrines in the Franciscan Church Interior in Italy (c.1230-c.1400)'
(PhD thesis, Courtauld Institute of Art, University of London, 2000).

iconostasis panels – currently an area of some controversy in the field of early Italian painting. Finally, I will revisit the demise of the Italian choir screen, the rationales and mechanisms behind its eradication, with special reference to the tradition's great survivor, the Frari in Venice.

THE FORM OF ITALIAN SCREENS: CONSTRUCTION AND APPEARANCE

It is difficult to know where to begin our story, as the origins of monumental choir screens in Italy remain elusive and understudied. There is a general if vague consensus that they are not native to the peninsula.[25] As far as we can tell, Italian screens and choir enclosures of the high Middle Ages followed the structural vocabulary of the so-called *schola cantorum*, comprising marble parapets which were sometimes surmounted by relatively open colonnades.[26] Monumental screens have been identified as early as the eleventh century, with examples proliferating in the decades around 1200.[27] The oldest *jubé*-style screen in Italy is in the Benedictine abbey church at Vezzolano to the east of Turin, datable on epigraphic evidence to c.1189 (Fig. 10.3).[28] At Vezzolano the screen seems to have formed part of a more general renewal of the abbey church, but another Benedictine survival in Sant'Andrea in Flumine at Ponzano Romano in northern Lazio reveals how monumental *tramezzi* could be inserted into

[25] E. Kirchner-Doberer, 'Der Lettner. Seine Bedeutung und Geschichte', *Mitteilungen der Gesellschaft für vergliechende Kunstforschung in Wien*, 9 (1956), pp. 117–22, saw Italian examples as isolated instances of German or French influence. E. De Benedictis, 'The "Schola Cantorum" in Rome during the High Middle Ages' (PhD dissertation, Bryn Mawr College 1983), pp. 155–62, similarly argued that monumental nave choirs (with associated ambos and pulpits) originated in Northern Europe.
[26] For a survey of surviving and documented arrangements, see T. Creissen, 'Les clôtures de choeur des églises d'Italie à l'époque romane: état de la question et perspectives', *Hortus Artium Medievalium*, 5 (1999), pp. 169–81. For Rome, see S. de Blaauw's magisterial analysis of arrangements at the Lateran, Santa Maria Maggiore and Old Saint Peter's: *Cultus et decor: liturgia e architettura nella Roma tardoantica e medievale: Basilica Salvatoris, Sanctae Mariae, Sancti Petri* (Vatican City, 1994).
[27] The most extensive treatment of this material is E. Russo, 'Lo scomparso Jubé della chiesa abbaziale di Pomposa', *Analecta pomposiana: Studi vari*, 31–2 (2006–7), pp. 7–43, who argues for the presence of a monumental screen over 2 metres deep with an accessible upper storey in the Benedictine abbey church at Pomposa, coeval with the building's 1026 consecration. Russo draws a Benedictine contrast between the solution at Pomposa and the Byzantine-style iconostasis screen erected by Desiderius at Montecassino c. 1071. While the latter looked to the Orthodox East for models, Pomposa 'guarda alle novità che vengono da ovest e da nord delle Alpi' (at p. 28). For the situation at Montecassino, see J. M. Sheppard, 'The Eleventh-Century Choir-Screen at Monte Cassino: A Reconstruction', *Byzantine Studies*, 9 (1982), pp. 233–42. Russo's paper was published in near identical form as 'Il *jubé* di Pomposa', in A. Calzona, R. Campari and M. Mussini (eds), *Immagine e ideologia: studi in onore di Arturo Carlo Quintavalle* (Milan, 2007), pp. 103–16.
[28] P. Salerno (ed.), *Santa Maria di Vezzolano: il pontile, ricerche e restauri* (Turin, 1997).

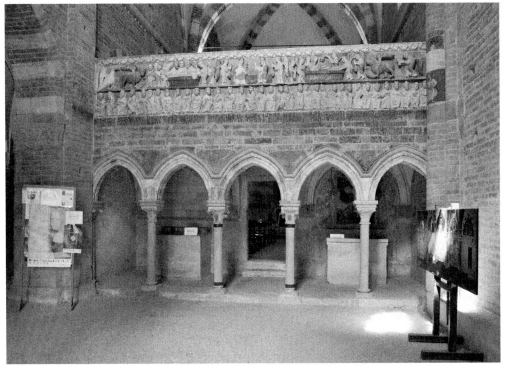

FIG. 10.3. NAVE SCREEN,
C.1189, BADIA DI SANTA
MARIA, VEZZOLANO.

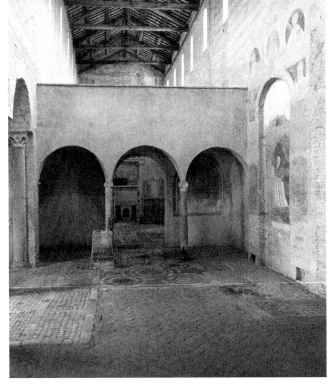

FIG. 10.4. NAVE SCREEN,
C.1300, BADIA DI
SANT'ANDREA IN FLUMINE,
PONZANO ROMANO.

older arrangements (Fig. 10.4).[29] At Ponzano Romano the well-preserved cosmati work floor establishes that the church was built with a full *schola cantorum* in the nave in the mid-twelfth century. Perhaps a century and a half later, around 1300, the *schola* was pared back to accommodate a monumental arcaded screen halfway down the nave. Similar alterations are recorded in the 1230s for the Early Christian basilica of Santa Sabina in Rome, where the church's new Dominican tenants transplanted two lecterns from the ninth-century *schola cantorum* to serve as pulpit atop a new screen wall, some 2.68m high.[30]

It seems likely that monumental choir screens bisected the Italian churches of the Benedictines – including the Camaldolese and Vallombrosan reforms – by the early years of the thirteenth century, although this is an area in need of further investigation.[31] The screen or 'transectum' preserved in the church of San Vittore overlooking Bologna – commissioned by a community of regular canons – seems to date from c.1240.[32] Evidence for the widespread construction of screens, however, only comes with the expansion of the mendicant orders. Fra Galvano Fiamma's fourteenth-century chronicle gives a particularly detailed account of the installation in 1239 of a screen within the Romanesque basilica of Sant'Eustorgio in Milan, ceded to the Dominican Order in 1220:

> At that time a wall was built that traversed the church, in the middle of which is a door, and there the friars that Dominic had sent to Milan are painted. Two windows were also made in the wall to either side, so that one could see the body of

[29] M. R. Guido and M. L. Vittori, 'L'abbazia di Sant'Andrea in Flumine presso Ponzano Romano e una singolare testimonianza di jubé', *Storia Architettura. Quaderni di Critica*, 2 (1975), pp. 22–9. See also Russo, 'Lo scomparso Jubé', pp. 24–5.
[30] J. B. Lloyd, 'Medieval Dominican Architecture at Santa Sabina in Rome, c.1219–c.1320', *Papers of the British School at Rome*, 72 (2004), pp. 231–92 (esp. pp. 251–9); the *tramezzo* must have been constructed soon after the Dominicans were given the church in 1222 and certainly by 1238, when its altars were recorded in an inscription. Ugonio's description of the interior, published immediately after the screen had been demolished in 1586–87, records how 'i due pulpiti di marmo usati da nostri maggiori per cantarvi l'Epistola, & l'Evangelio, & da i medesimi chiamati Amboni … questi trasportati dal suo antico luogo habbiamo visti noi appoggiati al muro, ch'appresso diremo, il quale divideva la Chiesa'; P. Ugonio, *Historia delle Stationi di Roma* (Rome, 1588), p. 9r and Cooper, '"In medio ecclesiae"', pp. 83–4.
[31] The sixteenth-century screen that still traverses the nave of the thirteenth-century Vallombrosan abbey church of San Michele at Passignano likely replaced an earlier dividing wall, see E. Gustafson, 'Tradition and Renewal in the Thirteenth-Century Franciscan Architecture of Tuscany' (PhD thesis, Institute of Fine Arts, New York University, 2012), pp. 260–1. We now have a detailed reconstruction for the Camaldolese abbey church of San Giovanni Evangelista at Sansepolcro incorporating a deep screen, termed a 'pergolo' in contemporary documents, see M. Mazzalupi, 'Altari, patronati, opere d'arte al tempo degli abati. Un saggio di topografia sacra', in A. Di Lorenzo, C. Martelli and M. Mazzalupi (eds), *La Badia di Sansepolcro nel Quattrocento* (Selci-Lama, 2012), pp. 1–44.
[32] For analysis of the San Vittore screen and relevant bibliography, see Russo, 'Lo scomparso Jubé', pp. 22–4.

Christ beyond. Above the wall a pulpit was constructed for the
singing of the Gospel, and in time three altars were built there,
as one can now see.[33]

Here in a nutshell Fiamma summarizes the key formal and functional
qualities of a Dominican *tramezzo*, explaining how it provided a liturgical
platform at the same time as distancing and framing the Mass.[34] His
description also indicates that the Sant'Eustorgio screen bore painted
images from the very beginning.[35]

Like Sant'Andrea in Flumine and Santa Sabina, Sant'Eustorgio was
another conversion job, a Romanesque interior reorganized to suit
the needs of its new Dominican community. But the mendicants were
soon erecting their own ever grander churches, and these new-builds
incorporated choir screens within their design. The most elaborate
example that can be reconstructed is the *tramezzo* formerly in Santa
Croce, Florence.[36] Its foundations were brought to light when the church's
pavement was relaid after the 1966 flood. At the time the supports were not
recognized as significant and were demolished shortly afterwards, another
consequence of the general ignorance of *tramezzi* at the time. Fortunately
sufficient measurements and photographs had been taken for Marcia
Hall to make the crucial connection with an architectural drawing of a
chapel façade for the Baroncelli family.[37] Her reconstruction of the Santa
Croce *tramezzo* has been amended in its detail but remains substantially
unchallenged (Fig. 10.2).[38] It seems likely that the Baroncelli drawing
recorded a modular design that was repeated across six of the screen's nine

[33] 'Item factus est murus isto tempore per traversum ecclesie, in medioque muri
factum est hostium, ubi depicti sunt fratres quos beatus Dominicus Mediolanum misit
ad habitandum. In muro etiam ex utraque parte facte sunt due fenestre, per quas videri
poterat corpus Christi interius. Super murum autem factum est pulpitum, ubi cantatur
evangelium; et in processu temporis facta sunt ibi tria altaria, sicut nunc apparet': G.
Fiamma, 'La cronaca maggiore dell'Ordine domenicano', in G. Odetto (ed.), *Archivum
Fratrum Praedicatorum*, 10 (1940), p. 326. Fiamma also records that 'usque ad ista
tempora non erat chorus, sed fratres super banchalia sedebant', affording a valuable
glimpse of the kind of provisional arrangements that must have been common as new
conventual churches were gradually equipped with their liturgical furniture.
[34] For extensive treatments of early Dominican screens, including the documented
examples in Bologna, Milan and Rome, see Cannon, *Religious Poverty, Visual Riches*, pp.
25–45; C. G. Gilardi, '*Ecclesia laicorum* e *ecclesia fratrum*: luoghi e oggetti per il culto e
la predicazione secondo l'*Ecclesiasticum officium* dei frati predicatori', in L. E. Boyle and
P.-M. Gy (eds) with P. Krupa, *Aux origines de la liturgie dominicaine: le manuscript Santa
Sabina XIV L 1* (Paris and Rome, 2004), pp. 379–443, esp. pp. 421–5.
[35] On the reconstruction of the Sant'Eustorgio screen, see now C. Travi, 'Antichi tramezzi
in Lombardia: il caso di Sant'Eustorgio', *Arte Lombarda*, 158–9 (2010), pp. 5–16.
[36] Hall, 'The "Tramezzo" in Santa Croce, Florence, Reconstructed', pp. 325–41.
[37] For this drawing, see now M. Borgherini, *Disegno e progetto nel cantiere medievale:
esempi toscani del XIV secolo* (Venice, 2001), pp. 155–63.
[38] For suggested revisions, see A. De Marchi, 'Relitti di un naufragio: affreschi di Giotto,
Taddeo Gaddi e Maso di Banco nelle navate di Santa Croce', in A. De Marchi and G.
Pirazzoli (eds), *Santa Croce: Oltre le apparenze (Quaderni di Santa Croce 4)* (Pistoia, 2011),
pp. 33–71.

bays.[39] The *tramezzo*'s pinnacles reached a height of 17 metres. Its deep structure supported a spacious upper storey suitable not only for Gospel readings and preaching, but also for accommodating the church's organ and the performance of liturgical dramas.[40] Furthermore, the integration of the screen wall and the nave piers established beyond any doubt that the *tramezzo* was coeval with the architectural superstructure of the church.

The lofty gables of the Santa Croce screen seem to have been exceptional, but structures on a similar scale can be reconstructed for other large mendicant churches. The *tramezzo* in San Francesco, Bologna also had an upper storey that was termed a 'solarium' in contemporary documents – literally a terrace or sun-roof.[41] Thanks to the excavations conducted by Alfonso Rubbiani in the 1890s we have detailed drawings of the Bologna screen's foundations.[42] Like the Santa Croce *tramezzo*, it was an arcaded structure with a solid wall to its rear and was divided into three bays across the width of the central nave. Rubbiani did not excavate the side aisles of the church and it is likely that the *tramezzo* extended across these as well.[43] The screen's upper storey was endowed with its own altars, the first as early as 1299, in addition to those in the arcade below.[44]

In their scale and ambition the Santa Croce and Bologna screens were commensurate with the very large, sophisticated, triple-aisled buildings for which they were designed. The majority of mendicant churches only had single-vessel naves and their screens were accordingly much less elaborate affairs. The best evidence for this simpler arrangement is the

[39] However, Hall, 'The Italian Rood Screen', p. 214, advanced this repetitive aspect of her reconstruction with notable caution.

[40] For the presence of organs on the upper storeys of the screens at Santa Croce and Santa Maria Novella, see ibid. Many Italian screens probably served as organ lofts but this aspect of their design requires further investigation. The use of the 'ponte' screen at Santa Maria Novella for Gospel readings on major feast days is recorded in early sources, see Hall, 'The "Tramezzo" in Santa Croce, Florence, Reconstructed', p. 340. For the performance of liturgical drama on Florentine *tramezzi*, see N. Newbigin, *Feste d'Oltrarno: Plays in Churches in Fifteenth-century Florence*, 2 vols (Florence, 1996), including English translations of the famous descriptions by the Russian bishop Abraham of Suzdal of the elaborate celebrations he witnessed in 1439 for the feasts of the Annunciation and Ascension, performed on the *tramezzi* in Santissima Annunziata (or, according to Newbigin, more likely San Felice in Piazza) and Santa Maria del Carmine. For reconstructions of the temporary but elaborate stage sets erected on these *tramezzi*, see M. Fabbri (ed.), *Il luogo teatrale a Firenze: Brunelleschi, Vasari, Buontalenti, Parigi* (Milan, 1975), pp. 56–60.

[41] The term appears in documents of 1299 and 1345, while the screen was also referred to as a 'pergolum' in 1300 and a 'pulpitum' in 1395, see A. Rubbiani, *La Chiesa di S. Francesco in Bologna* (Bologna, 1886), pp. 57–9 (documents transcribed at pp. 132–3).

[42] A. Rubbiani, *La Chiesa di S. Francesco e le tombe dei glossatori in Bologna: ristauri dall'anno 1886 al 1899* (Bologna, 1900), pp. 35–9. Rubbiani's handling of the documentary and archaeological evidence for *tramezzo* screens in Bologna was remarkably receptive for the time, and informed a particularly prescient (if somewhat speculative) screen installation in San Francesco for the exhibition of sacred art staged there in 1900, see Massaccesi, 'Il "corridore" della chiesa agostiniana di San Giacomo Maggiore', pp. 1–2.

[43] The point is made by Hall, 'The "Ponte" in S. Maria Novella', pp. 166–7.

[44] Rubbiani, *La Chiesa di S. Francesco in Bologna*, pp. 60–3.

so-called 'Fra Giovanni da Pistoia' plan from Arezzo, a mid-fourteenth-century blueprint for the local church of San Francesco (Fig. 10.5).[45] The parchment records the choir screen as it was initially conceived, as a simple curtain wall with two altars on its lay side. We can probably assume that the wall also supported a pulpit, but the plan does not record this.[46] As drawn, the screen shields a choir precinct in the upper nave which is separated from the *tramezzo* screen proper by a gap of several metres. Axial doors in both structures preserve the sight line of the high altar from the lower nave.

The single-nave Arezzo church is typical of hundreds of other mendicant buildings across Italy, and a substantial body of documentary evidence indicates that the screen arrangement in the 'Fra Giovanni' plan may be regarded as normative for them. No examples survive but we can draw on archaeological evidence from two Franciscan churches on the outer periphery of the Italianate world to demonstrate their structural qualities.[47] The Order's late thirteenth-century church at Glarentza in the Greek Peloponnese, excavated just a few years ago, offers a remarkable match of the Arezzo drawing.[48] In present-day Montenegro, the Franciscan church outside the city walls of Kotor, founded by a thirteenth-century Serbian queen, was levelled by the Venetians in the 1650s as a military precaution against a Turkish siege.

FIG. 10.5. FRA GIOVANNI DA PISTOIA(?), *PROJECT FOR, OR PLAN OF, SAN FRANCESCO, AREZZO*, PEN AND INK ON PARCHMENT, MID-FOURTEENTH CENTURY, ARCHIVIO CAPITOLARE, AREZZO (CARTE DI VARIE PROVENIENZA N. 873).

[45] First published by M. Salmi, 'Un'antica pianta di S. Francesco in Arezzo', *Miscellanea Francescana*, 21 (1920), pp. 97–105. For further discussion, see Borgherini, *Disegno e progetto nel cantiere medievale*, pp. 164–83 (dating the parchment between 1348 and 1364); D. Cooper, 'Access all Areas? Spatial Divides in the Mendicant Churches of Late Medieval Tuscany', in F. Andrews (ed.), *Ritual and Space in the Middle Ages: Proceedings of the 2009 Harlaxton Symposium* (Donington, 2011), pp. 93–6.

[46] The presence of a pulpit suggested by the analogy with the nearby church of San Domenico, see Cooper, 'Access all Areas?', pp. 96–8, and further discussion below.

[47] Archaeology offers rich possibilities for the study of screens, but few late medieval or Renaissance church interiors have benefited from excavations. A rare example is San Domenico, Savona, completely demolished in 1544 to make way for a fortress and excavated in the 1970s, revealing a screen traversing all three aisles with altar platforms by its western side, see M. Ricchebono, 'Ipotesi sulla chiesa di S. Domenico il Vecchio a Savona', *Atti e memorie della Società Savonese di Storia Patria*, 11 (1977), pp. 28–39.

[48] The recent excavation of the Glarentza church, see D. Athanasoulis, 'The Triangle of Power: Building Projects in the Metropolitan Area of the Crusader Principality of the Morea', in S. E. J. Gerstel (ed.), *Viewing the Morea: Land and People in the Late Medieval Peloponnese* (Dumbarton Oaks, 2013), pp. 111–51 (esp. pp. 123–5).

The site was excavated by Yugoslav archaeologists in the 1950s and again in the 1980s, exposing a small single nave church approximately eight and half metres wide divided by a simple wall *tramezzo* with two altars to its lay side set around a central doorway.[49] Close examination of the surviving base of the screen establishes that it was built independently from the nave walls. Only 40cm deep, the dividing wall was formed from thin slabs of cut limestone bonded around a central mortar core. It was clearly not a load-bearing structure and probably never amounted to more than a simple curtain wall.

With the Kotor church, a small convent in a remote centre, we encounter the mendicant rood screen at its most basic, at the opposite extreme from Santa Croce.[50] Most churches on mainland Italy would have boasted more complex structures. Even screens that began life as simple curtain walls accumulated vaulted arcades, monumental tombs and shrines by their western faces. If we return to Arezzo for a moment, remnants of frescoes and corbelling on the left nave wall preserve the vestigial outline of a vaulted chapel erected against the original *tramezzo* wall in San Francesco in the later fifteenth century.[51] Processes of accretion are especially important for understanding Italian choir screens. These were liminal barriers that provided multiple devotional *foci* for tertiaries, confraternities and the laity in general. Over time, tombs, shrines, altars, images and ex votos proliferated by their western façades.[52]

Compared to later additions or even eventual demolitions, we have relatively few documents relating directly to the initial construction of screens. The payments for the Baroncelli chapel suggest that in Santa Croce lay patrons funded their individual chapels on the *tramezzo*, although they evidently had to follow a prescribed template.[53] Moving to the far north, an isolated memorial from the Italian Ticino records that in 1315 the screen in the Franciscan church in Locarno – termed a 'pulpitum seu bargum' – was entirely funded by a local nobleman, together with its two side altars.[54] A

[49] For the excavations, see S. Mijušković, 'O ostacima jednog kotorskog istorijskog spomenika iz XIII vijeka (Les restes d'un monument du XIIIème siècle à Kotor)', *Boka*, 8 (1976), pp. 183–213; P. Mijović, 'O kasnoantičkim i srednjovjekovnim grobljima Kotora (Late ancient and medieval cemeteries of Kotor)', *Boka*, 15–16 (1984), pp. 161–91.

[50] The modest size of the Kotor convent is confirmed by a 1441 contract for a new choir in the church comprising only twenty-two stalls, see Kotor, Istorijski arhiv, SN VII, f. 177.

[51] Cooper, '"In medio ecclesiae"', p. 49.

[52] For the Dominican practice of burying the Order's saints and venerated *beati* by the lay side of *tramezzo* screens, see J. Cannon, 'Dominican Shrines and Urban Pilgrimage in Later Medieval Italy', in P. Davies, D. Howard and W. Pullan (eds), *Architecture and Pilgrimage, 1000–1500* (Farnham, 2013), pp. 143–63; Cannon, *Relgious Poverty, Visual Riches*, pp. 91–105.

[53] Drawing on the much richer documentation available for England, Eamon Duffy has convincingly demonstrated how screens in English parish churches were funded by lay benefactions: E. Duffy 'The Parish, Piety, and Patronage in Late Medieval East Anglia: The Evidence of Rood Screens', in K. French, G. Gibbs and B. Kümin (eds), *The Parish in English Life 1400–1600* (Manchester, 1997), pp. 133–62.

[54] V. Gilardoni, *I monumenti d'arte e di storia del Canton Ticino*, vol. I (*Locarno e il suo*

1300 testament from Bologna confirms that screens could be underwritten by lay bequests.[55] The only building contract I have found specifically for the construction of a screen takes us back to the Adriatic littoral.[56] In 1444 the Franciscans in Zadar contracted the master mason Giorgio da Sebenico, best known as the architect of Šibenik Cathedral, to construct a screen or 'podium' with three chapels in the middle of their church – 'in medio ecclesie', a turn of phrase frequently associated with screens in Latin documentation.[57] The church of Sveti Franje had been standing for over a century and the 1444 initiative may represent an upgrade from an earlier barrier.[58] According to the terms of the agreement, Giorgio was responsible for the vaults, columns and capitals, while the friars undertook

circolo) (Basel, 1972), p. 200, note 3: The manuscript source is online at http://www.e-codices.unifr.ch/en/oms/0001/182v/ and the relevant passage reads: 'Millesimo CCC.XV Anno Dominice incarnationis dominus Ugo domini Marchi de Zornigo Vallis Leventine in ecclesia Sancti Francisci fratrum minorum de Lorcarno ad expenssas proprias fecit fieri totum pulpitum seu bargum cum duobus altaribus scilicet Sancti Johannes Baptiste et Sancte Marie Magdalene sed et altare Sancti Johannis Baptiste dotavit de pulchro missali et calice.'

55 On 12–13 September 1300 the Bolognese scholar 'Dominus Marscillius quondam domini Manni de Mantighellis decretorum doctor' bequeathed 400 lire for his burial in San Barbaziano and for 'unum pergulum in dicta ecclesia construatur ad spondam muri, que est versus meridiem, usque ad spondam aliam dicte ecclesie, que est versus septentrionem, latitudinis congrue, ad modum perguli ecclesie Fratrum Minorum vel Predicatorum, ut melius et congruentius fieri poterit, in quo pergulo edifficetur unum altare'; the document is transcribed in *Analecta Franciscana*, 9 (Quaracchi, 1927), pp. 535–6. The bequest also provides an interesting instance of *modo et forma* transmission, in this case from mendicant buildings (San Francesco and San Domenico, Bologna) to a church officiated by regular canons (San Barbaziano). The document was partially transcribed by Rubbiani, *La Chiesa di S. Francesco in Bologna*, p. 133, but omitting the reference to San Domenico.

56 In addition, the general building contract for the church of San Francesco Grande, Padua, from 1416 contains a detailed clause for the construction of 'el mezamento de l'antedicta yexia cum duy altarj i quali altari habia le sue croxire poste su do colone de pria viva et etiandio de fare una croxira sora la porta del dicto mezamento de mezo quarelo cum la guaiana o de più ove sel besognasse et sora le dicte tre croxire fare un pozoleto se cante la epistola et el guangelio', see De Marchi, 'Il "podiolus" e il "pergulum"', pp. 386–7.

57 G. Praga, 'Alcuni documenti su Giorgio da Sebenico', *Rassegna Marchigiana*, 7 (1928), pp. 73–80: the contract of 9 October 1444 required 'magister Georgius lapicida' to complete within three years 'in medio dicte ecclesie unum podium cum tribus capellis sive cuuis de subtus, cum colonis bassis, capitelis, foliaminibus et aliis suis coherenciis, eo modo, forma, et ordine penitus nil addendo vel diminuendo prout plenius apparet et denotatur dictum totum opus designatum in uno folio papiri … et dictum opus totum facere, exceptis cuuis et podiolo, de bono lapide albo bene laborato et polito … et quod dicti fratres sive conventus debeant omnibus eorum expensis erigere murum qui erit post terga dictarum capellarum tantum quantum erit neccessarie et facere fundamenta pro colonis … si muri traversalis videlicet et quirinalis dicte ecclesie non essent boni et sufficientes pro dicto opere et egebunt aliquot aptamentam, quod ipsi fratres sive conventus teneantur et debeant, similter omnibus eorum sumptibus, dictos muros aptare ad sufficientiam prout expediet'. On the significance of 'in medio ecclesiae', see D. Cooper, 'Franciscan Choir Enclosures and the Function of Double-Sided Altarpieces in Pre-Tridentine Umbria', *Journal of the Warburg and Courtauld Institutes*, 64 (2001), p. 46.

58 On the Zadar church, see D. Cooper, 'Gothic Art and the Friars in Late Medieval Croatia, 1213–1460', in *Croatia: Aspects of Art, Architecture and Cultural Heritage* (London, 2009), pp. 77–82.

to prepare the foundations for the arcade, to erect the wall at the back of the screen and ensure that the church's superstructure was strong enough to support the screen. Alas, not one fragment of what must have been a richly decorated screen, for which Giorgio was paid 280 gold ducats, seems to have survived.

THE FUNCTION OF ITALIAN SCREENS: THE REGULATION OF PHYSICAL AND VISUAL ACCESS

There is now overwhelming evidence for screens being a standard facet of Italian church furniture by the fourteenth century.[59] There is much less agreement about what these barriers were designed to achieve. Did they divide laity from the clergy, or the laity between themselves according to gender?[60] Or, as Vincenzo Borghini claimed to remember in the 1580s, the pure laity from those sentenced to public penance and the straightforward unbaptized (who were surely a small minority in medieval Italy).[61]

What does seem clear is that mendicant churches were arranged to facilitate a tripartite division of their interiors. Choir precincts, often shielded by masonry revetments, were usually distinct structures from *tramezzo* screens.[62] Even in single-nave churches, lateral spaces or wings extended to the left and right of the conventual choir: the Arezzo plan provides a textbook example (Fig. 10.5). In triple-aisled buildings, the side aisles served a similar purpose. If choir precincts were the preserve of religious communities, some have argued that these lateral

[59] Writing c.1330, Opicinus de Canistris described how in his native Pavia 'habent autum omnes tam magnae quam parvae ecclesiae in medio murum cancellorum, quibus separantur a mulieribus viri, totum solidum sine formainibus vel fenestris, unde non possunt mulieres altare videre nisi per unum ostium in medio in parvis ecclesiis, in maioribus vero per tria ostia, quae cum necesse fuerit possunt claudi valvis, celebratis officiis': D. Ambaglio (ed.), *Liber de laudibus civitatis Ticinensis que dicitur Papia* (Pavia, 2004), p. 44.

[60] On this point the documentary evidence is mixed. Division by gender is suggested by Opicinus's text cited above. On the other hand, the Dominican General Chapter legislated in 1249 that 'intermedia que sunt in ecclesiis nostris inter seculares et fratres sic disponantur ubique per priores quod fratres egredientes et ingredientes de choro non possint videri a secularibus vel videre eosdem', see Cannon, *Religious Poverty, Visual Riches*, p. 25.

[61] V. Borghini, *Discorsi* (Florence, 1584), pp. 439–40; Hall, 'The "Tramezzo" in Santa Croce, Florence, Reconstructed', p. 339, characterizes Borghini's unlikely explanation as 'his understanding of an ancient practice of which he had learned in the course of his extensive reading'.

[62] The tripartite division is explicitly applied to the interior of San Marco, Florence (as reconfigured by Michelozzo for the Dominican Observants after 1435) in the convent chronicle compiled by Fra Giuliano Lapaccini (d.1458): 'Et sic triplex distinctio apparuit. Prima est chorus seu oratorium fratrum reclausum, tanquam a laicijs separatum. Secunda est chorus laicorum in secunda parte ecclesiae. Tertia est ecclesia inferior, quae dicitur mulierum'; see Hall, 'The *Tramezzo* in the Italian Renaissance, Revisited', pp. 219–20. San Marco was unusual in enclosing its choir precinct within an extended apse rather than the upper nave, but the system of access seems to reflect Dominican practice elsewhere.

and intermediate spaces beyond the screen were open to lay*men*, while lay*women* were confined to the lower nave west of the *tramezzo*. A number of documentary notices suggest this: indeed, contemporaries sometimes termed the lower nave explicitly as the 'women's church' (or the 'chiesa delle donne').[63] Arguments have been made for so-called 'longitudinal' segregation: that is, men to the right, women to the left.[64] There is some evidence for this practice in Italy, perhaps relating to the side aisles in larger churches.[65] However, the disposition of physical barriers indicates that interiors were principally zoned into a hierarchy of spaces moving down the church away from the high altar.

We should acknowledge that our evidence for segregation is patchy and contradictory. The Greccio scene (Pl. LVII) is sometimes invoked as proof that Italian screens functioned as absolute barriers to access, restricting women to the lower nave. A lesser known mid-fourteenth-century fresco from the Augustinian church in Piacenza, however, portrays women beside a high altar within a conventual choir precinct.[66] Many preaching scenes also depict the sexes divided but these images generally record sermons delivered from either movable lecterns or isolated pulpits sited in lower naves, a new typology which became popular from the late fourteenth century onwards.[67] This explains why the partition in the famous woodcut of Savonarola preaching in Florence Cathedral is only a curtain: here the

[63] According to the list of burials in Sant'Agostino, Siena, begun in 1382, a 'muro di mezo' divided the church into a 'chiesa di sopra' and a 'chiesa dala parte dele donne', see P. A. Riedl and M. Seidel (eds), *Die Kirchen von Siena*, vol. 1.1 (Abbadia all'Arco-S.Biagio) (Munich, 1985), pp. 146, 162. A testamentary bequest of 1492 for San Francesco, Città di Castello, specified the construction of a chapel 'in parte inferiori dicte ecclesie deputata pro residentia mulierum', see Cooper, 'Franciscan Choir Enclosures', p. 45, n. 124.

[64] M. Aston, 'Segregation in Church', *Studies in Church History*, 27 (*Women in the Church*) (Oxford, 1990), pp. 237–94 (primarily drawing on English material). For useful discussion of this point, see Hall, 'The *Tramezzo* in the Italian Renaissance, Revisited', pp. 221–2.

[65] Rubbiani, *La Chiesa di S. Francesco in Bologna*, p. 144, published fourteenth-century documents specifying the northern aisle of San Francesco, Bologna as a 'chorus dominarum'. This precinct may help to explain the 1374 bequest for an altar to be erected 'contigua seu iuxta capellam altaris Sancte Clare in dicta ecclesia [San Francesco, Bologna] constructam a latere dominarum'; the will is transcribed in A. M. Azzoguido (ed.), *Sancti Antonii Ulyssiponensis sermones in psalmos* (Bologna, 1757), p. clxiv. Matteo Mazzalupi has recently published an intriguing legacy from 1477 for Sant'Agostino, Sansepolcro (a single-nave church) for the construction of a chapel 'ad altare Virginis Marie positum post et ultra cancellos in latere et in parte dicte ecclesie ubi morantur et stant femine', see 'Altari, patronati, opere d'arte', pp. 7, 10 (the author interprets this as a reference to the left-hand side of the church beyond the *tramezzo* screen).

[66] R. Cobianchi, 'Gli affreschi del presbiterio della Chiesa di San Lorenzo a Piacenza: considerazioni iconografiche per il loro contesto agostiniano', in Centro Studi 'Agostino Trapè' (eds), '*Per corporalia ad incorporalia': Spiritualità, agiografia, iconografia e architettura nel medioevo agostiniano* (Tolentino, 2000), pp. 215–30, esp. p. 217 and Fig. 1.

[67] A. Randolph, 'Regarding Women in Sacred Space', in G. A. Johnson and S. A. F. Matthews Grieco (eds), *Picturing Women in Renaissance and Baroque Italy* (Cambridge, 1997), pp. 17–41, esp. pp. 21–7. On the trend towards separate nave pulpits for preaching, see De Marchi, 'Il "podiolus" e il "pergulum"', pp. 389–91.

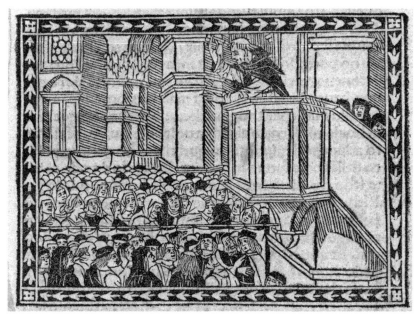

FIG. 10.6.
ANONYMOUS
FLORENTINE
ARTIST, *FRA
GIROLAMO
SAVONAROLA
PREACHING
IN FLORENCE
CATHEDRAL*,
WOODCUT
ILLUSTRATION
FROM THE
*COMPENDIO DI
REVELATIONE
DELLO INUTILE
SERVO DI IESU
CHRISTO FRATE
HIERONYMO
DA FERRARA
DELL'ORDINE
DE FRATE
PREDICATORI*,
FLORENCE, 1496
(INC 6316.10 (A),
HOUGHTON
LIBRARY, HARVARD
UNIVERSITY).

lower nave is being temporarily divided for the purposes of the sermon (Fig. 10.6).[68] The scene does not relate to the main choir precinct of the cathedral, sited beneath Brunelleschi's cupola. Permanent nave pulpits were built in Santa Croce and Santa Maria Novella in the Quattrocento, although they may have replaced earlier wooden lecterns.[69] Benedetto da Maiano's elegant balcony in Santa Croce was served by an internal staircase within the nave pier (which would have been challenging to hollow out of the pier without impairing the church's superstructure above).[70] Separate nave pulpits had the advantage of placing the preacher in the midst of his congregation; in effect they treated the lower nave as an interior piazza.

Fortunately the visual evidence for segregation can be supplemented by a range of archival sources. In 1385 the central door of the Santa Croce *tramezzo* was specified in a testamentary bequest as the point of division between men and women.[71] However, it is difficult to believe that the numerous chantry foundations beyond Santa Croce's screen would have been permanently inaccessible to laywomen, especially to members

[68] Randolph, 'Regarding Women in Sacred Space', pp. 26–7.
[69] Hall, 'The "Tramezzo" in Santa Croce, Florence, Reconstructed', p. 340, suggested that these may have replaced earlier portable pulpits of wood. A fifteenth-century wooden (and movable) pulpit survives in Dominican Observant church of Santa Maria di Castello, Genoa, see Gilardi, '*Ecclesia laicorum e ecclesia fratrum*', see p. 429, note 181, Tav. XI.
[70] For Benedetto's pulpit, see N. Ben-Aryeh Debby, 'The Santa Croce Pulpit in Context: Sermons, Art and Space', *Artibus et Historiae*, 29 (2008), pp. 75–93.
[71] In his will of 4 July 1385, Francesco Bruni asked to be buried 'iuxta portam que est propinqua coro et dividit locum hominum a loco mulierum', see Hall, 'The "Tramezzo" in Santa Croce, Florence, Reconstructed', p. 339, citing F. Moisè, *Santa Croce di Firenze* (Florence, 1845), p. 108, note 2 (giving the year as 1386).

of families who had endowed burial chapels there.[72] In fact, numerous documents place women beyond *tramezzo* screens. Recent work on the topography of notarial contracts has demonstrated that lay access to conventual spaces was much more widespread than hitherto believed – for both men and women. In cities across central Italy legal agreements were composed in choir precincts, chapels, sacristies, chapter houses and even inside dormitory cells.[73] While some of these contracts had conventual permutations, many did not concern the host institution at all. From betrothals to business deals, Italian notaries charted a remarkably diverse spectrum of secular activity across all areas of the church interior.[74]

So how should we reconcile the contradictory evidence for and against segregation? Timing is key. Each church had its own liturgical rhythm and access must have varied accordingly.[75] With the celebration of Mass at the high altar the *tramezzo* screen fulfilled its maximum design potential, distancing and framing the ritual for a lay audience. When mendicant and monastic communities celebrated the liturgical hours the laity would have been locked out of the conventual choir but could probably have accessed other areas beyond the *tramezzo* screen. Sermons from the *tramezzo* or a nave pulpit may have imposed other temporary restrictions on the mixing of the sexes. At other times, the laity may have enjoyed much more generous terms of access. Mendicant legislation hints at such gradations, as well as investing senior friars with discretionary powers to grant dispensations for individuals.[76] Access also depended, of course, on local enforcement and observance, which must have varied greatly, not only from Order to Order, but also according to the commitment and initiative of individuals.[77]

[72] E. Giurescu Heller, 'Access to Salvation: The Place (and Space) of Women Patrons in Fourteenth-century Florence', in V. Chieffo Raguin and S. Stanbury (eds), *Women's Space: Patronage, Place, and Gender in the Medieval Church* (Albany, 2005), pp. 161–83, has argued (p. 176) that 'women whose families had chapels beyond the rood screens may have enjoyed a special – albeit unwritten, and so far undocumented – status'.
[73] For relevant examples, see M. Israëls, 'Painting for a Preacher: Sassetta and Bernardino da Siena', in M.Israëls (ed.), *Sassetta: The Borgo San Sepolcro Altarpiece* (Florence and Leiden, 2009), vol. I, pp. 121–39 (esp. pp. 127–31); Cooper, 'Access all Areas?', pp. 90–107 (esp. pp. 100–3).
[74] Cooper, 'Access all Areas?', pp. 100–2.
[75] Hall, 'The *Tramezzo* in the Italian Renaissance, Revisited', pp. 218–19.
[76] For the Augustinian General Chapter rubrics on access, see I. Aramburu Cendoya, *Las primitivas Constituciones de los Agustinos (Ratisbonenses del año 1290): introducción, texto y adaptación romanceada para las religiosas* (Valladolid, 1966), pp. 50–1; discussed by Gustafson, 'Tradition and Renewal', pp. 272–4.
[77] In the northern Tuscan town of Barga the communal statutes composed in 1414 specified fines for women who transgressed the screen in the local collegiate church of San Cristoforo: 'Che nessuna donna non possa, nè debbia stare nella Chiesa di S. Cristofano, quando si dice la Messa, da' Cancelli in su; e che contro averà fatto, sia punito in soldi cinque ogni volta', see G. Richa, *Notizie istoriche delle chiese fiorentine, parte prima*, vol. I (Florence, 1754), p. 72; Cooper, '"In medio ecclesiae"', pp. 80–1; Randolph, 'Regarding Women in Sacred Space', p. 32. The medieval screen – a marble parapet rising

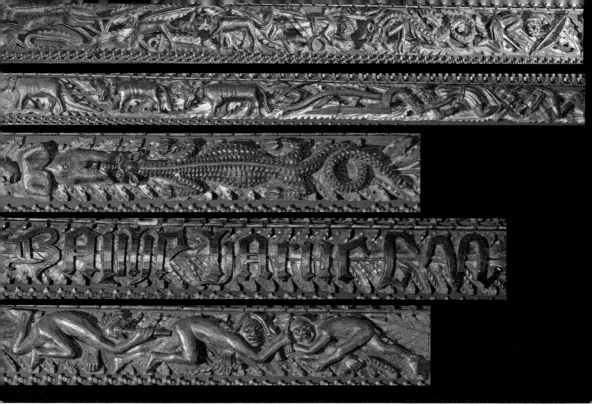

XXXII. NORTON FITZWARREN (SOMERSET). THE NARRATIVE CARVING SHOWING HUNTING AND PLOUGHING, WRESTLING AND RUDE PEA SHOOTING. THE CHURCHWARDEN'S NAME, RALPHE HARRIS, (D.1509) AND HIEROGLYPH INDICATING HIS ROLE AS CHURCHWARDEN IS PROMINENTLY SHOWN.

XXXIII. HOLNE (DEVON) COMPARED WITH TINTAGEL (CORNWALL). AT HOLNE, THE EFFECT OF THE MASON'S MITRE VISUALLY IS TO SHORTEN' THE LENGTH OF THE RAIL WITH THE PROMINENT VERTICAL JOINTS IN LINE WITH THE INSIDE EDGES OF THE POSTS AT EACH END. AT TINTAGEL, A TRUE SCRIBE JOINT WITH THE LEADING SQUARE MOULD ON THE RAIL INTERSECTING WITH THE SIMILAR MOULD ON THE POST. THE RAIL IS THEREFORE SHOWN AT ITS FULL LENGTH.

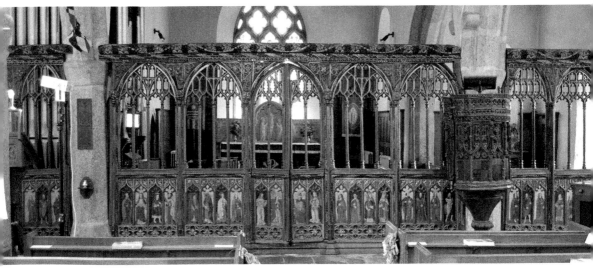

XXXIV. THE ROOD SCREEN AT HOLNE (DEVON), AFTER CONSERVATION TREATMENT.

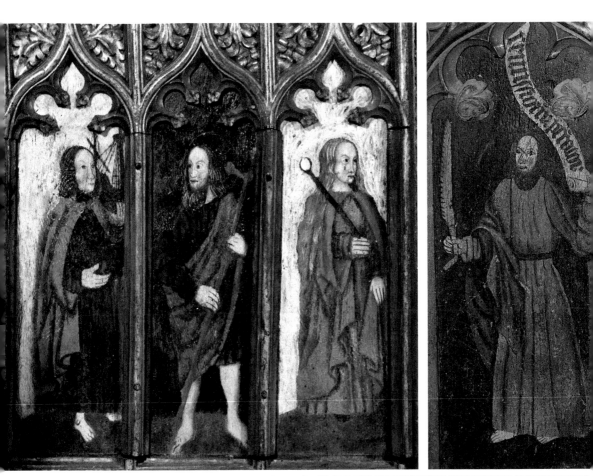

XXXV. SEVERAL CRAFTSMEN PAINTED HOLNE ROOD SCREEN (LEFT), ONE OF WHOM MAY HAVE ALSO WORKED ON THE KENTON SCREEN (RIGHT).

XXXVI. DETAILS FROM FIGURES ON THE
NORTH AND SOUTH SIDE OF THE CHANCEL
SCREEN AT HOLCOMBE BURNELL (DEVON)
DISPLAYING DIFFERENT PAINTERS' SKILL
LEVELS.

XXXVII. MUNTIN AT BRIDFORD (DEVON)
SHOWING THE LEAD TIN YELLOW SCHEME
ON THE REVERSE AND THE GILDED SCHEME
ON THE FRONT.

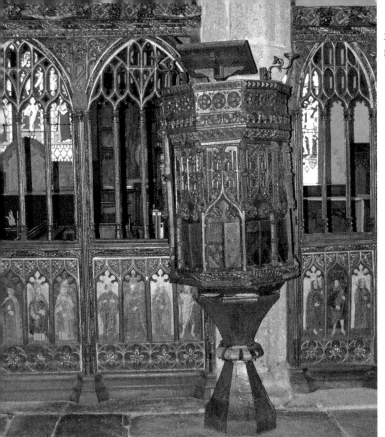

XXXVIII. THE SCREEN AND PULPIT AT HOLNE
FORM A SET TOGETHER.

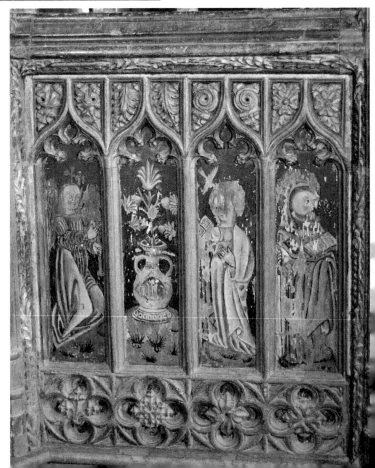

XXXIX. THE *ANNUNCIATION* FROM THE
SCREEN AT BUCKLAND-IN-THE-MOOR
(DEVON).

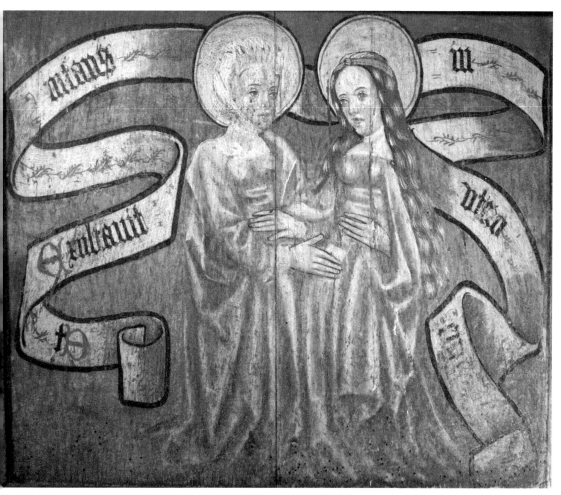

XL. THE *VISITATION* FROM THE REVERSE SIDE OF THE SCREEN AT ASHTON (DEVON).

XLI. CROSS-SECTION FROM SHERFORD ROOD SCREEN (DEVON), BAY 1, NORTH END SCREEN. 1) WOOD LAYER, 2) THIN YELLOW OCHRE GROUND, 3) RED OCHRE SECONDARY GROUND LAYER, 4) LEAD WHITE LAYER, 5) RED LAKE, CHARCOAL, LEAD WHITE AND YELLOW OCHRE, 6) YELLOW OCHRE, A LITTLE RED LAKE, 7) VARNISH AND SURFACE DIRT.

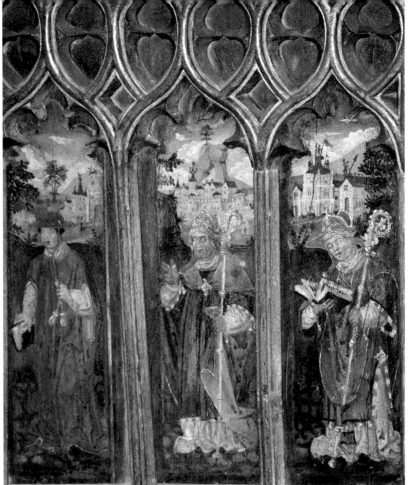

XLII. DETAIL FROM THE SCREEN AT LANREATH (CORNWALL).

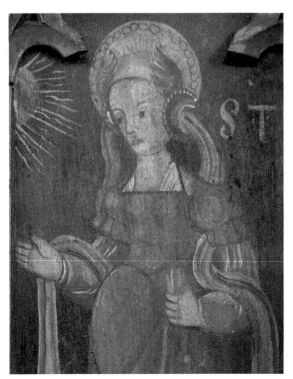
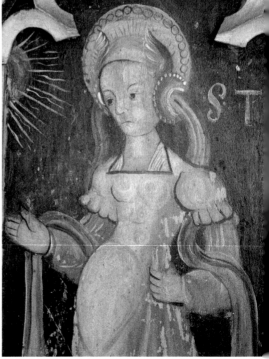

XLIII. INFRARED PHOTOGRAPH SHOWING A *PENTIMENTO* IN ST THECLA'S ARM, HOLCOMBE BURNELL.

XLIV. CROSS-SECTION FROM WILLAND ROOD SCREEN (DEVON) IN NORMAL AND ULTRAVIOLET LIGHT, FROM THE SOUTHERNMOST BAY, CRIMSON FROM FLOWER. 1) RED OCHRE GROUND, 2) YELLOW OCHRE AND A LITTLE LEAD TIN YELLOW, 3) MIXED SOURCE RED LAKE, 4) VARNISH.

XLV. AT CHERITON BISHOP (DEVON), THE HALOES AND CROZIERS ON THE FIGURE PANELS ARE UNDERTAKEN IN LEAD TIN YELLOW, WHEREAS THE TRACERY SURROUNDING AND THE WINGS OF THE CARVED ANGEL ON THE PIER CASING ARE GILDED.

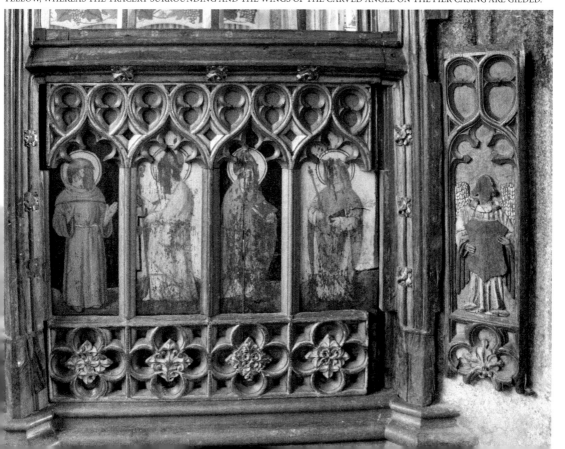

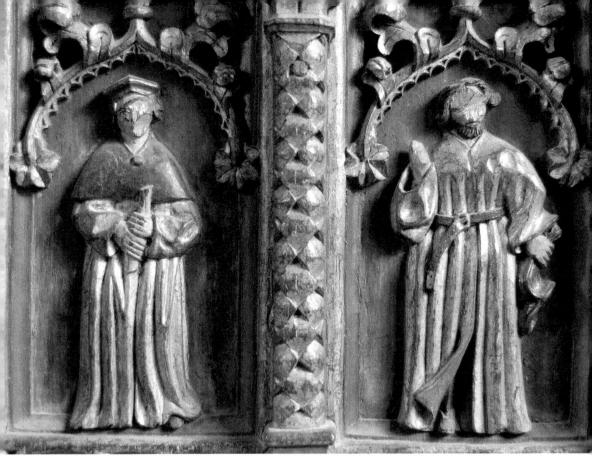

XLVI. AT BRIDFORD, THE THREE-DIMENSIONAL DADO FIGURES ARE GILDED.

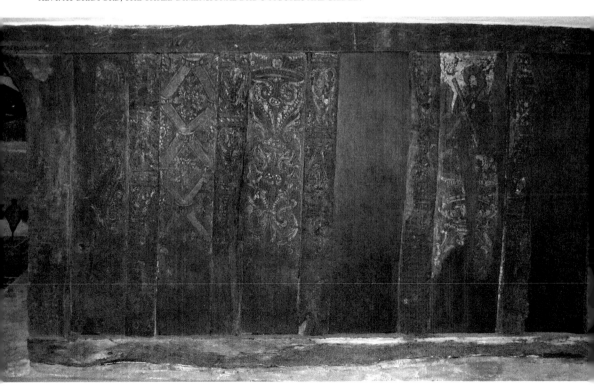

XLVII. THE PLANK AND MUNTIN SCREEN AT MARKER'S COTTAGE (DEVON).

XLVIII: DETAIL OF THE PELICAN IN HER PIETY FROM THE PLANK AND MUNTIN SCREEN AT LITTLE HARVEY FARM (DEVON).

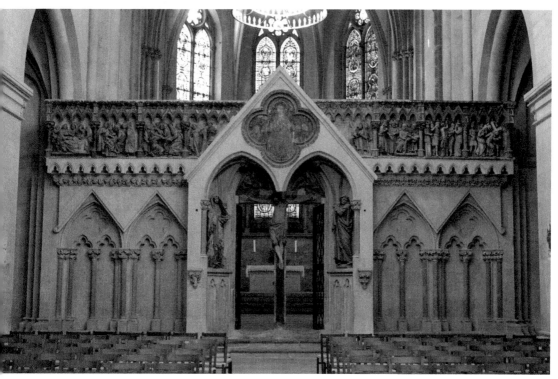

XLIX. NAUMBURG CATHEDRAL, WEST CHOIR SCREEN.

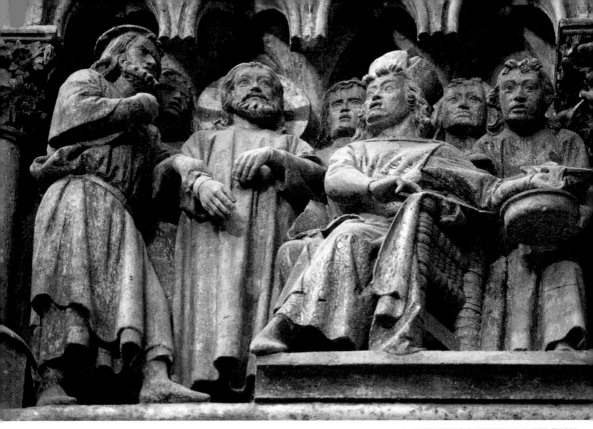

L. NAUMBURG CATHEDRAL, WEST CHOIR SCREEN, RELIEF OF CHRIST BEFORE PILATE.

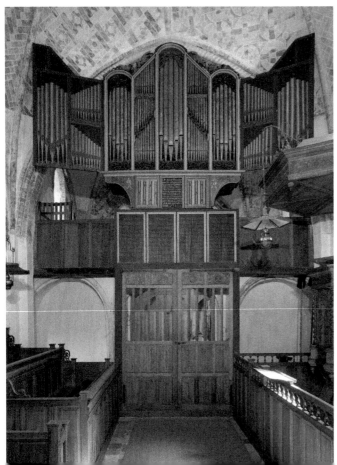

LI. KREWERD, VILLAGE CHURCH, GALLERY (C.1300) AND ORGAN (1531) VIEWED FROM THE NAVE.

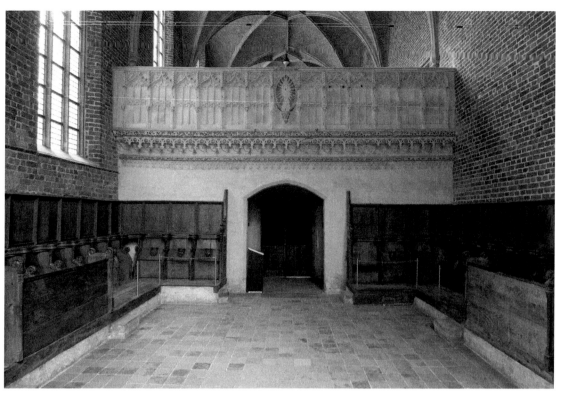

LII. TER APEL, FORMER MONASTERY CHURCH, GALLERY (C.1500) VIEWED FROM THE CHANCEL.

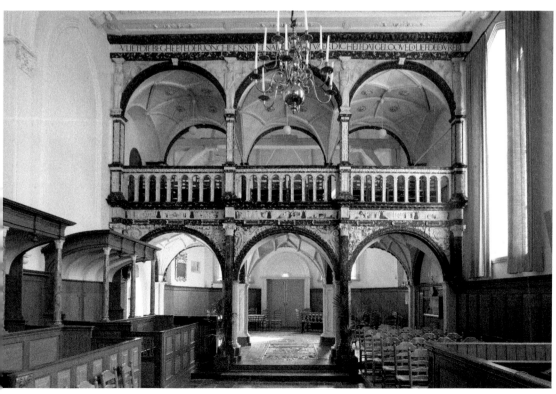

LIII. EASTEREIN/OOSTEREND, VILLAGE CHURCH, GALLERY (1554) VIEWED FROM THE NAVE.

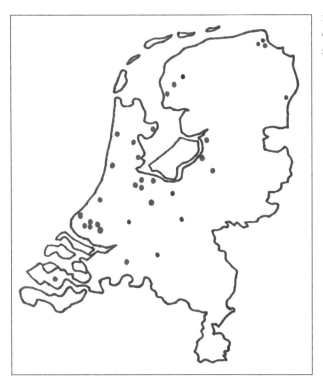

LIV. MAP OF THE NETHERLANDS SHOWING THE GEOGRAPHICAL SPREAD OF PRE-REFORMATION SCREENS (RED) AND GALLERIES (BLUE).

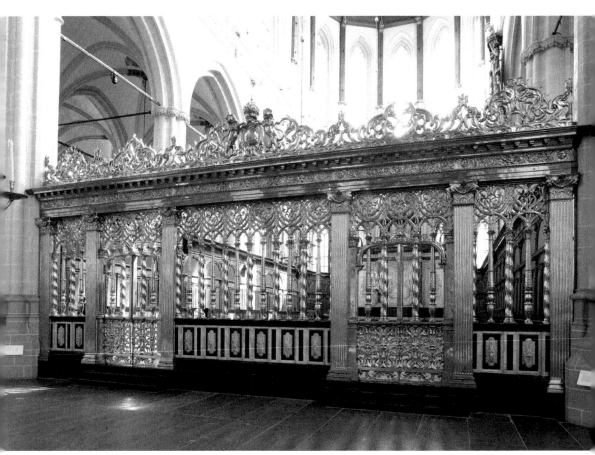

LV. AMSTERDAM, NEW CHURCH, PROTESTANT SCREEN (1647–50) VIEWED FROM THE NAVE.

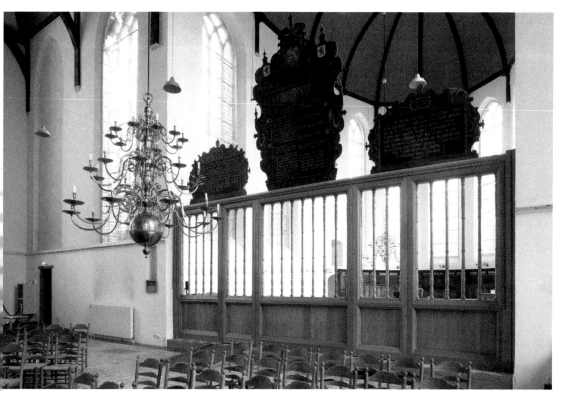

LVI. NOORDWIJK-BINNEN, ST
JEROME, PROTESTANT SCREEN
WITH TEXT PANELS (C.1650)
VIEWED FROM THE NAVE.

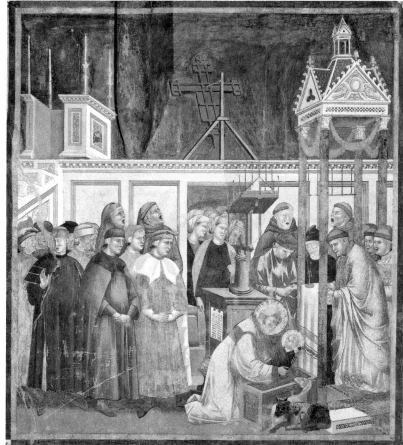

LVII. GIOTTO AND WORKSHOP,
*THE MIRACLE OF THE CRIB AT
GRECCIO*, FRESCO, C.1290–97,
UPPER CHURCH, BASILICA OF
SAN FRANCESCO.

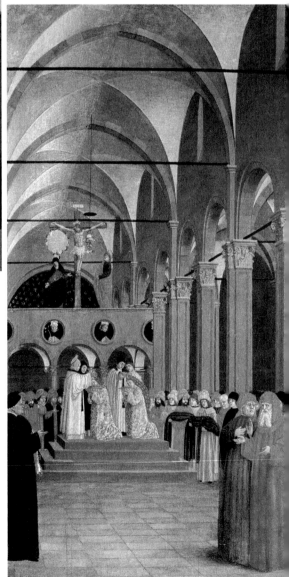

LVIII. MONTANO D'AREZZO (ATTRIB.), *BLESSED AMBROGIO SANSEDONI PREACHING*, FRESCO, C.1290, SAN DOMENICO, AREZZO.

LIX. ANGELO AND BARTOLOMEO DEGLI ERRI, *SAINT VINCENT FERRER BAPTIZING TWO CONVERTS*, TEMPERA ON PANEL, 61 X 34CM, C.1460–80, GEMÄLDEGALERIE, KUNSTHISTORISCHES MUSEUM, VIENNA (FORMERLY SAN DOMENICO, MODENA).

LX. GIOTTO AND WORKSHOP, *FUNERAL OF SAINT FRANCIS AND VERIFICATION OF THE STIGMATA*, FRESCO, C.1290–97, UPPER CHURCH, BASILICA OF SAN FRANCESCO, ASSISI.

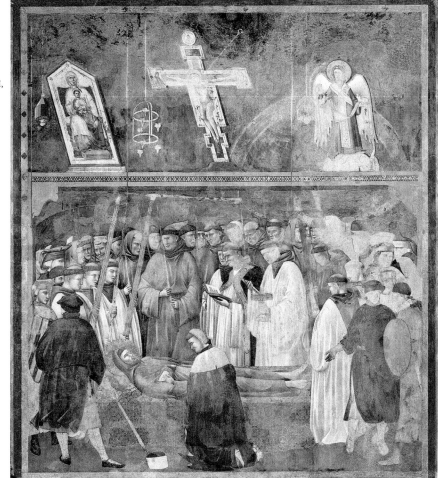

LXI. TITIAN, *ASSUNTA*, OIL ON PANEL, 690 X 360CM, 1516–18, BASILICA OF SANTA MARIA GLORIOSA DEI FRARI, VENICE, VIEWED THROUGH THE CENTRAL DOORWAY OF THE CHOIR SCREEN, SCULPTED BY PIETRO LOMBARDO'S WORKSHOP IN 1475.

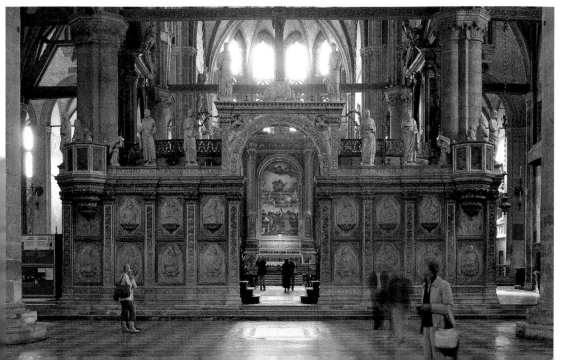

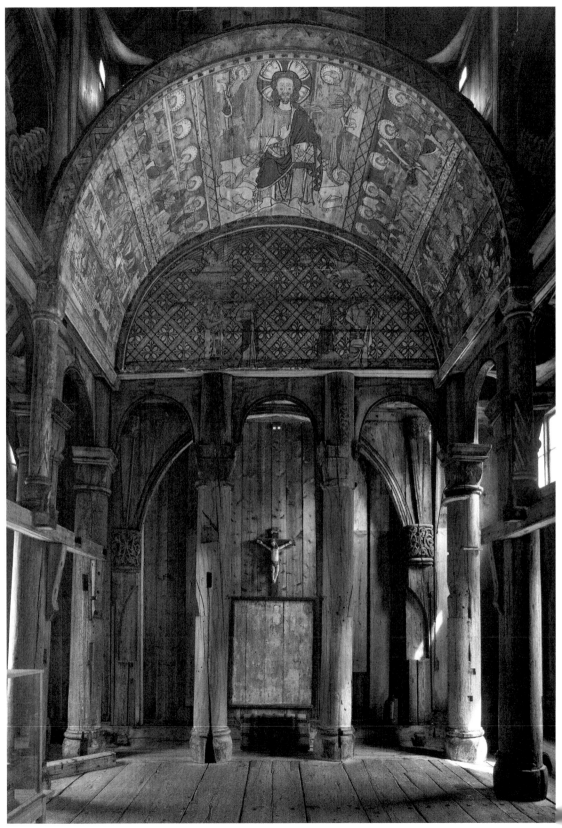

LXII. TORPO STAVE CHURCH, NORWAY, ROOD ALTAR CIBORIUM (AND REMAINS OF ROOD LOFT).

Understanding the blurred nature of access and exclusion has important implications: lay viewers may have been familiar with areas from which they were periodically excluded, and they would also have expected to return to them. Such permeable proximity is hardly surprising when one considers the myriad ties of kinship and social obligation that bound the clergy and the laity together within the Italian urban context.

THE DECORATION OF ITALIAN SCREENS: MURAL PAINTINGS AND 'ICONOSTASIS' PANELS

Even if Italian screens were more permeable barriers than we have tended to believe, they still constituted one of the most visually imposing features in the church interior. Over time many screens became encrusted with altarpieces, votive frescoes and other miscellaneous images. But their façade-like qualities also rendered them excellent stages for more coordinated iconographic displays. The screen in San Domenico, Arezzo has long since disappeared, but its location can be fixed thanks to breaks in the surviving nave frescoes.[78] At either end, the *tramezzo* wall was supplemented by murals that aped its form and amplified its function. To the right, the Dominican Blessed Ambrogio Sansedoni gives a sermon from a fictive pulpit that would have read as a continuation of the screen's upper storey (Pl. LVIII). To the left, the apostles Peter and Paul appear before St Dominic encouraging him to preach – Dominic's figure is obliterated but an inscription still lingers above where he would have knelt. These painted companions were doubtless intended to encourage and inspire the Dominicans who preached from the *tramezzo*, as well as exalting them in the eyes of their audience gathered in the lower nave. The programme may have extended across the western face of the *tramezzo*; we have evidence elsewhere for the decoration of Dominican screens with images of the Order's saints and *beati*, including a depiction of a screen embossed with roundels of holy Dominicans from an altarpiece painted by Angelo and Bartolomeo degli Erri c.1460–80 (Pl. LIX).[79]

The principal image on the screen would of course have been the central crucifix. Sculpted roods gradually became more prevalent after the middle

to just above eye level with an elevated pulpit projecting to the right – still divides the church at Barga.

[78] For more detailed discussion of the San Domenico murals, see Cooper, 'Access all Areas?', pp. 96–8; Cannon, *Religious Poverty, Visual Riches*, pp. 277–81; and Cooper, 'Preaching amidst Pictures: Visual Contexts for Sermons in Late Medieval Tuscany', in H. L. Kessler and R. Newhauser (eds), *Science, Ethics, and the Transformations of Art in the Thirteenth and Fourteenth Centuries* (Toronto, forthcoming).

[79] From the brothers' St Vincent Ferrer altarpiece for San Domenico in Modena, see D. Benati, *La bottega degli Erri e la pittura del Rinascimento a Modena* (Modena, 1988), pp. 135–62, 173–5. For further discussion, see Cannon, *Religious Poverty, Visual Riches*, pp. 40–1, 96–7.

of the Trecento, as with the polychrome statues depicted in the Degli Erri panel. Prior to that, painted panel crosses were more common; hundreds survive and the largest examples reach over six metres in height.[80] Pitched forward from the vertical, these enormous crosses loomed over the lower naves of Italian churches. Raised haloes pushed Christ's face down further towards the viewer below. The size and weight of these crosses necessitated support both from brackets below and from chains attached to the vaults or roof trusses above. The resulting stress placed on their carpentry required grids of reinforcing batons and precluded painted backs.[81]

But crucifixes were not the only painted panels elevated over screens. Another famous fresco from Assisi, the *Verification of St Francis's Stigmata*, depicts a central crucifix accompanied by two lateral panels, a gabled Virgin and Child and a curious cut-out St Michael (Pl. LX). A significant discussion currently underway amongst specialists of Italian panel painting is how common such ensemble arrangements were. Bram Kempers and Andrea De Marchi have presented evidence that the phenomenon was indeed widespread, certainly in central Italy.[82] Candidates for elevated images include Giotto's *Ognissanti Madonna*, Duccio's *Rucellai Madonna* from Santa Maria Novella and Giotto's *Stigmatization of Saint Francis* from San Francesco in Pisa.[83] In other words, a whole genre of early Italian panel painting – the monumental gabled dossal – is in the course of re-evaluation.[84] If true, we will also need to rewrite the early history of the Italian altarpiece, as all of these images have hitherto been categorized

[80] Cooper, "'In medio ecclesiae'", pp. 107–23; J. Cannon, 'The Era of the Great Painted Crucifix: Giotto, Cimabue, Giunta Pisano, and their Anonymous Contemporaries', *Renaissance Studies*, 16 (2002), pp. 571–81; Cannon, *Religious Poverty, Visual Riches*, pp. 47–69. For a recent survey of surviving examples, see M. Gaeta, *Giotto und die 'croci dipinte' des Trecento: Studien zu Typus, Genese und Rezeption mit einem Katalog der monumentalen Tafelkreuze des Trecento (ca. 1290–ca. 1400)* (Münster, 2013).

[81] For the structure of Giotto's Santa Maria Novella cross, see C. Castelli, M. Parri and A. Santacesaria, 'Tecnica artistica, stato di conservazione e restauro della Croce in rapporto con altre opere di Giotto: il supporto ligneo', in M. Ciatti and M. Seidel (eds), *Giotto: la Croce di Santa Maria Novella*, ed. Marco Ciatti and Max Seidel (Florence, 2001), pp. 247–72.

[82] B. Kempers, *Painting, Power and Patronage: The Rise of the Professional Artist in the Italian Renaissance* (London, 1992), pp. 36–51; A. De Marchi, "'Cum dictum opus cit magnum"; il documento pistoiese del 1274 e l'allestimento trionfale dei tramezzi', Umbria e Toscana fra Due e Trecento, in A. C. Quintavalle (ed.), *Medioevo: immagine e memoria* (Milan, 2009), pp. 603–21. The proposal that the beam in the *Verification of the Stigmata* fresco could be related to documented arrangements was first made by G. Coor-Achenbach, 'A Visual Basis for the Documents Relating to Coppo di Marcovaldo and His Son Salerno', *The Art Bulletin*, 28 (1946), pp. 233–47.

[83] On the *Ognissanti Madonna*, see I. Hueck, 'Le opere di Giotto per la Chiesa di Ognissanti', in *La 'Madonna d'Ognissanti' di Giotto restaurata* (Florence, 1992), pp. 37–50. For Duccio's *Rucellai Madonna* and related images from Dominican contexts, see Cannon, *Religious Poverty, Visual Riches*, pp. 71–89. For Giotto's *Stigmatization*, see D. Cooper, 'Redefining the Altarpiece in Early Renaissance Italy: Giotto's *Stigmatization of Saint Francis* and its Pisan Context', *Art History*, 36 (2013), pp. 686–713, esp. pp. 691–3.

[84] Victor Schmidt has suggested a new category of 'super icons' to describe these images, see 'Religious Panel Paintings: Types, Functions, and Spatial Contexts', in C. Sciacca

as altar retables — which may account for some of the resistance these new reconstructions have encountered.[85]

The obvious complication with the *Verification* fresco is that it does not depict images mounted on a screen wall, but rather on a type of beam, usually termed an 'iconostasis' in the Italian literature. The fresco is accurate in so far as beams could be independent from *tramezzo* screens: this was the case in the Upper Church at Assisi, where the stubs and supporting consoles of the thirteenth-century beam still remain, engulfed by the first and last scenes of the St Francis Cycle. A body of evidence can be assembled to suggest that beams were often combined with screens, and that their integration may hold the key to some of the more problematic aspects regarding the elevated display of panel paintings.[86] Frithjof Schwartz has recently identified symmetrical plugs on the nave piers of Santa Maria Novella and has persuasively argued that they fixed a beam which in turn supported Giotto's famous crucifix for the church.[87] The beam would have been nine metres clear of the nave floor, and easily above the upper storey of the *ponte* screen. It is possible to adduce other documented instances where beams were combined with screens. The merchant of Prato, Francesco di Marco Datini, lavished attention on his local Franciscan church, where he was eventually buried before the high altar. One of his many projects was a lost crucifix bearing his arms, which was said to have been mounted over the door to the choir, facing the main façade portal.[88] We learn from other sources that the church had a *tramezzo* screen and it would seem logical to place the cross over its central door.[89] But thanks to Datini's meticulous book-keeping, we also know that the merchant paid the local painter Arrigo di Niccolò ten florins to paint

(ed.), *Florence at the Dawn of the Renaissance: Painting and Illumination 1300–1350* (Los Angeles, 2013), pp. 79–91 (esp. pp. 80–4).
[85] For a sceptical view, see A. Tartuferi, 'Intorno a Giotto: una mostra, un libro e una proposta di attribuzione', *Commentari d'arte*, 19–20 (2013–14), pp. 26–38 (esp. pp. 26–8).
[86] Such combinations are well known north of the Alps, see J. E. Jung, *The Gothic Screen: Space, Sculpture, and Community in the Cathedrals of France and Germany, ca. 1200–1400* (Cambridge, 2013), pp. 48–9, for the arrangement at Halberstadt.
[87] F. Schwartz, 'In medio ecclesiae: Giottos Tafalkreuz in Santa Maria Novella', *Wiener Jahrbuch für Kunstgeschichte*, 54 (2005), pp. 95–114. A beam–screen combination at Santa Maria Novella was first implied by Bram Kempers in one of the illustrations to *Kunst, macht en mecenaat: het beroep van schilder in sociale verhoudingen 1250–1600* (Amsterdam, 1987), p. 70. The reconstruction also showed Giotto's crucifix off-set to the left and accompanied on the right by the *Rucellai Madonna* and perhaps for this reason the author chose not to include the drawing in the 1992 English-language translation of his book, *Painting, Power and Patronage*. However, the beam proposal (like many other aspects of Kempers's discussion) now appears remarkably prescient.
[88] The seventeenth-century description published by G. Marchini, 'La chiesa di S. Francesco in Prato in una descrizione del secolo XVII', *Archivio Storico Pratese*, 32 (1957), pp. 33–44, described 'un Crocefisso grande coll'arme de' Datini, stava già sopra la porta del Coro vecchio, in faccia alla porta maggiore della Chiesa' (at p. 38).
[89] The twists and turns of this exceptionally well-documented commission of 1395 are reconstructed by J. P. Byrne, 'Francesco Datini, "Father of Many": Piety, Charity and Patronage in Early Modern Tuscany' (PhD thesis, Indiana University, 1989), pp. 315–23.

the beam which ran beneath the crucifix in the middle of the church, as well as its 'mensole', presumably the supporting consoles at either end.[90]

More precise evidence for how beams and screens may have interacted in practice comes from San Remigio in Florence, a rare case where we have good evidence of a painted panel being placed over a screen in a parish church. Vasari saw the Uffizi *Lamentation*, attributed to Giottino, 'nel tramezzo' in San Remigio.[91] Andrea de Marchi has argued that Vasari's description indicates that the picture was set directly on top of San Remigio's screen, but direct examination of the current state of the interior suggests a more subtle solution.[92] The height of the former *tramezzo* is indicated by the remnants of the access stairwell on the far nave wall. But higher up on the inner faces of the nave piers there are symmetrical rectangular sockets suitable for taking a transverse beam. These raise the possibility that when Vasari described the Uffizi *Lamentation* on the San Remigio screen, he was in fact referring to an image set on a beam above the *tramezzo*.[93]

This kind of arrangement may help to explain one of the gnawing doubts regarding the elevated display of panel paintings: the visibility of subsidiary scenes. We know for sure that particular images with small-scale narratives were displayed high. Coppo di Marcovaldo's crucifix in Pistoia Cathedral was certainly mounted on a beam over the choir despite the narrative scenes on its apron; the documentation leaves no room for doubt.[94] There are other examples, like the 1386 inventory description of

[90] 'E più [Arrigo] dipinsi nella chiesa di San Franciescho una trave, cioè quella chè nel mezo de la chiesa, che va suso el Crocifisso, dipinsela a meze fighure cho fogliami, cioè le tre faccie chò le mensole. Viensene fiorini dieci'; see C. Guasti (ed.), *Ser Lapo Mazzei: lettere di un notaro a un mercante del secolo XIV con altre lettere e documenti*, vol. II (Florence, 1880), p. 413. For the remarkable survivial of a late thirteenth-century beam painted with half-length images of Christ and the apostles in Genova, see C. Di Fabio, 'Aspetti della pittura decorativa a Genova fra XII e XIV secolo: La trave del tramezzo presbiteriale di San Matteo, le stanze dei canonici della Cattedrale, il soffitto di casa de Turca', *Ligures*, 6 (2008), pp. 5–20 (esp. pp. 17–19, Figs 15–18).

[91] 'In questa tavola, che è posta nel tramezzo di detta chiesa (San Remigio) a man destra': R. Bettarini and P. Barocchi (eds), *Giorgio Vasari: Le vite de' più eccellenti pittori, scultori e architettori*, vol. II (Florence, 1967), p. 234.

[92] De Marchi, '"Cum dictum opus sit magnum"', p. 615, Fig. 16.

[93] For these sockets and a detailed consideration of the physical and documentary evidence for the reconstruction of the San Remigio *tramezzo*, see now M. Bandini, 'Vestigia dell'antico tramezzo nella chiesa di San Remigio a Firenze', *Mitteilungen des kunsthistorischen Institutes in Florenz*, 54 (2010–12), pp. 211–29 (sockets illustrated as Figs 15–16). While allowing for the presence of 'una trave che attraversava tutta la navata centrale e che serviva da sostegno alla struttura' (p. 220), Bandini follows De Marchi in setting Giottino's *Lamentation* directly on the *tramezzo* (reconstruction in Fig. 22).

[94] For the series of documents from 1274–75 pertaining to the commission and installation of Coppo's crucifix and related panels, see Coor-Achenbach, 'A Visual Basis for the Documents Relating to Coppo di Marcovaldo', pp. 233–47; and most recently A. De Marchi, 'La diffusione della pittura su tavola nel Duecento e la ricostruzione del tramezzo perduto del Duomo di Pistoia', in *Il museo e la città (Incontri 2): vicende artistiche pistoiesi dalla metà del XII secolo alla fine del Duecento* (Pistoia, 2011), pp. 61–85.

a panel depicting the bishop saint Zeno 'with histories of the life of the Saviour (i.e. Christ)' over the door to the choir in the abbey church of San Zeno in Pisa.[95] These narratives, as well as any inscriptions, could not have been visible from the floor of the church. But in the case of beam images, they may well have been legible to a viewer standing on the upper storey of a screen. Might such an arrangement explain the layout of Giotto's Louvre *Stigmatization*, where the three subsidiary narratives and painter's signature are arranged along the bottom of the panel?[96] In which case we may need to rethink the origins of the predella as well as the altarpiece.

THE DEMISE OF THE ITALIAN CHOIR SCREEN

From this analysis of 'iconostasis' imagery and the preceding discussions of the form and function, it should be clear how far there is to go before we achieve an adequate understanding of Italian rood screens. Arguably we need a collaborative project of the kind convened at Cambridge for the analysis of English screens to make real progress. The methodology would have to be different for Italy, since there are so few standing structures to work with. Refinements in georadar techniques may allow the study of *tramezzo* foundations without the need for invasive excavations. In the immediate term, the most promising material for non-extant screens is probably to be mined from later records documenting their removal. Arguments made for and against the demolition of *tramezzi* often help us to understand how screens were perceived and what functions they had been intended to fulfil.

A wealth of evidence now contradicts the simplistic view that the Counter Reformation, and specifically the Council of Trent, orchestrated the removal of screens across the peninsula in top-down fashion.[97] Their disappearance is better characterized as a complex and lengthy process

[95] E. Virgili, 'L'inventario dell'abbazia di San Zeno di Pisa (1386)', *Bolletino storico pisano*, 54 (1985), pp. 117–29 (at p. 123): 'Tabulam unam super hostio dicte ecclesie [in coro] iusta corum et in medio dictorum altarium precipiatur depinta sive ymago Sancti Zenonis cum storiis vite Sancti Salvatoris Yhesu Christi' (the archival source is Florence, Archivio di Stato, Notarile Antecosimiano 7985, f. 15r).

[96] Someone could see Giotto's 'predella' narratives, as the three scenes were faithfully copied later in the fourteenth century in a fresco by a local Pisan artist, see D. Cooper, 'Experiencing Dominican and Franciscan Churches in Renaissance Italy', in T. Kennedy (ed.), *Sanctity Pictured: The Art of the Dominican and Franciscan Orders in Renaissance Italy* (Nashville and London, 2014), pp. 53–4, Fig. 50.

[97] Trent had nothing to say on the merits or otherwise of nave screens. Carlo Borromeo, who took an active interest in church furniture and the separation of the sexes and the laity from the clergy, recommended the installation of longitudinal barriers running the length of the nave, a solution that had little long-term impact and which does not seem to have spread beyond his native Milan; see R. Schofield, 'Carlo Borromeo and the Dangers of Laywomen in Church', in M. Hall and T. E. Cooper (eds), *The Sensuous in the Counter-Reformation Church* (Cambridge, 2013), pp. 187–205.

driven by multiple factors and drawn out over several centuries.[98] The research of Joanne Allen has clarified that the motivations behind demolitions were rarely liturgical. Just as often the reasons were aesthetic, as the taste for unified interiors took hold.[99] Nor was the progressive removal of screens regarded as inevitable: screens were being renewed and rebuilt well into the sixteenth century.[100]

It is in this light that we should approach the unique survival of the nave choir in the Frari in Venice, completed by Pietro Lombardo's workshop in 1475 (Pl. LXI).[101] This was already a hybrid arrangement, consolidating the separate traditions of the choir and *tramezzo* screen into a single structure. Other screen–choir combinations can be reconstructed, some of them intermediate stages between the removal of *tramezzi* and the final clearing of church naves.[102] The Frari screen had a sculpted rood and twin pulpits, but no arcade and no side altars. Its great value is the manner in which we can still experience the telescoping of Titian's great *Assunta* over the high altar through the screen door. This was a carefully pondered vista. The *Assunta*'s monumental frame was erected in 1516, two years before Titian's enormous panel was completed, and it was scaled to suit the viewer in the lower nave (the cherub heads on the upper cornice

[98] The slow demise of the nave screen needs to be seen in relation to the trend towards apsidal choirs (or retro-choirs, that is with choir stalls located behind the high altar), explored in the essays collected in S. Frommel and L. Lecomte (eds), *La place du choeur: architecture et liturgie du Moyen Âge aux temps modernes* (Paris, 2012). Retro-choirs have been traced back as far as the thirteenth century in Umbria, see Cooper, 'Franciscan Choir Enclosures' (although in these early cases apsidal choirs may have been combined with nave *tramezzi*). For late Quattrocento developments in the Veneto, see P. Davies, 'Architettura e culto a Venezia e nelle città di terraferma, 1475–1490', in A. Nante, C. Cavalli and Pierantonio Gios (eds), *Pietro Barozzi, un vescovo del Rinascimento* (Padua, 2012), pp. 193–203.
[99] See J. Allen, 'Choir Stalls in Venice and Northern Italy: Furniture, Ritual and Space in the Renaissance Church Interior' (PhD thesis, University of Warwick, 2010), esp. pp. 140–92; J. Allen, 'Nicholas V's Tribuna for Old St. Peter's in Rome as a Model for the New Apsidal Choir at Padua Cathedral', *Journal of the Society of Architectural Historians*, 72 (2013), pp. 166–88. On the complex motivations behind alterations to the spatial configuration of church interiors, see also S. de Blaauw, 'Innovazioni nello spazio di culto fra basso Medioevo e Cinquecento: la perdita dell'orientamento liturgico e la liberazione della navata', in J. Stabenow (ed.), *Lo spazio e il culto* (Venice, 2006), pp. 25–51.
[100] For the sixteenth-century screens in Sant'Antonio in Castello and Santa Maria dei Servi in Venice, known from surviving architectural drawings, see Modesti, 'I cori nelle chiese veneziane', pp. 44–5, 49, Figs 16 and 17. Designs for a new screen were being considered for Sant'Andrea, Mantua at the very end of the sixteenth century, see P. Piva, 'Dal setto murario allo *jubé*: il "pòzo" di Sant'Andrea a Mantova nel contesto di un processo evolutivo', in E. Camerlenghi, G. Gardoni, I. Lazzarini and V. Rebonato (eds), *Società, cultura, economia: studi per Mario Vaini* (Mantua, 2013), pp. 69–70, Fig. 7.
[101] On the Frari screen, see now A. Sherman, '"To God alone the honour and glory": Further Notes on the Patronage of Pietro Lombardo's Choir Screen in the Frari, Venice', *The Burlington Magazine*, 156 (2014), pp. 723–8.
[102] For the case of San Francesco, Pisa, where the nave choir was renewed with a marble revetment in the 1520s (around the same time that the church probably lost its medieval *tramezzo*) before the stalls were finally moved into the *cappella maggiore* in 1577, see Cooper, 'Redefining the Altarpiece in Early Renaissance Italy', p. 704.

are notably crude at close range). High altarpieces must often have been designed with such vistas in mind, but the Frari seems to have been a particularly subtle and successful example. As far as we know, the choir's removal was never seriously considered by the Venetian Franciscans.[103] Arguably the Frari screen–choir survived not because of any liturgical function, but because it was perceived in different terms altogether, as the aesthetically successful frame for a work of art.[104]

[103] The Venetian tolerance of screens during the Counter Reformation seems to have been relatively high. The 'pontile' across the city in Santa Giovanni e Paolo was demolished as late as 1683, see M. Merotto Ghedini, 'Il tramezzo nella chiesa dei Santi Giovanni e Paolo a Venezia', in T. Franco and G. Valenzano (eds), *De lapidibus sententiae: scritti di storia dell'arte per Giovanni Lorenzoni* (Padua, 2002), pp. 257–62.

[104] Similar reasons may lie behind the full elevation *tramezzi* painted with fresco cycles that survive in Franciscan churches in Lombardy and Piedmont, see A. Nova, 'I tramezzi in Lombardia fra XV e XVI secolo: scene della Passione e devozione francescana', in A. Dallaj (ed.), *Il francescanesimo in Lombardia* (Milan, 1983), pp. 197–215; Hall, 'The *Tramezzo* in the Italian Renaissance, Revisited', pp. 228–30. These did not always guarantee survival, as in the case of the *tramezzo* scheme recently discovered at Novara, see A. L. Casero, 'Un tramezzo affrescato in San Nazzaro della Costa a Novara: alcune riflessioni e prime ipotesi', in M. G. Albertini Ottolenghi and M. Rossi (eds), *Studi in onore di Francesca Flores d'Arcais* (Milan, 2010), pp. 91–9.

11

CHOIR SCREENS AND ROOD LOFTS IN SCANDINAVIAN PARISH CHURCHES BEFORE 1300

EBBE NYBORG

In most countries medieval church screens have more or less disappeared leaving little or no trace. And yet they would, probably, have been common and widespread in European churches and most important to the liturgy and to the way the church and its mysteries were presented to the layman and woman. The choir screen was the 'antesanctum' or 'focal point of the sacred space', to quote two fellow Scandinavian scholars.[1] Precisely because of its important location in the midst of the church interior, the choir screen has fallen victim to shifting tastes and liturgical habits that have tended to sweep away everything outdated. So little is now preserved of medieval choir screens that in many European countries they are but 'ghost screens' in the minds of the modern scholar. This puzzle of scarce written and material evidence indeed calls for cross-disciplinary and trans-national work and cooperation. Scandinavia can contribute little when it comes to cathedrals and other major churches. Their quires were all 'opened' in the centuries following the Reformation. But such buildings would with no exception have possessed a medieval choir screen or a *pulpitum* from where announcements, reading (towards the quire), preaching and performance of music took place.[2] Our most interesting information therefore comes from rural parish churches. An

[1] A. M. Hoff, 'The Area between Chancel and Nave in Norway's Medieval Parish Churches: An Outline of the Subject's Research Status, with a Survey of Selected Scandinavian Literature', *Jaarboek voor liturgie-onderzoek*, 19 (2003), pp. 147–74; A. Nilsén, *Focal Point of the Sacred Space: The Boundary between Chancel and Nave in Swedish Rural Churches: From Romanesque to Neo-Gothic* (Uppsala, 2003).
[2] A. S. Johannesen and E. Møller, 'Lectorium', in *Kulturhistorisk Leksikon for nordisk*

important quality of this material is that it is almost exclusively as early as the high Middle Ages, from the twelfth to thirteenth centuries. Firstly, this means that it goes back to the times that saw the 'medieval reformation' and great changes in Eucharistic theory and practice, such as the doctrine of substantiation, the introduction of the elevation of the Eucharist and the rise of the feast of Corpus Christi. All these developments tended to change the Mass from a mystery, of which the congregation was only to perceive a glimpse, into a spectacle, where understanding, compassion and most of all seeing became all important.[3]

Secondly, the early date of our evidence means that – surprisingly – it seems to antedate the earliest screens and rood lofts known from parish churches in England, France and Germany.[4] This can however hardly be a true picture: we were not that inventive in Scandinavia. The architectural framework of the parish churches is rather uncomplicated. The development of most Danish and Swedish rural parish churches and several of the Norwegian examples began in the eleventh century with small stave (wooden) churches, which were replaced by Romanesque two-cell stone churches by the twelfth to thirteenth centuries. Many churches have retained this shape until today, but others have received late medieval additions such as a tower, a porch, or a new chancel transforming the church into a single-cell hall with no separating wall between the nave and the chancel. There are also churches that were built as single-cell halls in the late thirteenth to fourteenth centuries, especially in upper Norway and Sweden. And there is of course the speciality of Norway, its fully developed stave church from the twelfth to the thirteenth centuries, to which we shall return. Excavations have revealed the basic interior scheme of a typical Scandinavian stone-built parish church of the twelfth to thirteenth centuries.[5] There was a podium with the font in the west of the nave, and along its walls were low benches of stone or wood. The nave opened to the chancel by way of a more or less narrow chancel arch or triumphal arch – so called because it celebrated Christ's victory, and because it housed the crucifix or Rood, the main focus of the congregation. It should be noted that the wall between the nave and the chancel, the chancel arch wall or triumphal wall, was not a choir screen

Middelalder (Copenhagen, 1965). E. Møller, 'Om danske Lektorier', *Nationalmuseets Arbejdsmark* (1950), pp. 128–39.

3 B. Bolton, *The Medieval Reformation* (London, 1983); P. Browe, *Die Verehrung der Eucharistie im Mittelalter* (Munich, 1933); M. Rubin, *Corpus Christi: The Eucharist in Late Medieval Culture* (Cambridge, 1991).

4 A. Vallance, *English Church Screens* (London, 1936), p. 66; E. Kirchner-Doberer, 'Die deutschen Lettner bis 1300' (PhD thesis, Vienna, 1946), p. 5; M. Schmelzer, *Der mittelalterliche Lettner im deutschstrachigen Raum. Typologie und Funktion* (Petersberg, 2004), pp. 153–5; J. Kroesen and R. Steensma, *The Interior of the Medieval Village Church* (Louvain, Paris and Dudley, MA, 2005), pp. 177–210.

5 The fundamental contribution is O. Olsen, 'Rumindretningen i romanske landsbykirker', *Kirkehistoriske Samlinger* (1967), pp. 235–57.

as some scholars have assumed.[6] The wall is architectural, also in stave churches,[7] and what we will be looking for will mostly be screens and rood lofts that effectively close their opening arch. Flanking the arch were side altars with images, and sometimes we have also found archaeological and other material evidence of a rood altar in the arch or in front of it.[8] In the following discussion, we shall investigate each Scandinavian country separately, beginning with screens and proceeding with rood lofts.

NORWAY

The Norwegian evidence is the richest and most diverse.[9] Norway is also of special interest from an English viewpoint since Norwegian art and architecture can be expected mainly to follow English models. A few words about the architecture of the fully developed stave church: it is much more 'European' than one would think at first sight. It comprises a two-cell building with an apse, a clerestory having small round light-holes, a totally surrounding aisle and a turret on top, contributing to the somewhat pagoda-like appearance. Hopperstad church has one of the finest stave church interiors with a beautiful thirteenth-century side altar ciborium north of the chancel arch, and evidence of one more south of it. A rare survivor, the original chancel arch is preserved, telling us just how small and narrow chancel arches would have been in most stave churches (Fig. 11.1). It would make little sense to close this low and narrow chancel entrance off with any screening. Instead we find the arch flanked by trefoil open arcading at the eye level of the congregation. As the building is probably from the twelfth century, the arcading is thought to be secondary and from the thirteenth century. The similarity with early English screens, such as the ones in Thurcaston and Stanton Harcourt, is obvious.[10] However, in Hopperstad one could hardly speak of a screen, but rather of a chancel arch wall with architectural squints. I see such 'false' screens that are only known in stave churches as caused by the narrowness of their chancel arches and by the ease with which one could penetrate their relatively light wooden walls to allow the congregation to have a better view of the mysteries of the Mass.

[6] Hoff, 'Area between Chancel and Nave', p. 150; Kroesen and Steensma, *The Interior*, p. 178.

[7] It must be admitted that triumphal arch walls in stave churches are not raised to gable height and therefore they may much resemble a screen, cf. Fig. 11.1.

[8] E. Nyborg, 'Kreuz und Kreuzaltarretabel in dänischen Pfarrkrchen des 12. und 13. Jahrhunderts. Zur Genese der Ring- und Arkadenkreuze', in H. Kroohm, K. Krüger and M. Weniger (eds), *Entstehung und Frühgeschichte des Flügelaltarschreins* (Berlin, 2001), pp. 25–50.

[9] Norway also has the longest and most developed tradition of research into parish church choir screens and rood lofts. See the two most recent overviews by Anne Marta Hoff: 'Area between Chancel and Nave' and *Korskillet i Eidfjord* (Bergen, 1991), pp. 74–106.

[10] Both screens are illustrated in Hoff, *Korskillet*, as Figs 41–2.

A similar false screen probably existed in Reinli stave church. Here the last remains of the triumphal wall were removed as late as in the 1880s. However, an interesting drawing exists, made by the antiquarian Georg Andreas Bull, which shows – hardly what he saw – but rather what he thought he could reconstruct. There is nevertheless evidence that he was broadly right: a triumphal wall with a tiny arch is flanked by round-headed open arcading, very much like in Hopperstad. This church is thought to be from the thirteenth century, and there is little reason why the arcading openings to the chancel should not be original.[11]

In the interior of Torpo stave church one sees in the *antesanctum* a magnificent ciborium with a barrel vault having a painting of Christ in Majesty in the manner of Matthew Paris (Pl. LXII). On the back wall of the ciborium paintings show the mourning

FIG. 11.1.
HOPPERSTAD
STAVE CHURCH,
NORWAY,
CHANCEL ARCH
FORMING A
'FALSE' SCREEN.

Virgin and St John, Ecclesia and Synagogue as well as censing angels, all meant to accompany the now missing Rood in the middle. So the ciborium held the two most important Eucharistic images of its age and certainly belonged to a rood altar. But it also had an upper floor carried by still extant corbels. So it was a combination of a ciborium and a rood loft, datable c.1275–1300.[12] Astrid Schjetlein Johannesen, writing in 1961, found the arrangement without parallels but suggested that one might compare it with the two-storey chancel of Compton church in Surrey.[13]

However, the building at Torpo is older than the ciborium, probably from c.1200, and it seems that two pieces of evidence would point to

[11] Hoff, 'Area between Chancel and Nave', pp. 150, 160–2. Similar evidence is known from churches in Vangsnes and Rinde.
[12] H. Christie, in *Norges Kirker, Buskerud* (Oslo, 1981), pp. 122–37. On the paintings, S. H. Fuglesang (ed.), *Middelalderens billeder. Utsmykningen av koret i Ål stavkirke* (Oslo, 1996).
[13] A. S Johannesen, *Kinn kirkes lektorium og dets plass blant norske middelalderlektorier* (Oslo, 1961), p. 34 with note 174.

FIG. 11.2. TORPO
STAVE CHURCH,
NORWAY,
'GALLERY FRONT'
OF 'SCREEN'
WITH RUNIC
INSCRIPTION:
'TOROLF MADE
THIS CHURCH'.

the original situation: one is traces on the columns suggesting two small ciboria for side altars; the other is what scholars identify as a 'gallery front' or a 'screen' (Fig. 11.2) with openwork cresting, about 190cm long and 58cm high, which in more recent centuries has served as the back of a church bench. It has a 'Romanesque' open arcading with cushion capitals and indeed it would lead one's thoughts in the direction of a gallery front or a choir screen – but it is very difficult to be specific. In 1981, Håkon Christie suggested that it was a 'gallery front' and that it had belonged both to the original interior and to the late thirteenth-century refurbishment.[14] He illustrated his reflections by two reconstruction drawings that left several questions open (Fig. 11.3). Originally (left) the gallery front would have belonged to a postulated rood loft above the chancel arch, whereas in the thirteenth century it would have been reused as part of the rail of the documented rood loft. The reason why Christie did not interpret the rail as a choir screen was perhaps that he was aware of just how small and narrow the (now lost) chancel arch would have been. With a choir screen inside it there would hardly have been any admission whatsoever to the chancel. Similar questions are bound up with other interesting rails and crestings from stave churches, such as Hegge, Hurum and Lomen.[15] It would perhaps be a rewarding task to measure these items in proportion to the *antesanctum* architecture of their actual churches.

Now to the Norwegian stone churches of which some, as mentioned, are of the Gothic single-cell type. This applies to Eidfjord church which is dated c.1300 by the tombstone of its founder. The church still has its original choir screen, the best preserved one in Scandinavia, although it was somewhat modified during Protestantism. Anne Marta Hoff made a brilliant study on the screen in 1991, when she measured it meticulously and provided a credible reconstruction (Fig. 11.4).[16] The roof angles of

[14] Christie, *Norges Kirker, Buskerud*, pp. 130–7.
[15] Hoff, 'Area between Chancel and Nave', pp. 151, 160–2; E. Hohler, *Stave Church Sculpture*, vol. 1 (Oslo, 1999), pp. 161, 177, 194, 223.
[16] Hoff, *Korskillet*.

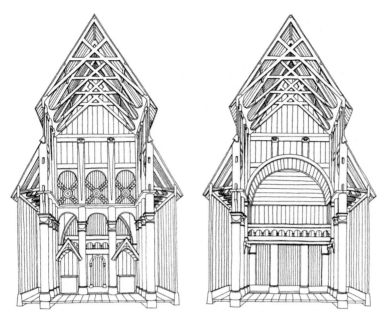

FIG. 11.3. TORPO
STAVE CHURCH,
NORWAY,
PERSPECTIVES
OF NAVE WITH
RECONSTRUCTION
OF *ANTESANCTA*
BY HÅKON
CHRISTIE 1981.
LEFT: C.1200.
RIGHT: C.1275–1300.

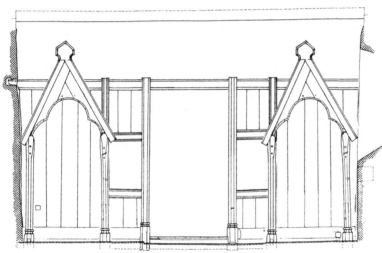

FIG. 11.4. EIDFJORD
CHURCH, NORWAY,
CHOIR SCREEN,
C.1300.

the ciboria for side altars have been ascertained, but not their canopies. Another point of doubt is the cresting of the central opening, of which there is no evidence. She has cautiously left it only with a horizontal beam. But one would rather expect a canopy carrying the Rood. One observes the rectangular openings alongside the choir entrance. They would have been meant for allowing the congregation to experience the miracle of the Eucharist at the main altar – in fact the same thing that we observed with the false screens or squints in the stave churches.

Now we shall turn to rood lofts in Norwegian stone churches. Rygge

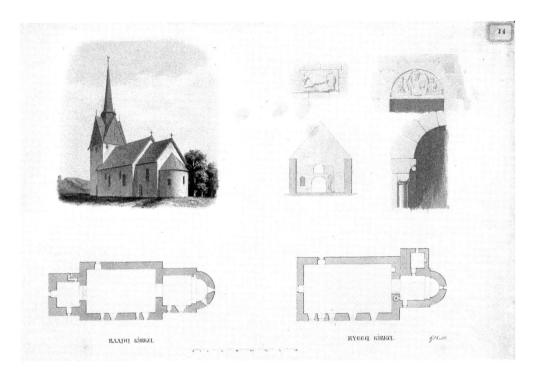

RAADØ KIRKA. RYGGØ KIRKA.

FIG. 11.5. RYGGE CHURCH, NORWAY, CHANCEL ARCH WALL WITH INTERNAL STAIRS LEADING TO OPEN ARCADE ABOVE THE ARCH (CENTRE).

church is one of the south-eastern, Jutland-inspired Romanesque buildings that could hardly be dated after 1200. A cross-section of the unusually thick triumphal wall shows a spiral staircase within the wall, leading from the chancel up to an open arcade high above the chancel arch (Fig. 11.5). Here one would have to imagine some sort of a balcony or rood loft. It would certainly not have had any screening effect, but nevertheless is informative.[17] The interpretation of the Rygge staircase as one leading to a rood loft is supported by similar structural evidence in other churches of the same date. One of them is Bamle, now only a ruin. From the chancel a flight of steps leads inside the wall to a door-opening inside the chancel arch on the south side just below the lintel. The door is not much more than 1m above church floor level. But we may imagine a rood loft floor in the arch corresponding with the door level and thus forcing anyone entering the chancel to bow humbly under the Rood.[18]

A similar access, only above the lintel, served a rood loft in the remarkable church at Tingvoll from the early thirteenth century. It is the largest and most complex raised structure of its kind in Scandinavia, and can here only be touched upon briefly, based on Anne Marta Hoff's suggested reconstruction (Fig. 11.6). The pointed chancel arch, 10m high, had no fewer than three levels. At ground level the arch was almost

17 Johannesen, *Kinn kirkes lektorium*, pp. 33–4; H. Christie, in *Norges Kirker, Østfold* (Oslo, 1959), pp. 258–9.
18 Johannsen, *Kinn kirkes lektorium*, pp. 29–35.

closed by a screen wall with a small round-headed choir entrance that corresponded with two flanking side altar niches. The second level would have been the rood loft itself with (probably) three further side altars, and access to an upper platform that would have served to minister the Rood.[19]

Turning to the mid-thirteenth century, an entire front or façade of a rood loft is in fact preserved in the small church of Kinn near Bergen. Since at least 1868 it has been standing leaning against the chancel arch wall. At that time it had no upper floor, and the middle section had been raised to the ceiling in order to open up the chancel arch. These alterations would almost certainly have been post-Reformation. In 1911–12 the rood loft was reconstructed, probably mostly correctly, as it is seen today with its front covering the upper part of the chancel arch

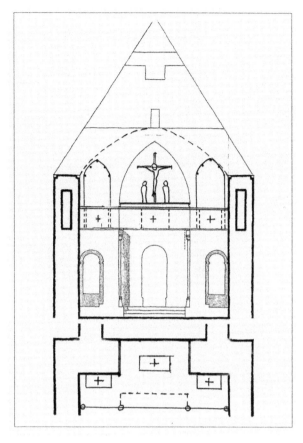

(Fig. 11.7). The rich carvings, once again in the style of Matthew Paris, show Christ in Majesty flanked by enthroned apostles and angels sounding the trumpet. We cannot say for certain where the Rood was placed. It could hardly have been inside the chancel arch; if so, it would have left little room for a screen. But rather we should imagine the crucifix standing on top of the rood loft. As the church is probably from the twelfth century, the side altar niches would originally have belonged to an older solution for the *antesanctum*.[20]

FIG. 11.6. TINGVOLL CHURCH, NORWAY, RECONSTRUCTION OF AN *ANTESANCTUM* WITH CHOIR SCREEN AND ROOD LOFT, EARLY THIRTEENTH CENTURY. BELOW PLAN AT ROOD LOFT LEVEL.

SWEDEN

We do not know of any choir screen or rood loft in parish churches from medieval Sweden, nor does it seem possible to point to remains of them with certainty. Nevertheless the existence of medieval choir screens has often been assumed. In 1930, the art historian Johnny Roosval thus

[19] A. M. Hoff, 'Korskiljeveggen I Tingvoll kyrkje', in M. Stige and T. Spurkland (eds), *Tingvoll kyrkje. Gåta Gunnar gjorde* (Trondheim, 2006), pp. 199–214.
[20] Johannesen, *Kinn kirkes lektorium*.

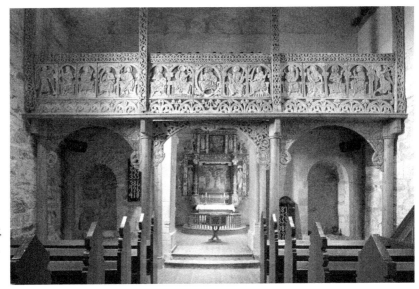

FIG. 11.7. KINN
CHURCH, NORWAY,
ROOD LOFT C.1250,
REINSTALLED
1911–12.

reconstructed the chancel arch of Stånga church on Gotland with a choir
screen. There was little foundation for this. Indeed he had no evidence
of anything but the splendid Rood and its interesting pedestal. So this
drawing is rather more imaginative than evidence-based.[21]

Roosval had, one may say, an obsession with Roods and especially
their roodbeams. He saw evidence of such beams and their screens below
everywhere. He did his best to have roods reinstalled on top of new beams,
according to what he thought was correct. This was therefore done all over
Sweden in his time, always with the Rood standing on the beam as in his
Stånga reconstruction. More recently, in 1991 and 2003, Anna Nilsén made
a welcome rebuttal to Roosval. She points out that choir screens were a
very important element in post-Reformation schemes, as they can still
be seen in a number of Swedish rural churches. Such screens have often
erroneously been interpreted as medieval survivals, notwithstanding their
Renaissance style. So Nilsén rightly cautions us not to take every beam
hole in the *antesanctum* area as evidence of a medieval roodbeam or choir
screen.[22] For the early period, the twelfth to the thirteenth centuries, Anna
Nilsén has sought evidence of small and narrow chancel arches. And
among other things she has pointed out odd altar-like 'tables' in the sides
of the arch at Horla and Suntak in western Sweden.[23] Generally however

[21] J. Roosval, 'Triumfkrucifixet i Stånga', *Gotländsk Arkiv*, 2 (1930), pp. 3–23. The
reconstruction is further discussed by Nyborg, 'Kreuz und Kreuzaltarretabel', p. 47, note
43, and Nilsén, *Focal Point*, pp. 161–4.
[22] Nilsén, *Focal Point*, pp. 29–108. The first edition of her book (in Swedish) was
published in 1991.
[23] Nilsén, *Focal Point*, pp. 43–8. For a possible Danish parallel see N. J. Poulsen in
Danmarks Kirker, Vejle Amt (Copenhagen, 2013), p. 1887.

she goes in the opposite direction to Roosval by claiming simply that there were practically no roodbeams, choir screens or parish church rood lofts in medieval Sweden.[24] This is unlikely to be true. One of her arguments against chancel screens is that some churches have elaborately moulded piers inside their chancel arches which, according to Nilsén, would have prevented the fastening of a screen. A brief glance at English medieval screenwork demonstrates that this is not a compelling argument. Choir screens could have been installed anywhere without leaving any traces.

DENMARK

In Danish parish churches there were certainly both choir screens and rood lofts in the twelfth to thirteenth centuries. In twelve to fifteen churches there is evidence of screens consisting of a transverse wall in the chancel arch to the height of the imposts having two round-headed side doors probably flanking a rood altar.[25] It must be admitted that the evidence is mostly scanty since all such arrangements have long ago been swept away. What can now be seen are the innermost voussoirs of the side doors. In Tikøb, an early brick church from c.1180, the original choir screen has probably been correctly reconstructed by Elna Møller in 1967.[26] As usual there are no actual vestiges of the rood altar, but the proportions speak for it. Clearly the congregation would have had no glimpse of the celebration of the Mass unless the wall had some sort of openings or squints. In Uggeløse church an investigation in 1971 revealed that between 1200 and 1250 the east end of the nave had been rebuilt with a similar brick screen that was combined with a rood loft above. The latter was ascertained by beam holes and two circular windows high up in the adjoining nave walls.[27] Further evidence comes from an ongoing project of measuring high medieval Roods and Crucifixion groups (as well as other saints' figures) in proportion to the chancel arches in question. In a sense this is Johnny Roosval's idea revived, but now with a more thorough investigation, and drawn to scale.[28]

[24] Nilsén, *Focal Point*, pp. 53–6, 91–107, 154–83.
[25] Examples in M. Rydbeck, *Skånes stenmästare före 1200* (Lund, 1936), p. 204; C. M. Smidt, 'Østermarie Kirke. Nye undersøgelser og gravninger inden for bornholmsk og skånsk Bygningskunst', Årbøger for nordisk Oldkyndighed og Historie (1940), pp. 84–116; C. M. Smidt in *Danmarks Kirker Bornholms Amt* (Copenhagen, 1954), pp. 390, 465, 558; B. Sundnér, *Maglarp en tegelkyrka som arkäologisk källmaterial* (Lund, 1982), pp. 96–8; A. W. Mårtenson, *S: Stefan i Lund* (Lund, 1981), pp. 77–9.
[26] Elna Møller in *Danmarks Kirker, Frederiksborg Amt* (Copenhagen, 1967), pp. 686–9.
[27] E. Møller and H. Græbe, 'Ugeløse kirke i søgelyset', *Nationalmuseets Arbejdsmark* (1972), pp. 67–76; Møller, *Danmarks Kirker, Frederiksborg Amt*, pp. 2004–8.
[28] Nyborg, 'Kreuz und Kreuzaltarretabel'. On the project, E. Nyborg, 'Dänische Holzskulptur vor 1300 – ein Forschungsprojekt', in U. Albrecht, J. von Bonsdorff and A. Henning (eds), *Figur und Raum. Mittelalterliche Holzbildwerke im historischen und kunstgeographischen Kontext* (Berlin, 1974), pp. 35–52.

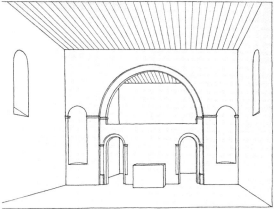
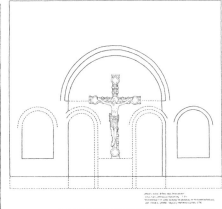

FIG. 11.8. DANISH
BRICK-BUILT
CHOIR SCREENS,
C.1200. LEFT:
TIKØB CHURCH
(RECONSTRUCTED
BY ELNA MØLLER,
1967). RIGHT:
ØRSLEV CHURCH
(RECONSTRUCTED
BY THE AUTHOR).

In Ørslev church a reconstructed screen like the ones in Tikøb and Uggeløse can be combined with an existing Holy Rood of c.1230–40 (Fig. 11.8). Its horizontal arms would have been fastened to a roodbeam resting on top of the screen, and on the supposed rood altar there is ample room for figures of Mary and John as mourners. The whole scheme appears harmonious, with a common 'level of devotion' applying to all three altars where more images of saints would have been sited. This could hardly be a coincidence.[29] Like the Rood in Ørslev most Danish parish church Roods would have been set up with the horizontal cross-arm fastened to a roodbeam behind, and with the head of Christ encircled in a glorifying and cosmic way by the triumphal arch. Such crucifixes and Crucifixion groups might have been part of a wooden screening similar to the arrangement in Ørslev.

The only fully reconstructable example is in the church of Bjerning in South Jutland (Fig. 11.9). A traverse screen beam, 311x39.5cm has curves for two side-openings and a relief carving of the Last Judgement with a kneeling ecclesiastical donor to the far left. It has been dendrochronologically dated to c.1220. It is possible to combine it with other carved and sculptured elements of which important pieces unfortunately were lost in a church fire in 1937, but which are known from photos. The *antesanctum* would have had the shape of an arcade that provides us with the approximate measurements of the now lost chancel arch. It would certainly have been quite crowded within the arch, with the mourners (only St Mary is known) almost touching the horizontal cross-arm. And the side doors would have been so low that one was forced to bow under Christ to enter the chancel. Contrary to the screens of solid walling, the wooden screen of Bjerning would have been somewhat transparent.[30] The same problem, that there was an intention to have more sculpture in the chancel arch than there

29 Nyborg, 'Kreuz und Kreuzaltarretabel', p. 34.
30 Ibid., pp. 39–41.

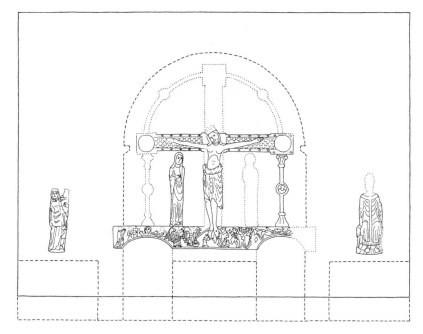

FIG. 11.9. BJERNING CHURCH, DENMARK (NORTH SCHLESWIG), CHOIR SCREEN, C.1220. ABOVE: SCREEN BEAM WITH RELIEF OF THE LAST JUDGEMENT AND AN ECCLESIASTICAL DONOR, NATIONAL MUSEUM, COPENHAGEN, DENMARK. BELOW: RECONSTRUCTION OF *ANTESANCTUM* WITH CHOIR SCREEN (OR ROOD ALTAR ARCHED RETABLE). (RECONSTRUCTED BY THE AUTHOR).

was actually room for, is also evident in the nearby Halk church. Here a huge similar arched crucifix can be reconstructed, also with contemporary saints' images on side altars (Fig. 11.10). The structure was so vast, that it could never have found room inside the chancel arch, but would have been placed on a broad altar table in front of the arch, as shown in plan. It would have been necessary to walk around the structure in order to reach the chancel entrance. So the reasonably transparent structure in Halk is perhaps not strictly speaking a screen, but rather a so-called arched retable.[31] However, it might tell us something more about the varieties of *antesancta* in high medieval Scandinavia.

Finally we come to the Danish rood lofts. Two of them are as early as the oldest Norwegian examples from the late twelfth century or the years around 1200. In Bøstrup church the chancel north wall has an original

[31] The same applies to the structure in Bjerning. See E. Nyborg, 'The Arched Retable – Meaning and Origin', in P. Grinder-Hansen (ed.), *Image and Altar 800–1300. Papers from an International Conference in Copenhagen 24. October–27. October 2007* (Copenhagen, 2014), pp. 162–87.

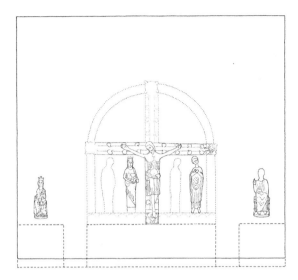

HALK KIRKE, HADERSLEV AMT OG HRD
JÆRNALDKIGRAPHE OG S-DAALENE, OPRINDELIG PERLDÆKNING I 2ø
REKONSTRUKTION EBBE NYBORG, TEGNET AF KARI-ANNE NIELSEN 1996

FIG. 11.10. HALK CHURCH, DENMARK (NORTH SCHLESWIG), RECONSTRUCTION OF SCREENING ROOD ALTAR ARCHED RETABLE, C.1250 (RECONSTRUCTED BY THE AUTHOR).

door to a flight of stairs inside the wall leading up to a door in the nave, placed high up the chancel arch wall. The only reasonable explanation is that the stairs led to a rood loft above the chancel entrance.[32] A similar rood loft with doors from the chancel arch can be reconstructed in Gislöv church in Scania.[33] A handful of other rood lofts are known from the thirteenth century, most of them because their carved gallery fronts, or parts of them, have survived.[34] They would have been rather similar to the Norwegian one in Kinn church. The best preserved one is in Nordhackstedt in present-day Germany and this consists of a framework with a large central Rood and eight flanking carved Passion scenes. At some time, probably after the Reformation, the Rood was taken out and moved to the north wall, while the gallery front as a whole was elevated

[32] Unpublished observations by Morten Aaman Sørensen.
[33] K. Jönsson, 'Lektoriet i Gislöv', *Hikuin*, 22 (1992), pp. 171–80.
[34] E. Nyborg, 'Passionsreliefferne i Store Rise kirke på Ærø. En lektoriebrystning fra o. 1300', in H. Johannsen (ed.), *Kirkens bygning og brug, Studier tilegnet Elna Møller* (Copenhagen, 1983), pp. 71–88.

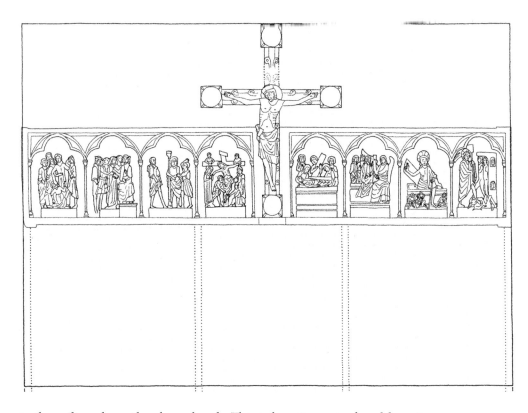

to the ceiling above the chancel arch. This is how it survived and how it FIG. 11.11. can be seen on photos from c.1900. The original position reconstructed NORDHACKSTEDT here (Fig. 11.11) was considerably lower and would have worked with a (NØRRE HAKSTED) smaller chancel arch. Curiously enough it is evident from the beams that CHURCH, from the beginning there was no upper floor behind the gallery front. GERMANY (SOUTH The gallery front just leaned on the chancel wall. So in Nordhackstedt SCHLESWIG), there was in fact no real rood loft but only a 'false' or 'sham' loft.[35] This RECONSTRUCTION was probably because space was lacking for a real gallery, and because the OF ROOD main reason for installing it was to imitate the richly sculpted *pulpita* of LOFT, C.1285 greater churches. This would, however, hardly have been usual. (RECONSTRUCTED BY THE AUTHOR).

CONCLUSION

We have observed both screens and rood lofts from the twelfth to the thirteenth century in Norway and Denmark and we suspected that they also might have existed in Sweden. As to the screens, the most extensive evidence comes from the stone structures going as far back as the late twelfth century. Two such screens, in Tingvoll and Uggeløse,

[35] F. Fuglsang, 'Bemerkungen zur Holzplastik des 13. Jahrhunderts im Herzogtum Schleswig', *Nordelbingen* (1957), pp. 7–18; Nyborg, 'Passionsreliefferne', p. 80.

were combined with rood lofts. It is possible that the interesting 'false' screens in Norwegian stave churches were known as early as the stone screens, and their resemblance to thirteenth-century English screens may give rise to the idea that there was some sort of European influence. Did stone churches with broader chancel entrances have similar real wooden screens? At least the structure in Eidfjord shows us a highly developed 'European' screen being set up in the decades around 1300. Rood lofts made of solid masonry are known from churches both in Norway and in Denmark belonging to the twelfth and early thirteenth centuries. Their main detectable feature is a flight of stairs inside the church walls. And since such stairways are rare features in our parish church architecture, we may conclude that this kind of rood loft was very uncommon. The type of rood loft known from the thirteenth century is simply a gallery in front of the chancel arch accessed by stairs or a ladder. From both Norway and Denmark we know that the gallery front could carry not only a central rood but also a carved sequence of sculptures or reliefs. From Torpo we know that there was a rood loft combined with a painted rood altar ciborium.

The Romanesque stone screens that would almost have prevented the view into the chancel were probably removed in the later Middle Ages or substituted by lighter and more transparent structures. Of such late medieval choir screens we have hardly anything preserved in Scandinavian parish churches. This is enigmatic given the multitude of other medieval fittings that have survived. On the other hand, our high medieval rood lofts probably remained in place and function until the time of the Reformation. And new lofts would to some extent have been installed in the late Middle Ages although very little evidence of this has been brought forth.[36] Therefore, our knowledge about choir screens and rood lofts in Scandinavia seems to end up contrary to that of the rest of Western Europe. Whereas the heyday of choir screens and rood lofts in parish churches is generally thought to have been the late Middle Ages, we observe no such blooming in Scandinavia. Conversely our Nordic material from the twelfth to the thirteenth centuries seems to antedate almost all the European evidence published. This could hardly be a true overall picture neither for Scandinavia nor for Europe as a whole. So we Scandinavians would have to take a closer look at our late medieval interior schemes and likewise it would be interesting if our European colleagues could trace the early choir screens and rood lofts that were in all probability the counterparts and models of those presented here.

[36] Late medieval rood lofts are known from Trondenes church in northern Norway and Barkåkra in Scania, Johannesen, *Kinn kirkes lektorium*, p. 26; O. Rydbeck, 'Trabes och lectorium I skånska kyrkor', in O. Rydbeck and E. Wrangel (eds), Äldre kyrklig konst i Skåne (Lund, 1921), pp. 178–86. See also Ebbe Nyborg in *Danmarks Kirker, Ribe Amt* (Copenhagen, 2000), pp. 1825, 3144, 3221, 3292.

Whereas choir screens were obviously meant to guard the sanctity and dignity of the high altar and prevent the laity from getting close to it, a number of different liturgical functions have, as already mentioned, been assigned to *pulpita* and rood lofts: announcements, reading, celebration of Mass, music performance and serving the Rood. It is an open question how many of these activities actually took place on parish church rood lofts with the limited staff at their disposal and at this early date. Indeed only the large and complex rood loft at Tingvoll seems to have had room for altars and for reading towards the chancel. Furthermore the sham rood loft in Nordhackstedt warns us that such structures may even have had little or no function at all but to provide the choir entrance with modern sculpted imagery. We do not know when the elevation of the Eucharist became a normal practice in Scandinavia.[37] But our stone-built choir screens from the twelfth and early thirteenth centuries would hardly have allowed a fraction of the congregation to have a glimpse of the mystery through the doorways. Contemporary screens of wood may have been equally exclusive. The Norwegian screens, false and real, with their squints flanking the choir entrance testify to an intended effort to allow laymen to see and participate. These are all from the thirteenth century. And from that century of Eucharistic evolution are also the relatively transparent choir screenings of wood that have been reconstructed in Denmark. The idea behind them was apparently that the congregation should be able to see in one glance the image of their crucified saviour and perceive his true body (elevated or not) sanctified at the altar behind.

[37] S. Helander, J. Gallén and L. Gjerlöv, 'Elevation', in *Kulturhistorisk leksikon for nordisk middelalder* (Copenhagen, 1958). In general, K.-L. Quirin, *Die Elevation zur hl. Wandlung in der römischen Messe* (Mainz, 1952). For parish church liturgy see S. Helander, 'Sockenkyrkans liturgiska profil', in R. Andersson, O. Ferm and G. T. Westin, *Kyrka och socken i medeltidens Sverige* (Stockholm, 1991), pp. 189–230.

BIBLIOGRAPHY

MANUSCRIPTS

CAMBRIDGE
Corpus Christi College, MS 177 (theological miscellany)
Trinity College, MS R.3.14

FLORENCE
Archivio di Stato, Notarile Antecosimiano 7985

KOTOR
Istorijski arhiv, SN VII

LONDON
British Library:
Add. MS. 32467
Add. MS 8987
Add. MS 23054
College of Arms, MS PCM I, II
Lambeth Palace Library:
MS 99
MS 1106
The National Archive:
CP40/1013, 1023, 1060, 1088
(K), C1/1116
PROB 11/24

NORWICH
Norfolk Record Office:
MS Rye 17, 6 vols
Consistory Court wills

OXFORD
Bodleian Library:
MS Bodley 596
MS Rawlinson B150 (chronicle of Dunstable priory)
MS Rawlinson D 939 (single-sheet almanac of c.1400)
MS Top. Northants e2
Trinity College MS 46 (psalter)

TRURO
Cornwall Record Office:
P 167/5/1

PRIMARY

Ambaglio, D. (ed.), *Liber de laudibus civitatis Ticinensis que dicitur Papia* (Pavia, 2004).

Anon., 'Observations concerning cochineel', *Philosophical Transactions*, 3 (1668), pp. 796–7.

Anon., 'An accompt of the use of the grain of kermes', *Philosophical Transactions*, 1 (1665–66), pp. 935–6.

Anon., *The Byble in Englyshe* (London, 1540).

Aramburu Cendoya, I., *Las primitivas constituciones de los Agustinos (Ratisbonenses del año 1290): introducción, texto y adaptación romanceada para las religiosas* (Valladolid, 1966).

Azzoguido, A. M. (ed.), *Sancti Antonii Ulyssiponensis sermones in psalmos* (Bologna, 1757).

Babington, C. and Lumby, J. R. (eds), *Polychronicon Ranulphi Higden monachi Cestrensis*, 9 vols (London, 1865–86).

Bacon, F., *Of the Proficience and Advancement of Learning, Divine and Human* (Oxford, 1605).

Barker-Benfield, B. C. (ed.), *St Augustine's Abbey, Canterbury*, 3 vols (London, 2008).

Boatwright, L., Habberjom, M. and Hammond, P. (eds), *The Logge Register of Prerogative Court of Canterbury Wills 1479–1486*, Richard III Society (2008).

Borghini, V., *Discorsi* (Florence, 1584).

Brewer, J. S. (ed.), *Monumenta Franciscana* (London, 1858).

Brown, J. E. T. (trans.), *The Scroll Considerans (Magdalene MS 248) Giving the Descent from Adam to Henry VI*, intro. G. L. Harriss (Oxford, 1999).

Burgess, C. (ed.), *The Pre-Reformation Records of All Saints' Bristol*, Bristol Record Society, 16 (1995).

Cirket, A. E. (ed.), *English Wills, c.1498–1526*, Bedfordshire Historical Record Society, 37 (1957).

Clementini, C., *Raccolto istorico della fondatione di Rimino, e dell'origine, e vite de' Malatesti* (Rimini, 1616).

Colgrave, B. and Mynors, R. A. B. (eds and trans.), *Bede's Ecclesiastical History of the*

English People (Oxford, 1969).

Collins, A. J. (ed.), *Manuale ad vsum percelebris ecclesie Sarisburiensis* (Chichester, 1960).

Colwall, D., 'An Account of the English alum-works', *Philosophical Transactions*, 12 (1677–78), pp. 1052–6.

—— 'An Account of the way of making English green-copperas', *Philosophical Transactions*, 12 (1677–78), pp. 1056–9.

Ellis, F. S. (ed.), *The Golden Legend or Lives of the Saints as Englished by William Caxton*, 7 vols (London, 1900).

Ellis, H. (ed.), *Chronica Johannis de Oxenedes* (London, 1859).

Erbe T. (ed.), *Mirk's Festial*, Early English Text Society Extra Series, 96 Pt 1 (1905).

Fish, S., *A Supplicacyon for the Beggers* (Antwerp, 1529).

Foster, J. E. (ed.), *Churchwardens' Accounts of St Mary the Great, Cambridge, from 1504 to 1635* (Cambridge, 1905).

Fowler, J. T. (ed.), *Rites of Durham*, Surtees Society, 107 (1902).

Fra Bartolomeo da Pisa, *Liber de Conformitate Vitae Beati Francisci ad Vitam Domini Iesu*, 2 vols, *Analecta Franciscana*, 4–5 (Quaracchi, 1906–12).

Frame, D. M. (ed. and trans.), *The Complete Works of Michel de Montaigne* (London, 1958).

Frere, W. H. (ed.), *Visitation Articles and Injunctions of the Period of the Reformation*, 3 vols (London, 1910).

Gerson, J., 'Considerations sur saint Joseph', in P. Glorieux (ed.), *Jean Gerson, Oeuvres complètes* (Paris, 1960–73).

Goulding, R. (ed.), *Records of the Charity Known as Blanchminster's Charity in the Parish of Stratton, County of Cornwall until the Year 1832* (Stratton and Bude, 1890).

Hanham, A. (ed.), *Churchwardens' Accounts of Ashburton 1479–1580*, Devon and Cornwall Record Society, new series, 15 (Exeter, 1970).

Hingeston, F. C. (ed.), *Johannis Capgrave, Liber de Illustribus Henricis* (London, 1858).

Hobhouse, E. (ed.), *Church-Wardens' Accounts*, Somerset Record Society, 4 (London, 1890).

Hort, A. (trans.), *Theophrastus: Enquiry into Plants*, vol. 1 (London, 1916).

Hussey, A., *Testamenta Cantiana … East Kent*, Kent Archaeological Society (1907).

James, M. R., *A Descriptive Catalogue of the Manuscripts in the Library of Corpus Christi College, Cambridge*, 2 vols (Cambridge, 1912).

James, M. R. and Jessopp, A. (eds), *The Life and Miracles of St William of Norwich* (Cambridge, 1896).

Kemp, M. and Walker, M. (trans. and eds), *Leonardo on Painting* (New Haven, 1989).

Lehmann-Brockhaus, O. (ed.), *Lateinische Schriftquellen zur Kunst in England, Wales und Schottland vom Jahre 901 bis zum Jahre 1307*, 5 vols (Munich, 1956).

Littlehales, H. (ed.), *The Medieval Records of a London City Church: St Mary at hill, 1420–1559*, 2 vols, Early English Text Society, Original Series, 125, 128 (1904–5).

Lomazzo, G. P., *A Tracte Containing the Artes of Curious Paintinge Carvinge and Buildinge, Englished by Robert Haydocke (1598), Oxford* (Farnborough, 1970).

Lorris, G. de and Meun, J. de, *The Romance of the Rose*, trans. F. Horgan (Oxford, 1994).

Louis, C. (ed.), *The Commonplace Book of Robert Reynes of Acle: An Edition of Tanner MS 407* (New York, 1980).

Luard, H. R. (ed.), *Flores Historiarum*, 3 vols (London, 1890).

—— (ed.), *Chronica maiora Matthaei Parisiensis, monachi S. Albani*, vols (London, 1872–83).

Meredith, P. and Tailby, J. E. (eds), *The Staging of Religious Drama in Europe in the Later Middle Ages: Texts and Documents in English Translation* (Kalamazoo, 1982), pp. 243–7.

Mynors, R. A. B., Winterbottom, M. and Thomson, R. M. (eds and trans.), William of Malmesbury, *Gesta Regum Anglorum*, 2 vols (Oxford, 1998–99).

Noel, W. and Weiss, D. (eds), *The Book of Kings: Art, War, and the Morgan Library's Medieval Picture Bible* (Baltimore, 2002).

Northeast, P. (ed.), *Wills of the Archdeaconry of Sudbury: 1439–1474: I Wills from the Register 'Baldwyne' Part I: 1439–1461*, Suffolk Records Society, 44 (Woodbridge, 2001).

—— (ed.), *Boxford Church Warden Accounts 1530–1561*, Suffolk Record Society, 23 (Woodbridge, 1982).

Northeast, P. and Falvey, H. (eds), *Wills of the Archdeaconry of Sudbury, part II, 1461–1474*, Suffolk Records Society, 53 (Woodbridge, 2010).

—— (eds), *Index of Wills of the Archdeaconry of Sudbury, 1439–1474* (Woodbridge, 2010).

Odetto, G. (ed.), 'La cronaca maggiore dell'Ordine domenicano', di Galvano fiamma, *Archivum Fratrum Praedicatorum*, 10 (1940), pp. 297–373.

Pressey, W. J., *The First Book of the Churchwardens' Accounts of Heybridge, Essex, c.1509–1532, Heybridge* (Heybridge, 1938).

Procter, F. and Wordsworth, C. (eds), *Brevarium ad usum insignis ecclesiae Sarum*, 3 vols (Cambridge, 1882–86).

Quintilian, *Institutio Oratoria*, Books IV–VI, trans. H. E. Butler, Loeb Classical Library, 125 (Cambridge, MA, 1921), pp. 406–9 (VI. I. 40).

Rice Garraway, R. and Godfrey, W. H. (eds), *Transcripts of Sussex Wills*, 2, Sussex Record Society, 42 (1938).

Smith, L. Toulmin (ed.), *The Itinerary of John Leland in or about the years 1535–1543*, 5 vols (Illinois, 1963).

Tyndale, W., *The Obedience of a Christen Man* (Antwerp, 1528).

Ugonio, P., *Historia delle Stationi di Roma* (Rome, 1588).

Vernatti, P., 'A relation on the making of ceruse', *Philosophical Transactions*, 12 (1677–78), pp. 935–6.

Vocabolario degli Accademici della Crusca (Venice, 1612).

Vocabolario degli Accademici della Crusca, 4th edn (Florence, 1729–38).

Waller, R., 'A catalogue of simple and mixt colours, with a specimen of each colour prefixt to its proper name', *Philosophical Transactions*, 16 (1686–92), pp. 24–32.

Weaver, F. W., *Somerset Mediaeval Wills 1501–30*, Somerset Record Society, 19 (Taunton, 1903).

SECONDARY

Alexander, J. J. G., 'The Pulpit with the Four Doctors at St James, Castle Acre, Norfolk', in Nicholas Rogers (ed.), *England in the Fifteenth Century: Proceedings of the 1992 Harlaxton Symposium* (Stamford, 1994), pp. 198–206.

—— 'Labeur and Paresse: Ideological Representations of Medieval Peasant Labor', *Art Bulletin*, 72 (1990), pp. 445–6.

Allan, J., 'Breton Woodworkers in the Immigrant Communities of South-west England, 1500–1550', *Post-Medieval Archaeology*, 48:2 (2014), pp. 320–56.

Allen, J., 'Nicholas V's Tribuna for Old St. Peter's in Rome as a Model for the New Apsidal Choir at Padua Cathedral', *Journal of the Society of Architectural Historians*, 72 (2013), pp. 166–88.

Anglo, S., 'The *British History* in Early Tudor Propaganda, with an Appendix of Manuscript Pedigrees of the Kings of England, Henry VI to Henry VIII', *Bulletin of the John Rylands Library*, 44 (1961–62), pp. 17–48.

Aston, M., *Broken Idols of the English Reformation* (Cambridge, 2015).

—— 'Segregation in Church', *Women in the Church*, Studies in Church History, 27 (Oxford, 1990), pp. 237–94.

—— *Lollards and Reformers: Images and Literacy in Late Medieval Religion* (London, 1984).

Athanasoulis, D., 'The Triangle of Power: Building Projects in the Metropolitan Area of the Crusader Principality of the Morea', in S. E. J. Gerstel (ed.), *Viewing the Morea: Land and People in the Late Medieval Peloponnese* (Dumbarton Oaks, 2013), pp. 111–51.

Ayres, J., *Domestic Interiors: The British Tradition 1500–1850* (New Haven, 2003).

Bacci, M., *Lo spazio dell'anima: vita di una chiesa medievale* (Rome, 2005).

Badham, G. and Biddle, M., 'Inscriptions in the Painting', in M. Biddle (ed.), *King Arthur's Round Table* (Woodbridge, 2000), pp. 255–83.

Bailey, B. A. (ed.), *Northamptonshire in the Early Eighteenth Century: The drawings of Peter Tillemans and Others* (Northampton, 1996).

Baker, A. M., *English Panel Paintings 1400–1558: A Survey of Figure Paintings on East Anglian Rood Screens*, ed. and updated A. Ballantyne and P. Plummer (London, 2011).

—— 'Representations of Sibyls on Rood-screens in Devon', *Report and Transactions of the Devonshire Association*, 136 (2004), pp. 71–97.

Baljeu, A. and Kroesen, J. E. A., 'Der Groninger Abendmahlschor und seine Beziehung zu Ostfriesland', *Emder Jahrbuch für historische Landeskunde Ostfrieslands*, 93 (2013), pp. 157–77.

Bandini, M., 'Vestigia dell'antico tramezzo nella chiesa di San Remigio a Firenze', *Mitteilungen des kunsthistorischen Institutes in Florenz*, 54 (2010–12), pp. 211–29.

Bangs, J. D., *Church Art and Architecture in the Low Countries before 1566: Sixteenth Century Essays and Studies* (Kirksville, MO, 1997).

Barclay Lloyd, J., 'Medieval Dominican Architecture at Santa Sabina in Rome, c.1219–c.1320', *Papers of the British School at Rome*, 72 (2004), pp. 231–92.

Barocchi, P., et al. (eds), *Giorgio Vasari: Le vite, indice di frequenza*, 2 vols (Pisa, 1994).

Baxandall, M., *The Limewood Sculptors of Renaissance Germany* (New Haven, 1995).

Beacham, P., *Devon Building: An Introduction to Local Traditions* (Tiverton, 1990).

Beal, T. K. and Linafelt, T. (eds), *Mel Gibson's Bible: Religion, Popular Culture, and The Passion of the Christ* (Chicago, 2005).

Beer, M. *Triumphkreuze des Mittelalters: Ein Betrag zu Typus und Genese im 12. und 13. Jahrhundert* (Regensburg, 2005).

Belting, H., *Likeness and Presence* (Chicago, 1997).

Ben-Aryeh Debby, N., 'The Santa Croce Pulpit in Context: Sermons, Art and Space', *Artibus et Historiae*, 29 (2008), pp. 75–93.

Benati, D., *La bottega degli Erri e la pittura del Rinascimento a Modena* (Modena, 1988).

Benoist, S. (ed.), *Mémoire et histoire: les procédures de condamnation dans l'Antiquité romaine* (Metz, 2008).

Berné, D. (ed.), *Sculptures souabes de la fin du Moyen Âge*, Exhibition Catalogue, Musée de Cluny (Paris, 2015).

Bettarini, R. and Barocchi, P. (eds), *Giorgio Vasari: Le vite de' più eccellenti pittori, scultori e architettori*, 11 vols (Florence, 1966–97).

Bierens de Haan, D., *Het houtsnijwerk in Nederland tijdens de Gothiek en de Renaissance* ('s-Gravenhage, 1921).

Biernoff, S., *Sight and Embodiment in the Middle Ages* (London, 2002).

Binski, P., 'The Patronage and Date of the Legend of St Francis in the Upper Church of S. Francesco at Assisi', *The Burlington Magazine*, 151 (2009), pp. 663–5.

—— *Becket's Crown: Art and Imagination in Gothic England, 1170–1300* (New Haven, 2004).

—— 'The English Parish Church and its Art in the Later Middle Ages: A Review of the Problem', *Studies in Iconography*, 20 (1999), pp. 1–25.

Binski, P. and Massing, A. (eds), *The Westminster Retable* (London and Turnhout, 2009).

Blake, H., Egan, G., Hurst, J. and New, E., 'From Popular Devotion to Resistance and Revival in England: The Cult of the Holy Name of Jesus and the Reformation', in D. Gaimster and R. Gilchrist (eds), *The Archaeology of Reformation 1480–1580* (Leeds, 2003), pp. 175–203.

Blomefield, F. and Parkin, C., *An Essay Towards a Topographical History of the County of Norfolk*, 11 vols (London, 1805–10).

Boldrick, S., Park, D. and Williamson, P. (eds), *Wonder: Painted Sculpture from Medieval England* (Leeds, 2003).

Bolton, B., *The Medieval Reformation* (London, 1983).

Bond, F., *Screens and Galleries in English Churches* (London, 1908).

Bond, F. and Camm, B., *Roodscreens and Roodlofts*, 2 vols (London, 1909).

Borgherini, M., *Disegno e progetto nel cantiere medievale: esempi toscani del XIV secolo* (Venice, 2001), pp. 155–63.

Brandsma, T., 'Doxalen in de Groninger Ommelanden' 1 and 2, *Groninger kerken*, 11 (1994), pp. 103–18, 141–51.

Brieger, P. H., 'England's Contribution to the Origin and Development of the Triumphal Cross'. *Medieval Studies*, 4 (1942), pp. 85–9.

Brigden, S., *London and the Reformation* (Oxford, 1989; new edition London, 2014).

Briggs, O. M., 'Some Painted Screens of Norfolk', *Journal of the Royal Institute of British Architects*, 3rd series, 41:19 (1934), pp. 997–1016.

Browe, P., *Die Verehrung der Eucharistie im Mittelalter* (Munich, 1933).

Brughmans, T., 'Connecting the Dots: Towards Archaeological Network Analysis', *Oxford Journal of Archaeology*, 29 (2010), pp. 277–303.

Bruzelius, C., *Preaching, Building and Burying: Friars in the Medieval City* (New Haven and London, 2014).

Bucklow, S., *The Riddle of the Image* (London, 2014).

—— 'Analysis of the Chalk Ground', in A. Massing (ed.), *The Thornham Parva Retable* (London, 2004), p. 225.

Bull, G. (ed. and trans.), *Giorgio Vasari: The Lives of the Artists* (London, 1965).

Burtt, E. A., *The Metaphysical Foundations of Modern Physical Science* (London, 1925).

Bynum, C. W., *Christian Materiality* (New York, 2011).

Caiger-Smith, A., *English Medieval Mural Paintings* (Oxford, 1963).

Camille, M., 'The Language of Images in Medieval England 1200–1400', in J. J. G. Alexander and P. Binski (eds), *Age of Chivalry* (London, 1987), pp. 33–40.

Campbell, L., 'The Early Netherlandish Painters and their Workshops', in D. Hollanders-Favert and R. van Schoute (eds), *Le dessin sous-jacent dans la peinture, Maitre de Flemalle–van der Weyden Colloque III* (Louvain, 1979), pp. 43–61.

Cannon, J., *Religious Poverty, Visual Riches: Art in the Dominican Churches of Central Italy in the Thirteenth and Fourteenth Centuries* (New Haven and London, 2013).

—— 'Dominican Shrines and Urban Pilgrimage in Later Medieval Italy', in P. Davies, D. Howard and W. Pullan (eds), *Architecture and Pilgrimage, 1000–1500* (Farnham, 2013), pp. 143–63.

—— 'The Era of the Great Painted Crucifix: Giotto, Cimabue, Giunta Pisano, and their Anonymous Contemporaries', *Renaissance Studies*, 16 (2002), pp. 571–81.

Cannon-Brookes, P., 'Art History, Connoisseurship and Scientific Literacy', *The International Journal of Museum Management and Curatorship*, 7 (1988), pp. 5–10.

Carruthers, M. (ed.), *Rhetoric Beyond Words: Delight and Persuasion in the Arts of the Middle Ages* (Cambridge, 2010).

—— *The Craft of Thought: Meditation, Rhetoric and the Making of Images, 400–1200* (Cambridge, 1998).

Casero, A. L., 'Un tramezzo affrescato in San Nazzaro della Costa a Novara: alcune riflessioni e prime ipotesi', in M. G. Albertini Ottolenghi and M. Rossi (eds), *Studi in onore di Francesca Flores d'Arcais* (Milan, 2010), pp. 91–9.

Castelli, C., Parri M. and Santacesaria, A., 'Tecnica artistica, stato di conservazione e restauro della Croce in rapport con altre opera di Giotto: il supporto ligneo', in M. Ciatti and M. Seidel (eds), *Giotto: la Croce di Santa Maria Novella* (Florence, 2001), pp. 247–72.

Cautley, H. M., *Suffolk Churches and their Treasures* (Ipswich, 1954).

Chedozeau, B., *Choeur clos, choeur ouvert: de l'église médiévale à l'église tridentine (France, XVIIe–XVIIIe siècle)* (Paris, 1998).

Christie, H., in *Norges Kirker, Buskerud* (Oslo, 1981), pp. 122–37.

—— in *Norges Kirker, Østfold* (Oslo, 1959), pp. 258–9.

Cobianchi, R., 'Gli affreschi del presbiterio della Chiesa di San Lorenzo a Piacenza: considerazioni iconografiche per il loro contesto agostiniano', in Centro Studi 'Agostino Trapè' (eds), *'Per corporalia ad incorporalia': Spiritualità, agiografia, iconografia e architettura nel medioevo agostiniano* (Tolentino, 2000).

Coldstream, N.,'"Pavilion'd in Splendour": Henry V's Agincourt Pageants', *Journal of the British Archaeological Association*, 165 (2012), pp. 153–71.

—— *Medieval Craftsmen: Masons and Sculptors* (London, 1991).

Collins, H., *Tacit and Explicit Knowledge* (Chicago, 2010).

Colvin, H. M., 'Church Building in Devon in the Sixteenth Century', in *Essays in Architectural History* (New Haven and London 1999), pp. 22- 51.

Constable, W. G., 'Some East Anglian Rood-screen Paintings', *The Connoisseur*, 84 (1929), pp. 141–7, 211–20, 290–4, 358–63.

Conybeare, E., *Highways and Byways in Cambridge and Ely* (London, 1910).

Cooley, A. E., *The Cambridge Manual of Latin Epigraphy* (Cambridge, 2012).

Cooper, D., 'Preaching amidst Pictures: Visual Contexts for Sermons in Late Medieval Tuscany', in H. L. Kessler and R. Newhauser (eds), *Science, Ethics, and the Transformations of Art in the Thirteenth and Fourteenth Centuries* (Toronto, forthcoming).

—— 'Experiencing Dominican and Franciscan Churches in Renaissance Italy', in T. Kennedy (ed.), *Sanctity Pictured: The Art of the Dominican and Franciscan Orders in Renaissance Italy* (Nashville and London, 2014), pp. 46–61.

—— 'Redefining the Altarpiece in Early Renaissance Italy: Giotto's *Stigmatization of Saint Francis* and its Pisan Context', *Art History*, 36 (2013), pp. 686–713.

—— 'Access all Areas? Spatial Divides in the Mendicant Churches of Late Medieval Tuscany', in F. Andrews (ed.), *Ritual and Space in the Middle Ages: Proceedings of the 2009 Harlaxton Symposium* (Donington, 2011), pp. 90–107.

—— 'Gothic Art and the Friars in Late Medieval Croatia, 1213–1460', in *Croatia: Aspects of Art, Architecture and Cultural Heritage* (London, 2009), pp. 76–97.

—— 'Franciscan Choir Enclosures and the Function of Double-Sided Altarpieces in Pre-Tridentine Umbria', *Journal of the Warburg and Courtauld Institutes*, 64 (2001), pp. 1–54.

Cooper, D. and Robson, J., *The Making of Assisi: The Pope, the Franciscans and the Painting of the Basilica* (New Haven and London, 2013).

—— '"A Great Sumptuousness of Paintings": Frescos and Franciscan Poverty at Assisi in 1288 and 1312', *The Burlington Magazine*, 151 (2009), pp. 656–62.

Coor-Achenbach, G., 'A Visual Basis for the Documents Relating to Coppo di Marcovaldo and His Son Salerno', *The Art Bulletin*, 28 (1946), pp. 233–47.

Cotton, S., 'Mediaeval Roodscreens in Norfolk: Their Construction and Painting Dates', *Norfolk Archaeology*, 40 (1987), pp. 44–54.

Cotton, S., Lunnon, H. and Wrapson, L., 'Medieval Roodscreens in Suffolk: Their Construction and Painting Dates', *Proceedings of the Suffolk Institute of Archaeology*, 43:2 (2014), pp. 219–34.

Cox, J. C., *Churchwardens' Accounts from the Fourteenth to the Close of the Seventeenth Century* (London, 1913).

Cox, J. C. and Harvey, A., *English Church Furniture* (London, 1907).

Crague, C. D., 'Belief and Patronage in the English Parish before 1300: Some Evidence from Roods', *Architectural History*, 48 (2005), pp. 21–48.

Creissen, T., 'Les clôtures de choeur des églises d'Italie à l'époque romane: état de la question et perspectives', *Hortus Artium Medievalium*, 5 (1999), pp. 169–81.

Crossley, F. H. and Ridgway, M. H.,'Screens, Lofts and Stalls, Situated in Wales and Monmouthshire', *Archaeologia Cambrensis*, 102 (1952–53), pp. 48–82.

Crossley, P., '*Ductus* and *memoria*: Chartres Cathedral and the Workings of Rhetoric', in M. Carruthers (ed.), *Rhetoric Beyond Words: Delight and Persuasion in the Arts of the Middle Ages* (Cambridge, 2010), pp. 214–49.

—— 'The Integrated Cathedral: Thoughts on "Holism" and Gothic Architecture', in E. S. Lane, E. C. Pastan and E. M. Shortell (eds), *The Four Modes of Seeing: Approaches to Medieval Imagery in Honor of Madeline Harrison Caviness* (Farnham, 2009), pp. 157–73.

Cunningham, D., 'One *pontile*, two *pontili*: The Choir Screens of Modena Cathedral', *Renaissance Studies*, 19 (2005), pp. 673–85.

Danto, A. C., 'Review of Freedberg, *The Power of Images*', *The Art Bulletin*, 72:2 (1990), pp. 341–2.

Davies, D., 'Architettura e culto a Venezia e nelle città di terraferma, 1475–1490', in A. Nante, C. Cavalli and Pierantonio Gios (eds), *Pietro Barozzi, un vescovo del Rinascimento* (Padua, 2012), pp. 193–203.

Dawes, J., 'Timberwork and Construction' in A. Baker (ed.), *English Panel Paintings 1400–1558: A Survey of Figure Paintings on East Anglian Rood Screens*, updated A. Ballantyne and P. Plummer (London, 2011), pp. 99–102.

Deacon, R. and Lindley, P., *Image and Idol: Medieval Sculpture*, Exhibition Catalogue, Tate Britain (London, 2001).

de Blaauw, S., 'Innovazioni nello spazio di culto fra basso Medioevo e Cinquecento: la perdita dell'orientamento liturgico e la liberazione della navata', in J. Stabenow (ed.), *Lo spazio e il culto: relazioni tra edificio ecclesiale e uso liturgico dal XV al XVI secolo* (Venice, 2006).

—— *Cultus et decor: liturgia e architettura nella Roma tardoantica e medievale: Basilica Salvatoris, Sanctae Mariae, Sancti Petri* (Vatican City, 1994).

Delamont, S. and Atkinson, P., 'Doctoring Uncertainty: Mastering Craft Knowledge', *Social Studies of Science*, 31:1 (2002), pp. 87–107.

Delleman, G., *Een rondleiding door de Grote of St.-Bavokerk te Haarlem* (Haarlem, 1985).

De Marchi, A., 'Relitti di un naufragio: affreschi di Giotto, Taddeo Gaddi e Maso di Banco nelle navate di Santa Croce', in A. De Marchi and G. Piraz (eds), *Santa Croce: Oltre le apparenze (Quaderni di Santa Croce 4)* (Pistoia, 2011), pp. 33–71.

—— 'La diffusione della pittura su tavola nel Duecento e la ricostruzione del tramezzo perduto del Duomo di Pistoia', in *Il museo e la città*

(Incontri 2): vicende artistiche pistoiesi dalla metà del XII secolo alla fine del Duecento (Pistoia, 2011), pp. 61–85

—— '"Cum dictum opus sit magnum": il documento pistoiese del 1274 e l'allestimento trionfale dei tramezzi in Umbria e Toscana fra Due e Trecento', in A. C. Quintavalle (ed.), Medioevo: immagine e memoria (Milan, 2009), pp. 603–21.

—— 'Il "podiolus" e il "pergulum" di Santa Caterina a Treviso: cronologia e funzione delle pitture murali in rapporto allo sviluppo della fabbrica architettonica', in A. C. Quintavalle (ed.), Medioevo: arte e storia (Milan, 2008), pp. 385–407.

—— 'Due fregi misconosciuti e il problema del tramezzo in San Fermo Maggiore a Verona', in A. C. Quintavalle (ed.), Arredi liturgici e architettura (Milan, 2007), pp. 129–42.

Denton, J., 'Genealogy and Gentility: Social Status in Provincial England', in R. L. Radulescu and E. D. Kennedy (eds), Broken Lines: Genealogical Literature in Medieval Britain and France (Turnhout, 2008), pp. 143–58.

Derolez, A., The Palaeography of Gothic Manuscript Books: From the Twelfth to the Early Sixteenth Century (Cambridge, 2003).

Di Fabio, C., 'Aspetti della pittura decorativa a Genova fra XII e XIV secolo: La trave del tramezzo presbiteriale di San Matteo, le stanze dei canonici della Cattedrale, il soffitto di casa de Turca', Ligures, 6 (2008), pp. 5–20.

Don, P., Kunstreisboek Noord-Holland (Zeist, 1987).

—— Kunstreisboek voor Zeeland (Zeist, 1985).

Donkin, R. A., 'Spanish Red: An Ethnographical Study of Cochineal and the Opuntia Cactus', Transactions of the American Philosophical Society, 67:5 (1977), pp. 3–84.

Doyle, A. I., 'Stephen Dodesham of Witham and Sheen', in P. R. Robinson and R. Zim (eds), Of the Making of Books: Medieval Manuscripts, their Scribes and Readers: Essays Presented to M. B. Parkes (Aldershot, 1997).

Duffy, E., Saints, Sacrilege and Sedition: Religion and Conflict in the Tudor Reformations (London, 2012).

—— The Stripping of the Altars: Traditional Religion in England c.1400–c.1580 (New Haven, 1992, 2nd edn, London, 2005).

—— 'Late Medieval Religion', in R. Marks and P. Williamson (eds), Gothic Art for England 1400–1547 (London, 2003), pp. 56–67.

—— 'The Parish, Piety, and Patronage in Late Medieval East Anglia: The Evidence of Rood Screens', in K. French, G. Gibbs and B. Kümin (eds), The Parish in English Life 1400–1600 (Manchester, 1997), pp. 133–62.

—— 'Holy maydens, holy wyfes: The Cult of Women Saints in Fifteenth- and Sixteenth-century England', in W. J. Sheils and D. Wood (eds), Women in the Church: Papers Read at the 1989 Summer Meeting and the 1990 Winter Meeting of the Ecclesiastical History Society (Oxford, 1990), pp. 175–96.

Dymond, D. and Paine, C., *Five Centuries of an English Parish Church: The State of Melford Church, Suffolk* (Cambridge, 2012).

Edwards, A. S. G., 'Middle English Inscriptional Verse Texts', in J. Scattergood and J. Boffey (eds), *Texts and their Contexts: Papers from the Early Book Society* (Dublin, 1997), pp. 26–43.

Eekhof, A., 'Opschriften op het koorhek in de Pieterskerk in Leiden', *Nederlandsch Archief voor Kerkgeschiedenis*, 23/4 (1930), p. 277.

Eisenstein, S., 'Montage and Architecture' (1938), *Assemblage*, 10 (December 1989), pp. 111–13.

Ellis, R., 'Jizz and the Joy of Pattern Recognition', *Social Studies of Science*, 41:6 (2011), pp. 769–90.

Elzenga, E. et al., 'De Grote Kerk van Oosthuizen. Opnieuw oogverblindend en oorstrelend', *Bulletin van de Stichting Oude Hollandse Kerken*, 57 (2003).

Evans, M., 'The Geometry of the Mind', *Architectural Association Quarterly*, 12 (1980), pp. 31–55.

Fabbri, M. (ed.), *Il luogo teatrale a Firenze: Brunelleschi, Vasari, Buontalenti, Parigi* (Milan, 1975).

Farnhill, K., *Guilds and the Parish Community in Late Medieval East Anglia, c. 1470–1550* (York, 2001).

Fawcett, R., 'The Master Masons of Later Medieval Norfolk', in S. Margeson, B. Ayers and S. Heywood (eds), *A Festival of Norfolk Archaeology* (Norwich, 1996), pp. 101–26.

—— 'A Group of Churches by the Architect of Great Walsingham', *Norfolk Archaeology*, 37:3 (1980), pp. 277–94.

Flower, H. I., *The Art of Forgetting: Disgrace and Oblivion in Roman Political Culture* (Chapel Hill, 2006).

Franco, T., 'Attorno al "pontile che traversava la chiesa": spazio liturgico e scultura in Santa Anastasia', in P. Marini and C. Campanella (eds), *La Basilica di Santa Anastasia a Verona* (Verona, 2011), pp. 33–49.

—— 'Sul "muricciolo" nella chiesa di Sant'Andrea di Sommacampagna "per il quale restavan divisi gli uomini dalle donne"', *Hortus Artium Medievalium*, 14 (2008), pp. 181–92.

—— 'Appunti sulla decorazione dei tramezzi nelle chiese mendicanti: la chiesa dei Domenicani a Bolzano e di Santa Anastasia a Verona', in A. C. Quintavalle (ed.), *Arredi liturgici e architettura* (Milan, 2007), pp. 115–28.

Freedberg, D., *The Power of Images: Studies in the History and Theory of Response* (Chicago and London, 1989).

French, K. L., 'Women in the Late Medieval English Parish', in M. C. Erler and M. Kowaleski (eds), *Gendering the Master Narrative: Woman and Power in the Middle Ages* (Ithaca, 2003), pp. 156–73.

—— *The People of the Parish: Community Life in a Late Medieval English Diocese* (Philadelphia, 2001).

Frommel, S. and L. Leccante (eds), *La place du choeur: architecture et liturgie du Moyen Âge aux temps modernes* (Paris, 2012).

Frugoni, C., 'Sui vari significati del Natale di Greccio, nei testi e nelle immagini', *Frate Francesco*, 70 (2004), pp. 35–147.

Fuglesang, S. H. (ed.), *Middelalderens billeder. Utsmykningen av koret i Ål stavkirke* (Oslo, 1996).

Fuglsang, F., 'Bemerkungen zur Holzplastik des 13. Jahrhunderts im Herzogtum Schleswig', *Nordelbingen* (1957), pp. 7–18.

Gaeta, M., *Giotto und die 'croci dipinte' des Trecento: Studien zu Typus, Genese und Rezeption mit einem Katalog der monumentalen Tafelkreuze des Trecento (ca. 1290–ca. 1400)* (Münster, 2013).

Geronimus, D. V. and Waldman, L. A., 'Children of Mercury: New Light on the Members of the Florentine Company of St. Luke, c.1475–1525', *Mitteilungen des Kunsthistorischen Institutes in Florenz*, 47:1 (2003), pp. 118–58.

Gibson, G. McMurray, *The Theater of Devotion: East Anglian Drama and Society in the Late Middle Ages* (Chicago and London, 1989).

Gibson, J. J., *The Ecological Approach to Visual Perception* (Hillsdale, 1986).

Gilardi, C. G., '*Ecclesia laicorum* e *ecclesia fratrum*: luoghi e oggetti per il culto e la predicazione secondo l'*Ecclesiasticum officium* dei frati predicatori', in L. E. Boyle and P.-M. Gy (eds) with P. Krupa, *Aux origines de la liturgie dominicaine: le manuscript Santa Sabina XIV L 1* (Paris and Rome, 2004), pp. 379–443.

Gilardoni, V., *I monumenti d'arte e di storia del Canton Ticino*, vol. I (*Locarno e il suo circolo*) (Basel, 1972).

Gill, M., 'The Doom in Holy Trinity church and wall-painting in medieval Coventry', in L. Monckton and R. K. Morris (eds), *Coventry: Medieval Art, Architecture and Archaeology in the City and its Vicinity*, British Archaeological Association Conference Transactions, 33 (2011), pp. 206–12.

—— '"Kenelm Cunebearn … Haudes Bereafed": A Reconstructed Cycle of Wall Paintings from St Kenelm's Chapel, Romsley', *Journal of the British Archaeological Association*, 149 (1996), pp. 23–36.

Giurescu Heller, E., 'Access to Salvation: The Place (and Space) of Women Patrons in Fourteenth-century Florence', in V. Chieffo Raguin and S. Stanbury (eds), *Women's Space: Patronage, Place, and Gender in the Medieval Church* (Albany, 2005), pp. 161–83.

Glasscoe, M., 'Late Medieval Paintings in Ashton Church', *Journal of the British Archaeological Association*, 140 (1987), pp. 182–90.

Glynne, S. R., 'Notes', *Archaeologia Cambrensis*, 5th series, 1 (1884), pp. 81–104.

Goddard, S. H., 'Brocade Patterns in the Shop of the Master of Frankfurt: An Accessory to Stylistic Analysis', *The Art Bulletin*, 67:3 (1985), pp. 401–17.

Gombrich, E., 'The Edge of Delusion', *New York Review of Books*, 15 (1990), pp. 6–9.

Gray, M., 'Images of Words: Iconographies of Text and in the Construction of Sacred Space in Medieval Church Wall Painting', in J. Sterrett and P. Thomas (eds), *Sacred Space, Sacred Text: Architectural, Spiritual and Literary Convergences in England and Wales* (Leiden, 2011), pp. 15–34.

Griffith, D., *The Material Word: Vernacular Inscriptions from Later Medieval England* (Turnhout, forthcoming).

—— 'The Scheme of Redemption on the Later Medieval Painted Panels in Bradninch Church, Devon', *Devon Buildings Group Research Papers*, 2 (2006), pp. 45–66.

Guasti, C. (ed.), *Ser Lapo Mazzei: lettere di un notaro a un mercante del secolo XIV con altre lettere e documenti*, 2 vols (Florence, 1880).

Guazzini, G., 'San Pier Maggiore a Pistoia: un inedito libro di testamenti trecenteschi ed una proposta ricostruzione degli assetti interni', *Bullettino storico Pistoiese*, 114 (2012), pp. 57–88.

Guido, M. and Vittori, M. L., 'L'abbazia di Sant'Andrea in Flumine presso Ponzano Romano e una singolare testimonianza di jubé', *Storia Architettura. Quaderni di Critica*, 2 (1975), pp. 22–9.

Haigh, C., *English Reformations: Religion, Politics, and Society under the Tudors* (Oxford, 1993).

Hall, A. R., 'The Scholar and the Craftsman in the Scientific Revolution', in M. Clagett (ed.), *Critical Problems in the History of Science* (Madison, 1962), pp. 3–24.

Hall, M. B., 'The *Tramezzo* in the Italian Renaissance, Revisited', in S. E. J. Gerstel (ed.), *Thresholds of the Sacred: Architectural, Art Historical, Liturgical, and Theological Perspectives on Religious Screens, East and West* (Washington, DC, 2006), pp. 215–32.

—— 'The Italian Rood Screen: Some Implications for Liturgy and Function', in S. Bertelli and G. Ramakus (eds), *Essays Presented to Myron P. Gilmore*, vol. II (Florence, 1978), pp. 213–18.

—— 'The "Ponte" in Santa Maria Novella: The Problem of the Rood Screen in Italy', *Journal of the Warburg and Courtauld Institutes*, 37 (1974), pp. 157–73.

—— 'The "Tramezzo" in Santa Croce, Florence, Reconstructed', *The Art Bulletin*, 56 (1974), pp. 325–41.

—— 'The "Tramezzo" in Santa Croce, Florence and Domenico Veneziano's Fresco', *The Burlington Magazine*, 112 (1970), pp. 797–9.

Hanson, J., 'The Prophets in Discussion', *Florilegium*, 17 (2000), pp. 73–97.

Harper-Bill, C. Rawcliffe and R. Wilson (eds), *East Anglia's History: Studies in Honour of Norman Scarfe* (Woodbridge, 2002), pp. 93–106.

Harriss, G. L., 'The King and His Subjects', in R. Horrox (ed.), *Fifteenth-Century Attitudes: Perceptions of Society in Late Medieval England* (Cambridge, 1994), pp. 13–28.

Hart, R., 'Description of the Engraving from the Ranworth Screen', *Norfolk Archaeology*, 1 (1847), pp. 324–33.

Harvey, J., *English Medieval Architects: A Biographical Dictionary Down to 1550*, revised edn (Gloucester, 1987).

—— *The Perpendicular Style 1330–1485* (London, 1978).

Haslewood, F., 'Notes from the Records of Smarden Church', *Archaeologia Cantiana*, 9 (1874), pp. 224–35.

Haward, B., *Master Mason Hawes of Occold, Suffolk and John Hore Master Carpenter of Diss* (Bury St Edmunds, 2000).

—— *Suffolk Medieval Church Roof Carvings: A Photographic Survey of Carvings on Hammerbeam Roofs* (Ipswich, 1999).

—— *Suffolk Medieval Church Arcades, 1150–1550* (Ipswich, 1993).

Helander, S., 'Sockenkyrkans liturgiska profil', in R. Andersson, O. Ferm and G. T. Westin (eds), *Kyrka och socken i medeltidens Sverige* (Stockholm, 1991), pp. 189–230.

Helander, S., Gallén, J. and Gjerlöv, L., 'Elevation', in *Kulturhistorisk leksikon for nordisk middelalder* (Copenhagen, 1958).

Heslop, T. A., 'Romanesque Painting and Social Distinction: The Magi and the Shepherds', in D. Williams (ed.), *England in the Twelfth Century: Proceedings of the 1988 Harlaxton Symposium* (Woodbridge, 1990), pp. 137–52.

Hobhouse, E. (ed.), *Churchwardens' Accounts of Croscombe, Pilton, Patton, Tintinhull, Morebath and St Michael's, Bath, Ranging from A.D. 1349– 1560*, Somerset Record Society, 4 (London, 1890).

Hoff, A. M., 'Korskiljeveggen i Tingvoll kyrkje', in M. Stige and T. Spurkland (eds), *Tingvoll kyrkje. Gåta Gunnar gjorde* (Trondheim, 2006), pp. 199–214.

—— 'The Area between Chancel and Nave in Norway's Medieval Parish Churches: An Outline of the Subject's Research Status, with a Survey of Selected Scandinavian Literature', *Jaarboek voor liturgie-onderzoek*, 19 (2003), pp. 147–74.

—— *Korskillet i Eidfjord* (Bergen, 1991).

Hohler, E., *Stave Church Sculpture*, vol. 1 (Oslo, 1999).

Hope, W. H. St J., 'The Funeral, Monument, and Chantry Chapel of King Henry the Fifth', *Archaeologia*, 65 (1914), pp. 129–86.

Hope, W. H. St J. and Atchley, E. G. C. F., *An Introduction to English Liturgical Colours* (London, 1920).

Houghton, W. E., 'The History of Trades: Its Relation to Seventeenth Century Thought as Seen in Bacon, Evelyn and Boyle', *Journal of the History of Ideas*, 2:1 (1941), pp. 33–60.

Howard, H., *Pigments of English Medieval Wall Painting* (London, 2003).

Hueck, I., 'La Basilica Superiore come luogo liturgico: l'arredo e il programma della decorazione', in G. Basile and P. Magro (eds), *Il cantiere pittorico della Basilica Superiore di San Francesco in Assisi* (Assisi, 2001), pp. 43–69.

—— 'Le opere di Giotto per la Chiesa di Ognissanti', in *La 'Madonna d'Ognissanti' di Giotto restaurata* (Florence, 1992), pp. 37–50.

—— 'Der Lettner der Unterkirche von San Francesco in Assisi', *Mitteilungen des Kunsthistorischen Institutes in Florenz*, 28 (1984), pp. 173–202.

Hughes, J., 'The Monarch as an Object of Liturgical Veneration', in A. J. Duggan (ed.), *Kings and Kingship in Medieval Europe* (London, 1993), pp. 375–424.

Hulbert, A., 'Painted Ceilings and Screens', in P. Burman (ed.), *Treasure on Earth: A Good Housekeeping Guide to Churches and their Contents* (London, 1994), pp. 34–48.

—— 'Notes on Techniques of English Medieval Polychromy on Church Furnishings', in J. Black (ed.), *Recent Advances in the Conservation and Analysis of Artifacts* (London, 1987), pp. 277–9.

Humfrey, P., 'Cima da Conegliano, Sebastiano Mariani, and Alvise Vivarini at the East End of S. Giovanni in Bragora in Venice', *The Art Bulletin*, 62 (1980), pp. 350–63.

Husenbeth, F. C., *Emblems of Saints by Which They Are Distinguished in Works of Art*, 3rd edn (Norwich, 1882).

Imesch, K., 'The Altar of the Holy Cross and the Ideal of Adam's Progeny: ut paradysiace loca possideat regionis', in E. E. Dubrick and B. I. Gusick (eds), *Death and Dying in the Middle Ages* (New York, 1999), pp. 73–106.

Ingold, T., *The Perception of the Environment* (London, 2000).

Israëls, M., 'Painting for a Preacher: Sassetta and Bernardino da Siena', in M. Israëls (ed.), *Sassetta: The Borgo San Sepolcro Altarpiece* (Florence and Leiden, 2009), vol. I, pp. 121–39.

Jacobikerk Utrecht [local guidebook] (Utrecht, 1977).

Jaeger, C. S. (ed.), *Magnificence and the Sublime in Medieval Aesthetics* (New York, 2010).

Johannesen, A. S., *Kinn kirkes lektorium og dets plass blant norske middelalderlektorier* (Oslo, 1961).

Johannesen, A. S. and Møller, E., 'Lectorium', in *Kulturhistorisk Leksikon for nordisk Middelalder* (Copenhagen, 1965).

Jonckheere, K., 'Images of Stone', in A.-S. Lehmenn, F. Scholten and P. Chapman (eds), *Meaning in Materials. Nederlands Kunsthistorisch Jaarboek*, 62 (2012), pp. 117–46.

Jönsson, K., 'Lektoriet i Gislöv', *Hikuin*, 22 (1992), pp. 171–80.

Jung, J., *The Gothic Screen: Space, Sculpture, and Community in the Cathedrals of France and Germany, ca. 1200–1400* (Cambridge, 2013).

—— 'Das Programm des Westlettners', in H. Krohm and H. Kunde (eds), *Der Naumburger Meister: Bildhauer und Architekt im Europa der Kathedralen*, 3 vols (Petersberg, 2011), 2, pp. 1137–46.

—— 'Beyond the Barrier: The Unifying Role of the Choir Screen in Gothic Churches', *Art Bulletin*, 82:4 (2000), pp. 622–57.

Jungmann, J., *The Mass of the Roman Rite: Its Origins and Development*, 2 vols (New York, 1959).

Kempers, B., *Painting, Power and Patronage: The Rise of the Professional Artist in the Italian Renaissance* (London, 1992).

—— *Kunst, macht en mecenaat: het beroep van schilder in sociale verhoudingen 1250–1600* (Amsterdam, 1987).

Kessel, V., 'The High Gothic Liturgical Furnishings of the Church of Our Lady (Liebfrauenkirche) in Oberwesel', in U. Engel and A. Gajewski (eds), *Mainz and the Middle Rhine Valley: Medieval Art, Architecture, and Archaeology*, British Archaeological Association Conference Transactions, 30 (Leeds, 2007), pp. 193–203.

King, D., 'A Multi-Media Workshop in Late Medieval Norwich – A New Look at William Heyward', in C. De Ruyt (ed.), *Lumières, formes et couleurs: mélanges en hommage à Yvette Vanden Bemden* (Namur, 2008), pp. 193–204.

—— *The Medieval Stained Glass of St Peter Mancroft, Norwich* (Oxford, 2006).

Kirby, J., Spring, M. and Higgitt, C., 'The Technology of Red Lake Manufacture: Study of the Dyestuff Substrate', *The National Gallery Technical Bulletin*, 26 (2005), pp. 71–87.

Kirby Talley, M., 'Connoisseurship and the Methodology of the Rembrandt Research Project', *The International Journal of Museum Management and Curatorship*, 8 (1988), pp. 175–214.

Kirchner-Doberer, E., 'Der Lettner. Seine Bedeutung und Geschichte', *Mitteilungen der Gesellschaft für vergleichende Kunstforschung in Wien*, 9 (1956), pp. 117–22.

Klapisch-Zuber, C., *L'ombre des ancêtres: essai sur l'imaginaire médiéval de la parenté* (Paris, 2000).

Kloek, W. T. et al. (eds), *Art before the Iconoclasm: Northern Netherlandish Art 1525–1580*, 2 vols, Exhibition Catalogue, Rijksmuseum (Amsterdam, 1986).

Knappett, C., *Network Analysis in Archaeology*: *New Approaches to Regional Interaction* (Oxford, 2013).

Knight, D. J., *King Lucius of Britain* (Stroud, 2008).

Koldeweij, A. M., 'Over Jan Fierens, geelgieter te Mechelen', in J. N. de Boer et al. (eds), *De Bavo te boek. Bij het gereedkomen van de restauratie van de Grote of St.-Bavokerk te Haarlem* (Haarlem, 1985), pp. 150–5.

Krause, H.-J., '"Imago ascensionis" und "Himmelloch". Zum "Bild"-Gebrauch in der spätmittelalterlichen Liturgie', in F. Möbius and E. Schubert (eds), *Skulptur des Mittelalters: Funktion und Gestalt* (Weimar, 1987), pp. 280–354.

Kreuz, E.-M, 'Spuren des Lichts in mittelalterlichen Kirchen', in Regensburger Domstiftung (ed.), *Dom im Licht – Licht im Dom: Vom Umgang mit Licht in Sakralbauten in Geschichte und Gegenwart* (Regensburg, 2004).

Kroesen, J. E. A., 'Het oudste koorhek van Nederland', in E. den Hartog and J. Veerman (eds), *De Pieterskerk in Leiden. Bouwgeschiedenis, inrichting en gedenktekens* (Zwolle 2011), pp. 235–9.

—— 'Die tralyen voert choer – enkele aanvullingen', *Bulletin van de Stichting Oude Hollandse Kerken*, 69 (2009), pp. 16–21.

—— 'Die tralyen voert choer. Middeleeuwse koorafscheidingen in Holland', *Bulletin van de Stichting Oude Hollandse Kerken*, 61 (2005), pp. 3–29.

—— 'Voorreformatorische koorhekken in Nederland', *Jaarboek voor liturgie-onderzoek*, 21 (2004), pp. 129–57.

Kroesen, J. E. A. and Steensma, R., *The Interior of the Medieval Village Church* (Louvain, Paris and Dudley, MA, 2005).

—— *Ostfriesische Kirchen und ihre mittelalterliche Ausstattung* (Petersberg, 2011).

Krohm, H. and Markschies, A., 'Der Lettner der Marienkirche in Gelnhausen: Grundlagen einer Neubewertung', *Zeitschrift des deutschen Vereins für Kunstwissenschaft*, 48 (1994), pp. 7–59.

Kroonenburg, J. et al., *De Grote Kerk van Naarden in historisch perspectief* (Naarden, 1984).

Laborderie, O. de, *Histoire, mémoire et pouvoir: les genealogies en rouleau des rois d'Angleterre (1250–1422)* (Paris, 2013).

Larson, O. K., 'Bishop Abraham of Souzdal's Description of *Sacre Rapprezentazioni*', *Educational Theatre Journal*, 9 (October 1957), pp. 208–13.

Lasko, P. and Morgan, N. J., *Mediæval Art in East Anglia 1300–1520* (London and Norwich, 1973).

Lautier, C., 'The Sacred Topography of Chartres Cathedral: The Reliquary Chasse of the Virgin in the Liturgical Choir and Stained-Glass Decoration', in E. S. Lane, E. C. Pastan and E. M. Shortell (eds), *The Four Modes of Seeing: Approaches to Medieval Imagery in Honor of Madeline Harrison Caviness* (Farnham, 2009), pp. 174–96.

Lave, J., *Cognition in Practice* (Cambridge, 1998).

Lave, J. and Wenger, E., *Situated Learning* (Cambridge, 1991).

le Goff, J., *The Birth of Purgatory* (Chicago, 1986).

Lewis, S., *The Art of Matthew Paris in the Chronica Majora* (Aldershot, 1987).

Lichte, C., 'Der Havelberger Lettner als Bühne: Zum Verhältnis von Bildprogramm und Liturgie', in L. Lambacher and F. M. Kammel (eds), *Die mittelalterliche Plastik in der Mark Brandenburg* (Berlin, 1990), pp. 101–7.

—— *Die Inszenierung einer Wallfahrt: Der Lettner im Havelberger Dom und das Wilsnacker Wunderblut* (Worms, 1990).

Lillie, W. W., 'Medieval Paintings on the Screens of the Parish Churches of Mid and Southern England', *Journal of the British Archaeological Association*, 3rd series, 9 (1944), pp. 33–47.

—— 'Screenwork in the County of Suffolk, III, Panels Painted with Saints', *Proceedings of the Suffolk Institute of Archaeology*, 20 (1930), pp. 214–26, 255–64; 21 (1933), 179–202; 22 (1936), 126-26.

Lindley, P. G., 'Worcester and Westminster: The Figure-Sculpture of Prince Arthur's Chapel', in S. Gunn and L. Monckton (eds), *Arthur Tudor, Prince of Wales: Life, Death and Commemoration* (Woodbridge, 2009), pp. 141–66.

Long, E. T., 'The Church Screens of Dorset', *Proceedings of the Dorset Natural History and Archaeological Society*, 42 (1921), pp. 61–80.

Long, P. O., 'The Openness of Knowledge: An Ideal and its Context in Sixteenth-century Writings on Mining', *Technology and Culture*, 32:2 (1991). pp. 354–5.

Lunnon, H., 'Observations on the Changing Form of Chancel Screens in Late Medieval Norfolk', *Journal of the British Archaeological Association*, 163 (2010), pp. 110–31.

Luxford, J., 'Catfield Church, Norfolk: A Lost Rectorial Brass and an Early Case of Brass-Preservation', *Journal of the British Archaeological Association*, 167 (2014), pp. 205–12.

—— 'Manuscripts, History and Aesthetic Interests at Tynemouth Priory', in J. Ashbee and J. Luxford (eds), *Newcastle and Northumberland: Roman and Medieval Art and Architecture*, British Archaeological Association Conference Transactions, 36 (Leeds, 2013), pp. 193–213.

—— 'The Iconography of "Saint" Edward II', *Burlington Magazine*, 154 (December 2012), pp. 832–3.

—— 'The Sparham Corpse Panels: Unique Revelations of Death from Late Fifteenth-century England', *Antiquaries Journal*, 90 (2010), pp. 299–340.

Lyu, S., Rockmore, D. and Farid, H., 'A Digital Technique for Art Authentication', *Proceedings of the National Academy of Sciences*, 101:49 (2004), pp. 17006–10.

MacCracken, H. N., 'Magnificencia Ecclesie', *Proceedings of the Modern Language Association*, 24 (1909), pp. 687–98.

McNeilage, R., 'Secular and Sacred: Two Case Studies in Polychromed Wood', in D. Odgers and L. Humphries (eds), *Polychrome Wood. Post-prints of a Conference in Two Parts Organised by The Institute of Conservation Stone and Wall Paintings Group, Hampton Court Palace October 2007 and March 2008* (London, 2010), pp. 213–27.

Mallion, J., *Chartres: le jubé de la cathédrale* (Chartres, 1964).

Marchini, G., 'La chiesa di S. Francesco in Prato in una descrizione del secolo XVII', *Archivio Storico Pratese*, 32 (1957), pp. 33–44.

Marks, R., *Windows and Wills: Fenestration and Glazing Bequests in England and Wales 1277–1583* (forthcoming).

—— *Studies in the Art and Imagery of the Middle Ages* (London, 2012).

—— 'From Langford to South Cerney: The Rood in Anglo-Norman England': The George Zarnecki Memorial Lecture, *Journal of the British Archaeological Association*, 164 (2011), pp. 172–210.

—— 'To the Honour and Pleasure of Almighty God, and to the Comfort of the Parishioners: The Rood and Remembrance', in Z. Opačić and A. Timmermann (eds), *Image, Memory and Devotion: Liber Amicorum Paul Crossley* (Studies in Gothic Art, vol. 2) (Turnhout, 2011), pp. 213–23.

—— 'The Dean and the Bearded Lady: Aspects of the Cult of St Wilgefortis/Uncumber in England', in J. Luxford and M. Michael (eds), *Tributes to Nigel Morgan. Contexts of Medieval Art: Images, Objects and Ideas* (London and Turnhout, 2010), pp. 349–63.

—— 'Picturing Word and Text in the Late Medieval Parish Church', in L. Clark, M. Jurkowski and C. Richmond (eds), *Image, Text and Church 1380–1600: Essays for Margaret Aston* (Toronto, 2009), pp. 162–202.

—— *Image and Devotion in Late Medieval England* (Stroud, 2004).

—— 'A Late Medieval Pilgrimage Cult: Master John Schorn of North Marston and Windsor', in L. Keen and E. Scarff (eds), *Windsor: Medieval Art and Archaeology of the Thames Valley*, British Archaeological Association Conference Transactions, 25 (2002), pp. 192–207.

—— 'Viewing Our Lady of Pity', in *Magistro et Amico. Amici Discipulique Lechowi Kalinowskiemu w osiemdziesieciolecie urodzin* (Krakow, 2002), pp. 101–21.

—— *Stained Glass in England During the Middle Ages* (London, 1993).

—— Yorkist–Lancastrian Political and Genealogical Propaganda in the Visual Arts', *Family History*, 12 (1982), pp. 148–66.

Marks, R. and Williamson, P. (eds), *Gothic: Art for England, 1400–1540*, Exhibition Catalogue (London, 2003).

Marshall, P., *Reformation England 1480–1642*, 2nd edn (London, 2012).

Mårtenson, A. W., *S: Stefan i Lund* (Lund, 1981).

Massaccesi, F., 'Il "corridore" della chiesa agostiniana di San Giacomo Maggiore a Bologna: prime ipotesi riscostruttive', *Zeitschrift für Kunstgeschichte*, 77 (2014), pp. 1–26.

Massing, A. (ed.), *The Thornham Parva Retable: Technique, Conservation and Context of an English Medieval Painting* (Cambridge and Turnhout, 2003).

Massing, J. M., 'Writing on Hands', *Print Quarterly*, 20 (2003), pp. 414–18.

Mazzalupi, M., 'Altari, patronati, opere d'arte al tempo degli abati. Un saggio di topografia sacra', in A. Di Lorenzo, C. Martelli and M. Mazzalupi (eds), *La Badia di Sansepolcro nel Quattrocento* (Selci-Lama, 2012), pp. 1–44.

Medlar, S., 'Decorative Motifs on Norfolk's Medieval Rood-screens', *The Quarterly: The Journal of the Norfolk Archaeological and Historical Research Group*, 30 (1998), pp. 6–10.

Merotto Ghedini, M., 'Il tramezzo nella chiesa dei Santi Giovanni e Paolo a Venezia', in T. Franco and G. Valenzano (eds), *De lapidibus sententiae: scritti di storia dell'arte per Giovanni Lorenzoni* (Padua, 2002), pp. 257–62.

Miedema, H., 'De bijbelse ikonografie van twee monumenten: de "kraak" te Oosterend (Fr.) en het grafmonument van Edo Wiemken te Jever', *Bulletin van de Koninklijke Nederlandse Oudheidkundige Bond* (1978), pp. 61–88.

Mijović, P., 'O kasnoantičkim i srednjovjekovnim grobljima Kotora (Late ancient and medieval cemeteries of Kotor)', *Boka*, 15–16 (1984), pp. 161–91.

Mijušković, S.,'O ostacima jednog kotorskog istorijskog spomenika iz XIII vijeka (Les restes d'un monument du XIIIème siècle à Kotor)', *Boka*, 8 (1976), pp. 183–213.

Mitchell, J., 'Painting in East Anglia around 1500', in John Mitchell (ed.), *England and the Continent in the Middle Ages: Studies in Memory of Andrew Martindale* (Stamford, 2000), pp. 365–80.

Mochizuki, M., *The Netherlandish Image after Iconoclasm, 1566–1672: Material Religion in the Dutch Golden Age* (Aldershot, 2008).

Modesti, P., 'I cori nelle chiese parrocchiali veneziane fra Rinascimento e riforma tridentina', in S. Frommel and L. Lecomte (eds), *La place du choeur: architecture et liturgie du Moyen Âge aux temps modernes* (Paris, 2012), pp. 141–53.

—— 'I cori nelle chiese veneziane e la visita apostolica del 1581. Il "barco" di Santa Maria della Carità', *Arte veneta*, 59 (2002), pp. 39–65.

Moisè, F., *Santa Croce di Firenze: illustrazione storico-artistica; con note e copiosi documenti inediti* (Florence, 1845).

Møller E., in *Danmarks Kirker, Frederiksborg Amt* (Copenhagen, 1967), pp. 686–9, 2004–8.

—— 'Om danske Lektorier', *Nationalmuseets Arbejdsmark* (1950), pp. 128–39.

Møller, E. and Græbe, H., 'Ugeløse kirke i søgelyset', *Nationalmuseets Arbejdsmark* (1972), pp. 67–76.

Monnas, L., *Merchants, Princes and Painters: Silk Fabrics in Italian and Northern Paintings, 1300–1550* (New Haven and London, 2008).

Morelli, G., *Italian Painters: Critical Studies of their Works*, trans. C. J. Ffoulkes (London, 1893).

Morgan, N. J., 'The Norwegian and Swedish *Crucifixi Dolorosi* c. 1300–50 in their European Context', in J. Nadolny et al. (eds), *Medieval Painting in Northern Europe: Techniques, Analysis, Art History. Studies in Commemoration of the 70th Birthday of Unn Plahter* (London, 2006), pp. 266–78.

Morris, J. E., *Little Guides: The West Riding of Yorkshire* (2nd edn revised, London, 1923).

Morris, R. K., 'The Development of Later Gothic Mouldings in England *c.* 1250–1400. Part 1', *Architectural History*, 21 (1978), pp. 18–57.

Mortlock, D. P. and Roberts, C. V., *The Guide to Norfolk Churches* (Cambridge, 2007).

Mulvaney, B. A., 'The Beholder as Witness: The *Crib at Greccio* from the Upper Church of San Francesco, Assisi and Franciscan Influence

on Late Medieval Art in Italy', in W. R. Cook (ed.), *The Art of the Franciscan Order in Italy* (Leiden, 2005), pp. 169–88.

Murat, Z., 'Il *podium* della pieve di Monselice nella descrizione di Pietro Barozzi', *Musica e Figura*, 1 (2011), pp. 87–117.

Murray, A., 'Scottish Renaissance Timber Painted Ceilings and the Stirling Heads Project', in D. Odgers and L. Humphries (eds), *Polychrome Wood. Post-prints of a Conference in Two Parts Organised by The Institute of Conservation Stone and Wall Paintings Group, Hampton Court Palace October 2007 and March 2008* (London, 2010), pp. 177–92.

Murrell, J., 'John Guillim's Book: A Heraldic Painter's Vade Mecum', *The Walpole Society*, 57 (1993–94), pp. 1–51.

Nadolny, J., 'Documentary Sources for the Use of Moulds in the Production of Tin-relief: Cause and Effect', in E. Hermens and J. Townsend (eds), *Sources and Serendipity: Testimonies of Artists' Practice. ICOM-CC Working Group on Art Technological Source Research (ATSR) 3rd International Symposium, Glasgow University, Scotland, 12–13 June 2008* (London, 2009), pp. 39–49.

—— 'One Craft, Many Names: Gilders, Preparers, and Polychrome Painters in the Fifteenth and Sixteenth Centuries', in J. Bridgeland (ed.), *ICOM-CC Preprints, 15ᵗʰ Triennial Meeting, New Delhi, 22–26 September 2008*, 2 vols (New Delhi, 2008), vol. 1, pp. 10–17.

—— 'All that's burnished isn't bole: Reflections on Medieval Water Gilding Part 1: Early Medieval to 1300', in J. Nadolny et al. (eds), *Medieval Painting in Northern Europe: Techniques, Analysis, Art History. Studies in Commemoration of the 70ᵗʰ Birthday of Unn Plahter* (London, 2006), pp. 148–62.

Needham, J., *Science and Civilisation in China, Volume 6* (Cambridge, 2000).

Newbigin, N., *Feste d'Oltrarno: Plays in Churches in Fifteenth-century Florence*, 2 vols (Florence, 1996).

Nichols, A. E., *The Early Art of Norfolk: A Subject List of Extant and Lost Art Including Items Relevant to Early Drama* (Kalamazoo, MI, 2002).

Nilsén, A., *Focal Point of the Sacred Space: The Boundary between Chancel and Nave in Swedish Rural Churches: From Romanesque to Neo-Gothic* (Uppsala, 2003).

Northeast, P., 'Suffolk Churches in the Later Middle Ages: The Evidence of Wills', in C. Harper-Bill, C. Rawcliffe and R. Wilson (eds), *East Anglia's History: Studies in Honour of Norman Scarfe* (Woodbridge, 2002).

Nova, A., 'I tramezzi in Lombardia fra XV e XVI secolo: scene della Passione e devozione francescana', in A. Dallaj (ed.), *Il francescanesimo in Lombardia* (Milan, 1983), pp. 197–215.

Nyborg, E., 'The Arched Retable – Meaning and Origin', in P. Grinder-Hansen (ed.), *Image and Altar 800–1300. Papers from an International Conference in Copenhagen 24. October–27. October 2007* (Copenhagen, 2014), pp. 162–87.

—— 'Kreuz und Kreuzaltarretabel in dänischen Pfarrkrchen des 12. und 13. Jahrhunderts. Zur Genese der Ring- und Arkadenkreuze', in H. Krohm, K. Krüger and M. Weniger (eds), *Entstehung und Frühgeschichte des Flügelaltarschreins* (Berlin 2001), pp. 25–50.

—— in *Danmarks Kirker, Ribe Amt* (Copenhagen, 2000), pp. 1825, 3144, 3221, 3292.

—— 'Passionsrelieferne i Store Rise kirke på Ærø. En lektoriebrystning fra o. 1300', in H. Johannsen (ed.), *Kirkens bygning og brug, Studier tilegnet Elna Møller* (Copenhagen, 1983), pp. 71–88.

—— 'Dänische Holzskulptur vor 1300 – ein Forschungsprojekt', in U. Albrecht, J. von Bonsdorff and A. Henning (eds), *Figur und Raum. Mittelalterliche Holzbildwerke im historischen und kunstgeographischen Kontext* (Berlin, 1974), pp. 35–52.

Oakey, N., 'Fixtures or Fittings? Can Surviving Pre-Reformation Ecclesiastical Material Culture be Used as a Barometer of Contemporary Attitudes to the Reformation in England?', in D. Gaimster and R. Gilchrist (eds), *The Archaeology of Reformation 1480–1580* (Leeds, 2003), pp. 58–72.

Ochs, K. H., 'The Royal Society of London's History of Trades Programme: An Early Episode in Applied Science', *Notes and Records of the Royal Society of London*, 39:2 (1985), pp. 129–58.

Ogden, D. H., *The Staging of Drama in the Medieval Church* (Newark, DE, 2002).

—— 'Gesture and Characterization in the Liturgical Drama', in C. Davidson (ed.), *Gesture in Medieval Drama and Art* (Kalamazoo, 2001), pp. 26–47.

Olsen, O., 'Rumindretningen i romanske landsbykirker', *Kirkehistoriske Samlinger* (1967), pp. 235–57.

Ozinga, M. D., *De Nederlandsche Monumenten van Geschiedenis en Kunst IV: De provincie Groningen – Oost-Groningen* ('s-Gravenhage, 1940).

Park, D., 'The Polychromy of English Medieval Sculpture', in S. Boldrick, D. Park and P. Williamson (eds), *Wonder: Painted Sculpture from Medieval England* (Leeds, 2003), pp. 31–54.

—— 'Romanesque Wall Paintings at Ickleton', in N. Stratford (ed.), *Romanesque and Gothic: Essays for George Zarnecki* (Woodbridge, 1987), pp. 159–69.

Pelletier, Y., *Les jubés de Bretagne* (Rennes, 1986).

Peters, A., *Tot cieraad van de Kerk en van een schone glans: het koorhek in de Grote of Sint-Bavokerk te Haarlem* (Haarlem, 1998).

Petrucci, A., *Public Lettering: Script, Power, and Culture*, trans. L. Lappin (London, 1993).

Pevsner, N., *An Outline of European Architecture* (Harmondsworth, 1963).

Pevsner, N. and Cherry, B., *The Buildings of England. Devon*, revised edn (New Haven and London, 2002).

Pevsner, N. and Wilson, B., *The Buildings of England. Norfolk 1: Norwich and North-East* (London, 2002).

Pfaff, R. W., *New Liturgical Feasts in Later Medieval England* (Oxford, 1970).

Phillips, J., *The Reformation of the Images: Destruction of Art in England, 1535–1660* (London, 1973).

Piponnier, F. and Mane, P., *Dress in the Middle Ages* (London, 1997).

Piva, P. 'Dal setto murario allo *jubé*: il "pòzo" di Sant'Andrea a Mantova nel contesto di un processo evolutivo', in E. Camerlenghi, G. Gardoni, I. Lazzarini and V. Rebonato (eds), *Società, cultura, economia: studi per Mario Vaini* (Mantua, 2013), pp. 57–78.

Plahter, U., Hohler, E., Morgan, N. et al., *Painted Altar Frontals of Norway, 1250–1350*, 3 vols (London, 2004).

Plummer, P. and Hulbert, A., 'English Polychromed Church Screens and the Problems of their Conservation in Situ', in *Cleaning, Retouching and Coatings: Technology and Practice for Easel Paintings and Polychrome Sculpture. Preprints of the contributions to the IIC Brussels Congress, 3–7 September 1990* (London, 1990), pp. 47–51.

Polanyi, M., *The Tacit Dimension* (London, 1966).

Poulsen, N. J., in *Danmarks Kirker, Vejle Amt* (Copenhagen, 2013), p. 1887.

Poulson, G., *The History and Antiquities of the Seignory of Holderness in the East-Riding of Yorkshire* (York, 1841).

Praga, G., 'Alcuni documenti su Giorgio da Sebenico', *Rassegna Marchigiana*, 7 (1928), pp. 73–80.

Procacci, U., 'L'incendio della chiesa del Carmine nel 1771', *Rivista d'arte*, 14 (1932), pp. 141–232.

Quintavalle, A. C. (ed.), *Arredi liturgici e architettura* (Milan, 2007).

Quirin, K.-L., *Die Elevation zur hl. Wandlung in der römischen Messe* (Mainz, 1952).

Rama, G.,'Spazio e liturgia in una chiesa dei frati predicatori: S. Anastasia in Verona (sec. XIII–XIV)', *Atti e memorie dell'Accademia di Agricoltura, Scienze e Lettere di Verona*, 177 (2000–1), pp. 395–419.

Randolph, A., 'Regarding Women in Sacred Space', in G. A. Johnson and S. F. Matthews Grieco (eds), *Picturing Women in Renaissance and Baroque Italy* (Cambridge, 1997), pp. 17–41.

Redknap, M., 'The Medieval Wooden Crucifix Figure from Kemeys Inferior and its Church', with a contribution by P. Hill, *The Monmouthshire Antiquary*, 16 (2000), pp. 11–43.

Renfrew, C. and Bahn, P., *Archaeology: Theories, Methods, and Practice* (London, 1996).

Riall, N., 'The Waller Tomb at Stoke Charity, Hampshire: Conservative Monument or a Late Pre-Renaissance, Perpendicular Work?', *The Journal of the British Archaeological Association*, 166 (2013), pp. 157–78.

—— 'A Tudor Cupboard at Cotehele and Associated Carpentry Work from the Welsh Marches', *Regional Furniture*, 26 (2012), pp. 23–72.

—— 'All'antica Ornament During the First Renaissance in England: The Case of the Draper Chapel at Christchurch Priory', *Proceedings of the Dorset Natural History and Archaeological Society*, 129 (2008), pp. 25–37.

Ricchebono, M., 'Ipotesi sulla chiesa di S. Domenico il Vecchio a Savona', *Atti e memorie della Società Savonese di Storia Patria*, 11 (1977), pp. 28–39.

Richa, G., *Notizie istoriche delle chiese fiorentine*, 10 vols (Florence, 1754–62).

Ridyard, S. J., *The Royal Saints of Anglo-Saxon England: A Study of West Saxon and East Anglian Cults* (Cambridge, 1988).

Riedl, P. A. and Seidel, M. (eds), *Die Kirchen von Siena*, vol. 1.1 (Abbadia all'Arco-S.Biagio) (Munich, 1985).

Roberts, E., 'Moulding Analysis and Architectural Research', *Architectural History*, 20 (1977), pp. 5–13.

Robson, J., 'Assisi, Rome and the *Miracle of the Crib at Greccio*', in Z. Opačić and A. Timmermann (eds), *Image, Memory and Devotion: Liber Amicorum Paul Crossley* (Turnhout, 2011), pp. 145–55.

Rogers, R., 'Hic Iacet ...: The Location of Monuments in Late Medieval Parish Churches', in C. Burgess and E. Duffy (eds), *The Parish in Late Medieval England*, Harlaxton Medieval Studies, 14 (Donington, 2006), pp. 261–81.

Rogge, C., *Grote of St. Laurenskerk Alkmaar. Rapport over het kerkgebouw en inventaris* (Alkmaar, 1996).

Roosval, J., 'Triumfkrucifixet i Stånga', *Gotländsk Arkiv*, 2 (1930), pp. 3–23.

Rosewell, R., *Medieval Wall Paintings in English and Welsh Churches* (Woodbridge, 2008).

Rosser, R., *The Art of Solidarity in the Middle Ages: Guilds in England 1250–1550* (Oxford, 2015).

Rubbiani, A., *La Chiesa di S. Francesco e le tombe dei glossatori in Bologna: ristauri dall'anno 1886 al 1899* (Bologna, 1900).

—— *La Chiesa di S. Francesco in Bologna* (Bologna, 1886).

Rubin, M., *Corpus Christi: The Eucharist in Late Medieval Culture* (Cambridge, 1991).

Ruf, S., 'Der erhöhte Christus also Richter und Erlöser: Das Gemälde im Giebelfeld des Naumburger Westlettners', in Krohm and Kunde (eds), *Der Naumburger Meister*, 3 (2012), pp. 300–17.

Russo, E., 'Il *jubé* di Pomposa', in A. Calzona, R. Campari and M. Mussini (eds), *Immagine e ideologia: studi in onore di Arturo Carlo Quintavalle* (Milan, 2007), pp. 103–16.

—— 'Lo scomparso Jubé della chiesa abbaziale di Pomposa', *Analecta pomposiana: Studi vari*, 31–2 (2006–7), pp. 7–43.

Russo, T. E., 'The Romanesque Rood Screen of Durham Cathedral: Context and Form', in D. Rollason, M. Harvey and M. Prestwich (eds), *Anglo-Norman Durham 1093–1193* (Woodbridge, 1994), pp. 251–68.

Rydbeck, M., *Skånes stenmästare före 1200* (Lund, 1936).

Rydbeck, O., 'Trabes och lectorium i skånska kyrkor', in O. Rydbeck and E. Wrangel (eds), *Äldre kyrklig konst i Skåne* (Lund, 1921), pp. 178–86.

Ryrie, A., *The Gospel and Henry VIII: Evangelicals in the Early English Reformation* (Cambridge, 2003).

Salerno, P. (ed.), *Santa Maria di Vezzolano: il pontile, ricerche e restauri* (Turin, 1997).

Salmi, M., 'Un'antica pianta di S. Francesco in Arezzo', *Miscellanea Francescana*, 21 (1920), pp. 97–105.

Salzman, L. F., *Building in England Down to 1540: A Documentary History* (Oxford, 1952).

Sandars, S. and Venables, E., *Historical and Architectural Notes on Great St. Mary's Church Together with the Annals of the Church* (Cambridge, 1869).

Sauerberg, M. L., Howard, H. et al., 'The Final Touches: Evidence from the Study of Varnishes on Medieval Polychromy in England', *Die Sprache des Materials – Kölner Maltechnik des Spätmittelalters im Kontext, Zeitschrift für Kunsttechnologie und Konservierung*, 26:1 (2012), pp. 241–58.

Sauerländer, W., 'Reliquien, Altäre und Portale', in N. Bock et al. (eds), *Kunst und Liturgie im Mittelalter* (Munich, 2000), pp. 121–34.

—— 'Integration: An Open or Closed Proposal?', in V. C. Raguin, K. Brush and P. Draper (eds), *Artistic Integration in Gothic Buildings* (Toronto, 1995), pp. 3–18.

—— *Gothic Sculpture in France, 1140–1270* (New York, 1972).

Saul, N., 'Bold as Brass: Secular Display in English Medieval Brasses', in P. Coss and M. Keen (eds), *Heraldry, Pageantry and Social Display in Medieval England* (Woodbridge, 2002), pp. 169–94.

Scharff, M., 'Early Medieval Painting Techniques in Northern Europe: A Discussion of the Use of Coloured Grounds and Other Notable Techniques', in U. Schiessl and R. Kühnen (eds), *Polychrome Skulptur in Europa, Tagungsbeiträge, Hochschule für Bildende Künste* (Dresden, 1999), pp. 47–52.

Schmelzer, M., *Der mittelalterliche Lettner im deutschsprachigen Raum. Typologie und Funktion* (Petersberg, 2004).

Schmidt, F., 'Die Fülle der erhaltenen Denkmäler. Ein kurzer Überblick', in J. M. Fritz (ed.), *Die bewahrende Kraft des Luthertums. Mittelalterliche Kunstwerke in evangelischen Kirchen* (Regensburg, 1997), pp. 71–8.

Schmidt, V., 'Religious Panel Paintings: Types, Functions, and Spatial Contexts', in C. Sciacca (ed.), *Florence at the Dawn of the Renaissance: Painting and Illumination 1300–1350* (Los Angeles, 2013), pp. 79–91.

Schofield, R., 'Carlo Borromeo and the Dangers of Laywomen in Church', in M. Hall and T. E. Cooper (eds), *The Sensuous in the Counter-Reformation Church* (Cambridge, 2013), pp. 187–205.

Schönlank-Van der Wal, M., 'Romanesque and Gothic Stone Baptismal Fonts in the Diocese of Utrecht', in E. de Bièvre (ed.), *Utrecht, Britain and*

the Continent: Archaeology, Art and Architecture, British Archaeological Association Conference Transactions, 18 (1996), pp. 163–71.

Schubert, E., Der Naumburger Dom (Halle a. d. Saale, 1997).

Schwartz, F., 'In medio ecclesiae: Giottos Tafelkreuz in Santa Maria Novella', Wiener Jahrbuch für Kunstgeschichte, 54 (2005), pp. 95–114.

Schweingruber, F., 'Botanisch-holztechnologische Bermerkungen zu den Untersuchungen mittelalterliche Skulpturen', Zeitschrift für Schweizerische Archäologie und Kunstgeschichte, 30 (1973), pp. 84–8.

Schweiso, J., 'Rood Stairs - an Analysis Based Upon a Systematic Sample from Three English Counties', Church Archaeology, 10 (2006), pp. 51–65.

Scott, K. L., 'The Genealogical Genre: BL Royal MS I.B.X', in Tradition and Innovation in Later Medieval English Manuscripts (London, 2007), pp. 87–117.

—— Later Gothic Manuscripts 1390–1490 (A Survey of Manuscripts Illuminated in the British Isles), 2 vols (London, 1996).

Scott, M., Late Gothic Europe, 1400–1500 (London, 1980).

Sekules, V., 'The Liturgical Furnishings of the Choir of Exeter Cathedral', in F. Kelly (ed.), Medieval Art and Architecture at Exeter Cathedral, British Archaeological Association Conference Transactions, 11 (1991), pp. 172–9.

Serjeantson, R. M. and Isham Longden, H., 'The Parish Churches and Religious Houses of Northamptonshire: Their Dedications, Altars, Images and Lights', Archaeological Journal, 70 (1913), pp. 217–452.

Sheppard, J. M., 'The Eleventh-Century Choir-Screen at Monte Cassino: A Reconstruction', Byzantine Studies, 9 (1982), pp. 233–42.

Sherman, A.,'"To God alone the honour and glory": Further Notes on the Patronage of Pietro Lombardo's Choir Screen in the Frari, Venice', The Burlington Magazine, 156 (2014), pp. 723–8.

Short, R. D., 'Graffiti on the Reredos of the Lady Chapel at Gloucester Cathedral', Transactions of the Bristol and Gloucester Archaeological Society, 67 (1946–48), pp. 21–36.

Simpson, J., Burning to Read: English Fundamentalism and its Reformation Opponents (London, 2007).

Sinclair, E., 'Investigating the Medieval Polychromy of West Country Rood Screens', in N. Streeton and K. Kollandsrud (eds), Paint and Piety: Collected Essays on Medieval Painting and Polychrome Sculpture (London, 2014), pp. 131–48.

—— 'Surviving Against All Odds: A Devon Late Medieval Rood Screen and a Tyrolese Altarpiece', in D. Odgers and L. Humphries (eds), Polychrome Wood. Post-prints of a Conference in Two Parts Organised by The Institute of Conservation Stone and Wall Paintings Group, Hampton Court Palace October 2007 and March 2008 (London, 2010), pp. 53–64.

Sinclair, E. and Richardson, I., 'The Polychrome-decorated Plank-and-muntin Screen at Marker's Cottage, Broadclyst, Devon, and its Context',

in J. Allan, N. Alcock and D. Dawson (eds), *West Country Households 1500–1700* (Woodbridge, 2015).

Skaug, E., *Punchmarks from Giotto to Fra Angelico* (Oslo, 1994).

Slater, L., 'Visual Reflections on History and Kingship in the Medieval English Great Church', *Journal of the British Archaeological Association*, 167 (2014), pp. 83–108.

Smidt, C. M., in *Danmarks Kirker, Bornholms Amt* (Copenhagen, 1954), pp. 390, 465, 558.

—— 'Østermarie Kirke. Nye undersøgelser og gravninger inden for bornholmsk og skånsk Bygningskunst', *Årbøger for nordisk Oldkyndighed og Historie* (1940), pp. 84–116.

Smith, P. H., *The Body of the Artisan* (Chicago, 2004).

Snow, C. P., *The Two Cultures and the Scientific Revolution* (London, 1959).

Spence, J., 'Genealogies of Noble Families in Anglo-Norman', in R. L. Radulescu and E. D. Kennedy (eds), *Broken Lines: Genealogical Literature in Medieval Britain and France* (Turnhout, 2008), pp. 63–77.

Spraggon, J., *Puritan Iconoclasm during the English Civil War* (Woodbridge, 2003).

Stabb, J., *Some Old Devon Churches: Their Rood-screens, Pulpits, Fonts, etc.* (London, 1908).

Steensma, R., *Protestantse kerken. Hun pracht en kracht*, 2nd edn (Gorredijk, 2014).

—— *De koorbanken in de Martinikerk te Bolsward en hun Europese context* (Gorredijk, 2012).

—— *Het gebruik van de middeleeuwse kerken in Overijssel voor de katholieke eredienst* (Delden, 2005).

—— 'Nissen en schilderingen als sporen van de katholieke eredienst in de middeleeuwse kerken van Noord-Holland', *Bulletin van de Stichting Oude Hollandse Kerken*, 59 (2004), pp. 3–29.

—— 'Het middeleeuwse doksaal in Nederland', *Jaarboek voor liturgie-onderzoek*, 16 (2000), pp. 187–218.

—— *Opdat de ruimten meevieren. Een studie over de spanning tussen liturgie en monumentenzorg bij de herinrichting en het gebruik van monumentale hervormde kerken* (Baarn, 1982).

Stenvert, R. et al., *Monumenten in Nederland: Gelderland* (Zwolle/Zeist, 2000).

—— *Monumenten in Nederland: Groningen* (Zwolle/Zeist, 1998).

—— *Monumenten in Nederland: Utrecht* (Zwolle/Zeist, 1996).

Steppe, J., *Het koordoksaal in de Nederlanden* (Brussels, 1952).

Strange, E. F., 'The Rood-screen of Cawston Church', *The Second Annual Volume of the Walpole Society*, 2 (1912–13), pp. 81–7.

Stroo, C. (ed.), *Pre-Eyckian Panel Painting in the Low Countries* (Brussels, 2009).

Struchholz, E., *Die Choranlagen und Chorgestühle des Sieneser Domes* (Münster, 1995).

Sundnér, B., *Maglarp en tegelkyrka som arkäologisk källmaterial* (Lund, 1982).

Tångeberg, P., *Retabel und Altarschreine des 14. Jahrhunderts. Schwedische Altarausstattungen in ihrem europäischen Kontext* (Stockholm, 2005).

—— *Mittelalterliche Holzskulpturen und Altarschreine in Schweden* (Stockholm, 1986).

—— 'Polychrome Sculpture in Sweden', *Studies in Conservation*, 15 (1970), pp. 316–26.

Tartuferi, A., 'Intorno a Giotto: una mostra, un libro e una proposta di attribuzione', *Commentari d'arte*, 19–20 (2013–14), pp. 26–38.

Taylor, C., 'Banwell Screen and Rood-loft', *Transactions of the Bristol and Gloucestershire Archaeological Society*, 35 (1912), pp. 116–38.

Theis, P., 'Die Oberkirche von S. Francesco in Assisi oder *De Missa Pontificali*: zur Ausstattung eines päpstlichen Sakralraumes', *Römische Historische Mitteilungen*, 46 (2004), pp. 125–64.

Thomas, Archdeacon, 'Montgomeryshire Screens and Rood-lofts', *Archaeologia Cambrensis*, 6th series, 4 Pt 2 (1902), pp. 84–120.

Thomas, D. R., *Esgobaeth Llanelwy: A History of the Diocese of St Asaph* (London, 1908–13).

—— *The History of the Diocese of St Asaph* (Oswestry, 1908–13).

Timmermann, A., *Real Presence: Sacrament Houses and the Body of Christ, c. 1270–1600* (Turnhout, 2009).

Tingle, E. C., *Purgatory and Piety in Brittany 1480–1720* (Farnham, 2012).

Tracy, C., 'Three Rood-screens in South-east Wales', in J. R. Kenyon and D. M. Williams (eds), *Cardif: Architecture and Archaeology in the Medieval Diocese of Llandaff*, British Archaeological Association Conference Transactions, 29 (2006), pp. 161–201.

—— 'An English Painted Screen at Kingston Lacy', *Apollo*, 146 (1997), pp. 20–8.

Tracy, C. and Harrison, H. M. J., *The Choir Stalls of Amiens Cathedral* (Reading, 2004).

Travi, C., 'Antichi tramezzi in Lombardia: il caso di Sant'Eustorgio', *Arte Lombarda*, 158–9 (2010), pp. 5–16.

Tripps, J., *Das handelnde Bildwerk in der Gotik*, 2nd edn (Berlin, 2000).

Turnbull, D., 'The Ad Hoc Collective Work of Building Gothic Cathedrals', *Science, Technology and Human Values*, 18:3 (1993), pp. 321–4.

Turner, D., 'Mural Paintings in Catfield Church', *Norfolk Archaeology*, 1 (1847), pp. 133–9.

Turner, S., *The Social Theory of Practices: Tradition, Tacit Knowledge and Presuppositions* (Chicago, 1994).

Tyers, I., 'Aspects of the European Trade in Oak Boards to England', in J. Kirby, S. Nash and J. Cannon (eds), *Trade in Artists' Materials* (London 2010), pp. 42–9.

Valdameri, C., 'Considerazioni sullo scomparso pontile di San Giovanni Evangelista in Rimini e sulla presenza a Rimini di Fra Carnevale', *Romagna arte e storia*, 91 (2011), pp. 5–24.

Valenzano, G., 'La suddivisione dello spazio nelle chiese mendicanti: sulle trace dei tramezzi delle Venezie', in A. C. Quintavalle (ed.), *Arredi liturgici e architettura* (Milan, 2007), pp. 99–114.

Vallance, A., *Greater English Church Screens* (London, 1947).

—— *English Church Screens* (London, 1936).

—— 'The History of Roods, Screens, and Lofts in the East Riding', *Yorkshire Archaeological Journal*, 24 (1922), pp.109–85.

Van Duinen, H., *Het doksaal van de Grote of St. Bartholomeuskerk te Schoonhoven* (Amsterdam, 2004).

Van der Ploeg, K., *Art, Architecture and Liturgy: Siena Cathedral in the Middle Ages* (Groningen, 1993).

Van Swigchem, C. A. et al., *Een Huis voor het Woord. Het protestantse kerkinterieur in Nederland tot 1900* ('s-Gravenhage/Zeist, 1984).

Van Wezel, G. et al., *De Onze Lieve Vrouwekerk en de grafkapel voor Oranje-Nassau te Breda* (Zwolle/Zeist, 2003), pp. 134–6.

Varner, E. R., *Mutilation and Transformation: 'Damnatio Memoriae' and Roman Imperial Portraiture* (Leiden, 2004).

Venables, E., 'The Church of St Mary the Great, Cambridge', *Archaeological Journal*, 12 (1855), pp. *245–55, 338–55.*

Verspaandonk, J. A. J. M., 'Het koorhek in de Grote of St. Bavokerk', in *Haerlem Jaarboek* (Haarlem, 1991).

Virgili, E., 'L'inventario dell'abbazia di San Zeno di Pisa (1386)', *Bolletino storico pisano*, 54 (1985), pp. 117–29.

Wabuda, S., *Preaching During the English Reformation* (Cambridge, 2002).

Wakelin, D., 'Writing the Words', in A. Gillespie and D. Wakelin (eds), *The Production of Books in England 1350–1500* (Cambridge, 2011), pp. 34–58.

Waldman, L. A., 'Dal Medioevo alla Controriforma: i cori di Santa Maria del Fiore / From the Middle Ages to the Counter-Reformation: The Choirs of Santa Maria del Fiore', in T. Verdon (ed.), *Sotto il cielo della cupola: il coro di Santa Maria del Fiore dal Rinascimento al 2000: progetti di Brunelleschi, Bandinelli, Botta, Brenner, Gabetti e Isola, Graves, Hollein, Isozaki, Nouvel, Rossi* (Milan, 1997), pp. 37–68.

Ward, B., *The Sequel to Catholic Emancipation* (London, 1915).

Wayment, H., *The Windows of Kings College Chapel, Cambridge: A Description and Commentary* (Cambridge, 1972).

Welch, E., *Art and Society in Italy, 1350–1500* (Oxford, 1997).

Wenger, E., *Communities of Practice* (Cambridge, 1998).

Westcote, T., *A View of Devonshire in MDCXXX: With a Pedigree of its Gentry*, ed. George Oliver and Pitman Jones (Exeter, 1845).

Whale, K., 'The Wenhaston Doom: A Biography of a Sixteenth-century Panel Painting', *Proc. Suffolk Institute of Archaeology*, 39 (2009), pp. 299–316.

Whalley, P., *The history and antiquities of Northamptonshire: compiled from the manuscript collections of the late learned antiquary John Bridges, Esq.* (Oxford, 1791).

Wheeler, R., *The Medieval Church Screens of the Southern Marches* (Woonton Almeley, 2006).

White, J., *Art and Architecture in Italy, 1250 to 1400* (Harmondsworth, 1966).

Whiting, R., *The Reformation of the English Parish Church* (Cambridge, 2010).

Whiting, R., *The Blind Devotion of the People: Popular Religion and the English Reformation* (Cambridge, 1989).

—— 'Abominable Idols: Images and Image Breaking under Henry VIII', *Journal of Ecclesiastical History*, 33 (1982), pp. 30–47.

Wieck, R. S., 'Prayer for the People: The Book of Hours', in Roy Hammerling (ed.), *The History of Prayer: The First to the Fifteenth Century* (Leiden, 2008), pp. 389–440.

Wilks, D., *Showing the Path to Heaven: A Celebration of Painted Panels in Devon Churches* (Exeter, 2014).

Wilson, C., 'Rulers, Artificers and Shoppers: Richard II's Remodelling of Westminster Hall, 1393–99', in D. Gordon, L. Monnas and C. Elam (eds), *The Regal Image of Richard II and the Wilton Diptych* (London, 1997), pp. 33–59, 274–88.

Wilson, R., 'Tudor and Merton Cottages, Sidmouth', *Transactions of the Devonshire Association*, 106 (1974), pp. 155–9.

Witsen Elias, J. S., *Koorbanken, koorhekken en kansels* (Amsterdam, 1946).

Wollheim, R., 'Giovanni Morelli and the Origins of Scientific Connoisseurship', in *On Art and Mind: Essays and Lectures* (London, 1973), pp. 177–201.

Woolf, R., *The English Religious Lyric in the Middle Ages* (Oxford, 1968).

Wrapson, L., 'Prints and Pastiglia: The Surviving Paintings of a Late-medieval East Anglian Workshop', in A. Wallert et al. (eds), *Postprints of Painting Techniques, History Materials and Studio Practice. A Conference held at the Rijksmuseum, Amsterdam, 18, 19 and 20 September 2013*, Amsterdam (forthcoming).

—— 'Ranworth and its Associated Paintings: A Norwich Workshop', in T. Heslop and H. Lunnon (eds), *Norwich: Medieval and Early Modern Art, Architecture and Archaeology*, *The British Archaeological Association Conference Transactions*, 38 (Leeds, 2015), pp. 216–37.

—— 'East Anglian Medieval Church Screens: A Brief Guide to their Physical History', *Bulletin of the Hamilton Kerr Institute*, 4 (2013), pp. 33–47.

—— 'East Anglian Rood Screens: The Practicalities of Production', in P. Binski and E. A. New (eds), *Patrons and Professionals in the Middle Ages. Proceedings of the 2010 Harlaxton Symposium* (Donington, 2012), pp. 386–404.

Wright, T., *The Town of Cowper: Or the Literary and Historical Associations of Olney and its Neighbourhood* (London, 1886).

Zilsel, E., 'The Sociological Roots of Science', *Social Studies of Science*, 30:6 (2000), pp. 935–49.

—— 'The Genesis of the Concept of Scientific Progress', *Journal of the History of Ideas*, 6:3 (1945), pp. 325–49.

UNPUBLISHED

Allen, J., 'Choir Stalls in Venice and Northern Italy: Furniture, Ritual and Space in the Renaissance Church Interior' (PhD thesis, University of Warwick, 2010).

Ashby, J. E., 'English Medieval Murals of the Doom: A Descriptive Catalogue and Introduction (MPhil thesis, University of York, 1980).

Baker, A. M., 'Figure Painting on Rood-screens in Churches of Norfolk and South Devonshire' (PhD thesis, Courtauld Institute of Art, University of London, 1938).

Byrne, J.P., 'Francesco Datini, "Father of Many": Piety, Charity and Patronage in Early Modern Tuscany' (PhD thesis, Indiana University, 1989).

Cooper, D., '"In medio ecclesiae": Screens, Crucifixes and Shrines in the Franciscan Church Interior in Italy (c.1230–c.1400)' (PhD thesis, Courtauld Institute of Art, University of London, 2000).

De Benedictis, E., 'The "Schola Cantorum" in Rome during the High Middle Ages' (PhD dissertation, Bryn Mawr College, 1983).

Gustafson, E., 'Tradition and Renewal in the Thirteenth-Century Franciscan Architecture of Tuscany' (PhD thesis, Institute of Fine Arts, New York University, 2012).

Hassall, C., 'Paint Analysis: Torbryan Church', Unpublished Report (London, 1999).

Howson, T., 'Suffolk Church Screens: Their Production in the Late Middle Ages and their Conservation Today' (PGDip in Building Conservation thesis, Architectural Association, London, 2009).

Hulbert, A., 'St Mary's Church, Uffculme, Devonshire. Polychromed Roodscreen', Unpublished Report (Childrey, 1984).

Kirchner-Doberer, E., 'Die deutschen Lettner bis 1300' (PhD thesis, Vienna, 1946).

Monroe, W. H., '13th and Early 14th Century Illustrated Genealogical Manuscripts in Roll and Codex: Peter of Poitiers' *Compendium*,

Universal Histories and Chronicles of the Kings of England' (PhD thesis, Courtauld Institute of Art, 1989).

Munns, J. M., 'The Cross of Christ and Anglo-Norman Religious Imagination' (PhD thesis, University of Cambridge, 2010).

Nadolny, J., 'The Techniques and Use of Gilded Relief Decoration by Northern European Painters c. 1200–1500' (PhD thesis, Courtauld Institute of Art, University of London, 2001).

Sinclair, E., 'Plank and Muntin Screen. Little Harvey Farm, Teign Harvey, Devon', Unpublished Report (Crediton, 2014).

—— 'Church of St Peter ad Vincula, Combe Martin, Devon. Rood Screen Polychromy Final Report', Unpublished Report (Crediton, 2013).

—— 'St Peter's Church, Buckland-in-the-Moor, Devon. Rood Screen: Polychromy Report', Unpublished Report (Crediton, 2013).

—— 'St Michael and All Angels, Alphington Devon: Rood Screen Polychromy, Assessment of Significance', Unpublished Report (Crediton, 2013).

—— 'Church of St Nicholas and St Cyriacus, South Pool, Kingsbridge, Devon. Chancel Rood Screen: Pilot Project Report', Unpublished Report (Crediton, 2012).

—— 'Church of St Mary the Virgin, Willand, Devon. Rood Screen Polychromy: Conservation Report', Unpublished Report (Crediton, 2012).

—— 'Church of St Peter ad Vincula, Combe Martin, Devon. Rood Screen Polychromy Report: Phase 2. April–October 2011', Unpublished Report (Crediton, 2012).

—— 'Church of St Martin of Tours, Sherford, Kingsbridge, Devon. Chancel Rood Screen Polychromy', Unpublished Report (Crediton, 2011).

—— 'Church of St Peter ad Vincula, Combe Martin, Devon. Rood Screen Conservation. Polychromy Report: Phase 1. April–October 2010', Unpublished Report (Crediton, 2010).

—— 'Church of St Mary the Virgin, Holne, Devon. Rood-Screen Report: Final Phase. April–September 2009', Unpublished Report (Crediton, 2009).

—— 'Parish Church of Combe Martin, St Peter ad Vincula. Roodscreen: Polychromy Report, Pilot Project', Unpublished Report (Crediton, 2009).

—— 'Church of St Mary the Virgin, Holne, Devon. Report: Work in Progress, April–October 2008', Unpublished Report (Crediton, 2008).

—— 'Church of St Mary the Virgin, Holne, Devon. Report: Work in Progress, April–October 2007', Unpublished Report (Crediton, 2007).

—— 'Church of St Mary the Virgin, Holne, Devon. Report: Work in Progress, April–October 2006', Unpublished Report (Crediton, 2006).

—— 'Church of St Mary the Virgin, Holne, Devon. Roodscreen: Pilot Week', Unpublished Report (Crediton, 2005).

—— 'Plank and Muntin Screen: Painted Decoration. Osmonds Farmhouse, Clyst Hydon, Cullompton', Unpublished Report (Crediton, 2004).

—— 'Markers Cottage, Broadclyst, Devon. Plank and Muntin Screen', Unpublished Report (Crediton, 1994).

Sinclair, E., Cheadle, E. and Oldenbourg, C., 'No. 21 The Mint, Exeter. Polychromy: Condition Report', Unpublished Report (Crediton, 2000).

Singer, B., 'Investigation of Paint Samples from 15th and 16th Century English Rood Screen Paintings', Unpublished Report, Northumbria University (Northumbria, 2012).

Tyers, I., 'Report 504'. Unpublished Report, Held at the Hamilton Kerr Institute, University of Cambridge (Cambridge, 2013).

Vandivere, A., 'From the Ground Up: Surface and Sub-Surface Effects in Fifteenth- and Sixteenth-Century Netherlandish Paintings' (PhD thesis, University of Amsterdam, 2013).

Williams, M. A., 'Medieval English Roodscreens with Special Reference to Devon' (PhD thesis, University of Exeter, 2008).

Wrapson, L. J., 'Patterns of Production: A Technical Art Historical Study of East Anglia's Late Medieval Screens' (PhD thesis, University of Cambridge, 2013).

—— 'Analysis of Paint Samples from *The Adoration of the Magi* (W.54-1928)', Unpublished Report, Hamilton Kerr Institute (Cambridge, 2014).

—— 'Analysis of Paint Samples from Medieval Screens, St Michael and All Angels, Alphington, Devon', Unpublished Report, Hamilton Kerr Institute (Cambridge, 2013).

—— 'Analysis of Cross-sections from Buckland-in-the-Moor Rood Screen', Unpublished Report, Hamilton Kerr Institute (Cambridge, 2013).

—— 'Analysis of Cross-sections from Devon Screens: Combe Martin, South Pool, Sherford, Heavitree', Unpublished Report, Hamilton Kerr Institute (Cambridge, 2012).

—— 'Analysis of Cross-sections from East Portlemouth Rood Screen', Unpublished Report, Hamilton Kerr Institute (Cambridge, 2016).

—— 'Analysis of Cross-sections from Willand Rood Screen', Unpublished Report, Hamilton Kerr Institute (Cambridge, 2012).

—— 'St Apollonia: HKI# 2700', Unpublished Report, Hamilton Kerr Institute, University of Cambridge (Cambridge, 2013).

INDEX OF NAMES AND PLACES

Abbenbroek (Netherlands) 205
Abcoude (Netherlands) 212
Abraham 198 n.14
Acle (Norfolk) 49, 83, 90, 95
Adam 88
Agincourt 109
Alban, St 110 n.33
Albans, St (Hertfordshire) 23, 113
Albrede, Agnes 64, 90
Albrede, John 64, 90
Alburgh (Norfolk) 38, 49, 67–69
Alby (Norfolk) 49
Alcock, William 61
Alfred the Great, King 111, 121
Alford (Somerset) 128
Alfwald I, King of Northumbria 110
Alkemade, Jan van 208
Alkmaar (Netherlands) 203 n.30, 207
Almondbury (Yorkshire) 16 n.21, 95
Alphington (Devon) 129, 159 n.45,
 162, 166, 168
Alps, The 199 n.19
Altarnun (Cornwall) 207 n.45
Ambrose, St 27
Amersfoort (Netherlands) 196–197
Amiens, Amiens Cathedral (France)
 193
Amsterdam (Netherlands) 203 n.30,
 205, 211, 217
Amsterdam, Rijksmuseum
 (Netherlands) 197
Andrew, St 172
Anne, St 147
Anthony, St 24–25, 27, 147

Antwerp 197 n.11, 202, 207
Apollonia, St 32–33, 35
Arezzo (Italy) 235
Arezzo, San Domenico (Italy) 232
 n.36, 239
Arezzo, San Francesco (Italy)
 232–233
Armel, St 146
Arthur, Prince of Wales 109, 115
Ashampstead (Berkshire) 9 n.5
Ashburton (Devon) 73, 125 n.4,
 140–141, 143–145, 148–149,
 157–158, 160
Ashprington (Devon) 152 n.13, 159
 n.45
Ashton (Devon) 80, 88, 159–161, 166
 n.56, 168–169, 207 n.45
Assisi, Basilica of San Francesco
 (Italy) 221, 222 n.6, 240–241
Athelstan, King of England 112
Athereth, William and Alice 52, 89
Atherington (Devon) 24, 126, 128,
 154–156, 200
Attleborough (Norfolk) 49, 90, 92, 98
Aught, Robert 148
Awall, John and Margery 83
Aylsham (Norfolk) 49, 65–67, 69,
 80, 89

Bacon family 78
Bacon, Francis 41
Baltic 33, 35, 42
Bamle (Norway) 252
Bampton (Devon) 154

Ban, Wilhelmus 204
Banwell (Somerset) 53, 125 n.5, 127 n.12, 142, 148
Barbara, St 82, 84
Barga, San Cristoforo (Italy) 238–239 n.77
Barkåkra (Sweden) 260 n.36
Barking (Suffolk) 49
Barningham (Suffolk) 49
Barnstaple (Devon) 137
Baroncelli family 230
Barozzi, Pietro, bishop of Padua 225 n.21
Barton (Cambridgeshire) 48 n.8
Barton Turf (Norfolk) 36, 61–63, 65, 82, 106, 156
Bath (Avon) 124 n.4
Bawburgh (Norfolk) 49
Baymonde, John 27, 29
Beaupel, Sir John 81, 155
Bede, The Venerable 113
Bede Camm, Dom 2
Bedfield (Suffolk) 49
Beeston Regis (Norfolk) 49
Beeston-next-Mileham 102, 160
Belaugh (Norfolk) 69
Belgium 200
Belstead (Suffolk) 160
Benschop (Netherlands) 204 n.36
Bere Ferrers (Devon) 159 n. 46
Bergen (Norway) 253
Berry Pomeroy (Devon) 159 n. 47
Bethlehem 85
Bettws Gwerfil Goch (Clwyd) 16, 17
Beverwijk (Netherlands) 203 n.30
Bewfield, Katharine 63
Bibury (Gloucestershire) 8
Binham Priory (Norfolk) 73–74, 76
Bishops Canning (Wiltshire) 91
Bishops Lydeard (Somerset) 22
Bishops Lynn see Kings Lynn
Bitton (Gloucestershire) 8
Bjerning (Denmark) 256–257
Blackawton (Devon) 16, 155, 159 n. 47
Blaise, St 24–27
Bleiswijk (Netherlands) 217
Bligh Bond, F. 2

Blomefield, F. 61, 93
Blomfeld, John 157
Bloxham (Oxfordshire) 98
Blundeston (Suffolk) 16, 99
Blythburgh (Suffolk) 22
Bocholt (Belgium) 211
Bodmin (Cornwall) 148
Bokenham, Osbern 27
Bole, J. 148
Bologna (Italy) 222, 234
Bologna, San Barbaziano (Italy) 234 n.55
Bologna, San Francesco (Italy) 231, 234 n.55, 236 n.65
Bologna, San Vittore (Italy) 229, 234 n.55
Bolsward (Netherlands) 195, 208
Bond, F. 2
Borromeo, Carlo 243 n.97
Bøstrup (Denmark) 257
Bourges, Bourges Cathedral (France) 189 n.33, 193
Bouryng, Thomas 147
Bovey Tracey (Devon) 84, 99, 159 n. 46
Bow (Nymet Tracey) (Devon) 152 n. 14
Boxe, Sir Henry de 161
Boxford (Suffolk) 73
Boyle, Robert 40
Bozeat (Northamptonshire) 88
Brabant 197, 205
Bradford on Avon (Wiltshire) 8
Bradninch (Devon) 88, 159 n.45
Bramfield (Suffolk) 36, 81, 85–86
Branscomb (Devon) 126
Brapaul, Sir John see Beaupel, Sir John
Brayne, John of Stoke 142, 144
Breda, Our Lady's Church (Netherlands) 205
Brent Eleigh (Suffolk) 85
Brettenham (Suffolk) 63–64
Bridford (Devon) 130, 135, 152, 154, 159–162, 166 n.56, 170, 207 n.45
Bridges, John 88
Bridgham (Norfolk) 49
Bridgwater (Somerset) 142

Bristol (Avon) 142, 148, 158

Bristol, All Saints 24, 125, 140,
144–145, 147

Bristol, St John the Baptist 21, 23,
146, 148

Brittany (France) 165, 197, 199

Broadwoodwidger (Devon) 155

Bromholm priory (Norfolk) 97

Bromsgrove (Worcestershire) 17

Broughton (Oxfordshire) 94

Brown, John and Agnes 89

Brundish (Suffolk) 49

Bruni, Francesco 237 n.71

Brushford (Devon) 9 n.5, 165

Brussels, Royal Museum for Art and
History (Belgium) 200

Buckfast, Abbot of 141

Buckland-in-the-Moor (Devon) 159
n.45, 162, 164, 168–169, 175

Bull, Georg Andreas 249

Burdon, William 154 n.21

Burford (Oxfordshire) 7

Burgess, William, Alice and Joan 94

Burgundy, Bishop David of 201

Burnham Norton (Norfolk) 49, 77,
80, 89, 99

Burstall (Suffolk) 49

Burton Dassett (Warwickshire) 10,
11, 13

Burwell (Cambridgeshire) 48 n.8

Butley (Suffolk) 49

Busby, Joan 22

Buxton (Norfolk) 49

Bynny, John 145

Bywatter, Thomas 92

Caiaphas 182, 185–186, 198

Cambridge 2

Cambridge, Great St Mary's church
(Cambridgeshire) 28, 48, 53,
140–141, 143, 145, 146

Cambridge, Jesus College
(Cambridgeshire) 53–54

Cambridge, King's College
(Cambridgeshire) 199

Cambridge, Pembroke Hall
(Cambridgeshire) 53–54

Cambridge, St John's College

(Cambridgeshire) 48 n.8, 53–54,
61

Cambridgeshire 27, 46, 48, 56, 61,
70, 155

Campsall (Yorkshire) 15, 16 n. 21,
94–95, 99

Canterbury, Canterbury Cathedral
(Kent) 13, 107, 113

Canterbury, Prerogative Court (Kent)
154

Canterbury, St Augustine's abbey
(Kent) 111

Canterbury (Kent) 199

Canistris, Opicinus de 235 n.59

Capgrave, John 109

Carbrooke (Norfolk) 49

Carhampton (Somerset) 137

Carpaccio, Vittore 222

Carpynter, Thomas 141

Carleton Rode (Norfolk) 49, 66

Cartmel Fell (Cumbria) 9 n.5, 126
n.9, 146 n.22

Carver, Robert 144, 157

Cascob (Powys) 16

Castle Acre (Norfolk) 83, 85, 99

Catalonia 8

Catfield (Norfolk) 100–122

Catherine of Aragon, Queen of
England 155

Cawston (Norfolk) 48, 49, 52, 65, 69,
89, 93, 99

Chagford (Devon) 129

Chamond, John 143

Champagne (France) 199

Charlemagne 111

Charles V, Emperor 208, 210

Chartres, Chartres Cathedral
(France) 177, 188–193

Charsfield (Suffolk) 49

Chelvey (Somerset) 148, 158

Cheriton Bishop (Devon) 159 n. 47,
162, 166 n.56, 168, 170

Cheshire 78

Chester, Alice 24, 125, 144–145,
147

Chester, Henry and Alice 125

Chester, Chester abbey (Cheshire)
107

Chesterfield (Derbyshire) 16
Cheveley (Cambridgeshire) 48 n.8
Chew (Somerset) 142
Chilton (Suffolk) 49
Chivelstone 159 n.45
Christ *see* Jesus Christ
Christchurch priory (Dorset) 81
Christopher, St 144, 177
Chudleigh (Devon) 80, 84, 87, 99, 121, 159 n. 46
Chulmleigh (Devon) 154, 158
Città di Castello, San Francesco (Italy) 236 n.63
Clamp, John and Edmund 90
Clare (Suffolk) 49
Clement (monk at Canterbury) 111
Clericus, Johannes 142
Clerk, Jan de 207
Clun (Shropshire) 89
Coates-by-Stow (Lincolnshire) 11, 13
Cocke, William 145
Coddenham (Suffolk) 49, 84, 99
Coenders, Berend 216
Colebrooke (Devon) 165
Coleridge (Devon) 165
Colles, Robert and Cecily 81
Cologne, Cologne Cathedral (Germany) 182 n. 12
Colton, John 64
Combe Martin (Devon) 127 n.12, 129, 153, 159 n. 47, 161–162, 165–167, 169–172
Combs (Suffolk) 49
Compton (Surrey) 249
Comysbury (Somerset) 145
Congresbury (Somerset) 140
Constable, W. G. 3
Constantine the Great, Emperor 112
Copenhagen (Denmark) 33
Coppo di Marcovaldo 242
Cordia, John and Elizabeth 98
Cornwall 11, 123, 124 n.4, 129, 130–131, 156, 169
Corpusty (Norfolk) 49
Cotton, S. 3
Cove, Thomas 90
Coventry, Holy Trinity church 25 n.48

Coverdale, Miles 72
Cranmer, Thomas 72
Cratfield (Suffolk) 49
Cromer (Norfolk) 89, 99
Cromwell, Thomas 72
Crosse, John 140, 145, 146, 157
Crostwight (Norfolk) 86
Croxton (Norfolk) 90
Croydy, Nicholas 121
Cullompton (Devon) 126, 128, 129, 131, 162, 164, 166 n.56
Cuypers, P. J. H. 204

Dartmouth, St Saviour's church 154, 159 n. 46
Dauntsey (Wiltshire) 10–11, 13, 23, 114 n.46
Daw/Dawes, John 143, 147, 149, 154
David, King 121
Davy, John 147
Dayfote, Thomas 144
Delft (Netherlands) 203 n.30
Denmark 258–261
Dennington (Suffolk) 102
Denston (Suffolk) 10
Deopham (Norfolk) 49, 73, 83
Derwen (Clwyd) 200
Descartes René 41
Desiderius 227 n.27
Devil, The 16
Devon 4, 11, 20–22, 24, 27, 52, 56, 80, 123, 124 n.4, 129, 130–131, 150–175
Dey, Jeferey 94
Dittisham (Devon) 139, 159 n. 46
Dodbrooke (Devon) 159
Dominic, St 229
Donyngton, William 7 n.1
Dorant, Agnes 89 n. 54
Dorant, Beatrice 89 n. 54
Dorant, Isabella 89 n. 54
Dorant, Robert 89
Dordrecht (Netherlands) 203 n.30
Dornebarne, R. 141
Dorset 123, 124 n.4
Draper, Robert alias Parsons 84
Drenthe (Netherlands) 201
Duccio di Buoninsegna 240
Duffy, E. 3

Dunchideock (Devon) 129
Dunstable, Dunstable priory
 (Bedfordshire) 111
Dunstan, St 26
Durham, Durham Cathedral 20, 107,
 114

East Allington (Devon) 155 n.27
East Anglia 2, 10, 11, 21, 26, 27, 30,
 33, 37–39, 41, 45–70, 77, 104,
 107, 130 n.19, 150–151, 155–156,
 158–160, 169–170, 175, 223
East Harling (Norfolk) 34, 49, 121
East Portlemouth (Devon) 27 n.53,
 159 n.45, 160, 162, 164
East Rudham (Norfolk) 121
East Ruston (Norfolk) 82
East Shefford (Berkshire) 9 n.5, 13
Easterein/Oosterend (Netherlands)
 197
Easton in Gordano 143
Edam (Netherlands) 203 n.30
Edgar, King of England 111–112
Edgefield 49, 98
Edmund Ironside, King of England 111
Edmund, St 24, 26, 83, 107, 111,
 114–115
Edward II, King of England 24, 109,
 110
Edward IV, King of England 72–73,
 117
Edward VI, King of England 73–74
Edward the Confessor, St 26, 111, 113
Edward the Martyr, St 114
Eidsfjord (Norway) 250–251, 260
Elberg (Netherlands) 207
Eligius, St 27
Elijah 88 n.49
Elizabeth I, Queen of England 71,
 73, 125
Ellingham (Hampshire) 13
Ely, Isle of 46 n.4
England 2, 7, 9, 27, 40, 42, 71, 75,
 97, 111, 117, 123, 126, 150, 199, 233
 n.53, 247
Enkhuizen 203 n.30, 209–211
Erasmus, St 26–27, 147
Erpingham (Norfolk) 90, 99

Erri, Angelo and Bartolomeo degli
 239–240
Essex 21, 56
Ethelbald, King of Wessex 111
Ethelbert, King of Kent 112–113
Ethelbert II, King of the East Angles
 114
Ethelbright, King of Wessex 111
Etheldreda, St 26
Europe 2, 4, 9, 11, 20, 33, 35
Eustace, St 18, 26
Eve 88
Exeter (Devon) 124 n.4, 153, 161
Exeter, Exeter Cathedral (Devon) 24,
 199–200
Exeter, Priory of St Nicholas 172
Exeter, Royal Albert Memorial
 Museum (Devon) 152 n.13
Exeter, St Mary Steps (Devon) 159
 n.45
Eye (Suffolk) 22, 49, 83, 113
Eynde, Jan van den 201, 205

Farthinghoe (Northamptonshire) 91
Felmersham (Bedfordshire) 89, 99
Ffeyzand, William 157
Fiamma, Fra Galvano 229–230
Filby (Norfolk) 49
Fish, Simon 76
Flamborough (Yorkshire) 200
Flanders 142
Flinders Petrie 70
Florence (Italy) 177–179, 226
Florence, Florence Cathedral (Italy)
 236–237
Florence, Santissima Annunziata
 (Italy) 178, 231 n.40
Florence, Santa Croce (Italy)
 224–225, 230–231, 233, 237
Florence, San Felice in Piazza (Italy)
 231 n.40
Florence, San Marco (Italy) 235 n.62
Florence, Santa Maria del Carmine
 (Italy) 179, 223 n.11, 231 n.40
Florence, Santa Maria Novella (Italy)
 224, 231 n.40, 237, 240–241
Florence, San Remigio 242
Floris de Vriendt, Cornelis 197 n.11

Ford, John 157
Foulden (Norfolk) 49, 69, 99
Foulsham 81
Fox, Richard, Bishop of Winchester 81
Foxley (Norfolk) 27–28, 50, 99
Foxton (Cambridgeshire) 48 n.8
Fraam Manor (Netherlands) 216
France 138, 199–200, 218, 247
Francis, St 221, 241
Frederick II, Holy Roman Emperor 109
Freefolk (Hampshire) 7
Fremund, St 114
Fressingfield (Suffolk) 50
Fribourg (Switzerland) 200
Frisia (Friesland) (Netherlands) 197, 199, 201, 212, 217
Fritton, St Catherine's Church (Norfolk) 38, 50, 67–69, 78, 80, 99, 156
Frye, John 154
Fyerens, Jan 202

Galt, John 90, 91
Garboldisham (Norfolk) 50, 82, 94 n.71
Gateley (Norfolk) 50, 81–82
Gazeley (Suffolk) 53, 143, 145
Gdansk (Poland) 33
Geervliet (Netherlands) 213
Gelderland (Netherlands) 201, 207–208
Gelnhausen, St Mary's Church (Germany) 177, 182–184
Gelyons, William 93
Genoa, Santa Maria di Castello (Italy) 237 n.69
Germany 37, 197, 199–200, 214 n.66, 218, 247, 258
Gerson, Jean 6
Gestingthorpe (Essex) 40
Gibson, Mel 182
Giles, St 147
Gillingham (Norfolk) 98
Giottino 242
Giotto di Bondone 221, 240–241, 243
Gislöv (Denmark) 258

Glarentza (Greece) 232
Glatton (Cambridgeshire) 9 n.5
Gloucester 25
Gloucester, St Peter's abbey 113
Gloucestershire 123, 124 n.4
God the Father 7, 13, 15, 22, 23, 29, 72, 74, 84, 93, 94, 115–116, 178–179, 192–194
Goderd, Roger 154
Golyght, William 144
Gooch, Thomas 61
Goodale, Wat 93
Gooderstone (Norfolk) 50, 65, 84, 99
Gooiland (Netherlands) 208
Gotland (Sweden) 254–255
Gouda (Netherlands) 203 n.30
Grafton Regis (Northamptonshire) 95
Great Britain 197, 200–201, 218
Great Hockham 13, 15
Great Malvern Priory (Worcestershire) 25
Great Walsingham 55
Great Yarmouth (Norfolk) 33
Greccio (Italy) 221, 236
Gregory, St 85–86
Gressenhall (Norfolk) 68 n. 55
Groningen 196–197, 201, 214, 216
Groom, William and Joanna 89
Grundisburgh (Suffolk) 83
Guetaria Lope 142
Guilden Morden (Cambridgeshire) 90, 99
Guillam, John 173–174

Haarlem 204
Haarlem, St Bavo's Church (Netherlands) 202–203, 216
Hagarth, Hein 197 n.11
Hague, The (Netherlands) 205
Halberstadt, Halberstadt Cathedral (Germany) 13 n.15, 20, 241 n.85
Halberton (Devon) 127–129, 133, 135–136
Halford (Warwickshire) 8
Halk (Denmark) 257–258
Hall, M. B. 3
Happisburgh (Norfolk) 50, 105

Harberton (Devon) 159 n. 47, 207
 n.45
Hardley (Norfolk) 50
Hardwick (Norfolk) 50, 158
Harpley (Norfolk) 50
Harrell, Robert 145
Harstong, William 90
Hatherleigh (Devon) 140
Havelberg Cathedral, Havelberg
 (Germany) 177, 179–82, 193
Hawkedon (Suffolk) 50
Hawstead (Suffolk) 50
Heavitree (Devon) 159 n.45, 162, 166
 n.56, 168–169
Hegge (Norway) 250
Heinenoord (Netherlands) 204
Helvoirt (Netherlands) 197
Hemingford Abbots
 (Cambridgeshire) 17
Hempstead (Norfolk) 26, 65
Hennock (Devon) 132, 159 n. 46, 162,
 166 n.56
Herod 192
Henry III, King of England 107–108
Henry V, King of England 109–110
Henry VI, King of England 26, 109,
 117
Henry VII, King of England 107
Henry VIII, King of England 25, 72,
 97, 155, 199
s'Hertogenbosch (Netherlands) 197
 n.8
Het Gooi (Netherlands) 201
Heybridge (Essex) 125 n.4, 140, 143
Heydon (Norfolk) 50, 89, 98
Heydon, Sir Henry 81
Heyward, William 78
Hexham (Northumberland) 114
Higden, Ranulph 110
High Ham (Somerset) 129, 135
Hitcham (Suffolk) 16
Holcombe Burnell (Devon) 157, 159
 n.45, 162, 166 n.56, 167–168
Hollesley (Suffolk) 50
Holm, St Benet of Holm abbey
 (Norfolk) 121
Holne (Devon) 155, 157, 159 n. 47,
 162, 164, 166–168

Holwierde (Netherlands) 197
Holy Ghost 13
Honiton, St Michael's Church
 (Devon) 154 n.21
Hook Norton (Oxfordshire) 13, 25 n.48
Hooker, Richard 125 n.5
Hooper, John, Bishop of Worcester
 125 n.5
Hoorn (Netherlands) 203 n.30
Hopperstad (Norway) 200, 248–249
Hopton, Robert 148
Horla (Sweden) 254
Hornton (Oxfordshire) 15
Horsford (Norfolk) 50
Horsham (Sussex) 21, 23
Horsham St Faith (Norfolk) 50, 82,
 94, 99, 114
Hotte, Thomas and Beatrice 87
Houghton St Giles (Norfolk) 85, 90
Hubberholme (Yorkshire) 90
Huizinge (Netherlands) 216
Hull, John 154
Humphrey, duke of Gloucester 110
Huntingdonshire 46 n.4, 56
Hurum (Norway) 250
Huxham (Devon) 156
Hykks, J. 140
Hyll, Galf. 64
Hylman, J. 140

Ickleton (Cambridgeshire) 8
Ijssel (Netherlands) 201
Inglesham (Wiltshire) 13
Ipplepen (Devon) 82, 159 n. 46
Ipswich, St Matthew's Church
 (Suffolk) 63–65, 92
Instead (Norfolk) 159
Isabella of England 108–110
Italy 32, 38, 220-245
Ixworth (Suffolk) 50

Jake, William 90
James the Less, St 68
Jenowr, John 12 n.12
Jeremias
Jerome, St 27, 86
Jerusalem, Mount of Olives 179
Jesus Christ 7, 8, 13, 15, 17, 18, 21, 22,

29, 74, 83–86, 91, 95, 96, 101, 103, 104, 107, 110, 111, 115–117, 145, 178–180, 182, 184–187, 189, 191, 193, 197–198, 202, 204, 210–211, 215, 217–219, 221, 230, 240, 242 n.94, 243, 247, 249, 253, 256
Jevan, Matthew ap 81
John Barleycorn 93
John the Baptist, St 18, 24, 35
John the Carver 158
John the Evangelist, St 8, 13, 16, 18, 46, 84–85, 92, 115, 143 146 n.22, 180, 182, 184, 210, 249, 256
Jonys, David 148, 157
Joseph, St 87–88, 189, 191
Judas Iscariot 185–187
Julian of Norwich, St 27
Jutland (Denmark/Germany) 252, 256

Kampen (Netherlands) 211
Kelshall (Herfordshire) 98
Kemeys Inferior (Monmouthshire) 126, 146 n.22
Kempley (Gloucestershire) 8
Kempston (Bedfordshire) 88
Kenelm, St 113
Kenn (Devon) 159 n.45
Kennemerland (Netherlands) 203
Kent 12, 21, 23
Kentisbeare (Devon) 128
Kenton (Devon) 80, 84, 99, 130, 157, 159 n. 46, 200
Kersey (Suffolk) 50
Kettering (Northamptonshire) 28, 94
Kimswerd (Netherlands) 217
King, Richard and Annete 89
Kings Lynn (Norfolk) 33
Kingsteignton (Devon) 159 n.45
Kingston (Cambridgeshire) 13, 14
Kingston Lacy (Dorset) 113
Kinn (Norway) 253–254, 258
Kotor (Montenegro) 232–233
Kotzenbüll (Germany) 200
Krewerd (Netherlands) 196

Lalaing and Hoogstraten, Antoine de 208

Lapaccini, Fra Giuliano 235 n.62
Lapford (Devon) 127 n.12, 137
Lanreath (Cornwall) 164
Latchingdon (Essex) 21
Lavenham (Suffolk) 50
Lawrence, St 24
Layham (Suffolk) 50, 60 n.32
Laxfield (Suffolk) 50
Lazarus 86–87
Lazio (Italy) 227
Leegkerk (Netherlands) 196
Leermens (Netherlands) 196
Le Faouët, Saint-Fiacre (Brittany, France) 165
Leiden (Netherlands) 204
Leiden, St Peter's Church (Netherlands) 202–203, 215
Leland, John 25
Leonard, St 168
Leonardo da Vinci 31
L'Épine, L'Épine Cathedral (France) 199
Lessingham (Norfolk) 50, 65, 67–69
Lewes (Sussex) 18
Lincoln (Lincolnshire) 18, 200
Lincolnshire 21, 23, 95
Lindsey (Suffolk) 50
Liskeard (Cornwall) 143
Litcham (Norfolk) 50
Little Abington (Cambridgeshire) 48 n.8
Little Gransden (Cambridgeshire) 48 n.8
Little Harvey Farm (Devon) 152 n.15, 163, 172–173
Littlehempston 152 n. 14, 164
Llaneilian (Gwynedd) 200
Llanelian yn Rhos (Clwyd) 18–19, 23, 26
Llanelieu (Powys) 9 n.5, 11
Llanfair Waterdine (Shropshire) 81, 89
Llanfilo (Powys) 16
Llangeview (Monmouthshire) 16
Llangwm Uchaf (Gwent) 200
Llannano (Radnorshire) 24, 200
Locarno (Italy) 233
Loddon (Norfolk) 50, 67–68

Lombardo, Pietro 244
Lombardy (Italy) 245 n.104
Lomen (Norway) 250
London 109, 111
London, Charterhouse 7 n.1
London, Old St Paul's Cathedral 107, 112–113
London, St Mary at Hill 73
London, Victoria & Albert Museum 152 n. 13, 159 n.45, 163, 168–169
Longinus 13
Long Melford (Suffolk) 22, 24, 79
Loveday, Thomas 40, 53, 61
Lübeck (Germany) 211
Lucius, King of the Britons 111, 113
Luke, St 41, 210
Lutma, Jan 217
Lütticke, Johann Jacob 187
Ludham (Norfolk) 11, 12, 13, 28, 50, 65, 89, 98, 106
Lydgate, John 27, 114
Lyon (France) 18
Lyon, Richard 20, 27, 29

Maassluis (Netherlands) 218
Maastricht (Netherlands) 196
Magdalene, St Mary 86–87, 147, 179–182
Magi 85, 191–192, 198 n.14
Maiano, Benedetto da 237
Malchus 186
Mallion, Jean 188
Malpas (Cheshire) 89
Mamhead (Devon) 159 n.45
Manaton (Devon) 130, 152, 159 n.45, 162, 164, 166 n.56
Marco, Francesco di Marco Datini 241
Mare, Thomas de la, abbot 113
Mark, St 85, 210
Marker's Cottage (Devon) 152 n. 15, 163, 172–174
Marsham (Norfolk) 50, 65, 69
Marston Moretaine (Bedfordshire) 10, 84, 98
Marsum (Netherlands) 214
Martin, Thomas 73, 90
Martyn, Roger 22, 24

Martyn, Thomas 154 n.21, 160
Marwood (Devon) 81, 126, 155
Mary, Virgin see Virgin Mary
Mary I, Queen of England 13, 71, 73, 90
Mary of Hungary 208
Mason, Henry 147
Matthew, St 68, 85, 210
Mattishall (Norfolk) 50, 84, 99
Mechlin (Netherlands) 201–202, 205, 211
Medemblik (Netherlands) 203, 216
Mei, R. 141
Melbourn (Cambridgeshire) 48 n.8
Melchisedek 198 n.14
Mercury 44
Mere (Wiltshire) 140
Methwold (Norfolk) 89
Michael, St 18, 144, 146, 240
Michelozzo 235 n.62
Midlands 21, 84
Mijnsheerenland (Netherlands) 205, 208
Milan, Sant'Eustorgio (Italy) 229–230
Mint, No. 21 The 152 n.15, 163, 172, 174
Mirk, John 8, 29
Mitcheldean (Gloucestershire) 96
Mochdre (Montgomeryshire) 126
Modena (Italy) 193, 226 n.21
Modena, San Domenico (Italy) 239 n.79
Monnickendam (Netherlands) 203 n.30, 211–212
Monselice (Italy) 225–226 n.21
Montacute (Somerset) 141
Montecassino (Italy) 227 n.27
Mons, Notre-Dame du Val des Écoliers (Belgium) 200
Montaigne, Michel de 31–32, 40
Montano d'Arezzo
Moses 211
Mydwynter, W. 141
Mylor (Cornwall) 82

Naaldwijk (Netherlands) 205
Naarden (Netherlands) 208–210

Naumburg, Naumburg Cathedral (Germany) 3, 22, 177, 184–185, 187–188, 193
Nayland (Suffolk) 83
Nederhorst den Berg (Netherlands) 212
Neell, John 89 n. 54
Netherlands 37, 195–219
Nettlecombe (Somerset) 140
Newbourne (Suffolk) 50
Niccolò, Arrigo di 241
Nicholas, St 83, 103
Nijmegen (Netherlands) 216
Nisse (Netherlands) 205
Noordwijk-Binnen (Netherlands) 217
Noordwolde (Netherlands) 216–217
Nordhackstedt (Germany) 258–259, 261
Norfolk 2, 3, 13, 15, 20–24, 32, 46, 48, 55, 56, 58, 60–63, 67, 70, 73–74, 81, 90, 92, 97, 101, 150–151, 155, 160, 164, 170, 175
Norfolk Museums and Archaeology Service 68 n.55
Northamptonshire 27
North America 2
North Bovey (Devon) 130, 135
North Burlingham, St Andrew (Norfolk) 50, 65, 80, 97
North Crawley (Buckinghamshire) 22–23, 84, 98
North Elmham (Norfolk) 50, 60, 89
North Holland 201–202, 205, 213, 216
North Huish (Devon) 132
North Petherwin (Cornwall) 140, 156
North Walsham (Norfolk) 92, 97
Northern, Robert 53
Northrepps (Norfolk) 50, 89
North Tuddenham (Norfolk) 50
Norton Fitzwarren (Somerset) 137, 154
Norway 247, 259–260
Norwich 46 n.4, 67, 83, 101
Norwich, Chapel of the Field 53
Norwich, St Augustine's Church 32
Norwich, St Michael at Plea 62
Norwich, St Peter Hungate Church 32, 68

Norwich, St Peter Mancroft Church 110–112, 114
Nottinghamshire 78
Novara (Italy) 245 n.104
Nymet Tracey see Bow

Offa, King of Mercia 112
Offton (Suffolk) 50
Olaf 111, 113
Oldham, Hugh, bishop of Exeter 155
Old Solbe 148
Olney (Buckinghamshire) 88 n.49
Oosterend (Netherlands) see Easterein
Oosthuizen (Netherlands) 213
Ørslev (Denmark) 256
Otterden (Kent) 23
Osmonds Farmhouse 152 n.15, 163, 172–173
Oswald, St 25, 111, 114
Oswin, St, King of Bernicia 113–114
Overijssel (Netherlands) 201, 211
Oxford, All Souls College (Oxfordshire) 109
Oxfordshire 56

Padua (Italy) 226 n.21
Padua, San Francesco Grande (Italy) 234 n.56
Painter, Anthony 157
Palmer, Jack 139
Pares, John 143, 147, 149, 154
Paris, Matthew 113–114, 117, 249, 253
Paris, Musée du Louvre (France) 191 n.33, 193 n.43
Passignano, San Michele (Italy) 229 n.31
Patrishow/Patricio (Radnorshire) 24, 200
Paul, St 25 n.48, 84
Payhembury (Devon) 129
Pelliton, James 154
Penshurst (Kent) 17
Pertenhall (Bedfordshire) 98
Perys, William 144
Peter, St 25 n.48, 29 n.59, 82, 180, 185–187
Peterborough, Soke of 46 n.4

Peter Tavy (Devon) 159 n.45
Philip, St 68, 170
Philip the Carver 199
Piacenza, San Lorenzo (Italy) 236
 n.66
Pichgar, Sir Matthew and Meuruc
 89–90
Piedmont (Italy) 245 n.104
Pilate, Pontius 182, 186, 198
Pilton (Devon) 127–128, 137, 154, 159
 n. 47, 160, 162, 166 n.56, 171
Pilton (Somerset) 140, 146, 148,
 157–158
Pisa, San Francesco (Italy) 240, 244
 n.102
Pistoia, Fra Giovanni da 232
Pistoia, Pistoia Cathedral (Italy) 242
Ploubezre, Chapel of Kerfons
 (Brittany, France) 165
Plouvorn, Chapel of Lambader
 (Brittany, France) 165
Plymouth, St Andrew's Church
 (Devon) 154 n.21
Plymtree (Devon) 113, 127 n.12, 159
 n.45
Pomposa (Italy) 227 n.27
Ponzano Romano, Sant'Andrea in
 Flumine (Italy) 227–230
Poortugaal (Netherlands) 207
Poringland (Norfolk) 84, 88, 106 n.17
Potter Heigham (Norfolk) 50
Powderham (Devon) 159 n. 48
Prato (Italy) 241
Priziac, Chapel of Saint-Nicholas
 (Brittany, France) 165
Puella Ridibowne
Pugin, A. W. 2
Pynning, Robert and Margaret 89

Quintillian 5

Raddington (Somerset) 128
Rant, Christopher 94
Ranworth (Norfolk) 50, 59, 65, 67,
 80, 170
Raunds (Northamptonshire) 13–15,
 87–88
Redcliffe (Avon) 142

Reinli (Norway) 249
Resterhafe (Netherlands) 200
Reynes, Robert 95
Rhenen (Netherlands) 196–197
Ringland (Norfolk) 84, 98
Ripon (Yorkshire) 200
Risby (Suffolk) 51
Robert of Bury, St 90
Rogere, John 7, 8, 15, 20
Rome (Italy) 75
Rome, Santa Sabina (Rome) 229–230
Ropsley (Lincolnshire) 92 n. 66
Roriczer, Matthias 41
Rotterdam (Netherlands) 201,
 204–205, 207, 213, 217–218
Rouen, France 138 n.20
Russia 2
Rygge (Norway) 251–252
Rynd, J. 141

Saenredam, Peter 197 n.8
Salisbury (Wiltshire) 124
Salisbury, Salisbury Cathedral
 (Wiltshire) 107
Salle (Norfolk) 69, 82, 84, 99
Salmon, John and Cycyly 28–29
Salthouse (Norfolk) 51, 81, 98
Sansedoni, Blessed Ambrogio 239
Savona, San Domenico (Italy) 232
 n.47
Savonarola, Fra Girolamo 236–237
Sansepolcro, Sant'Agostino (Italy) 236
 n.65
Sansepolcro, San Giovanni
 Evangelista (Italy) 229
Sativola, St 26
Scandinavia 4, 8, 9, 11, 199, 246–261
Scania (Denmark) 258, 260 n.36
Schleswig 257–258
Schoonhoven (Netherlands) 198–199
Schorn, John 25 n.46
Sebastian, San 142
Sebenico, Giorgio da 234–235
Sebert, King of Essex 112, 113 n.42
Seething (Norfolk) 83
Selwood Forest (Somerset/Dorset/
 Wiltshire) 140, 158
Sergeant, William 146

Shelton (Norfolk) 51
Sherford (Devon) 135, 137–138, 159 n. 46, 161–162, 165–166, 171–172
Shilton, Sir John 149
Šibenik, Šibenik Cathedral (Croatia) 234
Sidwell, St 151
Siena (Italy) 226
Siena, Sant'Agostino (Italy) 236 n.63
Sigebert, King of Essex 112
Silvester, St 90
Simeon, St 191
Simon, St 157
Sitha, St 27
Smarden (Kent) 73
Smyth, Jenkin 145
Snetterton (Norfolk) 51
Snow, C. P. 1, 4
Soham (Cambridgeshire) 48 n.8
Somerset 124 n.4, 129, 130, 138
Sotterley (Suffolk) 51, 85
South Burlingham (Norfolk) 38, 67–68
South Cerney (Gloucestershire) 8, 126
Southcote, Walter 155
Southampton (Hampshire) 142
South Holland 198, 201–202, 217
South Milton (Devon) 159 n.45
South Pool (Devon) 162, 164–165
South Walsham (Norfolk) 51, 90, 91
Southwell (Nottinghamshire) 200
Southwold (Suffolk) 51, 59, 63–65, 80, 82, 87, 121, 159, 170
Souzdal, Abram of 177–179, 231 n.40
Spain 199 n.19
Sparham (Norfolk) 80, 87, 99
Sprowston (Norfolk) 51
Spycer, John and Alys 7 n.1
Stabbe, W. 142
Stainer, Nicholas 157
Stambourne (Essex) 92, 99
Stånga (Sweden) 254–255
Stanton Harcourt (Oxfordshire) 248
Staunton (Nottinghamshire) 89, 99
St Buryan (Cornwall) 137
St Columb Major (Cornwall) 143
Stendal (Germany) 22, 200

St Erth (Cornwall) 53
St Kew (Cornwall) 146
St Sidwell's Artworks 139
Stephaton 13
Stephen, St 24
Stibbard (Norfolk) 51
Stibi, Johannes 147
St Margaret's (Herefordshire) 16, 24
Stoke by Nayland (Suffolk) 51
Stoke Dry (Hampshire) 81
Stoke Gabriel (Devon) 82, 159 n. 46
Stradishall (Suffolk) 169
Strasbourg, Musée de l'Oeuvre Notre-Dame (France) 191 n.33, 193–194
Stratford-upon-Avon (Warwickshire) 9 n.5
Stratton (Cornwall) 125, 129, 140–141, 143, 144, 146–147, 149, 154–155
Strensham (Worcestershire) 21–25
Steyngale, William 121
Sudbury (Suffolk) 61
Sudbury, St Gregory (Suffolk) 51
Suffield (Norfolk) 51
Suffolk 20–22, 46, 48, 55, 56, 58, 60, 61, 63, 67, 70, 84, 138 n.20, 150, 155, 160, 170
Sunham, William 81
Suntak (Sweden) 254
Sussex 56
Swafield (Norfolk) 51, 66
Swaffham (Norfolk) 92, n.66
Swann, William and Joanna 90
Swanton Abbot (Norfolk) 51, 160
Sweden 247, 253–254, 259
Swine (Yorkshire) 78, 89, 92
Swymbridge (Devon) 127 n.12
Sygate (Norfolk) 93

Tacolneston (Norfolk) 51, 59
Tavistock (Devon) 140, 145
Taylour, John 64
Tempsford (Bedfordshire) 140–141
Ter Apel (Netherlands) 196
Thame (Oxfordshire) 15
Thecla, St 167
Theophrastus 31
Thetford 34
Thetford, St Cuthbert 96

Thetford, St Peter 84, 99
Thomas, St 68, 87, 149
Thomas Becket, St 26, 92, 97, 103
Thompson (Norfolk) 83
Thornham (Norfolk) 51, 77, 80, 84,
 87, 99, 138 n.20
Thornham Parva Retable 2, 34
Thorpe-le-Soken 93, 99
Thriplow (Cambridgeshire) 53, 143
Thurcaston (Leicestershire) 248
Thurleigh (Bedfordshire) 17
Thwaite, All Saints (Norfolk) 38,
 67–69
Ticino (Italy) 233
Tikøb (Denmark) 255–256
Tillemans, Peter 88
Tingvoll (Norway) 252, 259, 261
Tintinhull (Somerset) 125, 127,
 140–142, 144–145, 147–148, 153,
 157
Titian 244
Tiverton (Devon) 154 n.21
Tivetshall (Norfolk) 51
Tjebbeszoon, Klaas 213
Torbryan (Devon) 152, 159 n.45, 161,
 163, 166, 171–172
Torpo (Norway) 249–251, 260
Totnes (Devon) 154
Trent, Council of 243
Trondenes (Norway) 260 n.36
Troston (Suffolk) 51
Troyes, Ste Madeleine (France) 199
Trull (Somerset) 140, 142, 145
Trunch (Norfolk) 38, 48, 51, 67–68,
 99
Tunstead (Norfolk) 10, 46, 51, 61,
 65–66, 83
Turin (Italy) 227
Turner, Dawson 86
Tyndale, William 75–76
Tynemouth, Tynemouth priory (Tyne
 and Wear) 113

Uffculme (Devon) 127, 129, 133–134,
 152 n.14, 163–164, 166 n.56, 171
Ugborough (Devon) 159 n.45
Uggeløse (Denmark) 255–256, 259
Uncumber, St see Wilgefortis St

Ungot, William 90
Uphill (Somerset)
Upper Sheringham (Norfolk) 24
Upton (Norfolk) 51
Urith, St 26, 151
Utrecht (Netherlands) 196, 197 n.8,
 204 n.36, 206–207, 212
Utrecht, St James' Church
 (Netherlands) 206–207
Utrecht, St Peter's Church
 (Netherlands) 197 n.8

Vallance, A. 3
Veneziano, Domenico 224
Venice (Italy) 226 n.21
Venice, Sant'Antonio in Castello
 (Italy) 222
Venice, Santa Maria Gloriosa dei
 Frari (Italy) 227, 244–245
Venice, Santa Giovanni e Paolo
 (Italy) 245 n.103
Verona (Italy) 226 n.21
Vezzolano (Italy) 227–228
Virgin Mary 13, 15, 16, 18, 23, 46, 76,
 83–84, 91–92, 94, 103, 115, 143,
 145, 146, 160, 172, 178–180, 182,
 184, 189, 191, 193, 202, 207, 240,
 249, 256

Wakelyn, John 149
Walberswick (Suffolk) 51
Wales 7, 9, 24, 200
Wall, Thomas and Alice 83
Walsham-le-Willows (Suffolk) 51
Walsingham 73–74
Walstan, St 26
Walters, John 102–103, 106
Warkworth (Northamptonshire) 95
Watlington (Norfolk) 51
Weasenham, All Saints (Norfolk)
 85–86, 98
Weesp, St Laurence's Church
 (Netherlands) 205–206, 215
Wellemans, Gregorius 202
Wellingham (Norfolk) 51, 89, 99,
 160
Wellington (Somerset) 154 n.21
Wells (Somerset) 124 n.4

Wells, Wells Cathedral (Somerset)
 107
Wenhaston (Suffolk) 11, 12 n.12, 18,
 23
West Country 10, 24, 37, 80, 123–149,
 151
West Worlington (Devon) 137, 138
 n.20
Westhall (Suffolk) 51, 58, 68, 82, 99
Westminster Abbey 2, 13, 110, 171
Weston Longville (Norfolk) 20, 27,
 51, 80, 84, 98
Westwick (Norfolk) 61–63, 156
Whimple (Devon) 159
Whissendine (Rutland) 48 n.8, 53
Wickmere (Norfolk) 84, 90
Widecombe in the Moor (Devon)
 159 n. 47
Wiggenhall St Mary the Virgin
 (Norfolk) 51, 159–160
Wilgefortis, St 26
Willand (Devon) 128, 152 n.14, 163,
 166 n.56, 168–170
William of Norwich, St 26
William I, King of England 107
Wiltshire 21, 124, 130, 137
Winchester (Hampshire) 81, 200
Wingfield (Suffolk) 51
Wisse, Engelbrecht Willemsz 203
Wiveton (Norfolk) 51, 55
Woel, Alex van der 205 n.37

Wolborough (Devon) 82, 128, 130,
 159 n.45
Woodbridge (Suffolk) 51, 63–64, 90,
 99, 114
Woodcarver, Stephen the 202
Wood Eaton (Oxfordshire) 17
Woolpit (Suffolk) 51
Worcester 25, 124 n.4
Worcester Cathedral, Worcester
 (Worcestershire) 109, 115
Workum (Netherlands) 212, 213 n.60
Worstead (Norfolk) 26, 51, 78, 87, 89,
 93–94, 99
Wrexham (Clwyd) 18
Wyverstone (Suffolk) 51

Yates, Simon 89
Yatton (Somerset) 24, 140–143,
 144–149, 157–158
Yaxham (Norfolk) 51
Yaxley (Suffolk) 58
Yelverton (Norfolk) 51, 87, 99, 138
 n.20
York (Yorkshire) 25, 200
York Minster (Yorkshire) 107, 109
Yorkshire 33, 78, 95, 164

Zadar (Croatia) 234
Zandeweer (Netherlands) 216
Zeeland (Netherlands) 205
Zeno, St 243

ALREADY PUBLISHED

The Art of Anglo-Saxon England
Catherine E. Karkov

English Medieval Misericords: The Margins of Meaning
Paul Hardwick

English Medieval Shrines
John Crook

Thresholds of Medieval Visual Culture: Liminal Spaces
Edited by Elina Gertsman and Jill Stevenson

*The Marvellous and the Monstrous in the Sculpture of
Twelfth-Century Europe*
Kirk Ambrose

Early Medieval Stone Monuments: Materiality, Biography, Landscape
Edited by Howard Williams, Joanne Kirton and Meggen Gondek

The Royal Abbey of Reading
Ron Baxter

*Education in Twelfth-Century Art and Architecture:
Images of Learning in Europe, c.1100–1220*
Laura Cleaver